SIQUEIROS

His Life and Works

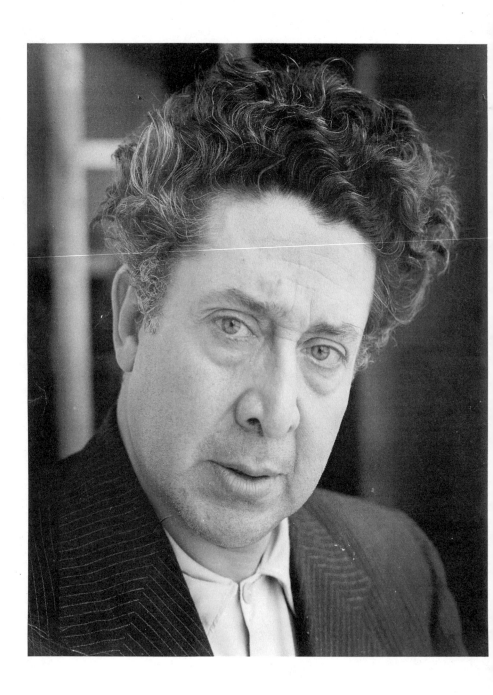

SIQUEIROS

His Life and Works

PHILIP STEIN

INTERNATIONAL PUBLISHERS, New York

DEDICATION

to "G.G."

Acknowledgements on page 372 and credits on
p. vi constitute an extension of the copyright page.

Library of Congress Cataloging-in-Publication Data

Stein, Philip.
 Siqueiros : his life and works / Philip Stein.
 p. cm.
 Includes bibliographical references and index.
 ISBN 0-7178-0709-6 (cloth) : $49.50. -- ISBN 0-7178-0706-1 (pbk.)
 : $29.95
 1. Siqueiros, David Alfaro. 2. Painters--Mexico--Biography.
 I. Title.
 ND259.S56S74 1994
 759.972--dc20
 [B] 94-20194
 CIP

CONTENTS

Black and white Figures section follows p. 86
 [] Figure numbers in bold brackets in text
List of Color Plates follows p. 178
Color Plates 1–83 follow list

Photo Credits:
 b & w figures: Juan Guzman, 20, 21, 22, 32, 35, 39
 John Roberts, 23, 24, 34, 36, 38, and frontispiece
 Jacqueline Roberts, 25, 26, 27, 28, 29, 30, 31

 plates: Juan Guzman, 9, 42
 John Roberts, 49
 Guillermo Zamora, 19, 55, 56, 58

Preface

In the years after the death of Siqueiros in 1974, in spite of his unquestioned artistic achievements, little notice had been taken of him by writers in the field of art. With the exception of Mario de Micheli, the articles of Raquel Tibol and a number of brief monographs by Mexican and American writers, Siqueiros's importance and place in 20th century art has been largely ignored.

Siqueiros was a painter of socialist conviction who, in his leadership of the Mexican Mural Movement, confronted the schools of abstract art rooted in capitalism. A force so strong and influential as that led by Siqueiros was dangerous and had to be halted, at least if the predominant culture had any say in the matter. Yet, in spite of a literary art criticism blackout, especially in the United States, the genius and technical ability that his works revealed could not be denied: taking the top honors at the Venice Biennial in 1950,* and the creation of his final spectacular mural, *The March of Humanity.* Of course, there was his politics; he was a dedicated Marxist-Leninist throughout his life. How could he dare to mix politics with "art"? How could he, Mexico's greatest portrait painter, organize the miners' union, march on May Day, then lecture on aesthetic theory for a modern world? Siqueiros was a smoldering creator, one who placed himself in the vortex of the events of the struggling masses that brought such turmoil to the world. The truth that guided him, that made him cry out for his beloved Mexico, had, in its Promethean anguish, sent him headlong into jail at the age of 64, when the State power sentenced him to 8 years. The worldwide protest that followed dislodged him from prison, but only after he had spent four agonizing years in a tiny cell. Yet at his advanced age, unbroken by the harsh experience, he soared to new artistic heights with the murals, *The Mexican Revolution* and *The March of Humanity.* Perhaps the politics of this dangerous Mexican maestro, whose artistic roots lay not only in the works of Masaccio and the masters of the Renaissance, but deeper yet in the great pre-Columbian art works of Mexico, was too much for the reigning culture that some years after his death had, they thought, finally buried all traces of the socialist philosophy of art—an unhappy experience that the dead maestro was spared. But in spite of all attempts to repress the memory of his

*The Venice Biennials have been the most important art shows in Italy, and one of the most prestigious in the world.

work, its influence could not be smothered. Younger painters across America, taken to painting murals in the streets, have found their greatest inspiration in the work of Siqueiros.

I have brought to these pages the life of no ordinary painter—as all who have known him will attest. An examination of all that he achieved in art could be only the attainments of a philosopher-painter of genius. Working closely with him through the years 1948 to 1958, perhaps his most productive years—12 murals—I was, needless to say, swallowed up by the magnetic emanations of the field surrounding him.

I wish to express by deepest appreciation to Angélica Arenal Siqueiros, who put her trust in this work and offered every assistance possible. Sadly she did not live to see the finished book. My thanks also to Adriana Siqueiros, Siquerios's daughter, whose cooperation was unstinting. And to Ann Warren who edited this work, my deepest gratitude for bravely tackling and clarifying whatever was necessary. Finally, my thanks to the Mahler Fund of the Gray Panthers for the grant which has been an important resource in writing this book.

SIQUEIROS

His Life and Works

1

In the Midst of the Great Lake
They Created Thee[1]

A work of art is a shell that covers a kernel—an idea. Each shell represents the developed style of the practicing artist endeavoring to reveal his kernel idea with some degree of philosophical content. But there are some empty shells.

Two schools of art have stood opposed to each other: the Parisian school—easel painters, representing kernel-less shells, and the Mexican school—the mural painters, representing full shells. This suggests the existence of two kinds of art and two kinds of spectators: "One attaches greater significance to contemplation and the other to feeling."[2]

It was not until the early part of the twentieth century that European artists began to take note of archaeological discoveries in Mexico and other ancient cultures. The Fauves and Cubists, busy experimenting with their own abstractionism, found inspiration in African art and that of the ancient Mexicans. But while the Europeans were nourishing their subjectivist art theories on the "abstract" qualities of Mayan and Aztec art, Mexican artists were coming to realize that the art of their ancestors could inspire their own works in support of the new national spirit that swept over Mexico from 1910 to 1920.

This consciousness was formalized in 1921 when, from Barcelona, David Alfaro Siqueiros—age 24—issued his call to the artists of Mexico to develop a new national art. "Let us," he wrote, "observe the work of our ancient people, the Indian painters and sculptors (Mayas, Aztecs, Incas, etc.). Our nearness to them will enable us to assimilate the constructive vigor of their work, to possess and synthesize their energy without falling into lamentable archaeological reconstruction."[3]

His "Three Appeals to the New Generation of Painters and Sculptors of Latin America for an Approach in Step with the Times,"[4] was a spark that would ignite a new social-aesthetic movement in the midst of the abstract revolution that was taking over all Western art.

Never, Never, Shall it Perish

The history of Mexico is tragic, of monumental proportions, and one must understand it in order better to grasp the significance of the deep

perturbations that molded the modern Mexican school of art. The suffering and grandeur of Mexico's human struggle reached heights as sublime as any human struggle in world history, and from this strife came the potent energy that activated the modern Mexican art movement.

"The men with Columbus saw a few baubles of gold, and that did it. They promptly went berserk, demanding a Midas treasure." The natives were forced as slaves to dig for gold, and "the gentle population was turned into violent enemies."[5] The Antilles Islands Indians lived free of the caste system that affected the Mexicans, and refusing to accept a dominating class, they were wiped out.

The Common Indians of Mexico, the *macehualli,* unhappily, could more easily adjust to the domination of new masters replacing the old. Their fate was sealed. Christian zealots dismantled their civilization stone by stone, put the torch to their codices and forced the Mexicans at swords' points to accept Christian superstitions. They had their strong Nahua culture, with its own explanations of the universe, and were easily led to embrace new ideas of the invisible, with which their tormentors effected their subjugation.

The wily and beguiling Cortés, with a force of about four hundred heavily armed men, including some on horses, was able to conquer and subjugate the alien culture that had put its trust in him, mistaking him for a god from the East. Cortés did not contradict Moctezuma when the Aztec king confessed that he believed him to be the god Quetzalcoatl, who according to prophesy was to return to Mexico that very year.

As Cortés approached Tenochtitlán, Moctezuma began brooding over the return of the god who would usurp his rule. The priests acted to halt the prophesied disaster by offering up increased human sacrifices to Huitzilopochtli, the god who led them, fought all other gods and protected them. For this favor the Aztecs fed Huitzilopochtli the still pulsating hearts of their sacrificial human victims. As more and more hapless Indians were marched to the blood-soaked altar, the antagonisms of the surrounding tribes toward Moctezuma increased greatly.

Three factors brought the Aztec civilization to its dreadful end; in order of importance they were the Spanish firearms, the conflicts among the Indians themselves, and the Quetzalcoatl myth.[6]

As Cortés marched across the country toppling idols and desecrating temples, his cannon created thunder and his horsemen appeared to the Indians to be half human and half animal, filling them with terror. "The Indians believed that the horse and the man were all one since they had never seen horses."[7]

Others had resisted. The Mayans had driven the Spaniards away from the coast of Yucatán a year earlier and did not believe them to be gods. And the Spaniards had already met Indian resistance on the March to Tenochtitlán—a fierce battle had been fought with the Tlascalans, who

slaughtered one of the horses and mortally wounded its rider. A trophy had been made of the horse's hide, and it had been sent on display to different villages.

The Aztecs were ready to resist, if only a word would come from Moctezuma. When he became Cortés's prisoner, his people did rise in insurrection, and it was when he tried to calm them that he died. Just how Moctezuma was killed is not known with certainty. The 16th century Indian historian Fernando de Alva Ixtlilxóchitl wrote: "They say an Indian hit him with a stone, causing him to die; although his vassals say it was the Spaniards who killed him by thrusting a sword into his bowels." His lifeless body was then thrown to the water's edge.[8]

Cuauhtémoc, the last great hero of the Aztecs, now came to center stage. He was Moctezuma's nephew, married to his daughter, Tecuichpo (he 25 and she 16). He was chosen to lead, not after Moctezuma's death but following the four-month rule of Cuitláhuac, Moctezuma's brave and wise brother. Under Cuitláhuac's brief reign—he died of smallpox—Cortés had been driven out of Tenochtitlán, suffering incredible losses. Cuauhtémoc, the new king, was a valiant youth "who made himself so feared that all his subjects trembled before him." Yet he was "of a genteel disposition, as was his body and his features, with a large and pleasant face and eyes more grave than meek."[9] But Cuauhtémoc's hostility toward the Christians knew no bounds, and all those he captured were immediately sacrificed.

The Spanish marauders, following the scent of gold, had entered the land with sword and cross. Sustained by their own religious mythology and displaying superior instruments of war, they were able with a small force to throttle the native civilization, weakened by the debilitating superstitions of the religion they thought sustained them. The mystique of the "White God" dropped away as their resistance began, but neither Cuitláhuac nor Cuauhtémoc's furious last stand could prevent the Indian civilization from sinking into oblivion.

The resistance of "the last Aztec emperor" became for the Mexican people the act that seemed to crystalize all their ancient values and aspirations. Cuauhtémoc became the apotheosis of humankind's struggle against its own predators. The Christians of the technically advanced society destroyed the evolved and evolving Mexican civilization with its characteristics and nature so different from their own. The evil onslaught that brought the downfall of the Aztecs in 1521 seemed inevitable.

Subsequent historical events visited on the original Mexicans ever greater misfortunes, and increasingly the name of Cuauhtémoc was evoked, becoming for both Indian and mestizo the hero-symbol of their liberation, as in Pablo Neruda's poem *Cuauhtémoc:*

Ha llegado la hora señalada,
y en medio de tu pueblo
eres pan y raiz, lanza y estrella.
El invasor ha detenido el paso
No es Moctezuma extinto

como una copa muerta,

es el relámpago y su armadura,
la pluma de Quetzal, la flor del pueblo,
la cimera encendida entre las naves.*

*The appointed hour has arrived,
 and in the midst of your people
 You are bread and root, spear and star.
 The invader you have stopped in his step
 You are not Moctezuma extinguished

 like an empty cup,

 You are the lightning with your armor,
 The feather of the Quetzal, the flower of the people,
 The flaming crest among the ships.

Already Streaked With Blood, I was Born

However, all did not proceed as the conquerors would have wished. The power of Indian blood as it began to mix with that of the conquerors brought forth a new resistance among the people, making them less pliable to manipulation by the Spaniards. The Indian and the Spaniard became the mestizo, tenacious and dominant. Having achieved their own high development and civilization, the Mexicans *were* different. Their "Egyptianism . . . seems to have touched all men and all things in Mexico which accordingly resist the pull of the torrent of universal evolution."[10]

So there stood Cortés with his marauding army, dumbstruck as the splendors of Tenochtitlán—at that time one of the world's largest cities—burst into view. It had a population estimated at 300,000 and presented a dazzling array of gorgeous colors, its temples and buildings polychromed, with flowers everywhere, including on the house roofs. Time has long since worn away the brilliant colors that glorified the Indian temples, but on some ruins residues of the original colors can occasionally be descried. The Aztec capital that so enchanted the Christian soldiers of fortune was a marvel of integrated architectural and artistic city planning.

Dedicated to the creativity of the gods, the cities of the early Mexicans meshed art, architecture and social existence to serve the great "deific presence," the creativity of the union of the earth and its fullness with the heavens above.[11]

The Maya civilization produced *the* classic art. But its culture, the loftiest of ancient America, had long been in decline when the white invaders arrived on the Yucatán coast. What was left of Mayan society, however, would sanction no interchange with the Spaniards and they fought fiercely, resisting all incursions, withdrawing deeper into the interior. The Spaniards pursued them relentlessly to their last sanctuary, Tayasala, the city they had built on an island in Lake Petén-Itzá in Guatemala. Unable to endure more, the Mayas succumbed in a last orgy of blood. The final mopping-up operation by the Spaniards took place as late as March 1697.[12]

The Mayan art possessed a powerful simplicity—refined, delicate and graceful, the work of artists of genius whose names can never be known. Its all-consuming religious theme—the oneness of earth, sky and life—integrally united the goodness of nature and the continuation of life. This social essence, profoundly rooted in the people's lives, would inspire the art that would arise from a future liberating revolution.

The first shipload of Aztec treasures that Cortés sent to Charles V caused a tremor of excitement in all who beheld them. Benvenuto Cellini, astounded by the work he saw, sought in vain to discover how a fish of silver with a delicate inlay of gold had been made. Albrecht Dürer, born into a family of goldsmiths, witnessed the triumphal entry into Antwerp of Charles V in 1521, bringing with him the rare objects Cortés had sent from Mexico. Enraptured, Dürer recorded the event in his diary:

> Further, I have seen things brought to the King from the new golden land: a sun, wholly of gold, wide a whole fathom, also a moon, wholly of silver and just as big; also two chambers full of their implements, and two others full of their weapons, armor, shooting engines, marvelous shields, strange garments, bedspreads and all sorts of wondrous things for many uses much more beautiful to behold than miracles. These things are all so costly that they have been estimated at a hundred thousand florins; and in all my life I have seen nothing which has gladdened my heart so much as these things. For I have seen therein wonders of art and have marveled at the subtle *ingenia* of people in far-off lands. And I know not how to express what I have experienced thereby.[13]

Teocuitlatl was the Nahua name for gold and meant literally, "excrement of the gods." The Spaniards, good representatives of European avarice, frothed at the mouth whenever they smelled its presence. "Columbus must work with the only powerful agent which sets people into motion; it is not even the promise of enjoyment, but the mere greed for gold; he must let the whole curse hold sway."[14]

When the art treasures from Mexico reached Spain they were duly recorded by the royal historian, with the comment, "I do not marvel at gold and precious stones. But I am in a manner astonished to see the workmanship excel the substance."[15] With the exception of a few pieces,

it was all melted into ingot, to pay for the upkeep of Charles V, his army, and the Holy Román Empire defending the Catholic faith in Europe.

Like an Artist he Paints the Colours of All the Flowers

Art played a leading role in the social organization of the ancient Mexicans, and artistic expression was integrally manifested in the daily pursuit of life's needs and survival. There were the massive architectural structures of religious temples, the truncated pyramids called *teocalli,* and the sculptures, all polychromed; the murals; pictographic codexes; the work of goldsmiths and jewel carvers, even the feather-weaving and pottery.

Art served as the vehicle between the reality of earthly existence and the primitive penchant for endowing the universe with a human nature. All art served as a link between the human being and the natural force of the universe. The artist was considered a *yolteotl,* a "deified heart," in the language of the Nahuas.

> . . . after speaking a long time with their heart and understanding perfectly the symbols of their ancient culture, they are transformed in the end into a *tlayolteuhuiani,* a sanctifier of things with their *deified heart;* determined to introduce the symbol of divinity into things: into stone, into murals, in clay, in works of jade and gold. A person capable of making a thing lie, so that without losing its own substance it takes innumerable shapes, of gods, animals, and men.[16]

In this way the artists brought the message of their religion, the *Nahuatl* concept of the universe, to the Indian masses, who might have been incapable of understanding its powerful and complex themes without such assistance.

From the exquisite feather mosaics, made from the plumage of tropical birds with glue extracted from orchids, to the monumental polychromed architecture, art manifestly was for expressing the ideas of the ruling elite. In ancient Mexico these were the superstitions that explained the power that the forces of nature exerted upon humankind. It was a religious philosophy which through plastic expression gave form to the environment of the cities in an aesthetically integrated design. Awesome as the monumental architecture, sculptures and designs appear to the beholder, they all served a fundamental means of educating the Indian masses about the mysteries of existence.

Highly sophisticated and stylistically developed, it was all very effective art. The total polychromed city was an environment that produced a sense of enchantment. Later, critics who had observed sculptures and structures in their colorless, ruined state, spoke of "heavy masses that were unyielding and static," that "embodies the rigidity of death."[17] When parts—details—are examined separate from the whole and without their

original polychrome, the visual experience is incomplete; the aesthetic impact that the overall integrated design would convey is lacking.

The fact is that without metals, without the wheel or draft animals, and with an economy based only on growing corn, beans and squash, the Mexicans "raised a fantastic number of buildings, decorated them with beautiful frescoes, produced pottery and figurines in unbelievable quantity and covered everything with sculptures."[18]

The Toltecs, the Mayas, the Zapotecs and the Aztecs produced a sophisticated, daring, audacious and breathtaking art that equaled the greatest the world had achieved.

> Of the great artisans that design with the use of the pen, and the sublime painters and sculptors whose work we have seen and contemplated, there are three Indians in the city of Mexico so excellent in their work as sculptors and painters . . . that it is said that if they were in the time of the ancient and famous Apelles, or Michelangelo, they would be numbered among them.[19]

The surprise is that Mexican culture had flourished in a relatively small corner of the world without benefit of the thousands of years of evolutionary development that nourished European civilization. The art of the ancient Mexicans had become a haunting inspiration as its mysterious power emanated through the centuries and captivated the modern world. Of these artists—the *tlayolteuhuiani*—the Nahua poet sang:

> *The good painter:*
> *the artist of black and red ink wisdom,*
> *the creator of things with the black water . . .*

> *This good painter, understanding,*
> *with god in his heart,*
> *holds a dialogue with his own heart.*

> *He knows the colours, he applies them, he shades them.*
> *He draws feet and faces, traces the shadows, brings*
> * his work to perfection.*
> *Like an artist*
> *he paints the colours of all the flowers.*[20]

2

Arrows Are Raining and Dust Spreads

Three hundred years of parasitic colonization sapped the strength and will of the Mexican people, following the Spanish conquest in 1521 and the destruction of their indigenous culture. We can touch only briefly on the struggles that molded and tempered the Mexican people, a history that would eventually make them responsive to social art and supportive of the movement that upheld it.

Newly independent in 1821, beset with overwhelming internal problems while seeking to establish and strengthen its own sovereignty, Mexico soon had to face the expansionist drive of its neighbor to the north. The United States sought to take advantage of the turmoil in Mexico, refusing to guarantee its borders and sending in settlers, many of whom owned slaves—although slavery was illegal in Mexico.

Wrote W. Z. Foster: "[A]nother monster land grab, one of the most shameful incidents in United States history, was shaping up in the Southwest. This was the series of events leading to the Mexican War of 1846 and to the stripping of our southern neighbor of one-half of her total territory."[1]

At the beginning of Mexican independence, Secretary of State Clay, claiming that the United States was "intimately interested in the cause of your independence," had sent Joel R. Poinsett, a congressman from South Carolina, to Mexico to see if that country would accept a modification of the boundary with the United States as set by the treaty with Spain in 1819. The true nature of Poinsett's mission was revealed in his coded messages to Secretary Clay: "It seems to me that it is very important to gain time if we want to extend our territory beyond the frontiers accepted by the Treaty of 1819. . . . The State of Texas is being rapidly populated by colonists, usurpers from the United States, a population they will find hard to govern." A few days later his coded message to Washington read, "I think it's of the greatest importance that we should extend our territory to the Del Norte River, as far as the Colorado or at least to the Brazos. We need to have at the frontier a strong race of white colonists."[2]

The Spanish had established numerous towns, missions and military posts in Texas from as early as 1690, but by 1830 its population of 20,000

were mainly North Americans, possessing 1,000 slaves. Under Mexican law, foreigners were forbidden to own land in the area of Mexico that bordered the United States, but that did not stop the invasion by North Americans. In 1836, the white settlers defeated the Mexican Army led by General Santa Anna and set up Texas as an independent country. North American textbooks told of the "Texas Revolution" and the "young Republic," and Texas was quickly recognized by the United States, France, Great Britain, Holland and Belgium. The land grab was completed in 1845 with the annexation of Texas by President Polk, who was elected on a platform of bringing Texas into the Union.

Mexico declared war, but internal weaknesses prevented its being any match for the United States. Military chiefs had control of the treasury, and the Church was concerned with preserving its own wealth and opulence. Meanwhile the Indian population—their own culture lost—lived in ignorance, superstition and poverty, bearing the burdens of extreme exploitation and misery. The country lacked national unity and its resistance was weak.

Texas was wrenched from Mexico even while that nation declared repeatedly that the legitimate rights over the usurped territory would be maintained. When Mexico did attempt to defend its territory, it was informed by the U.S. President that any attempt to invade Texas would be considered an offensive act against the United States. This despite the 1828 treaty between the United States and Mexico, which recognized the border already stated in the 1819 treaty between the United States and Spain.

In exchanges on the subject of Texas, in 1844 the Mexican Secretary of Foreign Relations, Rejon, declared: "The citizens of the United States that have proclaimed the independence of Texas went there not to live submissive to the Republic of Mexico but rather to add it to their country and in this way strengthen the peculiar institutions of the southern states, opening a new theater of the execrable system of the enslavement of the blacks."[3]

The influence of the slave-owning Southerners on their government was enormous, and for them the incorporation of Texas into the Union as a new slave state was urgent, indispensable for increasing their power in the U.S. Congress.[4]

Through deceit, trickery and superior military power, the United States forced Mexico to declare war. General Winfield Scott marched the same route that Cortés had taken 300 years earlier, captured Mexico City, and forced the Mexicans to sign a humiliating peace in 1847. "The intervention ended in a profound sense of loss of dignity and self-respect, laced with fears for the future of the country and a lasting phobia toward all 'interventions.'"[5]

Mexico, invaded and defeated by the United States, was forced to sue

for peace in order not to lose all her territory and thus disappear as an independent nation. The slaveholders and President Polk were eager for total annexation, but were somehow satisfied with gobbling up only all of northern Mexico from eastern Texas through what is now New Mexico, Arizona, Colorado and California. Joining the U.S. slaveholders and President Polk, who declared, "We ought to secure and make fruitful the conquests we have already realized, and in this view, we ought to keep our naval and military forces in all the port cities and provinces that are in our power or will be in our power in time,"[6] were the traitors in Mexico, who wished to have Mexico annexed to the United States, thus preserving their own privileges and interests.

General Sherman, who had been with the American invading army wrote in 1895: ". . . I remember the agitation that was caused by the war with Mexico. The general feeling . . . was that the war with Mexico was intentional, unjust, and started in order to extend the institution of slavery. There is no doubt that this was the object of the war."[7]

Juárez became provisional President in 1858, the first Indian to lead the Mexican people since the fall of Cuauhtémoc in 1521. The reform lasted until 1877 and saw the considerable power of the Church brought against the constitution and the reform laws. The Catholic Church had owned most of the land in Mexico and its income was greater than that of the state. The new constitution and the reform laws separated church and state. Stripped of power, its lands confiscated, the Church and its reactionary allies attacked. It took three years of beastly war before Juárez returned victorious in 1860 to Mexico City. By 1862 England, France and Spain began crawling onto Mexican soil under the guise of protecting their interests. Settlements were reached with England and Spain, but France stayed on, and in 1862 removed the Juárez government. In 1864 the Church, having regained its strength with the help of the French, invited Maximilian to become Emperor of Mexico.

This again led to war. Bitter suffering continued and once again, in struggle, the people triumphed. In 1867 Juárez recaptured Mexico City. "The civil war for the consolidation of the democratic Republic was transformed into a patriotic war against the armies of Napoleon III, who, guided by the Mexican reactionaries, attempted to make Mexico the throne of Maximilian of Hapsburg," wrote Vicente Lombardo Toledano. The war for independence took eleven years, followed by 35 years of struggle to establish a republican regime, a civil war to put down the Church and form a just civil government, and war against the French. "But the Mexican people are indomitable. There surged in them an extraordinary force overcoming their hunger and their anguish, and they found a leader to direct it. At the head, carrying the flag of the country in danger was a pure Indian of genius, Benito Juárez."[8]

Such events of Mexico's past filled the psyches of the twentieth-century Mexican painters, sculptors and engravers—psyches that burst with revolutionary thought, too advanced to be fulfilled, but spilling over from their art and elevating it.

Mexico is a beautiful country with extremely varied terrain, but with considerable geographical disadvantages. "The land itself is certainly one of the hardest to dominate; Only 10 percent can be tilled, and the rest is neither fertile nor level nor well watered. On this 10 percent live and labor more than 50 percent of the Mexicans."[9] Paradoxically, the cultures of pre-white Central America owed their existence to the discovery of maize—"a luscious grass with edible seeds growing on a single ear"—but they also owed their demise to its cultivation.

> It was the holy grain, the *teocentli* of the Aztecs. Its planting and harvest became the occasion for the most solemn sacrifices of the year, for it was the bread of life, and still is . . . The growing of maize can never be wholly a business of the peasant. It is a way of life.
>
> Maize exacts another more insidious tribute from her slaves. It is the most soil-exhausting of crops, and only in the great haciendas and state operated farms is the soil's fertility kept up by massive use of chemicals. In primitive conditions, which prevail in isolated communities, a plot of land *(milpa)* is good for two or three seasons at most, after which it is abandoned for several years. . . . [S]lash and burn agriculture and its wicked sister erosion . . . have been marching side by side in Mexico for thousands of years."[10]

Maize moved further and further up the mountainside, and the land was denuded beyond recovery. Centuries must pass for the decomposition of limestone and the accumulation of humus to create a new layer of soil. Some theorize that soil exhaustion may account for the mysterious collapse of the Maya civilization. Their dependency on corn may explain the massive migrations back and forth, which added greatly to the hardships of their struggle to survive wars, occupations and exploitation.

The war of liberation continued. Maximilian, though kindly disposed to the Mexicans, was a puppet who had been thrust upon them. They would never submit to becoming a French colony. In February 1867, after three years of furious fighting, the unwanted emperor was driven from Mexico City and took his last stand in Querétaro.

After bitter resistance he surrendered and a tribunal decided his fate: on June 10, 1867, he and two of his generals were brought before the firing squad. To the priest accompanying him, Maximilian said, "It is on such a beautiful day that I want to die." To General Miramón, standing at this right, "This is the place of the valiant." To the Mexicans, "I wish to God that my blood will bring happiness to my new Motherland."[11]

Mexico at the end of the nineteenth century was an impoverished country of fifteen million people. Porfirio Díaz, an Indian who had been a

general under Juárez, had seized power in 1876. His rule was long, lasting until he was forced to flee in 1911. As usual, this dictator had ruled for the benefit of the wealthy. Under his leadership one percent of the rural families owned 80 percent of the land. The Church had unprecedented power, and foreign imperialists were invited to operate in Mexico as they saw fit.

The wealthy prospered under Díaz, but for the rest the poverty was appalling. Ninety-five percent of the rural families were landless and the wages of agricultural workers were a daily fifteen to twenty cents. Wages had not changed for two hundred years, but the cost of living had risen by two hundred to five hundred percent. Land speculators moved in, appropriating the *ejidos*—the communal farms that extended back to the time of the Aztecs. The protests this engendered brought a government response of slaughtering the peons. Conspiring with the United States, Díaz warned his people that an uprising would bring a North American invasion. "A ridiculous aristocracy of cruel gentlemen," wrote Toledano, "constituted a new land-owning class. They hated the Indians. As mestizos they admired Europe and turned their backs on Mexico. Their growing wealth was called national progress and was the justification for enforcing tyranny at home."[12] A tyranny enforced by an army that snatched up the poor village youth to supply its manpower and then used that power to dragoon the countryside. As a song of the time went:

> *At the age of fifteen*
> *by a trick they seized me and made me a soldier at*
> *fifteen in Puebla*
>
> *And it did not please me*
> *this road to follow*
> *I deserted*
> *and I fled my home*
>
> *They brought me tied*
> *and bleeding*
> *for the blood*
> *they made gush from the veins*
>
> *Later the court*
> *sentenced me to death*
> *And I yielded*
> *with my sad luck*
>
> *Shoot, comrades*
> *shoot with courage*
> *two in the head*
> *three in the heart.*[13]

In his 1908 book, which contributed greatly to the Mexican Revolution,

John Kenneth Turner wrote that Mexico's appalling misery stemmed from

> the financial and political organization of the present rule of this country; in a word, that which is called the "system" of General Porfirio Díaz.
>
> It's true that these conditions have dragged from past generations through a great part of Mexican history. I do not in any way wish to be unjust to General Díaz; but in spite of the Spaniards making slaves and peons of the Mexican people, never were they experimented with and broken as they have been in the present. In the time of the Spaniards, the peon at least had his small parcel of land and a humble hut; but today he has nothing.[14]

The desire of the Mural Movement artists to bring about anew the integration of art and life had its antecedents in the integrated art of their ancestors, the ancient Mayas and Aztecs. Now, after four hundred years of tragic human drama, the modern Mexican art movement was ready to take shape.

Its setting encompassed the whole of Mexico, whose breathtaking natural beauty was one of extreme contrasts, of verdant fields, snow-capped peaks, lush jungles surrounding ancient cities, and rugged mountains rising from harsh deserts. It was a noble landscape of richly varied forms, all crowded between two seas. Here, in 1911, the violent scenes of the "first" Mexican revolution began. These upheavals of the country's turbulent history would underlie the formation of the cultural force that integrated itself on the side of the people's struggle and became known as the Mexican Mural Movement.

And it is likely that the fortuitous birth of three artistic talents of genius caliber, at a vital time in Mexico's exceptional history, helped so poor and underdeveloped a nation give rise to a powerful 20th century art movement. José Clemente Orozco, Diego Rivera and David Alfaro Siqueiros were all born during the dictatorship of Porfirio Díaz and grew up under it.

3

Siqueiros—in the Beginning

Siqueiros was 22 when he arrived in Europe in 1919. The trip abroad at that time was for the express purpose of continuing his art studies, which had been interrupted when he had joined the Constitutionalist Army in 1914. After his military service he was sent to Europe by the government with his captain's commission still in force to perform minor duties as a military attaché in various Mexican embassies in Europe. Living on his captain's salary in Europe, he could return to the art studies that the Revolution at home had interrupted.

Siqueiros's first two decades had passed with more than their share of tempering experiences. As a child in the state of Chihuahua, José David rode horses in the corrals of Camargo. There, on his grandfather's ranch, not yet in his teens, he helped round up and brand heifers and mules. By the age of fifteen, strong and robust, he was attending art school in Mexico City, and at that early age he participated in the famous strike of art students against the academic teaching methods of the San Carlos Academy of Fine Arts.

A youth full of vitality and exuberance, José David was soon in sharp conflict with his father, Cipriano Alfaro, a well-to-do bourgeois who was a devout Catholic and typically strict. There were sharp clashes between father and son until finally at age 15 the rebellious youth fled, never to return. At 17, with fellow students he joined the workers battling against General Victoriano Huerta's usurpation of the government. And in 1914, not yet 18 years, he entered the Constitutionalist Army to fight on the side of the Revolution.

As an infant, it was to the care of the paternal grandparents—an especially rash and audacious grandfather and an equally gentle and loving grandmother—that José David was entrusted, with his younger brother and older sister. Their mother had died when José David reached the tender age of two. Grandfather Antonio Alfaro Sierra left an indelible mark on him.

This Antonio's father, Anastasio Alfaro, was from Zamora, Michoacán; from his marriage to Luisa Reyes three sons—Antonio, Lugarda and Desiderio—were born. Antonio and Desiderio had fought in the Republi-

can Army of Benito Juárez, and it was Antonio, José David's grandfather, who became a heroic guerrilla fighter against the French. "Siete Filos"— Seven Blades— was the nickname he earned for his daring, cleverness and courage.

Siete Filos fought under General Maríano Escobedo, became a colonel, and took part in the siege of Querétaro that brought Emperor Maximilian to so unhappy an end. Earlier, fighting with Juárez's army, Siete Filos had been captured by the French but managed to escape. It was into this man's hands, and his wife Eusebita's, that the three Alfaro children were thrust. Upon the grandparents would fall the responsibility for their upbringing and education.

Teresa Siqueiros de Barcenas—José David's mother—came from an old Chihuahua family that was thought to have originated either in Galicia, Spain, or in Portugal. Anita Brenner wrote that Siqueiros's "fresh green eyes [were] inherited possibly from a Rumanian Jewish grandmother,"[1] but this has no verification. Siqueiros joked about having a Jewish grandmother, but he was referring to a kindly old Jewish neighbor who helped oversee and care for the children during their mother's illness. It was from his mother that José David was thought to have inherited his dominant characteristics—she came from a family of musicians, poets, actors and romantic adventurers.[2]

Cipriano and Teresa first lived in Mexico City, where they had been married [1] and then went back to Chihuahua, to the town of Santa Rosalia, today called Camargo. There, on December 29, 1896, José David uttered his first cries. His sister, Luz, was already three; a year later he would have a brother, Chucho. After Teresa died, Cipriano arranged to have his parents take the children to their ranch in Irapuato. Siete Filos, the military man, was a strict disciplinarian, but Eusebita countered his approach with her gentle manner. "Eusebita," recalled Siqueiros, "educated with the soft palm of her hand, and Don Antonio with the closed military fist."[3] But this ranch owner, who raised fighting bulls, was a colorful character and he brought constant excitement and stimulation— even overstimulation—to the three children. Siete Filos taught his grandchildren to ride fast horses, and often his idea of fun was to shoot at them as they hid, in terror, behind huge rocks.

Eusebita was Don Antonio's second wife. Much to the children's distress, she died while they were in her care. Not long after, Don Antonio took a third wife, and then an even more exciting life began for the children. José David, Luz and Chucho were taken out of school by carefree Siete Filos and their new, frolicking grandmother to share the pursuit of earthly pleasures with their grandparents. It could be said that Siete Filos was a *real* father to José David. A short while before Siete Filos died in 1927 at the age of 94, Siqueiros visited him and the two posed together for a formal photograph [6].

In 1907, when Cipriano discovered that his children were no longer attending school and were leading a disordered life, he removed them from their grandparents' custody and brought them to live with him in Mexico City. José David was then almost 11 years old. Along with his sister and brother, he was enrolled in the Franco-English School, directed by Marist priests. Fanatically religious Cipriano hoped to guarantee that under the Marist Fathers José David would be properly indoctrinated. But what more profoundly affected the young boy was his first exposure to art—the religious paintings hanging in the school. "To my father," Siqueiros later stated, "I owe my first awareness of the religious painting of colonial Mexico. The names [of painters] Juan Rodríguez Juárez, José Luis Antonio Rodríguez de Alconedo, Miguel Cabrera, the Echaves—both the elder and the younger—etc., all were familiar to me from the time I was very young."[4]

1910—Ferment—A Youth Starts to Paint

The winds of revolution were beginning to blow throughout the entire country in 1910, starting as a gentle breeze when Francisco I. Madero began to question the permanence of the system that had for so long held the country in its deadly grip. Madero had challenged the dictatorship of Porfirio Díaz with the publication in 1909 of his book, *The Presidential Succession in 1910.* It was a time when the wealthy were devouring the land and playing polo. The impoverishment of the masses was merciless as peasants were driven from their communal lands. Bands of insurgents began to appear throughout the country. Horsemen were riding the countryside harassing federal garrisons, cutting railroad and telegraph lines and setting canefields afire. Leading them at the beginning were Pascuel Orozco in Chihuahua and Francisco Villa through the rest of the north, while Emiliano Zapata organized his Zapatistas in the south.

José David was 13; his sister Luz, 17. Already possessed of a rebellious spirit, Luz resisted the religious orthodoxy of her father's home. She was a romantic Maderista and was beginning to exert a strong influence over young David. "The concrete fact," Siqueiros later wrote, "is that it was she, my sister Luz, who began to create in my thinking the idea of rebellion against the chief magistrate of the nation." Carried away with his newly discovered ideals, he timidly muttered to an elegantly attired coachman sitting atop a luxurious carriage the treasonable slogan, "Death to Don Porfirio," whereupon he received a lash from the coachman's whip that sent him howling across the Alameda. This he considered his first act of "suffering for the cause."[5]

In 1910 José Clemente Orozco was 27 and was exhibiting his drawings for the first time. They were in the exhibition of Mexican paintings spon-

sored by the national Academy of Fine Arts to celebrate the centenary of Mexican independence.

When he was seven, Orozco's family had moved from Zapotlán el Grande (now Cuidad Guzmán) in Jalisco, where he had been born, to Mexico City. Only a few steps from the primary school he attended was the printmaking shop of the master engraver and esteemed people's artist José Guadalupe Posada. Even before Siqueiros was born, Orozco and Diego Rivera had fallen under the spell of the great printmaker and separately, as children, they hung around the shop at 5 Santa Ines (now Calle Moneda), peering into the window and watching Posada at work.

José Guadalupe Posada, a Mexican artist of native originality, was born in 1852 and his last works were printed at the beginning of the Revolution. The deft engravings he created illustrated the popular ballads, the *corridos,* and in biting satire depicted the corruption in political life. His prints of the customs, fables, superstitions and jokes that belonged to the people—on cheap colored-tissue broadsheets—enjoyed immense popularity. He was one of the first to be free from foreign influences and he defined the true Mexican character, establishing the roots of the modern Mexican movement.

The sardonic *calavera*—the death's head or skull—found in much of his work—was a symbol that touched the Mexican psyche, finding both morbid and gleeful acceptance. At the end of the 18th century, funeral panegyrics had become so pedantic and ridiculous that they began to be parodied and burlesqued in satirical prints—the *calaveras.* The living delighted in composing verses that were postmortem judgments on important personages, and they sang these *corridos* on November 2nd, the religious holiday for the dead.

In the *calavera,* death continues active, but in its triumph it has lost its power to intimidate. The mystery of fear has disappeared from its image, and it is now the antithesis of that which is dreadful. When justice remains out of reach, the *calavera* evokes ineffable joy. Through his *calaveras* in "The Triumph of Death," Posada revealed the disease of the decadent society.[6]

Posada died in 1913, six years before the beginning of the Mexican mural movement. In one of his last *calaveras* he portrayed General Victoriano Huerta as a death's-head tarantula with a scorpion's tail, devouring other *calaveras.* His place in modern Mexican art can be considered seminal. He was the precursor of its graphic arts movement, and the muralists sought the popular base and social consciousness that his work inspired.

José David was too young to experience personally the inspiration Posada had radiated over Orozco and Rivera. It was a flamboyant and clever house painter and decorator, busy painting the rooms of the Alfaro house, who inspired the young José David. It was then the fashion for

the bourgeoisie to have skies painted on their ceilings, with cherubs and garlands of flowers painted in the corners. When this work began to unfold in the Alfaro household, the "great master" at work on the ceiling cast a spell that so charmed the youth that from that very moment, at the age of 11, he knew he would be an artist.

José David did not let the "great master" out of his sight for a moment while the work was in progress. He took note of the materials used and followed the maestro to the hardware store to watch him buy supplies. So mesmerized was he that he sported a large cravat in an attempt to imitate the affected attire of the house painter and went so far as to feign the lisp that properly belonged to his new-found love.

The local druggist gave him a colored print of Raphael's *Madonna of the Chair,* and with it firm advice that he first study the masters and then work hard to walk on his own feet. The boy promptly set out to paint a much-enlarged copy in oils. It was freely painted, without the usual grid squares, and the result surprised and amazed all who saw it. Soon, at the Colegio Marista Franco-Ingles, he would have his first art teacher, Eduardo Solares Gutiérrez.[7]

No Longer a Bourgeois

In that fateful year 1910, one hundred years after the establishment of Mexican independence, Porfirio Díaz had ordered a super gala celebration to commemorate that centenary and his 30 years of autocratic rule. Independence Day was September 16, and a month long exhibition of Mexican painting had been grudgingly admitted into the festivities. José Clemente Orozco and Diego Rivera were both exhibiting works for the first time, Orozco with drawings and Rivera with the paintings from his first four years of study in Europe.

Originally, art works by Mexicans were to be excluded from the celebrations. The Mexican bourgeoisie denigrated everything of Mexican origin and servilely admired whatever emanated from Europe. No expense was spared by the Díaz regime to import an exhibition of Spanish contemporary painters such as Zuloaga and Sorolla. But that was before Gerardo Murillo (Dr. Atl was his chosen Nahuatl name) raised his voice in protest and spoke out in defense not only of Mexican painting but of the artistic heritage of the original Mexicans. Dr. Atl, ardent in his nationalism and a radical, was the first to admire and support the culture of the Indian race. Born in 1875, he early championed the cause of Mexican national art. In 1906 he had issued a manifesto calling for the creation of a public art, maintaining that the rich were not interested in acquiring Mexican works of art and that only the state could support such production. Of the manifesto, Siqueiros would later write:

. . . [T]his manifesto by Dr. Atl was published just a few weeks after the great strike of the miners of Cananea. . . . One year later, in 1907, the Rio Blanco textile strike took place. In my opinion. . . . The two union events marked the beginning of that transcendant social movement known as the Mexican Revolution. It was in fact with those events that the Mexican Revolution started. . . . The simultaneity of the political and aesthetic events can now be seen. Now, as a consequence of the class struggle, the struggle of the two unions—a manifesto to the painters was produced. Of course, the professional painters and the professors of the School of Fine Arts . . . had no interest in Dr. Atl's manifesto. But it was the university students, we students who were not quite adults, who received the message.[8]

After the successful participation of Mexican artists in the centenary exhibition, Dr. Atl pressed on with his activism and formed an organization called the Centro Artistico, the main purpose of which was to petition the Díaz government to allot walls on which to paint murals. Surprisingly, the request was granted and the auditorium of the national Preparatory School was selected for the first murals. But then on November 20 the revolution began and any possibility that the first murals would be painted in 1910 was destroyed.

In March of the following year, the students at the San Carlos School of the National Academy of Fine Arts began a protest against anatomy professor Daniel Vergara Lope, who refused to permit drawing from live models and from dissected cadavers. At the time Siqueiros was a student at the national Preparatory School, but he was also studying art at the San Carlos Academy in the evening. There, because of the rigid, superficial and academic teaching methods, discontent among the more than three hundred art students ran deep. The attitude of the faculty was one of contempt for the students and it had prevailed at the Academy since it had been founded in colonial times.

On July 28, 1911, the art students declared a strike; a bitter year-long struggle ensued. During the strike the young artists were exposed to the catalyzing effects of the developing Revolution. Porfirio Díaz had been swept out of Mexico to exile in France and Francisco Madero was acclaimed the leader of the Revolution. Francisco de la Barra, Díaz's ambassador to Washington, served as interim president for six months and did his best to undermine Madero's election victory.

The country stumbled into a confusion of rebellions. Diego Rivera, for one, experiencing rueful disillusionment, removed himself from the tumultuous scene; for the next ten years, while Mexico burned, he painted in Paris. With Madero unable to control the nightmare of intrigue and defiance as opposing factions battled for control, the art students were sucked into the maelstrom as they pressed on with their strike.

Repercussions of the growing revolutionary activity in the country and the strike at school were being felt in young José David's home. A recent friendship he had struck up with a young poet was having a special influence. Jesus S. Soto, a delegate from the students of Guanajuato, had come to the capital to lend support to the striking art students. The two became close friends, and Soto, who was later to become governor of Guanajuato, opened 14 year-old José David's eyes to the existence of writing of a political nature: the works of Maxim Gorky and the anarchist Max Stirner.

This awakening intensified the conflict with his father. Cipriano Alfaro's social milieu involved some of the country's wealthiest landowners; it was to him that they entrusted their legal representation. One memorable day Cipriano was entertaining a number of wealthy clients for dinner; they had come together to discuss their concerns about the new land reforms that threatened their huge holdings. José David arrived late for dinner, "provoking a violent look of reproach" from his father. One of the wealthy landlords turned to the youth and said, "so then, Pepe, you are one of those who say, 'What's yours is mine and what's mine is also mine.'" Others chided him too, knowing his role as a striking art student.[9]

Unable to contain himself, José David jumped to his feet and in a trembling voice shouted, "The only thing I know is that all the *hacendados* are a pack of thieves." From the opposite end of the long table his father, now standing, flung a glass at him and shouted for him to get out. A terrible storm of emotion welled up within the youth. Slowly he rose from his chair and walked from the room, then with an explosive gesture he slammed the door, locked it from the outside and dashed up the stairs. In the elaborately furnished rooms, he proceeded to smash everything he could lay his hands on, and in a brief moment he had ripped down curtains, broken antiques and pulled down pictures and mirrors from the walls. He dashed downstairs, out onto the street, and there in a last defiant gesture he picked up stones and hurled them through the windows.[10]

José David took one last look at the astonished faces staring at him through the broken panes, then turned and ran, never to return. Too late had he been subjected to the Catholic dogma and strict discipline of his father's house. With burning youthful ardor, he was determined to stand alone and meet the world head on. He was taken in at the home of a classmate, José María Fernádez Urbina, and that first year on his own, Señora Fernández Urbina became a mother to him.[11]

At the San Carlos Academy, José David marched with the older striking students. On August 29, 1911, the newspaper *El Imparcial* reported that the director, architect Antonio Rivas Mercado, had been pelted with tomatoes and eggs by striking students as he stepped from his car. The students were determined to appeal all the way to the top, to the interim

President of the Republic, de la Barra, demanding that director Rivas Mercado—who had been a member of Porfirio Díaz's inner circle, one of his "cientificos"—be removed immediately.

Leading the Student Strike Committee were José Clemente Orozco, sculptor Ignacio Asúnsolo and Luis G. Serrano, who later invented a method of curvilinear perspective.[12] They drew up a list of demands that paralleled those being made by the workers in the revolutionary struggle. Besides calling for an end to obsolete and ineffective teaching, they wanted free meals, free rooms and free materials; and in solidarity with the Revolution they called for nationalization of the railroads.

To all of this the response of the editor of the newspaper *El País* was unambiguous: "What are these young anarchists thinking of? What devils of art have shown them the nationalization of the railroads? Their fathers should spank them and the police should take action and jail them."[13] The students then called attention to their protest with an exhibition of their work in the city's central park, the Alameda. This first contact with the public through their art imbued their bohemianism with a new sense of urgency.

Their struggle against professors and police continued for a year. The school was shut and two hundred students were arrested, José David Alfaro among them; they were locked in the city jail known as el Carmen—the country house. Nevertheless, the strike continued. When students were assaulted by mounted police, the entire university movement joined in, and the general populace supported the art students.

In time the students won; academism was dropped and a *plein-air* (open-air) school for the study of impressionism was established in the village of Santa Anita on the outskirts of Mexico City [2]. The methods and theories of the Impressionists were new and of great importance to the students of that period, and now they had human figure models. Orozco derided the school at Santa Anita, calling it a "Barbizon" amidst "pulque, cowboys, enchiladas, huaraches, and knife slashings."[14] It was no Barbizon; Santa Anita had its share of the impoverishment that pervaded all parts of the country. Nor could the students, under the tutelage of the Mexican impressionist Alfredo Ramos Martínez, recently returned from France, repeat the idyllic experiences of impressionism's innovators. Their studies were increasingly interrupted by the excitement and political unrest in the country.

In February 1913 a counterrevolutionary blow was struck against the Madero government by his chief of staff, General Victoriano Huerta. The Church, the wealthy, and foreign interests were allied in opposition to the government and took advantage of the general discontent and the warring factions. Madero's relentless attacks on U.S. imperialistic adventures in Mexico were responded to by Ambassador Lane Wilson with greater interference in the country's internal affairs. Wilson selected Vic-

toriano Huerta to smash the Madero government.[15] At the American embassy in Mexico City, "Wilson presented Huerta to his assembled diplomatic colleagues as the savior of Mexico."[16] The ambassador had made direct contact with Huerta through an embassy military attaché.[17]

Thus backed by the power of the United States, General Huerta conspired with counterrevolutionary forces led by Félix Díaz (Porfirio's nephew) to usurp the power of the presidency. Fighting erupted in the capital and from February 9th to 18th, the *Decena Trágica*—the tragic ten days—more than ten thousand people were killed. Madero and Vice-President Pino Suárez were forced from power, then treacherously murdered.

4

Battallón Mamá

The art students were not oblivious to events in the capital. At Santa Anita they were doing their best to concentrate on the study of light and its effect on the landscape but could not escape the news of what was happening in Mexico City. They heard that workers were forming Red Battalions at the Casa del Obrero Mundial—the worker's center founded by the Madero administration. Radicalized since the San Carlos strike, the students began to change the Santa Anita school into a center for anti-Huerta activity, taking up the fight for democracy that the Madero government had attempted to establish.

Of his participation two years earlier at San Carlos, José David was quoted as saying: "I was still a child; all I did was join the bigger boys to see how it was done and throw stones at things and people, hardly more."[1] Now 16 years old, his art studies were again interrupted; he became part of a group led by Alardin, a member of the Chamber of Deputies committed to act against the Huerta coup. José David's task, as he later said, "was invariably that of a combat student at the bottom, that is, the group of students that could shout the loudest and were best at hitting the mark with stones. But nothing more."[2]

A school janitor acted as a guide for the students who wanted to join the Zapatistas. With Mexico City and its environs in the hands of Huerta and his Porfirista generals, escape was dangerous. Three students on their way to join Zapata had been seized on the southern outskirts of the city,

galvanizing a mass of students into action to save them from execution. Over a thousand students broke into the Ministry of Government, scrambled up the stairs, and caught the Minister himself in his office by surprise. And before any alarm could be rung, Siqueiros, in what he called "my first direct revolutionary act," stayed the official's hand. "My fellow students all responded with loud applause for the young meddler, for all . . . were much older. Later, in the tranquility of the patio of our school, my quick act of sabotage against the military dictatorship of Victoriano Huerta elicited most eulogistic comments."[3] Not in vanity did he describe the event but proudly, as an act in his youth early in the Revolution.

Under Madero, to the satisfaction of the students, Dr. Atl had been appointed director of the San Carlos Academy, which had become the National School of Fine Arts. When the Huerta counterrevolutionary blow knocked down the government and murdered Madero, Dr. Atl threw his support behind the governor of Coahuila, Venustiano Carranza, a rich landowner who had served as a senator for 14 years. Carranza was the first important figure to come out against Huerta and was now a Constitutionalist under whom armed resistance to Huerta began.

As rebellion flared up in all parts of the country, a state of confusion arose among the workers of the Red Battalions. Should they follow the peasant leaders, Zapata and Villa, or Carranza the Constitutionalist? in a stirring harangue, Dr. Atl brought them to the side of Carranza. Later the question was asked: "Had the Syndicalists who organized the Casa del Obrero Mundial played a reactionary role by allowing themselves to be used by Carranza against Zapata and Villa?"[4]

While Dr. Atl was busy organizing the evacuation of all willing art students and workers from Mexico City, Huerta's militia uncovered the conspiratorial activity of the students at Santa Anita. The school was wrecked and students were sent fleeing in all directions; five students "disappeared forever."[5] José David Alfaro, as he was still called, and two close friends—sculpture student Juan Olaguibel and aspiring poet Jesus S. Soto—took flight and made their way to Veracruz. It was early 1914 and the city was controlled by Huerta.

In April, David Alfaro and his two companions witnessed the occupation of the port city by U.S. troops. Huerta's Federals had conveniently and quietly removed themselves from the city, leaving the populace unprotected. "The cry went from mouth to mouth," Siqueiros later wrote, "*'Los Gringos estan desembarcando.'* [The gringos are landing]. . . . With our boyish voices, almost crying, we begged for arms along with other youths."[6]

The three youths roamed the streets of Veracruz, seeking romantic adventure, even making an attempt to board a ship for Argentina. But in the end, caught up in patriotic fervor, they enlisted in the forces of the Constitutional Army.

The National School of Fine Arts in Mexico City, where Dr. Atl had been directing his revolutionary artists and workers, was now in the hands of the police. But Atl led the revolutionaries into an underground partisan contingent called *La Manigua*—the bush, or jungle—and they set out to reach Orizaba, on the road to Veracruz. Their purpose was to set up the newspaper of the Constitutional Army, *La Vanguardia*. José Clemente Orozco was with this group and he described the event:

> Convoys of trains were organized carrying the "Casa del Obrero Mundial" en masse to Orizaba. In one freight train the printing presses of *El Imparcial* were sent and in another train to Orizaba went Dr. Atl, some painters, and our friends and families.
>
> On arriving the first thing we did was to assault and sack the churches of the town. The church of Dolores was emptied and in the nave we installed two flat presses, various linotypes, and the apparatus for the engraving shop. The object was to publish a revolutionary newspaper called *La Vanguardia* and in the house of the priest of the church we installed the editorial board. The church of El Carmen was also stormed and the workers of "La Mundial" moved in to live there. The saints, the confessionals, and the altars were made into firewood for the women to cook with, while the ornaments from the altars and the priests we wore ourselves. We all went around decorated with rosaries, medallions, and scapulars.
>
> In another sacked church more presses and linotypes were installed. These for a newspaper that the workers edited. They were the workers who were organized into the first "Red Battalions" that Mexico had and later they fought brilliantly in battles against the Villistas.
>
> While the presses for *La Vanguardia* were being assembled, Atl preached from the pulpit the ideals of the Constitutionalist Revolution and a thousand-and-one projects that he had for changing everything: art, science, journalism, literature, etc.[7]

Siqueiros had a link to *La Manigua* in Orizaba when he was later attached to the headquarters of General Diéguez's *División de Occidente;* his duties, besides fighting the Villistas in Jalisco, included reporting the news from the front to *La Vanguardia*.

But now, while La Manigua guerrillas, under Atl's leadership, were setting up in Orizaba, José David was inducted into Carranza's Constitutional Army in Veracruz. He was placed in the *Battalón Mamá,* named thus for the youthfulness of its recruits, some hardly fifteen, by the older soldiers, who in high-pitched voices teased: "Mamá, mamá, where are you, mamá?"[8]

Outfitted in a regulation green uniform that included a simple straw peasant hat adorned with a red ribbon, the young art student endured the short but intense training in the Veracruz heat. But from there he was sent out on a journey of awakening so consequential that it would strike him like a thunderbolt. Keenly perceptive and at an impressionable age, the sights and life of Mexico that passed before his eyes as he rocked on

the troop train carrying him to war filled him with a sense of wonderment. He would later say:

> Our first exhibition in the street had given us an initial contact with the people. The army however, carried us before the pyramids and the marvelous temples of our extraordinary pre-Hispanic culture. It carried us before our greatest churches of the best periods of the colony, it put us face to face with an extraordinary past that was heretofore unknown to us. Our painting had been European-style landscapes—fundamentally French in character, but we now came in contact with popular art, which in general was despised by all our maestros, by all our professors, and by the men who determined the destiny of the country. Thus we discovered that Mexico had an amazing popular art—perhaps the most rich and varied of the whole world. And it was, I repeat, totally unknown to us.[9]

Besides the variety and originality of the art and architecture that traveling with the army revealed to him, the people's struggle for survival made a deep impression. The tide of war brought him for the first time into direct contact with the Yaqui and Juchitec Indian battalions and with the workers of the Red Battalions.

The train leaving Veracruz was full of boys, newly trained soldiers, as it moved south toward Tehuantepec, its destination. Aboard was the *Batallón Mamá,* and one of its members, José David, sat absorbed and entranced by the lush tropical beauty. As the train neared Tehuantepec, a deafening boom and a violent jolt brought it to a halt. Che Gómez, a famous Juchiteco chief, had attacked, hoping to derail the train and defeat its occupants. However, under the protective fire of the Constitutionalists aboard, the damage was repaired and the train sped off, pursued by Gómez's howling horsemen.

> The striker of San Carlos, that conspirator of Santa Anita against the usurper Huerta, still tender in military questions—tried to "calm the spirits" when the battle happened, screaming in the face of Che Gómez's fire: *"Calma, calma,* 'they are not bullets, they are the lights of tropical fireflies!"[10]

Badly shot up, the train arrived in Tehuantepec with the wounded and frightened youth, and many dead.

A Constitutionalist Soldier

In that summer of 1914, as José David Alfaro traveled south on a troop train to Tehuantepec, the character of the war was undergoing a qualitative change. In July the Huerta dictatorship fell, and bitter fighting broke out among three major factions trying to influence the outcome of the Revolution. Villa and Zapata, with their peasant armies in the north and the south, respectively, faced separate deadly confrontations with General Venustiano Carranza.

Carranza's background was that of the landowning class, but he had the support of the anarcho-syndicalists, workers who had been brought to his side by Dr. Atl and who were not yet ready to unite with the peasant movement. Along with the workers of the Red Battalions, Carranza had the support of intellectuals and liberal politicians. Those who fought with Carranza's forces believed they were preserving the new democratic government. It was thus that the city-bred developing intellectual, Siqueiros, accepted fighting with Carranza's Constitutionalist Army against the agrarian army of Pancho Villa.

The struggle became one of revolutionary factions fighting each other, and though victory finally went to the Carranza forces, it was the Revolution that lost out. Looking back, Siqueiros would write:

> First the battle was against the professional army, the Federal Army led by chiefs and officers educated in the military academies of Europe. Later, unfortunately, it was between ourselves, between revolutionaries over the agreement on a program that would correspond to the fervent demands of the people. It was a bloody struggle, very bitter. It destroyed the country from one end to the other.[11]

As a lowly private in the ranks, Siqueiros first saw action in the states of Veracruz, Chiapas, and Oaxaca; then he went north to Acoponeta in the state of Nayarit. After a year in battle he was commissioned 2nd Lieutenant and attached to the headquarters of General Manuel M. Diéguez, who was commander of the Northwest Division fighting Villa in the north. As a staff officer in the 13th Battalion, commanded by Colonel Melitón Albáñez, Siqueiros, not yet 19, fought against the Villistas in two battles for possession of Guadalajara and through the entire northern campaign. He fought for four years in a war of unrelenting brutality, a war in which prisoners were rarely taken alive. In Diéguez's pursuit of Pancho Villa, Siqueiros saw action in the battles of Sayula, Trinidad, Lagos de Moreno, a final advance on Guadalajara, and the taking of León and Aguascalientes; they afforded Villa no rest through Durango, Chihuahua, Sinaloa and Sonora.

Siqueiros was with General Álvaro Obregón at the Hacienda Santa Ana de Conde near Trinidad in the spring of 1915 when the general's right arm was blown off by a Villista grenade; later he himself received a leg wound at the battle of Lagos de Moreno. Obregón, in his report to Carranza wired from the Jalisco town Encarnación de Díaz on June 19, 1915, described the valor of General Diéguez and the 2nd Infantry Division of the Army of the Northwest, concluding his report with:

> I regret to communicate to you that in this action the left forearm of the brave and worthy General of the Division, Diéguez, Chief of the 2nd Infantry Division of the Northwest, was injured, though fortunately his wound was not grave and he is at present being properly cared for. On receiving more

details of this action it is my honor to inform you that together with General Diéguez, three officers of his staff were lightly wounded: Doctor Uribe, Medical major of his General Staff, and the General's aides, Moran and Alfaro. Our glorious Constitutionalist Army is to be congratulated for this victory. Respectfully, General-in-Chief, Álvaro Obregón.[12]

When the fighting ended, David Alfaro was twenty and had attained the rank of *capitan segundo* [3]. The effects on him of his experiences in the war were crucial and determinative. His youthful revolutionary spirit had gained a philosophical clarity that put him on the road to developing the fundamental political and aesthetic ideas upon which his art would be based. He said:

> The Army of the Revolution brought us to the geography, the archaeology, the traditions—and to the people of our country with their complex and dramatic social problems. Without this participation, it would not have been possible later to conceive and activate an integrated modern Mexican pictorial movement. When the armed struggle had ended we discovered from our youthful discussions of those years 1916–1918 that the traditional bohemian, the "Porfiriano" intellectual of colonial mentality—who invariably was on his knees before the expressions of European culture—had now been definitively substituted, within ourselves, by a citizen artist. A citizen artist interested in human problems and ready to take a fighting stand in the complexity of universal culture.[13]

Released from active duty and with no family ties to speak of, Siqueiros stayed in Guadalajara. In that city of many a bitter battle, a number of art students—now veterans of the civil war—converged and reestablished their ties of comradeship that had been torn apart by the Huerta coup. Flushed with victory, they had great enthusiasm and hopes for the Revolution to fulfill. A happy reunion took place, and the veterans, still art students, exchanged experiences and impressions, and anxiously tried to prophesy what the future held for their artistic careers. It became clear that the initial impetus of the San Carlos strike still inspired them. Siqueiros was outspoken and urged the artists to work seriously for the new order that Mexican society was about to embark upon. A series of meetings, which Siqueiros called the Congress of Soldier Artists, then took place in the Bohemian Center of Guadalajara. Among those taking part in the discussions were José Guadalupe Zuno, Xavier Guerrero, Jorge Stahl and Amado de la Cueva.

The views presented at the Congress of Soldier Artists were positive, full of optimism for the future, a sharp contrast to the cynicism and pessimism that gripped the artists of Europe at the end of World War I. At the meetings in Guadalajara, the Mexican artists poured out their war experiences and examined the political nature of their role. Taking their mission seriously, they published *El Occidental,* a small newspaper to disseminate their ideas.

A new potential for 20th Century art was being revealed, completely different in character from the direction that European art was taking. The Mexican artists, like the Europeans, had been scarred by the devastating experiences of the war, but Siqueiros urged his fellow artists to stand together and commit themselves to support of the Revolution. Soldier-artist José Guadalupe Zuno recalled:

> Already Alfarito's culture in history and art for that time was considerable. In spite of his youth, he earnestly took part in the many conferences and nobody received more attention when he discussed themes that related to methods and questions of form.[14]

The new Mexican constitution promulgated on February 5, 1917, was the most advanced and democratic of any nation at the time, and it inspired those attending the Congress of Soldier Artists, clarifying for them the true nature of their mission. About this beginning Siqueiros later wrote:

> For the first time in Mexico, and perhaps for the first time anywhere in the world of art, we were able to set clear concepts about the true public and social function of the art of Egypt, Greece, the Christian middle ages, pre-Hispanic America, the pre-Renaissance, the Renaissance, colonial Spanish America, etc. That is, an illustrative art as expressed in the Renaissance and corresponding to all the important periods of the history of art. We were then immediately able, more or less, to arrive at conclusions about the private, social, and elitist function of art that belonged to the post-Renaissance or capitalist world, and only to the most economically developed industrial countries. Thus we were able to arrive at judgments about decorative art (having no commitment to divulge ideology or philosophy, but to ornament, adorn, and complement aesthetically) as defined by the Renaissance. Impressions were exchanged by "new men," men in whom the bohemian parasite of the *decorativist* or *art purist* cycle (the last quarter of the 19th century and what passed of the 20th century), had been replaced by the germ, both individual and collective, of the citizen artist, and consequently with a philosophical citizen concept. This new artist, *witness of his time* (to use the recent appropriate expression of the new-realist colleagues of Paris) would open a new *anti-decorativist, anti-formalist* period, and thus a *new-illustrative* movement. Though in a poor semicolonial country (like Mexico) it would however, serve the entire world of today.[15]

The discussions of the soldier artists of Guadalajara had planted the seeds for Siqueiros to develop these thoughts.

In 1918, Pancho Villa had been driven far to the north and was no longer in any position to menace the Constitutionalist Army. Siqueiros, still in the army and supported by his Captain's salary, returned to Mexico City. There he immediately set out to produce a number of small *aquarelles* and drawings, works that represented his first step into the professional art world. Though naturally lacking confidence, he touched

his toe to the water, and his first public showing evoked a positive response. The critic of *El Universal Ilustrado* titled his review (November 15, 1918), "The Drawings of Daniel Alfaro Siqueiros."

Among the known first works to be exhibited was an *aquarelle, El Señor del Veneno, (plate 1)* 59 by 46 cm. Two dominant armed peasant insurgents, who appear to be Zapatistas, stand guard before a crucified black Christ depicted in the background. Enigmatic and executed with great strength of drawing, the figure was, commented Siqueiros, "a Christ changed from a blond Caucasian into a black-green African."[16] *Sugar Skulls* depicts a child of the bourgeoisie jumping rope while a poor Indian child sells candy skulls for the holiday, the Day of the Dead. Another, titled *1919*, is of war-ravaged Europe, with Peace an infant driving a chariot drawn by butterflies.[17]

These early works showed his strong feeling for plastic movement, which had also been expressed in the drawings he did of famous dancers then performing in Mexico City. Two such drawings won first prizes. For one of Pavlova, he was personally presented with a 50-peso gold piece by the great Russian ballerina herself, and for a drawing of Argentinita, the equally great interpreter of the Spanish dance presented him with another sum of money. He was further rewarded by having his drawings reproduced in *El Universal Ilustrado* on January 24, 1919 *(plate 2)*. The human form in movement held great attraction for him, and he made many drawings of dancers, especially of the famous obese Spanish dancer, Tortola Valencia, whose graceful and aesthetic movements of her corpulent body greatly charmed him.[18]

In this early period (1918–19), Siqueiros produced two self-portraits—one pastel and one charcoal [4] —and in oil, portraits of José Luis Figueroa and Carlos Orozco Romero *(plate 3)*. All revealed his exceptional talent as a portraitist. One portrait he did not paint, however, though he had wished to do so—his commanding officer, General Diéguez. After the battle of Sayula, when the officers were gathered at the dining table, Siqueiros offered to paint the general's portrait—when the war was over, of course. But the general had responded derisively, for all to hear: "I'm not going to lend myself for some stupid snotnose to practice on." For Siqueiros, "It was something that wounded me more than anything in my life."[19]

Finding Masaccio

Capitan Octavio Amador and Siqueiros were close friends—both had served in the headquarters of General Diéguez—and their friendship led to Siqueiros's meeting Graciela Amador, Octavio's sister [9]. Graciela was a writer, folklorist, puppeteer and revolutionary. In 1918, Siqueiros at 21 and Graciela, a few years older, were married. Siqueiros's planned

trip to Europe, ostensibly to continue his art studies, would also be their honeymoon.

The artists whose education had been interrupted by military service were now being given the opportunity to resume their studies abroad. Juan de Dios Bojórquez, Minister of the Interior in the new Carranza government, handled matters that affected artists who had fought in the Revolution. He got the commander in chief, General Venustiano Carranza, to sign the order that sent artists—Siqueiros, Ignacio Asúnsolo, Carlos Orozco Romero, Amado de la Cueva and others—abroad to study. Still in the service, each was assigned as a military attaché to a Mexican embassy in Europe, with the stipulation that they attend routine military lectures; otherwise their time could be devoted to art.

En route to Paris, Siqueiros and "Gachita" (as Graciela was called) stopped off in New York to seek out two Mexican colleagues. José Clemente Orozco and sculptor Juan Olaguibel, Siqueiros's boyhood friend, had been in the United States for over a year and were finding life in New York very difficult. Olaguibel was working at a very low wage for a company that turned out wax caricatures of famous personalities, and for equally meager pay, Orozco labored in a doll factory. He was perhaps the first of the Mexican artists to use a spray gun, but for painting the rosy cheeks of plaster "kewpie dolls." Both artists lived in miserable conditions in New York, which so distressed Siqueiros that he spent his travel expenses to make life for his two compatriots a little more agreeable. The telegram he sent to the War Department in Mexico, explaining that he had lost his money, brought the reply: "If you lost it, look for it, and stay there until you find it."[20] In effect, the reply was a military punishment; it was not repaid for six months, and not until then could he continue his honeymoon trip.

The couple now shared Orozco's misery and in desperation took a room in the same house. The period was one of extreme duress; they were penniless, unable to find work, and threatened with eviction. During the interminable wait for the check from Mexico, a bright moment came when the two painters were invited to a fiesta in the home of a rich patron in Brooklyn. With their last coins Siqueiros, his bride and Orozco boarded the subway for Brooklyn. And as always, the conversation of the two painters reflected discord.

Siqueiros expressed his great admiration for the remarkable achievement of a society that had built a train that ran underground with such precision. Orozco's reply that Siqueiros was a "real idiot hick" turned the conversation immediately into an acrimonious argument that attracted the attention of everyone in the subway car. Siqueiros then aimed his attack on Orozco's love, the sculptor Rodin. "This subway," he said, "is a thousand times more valuable than all of Rodin's work." Infuriated, Orozco kept repeating, "Provincial idiot, provincial idiot!" To add to their

misery, it was a bitter cold snowy evening and they never arrived at their destination. When they reached the street, they discovered that Orozco had lost the slip of paper with the address.[21]

Later than anticipated, Captain Siqueiros and his wife reached Paris in the latter part of 1919. They were immediately assaulted from all sides by the new trends that vanguard artists were developing: cubism, fauvism, dadism. Here was a decidedly different art world, not the one the Mexicans had in mind, arriving armed with their new outlook and social theories about art. The representatives of the new Mexican aesthetic values were making contact and colliding with the avant-garde theories of their European counterparts. These newcomers had just finished participating in a war of revolution, and the artists of Europe had just suffered the experiences of a war between capitalist nations.

Siqueiros at first found the unquestionable artistic stimulation of Paris quite engrossing. Diego Rivera had been in Paris through the entire Mexican Revolution and was deeply involved in the cubist movement. Paris was where Siqueiros first met Rivera, who was eager to hear the news about the Revolution—there was a great deal for the two loquacious artists to talk about.

Though the Revolution had been close to his heart, Rivera had been in Europe for ten years, deeply enmeshed in the French formalist movement. Siqueiros was ten years younger and at that moment still burning with the revolutionary fervor flowing from the struggle at home. He recalled Rivera in Paris:

> Rivera was then fundamentally occupied with the problems that evolved from the cubist period and with the beginnings of the typically constructive period of Cézanne. Interest had grown in that movement and I was infected with it by Diego. I spoke to him constantly about things Mexican, about the Revolution, about our doubts, about our criticisms of the painting of this period. I told him that it seemed to me that what was happening in Europe in the field of art was not part of an important movement. In reality at the bottom of all that was happening was a profound and fatal decadence. To this end we had many arguments in the beginning, but later almost all our points of view coincided.[22]

Attentive but restive, Siqueiros examined the new ideas, practiced some cubism and, fluent in French, pursued discussions with his new friends, the artists Léger and Braque. Fernand Léger tended to agree with Siqueiros who, as a foreign visitor, was expressing his ideas with extreme delicacy. Georges Braque, on the other hand, some thirty years Siqueiros's senior, was fond of the young Mexican mainly as a drinking partner. They were an inseparable pair on many revelling escapades.[23]

The works of Cézanne affected Siqueiros the most. He understood

> that this master had a profound critical concept about reality, or better, about realism. We are now able to say that his doctrines have been falsified and

weakened, serving ends totally contrary to those for which they were conceived. He wanted to restore to Western painting the fundamental plastic values which he considered it to have lost.[24]

In the end it was obvious that for Siqueiros the Paris experience was far more of a disturbing factor than a stimulating one. Mindful of events at home, too close yet to a war fought for lofty principles that he believed in, he could find no common philosophical and political ground with the French avant-garde. Their own war experiences had left them cynical and bitter.

Siqueiros and Gachita absorbed the ferment and unrest of Paris for two years. He comprehended well the world he was in, and in the end the ideals he had arrived with remained unshaken. An early article he wrote in Paris in 1921, for the Mexican paper *El Universal Ilustrado,* bore the title: "The Chauffeurs of Paris are Right." He told of the indignation of the French taxi drivers who had to listen to the foreign bohemian artists— 25,000 of whom resided in Paris, each with his or her individual theory of art—constantly arguing in taxis and cafés about aesthetic trivialities.[25]

A journey to Italy with Diego Rivera helped Siqueiros resolve his problem of evaluating the French formalistic trends. The two artists found inspiration in Italy and the key to the unanswered formulations of their previous discussions about the direction and problems of modern art in Mexico. Italy's art was of a different period, but for them the humanity was the same, its effect overwhelming. Siqueiros and Rivera traveled to Florence and Rome, not as tourists, but as artists searching for an answer to the problem they would have to face on their return to Mexico.

They stood before the murals of Giotto, Masaccio and Michelangelo, their discussions never ceasing. For Siqueiros, the excitement of the Renaissance murals nourished and strengthened the anti-formalist concepts he was evolving. Masaccio cast the greatest spell over him, yet he did not ignore new developments in the Italian art world. The Italian Futurists had issued their first manifesto in 1910; in Milan, Siqueiros paid a visit to one of its authors, Carlo Carra. Carra had joined Giorgio de Chirico's "metaphysical painting" movement, but what appealed to Siqueiros most was that Carra's aim, rather than to break with the past and the Paris school, was to synthesize the past and the present: "He sought a bridge between Giotto and Cézanne."[26] Siqueiros was attracted to the work of the Futurists, especially Carra's, for its plasticity and philosophical content. At the time he was unaware that in 1913 Mayakovsky and the more political Russian futurists had rejected the Italians, who were led by the pro-Fascist poet Emilio Marinetti.

His experiences with the Italians and the French clarified Siqueiros's understanding and put into perspective his thinking about the direction

that the post-World War I painters of France were taking. What it amounted to was

> a contact between a youthful restlessness possessing a large historical perspective of the Mexican Revolution, and a more mature but posthumous restlessness of the Europe of that period. It was a contact in the field of culture between a neoromanticism and a certain senile nihilism. For me, it was without doubt a contact between illustrative painting—neoillustrative—the root and trunk of an art of representation corresponding to the modern world, and decorative painting: formalistic painting of the so-called Modern School of Paris at its peak, and in a way, its period of greatest intrinsic value. It was a contact between the determination to strive for a new philosophy of a neohumanist nature, with one that was anti-humanist, or superhuman! Or of an epicurean inclination which is to say, ultra-individual or ultra-egotistical.[27]

The events surrounding the struggle that took place in Mexico when President Carranza proved reluctant to relinquish power after his term of office expired caused alarm and great consternation among the Mexican military-attaché artists in Europe. And with the disturbances at home, their paychecks were abruptly cut off.

Carranza, failing to implement the provisions of the new constitution, had attempted to hold on to power through a hand-picked successor he could control. But General Álvaro Obregón, popular with the people, led a revolt against Carranza; in June 1920, Carranza met the same fate as Emiliano Zapata, for whose murder he had paid 50,000 pesos six months earlier.[28]

With no income from Mexico, Siqueiros and Gachita were forced to seek whatever employment they could find. Siqueiros found a job in an iron works in Argenteuil, near Paris, doing industrial drawings, while Gachita went to work writing for the newspaper *La Vie Ouvriere,* edited by Gaston Monmousseau, a prominent member of the French Communist Party.

Earlier, in Mexico, Siqueiros had absorbed socialistic vibrations from Dr. Atl, from the anarchosyndicalists, from the writings of Max Stirner. Their impact on him had been strong, but not until his contact with French workers did he learn of the economic theories of Karl Marx and feel the effects sweeping through Europe from the Russian Revolution.

In a short time a new Mexican administration, headed by Obregón, resumed monthly allotments to the Mexican artists in Europe. In September 1921, José Vasconcelos, the Minister of Education, sent Siqueiros a letter requesting he return to Mexico. Vasconcelos was most eager to launch an extensive cultural program for the "new" Mexico. Siqueiros, however, asked to be granted more time and money to extend his stay abroad. Unexpectedly, Vasconcelos acceded to his request, stipulating that he return within a specified time.

Siqueiros's "duties" as military attaché carried him to various Euro-

pean countries. In Barcelona, with a handful of Latin American intellectuals, he brought out a cultural magazine, *Vida Americana*. Its one and only issue (May 1, 1921) was directed primarily to readers in Latin America and included the Siqueiros manifesto "Three Appeals to the New Generation of Painters and Sculptors of America for an Approach In Step with the Times." The manifesto helped form the ideological basis for the Mexican mural renaissance, which at that moment was ready to burst on the world scene.

Vida Americana's staff included Siqueiros and Gachita; Salvat Papasseit, the Catalan poet; Uruguayan Torres García, and others. They could not find the funds to continue publishing, but this one issue caused a stir among the Mexican artists in Mexico. Siqueiros had written the manifesto as a result of his discussions with Rivera and of the grand tour the two had taken together in Italy. "Without the intellectual help of Rivera," he wrote, "it would have been impossible for me to formulate 'The Appeal to the Painters of America.'"[29] Later he told an audience:

> In this proclamation I called for a new study of the problem of monumental art and spoke principally of the need for reuniting ourselves with the traditions of our country. In a certain sense I went further, declaring there could be no universal art, in the broadest sense of the word, which did not spring from a national art. That only from a strongly nationalistic art could there come a powerful universal art. Thus, as a consequence, it was necessary for us to take our own country as the point of departure toward great things.[30]

Back in Mexico City in 1921, painters and sculptors gathered—those who had fought in the revolution and those who had not—anxious to execute works of art for the new society. They were supported and encouraged mainly by the new Minister of Public Education, José Vasconcelos, who was in charge of the preservation and development of the nation's culture. A visionary philosopher, Vasconcelos encouraged all art as necessary and vital for uplifting and educating the masses, and he gave extraordinary support to the aspirations of the new muralists.

As long as the art leaned in a nationalist direction, Vasconcelos allowed the artists the fullest leeway in self-expression; little did he imagine or foresee the politically volatile course they would take. They were, after all, veterans of the strike at the San Carlos Academy, student artists who had fought against the despised usurper Huerta, artist-soldiers of the civil war, participants in the Congress of Soldier-Artists of Guadalajara, and recipients of the exhortations of Dr. Atl for a national mural art. And above all they had the challenging theoretical determinant for a modern Mexican national art flung at them from Barcelona by Siqueiros. That manifesto, "The Three Appeals," had called on the artists of the Americas to create a modern art that would relate to humanity and at the same time be in tune with the pulsations of a powerful modern industrial world.[31]

5

Murals for the Revolution

In August of 1922 Siqueiros and Gachita returned to Mexico. The "Movement" artists were at the National Preparatory School, where the government had commissioned the first walls to be painted. Diego Rivera, at the head of a group of painters, had just commenced his first mural and Roberto Montenegro was bringing his to completion.

Vasconcelos, fulfilling his high hopes, had the former Church of San Pedro and San Pablo (part of the Preparatory School complex) converted into a lecture and film hall; it was to be decorated with the "uplifting beauty of art"—all for serving and educating the people. Montenegro, thirty-six, painted there, assisted by a youthful and stocky Xavier Guerrero—son of Aztecs, soldier in the Revolution, and most knowledgeable in ancient Mexican painting methods and techniques.

Montenegro painted this first mural in oils and in the art-nouveau style of the period. It was a purely decorative work, titled *The Dance of the Hours,* and inasmuch as the composition was made up of Mexican figures and motifs, was expressive of the new nationalist spirit. Rivera's first mural, in the school's auditorium, and the works by artists painting in the patio, were not much different.

The new muralists, though anxious to further the cause of the Revolution with their art, did not yet fully comprehend the relationship of social philosophy to art, especially to the resurgence of mural art after 400 years. Social philosophy was the furthest thing from Montenegro's idea of mural painting. It was enough that his mural would decorate a public place. The painters were not yet politically aware enough to realize that the walls of the National Preparatory School were inaccessible to the masses who made the Revolution and thus were inappropriate for their murals. In their initial excitement and eagerness to start painting—on any walls—the prime importance of reaching the people had been overlooked. However, awareness would follow. It was all so new; there had never been an art movement concerned with addressing the people directly about their own social and economic welfare. The stirrings of the artists of the French Revolution had been too short-lived, and in the Soviet Union no artists had felt impelled to take the mural road.

The effect of the Revolution on the Mexican artists did bear some

resemblance to that of the 1789 Revolution on the artists of France. In the end, however, the aesthetic and social results achieved by the Mexicans reached some solutions that had eluded the French. In 1789 David, Gérard, Sergent and other artists joined the Republican cause, supported the idea of art as a political weapon, and took part in the Revolution in numbers far in excess of their representation in society.[1] Arnold Hauser wrote:

> Revolutionary France quite ingenuously enlists the services of art to assist her in this struggle; the nineteenth century is the first to conceive the idea *"l'art pour l'art"* which forbids such practice. . . . It is only with the Revolution that art becomes a confession of political faith, and it is now emphasized for the first time that it has to be . . . "a part of its foundations." It is now declared that art must not be an idle pastime, a mere tickling of the nerves, a privilege of the rich and the leisured, but that it must teach and improve, spur on to action and act as example. It must be pure, true, inspired and inspiring, contribute to the happiness of the general public and become the possession of the whole nation.[2]

However, the painters and sculptors of the French Revolution were never able to establish a functioning art movement that would serve society's cultural needs. Prior to the Revolution, they had worked under the patronage of royalty and the aristocracy. Boucher and Fragonard were court painters, working for the glorification and entertainment of that ruling class. The Revolution changed all that; the bourgeoisie, the new patron class, though it could not afford to support artists as the aristocracy had, opened the door to a new freedom and a new self-expression.[3]

Jacques Louis David, the greatest painter of the French Revolution, was also a representative from Paris to the National Convention. He voted for the execution of Louis XVI, was a member of the Committee of Public Safety, and after the Bourbon restoration, was imprisoned and finally banished as a regicide. Through the neoclassicism popular in that day, David had sought to express a philosophy that would be useful to the Revolution. But the bourgeoisie did not long accept the passionate revolutionary themes, and the salons—the only means for presenting works—encouraged smaller and smaller paintings, more and more portraits.[4] Murals, which conceivably could make contact with the people, were not dreamed of in the historical context of that period. Inspiration was found in the art of ancient Rome, not renaissance Florence. The direction and goals of the bourgeois revolution were not clearly formulated and did not serve to strengthen and guide the revolutionary fervor of the artists. Marx said:

> [U]nheroic as bourgeois society is, it nevertheless took heroism, sacrifice, civil war and battles of the peoples to bring it into being. And in the classically austere traditions of the Roman republic its gladiators found the ideals and the art forms, the self-deceptions that they needed in order to conceal from

themselves the bourgeois limitations of the content of their struggle and to keep their enthusiasm on the high plane of the great historical tragedy.[5]

However wiling the artists, they were prevented by the circumstances of historical events and the techniques they employed from taking more than a first step toward an art that would be responsible to society. Of the direction their art had taken, Hauser stated:

> Art ceases to be a social activity guided by objective and conventional criteria, and becomes an activity of self expression creating its own standards; it becomes in a word, the medium through which the single individual speaks to single individuals.[6]

To support their own revolution, Jacques Louis David and the artists around him painted in the revived classic style of the ancient Greek and Roman world. David Alfaro Siqueiros, with his Barcelona manifesto, set the stage for a public art for the Mexican mural movement, even within the confines of a faltering revolution.

The Russians found inspiration in the French Revolution, and succeeding where the French had failed, they emerged as the world's first socialist country. The Russian artists, including the avant-garde, fought on the side of the revolution, and among the most active was painter and poet Vladimir Mayakovsky. Tirelessly Mayakovsky traveled the vast expanse of Russia from village to village, reciting a powerful new poetry that accentuated the socialist vision of constructing a modern industrial society.[7]

In 1923 Mayakovsky edited the magazine *LEF* for the group of writers and artists he had organized into the Society of the Left Front, and in it he published his manifesto, his call to art for the new socialist society, pressing forward three main points:

> a—To promote the finding of a communist path for all genres of art; b—to revise the ideology and practice of so-called leftist art by discarding individualistic affectations and developing its valuable communistic features; c—to fight against decadence, against aesthetic mysticism, against self-sufficing formalism, and against indifferent naturalism for the affirmation of tendentious realism based on the utilization of technical devices of all revolutionary schools of art.[8]

Later, however, Mayakovsky began to defend formalism in his fight against the entrenched academicians. He was on the losing side. Philistine bureaucrats who wielded power, incapable of understanding the nature of so gifted a person, began to interfere with the creative processes of the dedicated Communist. Mayakovsky, at age 36, ended his own life.

In this early part of the 20th century the Mexican artists came to the realization that the mural was the logical form that painting should take in a society where the people had made a revolution. The subject matter

of the murals of necessity would be figurative and realistic; tendencies toward abstract painting, which the Mexican artists had studied and absorbed in Europe, could not serve the Mexican Revolution. Actually, the Mexicans of that period were involved only in figurative painting, but they approached the first walls with unsteady steps. Of that experience in the Preparatoria—the National Preparatory School—Siqueiros wrote:

> There our first work was produced. Ignorant of muralism, ignorant of public art, problems artists of our time did not care to occupy themselves with, we began in the most stumbling manner that one can imagine. We distributed the walls of the National Preparatory School as one would divide a loaf of bread, everyone a slice. In the central court, painting together as though they were preparing large paintings for an exhibition, were José Clemente Orozco and a young Spanish painter, Emilio García Cahero. Diego [Rivera] was placed in the Bolivar Amphitheater [the auditorium] and I painted the cube of a staircase. And in this way others painted sections of walls. But this fixed method of distributing the work was not the only error we committed as ardent muralists. We had yet to form a concept of the difference between easel painting and the construction of murals. But the most extraordinary and fundamental problem of all concerned our theme. The problem of a new thematic concept was tremendous, new, and incalculable.[9]

When Siqueiros arrived at the school he found the atmosphere charged with expectation and excitement. The new muralists were scurrying about, impatient to fulfil their destinies. In the auditorium on San Ildefonso Street, across from the main building, Diego Rivera was at work on the largest of the murals with assistants Luis Escobar, Xavier Guerrero, Carlos Mérida, Jean Charlot, and Amado de la Cueva. Charlot and de la Cueva soon left to work on their own walls in the main building, where Orozco and Cahero were already painting. Fermín Revueltas and Román Alva de la Canal had walls to paint in the main entrance of the old Colegio San Ildefonso (part of the same preparatory school); Fernando Leal and Charlot each had a wall in the stairwell of the same building. Siqueiros was drawn to a distant staircase in the section called the "Colegio Chico," where he envisioned forms entering the space of the vault that covered the staircase.

The Ministry of Education placed the artists on the payroll, designating to each a teaching position in the public school system. Siqueiros was thus officially classified as a "teacher of drawing and manual crafts at a salary of three pesos thirty centavos a day."[10]

Of the many problems that confronted the neophyte muralists, the first and most troubling was acquiring and understanding the actual techniques of mural painting. Diego Rivera, the most experienced of the group, chose for the monumental allegorical figures that filled his murals the ancient Greek encaustic method. This obsolete method called for the application of heat to pigments mixed with wax when applied to the wall. Fresco

was another ancient method that the muralists, inspired by the Italian Renaissance, felt they must use. Though none had experience with murals, their zeal to paint for the Revolution was not to be dampened by technical deficiencies.

Rivera, who claimed he had researched and studied the encaustic method, felt confident. Siqueiros, with little knowledge of either encaustic or fresco, used both. He painted the vault of the staircase in encaustic, but on the walls he stumbled along with the fresco technique. *Buon fresco,* true fresco, was the method they chose, except Rivera. However, before they could attack the walls, the true fresco technique had to be understood. Libraries were searched, and Mexican plasterers and cement laborers were queried, for in Mexico colored cement and plaster had long been in common use. The library produced a copy of Cennino Cennini's *Il Libro dell' Arte* in Italian, and the plaster and cement workers, the *albañiles,* revealed their "secret" formula for fresco. They advised the artists to mix the juice of the cactus plant, a slimy liquid, with the pigment before applying it to the wet plaster.

Though practical experience quickly brought competence in handling the "new" ancient techniques, the imperative problem of subject matter was as yet far from being understood. The themes of the first murals attest to the aloofness from any direct political commitment that pervaded all art up until that time. As Siqueiros explained:

> What happened was that the Movement did not understand that an art directed to the people, to all the citizens of the entire country, requires certain subjects. So thus, Diego Rivera began to paint in the Byzantine style: the symbol of eternity, the symbol of music, the symbol of dance, etc. José Clemente Orozco painted a madonna in a Botticellian style, surrounded by angels. García Cahero painted an exalted defense of the Spanish Franciscans who helped colonize the Indians. Fermín Revueltas, his liberalism notwithstanding, painted a Virgin of Guadalupe, but tried to save his revolutionary ethics by representing the angels with bronze Indian faces instead of as white conquerors. . . . As for myself, I painted the elements: water, fire, wind, etc., surrounding the figure of an angel painted in a more or less Mexican colonial style. Such was the confusion of our thematic material in a world in which public art, the art for all had disappeared.[11]

Siqueiros's mural *The Elements, (plate 5)* though it lacked any urgent social appeal, did exhibit the plastic concern that would absorb him in his future search for a modern realism. He alone had selected an architectural surface that would emphasize the movement of the forms he painted on it, though undoubtedly at the time his selection was intuitive rather than premeditated.

A monumental angel of great strength surrounded by an arrangement of symbols—wind, lightning and seashell—hovers primitively above the

staircase. Diego Rivera's comments about the mural were carried in the newspaper *El Democrata* on March 2, 1924.

> In the middle of a ceiling strewn with formal elements, interesting, original, strongly plastic, and emotive, Alfaro Siqueiros stamped a figure in which he made certain concessions, without, however, debasing plastic qualities. The result reminded me of a somewhat Syrio-Lebanese Michelangelo.[12]

The response of the people, of the workers, to the initial self-conscious efforts of the muralists was not anticipated. Revolutionary workers visiting the murals were puzzled by the subject matter. They understood the cultural value of art for the country, but the murals did not speak to their urgent needs. The artists were still not quite conscious of the real possibility that art could serve as political propaganda. This was a new stage in the history of art, and the forces of the Mexican Revolution were moving the artists in a direction they did not completely understand. These first government-sponsored murals, public art during a period of revolutionary construction, revealed the theoretical and political short-comings of the artists. When the response of the workers to the murals was less than enthusiastic—in fact, negative—the moment had arrived for a new consciousness to burst forth.

Siqueiros, who had had a brief relationship with workers and Communists in France, turned for advice to the new Mexican Communist Party. A representative of the Party, Rosendo Gómez Lorenzo, a Spanish writer from the Canary Islands, was sent to talk to the painters. The first piece of advice he gave them was that they must form a union; discussions would then take place about theme problems and how best to aid the Revolution with their art. But what immediately followed was that Siqueiros, Rivera, Guerrero and other artists joined the Communist Party of Mexico (PCM). It was not long before the three painters proved themselves responsible members and were elected to the party's Central Committee.

By the end of 1923, the painters who were members of the PCM organized a meeting at the home of Diego Rivera and his wife Guadalupe Marin. Except for Orozco, all the artists attended. Orozco was rarely on speaking terms with Rivera, but he did agree to become a member of the Union of Technical Workers, Painters and Sculptors, born of this meeting.[13]

Siqueiros was elected general secretary of El Sindicato—the union; Rivera had a post labeled Secretary of the Interior; Fernando Leal had that of Exterior, and Xavier Guerrero was their financial secretary. Two cooperatives, adjuncts to the union, were also formed: the Francisco Xavier Mina Cooperative (honoring the Spanish revolutionary who had fought for the independence of Mexico) to help individual artists on very meager salaries solve economic problems and meet their domestic needs,

and the Cooperative Workshop Francisco Eduardo Tresguerras to help all the artists meet their material painting needs. (Tresguerras was an important Mexican architect, sculptor and painter of the 19th century.)

The second meeting of El Sindicato was held in the Bolivar Amphitheater, facing Diego Rivera's first mural. The ardent revolutionary artists gathered there burned with new desires and manifested an ample degree of "infantile leftism." They voted to accept a proposal put forth by Diego Rivera that the union apply for membership in the Communist International. At this point the Communist Party theoretician, Gómez Lorenzo, leaped to his feet and lectured the artists on the nature of the class struggle, working-class ethics, and what their role was to be as artists working for the Revolution.[14]

The union had brought the artists to a deeper political awakening, and murals vastly different in content from the first ones were spreading over the walls of the Preparatoria. At first they had only wanted to paint "murals for the people"—public art. But now it was ideas for the people, murals plus ideas. Siqueiros was depicting his first "workers' struggle." Orozco turned from nude madonnas and prophets to denunciations of the Church, the bourgeoisie and the rich. Rivera abruptly ceased his spiritual rendition of the symbolism of eternal values and commenced painting the exploitation of workers and peasants by the ruling class.

Besides speaking out through their murals, the artists of El Sindicato used graphic art and the printed word, publishing a contentious revolutionary newspaper, *"El Machete."* The first edition appeared in March of 1924 and its masthead was a woodcut of a clenched fist under the word *Director,* and over the words *La Del Pueblo.* Siqueiros, Rivera and Guerrero made up the Executive Committee, Rosendo Gómez was the editor, and Gachita was a reporter. Orozco and the other artists of El Sindicato contributed drawings, and the staff was augmented by the use of pseudonyms, Siqueiros at times writing under the name Daniel A. Sierra.

The paper was dramatically printed in red and black, the woodcuts illustrating it presenting politically explosive material in an aesthetic bombast. The banner title was a woodcut by Siqueiros of a hand gripping a machete, the paper's name inscribed on the blade. A poem by Gachita that resulted from the collective thinking of the staff appeared with the newspaper's title:

El Machete sirve para cortar la caña,
Para abrir las veredas en los bosques umbrios
Decapitar culebras, tronchar todo cizaña,
*Y abstir la soberbia de los ricos impios. **
*The machete serves to cut the cane,
 To open paths in the dark forests
 To decapitate snakes, to clear the weeds,
 And to cut down the arrogance of the impious rich.

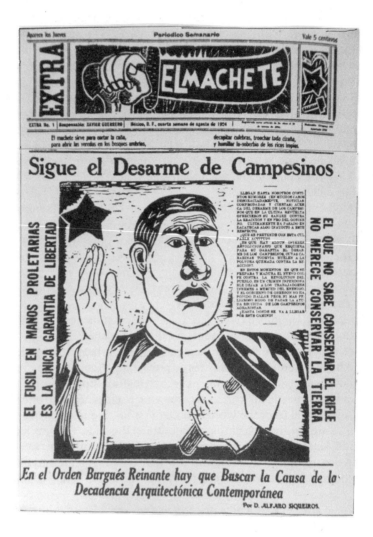

Graciela Amador worked at Siqueiros's side from 1918 to 1929, the duration of their marriage. They had shared in all the political and revolutionary activity of that period, and they separated without rancor, he being more married now to art and politics. About her, Siqueiros said:

> Gachita, with courage and constancy, had participated in all the great and at times bloody union struggles that were taking place in our country. At meetings, as well as when being subjected to persecution, she was always in the front lines. . . . Not only was she my wife, but she was the most intimate comrade through the entire period that I was a union leader. She was an example of a very pure and loyal revolutionary comrade.[15]

Gachita wrote songs and stories for *El Machete* and chronicled the union

struggles of one of the most explosive periods in the history of the Mexican working class.

Much larger than an ordinary newspaper, *El Machete* was really a poster to be pasted up on the walls of working-class neighborhoods and it became the cause of much friction between the government and the artists. Siqueiros was steering this aesthetic-political exploitation of the print media through increasingly turbulent waters. The pages of *El Machete* effectively released art into the revolutionary stream. Siqueiros had understood, more than most, the importance of having a newspaper published by the union. He was "the real driving force, people's tribune, manifesto maker, agitator of the organization."[16]

Siqueiros's earlier experiences—as correspondent from his battle zone for Dr. Atl's *La Vanguardia*, and as director of the single issue *Vida Americana*—had convinced him of the power of the printed message and of the importance of an artist-controlled press suffused with graphics to convey revolutionary political concepts. *El Machete,* he said,

> was an illustrated newspaper, for we knew that mural painting was not enough for public art. Without doubt, murals were an important form of public art, but another of great importance had been missing. This was multi-reproducible art—prints and engravings.[17]

6

El Sindicato, *El Machete*, and Murals: Stormy Days

Though still in his twenties, Siqueiros proved to be an extremely effective political leader. As secretary-general of El Sindicato he molded the artists into a force capable of exerting a strong influence on politicians to follow the road of the Revolution in shaping the new society. President Obregón, already less than faithful to the Revolution's aim, was under constant attack in the pages of *El Machete*.

In December 1923 another crisis of counterrevolution was brewing. Provoked by Obregón's choice of Plutarco Elías Calles to be his successor, a waiting combination of reactionary forces, led by the former provisional president, Adolfo de la Huerta, moved onstage. Generals Enrique Estrada and Guadalupe Sánchez began to return land to the *haciendados* and once again fighting erupted. It took ninety days to crush this counterrevolution and El Sindicato stood with the Obregón regime, seeing this action as the only possibility of furthering the Revolution.

The union issued its first artists' manifesto on December 9, 1923. Written by Siqueiros and published in *El Machete,* it condemned the attempted counterrevolution and at the same time upheld the need for the government to strengthen its support of public art. In the *Manifiesto del Sindicato de Obreros Tecnicos, Pintores y Escultores* politics and aesthetics were intertwined, their objectives proclaimed identical. Condemning the military mob of the two counterrevolutionary generals, the manifesto stated:

> To the indigenous race humiliated for centuries; to the soldiers converted into executioners by the praetorians; to the intellectuals who have not been debased by the bourgeoisie. On the one side, the social revolution more ideologically organized than ever, and on the other side, the armed bourgeoisie. Soldiers of the people; armed peasants and workers who defend their human rights against soldiers of the people, degraded, deceived, and subdued by military chiefs bought by the bourgeoisie. . . . On our side are those who clamor for the disappearance of an old and cruel order; in which you, worker of the field who makes the earth fecund, have your crops taken by the rapaciousness of the landowner and the politician, while you burst with hunger; in which you, worker of the city who run the factories, weave the cloth, and

form with your hands all the comforts that give pleasure to the prostitutes and miscreants, while your own flesh is broken with the cold; in which you, Indian soldier, voluntarily and heroically left the land where you work and gave your life to wipe out the misery with which for centuries the people of your race and class lived so that a later Sánchez or an Estrada will not use the great gift of your blood for the benefit of the bourgeois leeches who suck out the happiness of your children and rob you of your land and work.

The manifesto ends with a call to intellectuals, peasants, workers and soldiers to unite and "form one front to fight the enemy within"—the enemy at the time being Adolfo de la Huerta and his co-conspirators, Generals Estrada and Sánchez.

Siqueiros was 27 when he penned the manifesto. It reveals with devastating clarity that he had already distilled his philosophical and aesthetic beliefs into a potent ideological concentrate. Pointedly he linked and combined social and aesthetic problems, political and aesthetic problems, and the importance of ethnic values for the new art movement. He wrote in the manifesto that the Indian possessed

the admirable and extraordinary ability to create beauty: the art of the people of Mexico is the greatest and healthiest of the spiritual manifestations of the world, and their indigenous tradition is the best of all. It is great, because being popular it is collective and for that reason our fundamental aesthetic object resides in socializing artistic expression and doing away, absolutely, with bourgeois individualism. We repudiate easel painting and all the art of the ultra-intellectual cenacle of the aristocrat; and we exalt the manifestation of art for public utility. We proclaim that all aesthetic expression, foreign or contrary to popular sentiment, is bourgeois and contributes to perverting the taste of our race, as it has completely done so in the cities, and ought to disappear. We proclaim that this being our moment of social transition, between the annihilation of an old order and the implementation of a new one, the creators of beauty must strengthen themselves so that their work presents a clear aspect of ideological propaganda for the good of the people; making of art, that is at present an expression of individualistic masturbation, the attainment of beauty for all, of education, and of combat. Because we very well know that the implementation of a bourgeois government in Mexico will bring with it the natural depressing of the popular indigenous aesthetic of our race, which at the present time exists only in our popular classes, and which has already begun to purify the intellectual ways of Mexico; we must struggle to avoid this take-over for we know very well that the triumph of the popular classes will bring with it a flowering, not only in the social order, but a unanimous flowering of a cosmogenic and historically transcendent ethnic art in the life of our race, comparable to our admired and superb autochthonous civilizations; we must struggle without rest to obtain it.[2]

After a few more sections giving advice on how to struggle, the manifesto ends with: "For the proletarians of the world." The members of the union whose signatures it bore were David Alfaro Siqueiros, Diego Rivera,

Xavier Guerrero, Fermín Revueltas, José Clemente Orozco, Román Guadarama, Germán Cueto and Carlos Mérida.

Another fundamental manifesto produced by Siqueiros at this time helped lay the ideological foundation upon which the artists of the Revolution would build and substantiate the modern Mexican art movement. This second manifesto, written in March 1924, was titled "In the Margin of the Manifesto of the Union of Painters and Sculptors." Siqueiros clearly formulated the conclusions derived from experiences with the very first walls that the Revolution had been given to be painted. These conclusions had been evoked from the critical responses of the working class and from the struggle against bourgeois forces that were insidiously slipping back into power and slowing down the revolutionary process. Siqueiros, perhaps the most radical theoretician of the Revolution, attacked the reaction and tried to encourage intellectuals sitting on the sidelines to support the Revolution. His words in *El Machete* were pasted on walls throughout the city.

> El Sindicato has brought about a miracle by concretizing the aesthetic and social action of a group of Mexican intellectuals, who as intellectuals, or Mexicans, should have been rabid anarchic-individualistic; it has brought together all the painters and sculptors of spirit in Mexico who do not belong to that parasitical class of *artists*, who, waiting on the divine Muses, believe they have the right to enjoy all of life's pleasures at the cost of the rest, preferring especially social masturbation; every conscious painter and sculptor should above all be an artisan at the service of the *people* and their role within the function of the collective human need for beauty that they have to meet is the highest sentiment of civilization. And great beauty is not a personal work to be swallowed up by individual super-intellectual cenobites or those lacking-in-taste bourgeois hide dealers; it is food of the *people* and for the *people*, and all plastic expression that does not serve this end, that does not arise from this same source, would be a monstrous fruit fertilized by hysterical processes. The painters and the sculptors of El Sindicato understand that the highest commitment of their craft is to the life of the people of their region and to their race. They have understood that they must unite in a communist action of art production and social labor, imitating the primitive Italian artisans who put the beauty of their productions at the service of the Christian propaganda of that epoch, and they understand that putting all their impulses to serving social redemption will bring upon themselves the most enraged hatred of the bureaucracy.[3]

In the same manifesto Siqueiros further took the Mexican writers to task as a particularly servile group:

> . . . they live licking the feet (and even higher up) of the rich and the powerful, "picking up the nickel" that the Government throws to them, they are the servants of all the high public officials. . . . Their productions as social entities are of negative values that subsist outside of their race and land, ignorant of the life of the common people and the geography of Mexico. They live like

the masturbator in the story who in his lonely rock-hard bed possesses the most beautiful women in the world. The only possible remedy for their liberation is to transplant themselves from the "flowerpot" where they vegetate to the earth where they would live; to see and love the people of the village that surrounds them; stop thinking about Oscar Wilde and throw out the dictionaries and "menus" that they carry encased in their heads. They should understand that in social questions the intellectual does not have the right to be neutral, for this is the equivalent of being neuter, and in times of antiquity the strong subjected the neuters to torture as a warning. Abandon this eclecticism that underneath is no more than evident proof of cowardice, proof of the dreadful fear they have of hunger which ties their arms from all rebellious action; in a word they should stop thinking that they are privileged beings because of the *aristocracy* of their talent and therefore they have the right to be excused from all base acts; they should know that they are men of flesh and bones like the rest of us, with the same human rights but also with the same obligations to the community.[4]

Siqueiros's manifestos flowed through the pages of *El Machete,* and his edicts of revolutionary thought, his vivid and graphic statements, fell like hammer blows alongside the "scandalous" drawings that filled its pages. Of the three members of the newspaper's executive committee, Siqueiros and Guerrero supplied copy and drawings for its pages, while Rivera contributed only one article and never a drawing. Rivera had government mural commissions and was less inclined to offend the government; more often than not, he hindered the publication of the paper. Orozco, on the other hand, was a dependable contributor of his drawings.

El Machete, with its revolutionary manifestos and politically expressive drawings, proved to be a more effective voice for the artists than their first murals. These murals reached a public that would not accept them, a public for whom they were not intended—a preparatory school peopled with bureaucrats and bourgeois students, who soon turned hostile to their "shocking" content. Thus the murals in the *Preparatoria* greatly irritated the school population. This collision had not been foreseen by the artists and it added to their problems.

While the murals did not reach their intended mass audience, *El Machete* reached into all corners of the country, to areas where workers, peasants and Indian tribes were concentrated, to labor unions and agrarian committees. These masses were spellbound by its hypnotic content, the likes of which they have never seen, while it also offered them a disciplined and consistent leadership in their struggle.

The government, now vacillating in implementing the revolutionary program, was beginning to waver in its support of the artists. When *El Machete* appeared on the walls around the city with its denunciation of the sellout of the Revolution and the attendant corruption, the students violently assaulted the murals, and the government warned the artists they would have to give up their newspaper.

It was a period of growing tension between the artists and the forces beginning to oppose them. Siqueiros was both directing the newspaper and painting his way up the staircase of the Colegio Chico. The area he had chosen extended through two floors, and included the surfaces of six walls and two domed ceilings; two hundred square meters in all. He had reached the second floor level and felt he was on the verge of effecting a breakthrough.

From 1922 to 1924 Siqueiros had labored, fitfully painting the surfaces, but urgent outside commitments too often interrupted him. He was groping in this first mural experience for the formal thematic solution that would serve the needs of the present society. Thematically, the first stairwell was wide of the mark. On the ceiling he had painted a classical angel, on one wall a white-skinned St. Christopher, and on the opposite an Indian woman symbolizing a safe passage across the sea, the meeting of the two cultures. The ceiling and the St. Christopher wall were painted with the encaustic method, while the *Indian Woman* wall served to test the fresco. During the eight months that Siqueiros worked on this section he and the other artists were constantly subjected to an ever increasing stream of verbal and physical abuse from the unruly and incorrigible students. Forced to barricade himself within his stairwell, Siqueiros worked at night as often as possible.

On the walls of the second-floor stairwell Siqueiros drew on the wet plaster the outline of a theme deliberately devoted to a proletarian subject. Without romantic idealization, ethnologically expressive and powerfully delineated figures somberly and faithfully portrayed the Mexican Indian, conveying in their pathos and stoic mien the crushing effects of their exploitation. Four Indian pallbearers of a crude blue-painted wooden coffin, typical of rural Mexico, have the unmistakable ethnic features that until then were completely lacking in Mexican painting.

The Burial of the Martyred Worker (plate 6), as the mural was called, had a rough-hewn hammer and sickle painted on the coffin and it was a bold step forward for the muralists. While Siqueiros was painting this mural in January 1924, the governor of Yucatán, Felipe Carrillo Puerto, a Socialist, was assassinated. Deeply affected, Siqueiros wrote the governor's name on a slip of paper, placed it in a bottle and imbedded it in the coffin of the mural.[5]

Orozco, Rivera and the other painters gathered before this work and agreed that for its sheer daring, both in form and content, it would be the cornerstone from which the new movement would arise. "Siqueiros was the first," wrote Charlot, "to erect a naked Indian body as removed from picturesqueness as a Greek naked athlete, a figure of universal meaning within its racial universe."[6]

The union meetings, very often political-artistic discussions—sometimes with a Communist Party theoretician participating—helped the art-

ists become politically conscious, well aware of the meaning of artistic commitment to the Revolution. But vestiges of bourgeois bohemianism still clung to them. They could not resist the habit of picking away at the subjective nature of creativity. Diego Rivera even proposed that the members should consider smoking marijuana. He did manage to bring a "professor" to a union meeting and the attentive members were given a detailed historical and practical exegesis on the art of understanding and using the leafy stimulant. For a while the artists actually painted with marijuana-enriched imaginations. Siqueiros, however, soon put an end to this after the drug caused him to tumble off his scaffold and break a number of ribs. This experience brought him to the conclusion that the drug "disrupted our naturally rich and fertile imaginations."[7]

With each new edition of *El Machete* and the increased politicization of the murals, the Preparatoria students grew more belligerent and violent. Incited by reactionary professors, fanatically religious students kept up their attempts to destroy the "blasphemous" murals. Working on their murals became dangerous for the painters, and in self defense they carried revolvers. Siqueiros, painting in an isolated area far from the main patio, was a principal target. When a band of more than sixty students, shooting missiles through blowguns, leveled an attack against his mural, he defended himself by firing his .45 pistol over the heads of the student mob. The loud reports reached the far-off patio, alerting the thirty-odd artists to rush to the aid of the lone embattled painter. From another direction, the sculptor Ignacio Asúnsolo, his gun blazing, led a force of stonemasons against the enemy students.

A student was reported shot in the cheek, but the rioting did not end until a battalion of Yaqui Indians—soldiers of the Revolution who were camped in the patio of the nearby National Law School—arrived on the scene. When notified that the murals of the Revolution were under attack, the Yaquis had rapidly marched off to the Preparatoria and placed themselves under the command of the ex-officers, now artists. They drove off the students, and order was restored, but the damage inflicted on the murals was considerable.

This battle provoked a serious crisis, which shook El Sindicato to its foundation, and for the moment the new art movement, still in its infancy, was brought to a standstill. An added misfortune that practically sealed the union's doom was that the Minister of Education, Vasconcelos, had resigned in protest over President Obregón's handpicking of Plutarco Elías Calles as the candidate to succeed him. With Vasconcelos, patron saint of the artists, out of the way, the bourgeoisie and the bureaucrats could now turn their attention toward them.

As the bourgeoisie tightened their grip on the Revolution, their resistance to the artists' movement steadily grew. The critical and openly hostile Mexico City newspapers fomented resentment and opposition toward

the organized artists, who were clearly a force to be reckoned with. The effectiveness of *El Machete* so irritated powerful reactionary forces that the artists became the target of counterrevolutionary blows that forced El Sindicato to suffer the loosening of its bonds of unity.

Diego Rivera, for one, moved closer to the government side, withdrew his financial support of *El Machete,* and refused to sign the union's July protest to the government, which condemned the student attacks and the damage inflicted on the murals. But a major blow came from Vasconcelos's successor, the new Minister of Education, José Manuel Puig Casauranc. He presented the members of El Sindicato with an ultimatum: "If you continue publishing your newspaper, *El Machete,* with its political line of systematic attack on the government, which is the government of the Revolution, your contracts for mural painting will have to be suspended."[8] The government had now laid down the law. It would either be the murals, or *El Machete.*

Internal strife began to consume the union. There was a tumultuous meeting and a split took place. Rivera, supported by Emilio García Cahero and Jean Charlot, pressed for mural painting at any cost, "even if we have to sell our souls to the devil." Their stand in favor of the murals at this particular time implied inevitable acceptance of a government that was pursuing a course of compromising the Revolution. The majority of the artists stood behind Siqueiros, who said, "If they deny us the fixed walls of public buildings, we will continue our great mural movement by making portable murals of the pages of *El Machete.*" José Clemente Orozco, doubting that art and politics could mix, posed a third view. With his usual cynicism, he was for washing his hands of the whole mess and leaving the country. He would "send politics to the devil" and go abroad. He was supported indirectly by a number of painters outside El Sindicato. Manuel Rodríguez Lozano, Rufino Tamayo, Abraham Angel and Julio Castellanos were all leaving the unstable Mexican art scene to try their luck elsewhere.[9]

It was becoming clear that the Revolution was not going to prevail. Those who had grabbed government power did manage to halt the artists' union activities and would soon force El Sindicato to break up. However there was still one last piece of union business to enact. In a stormy meeting, Siqueiros argued for supporting *El Machete* and succeeded in bringing the majority of the artists to his point of view. After Diego Rivera refused to abide by the majority opinion he was expelled from El Sindicato by an overwhelming vote.

When Rivera's new murals in the Ministry of Education building were vandalized by right-wing religious fanatics, Siqueiros wrote (in the defiant and continuing *El Machete* of September 11, 1924) his "Protest of the Revolutionary Union of Painters and Sculptors Over the New Desecration of Painted Murals." In it he attacked "the armed sneaky cowards

who without conscience despicably desecrated the social painting of Diego Rivera, and who a few months earlier had destroyed the works of Alfaro Siqueiros and José Clemente Orozco." Siqueiros saw the attacks on the murals as a significant sign that the Revolution was being phased out by the resurfacing reactionary elements.

Imperceptibly they *mutilated* all the pedagogic support that benefited the producing class, interrupting at their beginning all the good intentions and nullifying at its birth all the good will. The mutilations in the revolutionary paintings are palpable, but the mutilation in the almost insignificant body of semi-revolutionary work of the present Government is imperceptible to the eyes of the *false revolutionaries*, or revolutionaries blind to understanding.

We point out the danger of the Knights of Columbus, the Catholic Women, the fossilized liberals, the mellifluous democrats and the entrenched bureaucrats who are destroying, until no stone is left upon a stone, the small revolutionary gains that were made with the strength of thousands of victims and a multitude of sacrifices.

The road has been opened for the reactionaries in the Ministry of Public Education to do their work. The obstacles, the true revolutionaries, have gradually been eliminated; the reactionaries are now masters of the situation and can operate with ease.

We can assume however, that their reign will not be long; the workers, the farmers and the revolutionary youth of the whole republic know very well that the very small advances realized by Minister Vasconcelos in the Ministry of Public Education do not have to disappear. . . .

. . .Strongly protesting against the profaning of a revolutionary work, it is our inescapable obligation to explain to the people of Mexico the source from which the vileness arises, stressing that Vasconcelos . . . had not fulfilled his obligation to protect an aesthetic work that belongs to the proletarian masses of Mexico and which was paid for with the people's money. His weakness in the face of a shameful act against the Mexican people encouraged the sons of the exploiters, the student "fifis," to cut off the collective forces helping the workers in their social revolution.[10]

The threat of loss of livelihood did not deflect the supporters of *El Machete,* and throughout the year the paper, which still received Orozco's vitriolic cartoons, continued to harass the government. No government activities escaped Siqueiros's sharp and deep critical stabs; his was the role of gadfly for the Revolution. In May of 1924, he had attacked the government's housing and building program in the pages of the paper, blaming the ever increasing power of the bourgeoisie for the poor design and shabby construction of the buildings and houses being erected. The bourgeoisie had been paying lip service to and misinterpreting what they called the "new dynamism" of modern life. Siqueiros called it the commercial dynamism of the speculator creating cheap and shabby merchandise, symbolized by the commercial exploitation of the automobile, "the hollow tin can, the very clear and concrete symbol of modern culture."[11]

For building houses that lasted one or two years rather than for centuries, he attacked the "ability of the architects" and the "inferiority of their architecture" as

> the physical consequence of the reigning bourgeois order, which is illogical, inconsistent, insubstantial, hysterical, and extravagant, and a society so constituted is removed from the precise biological reasoning of nature and cannot produce, cannot nourish, anything but an illogical arbitrariness in all the orders of human expression.[12]

He blamed the Mexican architects for following European influences that did not take into consideration geography and the physical nature of materials and, most importantly, the Mexican building workers.

> . . . the humble "maestros" on the job are not recognized, but the common sense and intuitive logic that they possess impels them to respect the rules, and if it were not for these men possessing the wisdom of experience, the buildings constructed by the engineers and architects of Mexico would already have fallen down. Yet they live despised and exploited by the bourgeoisie.[13]

The falseness of the concept of beauty and style that accompanies architecture of a purely ornamental nature he condemns as "illogical nonsense" and an extravagance in a period when the health, life and aesthetic education of the people must be of primary concern in housing. And as part of the concept of a "mercantilism that corrupts everything," the Revolution was supposed to "nip in the bud the superfluous, the improvised, the hollow and all the cheap merchandise invented by the rich in order to exploit the poor—and implant that which is solid, transcendent, definitive, pure science, and perfect hand work."[14]

Manifestos and slogans such as "The Rifle in the Hands of the Proletariat is the Only Guarantee of Liberty"—printed vertically in large letters on the front page of *El Machete*—continued to assail the government. Under cover of darkness the oversized pages of the paper were pasted on walls in the working-class districts. Finally, on December 13, 1924, the government moved to silence *El Machete*. The mural contracts of those painters who supported the paper were canceled, which left two artists painting murals for the government: Rivera, who had been expelled from El Sindicato, and Roberto Montenegro, who had never been a member.

In the immediate years that followed, the artists faced hard times, barely surviving. Siqueiros remained with the paper, penniless. Orozco received a few crumbs from a newspaper for some drawings and managed to acquire two small mural commissions—one in Francisco Iturbe's House of Tiles (later to become Sanborn's Restaurant); the other in the Industrial School of Orizaba. By 1927 Orozco would leave the country in disgust to try his luck in New York.

There was still a solid front of revolutionary painters, sculptors and

writers, with whose support Siqueiros still continued the publication of *El Machete*, flogging the government with unrelenting disputatiousness. In a letter he wrote to the Minister of Public Education, Puig Casauranc, we learn that he had been receiving three pesos a day as teacher's salary until June 10, 1925, when he was relieved of his teaching post for having been "deficient in work and continued failure to be present."[15]

Siqueiros called the charge a "false and ignoble subterfuge." From his friend Juan Olaguíbel, now head of the Department of Drawing and Manual Training, he had learned that the pro-government Confederación Regional Obrero Mexicana (CROM) had demanded he be fired because of his Communist Party affiliation and his constant attacks on the President of the Republic. Siqueiros wrote:

> I protest against this unjustified act, not for me personally, but because it sets a very serious precedent against all who work for the government for a living. Since it was impossible to remove me from my post (legally), which I earned with my skill in drawing, having taught drawing since I was fourteen, that is for twelve years, you and your employees had to scratch for reasons to justify my illegal firing. To discover my technical deficiency it was necessary to know that I was a Communist!
>
> To expel a teacher because he belongs to a revolutionary political party that upholds ideas contrary (naturally) to the official criteria, is an attack against freedom of thought; to expel a teacher of recognized experience and ability because he does not communicate with the ideas of the government, is an attack against the rights of the professional; but to defend yourself and your motives with a subterfuge damages your professional reputation and is very cowardly.[16]

The letter ended with a lecture on how the government could best reform itself, and brought no reply.

7

Into the Crucible—Labor Leader

While Siqueiros was still executive director of *El Machete*, it became the official voice of the PCM, the Communist Party of Mexico. "The revolutionary prestige of our newspaper was such," wrote Siqueiros, "that the Communist Party of Mexico asked us if we would agree, without changing it, to convert it into the official organ of the Party. . . . This in fact we did . . . exactly on the 16th of September, 1924."[1]

With his experiences, it was inescapable that the youthful Siqueiros would be drawn steadily closer to working-class life. Art was being pushed aside as the interests of the workers became his increasing concern. The conditions he now lived under were those of extreme deprivation, yet he had little regard for his own material situation. He wore tattered sweaters, rode a broken-down bicycle, and long since turned his back on his rather upper-middle-class background. He had "connections" in high places that stemmed from the civil war, but he rejected the bourgeois establishment that was ever ready and eager to accord him success if he would paint only for them. He was willing to forgo such temptations and even his art, for now he entered completely into the working-class struggle.

Now it was President Plutarco Elías Calles who clearly was not leading the people in the direction of the socialist revolution for which the war had been fought. The general amnesty he declared for all refugees opened the way for the wealthy, who had fled the country, to return to power.[2] On his disapproval of Calles, Siqueiros wrote:

> . . . my quarrel with Calles and Callismo centered around his surrendering when confronted with the essential program of the Mexican Revolution, his slowness and trickery in applying agrarian reform, his demagogic torpor in handling the religious problem, his support of the rising new rich class of bureaucratic origin and of the speculators of the Revolution; his hiding the true ideological antecedents and thus the programs of the real Mexican Revolution, and beginning the first steps of the corruption of the workers' movement on the one hand, and of the progressive intellectuals on the other.[3]

Siqueiros was now a leading Communist. He presided over a large meeting held in the auditorium of the Preparatoria on November 7, 1924, to celebrate the 7th anniversary of the Russian October Revolution. So-

viet Ambassador Stanislas Pestkovsky was introduced to the audience by Siqueiros with the words: "*Viva* the representative of the workers and peasants of Russia!" Then, following the ambassador's speech, he recited—with expression fitting the occasion—a poem by Robert C. Ramírez titled "*Bandera Roja*" (Red Flag).[4] This brought the house down!

Siqueiros was moving away from painting; deprived of the challenge, stimulation and inspiration that the murals had engendered, he felt no great urgency at that moment to turn to easel painting. Though he continued to supply some of the drawings for *El Machete,* disciplined political activities were bringing him to greater involvement in the labor movement and union organizing. "I must confess to you," he once said, "that from the year 1924 to 1930 I did not once think about painting, devoting myself completely to the cause of the workers and did not so much as attend one single exhibition. I had no idea whatsoever as to what was going on in the artistic field."[5] A slight detour from this intention took place at the end of August 1925 when Siqueiros attended the exhibition of photographs by Edward Weston and Tina Modotti in Guadalajara. Siqueiros reviewed the exhibit for the local paper *El Informador* stating that "The works of Weston and Modotti were the best proof that photography could be considered an independent art."[6]

Among discontented workers and peasants the period was becoming one of great political activity, with the Revolution still the rallying call and all struggle revolving around its objectives. On May Day, 1925, Siqueiros addressed a great mass rally in Mexico City for the defense of Sacco and Vanzetti,[7] and on June 13 he spoke at another mass meeting that dealt with U.S.–Mexican relations. At the latter meeting he condemned the subserviency of the Mexican government toward the United States. He railed against Yankee imperialism running the government, against the murder of unarmed agrarian reform workers, against the betrayal by the corrupt labor leaders of the right to strike, against the expulsion of militants from the unions, and against the Lamont–de la Huerta treaty with the United States, which "brings the workers and peasants tied hand and foot to North American imperialism for generations to come."[8]

At about this time Julio Antonio Mella,[9] a founder with other Cuban communists of the Anti-Imperialist League of America, was expelled from Cuba. Once in Mexico he became a member of the executive committee of the Mexican branch of the League. This brought him into immediate contact with Siqueiros with whom he soon became a close collaborator. Siqueiros was taken with the revolutionary eloquence of the 23 year old Cuban. Angélica had written that "There must have existed a great similarity between the two, above all when they dealt with their differences of opinion from the other leaders." They were "men of action, they moved in the oxygen of battle along with the masses. Their critical

judgement depended on the daily battles and on the arduous and complex problems in the unions and in the countryside."[10]

At the end of June, Siqueiros went to Guadalajara as organizer for the Anti-Imperialist League of America, one of a long list of organizations and committees that had been set up to channel and lead the revolutionary struggle. In the state of Jalisco, of which Guadalajara was the capital, the miners were in sharp conflict with the North American mine owners, and peasants seeking land reform were being murdered by the *Cristeros*, religious fanatics armed by the high clergy and the landlords [7].

Calles, as had Obregón before him, at first fought violently against the power of the Church, but then he reached an understanding with the landowners and the imperial neighbor to the north. This cooled his offensive against the Catholic Church and, in turn, the Church and the landowners slowed their counterrevolutionary violence.

> . . . [T]he high clergy stopped arming the *Cristeros* and Yankee Imperialism left Calles in peace. This is understandable: agrarian reform was paralyzed, the land was now not being distributed to the peasants, the great haciendas were not being touched, the peasant movement was repressed with violence.[11]

Though the task for which he had been sent to Jalisco—organizing the workers and peasants—was an urgent one, Siqueiros's allotment from the Communist Party in Mexico City was barely enough to keep him alive, so he accepted an offer from his friend Amado de la Cueva *(plate 4)* to assist on a mural he was painting in the University of Jalisco. It was a brief break away from the arduous and tense day-to-day struggle of the working masses and a return to an old love; and it helped ease the remorse he felt for having had to abandon his unfinished mural, *Burial of the Martyred Worker,* to the student vandals of Mexico City.

At de la Cueva's mural, Siqueiros was welcomed by his old friend, sculptor José Guadalupe Zuno. The three artists had been members of the Congress of Soldier Artists that had met in Guadalajara when the fighting of the Revolution had ended; as Siqueiros knew, Zuno was now governor of the state. As governor he was responsible for the university, the state capitol and his own governor's residence, which he himself was decorating. In Jalisco, Siqueiros could have walls to paint. Spurred on by a strong recommendation from the local government that all Guadalajara houses be freshly repainted, Siqueiros organized the first union of house painters of Guadalajara, with himself as journeyman member, since he was assisting de la Cueva to decorate the university.[12]

A few days after they had finished decorating a hall of the university, a terrible tragedy struck; on April 12, 1926, Amado de la Cueva was killed in a motorcycle accident. Siqueiros, grief-stricken over the loss, had no desire to continue the work. Soon after, Zuno was ousted from

office by the Calles government, and Siqueiros resumed his job of organizing the miners.[13]

Jalisco then had extremely deep silver mines and huge latifundia, fertile ground for organizing militant miners and peasants. The agrarian reform program was inactive, and American and British interests were in control of most of the mines. Brutally exploited, with little or no medical care, the miners were wracked with diseases of the lungs, while the peasants experienced feudal conditions of life.

The foreign companies kept hired bands of *pistoleros* to ward off any incursions by "revolutionists." Siqueiros moved in without fear, along with Roberto Reyes Pérez, who had assisted him on the murals of the Preparatoria, and a small number of young painters, to organize the miners and smash the "white" company unions.

Their organizing was done at a long list of silver mines: La Mazata, El Amparo, Piedra Bola, Cinco Minas, and La Nueva Espada Mining Company. Siqueiros was establishing new "red" unions. His organizing efforts were so effective that he and his group of young artist-organizers broadened their field of activity to include the states of Nayarit and Sinaloa, then went on to enthusiastic receptions through the northwest and the entire country.[14] Siqueiros proceeded to create the Federación Minera de Jalisco, followed by the powerful Federación Nacional Minera—each headed by the artist as Secretary General.[15]

Siqueiros next turned his attention to the peasants, and in October 1926 he initiated the convening of the National Peasants Congress of the League of Agrarian Communities, the main purpose of which was to bring the miners and peasants together in a united front. As impossible as this task seemed, remarkable advances were made, and in June of 1927 Siqueiros presided over a meeting of miners and peasants in the village of Hostotipaquillo, where the Confederación Sindical Unitaria de Mexico (CSUM) was founded—Siqueiros at its head. Out of this organization came the "Red Guards"—miners and peasants whose main purpose was to cooperate with federal troops fighting off the attacks of fanatical religious and counterrevolutionary elements. An exceptionally effective Communist Party was operating in Jalisco during this period and winning for itself a considerable following among the miners and peasants; in large measure, the great upsurge in strength could be attributed to Siqueiros's phenomenal organizing abilities.

El Martillo—The Hammer—was a colorful and dynamic newspaper that Siqueiros brought into being on October 17, 1926 as a powerful tool and adjunct to the organizing process. He had developed a special talent for using the print media to shower the masses with hammer blows to wake them from their lethargy. In Mexico City the editors of *El Machete* welcomed the paper:

Its material palpitates with actuality; its writing is transparent and clear as all newspapers of the working class should be; it vibrates with its contents, converting the newspaper into magnificent material for the attainment of its objectives: the education of the Jaliscan workers. *El Martillo* has been born at a propitious time; the struggle of the workers extends its front in many areas: the struggle against the bourgeoisie now has to turn itself against the dormant and cunning clericalism that is allied with an imperialism that intensifies its already ferocious offensive. Long life to *El Martillo!* Crush the bourgeoisie, the latifundia and the Jaliscan clergy.[16]

Siqueiros also created a second newspaper, *El 130,* which first appeared in June 1927. It combatted the repressive and counterrevolutionary activity of the Catholic Church. The paper took its name from Article 130 of the Mexican constitution, which mandated the end of Church power, the confiscation of its property, and—among other things—forbid it to operate schools. In the pages of *El 130,* Siqueiros assailed the outlawed schools, which the church operated clandestinely in complicity with municipal leaders who flouted the law.

Siqueiros worked as one with the workers and peasants, becoming a highly respected and influential labor leader in the state. On August 10, 1927, through the Confederacion Sindical Unitaria, he called for a general strike to protest the death sentences pronounced against Sacco and Vanzetti in the United States. Things were now going a bit too far for the Calles establishment; Siqueiros unchecked possibly could turn Jalisco into a "Red" state. There was little doubt that he was the deadly enemy of the mining and farming interests there, who were struggling to regain and keep control of their properties and profits within the changing scene.

The leading organization of workers in Mexico, the Confederación Regional Obrera Mexicana (CROM), had been founded in 1918 and in 1927, with 2,200,000 worker and peasant members, it was being sold out by its notoriously corrupt leader, Luis N. Morones. At that time, Calles, who was persecuting the worker and peasant movements by proscribing their right to strike, had the Communist Party outlawed.

Nor was Siqueiros ignored; increasingly he was subjected to harassment aimed at halting his activities.[17] In September, at the station in Guadalajara, the police forcefully removed him from a train that was to take him to the village of Etzatlán in a mining area that was being organized. In December, a faction in the Federación Minera de Jalisco conspired with the police to remove Siqueiros as the head and took over the union headquarters. False charges brought a union hearing and it was revealed that Siqueiros's salary amounted to a meager ninety pesos a month; that without reimbursement he paid many union business expenses; that the miners he led were efficiently and democratically organized; that the strikes of the Sindicatos Rojos had considerably improved their conditions of life and work.

The Second Convention of the Union of Miners of Jalisco and the Central Council of Conciliation and Arbitration found all the charges against Siqueiros groundless and gave him a full vote of confidence.[18] In spite of attacks by government, mining and farming interests, the influence and prestige of the Mexican Communist Party was then at a high peak, and "ex-painter" Siqueiros stood as the uncontested leader of the Miners' Union of Jalisco.

Five years had passed since the mural renaissance had exploded in Mexico. Only Diego Rivera—idiosyncratic but not about to rock the boat—continued painting murals on the vast expanse of patio walls at the Ministry of Public Education. As for the rest, those painters who had been with El Sindicato, the Calles government would not tolerate them. Siqueiros had moved deeper into the labor movement and drifted far away from art. In March 1928, as general secretary of the Confederación Sindical Unitaria [8], he led a delegation of some 40 or 50 miners, railroad workers, textile workers, common laborers and schoolteachers to the Fourth International Congress of Red Trade Unions in Moscow.

Diego Rivera happened also to be in Moscow at the time. He had been invited to attend the 10th anniversary of the Russian Revolution in November of the previous year and was still in Moscow when Siqueiros arrived. The two met. Rivera was sketching, lecturing, and negotiating a contract for a Moscow mural. Siqueiros, jolted back into the world of art, felt within him the old pang of remorse. The demands of the labor movement would still not allow his consorting with aesthetics, which he had sacrificed to more urgent priorities. All his creative force flowed into one endeavor at a time. "Even when I make love I concentrate on it so much, I know I am a good lover," he confided to a future wife.[19]

The first reunion of the two painters after their long period of separation was spent in a Russian café drinking tea. "Rivera spoke a little Russian that he had learned in Paris from Angelina Beloff, his wife, so he ordered the glasses of tea."[20] Later Rivera arrived at the hotel where Siqueiros was staying; he was accompanied by the Soviet poet Mayakovsky. They had an urgent problem they wished to discuss. It concerned the old bureaucratic academicians who were in control of Soviet art and who were suffocating any possibility of a new revolutionary art developing from the Russian Revolution. Mayakovsky was especially eager that both Rivera and Siqueiros accompany him on a visit to Stalin to speak to him directly and warn him of the negative effects the old academicians would have.

Siqueiros was surprised at the ease with which Mayakovsky arranged an audience with Stalin. In no more than two hours, they were told, Stalin would receive them. With his large mustache, Stalin looked to Siqueiros like a Mexican general. Mayakovsky introduced the two painters as representatives of the great Mexican mural movement. At the

same time he served as their interpreter, speaking to them in French. As Siqueiros remembered it, the conversation had a profound effect on him.

Mayakovsky placed the problem before Stalin: bureaucratic academicians were impeding progress in art, and what the Mexicans had done in their own country was proof of it. Stalin, however, was not convinced. Yes, he did think that the political revolution in the Soviet Union should have a corresponding revolution in the field of art. But then he pointed out that artistic revolutions are not produced parallel with political revolutions. He observed how each stage in the history of art continued "drinking from the fountain of the civilization that had been destroyed."[21] He then asked them:

> "Where are the real roots of this new art that you want for the new Soviet world? In the present formalism or vanguardism of Western Europe? Is it from there that we should start to realize our own? It seems to me that the academism Mayakovsky so eloquently fights, like the formalism he so eloquently defends, corresponds, though in different ways, to the moribund capitalist world."[22]

Stalin made clear to them that the state would support all those artists who create what will be useful to the progress of the Revolution. Stalin's thoughts in 1928 about art made a formidable impact on Siqueiros. Basically they agreed with his own reasoning from the time of his Barcelona manifesto in 1921. "I must confess," he later wrote, "that it made me think, and later I was able to consider it part of my fundamental doctrine."[23]

The Fourth Congress of International Red Trade Unions held its sessions; Rivera attended as an observer, Siqueiros as a delegate. Siqueiros believed that a speech to the congress in support of Trotsky by the Catalan Communist leader, Andrés Nin, had a decisive effect on Rivera. This became clear when the two painters traveled together on their return to Mexico.

From Moscow to Hamburg, where they were to board the SS *Rio Panuco* bound for Veracruz, their journey was diverting enough, as enroute they toured Prague and Berlin. But when the two were ensconced in the ship's cabin they were sharing on the long voyage home, the political fireworks started over their differences concerning Trotsky. The first half of the trip was sheer torture for both of them; they stopped speaking to each other and ate at separate tables, but had to sleep in the same room. The polemics they carried on through most of their lives can be said to have started in that stateroom. The traditional shipboard mid-passage festivities, however, brought about a reconciliation; the two decked themselves in costumes and, reveling in the gaiety of the occasion, they remained in a happier frame of mind for the remainder of the voyage.[24]

The Mexico to which Siqueiros and Rivera returned was being led

deceptively down a tortured and twisted path of "revolutionary construction."

The ideology expressed in the Constitution of 1917, that the masses must directly benefit from the Mexican upheaval, was gradually pushed aside during the 1920's. The old guard revolutionist generally came to enjoy thick carpets, fine food, easy women and the lure of the gambling table. It was quite a change to deal with the world of legality and sophisticated business after years of battle, and perhaps in order to cast off the rough manners of the country, many of the politicians of the 1920's refused to recall the misery of their village background. They had earned the right to direct society, and they did so by phrasing their conception of the state and its role in political terms.[25]

Clearly, any disruption of this process by Siqueiros would not be tolerated.

Police reserves were waiting on the dock in Veracruz as the *Rio Panuco* reached its mooring. They were on hand to receive the labor leader Siqueiros, returning from Moscow. As Siqueiros described it: "Rivera was put on a pullman to Mexico City. As for me, they took me in a second-class coach and then from the station to the penitentiary."[26] The trip to the prison, a tactic of harassment and intimidation, was to impress on him that the government was well able to handle any activity that threatened its authority.

Set free, Siqueiros returned to Jalisco and resumed his multifarious tasks and duties. In the summer of 1928 he organized and headed the Bakers' Union of Guadalajara; he played a leading role in the Fourth Convention of the Confederation of Workers of Jalisco and in the Committee Pro-National Assembly of Workers and Peasants. In November, representing the workers' bloc, he spoke at the important Worker-Management Convention convened to discuss the Labor Code being instituted by the interim President of the Republic, Emilio Portes Gil.

On this occasion, before Siqueiros spoke, the convention heard President Portes Gil and Vincente Lombardo Toledano, who was representing CROM. Siqueiros presented a list of 47 points that constituted the revolutionary program of the workers' bloc and called for strengthening Article 123 of the Constitution, the laws protecting the rights of workers, which were facing the danger of being "reformed" by the government. In his speech he warned:

> If you make such a reform, it should be to improve the conditions of the workers, with more guarantees, more rights; in a word to improve their situation in every sense so as to give them that for which they have been battling some eleven years. Because in the epoch of General Díaz, before the worker made the Revolution—and you know this very well—he was nothing more than a slave, his situation was dreadful and for this he made the Revolution. So consider the fact that the Revolution was made with much spilling of the blood of workers and peasants, with the spilling of the blood of many millions.

And you will also remember that when the Revolution started, promises were made to the peasants, that with victory they would no longer be earning less than a peso a day, and you know perfectly well that in actuality it was a lie, for there exist today in Mexico many thousands of peasants who earn the miserable wage of thirty centavos a day. What does this mean? It means that the initial promise of the Revolution has not been fulfilled. Hardly two hours from Pachuca, in the most important mining region, one finds all the workers without protection of the law. They are forsaken without houses and their suffering is untold. It is for this I insist that the laws be made decisively effective, and in addition, we must struggle to give still more to the worker for what he has won today is very little.

He then read the forty-seven terms of the Workers' Bloc and concluded with:

I tell you that the struggle of the classes is fatal and cannot be ended except by the implementation of socialism and the destruction of the capitalist regime. We come here to struggle in order to bring justice to the working class, and to make a reality of all the promises that have been made through the years. We all know that the terrible crisis that is holding the country back does not have its roots in Mexico, but is of an international character. And finally what I wish to say is that all reform that we seek should always seek to conquer new victories for the working class.[27]

The unity of the Mexican working class was for Siqueiros the first prerequisite for improving the worker's lot and for this he worked tirelessly, facing increasingly powerful opposition. When the Confederación Regional Obrera Mexicana held its 9th Convention in December 1928, Siqueiros addressed it in his capacity as General Secretary of the Comité de Defensa Proletaria and called for agreement on national union solidarity. In a long speech he outlined the forces that were dividing and weakening the labor movement, stressing how the ruling class was taking advantage of internal squabbles in the labor movement to further split it, and how the workers have been betrayed by so-called representatives of the Mexican Revolution.

"It is no secret to anyone," he told the CROM convention which supported the government, "that the great majority of these so-called representatives of the Mexican Revolution are now the new rich of Mexico, the owners of estates, the new industrialists, the new landlords, etc."[28] He called upon the workers to abandon their internal squabbles and join in mutual defense against the capitalist offensive. His speech was received with enthusiasm and the attending labor leaders agreed to convene what became the National Assembly of Unification of Workers when it met in Mexico City in January 1929. The result of this meeting was the acceptance of the Confederación Sindical Unitaria de Mexico, with Siqueiros as secretary general.[29]

With the growing strength of the labor movement there was a corres-

ponding increase in government opposition. CROM's corrupt leadership bowed to the demands of its rank and file—an estimated membership of 2,200,000—and accepted the National Union Solidarity pact proposed by Siqueiros. The dictatorial Calles, whose term as president had ended, still held complete political control of the country. Though he had not tried to have himself re-elected—which would have been illegal—after Obregón had been assassinated for *his* illegal attempt, Calles called himself the *jefe máximo* and controlled the three puppet presidents who had filled Obregón's vacant term in office at two-year intervals while U.S. Ambassador Dwight Morrow exerted control over Calles from the wings.

Against this opposition the Siqueiros-led Confederación Sindical Unitaria de Mexico (CSUM), with the support at that moment of CROM, mounted a strong campaign of agitation against the proposed "reforming" of the Federal Labor Code by Calles's puppet president, Emilio Portes Gil; against the Confederation of Pan American Workers—an instrument of "Yankee Imperialism"; and in support of the strike of the miners, textile and railroad workers.[30]

On February 5, 1929, as secretary general of CSUM, Siqueiros signed a manifesto that called for support of the half million striking workers in the mine, textile and transport industries. The situation grew serious and on February 17 he issued a call to the union members of the Confederation to donate half of their day's wages for the striking miners of Jalisco:

> This conflict that has gone on for more than a year is one of the most heroic actions of the working class of Mexico. The valor displayed by our comrade miners of Jalisco has inspired the highest praise from revolutionary workers and peasants throughout the world. The manner in which they have defended their rights, facing the assault of Yankee enterprise aided by the Minister of Industry and the traitor Morones, has earned our solidarity. A solidarity that should be immediate, for three hundred families of these comrades have been suffering the most horrible misery for many months. Their victory will be the triumph of the 150,000 miners in the republic and their defeat would be that of the largest and most exploited group in the country.[31]

Through the unions he had organized, Siqueiros was to a large degree responsible for radicalizing and raising the consciousness of the workers, who were now demanding that the Revolution bring them to socialism. Calles was growing more concerned that the unions were getting out of hand. In Jalisco, the government took the offensive, persecuting and arresting labor leaders. The leaders of the Confederación Sindical Unitaria and the Confederación Obrera de Jalisco [8] were expelled from the state, as was Roberto Reyes Pérez, Siqueiros's mural assistant, who was now the only workers' representative in the local legislature. In the capital, workers' rallies were calling for an end to government repression, while Calles, as *jefe máximo*, with the help of the corrupt leaders of CROM, succeeded in having all strikes by CROM members outlawed.

By mid-1929 the rapid leftward movement of the trade unions was all but halted. Land distribution had stopped. "By 1930 the average Mexican campesino was earning forty centavos daily. This, equal to eleven cents in U.S. money, was only half of what he had lived on under Don Porfirio."[32] CROM was subsequently corralled into the government bureaucracy, and the combined power of the national bourgeoisie and the imperial neighbor to the north was able to subdue and control the struggle of the revolutionary workers.

On May Day, 1929, a manifesto by Siqueiros was directed to the workers and peasants of the country, warning of the splitting of the labor movement by the corrupt leadership of both CROM and the Confederación General de Trabajadores (CGT), and by the government's Juntas de Conciliación that made arbitration obligatory. He warned that the bourgeoisie was using all its power to crush the workers and peasants movement, calling it "a picture of white terror and fascism," a systematic repression by the government, the bourgeoisie and imperialism, all of which resort to "arresting, expelling, and killing brave militants in order to bring to every unarmed and passive proletarian the combined exploitation of imperialism and the bourgeoisie."[33]

Siqueiros traveled to Uruguay and Argentina in May 1929 to participate in two labor congresses. As secretary general of CSUM he attended the Congreso Latino Americano in Montevideo, and as a member of the Central Committee of the outlawed Mexican Communist Party he participated in the Congreso Continental de Partidos Communistas de la America Latina.[34]

With increasing government repression at home, Siqueiros, while still abroad, sent two telegrams of protest. One went to the President of the Republic and the other to General Plutarco Elías Calles, "wherever he is to be found," protesting the murder by the army of two comrades, José Guadalupe Rodríguez, who had been a member of the delegation Siqueiros led to Moscow, and S. Gómez.[35] They had tried to organize a Soviet-style peasants' and workers' militia.[36] Siqueiros held Calles responsible for the killing of the two comrades in the state of Durango; was it not he who had brought about "the complete submission of the Mexican government to Yankee imperialism, betraying the Revolution?"

On his return from Montevideo Siqueiros was accompanied by the fiery Uruguayan poet, Blanca Luz Brum and her small son [10]. He resumed attending political gatherings of the coterie of active revolutionaries who gathered in the Mexico City apartment of the magnetic Italian photographer, Tina Modotti. There, in August, he first met Vittorio Vidali who two months earlier had been expelled from the United States. Vidali would later become Comandante Carlos Contreras organizer of the famous Fifth Regiment of the Spanish Civil War. At the end of the year,

December 14, 1927, Siqueiros was the speaker at the official closing of Tina Modotti's exhibition of photographs at the National University.[37]

HOY SABADO 14 DE DICIEMBRE DE 1929
SE CLAUSURA LA EXPOSICION FOTOGRAFICA DE
TINA MODOTTI
QUE PATROCINA LA
UNIVERSIDAD NACIONAL AUTONOMA DE MEXICO
A LAS 19 HORAS EN EL VESTIBULO DE LA BIBLIOTECA NACIONAL
(Av. Uruguay e Isabel la Católica)
HABLARAN: BALTASAR DROMUNDO
DAVID ALFARO SIQUEIROS
¡LA PRIMERA EXPOSICION FOTOGRAFICA REVOLUCIONARIA DE MEXICO!
¡ENTRADA LIBRE! ¡CONCURRA USTED!
CONCURRA USTED!

8

The First Long Sentence

Blanca Luz Brum was Siqueiros's wife, though out of wedlock. When she and her 3 year old child—the son of Peruvian poet Juan Parra del Riego, who had died of tuberculosis—arrived with Siqueiros in Veracruz, her first encounter with Mexican poverty was traumatic and would later deeply affect her poetry. Once in Mexico City, a serious problem assailed them; her presence precipitated a sharp conflict between Siqueiros and the Communist Party.

At that time the Party had been outlawed and was operating underground. Its members were being persecuted and hunted by the government, and when caught they were shipped to Islas Marías, the infamous penal colony off the Pacific coast. At the same time General Augusto César Sandino, the Nicaraguan resistance leader and national hero, was on very friendly terms with the Mexican government, so the Party considered Sandino untrustworthy and withdrew their support of him. They did not want to run the risk that he or any of his followers might reveal their secret meeting place and cause the arrest of the entire Party leadership. It followed for the PCM that since Blanca Luz Brum had a close political relationship with Sandino, she, too, was suspect.

Blanca Luz was stunned by the accusation. Like her uncle Baltazar Blum, she was a proud and independent thinker. He, a past president of Uruguay, had killed himself before he would permit the rebelling army to apprehend him in a coup d'etat.[1]

When the PCM ordered Siqueiros, a member of its Central Committee, to break his relationship with Blanca Luz, he understood their reasoning but could not accept their unanimous decision. A Central Committee member was obliged to follow Party discipline rather than "amorous sentiments." For Siqueiros, the PCM's concerns about security seemed infantile in nature, and he could not bring himself to abandon his wife and her child, alone and penniless in a strange country. So he became involved in a personal underground operation, hiding from the police in the Uruguayan consulate but secretly visiting Blanca Luz each night, artfully

dodging both the police and the Party members on his trail. He was expelled from the Party for breach of discipline; and captured by the police surveilling the consulate on May Day, 1930, when he foolishly wandered out to march in the parade.

Hauled off without warrant or charge to the Lecumberri Prison, the notorious "Black Palace" of Mexico City, Siqueiros was about to begin his first long period of confinement. He had been seized on a pretext surrounding an attempt on the life of President Pascual Ortiz Rubio, the second of Calles's puppets. Ortiz Rubio survived being shot in the mouth, but the incident gave the police an excuse to intensify their search and roundup of Communists. Included in the roundup was Tina Modotti who was also accused of conspiring to assassinate the President. She was expelled from the country and went to Germany. Siqueiros was never questioned in jail about the event, but he was not released until November 6, 1930.

With Blanca Luz and her child alone on the outside, prison was an especially bitter experience. Not only was he kept apart from the more than forty comrades already locked up, but for ten days he was in solitary confinement.

> . . . ten days incommunicado during which time I had practically no coffee. Those in charge of serving the mess would say to me: "If you want coffee put out your hands." . . . My dinner was served to me in the lower part of my sweater, which I stretched out to receive it. Not having utensils, I ate with my fingers. The sweater which had been white was now black and greasy in addition to the many blood stains. When I pleaded with them to bring me the blankets that my family and friends had undoubtedly brought, they answered with insults and ordered me to shut up. I was youthful and strong then and shouted back: "If you want me to shut up come in and shut me up yourself"; so six or seven jailers entered, jumped on me, and beat and kicked me in the face.[2]

Blanca Luz's living quarters in the flat of a sculptor friend of Siqueiros's had been raided by the police, who had removed all of his papers and art works. The sculptor, fearful that for having harbored a Communist he would lose a government commission for a bust of Obregón, threatened to throw Blanca Luz out. Nor would the Communist Party offer her any aid. Everyone was fearful of being in any way associated with the name of Siqueiros.

Later, the heartbreaking letters Blanca Luz wrote to him in jail were gathered together and published in a small book she titled *Penitenciaria, Niño Perdido* after the name of the bus that carried her on her regular visits to the Black Palace. In Buenos Aires, the book was published as *A Human Document*.

In one of the letters included in the book, she wrote:

This situation of the state of suspension that I am in with you causes a tremendous fear in me that I will become an unbearable and horrible nuisance to you in your life as a revolutionary. At night when I review your words and the seriousness and importance of your deeds during the period of life that we have been together, I feel that I am falling into a dreadful emptiness. I feel sure that our separation is near.

Then a few days later:

Never, as I do today, have I felt the desire to press you forever in my heart as did your mother, Teresita, your saintly and beautiful mother. But it is better, dear, that your mother had never seen you this way. To see your head so bowed and sad rips me and gives me tremendous grief that afflicts me with death.[3]

To ward off hunger for herself and her child she attempted to sell some small works by Siqueiros, but was refused; one person even told her, "Not until he abandons his ideas!" She struggled with her sanity and did everything she could from the outside to keep him from the depths of depression. She knew that he, with his bursting youthful vigor, was unable to adjust to the unbearable loss of freedom and was also deeply disturbed by the treatment he was being subjected to by the PCM.

Blanca Luz encouraged him to paint and supplied him with a meager amount of materials. And for reading, she managed to send in books by Marx, Engels and Lenin. She wrote him in August:

The bourgeoisie make jails for the poor and the communists. I am fearful. I have just finished going to the court and they have informed me of the unheard of verdict of the judges. Poor comrades! One must, however, wait. This is precisely the "justice" of an ignominious and barbaric regime based on the exploitation of man by man. I will really help so that you can leave as soon as it is possible for the freedom you long for but it is necessary to rely on your moral strength, your courage, and the manly dignity you had from the first moment.[4]

There was no sign that he would be freed, but as September approached, Blanca Luz began to feel some hope:

Leave your bowls and blankets for the other poor prisoners. Put together only your papers and my letters. I have everything ready, something tells me it is going to be very soon.[5]

On November 5, 1930, the day before his release, Blanca Luz wrote her last letter to him:

You are going to leave tomorrow. Your rigorous revolutionary ideology will serve, unconditionally, to weigh all our weaknesses because the Revolution requires total surrender in the painful dislodging of those most terrible desires of the flesh and the spirit. You are, however, also an artist and great. The museums of the New World will claim the painter of this transitory period in which we happen to live. You have participated in the petty bourgeois

revolution of your country, the first stage of the struggle; you have engaged the bullets of the Catholic persecutions, you have worked in the dreadful depths of the mines, you have battled in the papers, the illegality, the jail. Grasp then, the marvelous panorama, inside and out, realize your admirable work. Your present situation with the Party is in question. On the other hand, your situation facing the Government couldn't be more controlled and difficult. Tomorrow you are going to be free on conditional liberty for bail of three thousand pesos, because this has been decided by bourgeois justice. So what can one do?[6]

While a prisoner, Siqueiros did not escape the special attention of the government. An attempt was made by the authorities to talk some sense into him. Removed from his cell by soldiers of the Presidential Guard, he was driven to the National Palace and brought before General Lagos Cházaro, commander of the Presidential Guard.

Without preliminaries, the general asked Siqueiros point-blank why he hated the President. Siqueiros, who was at that time, as he claimed, "in the full-blow period of the measles of Marxist theory," answered with sarcasm:

For me, my General, the President of the republic is only a small gear, and most times the least important of the social machine, which cannot but move in an inevitable dynamic direction. If it does not, its teeth will break.[7]

Siqueiros's figure of speech—the broken teeth of the social machinery—was not a reference to President Ortiz Rubio's having been shot in the mouth. The general, however, and others in the room picked up on it and there was a sly snickering. General Lagos Cházaro then quickly added that the President knew of Siqueiros's and the Communist Party's innocence in the assassination attempt; those responsible had already been apprehended. The general tried to lure the wayward son of "their" Mexican Revolution back into the fold but had no luck. Nor did the head of the secret police, who tried next, imploring Siqueiros in a fatherly manner to realize that he was sacrificing his artistic production to politics and that as an artist and a veteran of the Revolution he could have practically anything he wanted.[8]

Siqueiros was taken back to prison unchanged. The fact that he was dealt with harshly in jail, isolated from his comrades, and denied privileges usually allowed prisoners, did not disturb him so much as the disciplinary action taken against him by the PCM and the campaign of slander that certain members indulged in to discredit him in the eyes of the working class. It did not take long for this disagreement, which Siqueiros attributed to a degree of infantile leftism within the Party leadership, to be exploited by Trotskyites and police agents inside the Party itself. The Trotskyites sided with Siqueiros in his defense of Blanca Luz and then attempted to drive a wedge that would cause a real split between him and the Party.

But Siqueiros did not blame the Communist Party or its philosophy for the problem. For him, if there was a problem of tactics, it was not the political platform that was at fault but rather the erroneous and provocative actions of individuals in the leadership. Later he wrote:

Step by step the Mexican Communist Party began to understand its grave error concerning the disciplinary measures it had taken against me. In the rules of military conduct it is stated precisely that the inferior is not obliged to follow the superior's order when it is obviously inapplicable. . . . Blanca Luz as a Sandinista was not an agent of the police because neither Sandino nor the Sandinistas were. In reality they were Nicaraguan patriots who for long years had fought against the North American marines. Sandino's action, in fact, was an epic example of the anti-imperialist struggle in Latin America and you could only blame weariness for his not having continued to the end when fatigue was already spreading among his own people and the people of Latin America. As for me, I had not committed so grave an offense as to warrant expulsion from the Central Committee and then to be accused of being an accomplice of a beautiful agent of the international police, who in order to dissemble writes poems.[9]

To further defuse Siqueiros and render him politically powerless, he was released from prison under a judicial order that he reside in the town of Taxco, where he would be subject to the authority of the mayor and the district's military commander, without whose permission he could not travel outside the town. He had been reinstated in the Party and restored to his former position on the Central Committee, but this relegation by judicial fiat to Taxco, "to jail in the outdoors, jail without bars," made political life difficult, if not impossible. Under these circumstances, he was forced to return to art.

Taxco—The Studio

Siqueiros was a man who had repressed within himself a towering artistic talent and was now challenged to permit its release. In Taxco, the passionate desire renewed and welled up in him, and in a year's span a torrent of paintings gushed forth. He was a "new" artist with a unique background of intense and unusual conditioning.

Taxco in 1931 was an isolated town in an area of defunct silver mines, with poor roads leading in and out. Though renowned for its beauty, it was not easy for tourists to reach. However, many foreign intellectuals and artists were aware of its existence and persevered in their desire and determination to journey to the beautiful hillside town.

Siqueiros and Blanca Luz, living in this Taxco "jail," began receiving the benefits of visits to "their" town by this band of hardy intellectuals. Silversmith William Spratling was living in Taxco and soon became a close friend.; Sergei Eisenstein, filming in Mexico, first met Siqueiros

there, as did George Gershwin and Katherine Anne Porter; and Hart Crane *(plate 11)* sat for his portrait.

Obeying the restrictions placed on him by the government, Siqueiros applied for permission to visit Mexico City, which was granted. Ione Robinson, artist and enthusiast of the mural movement, recalled attending several meetings in Mexico City in 1931 where Siqueiros spoke. He was attempting to organize a new artists' union but was unable to arouse enough interest.

In January 1932, Ione Robinson visited Siqueiros. "At Taxco we stopped to call on Siqueiros. I found him living with Blanca Luz in a house on top of a hill. A large red paper star lantern hung on the porch!" Joking with her, Siqueiros explained that his sole political activity at the moment was organizing the young boys who guarded tourists' automobiles into a union.[10] Siqueiros painted Robinson's portrait at this time, a somber rendition of head and shoulders in red attire, on a burlap canvas 34 by 22 inches.

Through his friendship with Álvarez del Valle, the Spanish ambassador, and under his patronage, it was arranged for Siqueiros to place his Taxco paintings on exhibit in the Spanish Casino, Spain's cultural center in Mexico City, on January 25, 1932. It was Siqueiros's first one-man show and marked his return to the world of art. The opening was a cultural event that evoked great interest; to it came a large number of Mexican artists, and intellectuals, including Sergei Eisenstein, Anita Brenner, Ione Robinson and Hart Crane.

Anita Brenner, who in 1929 had written *Idols Behind Altars*—a book that proclaimed the transcendence of the Mexican Mural Movement— spoke at the opening on the astonishing works exhibited, saying:

> We know that Mexico and the entire world have here a great painter, one of the greatest; but we know also that the greatness of his art surges from his rebellious spirit. . . . The power and the beauty of the paintings exhibited here are the expressions of the incisive and monumental ideology of the artist, who manifests the same implacable convictions with the brush as with word and deed.[11]

Over one hundred works, the production of his first year of confinement in Taxco, were on exhibition. There were sixty oil paintings—a great many of monumental size—lithographs, xylographs and drawings. The paintings were done on burlap, its surface made smooth with a thick white priming coat. The colors were of the Mexican earth, and the compositions combined a powerful formal construction with a new realism. Works such as *Mine Accident, Peasant Mother (plate 8)* and *Proletarian Mother (plate 12)* had a shattering effect in their startling revelation of the modern Mexican human condition.

The poignant *Portrait of a Dead Child* caused a stir especially among

those unfamiliar with the peasant custom of propping up a dead child bedecked in finery for the photographer to capture *(plate 10)*. Siqueiros had been summoned by a peasant family who had lost a child. After traveling a long distance on horseback to the peasant's house, Siqueiros discovered that it was a photograph they wanted. But he did not want to disappoint the family and explained to them that though a painting would take longer, it would be much better. The dead child, beautifully dressed, was then placed in a chair and supported by a sister who was not much older. Siqueiros did a watercolor sketch of the two children, from which he painted later in oils in his studio.[12]

Years later, referring to the 1932 exhibition, he told an audience:

> When I saw all my works gathered together there, near the murals we had painted in former times, I realized that my progress had been very little. . . . I was perhaps more skillful than before, but nothing more. Perhaps my concept of the body in space was better. But in reality the pictorial-psychological effect of my new work was almost identical to that of the old. My paintings were still passive, my theme mystical . . . sentimental rather than dynamic and activating. And from a passive theme comes a passive kind of painting, the result of which must necessarily be negative. Nevertheless, . . . ninety-nine percent of my subjects concerned the life of the people, the lives of the workers and peasants of my country. But they were not yet expressed in the proper words. They did not speak *their* language.[13]

What seemed so impossible a short while ago, when he was completely dedicated to the struggle of labor, was now a reality. He had switched his full creative powers back to painting, to facing the problems in art that intrigued him most: how best to speak through the medium of painting and force aesthetics to serve social justice.

After he had examined the exhaustive output of paintings of the year in Taxco, Siqueiros was of the opinion that not only his confinement there but the impoverished and underdeveloped state of the entire country could not further his development in the technical aspects of painting, could not help him solve plastic problems related to murals, especially in a modern highly industrialized world. Besides, he was still being harassed at the hands of the Calles-controlled government, which made it difficult for him to support his family.

He was granted permission by the Mexican authorities to exile himself and his family in the United States. With very little funds, a vague hope for an exhibition in Los Angeles, and an uncertain offer that he teach the technique of fresco painting in a school there, Siqueiros, Blanca Luz and her little boy arrived in California in the spring of 1932.

His reception in the United States was not entirely unhappy. There were two exhibitions in Los Angeles, the first introduction of his work in the United States. A small exhibit of lithographs opened on May 9, 1932, in Jake Zeitlin's bookstore, but then on May 12 fifty works of his

Taxco period went on display at the Stendel Ambassador Gallery. This show attracted many film personalities and opened up some doors in Hollywood, including those of actor Charles Laughton and film director Joseph von Sternberg.

The exhibit was enthusiastically received, but the opening was slightly marred with controversy when some viewers began to shower abuse on *Portrait of a Dead Child,* calling his subject too "savage" a custom for portraiture. Siqueiros's response was that it was much more savage and brutal to assassinate living Black people. This shocked the opening-night crowd, causing a scandal that spread to the press, and he was accused of insulting the country.[14]

The offer to teach had come from Nelbert Chouinard, director of the Chouinard School of Art in Los Angeles. Mrs. Chouinard was willing to employ the leftist Siqueiros, interested only in the fact that he was a known Mexican artist of talent. She paid him a small salary to teach the fresco technique, but it would soon be this *true* method that would bend to meet Siqueiros's demands.

9

Los Angeles, and A Future Wife

Difficult as it was in the United States during the Hoover period, "it was still possible at that time," Siqueiros wrote, "for Latin American revolutionaries to be in exile in the United States."[1] Though not exiled, the two other leading Mexican muralists were also in the United States at this time.

José Clemente Orozco had returned there in 1927 and was still there when Siqueiros arrived. Disenchanted with Mexican politics and unable to find economic support for his art at home, Orozco looked to the United States to solve his problem. In New York again, he was barely surviving and would have been forced to return to Mexico had not Anita Brenner brought him to the attention of Alma Reed, owner of the Delphic Studios.

Alma Reed, who was later to become Orozco's biographer, had been the beloved of the martyred Yucatán revolutionary Felipe Carrillo Puerto. Empathizing immediately with Orozco and his art, she set about offering assistance to help him survive. After presenting an exhibition of his drawings and paintings, she was able to obtain for him two important

mural commissions: one in 1931, for Frary Hall of Pomona College in Claremont, California; and the other in 1932, for the Baker Library of Dartmouth College in New Hampshire. He also painted two small murals in the New School for Social Research in New York City in 1931. Strongly political in subject matter, the New School murals were generally kept from public view behind locked doors.

Diego Rivera continued in the employ of the Mexican government and was kept sufficiently busy on murals in Mexico. However, he too had plied his trade in the United States. In 1929, three years before Siqueiros arrived, Rivera had been invited to paint two murals in San Francisco. But at that time Mexican revolutionaries were unwelcome and he was refused a visa. The rich San Francisco patrons then had to pull strings to lift the ban and permit Rivera to slip in; he finally arrived in November 1930. Surrounding himself in an aura of suspense, he revealed his mastery of the fresco technique first in the newly constructed San Francisco Stock Exchange and then in the California School of Fine Arts. In less than a year's time, he was back in Mexico at work on his murals in the National Palace.

In 1932, after the Los Angeles exhibitions, Siqueiros turned his attention to his job of teaching fresco technique at the Chouinard School of Art. He intended not only to teach the method but at the same time to produce a mural with the help of the students. He settled on an outside concrete wall for the project, though the true fresco technique was not supposed to be used outdoors. But the wall he had selected faced the street and commanded a greater area for public viewing.

Among artists and art lovers everywhere a mystical aura enveloped the ancient technique of *lavorare in frescho*—working on fresh plaster— weaving a romanticism around it and making it synonymous with murals. Siqueiros was beginning his quest for modern techniques and tools for painting and he spurned archaic methods, harboring within himself an aversion for fresco. He might have done as he was bidden and instructed in true fresco technique had the wall been indoors, but when he faced the nine-by-six meter concrete wall outdoors, it was obvious that traditional fresco could not serve as the medium. Ecstatically he proclaimed: "My friends, traditional fresco is dead!"[2]

This concrete outdoor wall, with the problems it presented and the modern technical solutions it required, suited his restiveness. The very idea of a mural in the street, facing the public, stirred in him the excitement that caused him to reject the traditional thousand-year-old method. Fresco was all the more emphatically anachronistic, especially considering the extraordinary synthetics that modern science and technology could supply in the most industrially advanced society in the world. From this moment on, Siqueiros began a more profound examination of the ramifications of mural painting in the 20th century. The Chouinard project

allowed him the opportunity to develop and apply his new mural concepts. For him, theory followed practice:

> It was the practice of painting, the logic of this uninterrupted exercise that made theory possible for me. Theory is discovered in that which is being done, and in a certain way the theory anticipates that which later comes organically.[3]

The Chouinard mural became an effective vehicle for practice and theory, and he established some fundamental concepts. He believed that the modern mural, addressed to all humanity, could be effective only when executed with the most modern and up-to-date materials and methods possible. The mural was

> . . . a work of great magnitude, physically ponderous, and required scientific solutions that were not absolutely necessary in small paintings destined to be the property of a useless and insignificant elite in the world population.[4]

Since the traditional fresco method of painting on wet lime plaster would not survive outdoors, Siqueiros proceeded to modify the "pure" method by substituting cement in place of lime, because of its more durable qualities outdoors. The cement would set faster, so a quicker application of color was needed. This led to the innovation, at least for Siqueiros, of the use of the spray gun in fine art. Also, for the first time, he thought that the composition of the mural would have to take into consideration a very active spectator moving about the street within visual range and the consequent compositional distortions.

Workers' Meeting [11] was the contemporary proletarian subject selected for the mural. To be portrayed were North Americans: Blacks, whites and Mexicans—in a racially integrated group. It did not take long for this message to reach racists, who immediately subjected the school to vehement verbal abuse. The Los Angeles newspapers joined the attack, and Mrs. Chouinard was forced to erect a wall high enough to shield the mural from innocent eyes. In the end, however, nothing short of total removal would satisfy the racist elements and this was duly accomplished by the Red Squad of the Los Angeles Police Department, armed with a court order.[5]

The students in the fresco painting class—some twenty artists, many of them accomplished and well-known—were beginning to understand the importance of mural painting for the United States. Siqueiros's first step was to teach the importance of collective endeavor for the monumental mural, the need to form an organization strong enough to ward off the blows that reaction would direct against their mural statements of commitment. "Mr. Fresco," as Siqueiros was nicknamed by his students, got them to organize into the Bloc of Mural Painters.

Blanca Luz chronicled the mural's progress in *El Universal*, the Mexico City newspaper.

In two weeks, with three spray guns and twenty North American painters, David Alfaro Siqueiros finished the fresco at the Chouinard School of Art. . . . He had declared that "Mexican fresco" is unsuitable because it is slow, because it is mystical and because in a vertiginous and violent city of capitalism it is archaic. Where skyscrapers are raised in twenty-four hours it is not possible to install the romantic fresco that takes three, four, and ten years to paint. Added to this are the new tools and the new techniques. As a revolutionary, he took only a few hours to discover that the Mexican fresco ended up being mystical in its form, its colors, its composition and its result. The new elements, he himself confessed, had opened up a new world, an unsuspected aesthetic: trim, solid, electric, definite, concrete. It is the aesthetic of this epoch, it is the aesthetic of the developing new society. . . .

He and his disciples have dedicated themselves to the formidable dynamism of the towers of steel, of levers, and of motors. . . . One must see him now in action; surrounding him are twenty artists, disciplined and attentive to this romantic and aggressive Mexican leader discovering the greatest and most marvelous elements for a new art. Elements that had been hidden, ignored, and utilized only for the most domestic and prosaic services. . . . For this reason we find him with the famous architects Neutra and Spolding, who, excited, are determined to support the revolutionary "pistolero." . . . But the end of the mural reserved a surprise, dangerous enough for Siqueiros and bitter enough for the sanctimonious California bourgeoisie.

. . . When the famous day arrived the mural was seen with astonished eyes. Siqueiros had painted a *Communist orator* encircled by a white female worker holding a child, a black worker with a child in her arms, and the rest of the group made up of the bricklayers who constructed the building. In short, he made a mural of agitation and propaganda.

The lecture of Siqueiros before eight hundred people the night of the inauguration was an insane barrel of dynamite: "against capitalism," "against North American imperialism," "against the filthy pompous painting of Europe and the United States," "in favor of a technical and mechanical revolution," and finally a call to the intellectuals to join the ranks of the proletariat, etc., etc., For this and the revolutionary mural, Siqueiros remained left out, and did not make the thousands and thousands of millions that Diego Rivera said he had made in the United States.[6]

That a Mexican painter, a revolutionary, was painting a mural at the Chouinard School quickly caught the attention of a Mexican art student who had been living off and on in Los Angeles since 1924. Luis Arenal could not pay the tuition to enter the fresco class at Chouinard, but he did convince Siqueiros, whose English was not yet fluent, that he could serve as his translator. Arenal, twenty-four, moved in the left circles of southern California and was a member of the cultural John Reed Club and of the Communist Party. He soon fell under the spell of the dynamic thirty-five year old maestro, became his assistant, and dragged him home to show him off to his family.

Señora Electa Bastar de Arenal, Luis's mother, was a widow with

four children; her husband had been killed at twenty-six fighting for the Revolution. During the presidencies of Carranza and of Obregón, Señora Arenal had been the director of a school for wayward girls. An honest educator and administrator, she had incurred the wrath of the politicians for being too critical of corruption in the school and was forced from her job. In order to find a better education for her own children, she had left Mexico in 1924 for Los Angeles.

In California she could find only menial work, so she returned alone to Mexico, where her chances of making money actually were better. The four children had been left in Los Angeles in the care of a friend, to continue attending the public school. After two years the children had been happy to return to their mother in Mexico, but by 1929 the fatherless family once again returned to Los Angeles. This time their luck was better.

Señora Arenal had opened a boardinghouse and restricted it to boarders who wished to study Spanish; thus she found some contentment in being able to teach. In this Los Angeles boardinghouse Angélica, at age 22 the second eldest of the Arenal children—a proud, dreamy, black-haired beauty—first encountered David, the 36-year-old painter from her own country. Her brother Luis introduced Siqueiros and Blanca Luz to his mother, his two sisters and his younger brother. Charming and gracious, Siqueiros, enjoying the warm atmosphere of the meeting, turned to Señora Arenal and said, "Why don't we move here? You can rent us a small apartment?"[7]

Siqueiros arrived at the boardinghouse with Blanca Luz and her little boy. As a couple, and especially as aliens, once in the United States they found themselves compelled to undergo the ceremony of a formal marriage. It made them less likely to be molested by the country's narrow conventions, and made it easier to find living quarters. Angélica Arenal was already the wife of a blond German-born husband and she was pregnant. Siqueiros took note of the young woman and her condition, and remarked openly to Blanca Luz and to everyone else on how beautiful Angélica was in her pregnant state.

Angélica's marriage was not of her own making. She was not in love. In her youthful innocence she had surrendered to the pressures of her mother. "He was a good German," her mother had told her, "and good Germans make all the girls happy."[8] The marriage lasted two years, and it was the last time she listened to her mother.

Siqueiros, Blanca Luz and the child moved into a small bungalow that was available, separate from the main house. The very first night they lived there left an indelible impression on Angélica's younger brother, Polo, who told me he remembered that from the moment Siqueiros and Blanca Luz moved in, the shouting and fighting started, and that night they smashed most of the furniture and dishes in the bungalow.

The new boarder charmed and fascinated the other boarders as well as the Arenal family. Siqueiros would write: "I first met Angélica in 1932 and from that moment her family became my family. Later the militant comrade became my wife."[9]

When he came home from the Chouinard mural, his clothes full of paint, Siqueiros would take his meals in the boardinghouse kitchen. A plate of beans, chiles and tortillas would be set before him, and the other boarders would all come in. Speaking of art and politics and the Mexican Revolution, he held them all spellbound—the North Americans and the Latin Americans. He was "organizing" in the kitchen, proselytizing and charming them. Angélica's only interest at the time was in what he was saying and she drank in every word. Her ambiguous thoughts and dreams were being clarified, leading her to appreciate her mother's struggle for her children's education—the trained educator forced in the United States to clean the homes of the rich and labor in a garment factory while Angélica, her sister Berta and brother Luis did menial jobs around the San Diego oil camps.

In the boardinghouse kitchen Angélica listened to Siqueiros's view of the world. Her marriage had sidetracked the hopes she had had of becoming a writer. She was a Catholic, though not devout, and unhappy in her present condition; Siqueiros's vibrant words kindled a new excitement in life for her. She wanted the truth, and read books and sat in on university lectures, trying to untangle the philosophies that might help her make some sense of a world that grew ever more depressing to her.

The kitchen lectures became a daily event of great fascination for her. The Marxist artist was separating sense from nonsense, and in his fearless display of rationalism she found joy. The only attraction he had for her at that period, she confessed, was the brilliance of his philosophical and political concepts, and—most important—the understanding he brought to her about the history of Mexico. Her father had died in the Revolution, she had not known him, he was almost forgotten. But when Siqueiros spoke of that event, the figure of her father loomed large. For the first time her father's life had become meaningful and she was proud of him.[10]

Siqueiros's first mural in the United States was stimulating for him and his team of artists, but for Nelbert Chouinard it was more like a nightmare. The mural, with its "intolerable" subject of the mingling of black and white workers, was finished in July 1932 but was destroyed by the racist authorities. The two weeks that it took the team of twenty to paint it was all the time that the public had to view it. Yet the sordid act of police censorship did not discourage the commission for two murals that followed. One was for the private home of a film director, and the other for a public mural on the Plaza Art Center building, a commercial enterprise on Olvera Street in the old Mexican section of Los Angeles. The

proprietor of the Plaza Art Center hoped to benefit from the publicity that showered on Siqueiros after the scandal of the Chouinard mural; besides, she herself would choose the theme. But she, too, would have to contend with political ideology being fed into a spray gun and then radiating out from a mural.

The mural for film director Dudley Murphy's house measured six by three meters and was done in *buon fresco*. Though the wall faced an outdoor patio, an overhanging roof protected it from the sun and the elements. Murphy offered no objection to the mural's theme and title: *Portrait of Present Day Mexico or the Mexican Bourgeoisie Rising From the Mexican Revolution Surrenders to Imperialism (plate 16)*.

On one side of the mural President Plutarco Elías Calles is painted attired as an outlaw, armed to the teeth and seated; to his right are two bags of gold. In the background two dead workers symbolize the victims of his repression; in the foreground, seated at the base of a pyramid, are two suffering and anguished women in a hopeless posture. Murphy was enthusiastic about the work and brought Siqueiros to the attention of the film colony. Later, he would propose making a motion picture about Siqueiros's life, a project that was never fulfilled.

The theme of the other mural was agreed upon by both painter and patron, but each had separate visions as to how the subject, *Tropical America*, (*plates 14 & 15*) would materialize. Mrs. Cristine Sterling, the owner of the Plaza Art Center, envisioned a happy lush tropical paradise with fruits, exotic plants and sensuous women. Siqueiros painted the lush foliage of the tropics, but added an overpowering symbol of the oppression brought by U.S. imperialism and capitalist exploitation.

Rising in the center of the mural for the six meters of its height is the Indian "victim," his hands and feet nailed to a double cross. Atop this cross perches the U.S. imperialist eagle; on both sides, the guns of guerrilla fighters protrude from the tropical jungle *(plate 13)*. The mural was thirty meters long and six meters high, and was on the upper outside wall of the building. A section of roof that extended below it served as a floor to walk on and paint from. He used cement fresco for the outdoor wall, as he had on the Chouinard mural, but this time the cement was black. He had innovated cement fresco for the outdoors and its rapid setting had encouraged the use of the spray gun, which he also modified by tying brushes to it, thus enabling him to use the brush while spraying if he so desired.[11]

As seen from below, the mural commanded a wide viewing area, and the mobility of the spectator was an important factor in planning the composition. The sun and weather did cause deterioration, which might have been restorable, but the mural was in the control of philistines, whose successive coats of whitewash resisted repeated later attempts at restoration.

Tropical America was finished at the end of August, 1932. Siqueiros had been assisted by twenty-five painters of the Bloc of Mural Painters and they had completed it in twenty days—he was working as rapidly as North American enterprises. The mural was formally presented to the public on October 9, and though it rained, the inauguration was a gala affair. A few days later, however, immigration authorities refused to approve his application for renewal of his visitor's papers, and he and Blanca Luz were forced to leave the country.

A reporter waxed poetic on the night of the mural's inauguration.

Resplendent in the night, the fresco of Siqueiros seems to fit into the arch of the sky over Olvera Street, such that one part of the great black stain of low roofs of Sonora Town has fastened on it masses of colored cement and sculptured forms. . . . [I]t seems consecutively to advance and retreat depending on the depth of the modeling. . . . From miles away *Tropical America* possesses us and commands us. The white rain fell and made the roof, that is the base of this new and strange force that has come to dominate the old Spanish district of Los Angeles, glitter. . . . David Alfaro Siqueiros with his head uncovered in the rain, is like the director of a great orchestra who leaves the shell in order to announce, in his newly acquired English, that the buildings of the future will be covered with these dynamic paintings, the special products of communism in art created by groups of artists who work together with the same desire.

A great multitude come and go to the roof, . . . making the event more dramatic, accelerating the stage time. Nevertheless the rain, which did not cease, did not extinguish the vehement desires to spend more time before this new and powerful force solidified on the highest wall of the Plaza Art Center. Before the equivocal or astonished shadowy humans that moved over the roof, the heroic creatures of the mural maintained their intense calm. . . . This night that we are living seems to be fifty to one hundred years in the future. The artist Siqueiros, whom the federal authorities seem so anxious to deport, is without doubt a dangerous type; dangerous for all the snarling and pusillanimous speculators and retailers in art and life. The federal agents justly claim that art is propaganda, for when the youth confront this gigantic dynamo that pounds in the night under the rain, or clamors boldly when the brilliant sun of midday shines in the plaza, they will possibly find in it the inspiration to rise in rebellion in future revolution, in art and in life, exclaiming: "Off the road, conservatives and old ones, here comes the future!"[12]

Siqueiros further flew in the face of the powerful reactionary elements of southern California when he led his Bloc of Mural Painters to join with the members of the John Reed Club of Hollywood in support of the Scottsboro Nine. To publicize and raise support for the famous case of the young Black men struggling to escape Southern lynch justice, an outdoor exhibit of paintings was organized on the front lawn of Señora Arenal's boardinghouse. The Red Squad of the Los Angeles Police Department soon visited the site and confiscated the paintings, all rich with political content. When eventually the paintings were returned, they were

full of bullet holes. Surely Siqueiros, the foreign artist, could not be permitted to remain in southern California any longer.

During his brief period of "refuge" in the United States, from May to November of 1932, he produced three murals. The great modern technology of the United States inspired and stimulated him, and his ideas on producing art that was both relevant and significant for the 20th-century working class became more clearly formulated. Speaking before the John Reed Club in Los Angeles on September 2, 1932, he said:

> The processes we used for monumental painting were without precedent. Our experiences were of great value for the radical transformation of pictorial technology. And equally, it was the beginning of a new sense of the plastic in consonance with the social and scientific nature of the modern epoch.

He encouraged the North American artists who made up his audience to forge ahead with murals of commitment:

> For the Bloc [of Mural Painters], modern elements and instruments of pictorial production represent a reserve of immense value for the proper essence of the plastic, and for political painting of agitation and revolutionary propaganda, which are the only possible vehicles for painters of Marxist conviction, and in general, for those who have been shaken by the present life.

This, his first experience in the United States, helped to reveal to him the shortcomings of the Mexican Mural Movement of the period ten years earlier:

> To anachronistic elements and tools there corresponds an anachronistic aesthetic. The Mexican Renaissance is an example: pretending to be modern it is archaic; pretending to be monumental, it results in being picturesque; pretending to be proletarian, it is populist; pretending to be subversive, it is mystical; pretending to be internationalist, it is chauvinistically folklorist; the march that we started to the Revolution was stopped by the most counterrevolutionary aesthetic and political opportunism.

One of the principal reasons for all this was the lack of adequate technical ability, too much relying for inspiration from art history:

> We drank from archeological fountains. . . . On a church organ you cannot produce psychologically subversive revolutionary music. With this instrument the most baroque dance is converted into a sacred song. Nor is it so of popular music just because it arbitrarily accommodates itself to flaming revolutionary lyrics. The aesthetic-psychological effect of popular music is to depress and not to impel, and it is in this case the principal role played by the music. Popular folk music is. . . the slave, the outcast, the peon of the feudal hacienda, and its aesthetic sense cannot serve as a voice of the modern industrial proletariat. The popular voice is one of plaintive and supplicant beauty. The voice of the proletariat is the voice of the class historically predestined to change the economic system of the world. The voice of the proletariat is a dialectical voice, aggressive, threatening and tremendously optimistic. This

is the way aesthetic expression should be that serves your struggle. This is the way the plastic of agitation and revolutionary propaganda ought to be.[13]

At the end of November, the Bloc of Mural Painters and innumerable well-wishers threw a farewell party for Siqueiros, Blanca Luz and their child. His short stay had left an indelible mark on the artists of southern California. "Siqueiros's coming to L.A. meant as much as did the Surrealists coming to New York in the forties."[14]

When they left for the port of San Pedro, they were escorted by immigration authorities and placed aboard the *West Nilus,* a Dutch freighter sailing for South America. Siqueiros was still politically persona non grata in his own country; this time his voyage of exile carried him to Montevideo, Blanca Luz Brum's home.

Left behind was Angélica Arenal, with a new and awakened consciousness. She would soon return to Mexico with the entire family.

The Mural Movement and the WPA

The Mexican muralists had spread their influence among the artists and the people of the United States during the Depression years. Siqueiros, Rivera and Orozco had left monumental works that reflected experiences stemming from the Mexican Revolution. Earlier, word had already spread to the North American artists that a renaissance of mural painting was taking place south of the border and a number of them were inspired to make the pilgrimage to Mexico.

George Biddle, Pablo O'Higgins, Isamu Noguchi, and Grace and Marion Greenwood all found Mexican walls on which to practice. With the exception of Biddle, who lived a month with Diego Rivera and painted his portrait, they painted their murals in the Mercado Abelardo Rodríguez, a popular market in Mexico City. Some years later Biddle was granted a wall to paint in the Mexican Supreme Court building.

Fierce economic difficulties during the Depression years had brought the U.S. artists to understand that government sponsorship of murals and other works of art was the only real solution for their survival. George Biddle, ardently enthusiastic about the Mexican Mural Movement, was instrumental in getting the federal government to subsidize art for the first time with the formation on December 3, 1933, of the Public Works of Art Project. A mural painting program, relatively vast in scope, was set in motion throughout the United States.

Biddle, from a well-to-do, influential New England family, brought about this turn of events with a letter to his old classmate and friend, President Franklin Roosevelt.

Dear Franklin: . . . There is a matter which I have long considered and which some day might interest your administration. The Mexican artists have

produced the greatest national school of mural painting since the Italian Renaissance. Diego Rivera tells me that it was only possible because Obregón allowed artists to work at plumber's wages in order to express on the walls of the government buildings the social ideals of the Mexican Revolution.

The younger artists of America are conscious as they have never been of the social revolution that our country and civilization are going through; and they would be eager to express those ideals in a permanent art form if they were given the government's cooperation. They would be contributing to and expressing in living monuments the social ideals you are struggling to achieve. And I am convinced that our mural art with a little impetus can soon result, for the first time in our history, in a vital national expression.[15]

"That," wrote William F. McDonald, "was in a certain sense the occasion that inaugurated the Public Works of Art Project, and after it, the whole arts program of the WPA."[16]

Roosevelt responded favorably and the machinery was set in motion. George Biddle had hoped that he would be entrusted with organizing the PWAP mural section and he was supported by artists such as Henry Varnum Poor, Thomas Hart Benton, Maurice Sterns and Boardman Robinson. Though they were less passionate than the members of El Sindicato, they were ready to join an organization of painters committed to the social ideals of the nation.

The Washington establishment was not yet ready to entrust the organizing of a government-sponsored mural program to an artist, least of all to Biddle, a "social democrat."[17] One of their "own," David Bruce—conservative, a corporation lawyer, but also an artist—was put in charge of Biddle's Mexican dream. Although his selection precluded the possibility that a group of government-supported mural painters might form a *union,* many murals were sponsored by the PWAP under Bruce. They reached every part of the country, employing as many as 3,600 artists, and were received by the public with tremendous enthusiasm.[18]

10

Exile: Montevideo—Buenos Aires

Searching once more for a haven abroad, hospitable or not, Siqueiros felt that he would indeed be in luck to find a country in the Americas where the unavoidable perturbations surrounding his political aesthetics would not stifle his creative drive. He expressed some of this torment when he wrote to his friend, silversmith William Spratling, on November 29, 1932:

> My very dear friend: When you receive these lines I will already be "swimming" aboard the *West Nilus* with destination Argentina. The authorities of this your country do not wish to extend me permission to remain here any longer. They have ordered me to leave immediately, notwithstanding that some hundreds of the most important intellectuals in the United States have requested that I be given more time to remain. With this I have lost a great opportunity in New York. It truly pains me to have to leave the United States because for some time now my imagination has been in the industrial zones here, such as Pittsburgh, St. Louis, etc. I had projected a trip by automobile through the regions populated by the blacks when the blow struck. In any case I believe I have done something interesting here. I have initiated a movement of outdoor murals that I judge to be very serious—murals "under the sun, under the rain, facing the street." If one muses over this, one recognizes its enormous importance, something absolutely new in the history of the world, establishing the basis of art of the future that would be "public to its fullest extent."[1]

Though for the moment Siqueiros lacked a base from which he hoped to develop further his new aesthetic ideas, his internationalist spirit helped him adjust to each foreign land he visited. In Montevideo, Blanca Luz was again home; Siqueiros tried to continue the momentum of painting that had been interrupted so abruptly in Los Angeles. In 1933 in Montevideo, busying himself on easel works, he used pyroxylin paint (automobile lacquer) for the first time on a painting that measured two meters by one meter. *Proletarian Victim* showed a nude female figure bound with rope and bowed down on her knees. Unsure about the qualities of the new paint, he reverted to oils for the finishing touches. But pyroxylin, despite its toxic vapors, satisfied Siqueiros and he used it exclusively until the advent of acrylic in later years.

In Montevideo, too, Siqueiros's presence was a source of excitement and stimulation for the artists and intellectuals. He soon induced them to organize the Writers and Artists League of Uruguay. He lectured in

February at the Circulo de Bellas Artes de Montevideo, and in March he presented an exhibit of paintings, lithographs, and photographs of murals. The two lectures—"The Technical Experiences of the Mexican Renaissance" and "The Work of the Painter's Bloc of Los Angeles"—brought to the Uruguayans a vivid picture of Mexican artists on the move.

They heard how the Mexicans, without any prior knowledge of mural painting technique, turned for understanding to the past—to the Italians, to the Indians of their own land. The Indians knew the ancient fresco technique and advised the would-be muralists how to plaster a wall with a mixture of well-slaked lime mixed with well-washed river sand. The artists were then taught how to mix the slimy sap of the nopal (a cactus) with water—to serve as a vehicle for painting when sized with dry pigments. And they learned to derive the pigments from natural earth and mineral sources: the Indians told them where to find the colors, how to remove them from the layers of earth, and how to wash and grind them.

Siqueiros explained how they learned from the construction job chief to avoid the dangers of humidity in the walls by neutralizing the wall, putting a layer of asphalt between it and the coat of plaster. The Indian workers taught them to regulate the consistency of the lime coat according to the wall. If the stone wall or the plaster undercoat was smooth, a rougher coat of plaster would be required, and vice versa. They also learned how to recognize when the lime was sufficiently set to begin painting.

The Mexican artists also probed the experiences of the Italian Renaissance muralists to understand composition problems that applied to monumental surfaces and that took into account the role of the spectator observing a large mural, not standing before an easel painting. The Mexican Renaissance, the artists of Montevideo were told, had resumed mural painting after a complete break of 400 years; they had had to rediscover the old techniques and rules of mural painting; and in so doing they had opened for the modern age unlimited possibilities for the future of mural painting.

In Montevideo, Siqueiros's own painting was developing in the direction of a new and stronger realism, while in his lectures to Uruguayan artists and writers he was formulating a clarifying aesthetic rationalism that espoused the ideals of public art. In March 1933, to the artists in the Studio of Plastic Arts of Montevideo, his subject was "The Educational Experience of Painting and Sculpture in Mexico." For the students in the Center for Architectural Students of the University of Montevideo, his subject was "Architecture, Sculpture, Painting: One Problem." The students were told:

When the aristocracy takes over art it degenerates; when it becomes individualistic it becomes inconsequential; when it ceases to be a work of conviction

and becomes a purely cerebral expression it enters totally into a process of corruption; it then breaks apart, is no longer a unified body and decays. The object of the great temples of antiquity was to continually dazzle the masses. The overall plasticity was a work of conviction and a collective material product, not only in respect to its fabrication but also in respect to its directorship. The architecture, the sculpture and the painting constituted one alive unified body; separating them would have been the same as mutilating them; architecture, sculpture, and painting were then a single problem, answering to a general plan—and to satisfy a popular need the sculpture was polychromed. The structures of ancient civilizations were the result of geographical realities, of material objects, of a corresponding technical development, and it was an eminently political product whose monumental character had for its object the subordination of the masses in order to give them an ideological homogeneity.[3]

In Uruguay Siqueiros did not ignore the reasons for his plight, and often enough he assailed the Calles-controlled government that kept him from his homeland: "This was my obligation outside of Mexico as well as in Mexico itself."[4] At the University of Montevideo he lectured on the Mexican Revolution, and the Latin American poverty he observed fed his revolutionary flame with new fuel. As a guest of the country, Siqueiros exercised restraint in political activity, but on May Day, when he addressed the Confederation of Intellectual Workers of Uruguay, he did not soften his words.

We want to be conscious collaborators with the proletariat. We have been the divulgers of bourgeois class culture, the culture of oppression of the working masses. We will be the ones to apply enthusiastically the new revolutionary culture that emanates from the proletariat. With our old works we propped up the bleeding, dying capitalist society. With our new works we will help rip out these supports in order to speed up its collapse. From the trenches of the bourgeoisie we attacked the Soviet Union with slander. Now we will defend her from the closed ranks of the proletariat in arduous but victorious advance. She is the first socialist country of the workers and the most powerful dynamo generating the final class battle. In exchange for the most miserable jobs we were the bureaucratic allies of the feudal bourgeoisie of Latin America. Thus we collaborated with those who were the brutal instruments of the imperialists. Today we are going to take our stand, physically and morally, in action that strikes at the power of the dictatorships.

We incited the wars the imperialists desired, which are a matter of life and death to decrepit capitalism. We now denounce their real motives and join our voices to those of the proletarian vanguard when they shout: "We will take up arms but only to fire them against the bourgeois class! With the arms of the imperialist war we will make the social revolution." The work that we shall put at the service of the proletarian cause will not be a fruit exclusively of emotions; it will be a revolutionary, cultural and aesthetic product, dialectically elaborated and resting on a materialist foundation.

We live on the outskirts of real life, locked up in the carnal and moral brothels of the rich. Now, with all our strength, we must enter into the

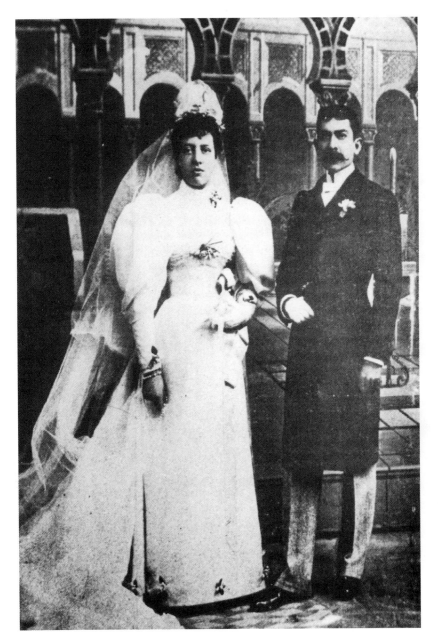

1. Siqueiros's mother and father, Mexico City, 1894

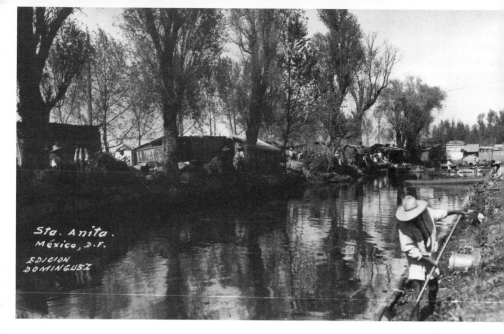

2. Village of Santa Anita, 1912

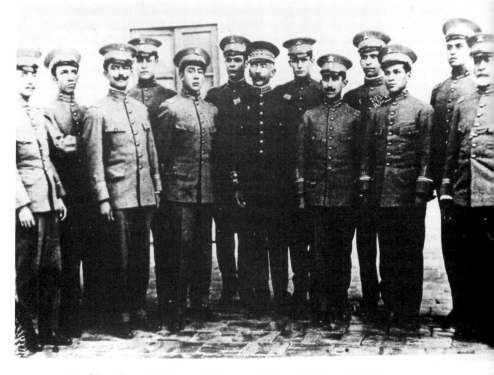

3. Siqueiros, 5th from left, as captain with General Diéguez, 1916

4. Self-portrait, 1918

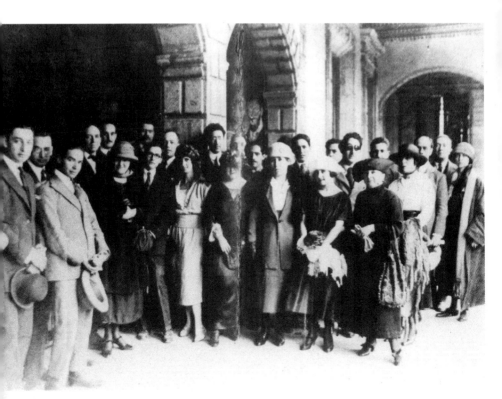

Siquieros with a group of Mexican artists, circa 1923, from left: 1) Augustin Lazo,
2) Orozco Romero, 4) Abraham Angel, 6) Adolfo Best Maugard,
8) José Clemente Orozco, 9) Jean Charlot, 17) Carlos Merida, 20) Siqueiros

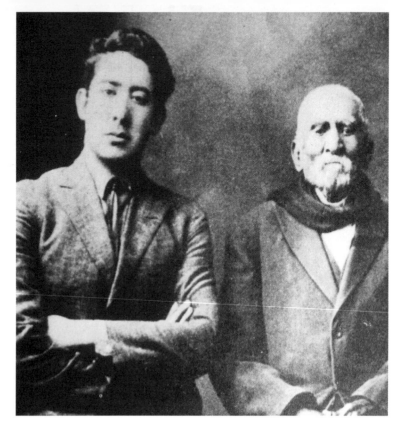

6. Siqueiros and grandfather Siete Filos, 1927

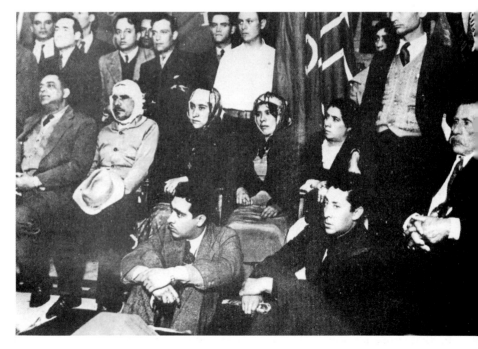

7. Siqueiros, 2nd from right, seated with victims of Cristeros

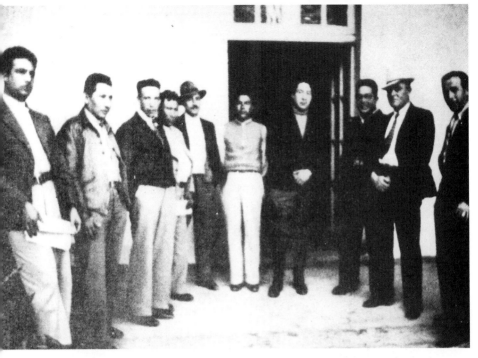

8. Siqueiros, 4th from r., Secretary General of the Confederation of Labor, Jalisco, 1925

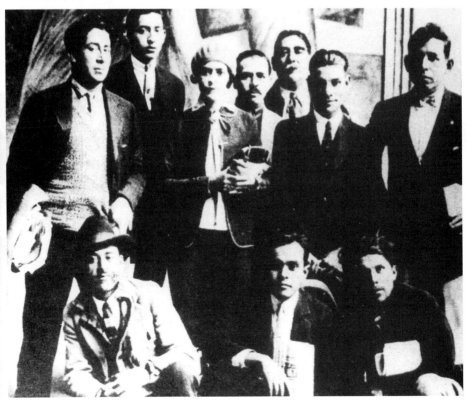

9. Siqueiros, left, with first wife Graciela and labor leaders. Vittorio Vidali at front row, left, 1929

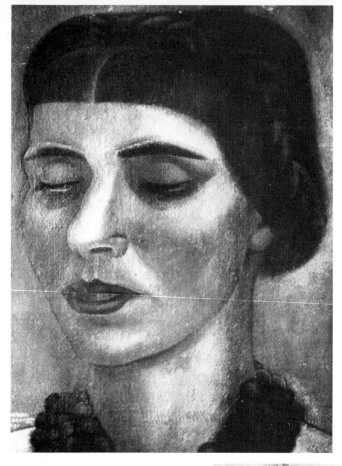

10. Blanca Luz Brum, por
 by Siqueiros, 1931

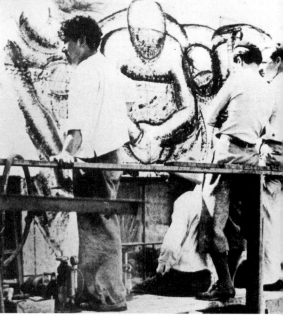

11. Siqueiros at work on mural, "Workers Meeting
 Chouinard School of Art, 1931

Maria Asúnsolo, portrait by
Siqueiros, 1935.
84" x 45.5" - pyroxylin

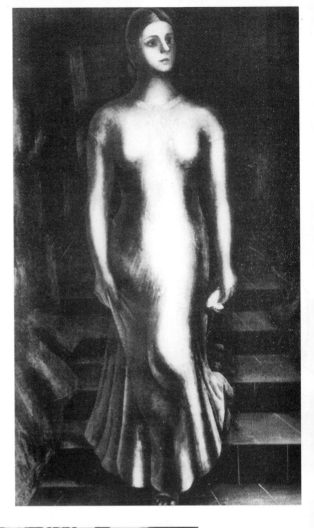

Siqueiros Experimental
Workshop, New York, 1936

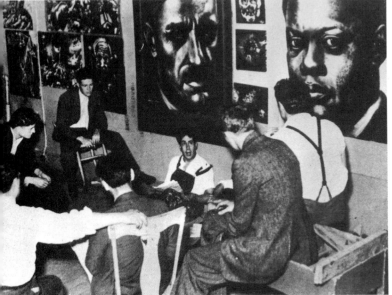

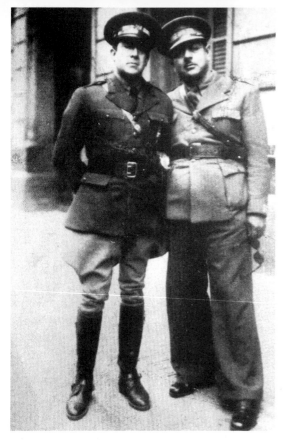

14. Lt. Col. Siqueiros and Commandante Juan B. Gomez, Spain, 1937

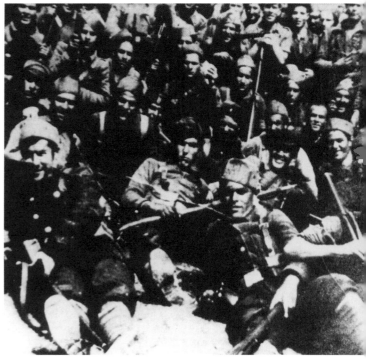

15. Siqueiros at the front, 1st figure, lower left

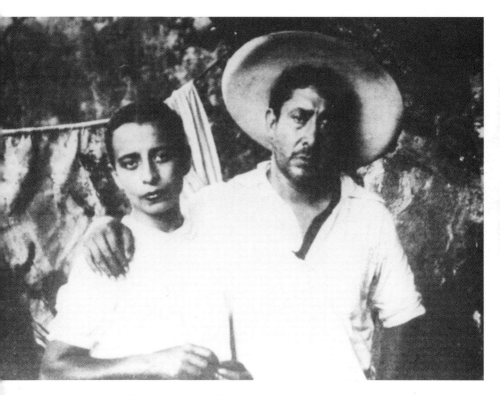

16. Fugitives: Angélica and Siqueiros, 1940

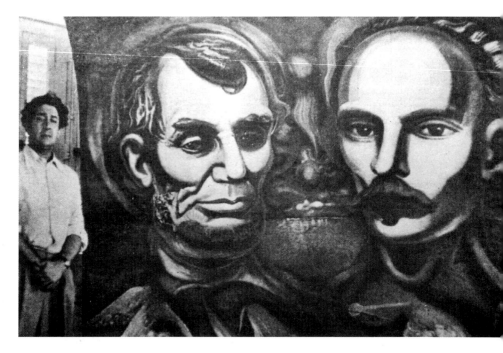

17. "Two Mountain Peaks of America," Havana, 1943

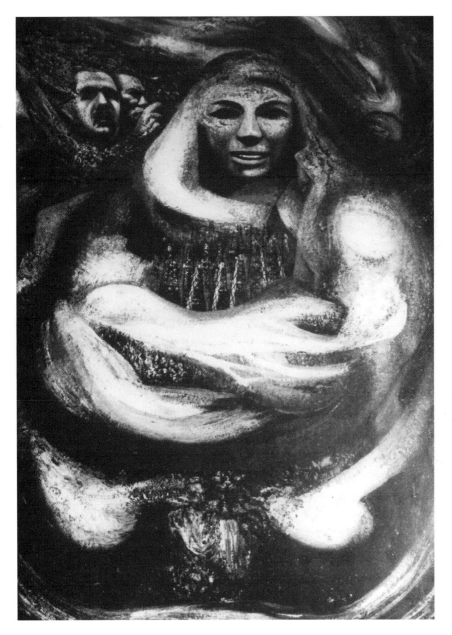

18. "The Dawn of Mexico," 1944, portraits of Cárdenas and Toledano in the upper background.

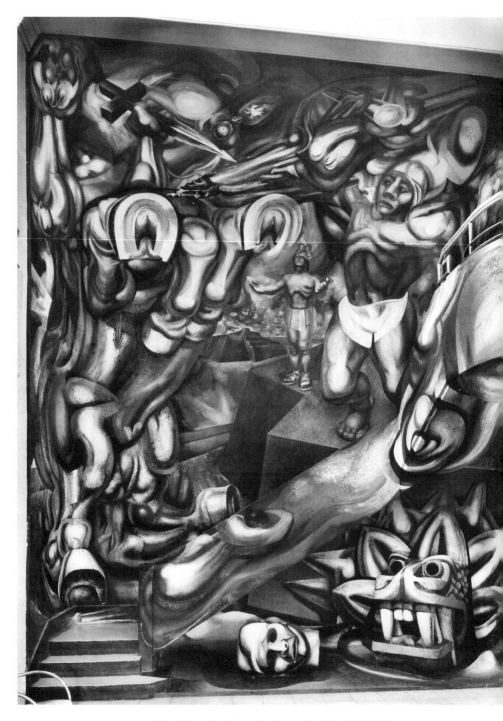

19. "Cuauhtémoc Against the Myth," 1944

20. Inauguration of mural "Cuauhtémoc..." l. to r., Maria Elena, daughter of
Lombardo, Angélica Siqueiros, Siqueiros, Vicente Lombardo Toledano
1944

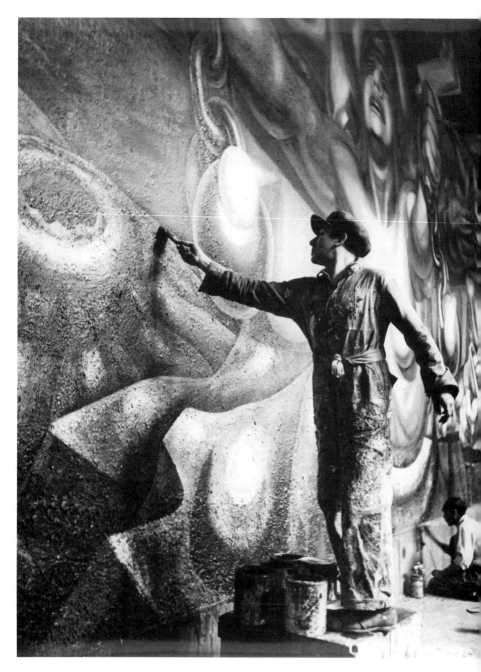

21. Siqueiros at work on mural "New Democracy," 1944

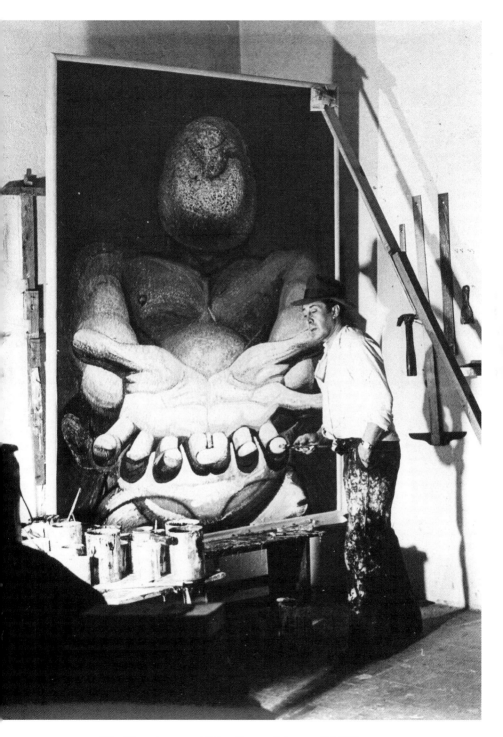

22. Siqueiros and "Our Present Image," 1947

23. San Miguel de Allende, Guanajuato, 1948

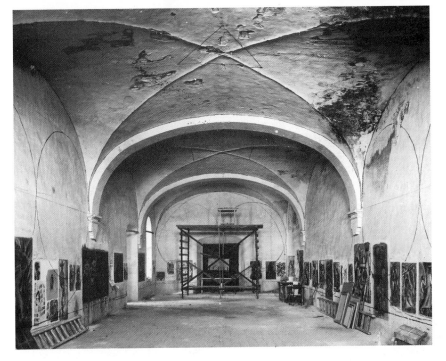

24. Nun's dining room used by students to practice fresco painting, San Miguel de Allende, 1948

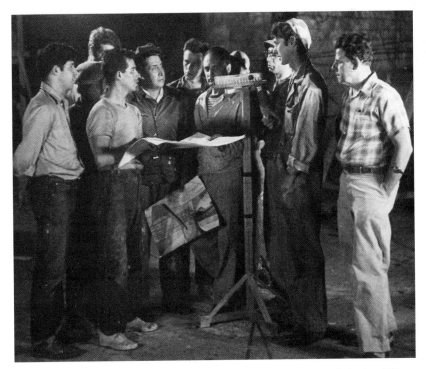

25. Siqueiros and students, l. to r., Ernest de Soto, Herman Grissle, Bill Hammil (face hidden), David Barajas, Siqueiros, Kent Bowman, Jimmy Pinto, Philip Stein, Jeff Selzer, Carl Young. San Miguel, 1948

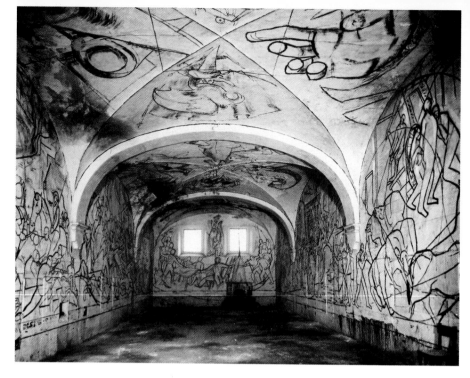

26. The students' mural.

27. The room made ready for the Siqueiros mural

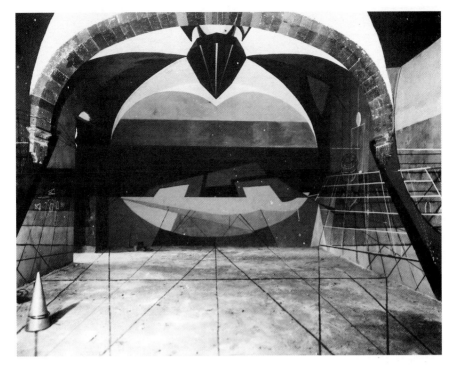

28. Development of composition, including floor

29. Baptismal font for Ignacio Allende

30. Atop the scaffold, Siqueiros and author

31. The bolt of lightning

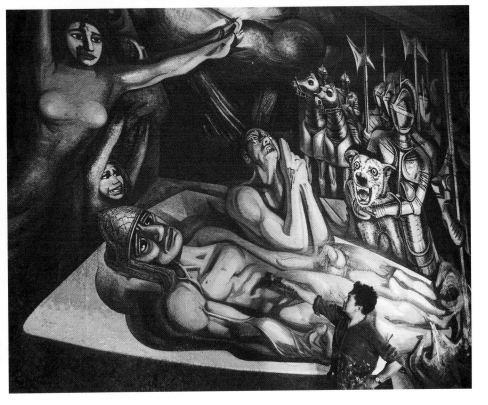

32. Siqueiros at work on the "Torture of Cuauhtémoc"

33. Guarding the Juárez monument from Sinarquistas, Mexico City, 1950

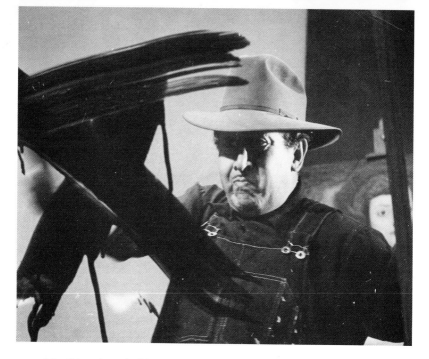

34. Siqueiros in his studio in Tlacopac, Mexico, D. F., 1949

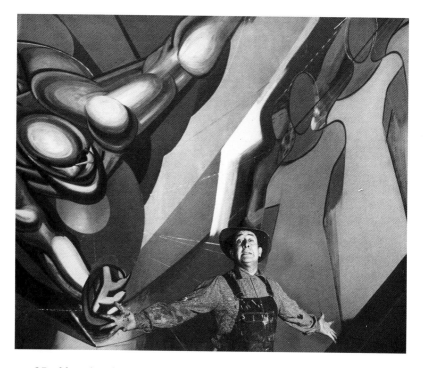

35. Mugging for the photographer, Hospital de La Raza, 1952

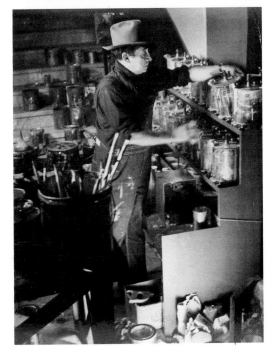

Siqueiros at paint-mixing machine, Palace of Fine Arts, 1951

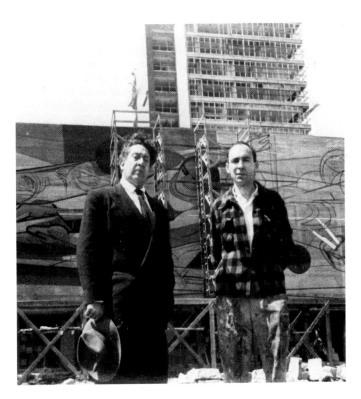

37. Siqueiros and author at University City, 1953

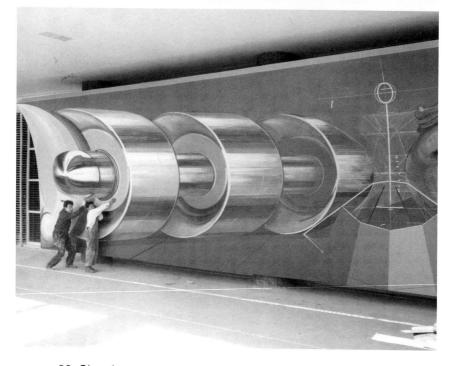

38 Siqueiros at mural, "Man, Master of the Machine," 1952

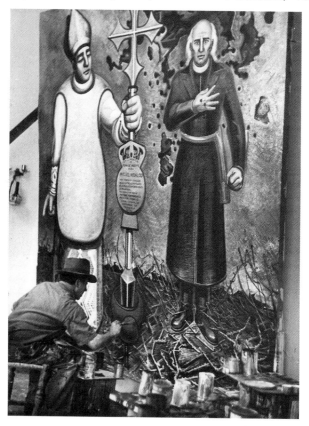

39. Siqueiros painting Padre Hidalgo, 1953

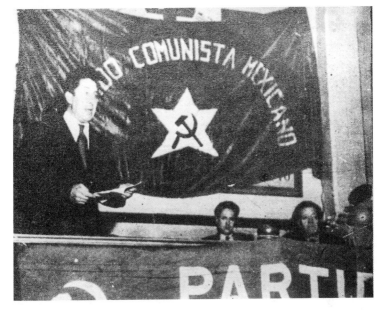

40. Siqueiros at meeting of Mexican Communist Party, early 1950s

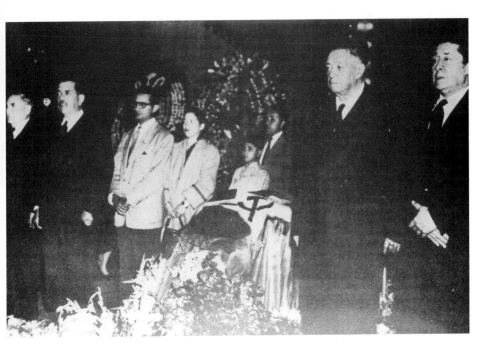

41. Paying last respects to Frida Kahlo. Front row, l. to r., ex-presidents
Emilio Portes Gil and Lázaro Cárdenas; Diego Rivera, Siqueiros

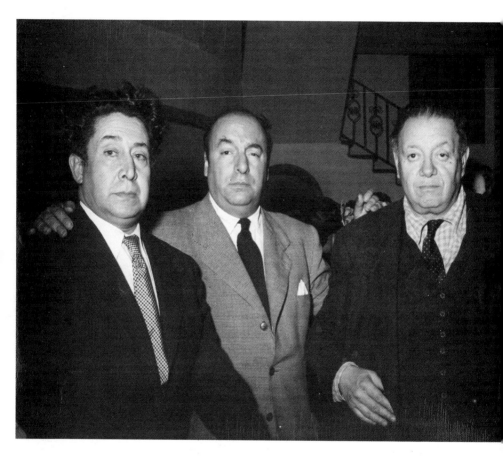

42. Siqueiros, Pablo Neruda, Diego Rivera, 1952

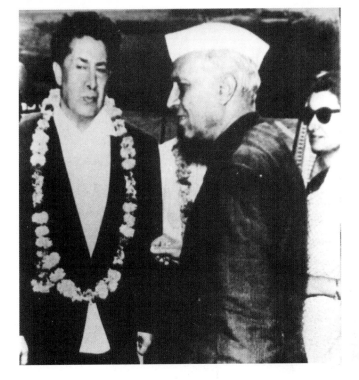

43. Siqueiros and Nehru, 1956

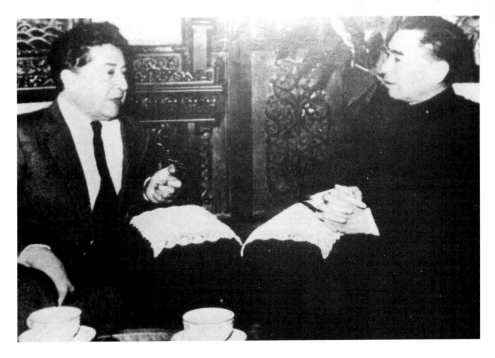

44. Siqueiros and Chou En Lai, 1956

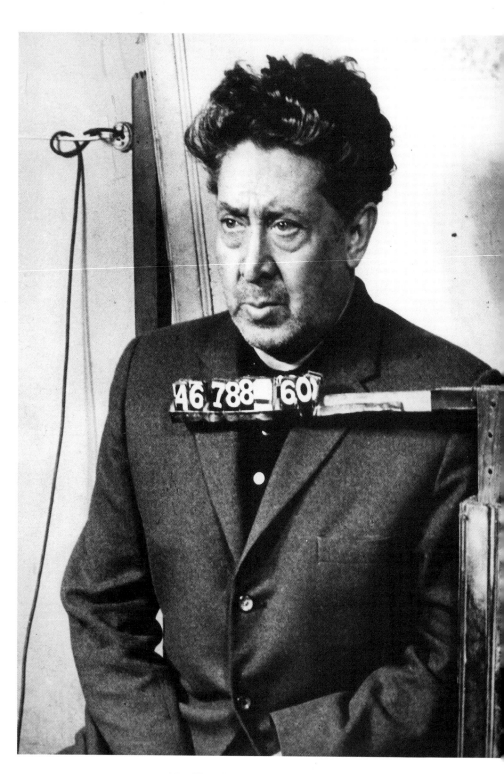

45. Siqueiros arrested, August 1960

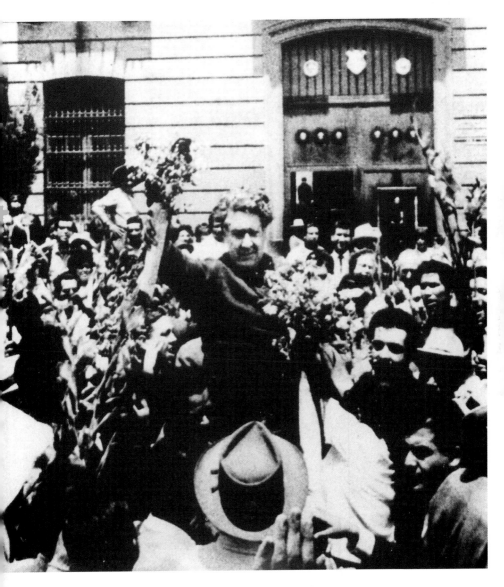

46. Freedom! July 13, 1964

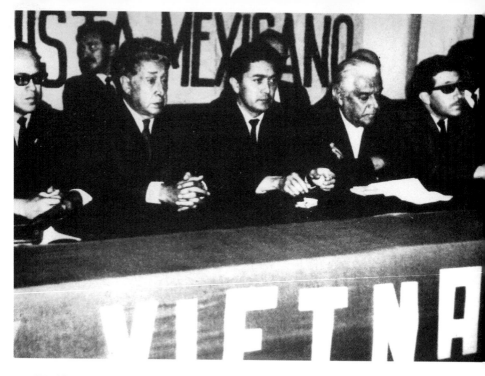

47. Meeting of solidarity with Cuba and Vietnam at the Téatro Lirico, Mexico, D.F., July 31, 1966

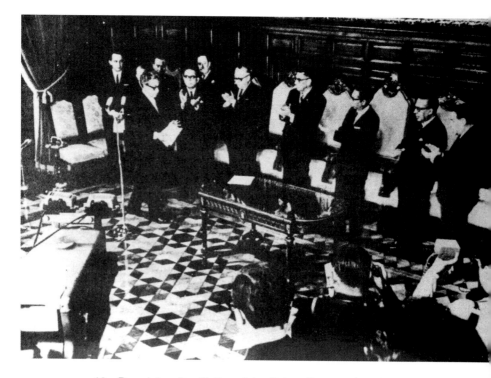

48. Receiving the National Art Prize, December 15, 1966

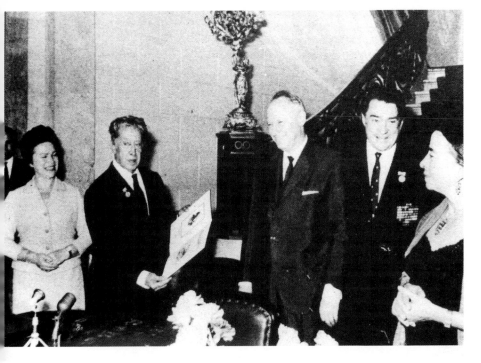

49. Receiving the Lenin Peace Prize, September 1967

50. Siqueiros with Tito, November 10, 1967

51. Angélica Siqueiros in 1982, standing next to the final
unfinished work of her husband. She died in 1989.

tremendous contemporary social drama that deals with the class struggle. Our works must document the large and the small struggles of the working class, which we must follow, moment by moment, as it advances heroically. At once and with discipline we must do our work. In this way our works will be the living essence of the ideology and purposes of the proletariat.[5]

The fiery speeches of the Mexican painter did not diminish his popularity among Uruguayan artists and intellectuals and won him note in Argentina. In June 1933 he was invited by "the first lady of Argentine letters," Victoria Ocampo, whose home in Buenos Aires was a salon for intellectuals, to present three lectures before the Asociación Amigos del Arte, which she led. Siqueiros and Blanca Luz left for Argentina, even though for her, ultra-right Buenos Aires was a particularly distasteful place.

Two stormy lectures were given, but then Victoria Ocampo, herself a conservative, canceled the third, having become frightened when she heard him say such things as:

The street spectator is distinct from the complacent gallery spectator. One has to put the painting that will be seen from afar by their eyes in such a way that the intensity of the theme and the plastic expression will be realized, will be felt. It is not possible to effect this fundamental change in painting without there being an ideological incitement. Still more: it is not possible to realize anything great without a spiritual content that encourages and strengthens this desire. We should understand that we ought to be tied to the grave problems of our epoch. We should lean toward the worker, we should be on the side of the weak nation pillaged by the stronger, we should hate war and aspire that the intellectuals and artists enjoy greater appreciation. Art without ideological content has no reason for being and has no permanence.[6]

Siqueiros was stirring up intellectual circles and rallying artists to the proletarian cause in what was an increasingly fascist, pro-Nazi Buenos Aires. Argentine artists wanted him to paint a mural in their country and they petitioned the President of the Republic, General Augustín P. Justo, to invite the Mexican to decorate a wall. Though a conservative, President Justo approved the idea. Siqueiros and a team of Argentine painters selected an outdoor wall on the Buenos Aires waterfront. Reaction was quick and violent, and the newspapers *Fronda, Bandera Argentina* and *Crisol,* all pro-Nazi, forced the President to withdraw his approval.

The rightwing press also attacked an exhibition of 14 paintings, 4 lithographs, and photographs of Siqueiros's murals that the Amigos del Arte had presented in conjunction with his lectures. *Bandera Argentina* led the attack with "The Monigotes [ugly paintings] of Alfaro Siqueiros and their Plastic Value," an article by Alfredo Tarruella.

Siqueiros does not know how to paint, and . . . lacks a disciplined, experienced, spiritual inner life. His works are ugly pictures. . . . Because Siqueiros is not an artist—he is a communist—a man in whose hands art is a pretext

and a means of propaganda. . . . Siqueiros cannot be an artist because he is a servant of the destroyers of Christian civilization, the Soviet Union, and a confessed accomplice of Soviet aberrations that want to destroy all the arts, eliminate easel painting, replace the spirit with the material and the noble brush with a mechanical one.

The Argentine ruling class would no more turn a deaf ear to what Siqueiros was saying and doing in Argentina than had their counterparts in Mexico and the United States. As he settled deeper into Argentine living, his aesthetic and political activities put him more and more on a collision course with the authorities, who had already jailed him briefly as a warning to desist from advocating, in his lectures on aesthetics, a new social order for the workers. The tumult was also eroding his relationship with Blanca Luz.

The opposition of the press toward Siqueiros was not unanimous. Natalio Botana, the wealthy owner of *Critica,* Argentina's most important newspaper, was captivated by the exuberance of the Mexican painter and offered him the pages of *Critica* as a forum for his ideas. For more than a year Siqueiros contributed a very popular column on art and politics to *Critica*'s weekly supplement. During that time he carried on a debate with his old boss José Vasconcelos, Minister of Education, during the latter's visit to Buenos Aires.

Both Siqueiros and Vasconcelos opposed ex-President Calles, who still wielded great power in Mexico, but they opposed him for different reasons. Vasconcelos gave interviews to the Argentine press, and Siqueiros's comments about those interviews in his column brought their differing opinions about Mexican politics and the Revolution into the open. To the fascination of the Buenos Aires public, a great debate blossomed in print: Siqueiros in *Critica* and Vasconcelos in the no-less-important newspaper, *Noticia.* "Without any doubt," Siqueiros later wrote, "our opinions constituted the most famous intellectual-political event in the Republic of Argentina in 1933."[8]

The debate left the pages of the newspaper and reached the auditorium of the University of Argentina, where the two were to face students eager to learn more about political events in Mexico. However, a group of revolutionary students plastered Buenos Aires with announcements of the debate that labeled Vasconcelos a counterrevolutionary and Siqueiros a revolutionary, causing Vasconcelos to cry foul; he refused to appear. Siqueiros did not condone the ill-advised act of the students, but he was also on the stage with no control over the situation, so he acceded to the requests of the audience and explained his views on the Mexican Revolution and the role of the embryo Calles oligarchy in developing and consolidating a Mexican rule allied to North American imperialism, burying the Revolution while singing a hymn to it.[9]

After the government rescinded its approval of the Argentine artists'

proposal that Siqueiros be given a wall to paint, publisher Botana offered him a commission to decorate a room in his home; it was semicylindrical in shape and was used as the bar. Though the room would not receive the audience to whom Siqueiros preferred to address his murals, its unconventional shape was a challenge and appealed to him. The mural, *Plastic Exercise,* was, he wrote, "a work that due to circumstance, appeared to be the fruit that was compelled by our own condition as salaried workers (a condition that would only disappear with the present society)."[10]

The bar, designed by architect Jorge Kelney, proved important for the technical innovations it encouraged. Siqueiros moved into the space bounded by 200 square meters of arched surface, armed with a spray gun and a movie projector. He was more absorbed in the problem of how to paint shapes on a semicircular surface than in the theme those shapes would delineate, especially in this hidden-away private bar.

Cement fresco technique was used, and for the finishing touches silicon paint, a new synthetic at the time. On this mural Siqueiros probed for dynamic forms that would relate to the zone of vision of a dynamic spectator. The architect's design was analyzed to uncover the foundation for the painted forms that would complement the overall structure. Abstract forms were then drawn on the curved surface and these in turn became the basis for objective forms. From points on the normal trajectory of the dynamic spectator, figures were flashed on the curved surface with the movie projector, enabling Siqueiros and his team to study the distortion on the curved surface. He was after the effect of changing "cinematographic" forms, which would become activated as the spectator viewed them while moving beneath the semicircular surface. Female figures were painted to float and twist by spectators who moved on a floor that was incorporated into the composition with polychrome. Undoubtedly, beverages served at the bar helped to heighten the cinematographic effect.

The moving spectator had now come to be of utmost significance for Siqueiros in determining the nature of the composition. He had attacked the problem in the L.A. murals, but in Botana's bar the concept was more fully developed, for the spectator moved in a more concentrated area.

> It was a pictorially active plastic that was due to the optic phenomenon obtained by the heightened use of the geometric topography of the corresponding architectural space. The dynamic use of the multiple visual perspective, of a "visual magic" it is fitting to say, was our recourse to a plastic "trick."[11]

Siqueiros felt that he had taken an important step that would further advance the realism of modern socially oriented mural art. Applying a cinematographic effect to monumental outdoor murals would be a powerful method of presenting ideas to the masses, and modern mechanical methods would be necessary for achieving these results.

The Italian futurists, not having understood this, died brandishing an abstract theory of "movement." Their catafalque was the easel painting. The "enemies of anachronism" died of anachronism. Now, naturally, they are fascists. . . . On this road the antecedents are very few and far between. Until now only "snapshots" of movement have been made (the formidable Paolo Uccelo for example). There has been a failure in the plastic to develop movement itself, for such a thing as movement could only be the job for our epoch.[12]

Plastic Exercise, though decorative, served as an experimental work which effectively broadened the capability of murals to speak to the masses of the modern age. And Siqueiros did not lose touch with the Argentine masses. He addressed many workers' meetings, tested Argentine jails, and had to contend with threats of expulsion by the police. But he also assumed the role of art critic.

Evaluating Argentina's major annual art exhibition, Siqueiros wrote a review in *Critica* (September 22 and 23, 1933): "The Twenty-third Salon as a Social Expression: A Symbol of Decadence, it Exhibits a Lamentable Passivity." It was a probing examination of the social root motivations of Argentine art.

Is there capability and personal values among the exhibitors of the Twenty-third Salon of Bellas Artes that opens tomorrow? There is, and very much. . . . [T]here are . . . painters of great capability and power. They are personally gifted, but . . . [t]hat which ought to interest us is that which can be useful in order to discover the social nature that the twenty-third Salon exhibits . . . in its connections with the historical realities of the present moment, and in its contact with the ideological unrest of the epoch.

. . . The Twenty-third Salon reveals with a vengeance the decomposition of the capitalist regime. . . . It reveals in an obvious way the disorder that prevails in intellectual as well as all other sectors of present life. It likewise exhibits the miserable plastic-pedagogic methods that are now in vogue.

. . . The Twenty-third Salon demonstrates the infinite emptiness that appears when the solid connection to social conviction is missing in a plastic work. Men and women—perhaps of genius, painters and sculptors of innate strength, walk and stumble and reel like the blind in their production, passing from one imitation to another, from one capricious plastic concept to another, from one eccentricity to another. Their emotive source of life is artificial: a pool of museum scholastics, or better, a fountain of a commercial speculative nature.

They receive aesthetic concepts as though they were canned food products. Works from French impressionism to pre-war constructivism appear in the exhibition. . . . For the great majority of the group that exhibited, there was nothing that indicated the existence of fifty million unemployed and hungry in the world. There was nothing that signified the heroic struggle that the working class was presently waging against the tyranny of the capitalist system. They preferred to continue possessing the muse that inspired the prattling bacchantes rather than capture the tremendous power of workers in action and in struggle.

. . . Preference for puerile, inane and ridiculous themes in an epoch when

the most cruel and intense battle in the history of the world is being waged between the classes. Still lifes, placid scenes, mystical nudes, in an epoch of tumultuous proletarian demonstrations and violent fascist aggression of the bourgeoisie! Ego-cerebral abstractions at the same time that cinematography and a revolutionary documental literature appear. In the epoch of Sergei Eisenstein, of Pudovkin . . . of Dos Passos, of Dreiser, of Ehrenburg, of Piscator, of the Bloc of Los Angeles, of Grosz . . . we have . . . a Salon where a feeling for the pictureque predominates, where the love for the "chic," for the "smart set," for the academic cadaver, invades everything.

. . . Shameful passivity in the face of the dreadful contemporary spectacle. Passivity that is in reality collaboration with a class completely incapable of "subvening" the most compelling material expenses of the intellectuals. Submission, gratis, to a class that walks off the edge of a cliff at the moment of its greatest economic dissolution and its most acute ideological corruption.[13]

By this time Siqueiros's welcome in Argentina was worn out, and Blanca Luz's endurance of the adversities of life with him was wearing thin. They were under surveillance by the Argentine police, and she dreaded the thought of suffering more of the experiences that resulted from his several jailings. Shortly before he was expelled from Argentina, they separated.

The expulsion was in December 1933, after Siqueiros had made an appearance before a large gathering of union workers. By this time Siqueiros had developed a great following among the artists and workers, who organized a large exhibition that included all the works he had done in Argentina. "Mexico," he wrote, "had never produced a mass movement that supported the work of a Mexican painter as the one produced in Argentina that supported me."[14]

All was to no avail. They took him three hundred miles to Bahia Blanca, the port city south of Buenos Aires, and there he was put aboard the freighter *El Trovador,* for a voyage to New York that took forty days.

11

Siqueiros Experimental Workshop, New York City

Though Siqueiros had been expelled three years earlier from the west coast of the United States, he entered the east coast unnoticed. He wandered blithely into New York, rented a room, contacted Alma Reed at her Delphic Studios, and arranged an exhibit of the paintings he had brought from Argentina.

Soon there was the *vernissage*—the opening night—of his portrait of Eva Mayer, a rich woman who honored him with a party at the Waldorf Astoria. In a lower Manhattan studio he had borrowed he began to experiment with new techniques and materials, which attracted a number of New York artists. The seeds were being planted that would soon grow into a sturdy strain of political art in New York. His first withering attack against Diego Rivera's politics was published in the *New Masses,* presaging the series of polemics the two would engage in the following year.

Since he remained in New York unmolested, Siqueiros delayed his return to Mexico, thinking it would be more expedient to return there after the newly elected President, General Lázaro Cárdenas, assumed office on November 30, 1934. Cárdenas had been selected by the *jefe maximo,* Calles, to be the Partido Nacional Revolucionario's candidate and his election had been a foregone conclusion. However, Cárdenas was not as pliant as Calles had imagined. A principled politician and one of the few generals who did not enrich himself after the Revolution, Cárdenas refused to respond to the strings that Calles was pulling. Supported by the workers and peasants, Cárdenas forced Calles to leave the country and to end his days in Texas exile.

The oppressive and despotic conditions of the long Calles era were brought to an end as Cárdenas ushered in a new period of Mexican democracy. Revolutionaries that Calles had forced underground were now freely resuming their normal political activity.

The atmosphere in Mexico City was electric. The Arenal family was there; they had returned home from Los Angeles. The political spark that the mentor had ignited in Angélica three years earlier had by this time become a revolutionary flame. With her two brothers she became part of the antifascist peace movement; they all had joined the Communist Party.

Siqueiros ended his three years of wandering in exile and returned aboveground to his homeland, full of exciting ideas and eager to immerse himself not only in aesthetic problems but in the political ferment that the Cárdenas presidency had inspired.

He spoke again at meetings—and *she* was in attendance. David had inspired Angélica in L.A. and she was eager to hear him again. Still, the attraction was intellectual, their thoughts were on so many other matters.

The Communist Party, now operating in the open, had to deal with dissension in its ranks as dogmatists and sectarians collided with artists and intellectuals, most often with the reinstated, fiery painter. Completely wrapped up now in formulating his own socio-technical-aesthetic theories, firmly Marxist, Siqueiros was nonetheless strongly criticized by the PCM for lacking discipline. He had always run ahead, and understanding from his Mexican comrades was not entirely forthcoming. At the time, Angélica Arenal sided with the Party in its criticism of him.[1]

With the changed political climate in Mexico the government—represented by the new Minister of Public Education, Gonzalo Vazquez Vela—now invited Siqueiros to lecture on art to the North American Conference of the New Education Fellowship, meeting in Mexico City. For the lecture series, "The Arts in the Mexican Schools," Rivera, too, was a speaker. His lecture (a day prior to Siqueiros's) was on "The Arts and Their Revolutionary Role in Culture." It was culturally uplifting and satisfying for the audience of North American schoolteachers.

On the following day, however—August 28, 1935—Siqueiros took advantage of the occasion to discuss "vital concerns" of the "movement" and set out to attack publicly the "counterrevolutionary" activities of one of its members, Diego Rivera. The audience, innocent bystanders, were totally unprepared. No sooner had Siqueiros started to speak, startling the schoolteachers, than the mountainous Rivera burst into the auditorium and seated himself in the front row. Siqueiros uttered no more than a few sentences before Rivera was on his feet demanding equal time to respond. José Muñoz Cota, the head of the Department of Fine Arts, was presiding over the lecture. He insisted that no debate was being held and that Rivera had had his opportunity to speak the previous day. But Rivera, not easily shunted aside, whipped out his pistol. Waving it in the air, he insisted that he be allowed to speak, and finally a date was set for the two revolutionaries to meet and debate on the following afternoon.[2]

A nervous calm was restored. Siqueiros proceeded with his theme: Rivera had not been properly understood; critics evaluated his work in a detached manner; he, Siqueiros, would search out and point to the cause of Rivera's opportunism—of which everyone was conscious; the revolutionary intellectuals recognized Rivera as a demagogue, but the root cause lay in the "so-called Mexican Mural Movement."

Rivera listened in silence as Siqueiros leveled charges that he had been

a destructive force within the movement of revolutionary artists; that Rivera had spent the entire period of the Mexican Revolution in his Paris studio, and then had become one of the "ideological directors" of the movement; that he had no conception of revolution or of the Mexican Revolution.

What Siqueiros said was familiar to Rivera, for it had all been published in New York a year earlier. At that time Siqueiros had written:

> In Paris he [Rivera] was the most outstanding mental snob of his time. He was the classic Montparnassian and Rotondeian. Nobody could get the better of him in speculative agility, or of his stretch of the imagination. His pre-cubist, cubist, and post-cubist work in Europe demonstrated his absolute detachment from the social problem. Thus it was, that he, the snob, later appropriated the Revolution exclusively as a platform for his declamations.

And when he was back in Mexico, "Rivera was the mental tourist par excellence. Indianist, folklorist, archeologist, (Picasso in Aztec land!). In Mexico he was the Mexican chauvinist of Indianism." Siqueiros attacked him for his failure to become an internationalist and for his lack of understanding that "revolutionary art is bound to reflect the international character of the revolution."[3]

He further charged Rivera with surrendering economically, thus delivering the painters into the hands of the government, and in effect being responsible for the destruction of the union. In 1922, Rivera was the senior artist most influential in steering the course of the mural renaissance and Siqueiros accused him of having selected the worst places for painting murals for the Revolution. "The Montparnassian was not capable of understanding that revolutionary art is art which is politically functional."

For Siqueiros, the influential Rivera had sabotaged the collective work by deliberately monopolizing the government murals, disrupting the movement and throwing it into political and technical chaos. When it came to *El Machete,* Rivera had been included among its directors in order to "neutralize" him. Except for one short article, he contributed nothing to the paper, yet he considered himself to be "the father and mother of the courageous creature." And he was part of a counterrevolutionary faction in the PCM.

As for Rivera's murals, Siqueiros found fault with his use of the "anachronistic" fresco method and his lack of technical inventiveness, and with the romantic attachment of both Rivera and the movement in general, to interior painting, fresco technique and the use of brushes. Siqueiros considered Rivera only a "sympathizer" of the revolutionary cause during that period, one who had never involved himself directly in any workers' struggles, and who had lent himself to the Party only when

he could play a star role in something spectacular. In order to protect his growing vested interest in mural painting, he had gradually moved to the side of the new bourgeoisie. This opportunism was evident in Rivera's murals:

He painted only general themes, abstract symbols, scholastic, pseudo-Marxist lectures. The academic and pedantic speech instead of the appropriate slogan of the moment. Friend of the pictorial political portrait, he never employs, however, the figures of the Mexican feudal (landowning) bourgeoisie who were in league with imperialism. Calles, its strong man, never appears on the scene in his role of demagogue-hangman, of the Mexican workers. He never painted . . . the victims of the Mexican counterrevolution. And Ambassador Morrow? Rivera could not very well portray politically his patron, the man who paid him $12,000 so that he could condemn the Spanish colonials in his fresco, as the symbol of oppression of the Mexican people, to be presented as a gift to the government of the respective state. Naturally, Rivera recalled Cortés of the Conquest. Cortés is long dead; but in no way did Rivera hint at the modern Mexican Cortés: on the contrary, the latter was a friend of his, and his widow is his godmother in the United States.[4]

And when the political repression grew intense, Rivera, in order to save his skin and his mural work, deserted the PCM, engineering his own expulsion by coming out as a Trotskyite and attacking the Central Committee of the Party. For this he was rewarded by the government with the post of director of the School of Fine Arts and escaped the imprisonment his comrades suffered in the May Day roundup of 1930.

Siqueiros underscored what he saw as Rivera's responsibility for the faltering and dissipating mural movement that had had so promising a beginning. In his critique he bore down hard on Rivera's courting tourism and the detrimental effect that this had on the movement.

The tourists found in Rivera their painter par excellence. Rivera found in them the augmenters of his fortune. The tourists wanted little paintings that could be shipped easily and one had to comply with their commercial demands. Thus was the door opened to "Mexican Souvenir Painting," to chauvinistic painting, which had to be substituted for the mural painting which we had started in Mexico with healthy revolutionary intentions.[5]

Siqueiros's lecture covered much the same ground as his *New Masses* article and left his audience of North American educators bewildered. But the newspapers printed the story surrounding the speech as sensational news and there was a great crush of artists, writers, art dealers, workers, North American intellectuals, etc. to attend the debate the following afternoon, to hear the oft-criticized Rivera respond publicly to his strongest critic, after a long period of silence.[6]

Siqueiros spoke first and reviewed the main points he had made the previous day. Then Rivera, defending himself, maintained that whatever

the Revolution was, petit bourgeois or other, it was the job of the artist to reflect it. Had he not at the beginning followed the order of the Communist Party, thus producing revolutionary works? And was the Communist Party ever wrong? As far as his joining the bourgeois government, had not Lenin advised boring from within? He defended his religious subject matter as being in conformity with Mexico's growth; besides, had not Siqueiros painted an angel in his first mural? As for *fresco*—houses are built with the same materials as in the past; why then, should frescoes be outmoded? Had not Marx said that art should be the result of social conditions? Was this not the case with his murals?

Rivera clung to the point that revolutionary work was possible even when cooperating with the government, and this defense became his main rationalization against the accusation of counterrevolutionary behavior. His arguments left the audience confused but Rivera proposed that the debates continue. The opposing sides—Rivera and his Trotskyite followers, and Siqueiros with the League of Revolutionary Writers and Artists (LEAR)—remained firm in their positions and the debates quickly degenerated into a series of repetitive charges and countercharges with no possible resolution of the differences or reconciliation of the forces.[7]

Siqueiros, a member of LEAR during this period, joined in its effort to organize a studio-school of revolutionary art that would disseminate its production to all the militant workers' and peasant's organizations. But circumstances would soon draw him back to New York and he contributed little to the effort. In January 1936, the Asamblea Nacional de Productores de Artes Plásticas elected him, along with Rufino Tamayo and Robert Guardia Berdecio, to represent Mexico at the American Artists' Congress that was to meet in New York in February. Three delegates were also being sent by LEAR: José Clemente Orozco, Luis Arenal, and Antonio Pujol. Of this group, Arenal, Berdecio and Pujol would join Siqueiros in establishing a studio in New York.

For Siqueiros, New York was the setting for a new upsurge in his artistic activity. Reactionary forces in Mexico had been worming their way back into the Cárdenas government. Work had been kept from him, and entrenched bureaucrats were once again bent on hampering every move he made. Political enemies had the power to fabricate charges at any moment that would send him off to jail.[8] Since his return to Mexico at the beginning of 1935 he had been in full political activity for the Communist Party and was also president of the League Against War and Fascism.

Now 39, Siqueiros felt the pressures of artistic fulfillment and accomplishment building up within him, and in New York, that fountainhead of industry and modernity, the flow of new creative ideas took possession of him.

Still, revolution was the raison d'etre of his art, of the creativity burst-

ing from him, of the ideas that were exploding. His painting technique was developing marvelously, nothing could stop this vital flowering period. Nor could the PCM hold him in rein. Revolution! revolution with art in capitalism's greatest industrial state.

Angélica Arenal was also in the United States at this time. She was now an active revolutionary and had been sent by the PCM to raise funds for the Mexican United Front, a coalition of progressive organizations supporting Cárdenas and at the same time demanding more revolutionary programs. Angélica had been advised by the PCM to contact Siqueiros in New York, to "mobilize" him and make him assist her in her search for funds. Her appearance in New York could not have been a more welcome sight in the gloom of Siqueiros's economically troubled situation.

Angélica came on the scene—all business, very proud and independent. Siqueiros's comrades had already wagered that she would never agree to meet with him. Siqueiros was then very much attached to the Mexican beauty María Asúnsolo, but this did not guarantee that one so comely as Angélica Arenal would not cause him to turn his head.

His amorous relationship with María Asúnsolo had developed during 1935, the year of his return from exile. Her Mexico City home was a salon for artists, and she devoted time to helping them find exposure for their works. Siqueiros had painted two personally involved portraits of María—a majestic full-length figure of her descending a staircase, with an endearing inscription and his signature [12], and another depicting her as a child. From New York he wrote to her devotedly, sparing no details of the progress he was making with his painting. But when Angélica later returned to Mexico, the letters to María stopped and the letters to Angélica began.

Angélica at 24 was now writing for the Communist press, and traveled to New York, Chicago and Philadelphia raisings funds. She made speeches defending the Cárdenas government and attacking Al Smith and the Liberty League for spreading lies that the Catholics could no longer attend church in Mexico. She captivated everyone in progressive circles and was welcomed as though she were Mexico's ambassador.

Siqueiros was more than willing to assist her, but she was busy with her tasks and could rarely be found. His only desire was to be with this independent, difficult and maddeningly beautiful woman. While their commitment to one another grew stronger, Angélica's political work came first. Finally, after much insisting on his part that together they would make good comrades working for the Party; she a writer, he a painter, and that both could live a marvelous life together, Angélica with some misgivings sent for her young daughter in Mexico and moved into a small apartment with Siqueiros.

She was strongly attracted to him, but after her first unfortunate mar-

riage she hoped to exercise more caution. As she watched him tenderly care for her little daughter she knew he was *right,* but for the moment she did not trust him. They lived together for a couple of months during 1936, but these two very unique personalities would require a longer period of adjustment. At first it seemed too difficult; Angélica returned to Mexico.[9]

He wrote to her asking her to come back:

> I knew for a long time that some day you and I would have to love each other, and if our love arrived late it was certainly no fault of mine; but still there remains for us a long road ahead that we will travel together, a marvelous road of work, always for the revolution; a road of such affection, of our affection. You will see! you will see! What we will do supporting each other, in the same spiritual state, for we will both find when we search, groping in the shadows of the night, that in this condition we should find security in the good quality of our love. . . . I am certain that for me you represent revolutionary work, revolutionary strength, peace in the little things of life in order that all our energy and all our efforts may serve the revolution.[10]

But before Angélica could return to New York, the war in Spain would separate them by an even greater distance.

During this period in New York, Siqueiros was able to produce a vast amount of politically useful work, without restriction. In April 1936 he moved into a workspace at 5 West 14 Street and there began seriously to investigate and apply modern techniques [13]. His New York studio would be a workshop to "cooperate with the workers' movement in the United States."[11] He experimented with and exploited modern materials and techniques, and his work became politically functional. The period of Roosevelt's presidency was a propitious one for Siqueiros; unhampered, he was able to produce works that openly supported the political activity of the Communist Party of the United States.

On the technical side, the objects of his experimentation were spray guns, cameras and any modern tool that would help. The modern paint was pyroxylin, the automobile lacquer of a cellulose nitrate base. Pyroxylin was an extremely durable medium that not only enhanced the intensity of the pigments but it produced accidental effects of great beauty if the colors of the rapidly setting paint were encouraged to flow together momentarily. The control and utilization of these effects especially intrigued Siqueiros. An opposite interpretation was given to these accidental effects by the North American painter Jackson Pollock. Pollock had been attracted to the Siqueiros Experimental Workshop and took special note of the pyroxylin paint as it dripped on the floor. In the random dripping and the subsequent effects of the quick-setting pyroxylin paint lay Pollock's future style.

But of greater significance was the direction in which Siqueiros was

leading the North Americans who worked with him and the works that were being created. There were twelve to fifteen artists in the workshop collective and they produced functional art for labor and political organizations, including paintings and posters for political rallies and floats for parades. It was the period of the rise of fascism in Europe and of heightened anti-fascist activity in the United States.

Two paintings that Siqueiros produced at this time were successful for him in clarifying the problem of the superimposition of technique, aesthetics and politics. They were entered in the anti-fascist exhibition that the American Artists Congress sponsored at the New School for Social Research on April 15, 1936. The paintings—*The Birth of Fascism* and *Stop the War*—were small works that involved experimental techniques; each measured 90 by 75 centimeters.

In *The Birth of Fascism (plate 18)* Siqueiros probed the accidental effects that the pyroxylin paint was uniquely capable of producing; bending them to his will he produced a work of outspoken clarity. A raft floats on a tempestuous sea (the sea delineated by the accidental effects of the pyroxylin). Aboard the raft the mother of fascism—painted face of a whore—in the act of parturition, delivers a three-headed monster: Hitler, Mussolini and Hearst. To one side, the arm and head of a submerged Statue of Liberty protrude from the swirling water. In the foreground on the opposite side floats a book, symbol of the religions, morality and the philosophy of the bourgeoisie, while in the distance the structure of the first land of socialism is visible. Later (in 1954) Siqueiros made a number of changes—a weird-shaped shroud covered the three-headed monster; the book was removed; the sinking Statue of Liberty disappeared beneath the water and a swirling swastika took its place.

Stop the War (plate 19) was a direct call to action. With spray gun, stencil and brush, Siqueiros depicted a mass of humans surging forward to overthrow the capitalist instigators of war. Symbols of capitalism and war rise in the background: the bloated face on the bourgeois who clutches a swastika; another in a gas mask; war surrounds the Eiffel Tower; but in the background a lighthouse of "international communism" sends its beam over the masses, and steel structures of the Soviet Union rise.

Of course eyebrows were raised. Was this art or pure propaganda? As far as Siqueiros was concerned, he had made the transition, he would make propaganda art. He had written to María Asúnsolo:

> I was now able to think plastically of the political problems. Before it was almost impossible for me. The emotional and sensual part of art dominated me entirely. A pleasing texture or beautiful abstract form made me forget the initial proposition of my political thinking. Now I have the strength to sacrifice those things in my painting which do not keep in step with my mental object.[12]

In New York, Siqueiros refined his painting with a use of clear political concepts and entered the territory that had always been forbidden to "art." In the past, artists had indulged in naturalistic creations depicting "suffering humanity" but Siqueiros was fathoming how to bring the *causes* of that suffering to light in plastic terms. The Russian and Mexican revolutions had suddenly wrenched art from its self-indulgent world. Artists who joined those momentous events struggled to infuse their art with collaborative themes. The new Soviet government supported the artists and their "agit" art, while in Mexico the artists organized and fought to maintain the support of their own government. And earlier, the painters of the French Revolution, though tied to tradition, believed that art must convey a message, and their paintings supported the revolution.

The political works of art that poured out of the Siqueiros Experimental Workshop were not sufficiently remunerative, if at all; to meet expenses, Siqueiros had to turn out portraits and easel works of a nonpolitical nature. But in the main he guided the workshop team in fulfilling their revolutionary commitment, painting to satisfy the needs of proletarian organizations and especially of the Communist Party (CPUSA).

Initiating the use of the slide projector, monumental posters were produced in many copies, their subjects limned in a giant enlarged size. Siqueiros and his workshop team received a tremendous ovation when two huge paintings (each 12 by 9 meters) of the Communist Party's candidates for President and Vice-President of the United States, Earl Browder and James Ford, were lowered before 25,000 people attending a political rally in New York's Madison Square Garden in June 1936. The two portraits were products of the Experimental Workshop's photo-projection method.[13]

The painters of the Siqueiros Workshop also met the needs of proletarian outdoor events, creating floats for parades such as one for May Day, 1936—a huge polychromed sculpture in motion: a rising and falling hammer, marked with the hammer-and-sickle symbol, smashing Wall Street, a ticker-tape machine. From that float the necessity for forming a third party, a farmer-labor party, was also proclaimed. Two floats for that May Day parade were made for the League Against War and Fascism. For July 4, 1936, a day that the Left proclaimed as Anti-Hearst Day, Siqueiros and his workshop team created a float mounted on a boat, to sail before millions of bathers on the beach at Coney Island. The thirty-foot boat sailed the sea with Siqueiros and two 14-foot-high manikins of Hearst and Hitler seated back-to-back with revolving interchangeable heads. Stationed high up within the manikins and activating the revolving heads was Luis Arenal, who at times came perilously close to falling into the sea as the boat rolled in the rough waters.

New York, too, was the city of glitter for Siqueiros. He had dealt with galleries and wealthy patrons of the arts, but perhaps that world touched

him most through a close friendship he enjoyed with George Gershwin. The two had met a few years earlier in Taxco, and Gershwin, an amateur painter and an enthusiast of Siqueiros's work, owned his painting *The Child Mother* (plate 17).

In the pulsating metropolis, the two engaged in engrossing discussions in which they compared their respective fields of endeavor, the similarities of structure in painting and music. They agreed that there was a relationship between polychrome and movement in painting, and rhythm and sonority in music; between composition in painting and arrangements for orchestra. In their mutual admiration of each other's work, Gershwin claimed he heard sounds in Siqueiros's colors; in turn, Siqueiros saw color and form in Gershwin's music.[14]

A year before Gershwin died at 39, Siqueiros painted an extraordinary portrait of him. Indecisive about the kind of portrait he desired, Gershwin steered the project through a number of radical changes. At first he requested that Siqueiros paint just his head, but when the painter arrived at Gershwin's Park Avenue apartment with a 60 × 40 centimeter canvas, Gershwin had changed his mind—he wanted a full-length portrait. Siqueiros returned the following day with a canvas of the appropriate size, only to find that Gershwin had now decided to be painted playing the piano. Finally, the canvas measured 2.5 meters by 1.6 meters.

Gershwin is portrayed in oils at the concert grand as seen from the rear of the stage, with the entire concert hall as background (plate 20). Possibly to forestall any further changes, Siqueiros painted the hall with a packed audience. Gershwin was impressed with the painting's grandeur and begged Siqueiros to paint the members of his family in the front row. Gershwin's family was large and he wanted even deceased relatives included. However, Siqueiros met the challenge, and included himself on the last seat of the front row.

So overjoyed was Gershwin with the finished painting that he called for a celebration, and for his so illustrious star painter nothing less than a bacchanal at the Waldorf Astoria would suffice. As remembered by one of the two male participants, Gershwin's "prestige" at the time "guaranteed" the attendance of thirty Broadway showgirls.[15]

12

Spain: Captain to Lt. Colonel

In December 1936 two old friends paid a visit to Siqueiros at his New York Experimental Workshop. Poets and writers, wife and husband, Marí Teresa León and Rafael Alberti had just arrived from Mexico and were on their way home to Spain to join the government's struggle against Franco. Siqueiros's sympathies lay with their cause and he took very seriously their suggestion that his workshop should be in Spain serving the Republican cause.

Siqueiros was well aware of the threat of a fascist takeover in Spain. The year before, Siqueiros had painted María Teresa's portrait in Mexico, and now the words that passed between him and the Albertis were enough to send him packing. Without further ado he gathered up his painting materials, mailed off a box of his personal effects to Angélica in Mexico and left the Experimental Workshop in the hands of his North American comrades.

Joined by a handful of Mexican artists, Siqueiros embarked for France, enroute to Spain, and reached his destination in late January 1937, 6 months after the counterrevolution had begun. Madrid had been under siege since November and the provisional capital had been moved to Valencia. There Siqueiros went to contact the Director General of Fine Arts of the Spanish Republic, José Renau. The director general, 30 years old, was immediately inspired with Siqueiros's idea of an art workshop that would serve the cause; however, he knew that the crisis of the moment would militate against such an idea. It was a realization Siqueiros had also reached the moment he entered Spain.

But Renau could arrange a conference, and in February Siqueiros was introduced to an audience that packed the auditorium of the University of Valencia and included many artists in uniform. His lecture, "Art as a Tool of Struggle," left an indelible impression on his listeners and there was the usual hysterical reaction among the esthetes present. Renau himself was greatly affected and would eventually, as a refugee, seek out Siqueiros in Mexico.[1]

The lecture was the last contact with art that Siqueiros would have in Spain; he presented himself at the headquarters of the famous Fifth Regiment to volunteer as a soldier.

The Fifth Regiment was the greatest fighting unit of the Spanish Civil war. It was organized and led by the Italian Vittorio Vidali, who used the *nom de guerre* Carlos Contreras. Comandante Carlos was the representative of the Comintern, a tough organizer and disciplinarian who under the conditions of war had many a coward and deserter shot, but with the Spanish Communists Enrique Lister and Juan Modesto Guilloto, he guided and molded the Fifth Regiment into what Herbert L. Matthews called "one of the great revolutionary military units of all times."[2]

As political commissar Contreras saw to it that all the soldiers of the Fifth Regiment, especially the workers and peasants without Communist Party affiliation, were politicized to the extent that they understood the meaning of fascism and would have no doubts as to what enemy they were fighting. He built the regiment into a self-contained model with its own munition factories, repair shops, hospitals and rest homes. Aviators and tank men were trained, newspapers published and orphanages established.

The two Spanish Communists who organized the regiment with Contreras, ex-quarryman Lister and ex-woodcutter Modesto, under both of whom Siqueiros fought, were to become two of the greatest generals of the war. Poets wrote about them: Antonio Machado, "To Lister, Chief of the Ebro Army;" Emilio Prados, "To the Comrades of the Thaelmann Battalion and to Modesto Guilloto, its Commander;" and Rafael Alberti, "I'm From the Fifth Regiment."

When he arrived at the headquarters of the Fifth Regiment to volunteer his services, Siqueiros at 40 was four years the senior of Comandante "Carlos." Since both had been in the United States, their political activities there gave them much to talk about. Siqueiros put the question to Contreras: would he be more useful painting or fighting? Contreras did not answer directly but asked Siqueiros if he would like to accompany him to the front at Madrid on the next morning. Siqueiros accepted the invitation, settling the question.

Madrid was under siege, being defended in a superhuman effort by all able-bodied persons, and the Fifth Regiment was responsible for organizing the city's defense. Siqueiros arrived at the command post on the Madrid front in February 1937 serving as Contreras's aide. Comandante Modesto, who was there, was in charge of the forces fighting fiercely at La Marañosa in the Jarama Valley.

One of Modesto's battalions had to be warned of a threatened encirclement by the enemy. Siqueiros volunteered to carry the message. Comandante Modesto was pleased with his offer, and on a map he indicated to Siqueiros the safest and shortest direction through the line of fire to the threatened battalion. Still in civilian clothes, the painter carefully and quickly found his way to his objective. He remained all day, fought with the embattled group, and when night fell, he returned to the command

post covered with mud and grime. There was a celebration for the success of his mission, and Comandante Enrique Lister raised a toast to the health of the new recruit.[3]

Following this action, Siqueiros wrote to Angélica on February 17 from Madrid:

> I write to you after my first military action and after having slept for five hours this afternoon. At dawn an important offensive of our forces was initiated to clear the enemy from the Madrid-Valencia highway. I worked all through the night with the chief of the Fourth Division and in the morning I became his official messenger. I have felt an immense joy in knowing I can be useful in this great struggle for the freedom of all the peoples of the world. I have lived through a splendid morning in the midst of the artillery duels, under the terrible aeroplanes that bombed our columns on the march. All my past experiences came together to help me fulfill the duties with which I was charged.[4]

He hoped that the fact that he had been a captain in the Constitutionalist Army of Mexico would be considered when his rank and responsibility were settled. In the meantime, his leadership and organizing ability were appreciated; Comandante Lister, much to the chagrin of Comandante Contreras, borrowed Siqueiros's services as an aide. In view of his previous military experience and rank, he was made a *comandante,* a rank equivalent to major, and a promotion over his rank in the Mexican War.

Under Lister, Siqueiros was first given temporary command of a group of tanks fighting at Marañosa and El Pingarrón, south of Madrid, and then command of the 82nd Brigade, a mixed brigade of anarchists who fought at Teruel.[5] The disregard of the anarchists for any and all rules of military discipline was an ordeal for Siqueiros. Cajoling them and threatening them with execution was of little use, yet he did better than most; as much as the anarchists hated the Soviet Union, they loved Mexico and their Mexican chief.[6]

By March 28, 1937, Siqueiros was the education officer on the Teruel front and rapidly rose to the rank of lieutenant colonel [14]. In addition to commanding the 82nd Brigade he became the chief of the 46th Motorized Brigade, which under the command of Captain Uribarri was known as the "Phantom Column" for the rapidity with which it moved into action.[7] Leading the 82nd Brigade, Siqueiros took the town of Celades, just north of Teruel; then, with the Phantom Column he moved to the Toledo-Córdoba sector, fighting from Guadalupe to Granja de Torrehermosa [15] and ending with the command (as a foreigner, it was provisional) of the 29th Division and its sixteen thousand men.[8]

Siqueiros wrote endearing letters to Angélica, and she worried about the danger to his life. The slaughter in Spain was atrocious and there was good reason to believe that he might not return. She wanted to go there, to volunteer for the struggle, to find him. Her determination grew and

she sought to find a way to get to Spain. She was now working as a reporter for the government newspaper *El Nacional* and was an active member of the PCM; at the time these were positive factors. Angélica requested of the Minister of Communications that the government send her to Spain as a newspaper reporter. The moment was propitious; not only was it agreed that she would report on the events of the war for *El Nacional,* but she would also carry a secret document from the Mexican government to the Spanish government.

When Angélica was ready to leave the country, she was given a sealed envelope (she did not know it contained the key to a secret code that would pass between the two governments) and was briefed on her mission by the Foreign Ministry. In March of 1937 she traveled by train from Mexico City to New York where she boarded the *Ile de France.* Aboard ship, a group of young North American doctors, on their way to join the Abraham Lincoln Brigade, befriended her with protective interest—they were all traveling to Spain together.

On their first night in Spain, during an air raid, the doctors rushed to a shelter, leaving her sleeping soundly. It was not to be the last time that men would leave her in the lurch to save their skins. In the morning, they left together on the train for Valencia and though they parted the best of friends, Angélica could not forget the previous night.

Valencia was a shock. In Mexico she had heard that all of Spain was at war. But here in Valencia, coffeehouse after coffeehouse was full of men, of bureaucrats endlessly talking, volubly chattering, as though the country were at peace. She was perplexed. Nevertheless, her first task was to deliver the official envelope she was carrying to the designated government ministry. There, Minister of Finance Juan Negrín, who was soon to become Premier, received her. It was midday, and his office was on the top floor, twelve stories up. Angélica was standing before him— he had received the envelope and was thanking her—when the air-raid sirens sounded. He asked to be excused and rapidly left the room, heading for the shelter, leaving her standing there. What should she do? She sat down and waited for the all clear to sound. When Negrín did not return, she left, her mission accomplished. It was another thing she never forgot.[9]

When Angélica arrived in Valencia, Siqueiros was at the Estremadura front, far to the west. It was April when she received his letter telling her that he knew of her arrival and would soon obtain a safe-conduct for her to come to the front. In the meantime, Angélica remained in Valencia and went to work for the Communist newspaper, *La Prensa Rojo.* It would be two months before they managed to meet.

Siqueiros followed military orders strictly. Civilians, especially women, were not permitted at the front. Those women who had fought earlier in the militia were now being considered a "problem" and the government took measures to keep them away from the fighting. When

Siqueiros seemed to be resisting arranging for her visit, Angélica simply obtained permission herself to make the trip to Córdoba in her capacity as a war correspondent.

Once in Córdoba, Angélica explained to the military officials that she was a Mexican journalist searching for the Mexican officer Siqueiros. Officers and enlisted men scurried about, and promptly a car was provided to take her to Coso Blanco, a small village on the front line. Siqueiros was not in his quarters when she arrived, but there was no lack of attention to the very attractive Mexican war correspondent. One lieutenant volunteered to help her get her story by being her guide at the front lines. Angélica, eager to see David, agreed to go. Two horses were saddled and, though unaccustomed, Angélica fearlessly rode with the lieutenant to the front.

In the meantime Siqueiros had returned and the news he heard could not have distressed him more. He took the infraction of the rules seriously, and when finally they met, he immediately, in her presence, sharply dressed down the soldiers for permitting her to visit the front. With this greeting, Angélica's high spirits fell; paying no heed to his entreaties, she got into her chauffeured car and left. With all haste and very contrite, Siqueiros followed her back to Valencia. There, with an armful of roses and professions of love, forgiveness did come, but not easily.

It was in this setting, however, that they agreed to be legally married. Theirs was a military wedding, in Valencia, and the ceremonial ritual was performed by Comandante Enrique Lister. Siqueiros may have assumed that marriage would restrain Angélica's assertive spirits, but there was no way that she would accept the military restrictions. Shortly after the wedding banquet they went their separate ways, seeing very little of each other during their remaining months in Spain.[10]

After Angélica presented her press credentials to Comandante Carlos Contreras, she obtained a pass that allowed her to visit all the fronts. Siqueiros had to accept the news that she was reporting the war for *El Nacional* from the front at Córdoba, a few miles from where he was fighting.

In Córdoba, Angélica helped set up a newspaper for distribution among the soldiers; one that laid stress on poetry and art. She toured the front lines, sent regular dispatches back to Mexico, and dared to cross into enemy territory under cover of darkness with a band of guerrilla fighters to report on their activities. On a few occasions she and Siqueiros found opportunities to be together. When she watched from the window in their small hotel as enemy planes dropped their bombs to earth, he accused her of enticing him to violate military orders by not taking shelter.[11]

In November 1937 Angélica received an urgent message that her mother was very ill and that she should return home at once. Meanwhile, Siqueiros's father had died. But even more on his mind was his determi-

nation to speak to Cárdenas about the matter of Trotsky in Mexico. The military command, however, ordered Siqueiros to report to the Spanish Minister of War, Indalecio Prieto, in Barcelona, where the seat of government was now located. Siqueiros was to go to Mexico, to present Cárdenas with an urgent appeal for desperately needed gunsights for artillery, and bombsights for airplanes. Cárdenas, it was hoped, would be able to obtain these from the United States.

Attired in civilian clothes, Siqueiros and Angélica traveled to Toulouse, where a secret message was picked up. They continued to Paris by train and there arrangements were made for them to sail on the *Normandie* from Le Havre. The voyage took five days to New York, where air-flight tickets to Mexico, paid for by the Cárdenas government, awaited them.

At home Angélica was angered to discover that her mother's illness was a ruse to make her return from Spain, and she remained with her husband to assist him with his mission. While Cárdenas was taking the steps needed to acquire "for Mexico," the desperately needed optical instruments, Siqueiros and Angélica lived at Los Pinos, the President's residence, for three days.

During that time Cárdenas sought to enlist Siqueiros's aid in selecting the right person to be Mexican ambassador to Spain. Cárdenas wanted to appoint lawyer and statesman Narciso Bassols, but a strong disagreement had arisen between them. Bassols felt he had been betrayed by Cárdenas, for at the very moment he was representing Mexico at talks in Geneva with the Soviet foreign minister, Maxim Litvinoff, on the question of restoring the diplomatic relations that ex-President Portes Gil had broken, a newspaper had been handed Litvinoff with headlines that Trotsky had been granted political asylum in Mexico by Cárdenas. The talks then broke off, and Bassols resigned.

Cárdenas would not give up on Bassols, and during those three days of waiting he sent Siqueiros to speak to him. But Bassols would not agree to talk to Cárdenas, nor could Siqueiros convince him to accept the ambassadorship. It was then that Cárdenas accepted a suggestion by Siqueiros that he name Adelberto Tejada, then governor of Veracruz, to be ambassador.[12]

When the hoped-for moment arrived, Siqueiros presented Cárdenas with a report he had prepared on Trotsky, but he got a cool response and let the matter drop. When the optical instruments were ready for delivery from the United States, Cárdenas lost no time in providing Siqueiros with a diplomatic passport to see that they were safely escorted to Spain. Siqueiros and Angélica agreed that he would return to Spain alone; reluctantly, she would remain behind and await the end of the war.

During his stopover in New York, Siqueiros outfitted himself with a much-needed army uniform and by December 2, 1937, he was writing to

Angélica from Paris. He told her that his rapid travels were giving him an entirely new sense of the scale and order of things in time and space, and that the "landscape" of his own country and of the world had undergone a "definitive change."[13] The following day he crossed into Spain and with his closely guarded precious materiel made his way to Barcelona. In the month that he had been away the military situation had changed little. The western half of the country was still firmly in the grip of the fascists, but now with the intensifying pressure of the Franco-Hitler-Mussolini combined forces.

One day in Valencia, before he returned to his command post, he, Renau and Ernest Hemingway sat at a seaside restaurant and over dinner and "bottles" of whiskey tirelessly discussed everything they knew about the phenomenon of Spanish anarchism, its virtues and its foibles. Hemingway saw the anarchists as virtuous, while Siqueiros, who was faced with the problems of discipline on the field of battle, could see only their foibles; Renau, an ex-anarchist, recounted his experiences. The three, as Renau described it, sat in the restaurant for over seven hours, each upholding his own point of view but with sodden and extreme deference for the others' opinions.[14]

A short time after Siqueiros returned to the Estremadura front he was ordered to report to the headquarters of the Servicio de Inteligencia Militar (SIM) in Valencia. SIM, with its reputation for relentlessly ferreting out spies, fifth columnists and *agents provocateurs,* called on Siqueiros to undertake a dangerous assignment inside fascist Italy.

He was simply to bring back from Italy a copy of a banned Italian magazine. The recent issue he was to find had been withdrawn within 24 hours of its publication, and its editors and staff had "disappeared" from the face of the earth, because an article in it revealed the complete Italian military operation in Spain. Naturally, the command of the Loyalist forces wanted the magazine. It was a risky venture but it was not in Siqueiros to refuse. Armed only with his Mexican diplomatic passport, he would find the magazine and return with it.[15]

Attired once again in civvies, he passed through a number of air raids and made his way to Port Bou on the Spanish border. Crossing into France, he faced the harassing inspection by the unsympathetic French customs officials. He traveled to Paris by train and there he boarded the Paris-Rome Express.

In Rome he settled himself in a small hotel, and without losing any time set about his task. His first stop was the Mexican Embassy. The chargé d'affaires, Mexican poet Manuel Maples Arce, was stricken with terror when Siqueiros explained what he wanted. So from this quarter he could expect no help. To further complicate matters, a Mexican pianist named Ordóñez recognized him on the street and insisted on taking him to a party to meet other Mexicans. With great misgivings, he agreed to

go. The party was a dreary affair attended by a pro-fascist Mexican arty set—and by Nazi soldiers!

The following day, he was feeling the ill effects of a distasteful night of drinking when the incredible happened.

> I hailed a horse-drawn coach and told the driver to take me to a trattoria in the district where I could get some good goat and red wine. The *capreto arrosto con vino roso* is the typical dish of Rome. I arrived at the recommended place and paid the coachman. The trattoria was empty, I was the only patron. After curing myself of my hangover with practically a whole bottle of red wine, I got up to look for the water closet. I passed through a small room and then entered another where, to my astonishment, on one of the tables was the magazine I was looking for. Rapidly I thumbed through the pages, thinking it must be an old issue—but nothing of the sort: here it was, the article by General N.[16]

Unseen, he hoped, Siqueiros concealed the magazine on his person, and before his dinner arrived feigned an excuse that he had forgotten he had a date, and paid his bill. Once on the street he walked in a rapid convoluted manner over a long distance, fearful that the ease with which he had discovered his quarry must have been a trap set for him, especially after the party of the night before. Finally he took a cab to his hotel, gathered his belongings and checked out. Anxious to get away from Rome as quickly as possible, he hailed a cab and asked to be taken to Genoa, a distance of some 530 kilometers. There, after hours of waiting, he boarded the Paris Express; until the train crossed safely into France, his trip was nerve-wracking.

With such incredible luck, the entire operation took only four days. The SIM officers were waiting anxiously in Paris for the material, and Siqueiros was commended for his successful mission. It was one of his last acts of the war. In September 1938, Premier Negrín went before the League of Nations and agreed to have all foreign volunteers—six thousand were still in Spain—withdrawn. He trusted that the Germans, Italians and Moors would also be withdrawn—but they were not.

Siqueiros was to gather the remnants of the original 533 Mexican volunteers and lead them back to their homeland. The Mexicans—as well as the Spanish-speaking volunteers from other countries—had not been grouped into battalions of their own but rather had all been incorporated into the Spanish Republican Army. By November the Mexican survivors had straggled back to Paris from all parts of Spain—they numbered 52. Theirs had been perhaps the greatest casualty rate of the war. Siqueiros was extremely depressed at this decimation; he had witnessed the futility of war in face of "great power" opposition.

Most disturbing to Siqueiros was the fact that the Spanish government had never declared war on the fascists. Officially they called the civil war a "state of alarm," and the government did not fight according to the

strict rules of war, which would have forced them to maintain a properly disciplined army of Spanish soldiers, most of whom were not so politically advanced as the volunteers from abroad. It disturbed him, too, that the military tribunals of the Republican Army often were made up of old generals who admired the French and rarely meted out proper military justice to deserters and snipers.

Nor did he think that the Spanish government had properly mobilized all forces. "In Mexico," he wrote, "the military chief of a force operating in a zone was invariably at the same time the zone's chief. Thus, in the Mexican Revolution there was not the duality of government that unfortunately happened in Spain." Siqueiros later confessed that there were moments when the commanders, in their frustration, were at the point of conspiring to take the reins of government from the civil authorities, the "lawyers" in Valencia and Barcelona. Had they done so, he felt, the war might have been properly prosecuted.[17]

During the brief period in Paris while he awaited the gathering Mexican survivors, Siqueiros began to allow thoughts of art to wander back into his mind. On November 21 he was invited to speak on art by the Maison de la Culture. His talk, which took place in the Galerie d'Anjou, was on "Art in the Contemporary Social Battle—And the Experience of Modern Mexican Political Painting—Contrasted with the Present Apolitical Art of Western Europe." In a letter he wrote to Angélica on November 29, he told her of how after two years of being completely involved with the war, aesthetic ideas were once again beginning to preoccupy him.[18]

Traveling home was exceedingly slow. After leaving Le Havre, Siqueiros and his Mexican contingent were forced to wait weeks in England while their ship, the *Tricornia,* underwent repairs in Southampton. When they finally reached New York, the United States government forbid the Mexicans to debark. Only after the intervention of President Cárdenas were they permitted to travel by bus to the Mexican border, with an escort of U.S. marshals. In January 1939 they arrived in Mexico City.

Driven from the storm in Spain, Siqueiros found new turbulence awaiting him in his own society. His arrival provoked a hostile reception from the old Spanish community in Mexico. They were the *gachupins,* Spaniards who had settled in Mexico. Most were well established, well-off, and part of the Mexican business world, and almost all were Franco supporters. Their greatest fear was that Mexico would admit a flood of refugees from the toppled Spanish republic, and Siqueiros became the target of much of their ire.

He was accosted with insults and physically assaulted on the streets and in cafes: the *gachupins* mocked him with the title *El Coronelazo,* originally given him by a Spanish editor of the Mexico City newspaper

Ultimas Noticias. El Coronelazo—the big colonel *(plate 31)*; he proudly adopted the sobriquet and signed his paintings with it. Arguments began to rage between Siqueiros and the *gachupins* as the Spanish War was carried to Mexican soil. At one point Siqueiros had thousands of leaflets printed, "Let's Exchange the *Gachupins* for Spaniards."[19]

The fears of the pro-Franco Spaniards that Siqueiros would influence his old friend Cárdenas to admit a large number of Spanish refugees were well-founded, for assisted by Angélica, he did set about the task of aiding veterans of the Spanish Republican Army and their families. He formed the Sociedad Francisco Javier Mina, named for the Spaniard who had fought for Mexican independence. Siqueiros and Angélica also published a small magazine called *Documental*. In any case, these activities played no small role in the decision of Cárdenas, the only Latin American leader who actively supported the Republican cause, to admit thousands of Spanish refugees into Mexico.

The *gachupins'* response was to finance a hysterical and strident newspaper campaign against Cárdenas and the refugees. This in turn gave rise to a mass demonstration of students and workers held in front of three leading pro-Franco newspapers. As Siqueiros was speaking from atop a truck, rocks were hurled from within the crowd at the *Excelsior* building, smashing windows. Rocks were then hurled at *El Universal* and *Novedades;* Siqueiros implored the crowd not to be provoked into violence but the police used tear gas and a full-fledged riot was soon in force.

While the police were firing their guns on all sides, Siqueiros moved into the crowd to calm the demonstrators and he managed to rescue the police captain in charge, who had fallen into the hands of the rioters. In spite of these actions, he was charged with being responsible for causing the riot. A case against him was developed that embroiled him in court actions, and "orders from above"—as Siqueiros expressed it—even forced the captain whose life he had saved to testify against him. Though the case finally was thrown out for lack of evidence, he had been harassed and kept from his work for a long period.

Despite his commitment to political activity, Siqueiros managed an outpouring of easel works; they were exhibited at the Pierre Matisse Gallery in New York City from January 9 to February 3, 1940. Seventeen new works were shown, including such masterpieces as *The Echo of the Scream (plate 24)*, *The Sob (plate 22)*, and *Ethnography (plate 23)*, paintings that became part of the collection of New York's Museum of Modern Art.

He was then also preoccupied with the "problem" of Trotsky's presence in Mexico. In Spain, Siqueiros had heard Mexico condemned for granting asylum to Trotsky, and had pledged to do something about the situation when he returned. But he was commissioned to paint a new mural for the electricians' union in July 1939, and his thoughts about Trotsky were for the time being put aside.

So much had happened and was happening in the world, and there were so many things to say that soon his ideas, expressed in his paintings, began to spread over the walls surrounding the main staircase of the new building of the Sindicato Mexicano de Electricistas. Siqueiros's contract with the SME officials allowed him to select whatever walls he wished, but the theme had to concern their industry. Six painters formed the mural team; each—Siqueiros included—would receive 17.50 pesos a day, the same salary as a union official. The union would pay for all the materials, and the mural was to be completed in six months.

Siqueiros had selected the three walls and a ceiling that enclosed the main stairway. He visualized a composition that would be a unified entity, one that would envelop the area as though no walls existed.

The painters who joined Siqueiros for this mural included José Renau, Antonio Rodríguez Luna and Miguel Prieto—three Spanish painters who were now refugees in Mexico; Antonio Pujol, a Mexican who had fought in Spain; and Luis Arenal, who had not been there. Roberto Berdecio and Fanny Rabel also worked on the mural for brief periods. Siqueiros hoped that the experience with Mexican mural technique would influence the three Spanish painters but only Renau became a reliable adherent; Rodríguez Luna and Prieto left while the mural was still in its early stage.

Siqueiros had explained to the artists assisting him how they would endeavor to work democratically as a team. Each painter would be encouraged to contribute his or her utmost and each would enjoy full rights of self-expression, aimed of course at benefiting the integrity of the work. Siqueiros had the best of intentions, and believed in collective teamwork as applied to mural painting, but in practice the application of teamwork invariably ran into difficulties. Renau accepted as "pure courtesy" Siqueiros's encouragement of individual initiative and contributions, "for none could deny that he was the *maestro*, both in his own right and in principle."[20]

The importance of disciplined teamwork took precedence over individual considerations, and working under a directing maestro rendered personal initiative somewhat inoperative, at least if a unified work was to result. The mural team held meetings, the work was distributed, and the collective ran smoothly so long as all were ideologically in agreement and willing to accept the maestro's orders. But as the work progressed the real problem would be with individual interpretations of subject matter. The two Spanish painters left when Siqueiros had the centrally located eagle—symbol of imperialism—which had been painted by Rodríguez Luna, repainted. "It was a nice flesh and feather eagle, not the metal eagle we wanted."[21] Roberto Berdecio painted an old-fashioned stone smokestack; Siqueiros changed it into an iron one. And Renau was on the verge of leaving after Siqueiros repainted the smoke that he had painted.[22]

The maestro had done the best that could be expected in trying to

extract from each individual artist a genuine interest in the project, since it was his belief that a mural can absorb the work of more than one single artist. Or as he modified his idea:

> Our work of the Sindicato de Electricistas is authentic proof that such a procedure is possible and indispensable for works of great physical magnitude. It is clear as evidenced by our recent experience, that all work of this nature needs a coordinator, or to put it more clearly, a director similar to the conductor of a great symphony orchestra.[23]

After the subject matter of the mural had been agreed upon, and the functional and spatial character of its composition—its relationship to the surfaces to be painted and to the eyes of the spectators—had been resolved, the work could proceed. Siqueiros led the team to his compositional concept by first having the general orbit and visual activity of the approaching, ascending and descending spectator plotted on a model of the walls and staircases.

Before any painting could start, the walls were washed with a 10% solution of hydrochloric acid to remove all impurities, even though the building was new. Then two coats of pyroxylin primer were applied to seal the surface and prevent the inner dampness of the walls from rising to the painted surface. It would have been preferable to build a false wall over the existing structure, but to save time and money this step was eliminated.

The union officials wanted a theme representative of the Mexican electrical industry. The muralists, however, agreed that such a subject would be anachronistic, given the state of the world at that moment. The union workers did not especially favor a theme that glorified their daily work, so the artists held conversations with them and won them to the idea of a political theme. When the workers carried this opinion to their leaders, they agreed to allow Siqueiros complete freedom of expression, asking only that he promise to represent the electrical industry in at least a third of the mural.

Since the mural was to be painted for a purely workers' domain, Siqueiros was confident that his political portrait of the world would be well received. To capture the spirit of the time, a photomontage effect was created that made of the mural a newsreel-like documentary. Current news photographs of fascism in action were flashed with a projector onto the four planes to be painted. The images were traced on the walls and ceiling, creating the desired composition. The problem of a unified composition for surfaces that were at right angles to each other was thus overcome.

The mural, *The Portrait of the Bourgeoisie* (plate 25), was done with pyroxylin paint, utilizing the spray gun as well as brushes. Though it was not massive, into its one hundred square meters were crammed the fig-

ures and symbols of the disaster that beset the human race in 1939. Towering in the middle of the center wall was a symbolically conceived machine, "the infernal machine of capitalism," containing within it portraits of actual murdered victims of Spanish fascism and nazi concentration camps. (This was the original version; the day after Siqueiros's forced absence from the mural—May 24, 1940, the time of the assault on Trotsky's house and headquarters—the union leaders would demand that the heads of the victims of fascism be removed from the mural. This task then fell to Renau, who covered the heads by painting gold coins pouring from the machine.)

To the side of the "infernal machine" are painted the three representatives of the imperialist powers: the United States, Great Britain and France. Attired in formal dress, they wear gas masks and helmets, and each is identified with the flag of his country painted at his waist. (These symbols, too, Renau would have to remove, as well as those identifying three figures on the opposite side: the nazis, Italian fascists and the Japanese.) On opposite walls of the swirling panorama, two major figures loom: one a demagogue, with the head of a parrot, harangues before a microphone, beguiling with a flower and simultaneously brandishing a dagger; and the other, a revolutionary fighter, a most forceful and dynamic figure of a worker, with rifle in hand charges forward (plate 26).

The Mexican electrical industry is represented with electric power lines suspended from towers that reach to the sky and the SME banner flies aloft while underground electric generators turn out energy. And in the background, the nazis put the torch to the institution of democracy. It was a work of great complexity and beauty, and it established Siqueiros's reputation as a master.

13

Leon Trotsky

I have never denied and I don't deny now that, objectively, my participation in the assault on the house of Trotsky on May 24, 1940, was subject to the authority of the law, that it constituted a transgression of the law and for this transgression I spent long periods in jail, more than three years in exile, the loss of large sums deposited for bail, and an offensive defamation of character on an international scale.[1]

At about the time Siqueiros arrived in Spain, Trotsky arrived in Mexico. President Cárdenas, through the intervention of Frida Kahlo and her husband, Diego Rivera, had granted Trotsky political asylum when he was being pressured to leave Norway and found it difficult to find another haven. A friendly reception awaited him when his ship docked at Tampico on January 9, 1937; Frida Kahlo and a few North American Trotskyites were on hand to welcome him, and then, escorted by Kahlo, he traveled to Mexico City on the presidential train that the government had provided in his honor. At a small stop just outside the city the train came to a halt and Diego Rivera joined the escort.

Rivera brought Trotsky to his "Blue House" in Coyoacán, on the southern outskirts of Mexico City, where he remained for two years before moving to the ill-fated house on Calle Viena in the same suburb. It was in the Blue House that Trotsky wrote the Draft Program for the Fourth International. On September 3, 1938, 21 delegates, representing the small number of Trotsky followers around the world, met in France and adopted that program. The Blue House in Coyoacán thus became the seat of the Fourth International.[2]

Cárdenas was an astute and politically liberal politician, but he exhibited a certain naiveté concerning the storms swirling around Trotsky; not only had he granted him political asylum, but he made him a guest of the country. For this particular guest the government had to provide around-the-clock police protection. Despite Trotsky's warm reception from the government, the Riveras and North American followers, his presence was actively opposed by the Confederación de Trabajadores Mexicanos (CTM) led by Vincente Lombardo Toledano, and the Partido Communista Mexicano (PCM).[3]

When Trotsky's quest for refuge ended in Mexico, shock waves rever-

berated through the fighting forces in Spain, with the Mexican volunteers feeling their greatest impact. Mexico had enjoyed the highest esteem in Spain for its unqualified support of the Loyalist cause, but it had now shaken the confidence of the powerful Communist forces fighting the war. The Trotskyites' Partido de Obrero de Unificación Marxista (POUM) had been notoriously unreliable, both in bearing their share of the fighting and supporting the Popular Front.

In May 1937, five months after Trotsky arrived in Mexico, the POUM, conspiring with the Federación Anarquista Iberica (FAI), attempted a counterrevolutionary coup against the government of Spain in the midst of the desperate struggle. Showing little interest in fighting the fascists, the forces of the Anarcho-Trotskyite alliance abandoned their positions at the front and moved their men and arms back to Barcelona, knifing the government in the back.

Willing to resort to any method that would eliminate the influence of the Communists, they were not above collaborating with the fascist agents operating within Barcelona. A message sent to Hitler on May 11, 1937, by the German ambassador to Spain told how Franco's agents operating in Barcelona had collaborated with the Anarcho-Trotskyite alliance and brought about the street fighting that cost the Spanish people 860 dead and 2,600 wounded (Siqueiros's figures), and the disruption of the government's war effort, before the Trotskyites were crushed.[4]

All of this had rebounded especially hard on the Mexican volunteers, for Trotsky—now sheltered in Mexico—was considered the mastermind behind the anarchists' activities. Siqueiros and his compatriots became butts for abusive remarks. At Communist meetings and rallies for the support of the war effort, aid from Mexico was ignored, while other countries providing less were lauded. These events in May in Barcelona gave Siqueiros great concern, and he began to discuss the problem of Trotsky in Mexico with the Mexicans in Spain.

As Siqueiros understood it, Trotsky was enjoying the protection of the Mexican government and under that protection was directing operations against the Soviet Union and its aid to the Spanish Republic. Siqueiros and a handful of the Mexican volunteers, toughened by the fighting they were experiencing, saw no reason not to agree that—at any cost—the "headquarters" of Trotsky in Mexico would have to be shut down. It was a pledge they made to everyone in Spain, and a steady stream of cables began to reach Cárdenas from Spain, protesting Trotsky's presence in Mexico.

Once Siqueiros was back home, his thoughts were on whether it was in his power to dislodge Trotsky from Mexico. Cárdenas refused to discuss the matter with him, and the innumerable telegrams of protest were to no avail.

But, with the war in Spain now ended for Siqueiros, he was filled with

an overflowing desire to paint. He had to prepare an exhibition of new works for the Matisse Gallery and finish painting the mural for the electricians' union, so he laid aside any pressing thoughts he might have had about the Trotsky "problem."

A year passed since Siqueiros's return from Spain, and Trotsky's house was still guarded by a squad of Mexican police outside: inside, Trotsky was surrounded by heavily armed foreign bodyguards, and continued to issue directives to his followers.

In April 1940, when the electricians' union mural was nearing completion, Siqueiros, unknown to the PCM, began planning an action against Trotsky, sharing the secret with two members of the mural team. It was at this time that he made a quick trip to Hostotipaquillo, a village in the mining region of Jalisco, where he recruited two miners of old acquaintance to join in his plans. He would deliberately create an uproar that would force Cárdenas to consider the expulsion of Trotsky from Mexico.

With Hitler's army poised on the Russian border ready to strike, Siqueiros felt the need to mount an act of protest. To stop Trotsky from using Mexican soil as a base for his attacks on the Soviet Union would be a way of doing his bit to help save the first land of socialism, of keeping the promise he had made in Spain after the Trotskyite treachery in Barcelona.[5]

Siqueiros continued to appeal to Cárdenas to resolve the problem in a peaceful manner, but Cárdenas refused to discuss the matter with his old friend, instead presenting each Mexican veteran of the Spanish War with a 500-peso award for their sacrifice in Spain. Siqueiros later recalled:

> Naturally my 500 pesos served more than ever to overwhelm General Cárdenas with telegrams, now not asking but in fact summoning him to close what I called "the counterrevolutionary headquarters of Trotsky in Mexico," but without the slightest success in this respect.[6]

Now his assault on the headquarters of the Fourth International would attempt to force shutting it down and thus putting an end to Trotsky's base in Mexico. The object of the attack was threefold: to cause the greatest commotion by firing their guns; to show that the Mexican government could not guarantee Trotsky's safety in Mexico; and to abscond with certain documents from the archives.

> We knew the violent death of Trotsky or any of his bodyguards would not impede the development of Trotskyism as an international current, but rather would be counterproductive, since its practice had already been established with the slogan, "against Stalin all alliances and measures are good." So from the beginning it was agreed to avoid all bloodshed and if we were not successful in carrying off the documents, above all, documentary proof about the amounts he and his representatives received from the ultrareactionary news-

papers of the United States, especially the Hearst chain, the scandal that our act would produce would constitute an element of great force in obliging the government of Cárdenas to eliminate Trotsky's headquarters in Mexico.[7]

Siqueiros believed this would work because Cárdenas was moving toward greater support of socialism and the Soviet Union in its time of trial.

To maintain secrecy, Siqueiros divided his small army of 25 into small groups, each unknown to the other. Near midnight on May 23, Siqueiros met with the group he would lead in an apartment on Calle de Cuba in the downtown area of Mexico City, while elsewhere at various locations the others were meeting. Siqueiros had not until that night revealed the true nature of their mission. They had been told that their job was to raid an Almazanísta center to capture arms. (Juan Andrew Almazán was the reactionary presidential candidate in the approaching elections. Incidentally, his new publicity director was Diego Rivera. Idiosyncratic Rivera had broken with Trotsky, and had joined the Almazán campaign.)

At the midnight meeting on Calle de Cuba the conspirators donned their raiding costumes. Antonio Pujol was dressed as an army lieutenant; Néstor Sánchez Hernández and two others were attired in borrowed police uniforms. Siqueiros had left to issue the final instructions to the other groups; when he returned at 2 a.m., now May 24th, he was dressed as an army major, wearing eyeglasses and a false mustache. The last-minute instructions were that great care was to be taken in overpowering the police so as not to alert those inside the house. Once the police guard had been neutralized, gaining admittance through the powerfully locked entrance would be no problem. For, as Siqueiros explained while they were driving, one of Trotsky's guards had been "bought off."[8]

When the car reached Coyoacán in the early morning hours, 15 minutes from the center of the city, it was parked on the next street parallel to Calle Viena. Siqueiros checked his watch, then gave the order to proceed. As they rounded the corner they saw two policemen guarding the big doors of the Trotsky house. A short distance away was the corner guardhouse, where three policemen were asleep. It was shortly before 4 a.m. As Siqueiros and his lead team moved forward, the other groups appeared out of the darkness but remained out of sight of the police.

Three figures in uniform approached the police standing guard, who at first thought that superiors were making the rounds, checking up. "Lieutenant" Pujol, accompanied by two of his "police," greeted the guards at the entrance and inquired as to how things were going. As he waited for a response Pujol watched their eyes catching sight of two figures entering the guardhouse. It was then that he ordered the dumbfounded guards to raise their hands. "Major" Siqueiros, inside the guardhouse, had awakened the three policemen and ordered them to dress. The five policemen

were then tied up, and with a *"Viva Almazán, muchachos!"* to add confusion, Siqueiros left them guarded by one attacker.[9]

Trotsky's house was opened from the inside, and the raiders moved in and took control. The room containing the archive was locked and left untouched, while a continuous round of shots was fired creating bedlam. Trotsky lay hidden under his bed shielded by his wife, Natalya. It was over in a matter of minutes. Some two hundred shots were fired, and the attackers raced off in Trotsky's two autos. Robert Sheldon Harte, Trotsky's guard on duty, was driving one.

This act of political violence left a path strewn with adverse effects that for Siqueiros, not to mention the others, resulted in months of hiding, jail, and years of exile. The documents that Siqueiros had hoped to find had not been searched for in the confusion, and Trotsky was not expelled from Mexico for being the source of troublesome political controversy. Three months later, in an attack unrelated to Siqueiros and his small army, Trotsky was brutally murdered.

For a little more than a week after the raid, Siqueiros was able to continue painting. However, he was not completely unnoticed, for Trotsky himself suggested Siqueiros's name in a statement he gave to the police seven days after the assault.[10] The newspapers mentioned Diego Rivera's name because of his break with Trotsky some thirteen months earlier and his support for Almazán. Fearful of being dragged into the case, Rivera hurriedly packed his bags and left for New York.

But by a crazy twist of fate, General Leandro A. Sánchez Salazar, chief of the Secret Service of the Mexican police and in charge of solving the Trotsky case, happened to be standing at a bar having a whiskey within earshot of some streetcar conductors who were imbibing beer laced with tequila. He heard them proclaim that police were involved in the Trotsky attack, for had not their friend, a police officer they named, lent out three police uniforms to an unnamed person just prior to the raid?[11]

That was it; the case was as good as solved. With little trouble, the police officer responsible for the loan of the uniforms was tracked down, and one by one the conspirators were brought in. Néstor Sánchez Hernández, 23, revealed all the details and named Siqueiros as the leader. When Luis Mateo Martínez, a 26-year-old rural schoolteacher and Communist Party member, was arrested, the word went out that a break in the case was near, and Siqueiros went into hiding.

One month after the attack, Robert Sheldon Harte's body was discovered buried in the dirt floor of a kitchen in a small farmhouse near Coyoacán. The house had been used by the raiders, but Harte's true allegiance and death have never been cleared up.

Siqueiros's decision to flee was a desperate one. The notoriety of remaining at large, he thought, would be to his advantage. But there was

no escape from the immediate threat to his freedom. Although eventually the court would acquit him of the charges of homicide, attempted homicide, use of firearms, criminal conspiracy and usurpation of official functions, the price he would pay for his political adventurism was a dear one.

On June 23 the Communist Party issued an official declaration which stated in part:

> With the object of avoiding confusion and of making clear its own political attitude, the Mexican Communist Party hereby states most categorically that not one of the participants in said attack is a member of that Party; that all of them are uncontrollable elements and provocateurs; that an act such as that carried out at Trotsky's house is entirely contrary to the genuine ideas of the workers' battle and has nothing to do with us.[12]

The FBI, in its files, commented:

> Dionisio Encina, President of the Communist Party of Mexico, stated that the CP had no part in the attack on Trotsky in which Siqueiros appeared to be guilty, and further, Siqueiros had never represented the CP of Mexico.[13]

The U.S. government, through its various agencies—Military Intelligence, the State Department, the FBI (whose file on Siqueiros is more than 50,000 pages), the Immigration Service; the CIA, and Navy Intelligence—had through most of Siqueiros's life been surveilling his every move, and with the Trotsky affair the flow of information about him multiplied considerably. Their documents indicate that information was gathered from an army of volunteer informers, from mail openings, wiretaps and raids on organization files, and from the print media. The FBI files contain 163 variations of the name José David Alfaro Siqueiros.

Three months after the Trotsky attack, a U.S. State Department document marked "secret" curiously labeled Siqueiros "a German agent in Mexico."[14] U.S. Army Intelligence sent a copy of this report to the FBI:

> On March 5, 1939, Alfaro Siqueiros was the speaker at a meeting held by the Sindicate of Teachers in the Palace of Fine Arts for the returned Mexicans who had volunteered in Spain. Siqueiros was said to be one of the oldest communists in Mexico, one of the founders of the "Machete," CP newspaper, and one of the first Mexicans to volunteer to fight in Spain. On April 5, 1939, Siqueiros and other CP leaders were arrested and ordered imprisoned for stoning the offices of the newspapers "Excelsior" and "El Universal," following the expulsion of Spanish leaders. In October 1940, Siqueiros was arrested for complicity in the assault upon the house of Trotsky and the murder of Robert Sheldon Harte, released on bond April 28, 1941, and he departed that date for Havana, Cuba. On approximately June 16, 1941, Siqueiros was admitted to Chile.[15]

Army Intelligence could tell the FBI no more than the world already

knew. One informer, "name deleted," advised the FBI "that in 1940 he was introduced to Louis (sic) Arenal Bastor and David Alfaro Siqueiros, who were implicated in the first attack on Trotsky in Mexico in May 1940. These introductions were made under fictitious names by (name deleted).[16]

The files of the FBI and other U.S. agencies were being stuffed with every scrap of information and report of Siqueiros's activities at this time. Informers, their names protected, supplied innocuous information that the U.S. government avidly collected. "Deleted names" reported to the FBI:

> Mexican police were watching the west coast port of Manzanillo for the purpose of intercepting David Alfaro Siqueiros, Stalinist agent charged with having been one of the gunmen in the Trotsky affair . . . Dependable persons who were acquainted with Siqueiros reported his presence in New York.[17]

The jumble of information the FBI collected noted the "fact" that Siqueiros was "in the Red Army in Spain in 1937," and included irrelevant information about him in FBI file 65-29162, captioned "Jacques Marnard Van Dendreschd" (their rendering of the name of Trotsky's real assassin). The U.S. Office of Naval Intelligence gathered confused information on the subject. "Name deleted" reported that Siqueiros was "a leading PCM member and a leader of the 'Vigilante Committee' which assassinated Leon Trotsky."[18]

U.S. Army Intelligence collected the information that "one Arenal, a student and associate of Siqueiros, and Siqueiros were 'fanatic Stalin communists' and were involved in above incident [the assault of Trotsky's house] as well as in Trotsky's murder in August, 1941" [sic].[19] Also in the FBI file was the false information that it was Luis Arenal "to whom Trotsky's death had been attributed."

In the search for Siqueiros, the U.S. State Department included his name on its lists of "Persons Suspected of Belligerent, Subversive, or Other Activities Inimical to the Interests of the United States," and disseminated the information that "Alfaro Siqueiros of Mexico City obtained two passports, one under the name of Alfonso Rojax and one under the name of Miguel González. He stated he was born in Guadalajara. It was known that he was a communist and a saboteur."[20]

Hostotipaquillo

After searching Cuernavaca, less than an hour's drive south of Coyoacán, General Sánchez Salazar turned his attention to Guadalajara, far to the northwest. He had received reports that Angélica, carrying two valises, had boarded a train in Mexico City bound for Guadalajara. Agents he dispatched to Guadalajara verified the fact that on Thursday, June 2,

ten days after the assault against Trotsky, Siqueiros had passed through Guadalajara on his way to Hostotipaquillo, to the north and west.

Recessed in the foothills of the western slope of the Sierra Madres, Hostotipaquillo was surrounded by the mines of the state of Jalisco and was all too familiar to Siqueiros. General Salazar knew he would have a difficult time, for Siqueiros would be hidden and protected by the union miners he had organized 15 years earlier. His arrival in Hosto—as the townspeople called it—was known to only three persons: the mayor, the municipal secretary, and the chief of the armed Agrarian Guard. Later an old miner shared in the secret.

Angélica left her young daughter in her mother's care and joined Siqueiros. Both remained hidden, even from the inhabitants who held him in high esteem.

They wore simple peasant clothes, and Siqueiros grew a long drooping mustache, cut his long curly hair short and let the sun burn his complexion dark. Through the months they lived in two different homes: that of the municipal secretary and—away from town—in an old miner's house. In the mountains there were several safe sleeping spots, and the two would often ride there on horses, where Siqueiros would paint landscapes in settings which under less sorry conditions would have been idyllic [16].

Angélica, attired in her peasant dress, slipped undetected into Mexico City several times. She would cautiously visit her daughter, but her more important mission was to post articles written by Siqueiros, usually critical of the government, to newspapers and magazines. General Salazar was aware that the Mexico City postmarks were to throw him off the trail and was not impressed.

When the murder of Trotsky took place on August 20, Salazar dropped his hot pursuit of Siqueiros, who had already been in hiding for three months. But once the murder case was closed, Salazar doggedly resumed the search that was beginning to obsess him. On September 25 he left for Guadalajara, vowing not to return until Siqueiros was captured.[21]

One of Salazar's agents, a good Catholic, feigned a need for confession and tricked the local priest into leaking to him the information that Siqueiros was indeed in the vicinity, that he would sometimes sleep in the mayor's house and other times at the municipal secretary's.[22] Salazar was sure that he was on the right trail when Chucho, Siqueiros's brother, dressed as a woman, was followed to Hosto. It did not take long for word to reach Siqueiros that Hosto was crawling with Mexico City secret police. Angélica was on one of her trips to the capital, and Siqueiros faded into the mountains.

Salazar, in disguise and acting the role of a politician from Mexico City, went to see the mayor, who saw through his disguise immediately and told him so. The mayor further tantalized the general by telling him

that yes, he did see Siqueiros, that he was ill, and that he went into the mountains where it was good for his health.[23]

After thirteen days in Hosto, Salazar was frustrated to the point of exasperation. He was on the verge of admitting failure and requested permission to return. But one of his agents brought in a sick miner from Cinco Minas, a mining village not far from Hosto. Cristóbal Rodríguez Castillo had years before worked with Siqueiros, organizing the miners' union. Now suffering from silicosis and with a large family to care for, he was easy prey and fell victim to Salazar's devious twist of the screw. Salazar told him:

> I can't conceive that you think more of your friendship for Siqueiros than of your liberty, and above all, of the well-being of your family. I have in my possession statements and undeniable proof that you have given protection to the painter who you know is a fugitive. If you refuse to tell me what you know about the whereabouts of Siqueiros, I am very sorry, I shall have to bring you to Mexico City. On you depends your future luck.[24]

Cristóbal Rodríguez Castillo told General Salazar a long story about how he had helped Siqueiros recruit miners for the Trotsky raid and about all the artist's movements from the time he arrived in Hosto four months earlier. It was midnight when Rodríguez Castillo fell silent. But the last detail for which Salazar had been waiting patiently had not been divulged: Where, at this very moment, could Siqueiros be found? With resignation, Rodríguez Castillo gave the answer: a small ranch named San Blasito on the outskirts of the village of Magueyito, about 20 miles away, over very difficult terrain.[25]

Three days earlier, Siqueiros had been forced to flee the house of Hosto's municipal secretary. As he left by the window, troops were approaching; unable to reach his horse, he fled on foot into the brush. It was fortunate for him that at that moment Angélica was in Mexico City, for it took three agonizing days on foot to reach his hideaway at the San Blasito ranch.

Forced to find his own way, without a guide, avoiding the road and for those three days without any food, he groped over the rough ground, slept in caves, and fled from nests of coral snakes. Exhausted, he arrived at the outskirts of Magueyito. At a roadside hut where food was sold beneath a burning sun, he replenished his strength with frijoles, tortillas and water, only to hear from the proprietor that soldiers were all about looking for a dangerous criminal.

Furtively he left the hut and made his way between huge boulders up the mountain to a secret cave. The small ranch of San Blasito now lay below him. The poor Ibarra family had rented Siqueiros and Angélica a room, but they did not know about the secret cave in the mountains above the ranch. Nor did the family have knowledge of just who it was

they had taken in as boarders. They thought David and Angélica were eloping lovers—Marcario Sierra and Doña Eusebita—hiding from Doña Eusebita's family. This also served to explain why Siqueiros was heavily armed.

It was a hot dank night, and the mosquitos drove Siqueiros from the cave, forcing him to move to higher ground. Earlier a heavy shower had left the ground wet, and Siqueiros fell into a deep sleep in a puddle of water.[26]

"Surrender, you son-of-a-bitch!" was the shout that rudely awoke him at dawn. His hands were bound behind him, and they marched him off with a rope around his neck. He was filled with fear and trepidation. Were they taking him to some lonely spot in the mountain to be executed? The "law of flight," he knew, was often used by the police and the army, and he was sure that at any moment he would be shot from behind as he "ran to escape."

He began reviewing the events of his life, but even as he was wondering how death would come, shots rang in the distance. The police brutally flung him to the ground, bloodying his face as it smashed against the rocks. Moments later he was helped to his feet, the blood wiped from his face, and a cigarette placed between his lips. They apologized for handling him so roughly and explained that they were returning by circuitous route to avoid any possible confrontation with miners who might attempt to rescue him. And, as they further explained, the President had ordered that he be brought back alive and unhurt at all costs. The shots that had rung out, it was discovered, were not from miners but from a lost battalion of soldiers.[27]

After marching for an hour over rugged terrain they arrived at the spot on the road where they were to meet General Salazar. Captured at the same time was Marcos Orozco, Siqueiros's bodyguard and guide. He had arrived by himself from Hostotipaquillo and was captured before he could make contact with his chief. A caravan of cars arrived in short order, and General Salazar stepped out of one to face his quarry. They met on common ground as veterans of the Mexican Revolution. Salazar's first words were an order that Siqueiros be untied immediately. Then in a most amiable manner he began to reminisce with his prisoner about the Revolution. And the officer who had commanded the soldiers in the manhunt conveyed to Siqueiros the best regards of his chief, Colonel Jesus Ochoa Chávez, who was too ill to be present but wished to be remembered as an old comrade of the Revolution.

Before the small army set off for Hostotipaquillo, General Salazar ordered the police agents and soldiers to form ranks. The 60-70 men stood at attention and listened to the general's short speech eulogizing Siqueiros; though he would have to pay for his offense, he was a veteran of the

Revolution and a great painter to the glory of the country; he added that Siqueiros was not to be treated as their prisoner but as their chief.[28]

The procession back to Hosto turned into a parade of celebration for the prisoner. Word quickly spread that he had been captured, and his entrance into town was greeted with cheers of "Viva Siqueiros." Miners and their families rushed out with flowers and fruits to greet the revered benefactor who had led them in the struggle to improve their life.

A farewell banquet was hastily arranged by the mayor. Siqueiros recalled it all as he reminisced in prison to a reporter in later years. His face swollen and scratched, he was seated at the center of the table, General Salazar to his right and the officer of the Eighth Battalion to his left. Everyone was toasted; Siqueiros as the guest of honor; the President of the Republic; the police agent Pancho Figueroa Arceo, who as luck would have it had captured Siqueiros on October 4, the "Day of Pancho," his own saint's day.

At 5 o'clock that day General Salazar was ready to say good-bye to Hostotipaquillo. In custody besides Siqueiros and Marcos Orozco were a handful of people, including two women. All were accused of aiding and concealing the fugitive.

When General Salazar's victorious army reached Zitácuaro, 61 miles west of Mexico City on the following day, General Nuñez, the chief of the Mexico City police, and at least a hundred reporters were already on hand. Once in the custody of the Mexico City Police, Siqueiros was again answering the questions of the press.[29]

The Argument in Court

After 4½ months in hiding, Siqueiros was behind bars in Mexico City for 6 months before he was brought to trial. He spoke in his own defense and was acquitted of the most serious charges: homicide, attempted homicide, criminal conspiracy and the use of firearms. Lesser charges of trespassing and breaking-and-entering were pending, but he was eligible for release on bail.

Siqueiros defended himself with a long exposition that included a detailed explanation of Trotsky's political significance in Mexico and how he had influenced events both at home and abroad. Contrary to all legal practice for political refugees in Mexico, Trotsky had established a tribune in Coyoacán, which "contradictorily" had been granted him by "Mexico's most progressive President." For Siqueiros, political reasons made the attack on Trotsky's house not only possible but inevitable, a necessity.

The bourgeoisie of Mexico and of the world, who had despised the Trotsky of the Russian Revolution, now

extended a fraternal hand to Trotsky the anti-Stalinist, "to the greatest enemy of our greatest enemy" [who] with an ample baggage of sophistry, supports the local and world counterrevolutionary struggle.[30]

Siqueiros explained how he saw Trotsky as a serious disruptive force, interfering in internal Mexican politics with his opposition to the Popular Front at the time of its formative stages around Cárdenas. Siqueiros also expressed great disappointment that Mexico's organized masses, submissive to Cárdenas, their new "patriarchal *caudillo,*" lacked any strong opposition to Trotsky's operating from Mexican soil. In Spain, he said, he had received news that there had been some opposition to granting Trotsky's asylum, but "in the form that seemed more like the mournful cry of a deer making filial demands than the exigency and combative will of the popular, proletarian, and revolutionary masses." Other voices from Mexico had told him of the "Maderista suicide of Cárdenas" and of his "strange mixture of romantic and populist chief."[31]

The Communist Party, too, shrank from any opposition to Cárdena's actions. "They considered that anything that would endanger or break the unity of the progressive forces of Cárdenism was contrary to their position." This did not mean that the vanguard forces, the proletarian class, should with their silence become subordinated. But the labor movement was capitulating "before the neo-progressive bourgeoisie that governs the country,"[32] and the revolutionary proletarian movement was giving up its political independence and leaving the road of the Popular Front.

Siqueiros told the court of the failure of Spain's Republican government to declare a "state of war," and how this had left a fertile area for the "espionage, sabotage, treason and provocation of Trotskyism—the most effective nucleus for the demagogy of Franco's Fifth Column in the Loyalist zone." Fifth Columnists, "in the shadow of the government of the Popular Front," moved freely within the political, labor, agrarian and military organizations. Siqueiros told how the Republican authorities had taken "thirteen months to discover that the political party of Trotskyism in Spain (POUM) engaged in espionage, sabotage and provocation as a dependency of the headquarters of the so-called Nationalist Army."[33]

He spoke to the court about the tragedy of Barcelona, far to the rear of the Republican front, of the POUM-engineered uprising and its disastrous results.

An armed uprising directed BY THEM, in complicity with all the ambushers of the rear, with all the disguised anarchist rabble, with all those whiners demanding capitulation, with the bourgeois wanting peace at any price—and in their treason [the Trotskyites] using *the trick of the "transformation of the Civil War into proletarian revolution,"* over the *"conciliators of the Popular Front."* An uprising that cost the Spanish people 850 lives and 2600 wounded. In the end it was the masterpiece of *our refugee* of Coyoacán; of the *"poor persecuted*

politician," romantically isolated in Mexico by President Cárdenas. (Emphasis in original.)[34]

In Mexico, Siqueiros said, Cárdenas was moving toward "the concept of the *Neutral Government*," and a demagogic Trotskyism reinforced this attitude daily, applying it even to the police and the diplomatic corps. Though Cárdenas had moved forward with radical social reforms, reactionaries and counterrevolutionaries were waiting in the wings preparing their counteroffensive. This "was a panorama," Siqueiros told the court, "very similar to that of the Spanish Republic in the period before the hand of reaction struck its blow."[35]

Siqueiros instructed the court on the meaning and consequences of having tolerated the political activities of Trotsky in Mexico:

> The fact is that the greatest of the dissemblers of the Revolution . . . managed in a brief period to transform the tribune given to him by President Cárdenas into the headquarters of national and international counterrevolutionary politics, protected day and night on the outside by the pistols, rifles and bayonets of ten members of the Mexican police, and on the inside by the arms of ten foreign gunmen. It was a political center with secretaries and typewriters, with daily connections . . . to the city outside and . . . to lands abroad, with free means of transit through the United States. Naturally, all of this within view and with the approval of the Minister of Government of Mexico.[36]

Siqueiros prepared for the court a thorough examination of Mexico's political life, which he held responsible for his commission of the act for which he was being tried. He argued that the forces that should be struggling for the Revolution in Mexico were disarming themselves by placing everything in the hands of Cárdenas, "the good patriarch." For the Mexican Revolution to survive, a popular front was needed, but after three and a half years "of the most friendly regime," no such front had materialized, for the party of Cárdenas, the Partido de la Revolución Mexicana (PRM), was now "in the hands of *sub-caudillos* of the new-rich class."

He told the court that he had requested special leave from the war in Spain so that he might return to Mexico to see Cárdenas and explain to him the problems that Trotsky was causing. "I wanted to point to the fatal error of granting Trotsky a refuge in Mexico and to present documents of the work that this renegade had brought to the fore in Spain." In his best diplomatic manner, Siqueiros met with Cárdenas. "I wrote a forty-page report which I personally gave to him."[37]

Of his return to Spain, he told how he despaired over the fatal course of the war and over the fact that his visit to Cárdenas had not produced results.

> Trotskyism . . . in the course of this war . . . had the means to qualify as the most appalling demagogic arm of counterrevolution in every country. This I saw and experienced in the very ranks of the units under my command. Its

daily hypocritical alliances with the spies, saboteurs, provocateurs, defeatists, deserters, and capitulators of the Fifth Column of Franco within the ranks of the Republicans.[38]

The fact that the progressive government of his country, which had given such support to the Spanish people, "could shelter on its territory nothing less than the headquarters that conceives, organizes and executes these inequities covered with a Tartuffian cloak of supposed Marxist orthodoxy," brought him, he told the court, into sharp conflict with the Cárdenas government. His experience with Trotskyite subversion was firsthand: "the principal target attacked by such traitors was the Spanish Communist Party." Spain's defeat, he pointed out, was caused not only by the betrayal of the Loyalist cause by the "great democracies" and by the errors of the Republican government in waging the war, but also by the ambushes of the "so-called Marxist-Leninists of the international band of *provocateurs* directed by Leon Trotsky from his headquarters in Coyoacán, Mexico."[39]

He then painted a broad panorama of the reactionary climate he found in Mexico after his return from Spain. Fascist parties were reviving and counterrevolutionaries from Porfirioistas to Callistas were

petulantly strutting about everywhere, including inside the entire official apparatus. And, in the land of the government which expresses solidarity with the [Spanish] Republic, the Spanish Falange ostentatiously and with impunity functions with absolute freedom, exhibiting their fascist uniforms and emblems in the cafes.[40]

In the revived activity of the right-wing extremists—Golden Shirts, Sinarquistas, and the anti-communist Revolutionary Party—he saw a serious threat to eliminate the Revolution. With this "common anti-Stalinist front of reaction . . . Trotsky, the maestro and leader of his Fourth International, performed his special task"—to destroy Cárdenism and the Revolution.[41]

Trotsky was not personally against Cárdenas, but only against the "proletarian-popular" and "bourgeois-progressive" concentration that formed Cárdenism, "while articulating all the time in high and low theory against the tactic of the Popular Front—his pickaxe blows not against the arch but against the columns." Trotsky's

simplistic and perfidious theory of proletarian revolution at all costs, is for present-day Mexico, as it was for Republican Spain, more than stupidity; it is a precise, demagogic, reactionary accomplishment. Stupid of Trotsky? Doubtless a cretin, Trotsky? No, intelligent! The very intelligent work of a counterrevolutionary provocateur.[42]

Siqueiros explained how Trotsky maintained that he was not interfering in the internal politics of Mexico, but was only attacking GPU agents

who, according to Trotsky, were the main support of the Cárdenas government and thus the *"only victims"* of his attacks. Attacks, argued Siqueiros, that "originated in a species of high politics situated in the stratosphere of the Revolution, not on the ordinary political surface of everyone else." For Trotsky the politician, to join with fascists in attacking what he wished to attack, meant nothing.[43]

At this point Siqueiros cited Trotsky's willingness to appear as a friendly witness before the notorious Dies Committee of the U.S. House of Representatives, which at the time was carrying on an inquisition against U.S. progressives. When the Dies Committee turned its attention to Cárdenas and his reforms, especially the nationalizing of the oil industry, Trotsky agreed to talk to the committee about "Stalinism," but his trip did not materialize. It was of little importance to Trotsky that he joined with an arch-reactionary such as Dies; he defended himself with the claim that his program was different.[44]

In Spain, Trotsky—in the name of the Proletarian Revolution at all costs, "a stupid and pharisaical doctrine"—had caused opposition to the Popular Front that resulted in the Republican coalition being "shot in the back by Francoism and international Fascism." In Mexico he was equally disruptive.[45]

Nor did the fact that Trotsky was now dead diminish his lingering work. "Trotsky is surely dead but the putrefaction of the politics of his perverted madness spitefully lives on. His work, carried on by proselytes and disciples, was "still making the bourgeoisie of Mexico and the entire world applaud furiously his words of the 'true Revolution and the true Marxism-Leninism.'"[46]

Hardly a desperate self-defense. Siqueiros's concern was more with explaining the significance of Trotsky's refuge in Mexico and how his own appeals to Cárdenas and the Communist Party to act decisively with regard to Trotsky had failed. Thus had he arrived at the decision that Trotsky's refuge would have to be exposed as a headquarters.

> I considered that as a Mexican revolutionary there would be no greater honor for me than to contribute to an act that helped expose the treason of a political center of espionage and provocation that was seriously contrary to the national independence of Mexico, the Mexican Revolution—that counted me among its soldiers and militants from the year 1911—and of the international struggle for the cause of Socialism.[47]

The day before Siqueiros was to be set free on bail, Secret Service agents appeared at his cell and escorted him out through a back door to the street. There the warden was waiting for him; they were old friends, both had been captains in the Revolution. Two limousines were waiting, and Siqueiros was directed to enter one, in which he found the attorney

general of Mexico seated. The warden got in too, and they drove off, followed by the second car, carrying police agents.

Attorney General José Aguilar y Maya told Siqueiros where he was being taken—President Manuel Ávila Camacho wished to speak to him and his liberty would depend on the outcome of the conversation. The conspicuous gaudiness of the President's new private mansion appalled Siqueiros's aesthetic sensibilities and filled him with a feeling of foreboding. At its entrance he was received by the chief of the Presidential Guard; alone, and with the greatest deference, he was escorted to the President.

A very friendly and personal greeting extended to him by the President further perplexed him. But then Ávila Camacho began to speak of his experience with Siqueiros in the Revolution. During a tremendous storm at the time of the Battle of Guadalajara, then-Lieutenant Camacho, the army paymaster, was stranded and all the soldiers refused him shelter in the hut in which they were quartered. But Siqueiros had grabbed Camacho by the arm and offered him his straw mat to sleep on. It was that night, when they slept together, that President Camacho now recalled to Siqueiros, who had not known that the individual to whom he had offered shelter was now the President.

Camacho then told Siqueiros that he was going to have his liberty, but only under the condition—and this for his own safety—that he leave the country immediately. The President told him that he had information there was a plot to kill him, and he did not want anything like that to happen during his term of office. Siqueiros then made the plea that since the court had cleared him of all serious charges, rightfully he should be permitted to remain free on bail in the country. But Camacho was insistent; he assured Siqueiros that in time his bail of 10,000 pesos would be returned, and that in Chile, where he would be given asylum, the Mexican ambassador, Octavio Reyes Espindola, would help him obtain a wall on which to paint a mural.[48] There was no recourse; Siqueiros had to accept the condition. The expulsion he had sought for Trotsky now fell on himself.

For the two weeks that it took the government to work out the plan and the details of his departure, Siqueiros and Angélica lived in a flat hidden away from the press and others. It was at this time that Siqueiros painted a portrait of Simon Bolivar, who was greatly admired by Camacho. He wished to present it to the President; just before he left the country, Siqueiros gave the painting to his brother Chucho to deliver, but Chucho, always in dire financial straits, instead sold it to the President's brother, Maximino. Camacho never knew that Siqueiros had painted it for him; nor did Maximino.[49]

14

Exile in Chile

At 6:30 a.m. on April 28, 1941, Miguel Alemán, then Minister of Government, was on hand at the airport with all the necessary papers and tickets. Siqueiros, Angélica and 8-year-old Adriana said their good-byes to Angélica's mother, Señora Arenal, and to Chucho, and boarded the plane. Havana was to be their first stop, and they settled in their seats feeling uneasy about the new adventure that lay before them. As Siqueiros scrutinized his air tickets and papers, he was surprised and disturbed to find no airline tickets beyond Panama. His friend Pablo Neruda was the Chilean consul in Mexico City, and had arranged the Chilean visa that was attached to his passport. But between Panama and Chile, there were no travel arrangements. To further complicate matters, though Siqueiros did not know it as their journey began, the Chilean ambassador to Mexico, Manuel Hidalgo y Plaza, was busy overturning Consul Neruda's granting of the visa.[1]

Worried about being stranded in Panama, where the North Americans were well established, and fearful that North American Trotskyites would be waiting there for him, Siqueiros changed his itinerary. In Barranquilla, Colombia, their last stop before Panama, he succeeded in changing their flight to Bogotá. He decided to keep out of sight as much as possible, and resorted to surface travel for the remaining 3,500 miles. The trip overland by whatever form of transportation they could find was arduous indeed, but the breathtaking beauty along the way made it exciting.

By train, auto and small plane they groped their way down the west coast of South America. From Bogotá they traveled by train to Cali on the west coast of Colombia. There a newspaper report convinced him that he had made the correct travel decision.

> Arriving in Cali, what was my surprise but to read a newspaper in which there was a United Press dispatch to the effect that I had mysteriously disappeared from Barranquilla, and that I had purposely planned to avoid the anti-Stalin demonstrations of the Trotskyites waiting for me at the airport in Panama. With this, I had not the slightest doubt about my suspicion that a trap was set for me in Panama.[2]

They left Cali as soon as possible, but with no southbound flights immediately available, they hired at great cost a chauffered, run-down auto

for the very difficult 350-mile drive to the border of Ecuador. It was a drive over barely passable roads but rapturously beautiful. Here they were, three foreigners traveling through Colombia without proper Colombian visas, with hopes of crossing into Ecuador without Ecuadorian visas. But Mexicans rarely appeared at the two border outposts, and Mexico was highly esteemed by both Colombians and Ecuadorians. So the arrival of the Mexican family caused a sensation and they were permitted to continue on their journey without the slightest concern about their documents.

By the time they reached Lima, Siqueiros received the news that in spite of the intervention of President Ávila Camacho, his visa had been rescinded by the Chilean president, Pedro Aguirre Cerda, upon the urging of his ambassador in Mexico City. Nevertheless the intrepid trio pressed southward determinedly, remaining away from the beaten path. They had traveled problem-free through Colombia, Ecuador and Peru without the respective visas, and were now ready to try to enter Chile.

If they flew to Santiago, they were sure to be stopped. Siqueiros bought tickets on a Peruvian "airline" to fly them from Lima to the Peruvian border town Tacna. It was a harrowing trip, in a dilapidated, doorless plane that flew treacherously close to the Andean peaks. Once again, the border guards, who had never seen Mexicans, especially in so remote an area, were astounded. The Chilean authorities in Santiago, the capital, did not imagine that Siqueiros, Angélica and the child Adriana would venture so preposterous an overland journey and so had neglected to inform their border stations that Siqueiros was not to be admitted. Armed with the visas Pablo Neruda had arranged, the three crossed into Chile and were welcomed at the border as rare and esteemed Mexicans. Shortly, the three weary travelers were lodged in the Hotel Nacional at Arica, a few kilometers away.[3]

The Arica police arrived at Siqueiros's hotel room next morning and ordered him to remain in his room until instructions arrived from the capital, far to the south. Without Peruvian papers, they could not expel him back over the border. However, Arica's small intellectual community heard of Siqueiros's presence in town, and they intervened, assuring the police that he was an important personage of the arts; immediately they began preparing a banquet in his honor. The police of the small remote city lifted the restriction and permitted Siqueiros and his family to attend the banquet. At the same time, responding to the pressure of his new intellectual friends, the Arica police acceded to his request for telephone contact with Octavio Reyes Espindola, the Mexican ambassador in Santiago. The ambassador then prevailed upon Chile's President Aquirre Cerde to discuss the problem with Mexico's President Camacho by telephone. Camacho, anxious to avoid having Siqueiros return immediately to Mexico, explained to Aguirre Cerda that Siqueiros had not been ex-

pelled from Mexico but on the contrary was being sent to Chile for the sole purpose of painting a mural in the new elementary school in Chillán, which Mexico was donating to Chile (the area had been ravaged by an earthquake). Aguirre Cerda accepted Camacho's explanation and agreed that Siqueiros could stay, but he would have to remain confined to the town of Chillán,[4] 400 kilometers south of Santiago.

Mural: Death to the Invader

Siqueiros arrived in Chillán with his family in May 1941. Although he was provided with room and board, and had a mural to paint, with helpers and materials supplied, there was no financial remuneration and little possibility of earning money from small works, since a Chilean art market was nonexistent. The long journey to Chile had consumed the small financial reserve they possessed and they were now quite destitute. The family lived on the school construction site in a small, rude, incomplete dwelling that would later belong to the school's caretaker.[5] Food, too, was a problem, for the Chilean meals prepared for them by the wife of the construction foreman were full of grease and onions and most often intolerable.[6] They were fortunate, however, in having an abundance of fresh fruit, for Chillán was situated in the heart of the Central Valley, Chile's fruit- and wine-producing district.

The library of the Escuela Mexico, the new Chillan elementary school, was dedicated to Chile's president, so it was La Sala Aguirre Cerda. It was a room 25 meters long and 7 meters wide, with a ceiling 6 meters high. When he stood within it for the first time, Siqueiros visualized compositional forms that would push through the walls and ceiling, optically expanding the room. The two principal opposite walls, which would carry the thematic content, were to be altered with the introduction of a concave surface that joined them to the ceiling, to be treated as one continuous surface. The permanent structure was covered with a surface that combined masonite and plywood.

Thematically, on each of the two concave walls he would depict a history—one of Chile and one of Mexico— and the two would be part of the common history of Latin America. The title of the mural could apply not only in Mexico and Chile but in every country of Latin America— *Death to the Invader (plate 27)*. Before delineating the historical facts in plastic terms, Siqueiros prepared a dynamic understructure for the composition, to create the optical illusion of opening up the surfaces and dissolving them into space.

The illusion he was seeking was achieved by directing the placement of lines and forms on the walls and ceiling, having stationed himself on the opposite side of the room at spots which he considered average locations of future spectators. Thus viewed, after the sides of the wall are

extended upward by specific lines drawn onto the ceiling—especially with color brought into play—the ceiling appears to be a continuation of the wall, to have been pushed straight up as though it were part of the wall plane.

Compositional forms, conceived from the spectator's station or trajectory, were then painted on the ceiling as though it was part of the wall it adjoined. In this way, two unifying compositional forms—the volcano for Chile, and fire for Mexico—intertwined in the center of the "ceiling-wall." At the same time, two small side-wall extensions adjoining each of the concave walls were incorporated by visual tricks into the planes of the concave walls. Thus the planes of the entire surface were linked into one cosmic space on which Siqueiros painted the heroes of Chilean and Mexican history in monumental proportions. The concave walls imparted the effect of greater depth and at the same time helped to activate the forms that were painted with a repeated superimposition of their shapes. An illusion of massive mechanical movement of forms resulted as the spectator traversed the room.

Of his approach to the thematic material Siqueiros wrote:

> I did not want to paint some facts about the history of the two countries, as important as these were. I wanted to paint the entire history, or at least the fundamental motor drive of the entire history of both peoples, and still the historical simultaneity of their struggle, for both are people of Latin America.[7]

Facing the wall of Chile's history and on the left, high on the rocks of the Andes you will see the distant figure of Lautaro calling his people to arms. The famous Araucanian Indian warrior led his people to resist the Spanish invaders and became the inspiration for every South American liberator who followed. Behind Lautaro and following his agitated movements looms the shadowy figure of Luis Emilio Recabarren, founder in 1909 of the Workers' Federation of Chile and in 1922 of the Communist Party of Chile. In the foreground one sees Caupolican, the powerful Araucanian chief who fought the Spaniards, striking them with the cadavers of their own soldiers before dying stoically from the most atrocious Spanish torture. His phantasmagoric figure hurling lances looms five meters tall over the slain armor-clad conquistadors. But there, almost charging out of the center wall space, is the Araucanian Galvarino, barbarously mutilated, his hands chopped off by the invaders from Spain. In this condition he ran the length and breadth of the Andes sounding the alarm and mobilizing his people to resist the Spaniards.

Juxtaposed with the head of Galvarino, and spanning 300 years of history is the head of Francisco Bilbao, the great Chilean writer and freethinker. The confusion of their painted arms and legs impels their forward movement. To the right and slightly behind the two leaders—no less important, though plastically less dominant—is the figure of Bernardo

O'Higgins, Chile's first president, who was born in Chillán and here raises the flag of Chilean independence.

Siqueiros's plastic expression of the "motor drive" of Chile's history ends with the image of the progressive President Manuel Balmaceda, who ruled at the end of the 19th century. From the side panel—which flattens out optically, extending the principal wall—Balmaceda surveys the panorama of history. Then, as the spectator's eyes move upward above the drama of the apocalyptic history of Chile, they are directed across the ceiling space by erupting volcanic forms that connect with the flame forms which rise from the tour de force that represents the history of Mexico. The entire surface has become one space.

For Mexico, one figure symbolizes resistance to the Spanish. Towering 6 meters high, Cuauhtémoc moves away from the spectator, climbing the steps of a pyramid into the space of the concavity, his bow vibrating as he unleashes arrows that strike the flaming Catholic cross-sword pointed at him, the cross-sword that was the instrument for extracting gold from the Indians. Intensely energized, Cuauhtémoc's figure continues with phantom mutilated victims of the conquest charging forward over the bearded conquistador, dead underfoot, a lance piercing his chest. This *coup de main,* this slaying of the conquistador, is the ideological source, the inspiration of all subsequent revolutionary struggle in Mexico. Once and for all, the myth that so crippled the Aztecs was exploded, the myth of the invincible white god.

Standing in the wings, on both sides of the slain conquistador are the revolutionary leaders of Mexican history. On the left are the figures of Morelos, Hidalgo and Zapata. In the foreground, symbolizing a vigorous, active Mexico, is the animated figure of a young woman—the Adelita of the popular song of the Revolution. This figure, modeled by Angélica, leaps from the concavity. To the right are the figures of Juárez and Cárdenas.

The schoolchildren called it "The Room of the Giants." As they ran beneath the mural space, they laughed; they loved seeing the painted forms move and turn from one position to another. Siqueiros thought they were the first to prove the mural's cinematographic effect.

So taken with the work was Lincoln Kirstein, curator of Latin American Art at New York's Museum of Modern Art, that he wrote a critical analysis of it. In his article, "Through an Alien Eye," he wrote that after seeing most of the major murals of the world, he now experienced for the first time a mural that represented a new school of art, the school that had sprung up in Mexico.

The polemic is essentially a technical polemic. Here for the first time and in a manner that is final, Siqueiros has fixed, at times primitive, the beginning of a tremendous plastic and spatial revolution. In Chillán one encounters the most important new synthesis of plastic elements since the cubist revolution

of 1911. And when one thinks of *Guernica* (frightful and inclined to heroic and decorative failure), one is positive of the triumph of Siqueiros.

The forms begin to move in their own atmosphere. The arms and legs seem to be surrounded with the vapor of a photographic double-exposure . . . The spectator, instead of placidly contemplating a remote vision, finds himself physically implicated in a violent battle. The flesh of the knee of Galvarino crushes the steel armor of the conquistador who in turn has smashed the royal magic mirror under the weight of his metal. One hears the clamor. Only in the face of San Esteban that is reflected in the olive-green armor of the claudicant Count Orgaz can be seen a similar technical domination over materials, surface and psychological associations.

. . . [I]f the room had been a sphere instead of a rectangle with adaptations, there would not have remained any free space that would not have been painted, not even the floor would have remained intact . . . On these walls we do not have the coarse, easy generalization of forms or surfaces common to Rivera, nor the ideological disorientation that in Orozco provokes his instinctive and frequent violence. In Siqueiros, the dominant characteristic is the use of intelligence. Everything is reasoned, construed, examined, and addressed. We are very far from the romantic "realism" of the early days of the Sindicato. In exchange we have a new classicism of an emotional and poetic realism, not decorative, not exotic, antiromantic.[8]

On March 25, 1942, in the presence of President Aguirre Cerda and Mexican ambassador Octavio Reyes Espíndola, the mural was inaugurated. With this work Siqueiros had more than justified his troubled stay in Chile. The chains that confined him and his family in Chillán were removed, and he was granted permission to reside in Santiago.

With his new freedom, Siqueiros, Angélica and Adrianita toured through some of southern Chile and there they were appalled to find large nazified German communities in Valdivia and Puerto Montt. The children of German immigrants had earlier settled in these cities and were now supporters of Hitler.[9] Though President Cerda headed a popular-front government, the profascist element in Chile was large. Siqueiros, the antifascist fighter, despised what he saw of the Nazis reveling in Chile and he was ready to do anything and accept any task that would aid the Allied war effort.

U.S.-Siquieros Collaboration

Lincoln Kirstein's enthusiasm for Siqueiros's work led him to offer the artist an exhibition of his paintings in the very near future in the Museum of Modern Art. It was something to look forward to; anxious to leave Chile, Siqueiros hoped he would get to New York. Still unable to enter Mexico, he did, however, obtain a visa to visit Cuba. He had been lecturing in Santiago, focusing on the responsibility of the artist in face of the

world struggle against Nazi fascism, and it was his intention to lecture on this subject as he traveled north to Cuba.

Siqueiros's talks on the subject of art as a weapon against fascism had caught the attention of Claude G. Bowers, then U.S. ambassador to Chile. Bowers realized that Siqueiros could be extremely valuable in rallying popular support in Latin America for the Allied war effort and he succeeded in drawing Siqueiros in under the wing of the U.S. State Department. Amazing as this seemed, there was no contradiction in their joining forces since their common purpose was the defeat of Hitler. This "alliance" was further strengthened when Nelson Rockefeller offered to sponsor a mural to be painted in New York by Siqueiros and a team of Latin American artists at the end of a planned speaking tour.

In December 1942, prior to the Rockefeller offer, Siqueiros applied to the U.S. Embassy in Chile for a visa to enter the U.S., basing his request on Kirstein's promise of an exhibition of his works in the Museum of Modern Art. Ambassador Bowers was most willing to issue the visa, but State Department procedures required that Siqueiros provide a formal confirmation of the promised exhibit. Siqueiros then cabled the museum and explained his need for the confirmation of his exhibit. But the reply he received on December 12 stated: "Arrangements not yet completed. Will cable you final decision as soon as possible."[10] For Siqueiros it was an urgent matter and he immediately sent a second cable urging the museum, "on the basis of a museum invitation," to use their influence to help him obtain his visa. This cable went unanswered.[11]

Neither Siqueiros nor Ambassador Bowers knew of any behind-the-scenes State Department activity. But there was a State Department memorandum from Washington to Spruille Braden, the U.S. ambassador to Cuba.

In . . . view of Señor Siqueiros's communistic connections and his implication in the death of Sheldon Harte . . . it would be well to discourage the exhibition. Accordingly, the Department and the Office of the Coordinator suggested to the Museum of Modern Art that the exhibit be called off and that an exhibition of Latin American painters in general be substituted. This suggestion was followed and no invitation at any time was sent to Señor Siqueiros.[12]

There was, however, some confusion in the matter, and when Ambassador Bowers, in a telegram to Washington, sought permission to issue Siqueiros a visa, he received the reply that if Siqueiros was "a native of the Western Hemisphere he is exempt from the new procedure.[13] So Bowers issued him the U.S. visa.

After a number of speaking engagements in Chile on behalf of the war effort, Siqueiros organized in Santiago the Provisional Continental Committee of Art for the Support of the Victory of the Democracies, and then began his return trip northward. When he arrived with his family in

Lima, Peru, on March 19, 1943, he was traveling with a grant from the coordinator of Inter-American affairs of the U.S. State Department. Though officials of the Peruvian government raised their eyebrows about his mission, he was greeted on arrival by the people, with orchestras playing and much fanfare.

Lima was the first stop of his official speaking tour and on March 22 he spoke in the packed assembly hall of the Escuela de Artes Plásticas de Lima. José Sabogal, director of the school, introduced Siqueiros to the students, faculty, artists, and such dignitaries as the director of the National Museum, the Mexican ambassador to Peru, Colonel Adalberto Tejada, the Chilean ambassador, Luis Subercassaux, the director of culture of the Ministry of Education, the Minister of Information and Propaganda, Esteban Pavletich (who reminded Siqueiros that they had known each other in Mexico), and the Cultural Relations officer of the U.S. Embassy, George C. Vaillant. In his report to the State Department, Vaillant described Siqueiros's talk as an appeal to the artists to use their talents to fight for "world democracy and the abolishment of totalitarianism . . . There was very evident sympathy all through this speech which Mr. Siqueiros delivered in a masterly and moving manner . . . The applause was loud and genuine."[14]

Traveling northward on his "Art for Victory" lecture tour, Siqueiros spoke next on March 24 in Guayaquil, Ecuador. There his talk was sponsored by the Sociedad de Artistas y Escritures Independientes, and two days later the Sociedad Juridico-Literaria sponsored his talk at the Central University of Quito. In each place he asked the artists to give of their time or their work or both to the struggle against the Nazis, and in each place committees were formed for the purpose. Then, after speaking at the University of Panama, he arrived in Cuba. On April 16 the Confederacion de Trabajadores de Cuba presented him with a reception in his honor, and on April 20 he gave a talk, "In War, Art of War." Among the high-ranking persons attending was the Minister of War, who had been sent by President Fulgencio Batista as his emissary.

Siqueiros traveled from country to country rallying the South American artists to active support of the Allied war effort. Given his speaking and organizing abilities, which the U.S. Government had recognized and put to work, he was exceedingly effective. But Siqueiros was far from being in the good graces of the country that had enlisted his aid. With the greatest anticipation he looked forward to reaching New York and working on the Rockefeller-sponsored mural that would celebrate peace; he had no knowledge that the State Department had forbidden the Museum of Modern Art to show his work.

Siqueiros's next stop would be Miami, and he hoped to receive advance funds from Rockefeller for the mural. But the State Department had been trying to contact him as he moved up the coast of South America, to

inform him that Ambassador Bowers had mistakenly issued him that visa. Ambassador Braden in Havana was asked to locate Siqueiros and have him surrender the visa.

In his "strictly confidential" message to Braden, Philip W. Bonsal, chief of the Division of American Republics of the State Department, advised:

> Should Siqueiros, however, arrive in Miami, immigration officials would have to deny him admittance to the United States because of the provisions of law which forbid the entry of known Communists . . . I am writing you this personal note in order to urge that you do everything you can to get in touch with Siqueiros if he is still in Cuba and inform him that due to provisions in the law it will be impossible to admit him to the United States, and telling him that you have been instructed to cancel his visa in view of the absolute impossibility of enabling him to enter the country.

Bonsal then suggested that some "consolation" project for Siqueiros be developed, such as an "anti-Axis poster" in Havana. "The main objective I have in mind, of course, is to avoid any unfavorable publicity that would almost certainly appear should Siqueiros be refused entry in Miami and shipped back to Cuba."[15]

Siqueiros probably thought the telephone call from the American embassy, after his April 20th speech, was about hastening his departure for New York. Why else were they sending someone to speak to him? When the phone rang again in his hotel room a short time later, he was told that Comandante Durán was waiting below to see him. Comandante Durán of the famous Fifth Regiment of the Spanish War was his friend, and Siqueiros told him that at that moment he was expecting a visitor from the American embassy. When Durán told him that it was he who was the emissary, Siqueiros was amazed.

Gustavo Durán had commanded the Steel Company, a unit of motorized machine gunners; at 29, had been the head of a division; had been chief of the Madrid Servicio de Investigación Militar—and now he was an aide to the American ambassador to Cuba, copper magnate Spruille Braden. It was an example of how the war against Hitler had united otherwise incompatible political beliefs.

Durán reported in a "strictly confidential" memorandum that he had told Siqueiros that he "had been sent to inform him that his visa to the United States had been canceled in view of the fact that he is, or is said to be, a member of the Communist Party, which he emphatically denied." (Though Siqueiros followed his own communist discipline, he had not returned to the PCM since his 1930 expulsion.) Durán also explained to Siqueiros that the cancellation was due to a technicality of the law and

> could not be construed as meaning that our Government [sic] did not recognize his value as an artist or that the work which he had been doing in recent months for the United Nations [the Allies] was not deeply appreciated. . . .

Although the news was a very hard blow to him, for the record, tears came to his eyes when he learned that he could not go to the States and he made great efforts to control himself, he accepted it in a most reasonable manner.[16]

Siqueiros conveyed to Durán his great disappointment at being deprived of the opportunity to paint once again in New York City and told him that the forced change of plans put him in a very precarious economic situation—political pressures made it impossible for him to return to Mexico. Though President Camacho had personally advised and assisted him, legally Siqueiros had left the country by jumping bail. There was no guarantee that charges surrounding the Trotsky assault had been dropped, and he mistrusted any assistance that came from the high office of the President.

State Department officials dealing with his problems were sympathetic and sought to alleviate his economic plight by arranging, through Nelson Rockefeller, to have him produce a work in Cuba for the American-Cuban Committee. Siqueiros at first rejected the idea on principle, but after a call from Rockefeller he agreed to do a large painting. So the State Department succeeded in avoiding negative publicity, and for Siqueiros there was the commission that brought him much needed funds. He produced a large painting composed of two monumental heads—José Martí and Abraham Lincoln—which he titled *Two Mountain Peaks of America* [17]. The work was hung in the Museum of Modern Art of Havana. An FBI report stated:

> Inasmuch as Alfaro was a well-known artist and anti-Fascist fighter, the State Department, as a "consolation" project to explain his continued residence in Cuba, obtained him a grant of $2,500 through the Rockefeller Coordination Committee to paint a picture of José Martí and Abraham Lincoln. Alfaro received $1,750 in advance and on its completion, or about 11/20/43, he received the balance. He associated with the communist leaders in Cuba.[17]

Stranded in Cuba

Siqueiros stood next to Fulgencio Batista reviewing the 1943 May Day parade in Havana; he was the President's invited foreign guest. Being thus acquainted with Batista, Siqueiros thought, could help make the situation for his family more comfortable and possibly help him get him a mural to paint. When he was able to bring to Batista's attention this wish to paint a mural for the government, with a team of Cuban painters, the President told Siqueiros to locate an appropriate wall for the project.

An old fortress by the sea was found which contained surfaces that appealed to Siqueiros. The theme of the work was to be "The Struggle of the Cuban People for National Independence and Democratic Liberties." But then Siqueiros discovered there was not only nationalist resent-

ment of him as a Mexican, but that Batista himself had been influenced by a campaign against Siqueiros, based upon his having been denied entry into the United States. Batista began to employ the same delaying tactics as the Mexican bureaucrats, which Siqueiros knew only too well.

Personal inactivity was something Siqueiros could not tolerate easily for long. He was provisional president of the Comité Continental de Arte Para la Victoria and in this capacity he gave frequent talks, but needed some way to support his family. He abandoned any hope that the Cuban government would sponsor a mural, and failed with another project, for the Worker's Palace, but welcomed a request that he paint a small mural in a private home, that of Señora María Luisa Gómez Mena, the wife of one of Cuba's wealthiest sugar magnates.

The wall surface of the Gómez Mena residence was in a passageway that overlooked the street. Though small in scope, the surface was formed into a concavity that linked wall, ceiling and floor, a total of 40 square meters. Here a mural was painted that was a "diamond" of concentrated intensity, dazzling the eyes with its multiplicity of active forms. *Allegory of Equality and Fraternity of the White and Black Races in Cuba (plate 28)* had found a wall to settle on, albeit one provided by the house of a millionaire. His inspiration for *Allegory of Equality* derived from General Antonio Maceo, Cuba's venerated black hero who led the struggle against the Spanish and the freeing of the slaves. Siqueiros claimed it was his intention "to give some small support to the progressive sectors of the Cuban people against the remains of racial discrimination that lamentably subsist in the democratic land of Maceo."[18]

The plaster wall and small section of ceiling were fitted with a covering of plywood; then pyroxylin paint was applied to the surface with both brush and spray gun. The layout of the composition was boldly symmetrical: to left and right of center are two large seated figures—a black woman and a white woman; a flaming human form representing the sun with its lifegiving force floats in the space above, the hand of its extended arm touching two superimposed knees of the female figures, united in their identical forms though different in color. Burning and glowing bright, the sun gives all of nature life as luminous tropical plant forms embellish the lateral spaces of wall and ceiling.

For Siqueiros, nothing was more intriguing than the trick of making optically real forms float in a space that was also optically real.[19]

I followed my previous attempt of "making the concavity convex and the horizontal plane vertical" exclusively by means of pictorial tricks. When finished, I was firmly convinced that the experience of this small Havana mural would allow me to further enrich such phenomena in subsequent works.[20]

In *Allegory of Equality* Siqueiros created the sensation of forms that were alive in space. A straight line drawn on the curved surface appeared

straight to the viewer from only one position; everywhere else it seemed a curved active line. Within the confined small corridor, the mural that was 3.5 meters wide and 5.5 meters high conveyed the illusion of massive forms floating and settling in a new space.

The working conditions at the Gómez Mena home were often unsettling because of the series of parties that Señora Gómez Mena threw for her large circle of wealthy friends. They became such a nuisance to Siqueiros and the three Cuban painters assisting him that they erected a barricade around the mural.

To pay off the arrears of his bill at Havana's Hotel Sevilla Biltmore, Siqueiros began another work at this time—for the hotel lobby. He still expected the commission from Rockefeller for the Martí-Lincoln painting, so he, Angélica and Adrianita stayed on at the hotel. In the lobby he painted a large work, 2.5 x 3 meters in pyroxylin on masonite, titled *The New Day of the Democracies*. This painting later inspired an amplified version of the Palacio de Bellas Artes in Mexico City. After the Cuban Revolution it was placed in the National Museum of Cuba.

Although he was compelled to remain in Cuba, Siqueiros did not withdraw from his activities and he continued to deliver his talks on Art for Victory, spreading ideas among the Cuban artists not only about the Mexican Mural Movement but also on how the war against the fascist powers presented them with a historical opportunity to enter the struggle with their art. It was foolish, he pointed out, to depend on so unstable a market as the tourist trade in Cuba and the galleries in the United States. The artists must win the support of their own government, uniting their demands with the democratic demands of all the Cuban people. Then a new Cuban national art, tied to all the expressions of universal art, would arise, and for this, he told them, they had every potential.

In a final lecture, Siqueiros's socioeconomic explanation of art history became more personally meaningful to the Cuban artists when he presented a "constructive criticism" of the works of each of 29 artists in an exhibition at the Salon de Pintura y Escultura de Artistas Cubanos in September 1943. With patience, delicacy and frankness, he discussed each artist's work, making it clear beforehand that he was

> . . . not able to believe in the autonomous work of art, the work of art suspended in space, the work of art that is neither here nor there in time and history. But I will make my criticism in the most fraternal way and with a feeling of solidarity . . .[21]

It was his opinion that at the time Cuban art was still in a purely instinctual stage, without theory, though oriented toward creating a national art of a universal nature. Cuba's talented painters, he thought, could develop a most important art movement, but most of them were too strongly attached to the School of Paris. He could detect a collective

impulse among them—an important sign, for history has shown that such collective impulses have been precursors of the emergence of a true school. But their main shortcoming was the lack of a fundamental aesthetic theory and doctrine.

> Instinct is not enough. Idealizing instinct is the work of snobs that disturbs the development of the renascent schools of art of the modern world. If only initially for the moment, you must acquire an analytical base. Taste, which today is your only thermometer of judgment, has to be progressively substituted by adequate understanding of the geographical, human, social, technical and industrial causes that generate aesthetic phenomena.[22]

Continuing, Siqueiros disputed the notion that their failure in this area stemmed from their country's lack of a strong national artistic tradition such as Mexico, Peru, Bolivia and Ecuador had. He emphasized the similarity, the common nature of all Latin American countries.

> Legally the countries of Latin America constitute different nationalities, different geographical borders, but in general terms their racial, idiomatic, social and cultural antecedents are exactly the same. In reality the countries of Latin America form one great continental nationality, subdivided into twenty-one provinces whose geographical borders have been produced for known historical reasons in a most arbitrary manner. . . . Can you reasonably maintain that the powerful Indian and Spanish colonial traditions of Mexico, of Guatemala, of Ecuador, of Peru, and of Bolivia do not pertain equally to the people of all the countries of Latin America as well as a part of the inhabitants of the United States? Furthermore, were not the particularities which are common to the Latin American countries the chance result of the implicit fact of Spanish culture, the bridge of the Greco-Román or Occidental culture to America?[23]

Siqueiros hoped to have the Cuban artists accept the fact that the Nahua and Maya cultures of Mexico, the Maya-Quiché of Central America and the Inca culture of South America belonged as much to them as to those who lived in the immediate territories. It was the same, he explained, with the inhabitants of northern Mexico, who considered the culture that thrived far to the south to be their own. He ended his lecture by reemphasizing the role the Mexican artists had played not only in their revolution but in formation of an art movement of international importance and stressing that the war against fascism was now presenting the Cuban artists with their first great historical opportunity to build a Cuban art movement. He warned that if they missed this opportunity, winning state support would later be all the more difficult.

But not until the Cuban Revolution in 1959 were those forces brought into play that created "a functioning Cuban art, tied to the human problems of Cuba, to its entire national life, and as an integral part of the modern world."[24]

In the festive antics of the high-living pleasure seekers at the Gómez Mena house, overindulgence in drugs had caused the death of a young woman there. The press, ever ready to attack Siqueiros at every turn, exuberantly noted that he was painting a mural in the house, and in lurid headlines blamed him for the woman's death—had he not been a revolutionist in the Mexican War? fought in Spain? and been the *pistolero* of the assault against Trotsky? The tabloids shrieked that he fed drugs to the woman because she refused his advances, and the stories grew more fantastic when the blame was shifted to Angélica, who supposedly jealously administered the drugs to the victim. At least, she and Siqueiros got to laugh at the concocted newspaper stories.[25]

Señora Gómez Mena, unhappy with the finished mural's ideological content and innovative style, refused access to *Allegory of Equality* to all—the newspapers, the critics and the public. Siqueiros had not expected it to be a public mural but he did not anticipate the extreme reaction of the wealthy patroness. Though the "gem" of a mural was outside the house proper, it was on private property, and if the owner wished to keep all eyes away from it, there was nothing Siqueiros could do about it.

Siqueiros lectured about the mural, and the curiosity of Havana was aroused, but there was no way that the mural could be seen, aside from black-and-white photographs. He sought to retaliate by printing thousands of leaflets that contained a photograph and explanation of the mural, as well as his invitation to the public to view it, giving the Gómez Mena address. The inquiries were so numerous that the Señora was forced to leave the house and live in one of her other properties.

From the mural and the Martí-Lincoln painting, Siqueiros earned his only money in Cuba. The first two payments ($1,750) were lost when his wallet was left in a taxi and never recovered. The letters he wrote to Alfred Barr and Lincoln Kirstein at the Museum of Modern Art, seeking support for some mural project in Cuba, brought no results. Earlier, in June, he had written to Joaquin Almendros, a Chilean artist friend, to assure him that as soon as his financial situation improved he would pay back his debt, and telling him about not being able to reach New York (with the added problem that his baggage had already been shipped), which was for him "a real catastrophe of a material order," that "blew up" his mural and even the "creation of a Comité Continental de Arte para la Victoria in New York."[26]

Siqueiros had been away from Mexico for almost four years when word reached him that his return would now be possible. Vincente Lombardo Toledano wrote that President Camacho had now given assurances that he could set foot on Mexican soil. A similar message came from his brother, Chucho. In Cuba, too, he received assurances from the police that they would not detain him in the investigation of the drug-related

death in Señora Gómez Mena's house; he was free to leave anytime he wished.

However, Siqueiros preferred to exercise some caution and asked for legal protection to guarantee he would not be taken into police custody on his return. Friends and family hired the well-known lawyer Federico Sodi, and also Ruperto Jiménez Mérito, Angélica's uncle, to take the case and see if he could get an amparo (a writ of habeas corpus).

When they were finally ready to leave Cuba, Siqueiros, Angélica and Adrianita passed out more leaflets that invited the public to visit the mural in Señora Gómez Mena's house, continuing until the moment they had to board the plane.

15

Cuauhtémoc Against the Myth

The lawyers did obtain government guarantees that Siqueiros could enter Mexico without molestation, but to avoid any possible attacks from his enemies, he was to do so without publicity and, more important, should confine himself to his living quarters for an unspecified period of time.

The three arrived at the Mexico City airport on a night in November 1943 and were met by Chucho, Angélica's mother and a lawyer. Their arrival went unnoticed and they were whisked away to a house in the Roma district of Mexico City. This house, Sonora 9, where Siqueiros and Angélica would remain hidden away in strict self-confinement for six months, was a three-story private dwelling owned by Angélica's mother.

There were a few rare moments when they furtively ventured out. On one occasion they were spotted by a reporter from the newspaper *Excelsior* on a Lomas de Chapultepec bus. The reporter flew to Siqueiros's side. "Hey, David! Since when have you been here?" To which the startled Siqueiros replied, "A very short time." Then he grabbed Angélica and rushed from the bus. "A large green hat," the reporter wrote, "typical of the negligence of his dress, covered his eyes almost completely." Though followed by the reporter, they managed to disappear into an office building on Avenida Juárez. The press report noted that it was a mystery how Siqueiros had entered the country unnoticed, and did not fail to mention his having left the country without resolving the problem of his responsibility in the attack on Trotsky.[1]

Voluntary house arrest would not continue indefinitely and Siqueiros planned to come out in public with the presentation of a new mural. The house at number 9 had a short narrow entrance hall, which opened into a large central room with a ceiling six meters high. A large wall to the left was broken by a stairway, but with the two small walls at right angles and a small portion of the ceiling, there was an area of 75 square meters for a mural that would keep him oblivious to his plight for the better part of his sequestered period.

Assisted by artist Luis Arenal and an Indian helper, Epitacio Mendoza, Siqueiros started the work he would title *Cuauhtémoc Against the Myth* *(plate 29)*. To form a concavity, curves were constructed where the planes of the walls and ceiling intersected. A false wall of Celotex composition board was constructed, over which pieces of cotton cloth, less than a meter square, were glued. When this was completed and primed with pyroxylin paint, an extremely strong and unified surface resulted. The problem of the stairway was resolved when the banister was removed and the remaining solid obstruction was incorporated into the composition of the mural. As for the composition, Siqueiros was strongly motivated to compose forms that would activate themselves relative to the 40 or 50 steps that a spectator would normally take when passing before the mural.

For the Mexican people, the symbolic significance of Cuauhtémoc, the last Aztec emperor, was still dormant in 1944. To extol the Mexican Indian emperor as a symbol of resistance had never been encouraged. But in his mural in Chile, Siqueiros had resurrected the Indian hero and painted a graphic impression of his struggle. Now the Cuauhtémoc that Siqueiros brought forth, powerfully delineated with an ultramodern dynamism, came as a daring, surprising and thrilling spectacle. The mural contained an explosion of the force of resistance directed against a predatory enemy—the imperialism that since its arrival in 1519 still held Mexico in its deadly grip.

In a landscape setting, dominated with pyramidal forms, a mighty battle between two powerful antagonists fills the foreground. Cuauhtémoc, his feet firmly planted on a pyramid base, confronts the invader, the "centaur of conquest," who arrives with the Cross of Christianity; the Cross is fashioned into a dagger. The centaur is mythological; in 1519, when the Spaniards arrived astride horses, the Mexicans, to whom the horse was unknown, saw new, large, powerful creatures—half animal, half human. The centaur added to the myth of Quetzalcoatl's return.

Rearing up the entire length of wall and ceiling, every muscle tense and quivering, furious hoofs beating the air, the wounded centaur, its superimposed flailing arms grasping a gold cross-dagger and blazing sun, faces an onrushing flaming spear. Cuauhtémoc, in pulsating movement, flings the flaming obsidian-tipped spear to the heart of the rearing centaur. Siqueiros has here objectified an important subjective element of the

event. The symbolism that expressed the subjective nature of religion, common in the works of Renaissance painters, Siqueiros may have carried to a higher philosophical level, objectifying subjective reality rather than religion. The flaming spear he painted as one with the arm of Cuauhtémoc, and in that arm the throbbing heart of the Aztec chief is visible. The *passion* of resistance is painted, the *heart* of man flings the spear.

In the center background, counteracting the turmoil of the epic struggle, stands the emperor Moctezuma, his attitude one of surrender, defeated by the myth. With his arms extended in supplication, he resigns himself to the fate of the Quetzalcoatl legend. The drama is further intensified by the introduction of sculpture, which protrudes from the two dimensions of the painted wall and enters the spectator's space. The severed head of an Aztec idol lies on its side, and a large serpent's head protrudes from the base of a pyramid painted on the wall; both heads were cast in concrete and polychromed.

The finished work would announce the return of Siqueiros to Mexican society. In May 1944 a leaflet appeared in Mexico City announcing the forthcoming public presentation of the new work by Siqueiros on June 1 at 7:30 P.M., but the leaflet from El Centro de Arte Realista Moderno bore no address; Siqueiros was hesitant about revealing his exact whereabouts. Besides announcing the mural's inauguration, the leaflet proclaimed an intention to breathe new life into the stagnating mural movement.

Siqueiros did not intend to tiptoe back to society, as the authorities would have preferred. Rather, he was entering with a burst of political-aesthetic activism, seeking to pick up the reins that no one else had taken after he was forced to leave the country. El Centro de Arte Realista Moderno, which he had invented, would be the starting point, "the focal point of theory and practice (naturally more advanced), of a movement for the recuperation of the original program of the Sindicato de Pintores, Escultores y Grabadores de Mexico (1921-1925) that was the impulse of Mexican Muralism."[2]

He called on the Mexican artists to organize once again to develop the new stage of modern Mexican painting. El Centro de Arte Realista Moderno could function as a school for theoretical investigation and as a workshop to produce artworks for the private market and the state. El Centro would be an alliance of artists to defend their rights; he saw it functioning as a vital lecture center and projected a monthly magazine, *Realismo*. The leaflet said that the "founders" of the new organization were the originators, continuators and intellectual friends of the "First Period," but it was unsigned and without an address.

Much to his relief, the leaflet brought no adverse response from either the government or his many enemies in the press. June 7 was selected

for the inauguration, and Sonora number 9 was revealed as the secret location of El Centro de Arte Realista Moderno.

The event was a notable one. Well-wishers packed into Sonora 9. The mural was astounding [19], and the general feeling prevailed that new blood was being pumped back into Mexican cultural life. Vincente Lombardo Toledano, at the time the president of the Confederación de Trabajadores de la America Latina, spoke at the inauguration [20].

> Those who judge us from outside, in addition to speaking about the destruction of the latifundia, of dictatorship, of expropriation of oil, and of the distribution of land, speak of Mexican mural painting, because they are all results of the same phenomena. There is no difference between the expropriation of oil and this mural.[2]

Cuauhtémoc Against the Myth was an inspiring mural, but the feeble movement rallied little to the light from its flame. The artists who had created the Mexican Mural Movement had long dispersed and drifted apart; the movement that had brought world recognition to Mexico and its art no longer functioned as an organized force. Without the support of a revolutionary government, the artists had to shift for themselves, barely surviving, despite their prestige.

Very few murals were being painted when Siqueiros returned to Mexico. Orozco and Rivera had just resumed work after a long period without walls to paint; Juan O'Gorman was working on a fresco in the Bocanegra Library in Patzcuaro, and Fernando Leal was painting in the San Luis Potosi railroad station.

Orozco in 1939 had finished his Guadalajara murals after three years of work, had painted a small mural in the library of Jiquilpan, Michoacán in 1940, and in 1941 painted the murals in the Supreme Court. At the end of 1943, when Siqueiros returned to Mexico, Orozco was painting a mural in the Hospital de Jesus in Mexico City. Rivera, after nine years without a mural commission, was painting one in the National Institute of Cardiology, was creating a series of nudes for Ciro's nightclub in the Hotel Reforma, and was resuming work in the National Palace.

Having recently returned from exile, Siqueiros had little hope that he would soon find a mural commission. Easel painting, however, kept him eating. This was when he painted his famous self-portrait and his allegory of the nationalization of petroleum, *The Dawn of Mexico* [18].

While his Cuauhtémoc mural was enthusiastically received, the same could not be said for his manifesto concerning El Centro de Arte Realista Moderno. With the general apathy that the revolutionary reverse had caused, few artists responded, and in some quarters there was resentment.

José Chávez Morado (representing a younger generation of muralists) wrote an attack on the "Plan Siqueiros," as his manifest was labeled by

its detractors. It was printed in the Communist Party newspaper and thus represented the Party position. Chávez Morado agreed with Siqueiros that Mexican art had failed to meet its social commitments, but he objected strongly to the fact that the manifesto had been issued without prior discussion among artists. Beyond this, he wrote that Siqueiros had "created obstacles for discussing this fundamental premise" when he proclaimed, "with alarming emphasis, the superiority of monumental art (physically monumental) over easel painting."[4]

Chávez Morado was not against the mural but he did not share Siqueiros's belief that an easel painting could not be a work of public art because it was primarily destined to be an ornamental complement to a home's interior—a home of the rich. For him, the

> . . . physical nature of the easel painting gives it the great faculty of being transported and exhibited in various places, and for that reason, the State ought to consider the easel painting of equal importance to mural painting as a public art and construct museums, organize traveling shows, etc.[5]

Further, Chávez Morado objected to the fact that Siqueiros considered the monumental art of the early Indian civilization superior to the traditional folk arts of Mexico.

> If we take pride in the pyramids and the baroque facades, we should be equally proud of the Indian ceramics and the popular religious paintings, even if they do not have the "professionalism" that Siqueiros urges for the work of art. And not to overlook the political situation that at present affects us, we ask: what perchance is Siqueiros looking for, a Caesarean art? Why does he, through the history of art, exalt exclusively the official monumental art?[6]

He then came to the defense of liberalism, which Siqueiros claimed encouraged private art. Chávez Morado claimed that liberalism helped bring about national unity, and in a bitter summation he advised Siqueiros to revise his ideas before the right-wing Partido Acción Nacional and the Sinarquistas used them to their own advantage.[7]

Chávez Morado's critique derived from a bourgeois philosophical base that held sacrosanct individualism in art and did not seem to grasp the meaning of Siqueiros's oft-cited examples of public art—the Gothic church, the Mayan temple, the shrine of India—all created by anonymous artists. In his manifesto Siqueiros stated:

> The art of the liberal and embryonically democratic past is an art that due to its physical nature was almost exclusively private and in virtual contrast with the integrated fundamentally public art of the classic and renaissance periods of art history.[8]

Without a mural to paint and without success in rallying artists into organizational activities around his proposed Centro de Arte Realista Moderno, Siqueiros energetically turned out large easel works such as

The Esthete in the Drama, which perhaps best expressed his mood. In the painting, the subject's hands are clasped in ecstasy, the eyes filled with tears of artistic contemplation. Barely visible is a tiny figure before a tiny easel, painting a tree—the easel painting has turned against itself.

The Dawn of Mexico, also painted at this time, portrays a huge stonelike female figure holding in her embrace the oil wells of Mexico. Behind Mother Mexico appear the heads of Cárdenas and Toledano. Siqueiros's easel works were sections of murals.

The Door Opens

In 1944 Siqueiros was 47, a man of robust build, medium height, fair complexion, soft green eyes and a healthy crop of bushy black hair: he overflowed with energy, possessed a plethora of new concepts for murals, but had no walls on which to apply them. (He had been in his own country only long enough to paint three murals: one in the Preparatoria, one for the Electricians' Union, and one at Sonora 9, for himself.) And now he was unsure of the government's attitude toward him since his return from exile and was reluctant to petition the ministers for a wall. He was still being accused in the press of being a fugitive from justice.

It was thus a great surprise when Lombardo Toledano brought him the message that Javier Rojo Gómez, the mayor of Mexico City, was offering him a wall of a municipal building of his choice on which to paint. Angélica, deeply concerned about his dispirited state, had been contacting officials and unbeknown to Siqueiros had at last found a sympathetic politician.

It would be his first mural for the government since 1922! He chose an area in an 18th century colonial masterpiece of a building, the *ex Aduana* of the Plaza Santo Domingo, the original customhouse of Mexico City. There were long bureaucratic delays before a contract was finally signed on January 4, 1945. By then a second opportunity was available. The director of the Instituto Nacional de Bellas Artes, composer Carlos Chávez, offered Siqueiros a wall on the third floor of the Palacio de Bellas Artes, between the murals by Rivera and Orozco. So on Sptember 13, 1944, months before the signing of the delayed *ex Aduana* contract, Jaime Torres Bodet, minister of education, signed a contract for the Bellas Artes mural, and Carlos Chávez ended up with a portrait of himself by Siqueiros *(plate 50).*

Siqueiros had returned to a Mexican art "family" that was radically different from what he had known earlier. All pretense of revolutionary commitment had disappeared, and artists were forced to ingratiate themselves with public officials to find work. The Department of Aesthetic Education was directed by poet-writer Carlos Pellicer, who opened the

doors of government support to the bourgeois intellectuals, formalists and esthetes.

No longer did Mexican society have the revolutionary cultural activity that Siqueiros had helped to shape, and a year after he had squeezed into a room of the house of the government he wrote a critical open letter to Minister of Education Jaime Torres Bodet. The letter attacked Torres Bodet for the action of Carlos Pellicer and his Department of Aesthetic Education, which was ignoring the force in Mexican art created by the Revolution.

Torres Bodet was also reminded that in his public pronouncements he condemned the ivory tower artist and decried "the painful divorce between life and the intelligentsia, between politics and culture," and had said that it was "the job of the new generation to purify and humanize culture, and to combat the arid abstractions that were threatening to drown out art, science, and thought."[9] Siqueiros commended the minister for those professed beliefs but told him directly that the Department of Aesthetic Education under his charge was involved in policies that ran counter to his expressed wishes.

The open letter also detailed every shortcoming that Siqueiros found in contradiction with the minister's principles and offered him a generous number of suggestions for reform. He should dismiss officials who did not put his doctrine of democratization of knowledge and culture into effect, the Department of Aesthetic Education should be an organ that serves the state in its "multiple progressive activities." And a national provisional council of the arts should be formed to act as a consultative body.[10]

Under the aegis of the Centro de Arte Realista Moderno, Siqueiros continued to issue manifestos and articles that called for a government program that would effectively bring the arts into close collaboration with the political and social life of the country. The two mural commissions that he now had in hand would be expressive of the role of art in the program he was advocating. Since the contract for the Palacio de Bellas Artes mural had been signed first, work was begun in that building. His new work there would be flanked by the murals of Orozco and Rivera, two works painted in 1934 using the fresco technique. Siqueiros's work between the two frescos would have three parts. The central section was 12 meters wide and 5 meters high. On each side of this section, at a distance of 3 meters, were two complementary panels, each measuring 2.5 meters wide and 4 meters high.

His contract stipulated that the mural was to be finished for the November 20th celebration of the 34th anniversary of the start of the Mexican Revolution, and Siqueiros sought to coalesce symbolically this historical event and the approaching Allied victory over the Axis powers. It was his intention to eliminate all considerations of an aesthetic nature that

might interfere with the mural's intended function or run counter to the original principles of the Mural Movement. He called what he was doing "new-realism" and considered fundamental to it the combination of objective and subjective reality.

The precise location of the surface to be painted took into consideration Siqueiros's theory of the active spectator. For the stationary spectator, who in this case would be dominant, there was an excellent viewing point directly in front of the wall but no closer to it than 15 meters. The opening of the Palacio's lobby extended four stories to the ceiling and was directly in front of the mural to be painted; however, a space three meters wide afforded the spectator an opportunity to walk by and view it from that distance.

With columns on each side obstructing a clear lateral view, Siqueiros settled on two principal spectator trajectories. A moving spectator would enter the passageway in front of the mural, from either side, and the stationary spectator would be at the central viewing point 15 meters away. These spectator determinants would influence the composition. A central principal figure would be painted to burst forward toward the stationary spectator and would also turn to face those approaching from either side of the passageway that was directly in front of the mural.

The false wall to be painted was made up of Celotex panels mounted on a wooden stretcher, with muslin then glued to the surface and primed with a gray coat of pyroxylin paint.

In the center, bursting from a volcano, is an allegorical female figure representing *New Democracy*. The visible half of this nude figure fills the height of the mural. Adorned with a red Phrygian cap, her head is thrust back; her face tense, she thrusts her two arms forward into space. From her wrists the weights of enslavement still hang on chains, while in her hands she grasps the torch of liberty and the lily of peace. From behind her, on the right as one faces the mural, a muscular male arm strikes its fist forward into space. Below the fist, in the color of gray death, lies the lifeless Nazi figure. In the panels on the right and left of the center mural are painted the victims of fascist aggression.

Assisted by the painters Luis Arenal and Federico Silva, and his helper Epitacio Mendoza, Siqueiros finished the mural (except for the side panels) within two months. There was a momentary delay when one of Siqueiros's cigarettes ignited lacquer thinner and started a fire, causing minor damage to the floor, but the mural was ready for the November 20th celebration [21]. The two complementary panels, *Victims of the War* and *Victim of Fascism,* were finished in time to celebrate the Allied victory the following year. The *new* democracy hopefully would arise from the defeat of the Axis powers. In the mural *New Democracy (plate 30)* humanity—modeled by Angélica—struggles out of a volcano, heavy chained weights still impeding her liberation.

Most critics were startled out of their wits, astounded by the tour de force; and they were ill-equipped to understand, much less accept, the work. A mural so proselytizing, a painted statement so political, was beyond critics whose craft revolved around aesthetic evaluations of easel works that adorned the homes of the rich. The tenets of the Mural Movement were unacceptable or unknown to them, and public art was still an alien concept. A painting that spoke out so directly and with such clarity clearly could not be art. The new Siqueiros mural was "baroque," it was a "poster," it was "too impassioned and fiery," its theme was "obvious"— so said the majority of bourgeois critics.[11]

Siqueiros's painting was now seen as representing a threat to the burgeoning bourgeois art establishment, though the importance of his work in Mexico and abroad was recognized. After years of imposed exile, he had stepped openly into the mainstream and with great courage reentered the nation's political life. In a magazine article he dealt with the Mexican film industry. Considering the transcendent importance of the industry's effect on society, he called for its nationalization as the only way to remove it from the hands of corrupt commercial interests bent on turning out poor imitations of Hollywood. Only nationalization could transform so powerful an educational medium to serve the Revolution and the people.[12]

In another article Siqueiros held that the recently formed National College was purely symbolical, serving the cultural and scientific prestige of the nation in a most benign manner by honoring its most distinguished intellectuals as members. The College should be a potential and responsible force to inspire the arts and sciences to higher attainments, bringing a greater contribution to Mexican culture, but instead he found it to be a platform for each individual member to extol his or her personal endeavor. Orozco, for example, found that his membership rewarded him with an annual exhibit of his work—which could happen elsewhere at any time. Likewise with Rivera—an exhibit or a talk.

With this consistent adversary position, Siqueiros could be sure that a seat in the National College would be kept out of his reach. Nevertheless, he volunteered the advice that culture and science were the foundation upon which the social and political reality of the people are founded. "The people of Mexico have to know whether the intellectuals of the College derive their thinking from a national reality, or is [it] derived from abstract speculation of a purely intellectual and provincial nature." He wanted the members to let their voices be heard in all the national media, "all forms within their reach."[13]

In October 1945 Siqueiros gave a talk on "Painting in Mexico and the Soviet Union" at the Mexican-Russian Institute for Cultural Exchange. On May 8, 1946, he made his first open political speech since his return. A huge gathering had been organized by the Francisco Javier Mina Soci-

ety of Spanish War Veterans, in Mexico City's Arena Mexico, and there Siqueiros warned of Truman's imperialist threat to Mexico and the world, and of the dangers in tolerating the extensive pro-Franco activities of the dictator's supporters in Mexico; he called on all the popular forces to join the "National League Against Fascism and Imperialism and for Peace."

Within Siqueiros there was now solidified an all-encompassing political-aesthetic design, a concentrate of what he considered to be the purpose of his artistic efforts: to serve, build and improve the life of the people. Immersed in the political and social life of society, he painted, lectured and wrote compellingly. He faced and dealt with practical everyday problems, and as a teacher he proselytized on the facts of existence as explained by Karl Marx. Though he was a reliable and faithful comrade, often his ingenuity could not be held in rein by the PCM; in his creativity he was far off in the future.

Siqueiros's painting, lecturing and writing were strengthened by his comrade Angélica's supportive role. Without the solid quality of her participation—at the expense of her own writing—David's mission might not have held together, or would have been far more difficult. Angélica understood that the important priority was that he *paint*. She stuck to a close collaboration, for love, for the inescapable power that was his, and she endured to the end, 37 years.

Assisted by her, Siqueiros compiled a collection of his writings in a small book of 127 pages, *No Hay Mas Ruta Que La Nuestra—(There Is No Other Way but Ours)*. It bore the subtitle, "The First Bud of Profound Reform in the Plastic Arts of the Contemporary World,"[14] and it was the first work (since Anita Brenner's 1929 *Idols Behind Altars*) to address itself to the Mexican Movement, becoming *the* theoretical work of that movement and of new-realism.

Under Siqueiros's persistence and guidance, the Mural Movement slowly began to reassert itself. In 1946 he suggested to the government that a department for the study, research and investigation of new painting mediums for the fine arts be established. He stressed the importance of teaching the artists to understand the chemistry, reliability and permanence of the new plastic paints. He also requested that the new department take on the responsibility of protecting and preserving the country's murals.

Supported by Orozco and Rivera, Siqueiros successfully convinced Minister of Education Torres Bodet, and the Institute for Chemical Investigation of Plastic Materials was established in the National Polytechnical Institute. The painter José Gutiérrez was appointed director, recommended by Siqueiros to head the project. He was an eager researcher of modern materials who had first found inspiration in Siquieros's experimental workshop in New York.

The money allotted was extremely meager, but Gutiérrez and one

chemist researched and analyzed the fundamental properties of the new synthetic paints used in the fine arts. Classes, unique in the world, were organized and artists from Mexico and abroad came to study there. The Institute for Chemical Investigation of Plastic Materials became an important adjunct of the Mural Movement. Gutiérrez developed a reliable acrylic paint for the fine arts, screening out impurities and unnecessary additives from the commercial products. He also perfected careful procedures for that most important stage of mural painting, the initial preparation of the wall surface. Often, when new murals were started, Gutiérrez was on hand supervising the preparation of the walls.

Funds for murals were always sparse, but the mural painters, their art tied to society's struggle, were prepared to survive on the frugal fees the government paid them, trying to supplement their incomes with the sale of their smaller works. Yet, they produced masterpieces with the pitiful sums they were paid.

16

Patricios y Patricidas

The Plebs against the Patricians

The *ex Aduana,* the original customhouse of Mexico City, stood a few blocks to the west of the principal square, the Zocalo. A Spanish Colonial building of great beauty, it was built in 1721, and was now a designated national monument. In January 1945, with his contract finally signed, Siqueiros commenced preparations to decorate the two walls and ceiling that encased the building's main stairway. Once at work, providing there were no interruptions to interfere with his powers of concentration, he painted rapidly and with white-heat intensity.

From the beginning, the 260 square meter mural (eventually expanded to 400 square meters) was plagued with problems from both bureaucratic red tape and from the physical condition of the antique building, plus innumerable political commitments that often brought the work to a halt. Almost immediately after the contract was signed, the National Institute of Anthropology and History held up the work for seven months before it would approve of a mural being painted on a historic monument.

When work finally began, a new interruption knocked on the door.

Lombardo Toledano sent his son-in-law, painter Federico Silva, to enlist Siqueiros's aid in creating a political magazine to support Miguel Alemán's bid for the presidency. At the time it was believed that Alémán would return to the road of Cárdenas, and Siqueiros was sympathetic to this cause. He agreed to produce the magazine, called *1945,* and the following year, *1946.*

The project not only interrupted work on the mural for nine months but brought out sharp differences between Siqueiros and Toledano and caused their split. Toledano objected to the radical stand that Siqueiros was taking in the magazine, where as well as supporting Alemán he was at the same time attacking the corrupt government establishment and putting forth a strong anti-imperialist position. It was a magazine of vitriol with a large glossy format, full of sardonically powerful photographs, paintings and drawings. Toledano wanted to avoid stepping on too many toes and insisted that Siqueiros cease mentioning names in his attacks on corruption. Siqueiros refused.

After the first three monthly issues, each progressively more radical, Toledano abandoned the magazine. Siqueiros continued it for two years. He paid the expenses of the last five issues out of his own pocket. The FBI had a file under "1946" (Magazine printed in Mexico), in which it was noted that Siqueiros "was the principal inspiration as well as a member of the Directive Committee. The publication was strongly anti-United States, anti-clerical, anti-imperialistic, and pro-communist."[1]

On January 5, 1945, the FBI's Office of Censorship placed on record that Siqueiros was on the Bureau Special Watch List and that his mail, both incoming and outgoing, was intercepted in "Censorship field stations." No doubt a private letter had been read by sneaky eyes when the "Office of Censorship" reported in May:

> [name deleted] visited in Mexico, purportedly for the purpose of gathering material for a book. While there she met José David Alfaro Siqueiros, a suspected Russian espionage agent.[2]

Busy in the shadows, U.S. Military Intelligence reported in March: "Julio Oliva de Armas, a dangerous communist in Mexico, D.F., had important political connections in Mexico, among them was David Alfaro Siqueiros."[3]

The work on the mural progressed fitfully. A towering primitive scaffold of great strength, like those used in Renaissance Italy, was erected by a carpenter, using huge wooden beams. The carpenter, a man named Miranda, was an experienced bridge builder, though one of his hands had only two fingers, and he was the maestro on whom Siqueiros depended. As in the case of his earlier murals, Celotex composition boards (each 4 x 8 feet) were mounted on wooden stringers fastened to the building's masonry wall, and curved plywood covered the junction of ceiling and

wall. Muslin cloth in overlapping pieces over the entire wall and ceiling concealed the seams at the boards' junctures and created a strong surface that was further enhanced with a thick coat of gray pyroxylin primer.

The huge ceiling that spanned the court 15 meters below covered a magnificent arrangement of four stairways. To paint on the ceiling, Siqueiros and his assistants had to move about on boards resting precariously on the scaffold structure. The boards were not fastened to the scaffold so they could be moved easily from side to side to enable Siqueiros to see and to plan the work from below.

The fundamental forms that represented the compositional base of the mural's subject were first laid out with line drawing. This flowed from the overall image that Siqueiros carried in his mind. Pedestrians moving through the court and up and down the stairways were a governing factor in the form the composition took. As he walked their trajectory, Siqueiros visualized the struggle of giant forces swirling above them, forces affecting their everyday lives.

The title of the mural, *Patricios y Patricidas (Patricians and Killers of Patricians) (plates 40, 41)* was perplexing, and the long years it remained unfinished, encased in the scaffold, added to the enigma. In the far reaches of the concavity of the east wall, Siqueiros, in a superb rendition, had two massive figures hovering menacingly in space far above the spectators: Franco, with the ears of a pig, thrusts forward an arm in which he clutches his light of progress—a short, burning candle. A second flying figure close behind him, horned and mouthless, represents imperialism. In one hand it grips the atomic bomb; in the other, the world on the end of a scepter. In the space behind and surrounding them, smoke swirls in tumultuous forms while flames lick forward toward the center of the ceiling.

This much had been completed—about one-quarter of the mural—when in September 1946 the bureaucracy cut off the money. The composition of the theme was in place; the patricians, a number of figures partially painted, were tumbling headfirst, discarded into a pit, the garbage dump of history. On the west wall were to be painted the *Patricides,* the progressive heroes of Mexican history. The work came to a halt while Siqueiros fought the bureaucracy for ten months, pleading for the necessary money, $230 a month. From this sum he was supposed to pay for materials and the salaries of his helpers. What was left, if anything, was his. The promises that he would receive the payments were never fulfilled. To raise money for the mural, he produced easel works that could be sold.

The troublesome situation dragged on. Seeking the aid of the director of the National Institute of Fine Arts, Carlos Chávez (although his office had no jurisdiction over a mural commissioned by a Federal District department), Siqueiros wrote a letter protesting that he could no longer

afford to pay for the mural himself. He complained that though bureaucrats had time and again assured him he would receive his money, it had never happened, and he was forced to suspend work on the mural. He told Chávez the bureaucrats in the Federal District department did not take seriously questions dealing with art and culture; not only he but all artists were victims of their indifference and were treated with equal disdain. In addition, because work on the mural was being delayed, Siqueiros was forced to put off an invitation that the Italian government had extended to Orozco, Rivera and himself to paint murals in Italy.[4]

As for the murals in Italy, the Italian government canceled the invitation to all three Mexican painters after being warned by the Mexican ambassador to Italy, Antonio Armendáriz del Castillo, about their politics. This prompted the recall of Armendáriz del Castillo and he was shipped to a new post in South America, but the damage was not undone.[5]

The wounded mural of the *ex Aduana,* with its completed fragment of unsurpassed technical brilliance, power and beauty, had been dealt a cruel blow by the bureaucracy, from which it never really recovered. For years the scaffold remained in place, forcing the public to walk beneath it and accept the inconvenience of the sealed-off stairway to the west side.

As much as he disagreed in principal with easel painting (a mode he considered dear to the bourgeoisie), Siqueiros knew that mural painting, even in Mexico, was still too limited in scope and remuneration. So in the period after his return from exile, he had produced many "necessary" easel paintings. Now he was given a major exhibition, his first in Mexico in 15 years, to open in the Palacio de Bellas Artes on October 29, 1947. After his recent murals, a real public interest in the work of Mexican artists had been rekindled, and the announcement that he would exhibit 70 new works created an air of excitement. Most of the paintings were of large dimensions and had been painted during the period when he was preoccupied not only with the *ex Aduana* mural but with the magazines *1945* and *1946,* clearly proving that his productive capacity was phenomenal.

The exhibition of Siqueiros's new works in the Palace of Fine Arts burst upon the city like a violent explosion. The "new-realism" he brought to painting dispelled once and for all the doubt as to whether he was more politician than artist, for at that moment he was acclaimed by most to be one of Mexico's greatest painters. Over a thousand people thronged the opening; Fernando Gamboa, the museum curator, was forced to close the doors and turn away the overflow crowd. Diego Rivera came and for a while was able to draw attention away from the paintings because he had arrived escorting Mexico's beautiful and leading actress, María Felix. Later Siqueiros remarked: "For half an hour the supremacy of sex appeal over plastic appeal was proven to us."[6] Eduardo Pallares,

writing in *El Universal*, expressed perhaps what most experienced when the paintings were viewed for the first time. So unconventional and spellbinding were the works that in his article, "Aesthetic Revelation," Pallares felt compelled to write of the consternation and great feeling of ambivalence that shook him.

It is not for me to judge these works, I only want to leave my personal impressions with the most sincerity possible. The first thing I felt was a kind of very intense shaking inside me, as though something strange entered my physical being and awakened in it deep resonances. Fear, attraction, repulsion or pleasure? I felt everything, though in an embryonic and confused form.

. . . I walked through the first salon nervous and displeased. Was this audacity of the painter tolerable? . . . something stronger than all my wretchedness held me and made me contemplate . . . the pictures as living things and sovereign qualities challenging my hostility and delighting and subjugating me . . .

The defeat was completed very quickly and . . . my eyes discovered a new world, . . . the paintings acquired a sculptural value they did not before possess. Through the magic of the artist they became corporeal, and with the boldness of animated beings they seemed to leave their frames and say to me: we have more life than you who soon will be dust, and when nobody guards even a small memory of you, we will still survive to hopefully enjoy the eternity that supreme beauty bestows on everything she touches.

The portraits especially abandoned their pictorial essence and acquired an astonishing plasticity. The one of *Señora Urueta de Villaseñor* (plate 38), with her large eyes and avid expression, contemplating the world, greedy to capture all the beauty that exists in it, humbled me in its attraction *Our Image:* (plate 33), its symbolism is very profound and everything in it is expressive and strong. Perhaps these two of note are the ones that characterize Alfaro Siqueiros.[7]

After he had visited and revisited the exhibition, Pallares's conclusions were reinforced and his conversion was nearly complete.

The painter knows what he wants and possesses the technique that permits him to express it with a profoundness and dynamism of the highest quality [T]he line, the drawing, the color, the ideas, all are precise and defined, and in a certain way aggressive and bruising. The themes he uses . . . are expressed without concern for the fact that some of them challenge the world in which he lives. The colors he employs possess such an intensity and luminosity that next to them many masterpieces seem anemic

He is an apocalyptic painter and a prophet of communism. In *Pedregal* the three women on the mountain ridge in the midst of cosmic disorder evoke in our mind the end of the earth, but undoubtedly the painter's mind is fixed on the social revolution he awaits and for which he works. The portrait of Karl Marx is enigmatic, somber, and strong in its simple plasticity, as is the venomous caricature, *Guardian of Peace*.

If art has for its end to shake the conscience and vibrate the nerves, then . . . the exhibition of Alfaro Siqueiros is an aesthetic note of the first order that places Mexico at the vanguard of revolutionary painting Whoever desires to understand [communism's] . . . vision of the world, should go to

the gallery of Bellas Artes Whoever feels with such vehemence life's problems, and portrays them as a rolling force by means of a plastic symbolism of the movement of curved lines, is capable of greater audaciousness.[8]

However, Pallares had reservations. He ended by boldly posing the question that the exhibition had inspired him to ask: Will the hearts and minds of the people be won by the "cold and calculating system of North America or by the impetus and vitality of Russian communism?" Then, on an existential note, he concluded that neither the intrinsic justice of political systems nor the power of the creative mind will affect the power that irrational nature holds over destiny.[9]

Siqueiros was confident of some success in selling his easel works, usually without the assistance of an entrepreneurial art dealer. He could now acquire for Angélica, Adriana and himself a new home and studio, improving on the less than desirable living and working accommodations at Sonora 9. Angélica's mother had become adept in real estate deals of a modest nature; thanks to her, David and Angélica were at long last able to settle in their first "real" home. For Siqueiros this home seemed least important on his scale of interests; however, now 51, he did appreciate having a studio built according to his wishes.

There were two houses on the small secluded property that Señora Arenal had purchased at the southern end of Mexico City. At the end of a dirt road in the Tlacopac district, number 5 Jasmines was a one-story brick house with attached studio, for David and Angélica. A few meters away was an older house, in which Angélica's mother resided; both were surrounded by a single stone wall. Not easily reached, the new studio offered welcome isolation, and here Siqueiros painted his masterpieces: *Nuestra Imagen Actual* [22], *(Our Present Image) (plate 33)*, *Cain in the United States (plate 36)*, and many portraits, including those of Angélica *(plate 34)*, and Orozco *(plate 35)*. In their new house, visitors could be received comfortably, as was Sergei Eisenstein, whom Siqueiros entertained with a Mexican dinner that contained only black food: black frijoles, black mole, black tortillas, a black dessert—the fruit zapote—and of course, black coffee.

The North Americans of San Miguel de Allende

There was a provincial art school in the small town of San Miguel de Allende, where a large colony of North American art students, isolated from the main currents of Mexican art, were studying. San Miguel de Allende is 220 miles northwest of Mexico City, at an altitude of 6,400 feet, on the Mexican plateau known as El Bajio. It is a lovely town, with Spanish Colonial architecture, dreamy and idyllic, and it has a historical

heritage that is among the proudest in modern Mexico, for San Miguel had been a center of brutal struggle in the War of Independence. Ignacio Allende, one of the leaders, had been born there, and 25 miles to the north is Dolores, the town where Padre Miguel Hidalgo y Costilla had set the War of Independence in motion [23].

The Escuela Universitaria de Bellas Artes, where Siqueiros was invited to lecture in 1948, was a small private art school that had for a number of years attracted tourists from abroad, mainly North Americans who dabbled in painting and crafts. The school had been founded in 1938 by Felipe Cossio del Pomar, a Peruvian artist and writer, in collaboration with Sterling Dickinson of Chicago, an ardent student of Mexican culture. Cossio del Pomar was also the owner of a large ranch on the outskirts of San Miguel, the Rancho del Artista, used as a hotel for students. To attract business he directed publicity to the United States that proclaimed the Escuela Universitaria to be a school "for students of discriminating taste, situated in beautiful surroundings and under the direction of renowned international instructors," located in the country of the most exciting art renaissance of the contemporary world. "The faculty of the school is of the first order, including the most famous Maestros of the Latin American Renaissance."[10]

The school did not measure up to the claims made for it, but it did satisfy the needs of North American tourists who dabbled in art. Early in 1946, Cossio del Pomar had sold his property and returned to Peru, but the publicity directed at the United States suddenly began to produce results, attracting serious art students. More than a hundred of them, all veterans of World War II with U.S. Government tuition grants, began to arrive in San Miguel to study with the Mexican maestros.

Gachita Amador, Siqueiros's first wife, lived at the school, and as a folklorist of note fraternized with the North American artists. All told, in 1948 some two hundred of them and a smattering of other foreign artists were in the town of 8,000 San Miguelians. Two years earlier Rufino Tamayo, a regular visiting teacher at the school, had tried unsuccessfully to entice Siqueiros to come to San Miguel. But now it was Gachita who contacted Siqueiros and urged him to accept an invitation to lecture there. The invitation was from "Director" Alfredo Campanella, to whom Cossio del Pomar had sold the school as well as the ranch/hotel. Siqueiros was asked to teach a course as a *maestro extraordinario* (visiting professor), his pay to be 150 pesos a day ($17) for a period of no less than fifteen days. Travel expenses would be paid, but the agreement "recommended" that he and Angélica stay at Campanella's hotel—now called Rancho de Bellas Artes and San Miguel's most expensive—with the bill for this to be deducted from his fee.

In October 1948 Siqueiros and Angélica drove up to San Miguel de Allende in their old car. She was at the wheel, for he did not drive.

Among the North American students there was much buzzing about Siqueiros having a notorious reputation. The art students caught their first glimpse of the Maestro and his wife as they were escorted over the cobblestone streets by a group of the town's dignitaries and Director Campanella with his entourage. Siqueiros, heavy-set and of medium height, was very erect, in military bearing. He was attired in his customary black suit, and a dark gray fedora covered his thick crop of bushy black hair and shaded his aquiline nose and green eyes. Angélica, also attired in black, strolled at his side, slim and very Spanish in appearance, with her glistening black hair tied back tightly in a bun.

To the foreign students who knew little or nothing about this "revolutionary" couple, their appearance was striking and impressive. A number of important Mexican artists had already been presented at the school, but not until Siqueiros's arrival did the atmosphere become electric. The students suddenly realized that they were being brought into contact with one of the founders of the Mexican Mural Movement. In the isolation of San Miguel de Allende they were a long way from the murals of Mexico City, and the only contact they had had with the Mexican Mural Movement was a visit to Diego Rivera's birthplace 30 miles away in Guanajuato.

Siqueiros began his first lecture the next morning, on Monday. The students were packed into a makeshift lecture hall. Seated at a table with a book before him, Siqueiros spoke in English, and for five consecutive mornings the energy and excitement of the Mexican Mural Movement reverberated through *Las Monjas,* the Nuns' Dormitory of the former Convento de la Concepcion. The Convento, a beautiful though ill-preserved Spanish Colonial historical monument, housed the Escuela Universitaria de Bellas Artes.

Siqueiros's words fell upon the innocent ears of the North American art students, who until then had been pursuing their studies in the idyllic isolation of pastoral San Miguel de Allende under the illusion that they were absorbing the influence of Mexican art.

But as Siqueiros spoke, the history of the Mexican Mural Movement unfolded, and the substructure of modern Western art was dismantled. The students' response to his lectures was enthusiastic; their interest had been fired to the point that along with their innumerable questions about mural painting there was a unanimous chorus requesting that he demonstrate the mural technique. But Siqueiros said that "teaching the technique of mural painting," was contrary to his teaching "methods." But then the students and faculty took him to the "fresco room," where the technique of fresco painting was taught. It was an enormous chamber that was said to have been the Nuns' Dining Hall, and its walls were dotted with small samples of fresco painting. The breadth of the room, with its long rectangular space and vaulted ceiling caught Siqueiros's

attention. Then and there he lectured the faculty and students on how to create a mural for a room of this particular shape.

Campanella proposed that Siqueiros, assisted by the students, should actually paint a mural in the room he admired. The offer was not surprising; Campanella had been under fire from both faculty and students for the innumerable shortcomings that plagued the school and for dismissing (and then reinstating) the real director, Sterling Dickinson, who was respected by both faculty and students.

When Siqueiros was in San Miguel de Allende again on April 3, 1949, these problems were simmering in the background. And though Campanella would have preferred not having Siqueiros at the school at that moment, he sought to use him to his advantage.

Transported by the "feeling" of the huge Nuns' Dining Hall [24], and visualizing its possiblities, Siqueiros agreed to paint a mural with the students. It was a major project, 516 square meters in all, and it was to be done in a period of five months for $1,500, the price at that time of two portraits. The expenses for materials and for resurfacing of the walls, ceiling and floor were to be borne by Campanella. The agreement stipulated that Siqueiros was to work on the mural for at least the first ten days of each month and that the mural was to be completed in time for the Independence Day celebrations on September 16.

The mural team was made up of 24 faculty and students. Siqueiros had the students form a semblance of an organization and explained at a meeting how each individual in the team would contribute in the most democratic way possible. The theme, discussed and accepted by all, was to depict the life of General Ignacio Allende.

San Miguel was the birthplace of Ignacio Allende, the wealthy Creole who had been a captain in the army of Spain and an ardent admirer of the French Revolution. He had founded a secret society of Creoles (Mexican-born Spaniards) that conspired against the rule of the *gachupins* (Spaniards in Mexico, born in Spain). They held their meetings disguised as a literary society in Querétaro, not far from San Miguel. It was to one of these meetings that Captain Ignacio Allende brought the parish priest of the nearby town of Dolores, Miguel Hidalgo y Costilla.

Padre Hidalgo—idealist, father of two illegitimate children, and follower of the French Enlightenment—made his home in Dolores a center for the free exchange of ideas among his Indian, mestizo and Creole parishioners. Hidalgo and Allende led the struggle for independence that began in the early hours of Sunday, September 16, 1810, with Allende riding his horse at full gallop from San Miguel to Dolores to warn Hidalgo that their conspiracy had been uncovered. Hidalgo took things into his own hands and before the sun had risen he set the church bells ringing, his "Cry of Hidalgo" summoning the people to take up arms against

Spanish rule. The insurgents poured out of Dolores and sacked San Miguel as they passed through, shouting "Death to the *gachupins*." Tens of thousands joined the rebellion, and a frightful civil war swept the country for ten months. Hidalgo and Allende were captured, and their severed heads hanging in an iron cage in Guanajuato served as a grim warning and brought the insurrection to a temporary halt. The die had been cast, however, and from then on the move of the people toward independence was unwavering.

This was the historical material that Siqueiros and his student assistants would use for the mural's thematic content. The town yielded up additional facts about Allende's life to the team of art students doing the research, and a new spirit took hold at the Escuela Universitaria de Bellas Artes as Sqiueiros involved the students in the Mexican Mural Movement.

The first approach to the mural, as suggested by Siqueiros, was to discover the underlying geometrical structure that the architect might have employed in the classic colonial design [25]. This would be analyzed in order to incorporate its essential design characteristics into the mural's composition. It was discovered that the design of the long chamber was based on a series of ellipses laid out lengthwise and tangentially around the room. The long wall was divided into four sections by the underlying ellipses; the short wall was the width of one ellipse. The ribbed and vaulted ceiling had been generated by ellipses that crossed the ceiling diagonally from section to section. Now Siqueiros had the students construct a scale model of the room made entirely of ellipses shaped with wire. He carried the exercise a step further, encouraging the team to analyze the classic Spanish Colonial buildings that surrounded San Miguel's central plaza; they discovered that the golden section was employed in the design of the façades.

With the fundamental design characteristics unearthed, they could now take the first step toward creating the composition. The architect's original ellipses were drawn on the walls around the room, and in each ellipse the two tangential circles basic to its construction. The actual preparation of the walls for the mural could begin. This would require removing deteriorated plaster to make way for the new surface. But Siqueiros thought that first he would give the students the opportunity to use the old plaster wall to draw their own version of Allende's life. And so, during a period when Siqueiros absented himself from San Miguel, the budding muralists proceeded with their drawings.

Cartoons by the faculty and students covered the wall and ceiling surfaces, and an effort was made to incorporate the elliptical substructure of the architectural design. The panorama of Allende's life unfolded around the room: the baptism of the baby Ignacio; the Indians persecuted

by the Spanish; the education of Allende; the secret meetings in Queré-
taro; Hidalgo's call to arms; the battles that followed; the capture, execu-
tion and decapitation of the four principal leaders—Hidalgo, Allende,
Juan de Aldama and José Maríano Jiménez.

When Siqueiros returned to San Miguel, the Nuns' Dining Hall was
entirely covered with drawings. His initial impression, though his tolerant
demeanor did not betray it, understandably had to have been one of
dismay. Before proceeding with the next step, the removal of the plaster,
Siqueiros led a discussion during which the errors of the new muralists
were analyzed. Their major fault was that the team had divided into small
groups, each responsible for depicting an event in Allende's life. These
events were drawn on the wall as separate pictures, separate murals—
the new muralists were not yet ready to face the challenge of a unified
composition for the entire room [26].

José Gutiérrez of the Polytechnical Institute was brought to San Miguel
to supervise the preparation of the room, from resurfacing the walls and
ceiling with cement to selecting appropriate paint. Permission to renovate
the room in the historical monument was obtained from the government,
and the school supplied the workers to remove the old plaster and replace
it with cement. But before the plaster was removed the drawings by the
faculty and students were photographed by the team photographer, John
G. Roberts. Siqueiros did not intend to ignore his assistants' initial ideas.

Once it was stripped down to its brick substructure, Gutiérrez had the
entire room washed with a solution of potassium cyanide: one teaspoon
to a liter of water.[11] With the impurities thus removed or neutralized,
two coats of cement were then applied to the walls, ceiling and floor, to
produce a surface stronger and more permanent than the plaster. Once
the cement was dry, two coats of clear vinylite primer were to be applied
by the team. Gutiérrez recommended its use because of its flexibility,
and he instructed the team in preparing it by dissolving vinyl acetate
resin in methyl isobutyl ketone, a strong solvent. There was little concern
at the time for the health hazards these new chemicals posed.

A primitive but sturdy scaffold was erected [30] by workers, and the
new muralists spread the clear vinylite over the walls and ceiling. The
chamber was now ready to receive the first brush strokes [27] of the
vinylite paint that the team had prepared from dry pigments. "Look at
this plastic," Siqueiros told an art critic. "It is strong, it sets immediately,
and it is almost a part of the cement."[12] With the new paint Siqueiros
was ready to give form to the visual tricks that would break through the
walls and ceiling into a new imaginative space.

Without any preliminary sketches, Siqueiros conceived the composi-
tion while traversing the path that he surmised a spectator would follow,
and during this activity he directed the students, showing them where to
mark the lines and forms on the mural surface. His object was to have

the spectator enter a space where the presence of walls, ceiling and floor would not be fixed and limiting, where surrounding active forms expressing the history of Allende's life would bring a throbbing experience of the reality of these events.

Wall surfaces were to extend into the ceiling and floor, and vice versa. It would all be one space [28]. To an art critic visiting the mural he said, "All will be painted, including the floor; everything in movement: the forms, the volumes, the floor, the walls, and in the ceiling vaults, bolts of lightning will rotate as though they were alive [31]. This is life. Go on the street, everyone is moving. Everybody moves with you. Death actually is the impossibility to perceive movement."

Caught up in the excitement, the art critic wrote:

> With his energy, Siqueiros has electrified his helpers, the moving scaffold, the walls, the ceiling vaults; everything in movement; directed with such efficiency that I myself had a desire to immediately join the work.[13]

The new muralists moved gingerly on the loose planks atop the scaffold. From the floor below, Siqueiros shouted directions and those above tried to grasp the meaning of his madness. A bolt of lightning, symbolizing the struggle for Mexican independence, flashed across the ceiling but at the same time seemed to come straight down from space, through the ceiling. When compositional lines from the walls were extended on the floor, the stable support of the floor began to be undermined. Allende's baptismal font, the first fact of his life to take form in the mural, was painted to turn toward the spectators at various points on their trajectory [29].

But the mural never progressed beyond this promising stage. Campanella stepped in and, attempting to bend the project to his own personal advantage, caused it to grind to a halt.

The September 16 Independence Day celebration was especially spectacular in San Miguel de Allende, and the inauguration of the mural was to be part of the forthcoming fiesta. Campanella, however, was now thinking of exploiting Siqueiros's presence at the school and he attempted to extend the contract beyond the September closing date by slowing down the work on the mural. When Siqueiros would not accept changes in the contract, Campanella began to impede the mural's progress by failing to supply necessary materials and proscribing work during vacations and holidays. Siqueiros then realized that Campanella was attempting to use him "in order to show that an artist of international prestige works and teaches in the school and thus he could tranquilly continue exploiting the business."[14]

The differences between Siqueiros and Campanella grew more serious, and on July 6, 1949, Siqueiros directed a letter of protest to Sterling Dickinson, the school adminstrator, the members of the faculty, Bill Hammill and George Reed, who were president and secretary of the

Student Council, Manuel Gual Vidal, the Minister of Education, Carlos Chávez, director of the National Institute of Fine Arts, all intellectuals, and the press. In the letter he contested the interruption of work on the mural, *Monument to Ignacio Allende:*

> I did not abandon the work nor cancel the contract I only refuse to collaborate with the lawyer Alfredo Campanella who happens to be director of the school by reason of a mercantile operation of hypothetical legality; he lacks the most elemental knowledge of the general ideas of the plastic arts and it could well be that he . . . is causing harm to the young foreign artists . . .; he had the audacity to make me an offer that would change the contract and involve me by complicity in those ready-made pleasures that the school had produced over the years or perhaps rather, a provocation to exclude me from possibly being a witness to the same.[15]

The letter concluded with a call to all artists to immediately boycott the school.

The boycott was supported by practically every Mexican artist, including those friends of Campanella who had worked at the school—Rufino Tamayo, Carlos Mérida, Federico Cantú and Roberto Montenegro. The faculty, most of whom were artists from the United States and Canada, expressed their solidarity with the Mexican artists and joined the boycott; at a meeting of the student body on July 18, the students voted 130 to 5 to stand with the faculty. The school thus was effectively closed, and in turn the U.S. Veterans Administration withdrew its accreditation, automatically cutting off the veterans' funds. However, Nathaniel R. Patterson, the attaché for Veterans' Affairs at the U.S. Embassy in Mexico City, let it be known that approval could be reinstated if the school functioned and fulfilled all the V.A. requirements.

The dispute was not settled quickly, and the students urgently needed the reinstatement of their financial allotments, so they, the faculty and ex-administrator Dickinson decided to organize a new school that would meet the requirements of both the Mexican government and the U.S. Veterans Administration. A suitable building was available and a great collective effort was made by every art student and teacher to equip and create the new school. Siqueiros's protest to the Minister of Education and to the National Institute of Fine Arts brought the Mexican government to the side of the San Miguel strikers.

In less than a month the new school was completely organized and equipped; on August 9 the Mexican Ministry of Education sent a representative to make the necessary inspection. The new school won high praise and the recommendation that it be incorporated into the National Institute of Fine Arts as a nonprofit institution. Carlos Chávez signed the order and the school became part of the Mexican educational system. Dr. Antonio Ruiz, a painter, was appointed provisional director.

Whatever Mr. Patterson's reasons may have been—the Veterans' Af-

fairs attaché was known to have been on intimate terms with the Campanella family—he never conveyed the facts of the problem to Washington, nor did he ever act on behalf of the veterans. According to the petition the veterans directed to the President of the United States, it was Carl Strom, the Consul General in Mexico City, Patterson and his assistant Charles Sommers who did everything in their power to hinder the new school and avoid recognizing it, while encouraging Campanella to seek approval of a newly organized school. In light of the continuing boycott, recognition would be impossible.

Campanella, feeling the riches he had been deriving from the school slipping through his fingers, carried on a campaign of vilifying and smearing his opponents in the press, having anonymous threatening letters sent, stirring up backward elements to run the gringos out of town, even having the house of Student Council member John W. Johnson, a retired army colonel, bombed.[16]

In the end the new school of the Mexican National Institute of Fine Arts was not even considered for recognition by the Veterans Administration. Greatly offended, Director Ruiz resigned. The students who depended on the V.A. for their income were forced to leave San Miguel, but Sterling Dickinson and a handful of instructors remained and did manage to operate a quietly pastoral art school. The promise of a great mural in San Miguel de Allende went unfulfilled, and darkness and gloom settled in the Nuns' Dining Hall of the old Convento. On its walls and ceiling Siqueiros left what will now always remain his tribute to General Ignacio Allende: those first insistent strokes—a baptismal font and a bolt of lightning.

Though there was no acknowledgment from Washington concerning the difficulties encountered by the war veteran art students in Mexico, the FBI monitored the situation, gathering for its files many spurious reports. One, stamped *secret,* stated:

> The following references on David Alfaro Siqueiros contain information pertaining to his associates and activities as an artist and instructor in connection with the Escuela Universitaria de Bellas Artes, art school in San Miguel de Allende, Mexico. It was charged that Siqueiros used his employment in the school to convert American war veterans to communism, and the school was removed from the U.S. Veterans approved list because of communist infiltration, stemming mainly from the influence of Siqueiros. As a result of a quarrel between Siqueiros and his ideology and the school's director, the school was closed in 1949.[17]

The FBI secret file about events in San Miguel was based on 35 references from individuals and sources whose names were not revealed. One such informant sent a telegram to the gossip columnist Walter Winchell, with a tale that the V.A. was being "pressured" into approving the school.

Another volunteered the information that the previous owner of the
school, Cossio del Pomar (who had long since returned to Peru), was a
Mexican who had plotted with Sterling Dickinson and Siqueiros to take
over the school. A large number of students were labeled communists;
one informant reported that communist students and professors in a "pre-
arranged scheme" at a meeting of the students had forced the adoption
of a motion to join the boycott.[18]

During this period, through articles in leading magazines and news-
papers, and his lectures, Siqueiros was becoming more influential in
Mexico's cultural and political life. Rather than backing a communist
conspiracy to take over the school, Siqueiros guided the students over
his path, one of discarding the philosophy of the modern art of the
bourgeoisie. Before he arrived in San Miguel, an article he had written
attacking the modern French school of art appeared in the magazine of
the National Institute of Fine Arts. The students of San Miguel acquired
copies and were busy trying to grasp the essence of the Spanish text and
understand what he was driving at.

Siqueiros defended the modern Mexican movement against attacks by
bourgeois art critics. Unafraid, he struck at the sacred idols of the French
school with powerful blows. Of the four currents of art operating in the
world—naturalism, formalism, Socialist realism and new realism—only
formalism and new realism, he pointed out, were pertinent to Mexico,
and there the confrontation would take place. He examined the critical
methods of the schools of art; the formalist critics of the Paris school
lacked "doctrinal unity," and in Mexico, if they possessed anything, it
was

> nebulous, contradictory, sectarian, and antisocial. In essence Epicurean, and
> being ultraindividualistic, the theorists of anti-realism or of the formalism of
> Paris in Mexico, like the "art purists" the world over, cannot use any manner
> but that which is exclusively emotional and impressive in their critical apprais-
> als of the art of painting.[19]

Siqueiros included a favorite anecdote about Picasso's answer to a
question concerning the meaning of a painting:

Picasso: What did you have for lunch?
Answer: Oysters.
P: And do you like oysters?
A: With a passion!
P: And do you understand oysters?
A: No!
P: Then why do you want to understand painting?[20]

Siquieros continued:

Instinct and taste constitute their only module and base of rationalization. Neither more nor less than people of prehistory, the cave dwellers. But how would it be if poisoned mushrooms were eaten instead of oysters? And it is not that I consider instinct a purely sensorial preception that . . . cannot fashion any constructive analysis or any creative analysis Art is not an autonomous phenomenon generated alone and later floating alone in the space of society and life, but rather something that arises from the world and the people; something that . . . anticipates the subsequent period and always expresses the general characteristics of the society in which it acted and in which it is anticipated it will operate.[21]

He cited examples from the critics "who for many years have been matter-of-factly and spiritually tied to the anti-realism or formalism of Paris in a posture of faithful Latin American disciples." They did not actually give concrete examples of what they disagreed with; citing Cardoza y Aragon, Siqueiros wrote that his critiques were full of

pictorial-literary metaphors that, I would imagine, were from the subconscious, formed during a dream and as nebulous as the dream itself. Which is to say, typical intellectual dogmatic statements that say nothing to empirical critics who act in the area of political thought and simply the verbal theoretical posturing of Montparnassian bohemians everywhere.[22]

Cardoza y Aragon had raised the point that the Mexican Revolution was at that time almost forty years old and that existing conditions were different. To this Siqueiros responded:

Have the political conditions of Mexico changed? Have the Mexican Revolution, the antifeudal revolution, and the international Socialist Revolution, which was of such prime importance and still is, in the genesis and evolution of Mexican contemporary painting? . . . They imply that in the revolutionary conditions of the present world, the most revolutionary of all time, conditions in our country support the anti-realist formalism of Europe and therefore a return to the market of the oligarchy which is served by counterrevolutionary abstractionism.[23]

Siqueiros noted that Cardoza y Aragon had referred to Rufino Tamayo as "a worthy successor of the artistic tradition of Mexico because his work is contrary . . . to the work of José Clemente [Orozco], Diego [Rivera], and Siqueiros The great significance of Rufino Tamayo's work resides in the fact that it is . . . not only different and in opposition . . . it enriches the panorama of Mexican art by placing Mexico on another road." Siqueiros then asked "Why did the virtue of Tamayo reside in being the continuation of the nonrealism of Paris rather than the continuation of our tendency?"[24]

Then he attacked the followers of the French school for their denial of any "technical-formal" progress in art history, citing a long list of developments, including the contemporary search for the subjective in art. But that formalism itself, he held,

was in no way an added transcendental contribution to the sum of accumulated values through history, but rather a rebellion . . . extraordinarily important— against the academic routine imposed in the field of culture of the Western world during the three centuries of decadence that followed the Renaissance.

European art had moved from Fauvism to political nihilism "because of the lack of an adequate political subsoil . . . and art remained a manifestation of purely snob speculations for the exclusive benefit of the plutocratic minority.[25]

When it came to the question of materials and methods, Siqueiros chided the critic who should have known better than to call all murals "frescos," or who said that oil paint would have given "better refinement" to his own easel works.

> Why? The explanation would have been useful! But there is no doubt: In these cases that are specifically technical, pictorial poems are of no value. It is much easier to say, "plastic symphony," "the orchestration of color" or "reverberating wings and foam of Matisse," than to enter into a strictly professional analysis.[26]

For the formalist critic there was no meaningful distinction between the various materials that made up a work of art. Siqueiros believed that they did not properly understand how the materials inevitably determined the work's character, did not grasp that fresco served solely fresco painting and an oil painting was that which was uniquely executed in oil.

Since the theorists of formalism ignored the historical antecedents and social causes that gave rise to the Paris school, Siqueiros did not expect them to appreciate the social underpinnings of the modern Mexican movement. In his judgment, no constructive criticism could be expected from them. It was obvious that since they were opposed to the "new-humanist sentiment" of the movement, they could not understand it.

> For them, the formalist poets of art criticism and their friends of the snob intellectual surroundings, the Mexican Movement was only a traditionalist branch on the great tree of modern French painting, or in the words of Luis Cardoza y Aragon, "only an interesting graft on said tree," something like the graft of *zapote-mamey* Mexicanism to the pear of France. The monocled eye of the Parisian "artpurists" impedes them from seeing that between the formalism of Paris and our movement in Mexico, there exist basic differences.[27]

Siqueiros believed both schools followed Cezanne's dictum: "to make of Impressionism something solid and durable like the art of museums—to structure geometrically," but their directions were diametrically opposed. The formalists were looking for form for form's sake, while Siqueiros and the Mexican functionalists were searching for form that would endow their realism with greater eloquence. Siqueiros believed this search had been the object of artists in all the great periods of art and that it was the job of the critics to inspire them to this purpose.

He did not deny the need to include creative instincts and emotions in critical analysis of art but when the Mexican critic Xavier Villaurrutia leaned on Mallarmé's "poems are not made with ideas, only words," Siqueiros responded that

> . . . on a functional social scale, on the scale of Greek art, of Byzantine, of the scale of the Gothic, of the pre-Hispanic art of America, of the scale of the Renaissance and of the integrated plastic of the functionalist movement of Mexico, the basis of judgment would have to be very different.[28]

Then he pointed out that while the formalist critics in Mexico were calling for a return to abstractionism, the Mexican muralists were being invited by the Italian government to decorate buildings in Rome, and the director of the Stedelijk Museum in Amsterdam, Jan Heyligers, was calling upon the Mexican muralists to come to Europe and help rescue the art of Europe from its "grave impasse."[29]

Could he inspire a new Mexican school of pro-realist critics who would rid themselves of the remnants of the "bohemian emotionalism of the art purists"? He wanted to teach them to accept the historical and social foundation of modern Mexican art and thus develop a system of professional criticism that would serve to inspire and guide the Mural Movement. But the critical voice that could reach the level of the modern Mexican movement and serve the needs of its painters and sculptors never developed. This was the polemic that the students of San Miguel de Allende found themselves drawn into when Siqueiros came to lecture.

17

Artists and Communists

During the 1940s the Mural Movement had revived. Orozco, Rivera and Siqueiros had reached their prime, and murals, now a part of the cultural mainstream, were being viewed by the public with great interest. In 1948, when Siqueiros was at work on the mural for the *ex Aduana* and beginning his involvement with the school in San Miguel de Allende, Rivera was painting in the National Palace and the Hotel del Prado, while Orozco was doing murals in the Normal School and Chapultepec Castle. Elsewhere in the country some 35 artists were painting murals; a great upsurge of mural painting was about to begin, ushered in with the help of a government building boom.[1]

Along with artistic endeavors were political considerations. Siqueiros had never separated himself from the Communist Party in spirit, but for a long period he was forced to remain on the outside (the altercations surrounding Blanca Luz Brum, the attack on Trotsky, the years of exile). This had come now to an end with his reinstatement on the Central Committee. Rivera, who had been expelled from the PCM in 1936, was unhappy at repeatedly being denied readmission; Orozco, a political loner, had never joined the Party.

In his studio at home Siqueiros had been at work on a portrait of Venustiano Carranza *(plate 51)*, which the director of the National Institute of Fine Arts, Carlos Chávez, had commissioned him to do in June 1948. Now, zipped up in a coverall, he was putting the finishing touches on the powerful and stirring portrait, for which he was paid 4,000 pesos ($450). It became the centerpiece of the government's Gallery of Presidents. Still, he did not put the San Miguel mural out of his mind. While Campanella owned the property, work could not be resumed, but Siqueiros hoped that eventually a patronage could be set up that would support the project and allow him to decorate the interior of the "box" that so intrigued him.

There was now more support in Mexico for his works, and as mural opportunities began to open up, the profundity and intensity of his aesthetic endeavors encroached more and more on his political activities. There were conflicts with Party members, particularly those who lacked an understanding of the nature of his talent, of his genius.

Rivera, on the other hand, with his idiosyncratic behavior, was politically unreliable. His big split with the PCM had been in 1928, at a time when it was being severely repressed by the government. In an act openly defiant of Party policy, the "wonderful charlatan," as Pablo Neruda called him, accepted a government post as director of the National School of Fine Arts. At a meeting where he was strongly criticized by Siqueiros and others for his lack of trustworthiness, Rivera listened impassively while cleaning his pistol on the table. When finally there was a motion to expel him, Rivera voted along with the others for his own expulsion, explaining that he wanted the vote to be unanimous.[2]

But in subsequent years Diego Rivera had mellowed. Still a political person, during the late 1940s he had arrived at the point of formally requesting that he be allowed to return to the PCM, the party he had first joined in 1922. Readmission was no easy matter. It took a number of years, during which time Rivera cooperated with the PCM; finally, after four applications for readmission, his past errors were accepted as due to his artistic temperament and on September 26, 1954, he once again became a Communist Party member. However, in his mural in the Palacio de Bellas Artes there still remained Trotsky, his followers and the Fourth International—though Siqueiros had taunted Rivera on numerous occa-

sions about removing the scene since he was so anxious to return to the Party.

Siqueiros was often pulled asunder by his desires for political action on the one hand, and his creative mind seeking to soar to aesthetic heights, on the other. This dichotomy was often not appreciated by comrades who suffered no such inner conflicts. Yet Siqueiros performed the tasks that were duties for all party members: knocking on doors of prospective contributors to raise funds; gathering signatures on the street for petitions; marching in parades. There had been clashes, as in 1930 when he defended his marriage to Blanca Luz Brum. At the time the differences between him and the Party were written about in *El Machete:*

> Siqueiros claims that the masses demonstrate a complete apathy, passivity, and obstinacy in the struggle. Siqueiros has not been able to understand that if the masses do not demonstrate as much combativeness as they do in other countries it is because of the lack of activity of the Communist Party in opposing the work of the . . . leaders and the demagoguery of the Government.[3]

But the Party came to his defense when he was seized by the police during the 1930 May Day parade. In the ensuing years he had suffered imprisonment, confinement in Taxco, exile in Los Angeles and Argentina. With Cárdenas in power, Siqueiros had returned to Mexico and to the PCM. On November 20, 1935, he played a leading role in the bitter clash in front of the National Palace between Party-led workers and the Golden Shirts of the fascist *Acción Revolucionaria Mexicana* party. But Siqueiros was soon off to New York, and when he finally returned to Mexico it was from the war in Spain and in 1939.

The PCM was then in a troubled state. Its leadership was reshuffled when a qualitative change in revolutionary strategy was pressed upon it by the Communist International. The world crisis loomed and special importance was placed on Mexico for its strong revolutionary tradition, its new progressive president and its considerable influence throughout Latin America. The Mexican Party was instructed to initiate a strategy that would help ward off world fascism, which threatened the Soviet Union.

The new policy, "Unity at all Costs," meant that the PCM would give unqualified support to Cárdenas and to the *Confederación de Trabajadores de Mexico* (CTM). The latter was led by the reformist labor leader Vincente Lombardo Toledano and the not-to-be-trusted Fidel Velázquez. The mistaken idea was held abroad that Toledano represented the left in Mexico, influencing the Communist International to trust him.

This, according to Hernan Laborde, the PCM leader, "weakened the political independence of the Party in the course of its cooperation with the left wing of the democratic-bourgeois regime (Cárdenism)."[4] So the Communist Party leaders rejected the new tactics and accused those who

went along with the policy of "Unity at All Costs," including Siqueiros, of tailing behind the bourgeoisie. Then, in March 1940, Victorio Codovilla, the Argentine representative of the Communist International, ordered the dissidents expelled, among them party leaders Hernán Laborde and Valentín Campa. Siqueiros strongly disagreed with Codovilla's action, but he was soon beset with the Trotsky affair and his ties with the Party loosened.

In late 1943, when he returned from South American exile, Siqueiros moved cautiously, avoiding the limelight in regard to returning to the Party. The Trotsky attack had not been forgotten. As the time that he remained outside the Party lengthened, so did their differences. Early in 1947 Siqueiros sent a letter to the Central Committee requesting the opportunity

> to present my points of view about theories and tactics which are not in accord with those being pursued by the present national leadership of our party. I believe the plenum should know of these differences. The future health and activities of our political organization require it. An elemental respect for the internal democracy that is established by our statutes demands it. The plenums as well as the congresses are for the reconsideration of political judgments, not for evading them. And since in this case an old comrade with a respectable past and the sympathy of a large proportion of the masses is making the request, I ask that the plenum accord me an invitation to present a series of concrete proposals upon which my point of view is founded.[5]

His request met a cold reply. On February 15 Albert Delis, the president of the Central Committee, sent the following communication:

> The plenum of the Central Committee rejects the attitude you take in your letter, for it is not normal for any Communist to threaten his party as you have done, to make personal propaganda on your own and to use the Party as a platform by having a special congress called if the plenum of the Central Committee does not accept your proposals.
>
> Such an attitude is nothing but a frank petty bourgeois display that has nothing to do with a militant Communist, and threatens the discipline and rules of the democratic centralism of the Party.
>
> Only the fact that you have loosened your ties to the active life of the Party can explain why you do not know that only this full Committee can call a special congress.
>
> And finally, the plenum believes that if you are as disciplined as you indicate in your second letter, then you should actively work to fulfill the Party's function and the accords of this plenum.[6]

In spite of the sharp words of disagreement, antagonisms ameliorated, and if Siqueiros was thought to be less than an exemplary Communist Party member, it was because it was not always understood that powerful artistic demands ruled his life. Still he was bent on proving that the mix

of politics and art was compatible and his painting, writing and lecturing
were clear examples.

There were nineteen murals being painted in Mexico in 1948, not an
excessive number, but all were sponsored by the "revolutionary" govern-
ment. It had learned that it was expedient to keep the volatile muralists,
at least the Big Three, busy on walls rather than deal with the political
inflammation their idleness would provoke. Their "provocative" mural
statements were "dangerous" enough.

In June a storm flared up around the mural Diego Rivera was painting
in the Hotel del Prado, a new government hotel. As was the custom, holy
water was to be sprinkled in the building, and in this case the blessing of
the hotel was to be performed by the archbishop of Mexico, Luis María
Martínez. Nine months earlier, Rivera had completed a section of the
mural, *Dream of a Sunday in the Alameda;* painted among its large cast
of characters was the 19th-century Mexican politician Ignacio Ramírez,
El Nigromante (The Necromancer), prominently portrayed holding a slip
of paper bearing his well-known belief, *Dios no Existe.* When the arch-
bishop arrived to perform the blessing, he of course, refused to do so
unless the offending words were removed from the mural.

During the previous months, it was well known that the "scandalous"
words had been painted in the mural but there had been little noticeable
reaction. Now, with the archbishop's verdict, the newspapers mounted
an extraordinary campaign of vilification against Rivera. He refused to
change the mural and explained his position to a reporter:

> To affirm "God does not exist," I do not have to hide behind Don Ignacio
> Ramírez; I am an atheist and I consider religions to be a form of collective
> neurosis. I am not an enemy of the Catholics, as I am not an enemy of the
> tuberculars, the myopic or the paralytics; you cannot be an enemy of the sick,
> only their good friend in order to help them cure themselves.[7]

The publicity in the newspapers had been riot-provoking, and Rivera's
adamant stand—"I will not remove one letter from it"—brought forth a
mob of some thirty students who crashed into the Hotel del Prado, van-
dalizing everything in their path. In the dining room, the site of the mural,
a knife was used to scrape the words *no existe* from the mural, leaving
Dios untouched. Malevolently, they further violated the mural by defac-
ing the self-portrait of Rivera as a young boy. Newspaper reports praised
the desecration of the mural.

On the very night the mural was assaulted, not two blocks away in the
restaurant Fonda Santa Anita, Rivera, along with Mexico's leading artists
and intellectuals, was attending a dinner honoring Fernando Gamboa,
director of the museum of Fine Arts. Gamboa was speaking on the threats
to freedom of expression by the forces of intolerance when word arrived

about the attack on Rivera's mural, causing a stir in the audience. Near midnight, when the guests left the restaurant,

[a] stentorian voice was heard filling Avenida Juárez, saying: "Let's go to the Hotel del Prado!" It was the voice of David Alfaro Siqueiros, who arm-in-arm with José Clemente Orozco and Dr. Atl, marched at the head of 100 people. Among them were the distinguished artists and writers of national and international fame: Diego Rivera, Gabriel Fernández Ledesma, Leopoldo Méndez, Juan O'Gorman, Frida Khalo, María Asúnsolo, Raúl Anguiano, José Chávez Morado, José Revueltas, Arturo Arnaiz y Freg, and many others. Someone told the doorman of the hotel: "We are reporters." "Everyone?" he asked. "Everyone!" And the group marched to the luxurious dining room, where at this hour, amid the notes of a Chopin waltz played by a chamber orchestra, were dining at various tables the lawyer Aaron Saenz, the doctor Rafael P. Gamboa, Secretary of Health and Welfare, and the lawyer Rodolfo Reyes, untiring propagandist for Franco Spain. At the shout of "Death to imperialism!" hurled by Alfaro Siqueiros, the orchestra stopped, the waiters left, and the women present were startled as the artists entered the dining room. "Viva Madero! Viva El Nigromante!" the historian Dr. Arturo Arnaiz y Freg shouted at the top of his lungs. "Death to the Archbishops who bless whorehouses and beauty salons!" in his turn shouted Raul Anguiano. A woman, the granddaughter of Ignacio Ramírez, climbed atop a table and exclaimed: "The freedom of expression that made the words of El Nigromante and the fresco of Rivera possible must be respected."

Diego Rivera then climbed on a chair, asked for a pencil and calmly began to restore the destroyed inscription: "Dios no existe." Juan O'Gorman held up a delicate cup containing water for the artist to moisten an improvised brush. Meanwhile *vivas* could be heard for Juárez, Madero, El Nigromante and the Flores Magóns. After which Rivera, directing himself to Rodolfo Reyes, said: "As yet in Mexico, Franco is not in command." Directing himself to the manager of the hotel: "This hotel belongs to the people, it has been built with the money of the employees." He then threatened that the hotel manager be ousted by the workers. "And those that are there dining in evening clothes," pointing again at Rodolfo Reyes, "they will be finished like Mussolini: hung by the feet.

Siqueiros then announced: "As many times as they take out the sentence we will come to paint it in." When the artists left the Hotel del Prado, the doorman, in his most correct manner, asked, "Shall I call a taxi, gentlemen?"[8]

The archbishop, not wishing to cause the hotel financial loss, offered Catholics a special dispensation to allow them to stay at the hotel, acting freely according to their own consciences. As for Rivera, he offered his own solution to the problem:

That the Hotel del Prado be blessed by the Archbishop in order that with divine help the establishment will realize the best possible business, and that my mural be cursed so I may go tranquilly to hell, *tutti contenti*.[9]

Controversy continued to rage around the mural, and the hotel did not

go out of its way to protect it from continued attacks by vandals. Finally Torres Rivas, the manager, had a movable screen cover the mural's full dimension. However, if the maitre d'hotel was tipped, the screen doors would be opened and the beauty concealed behind them revealed to the diners.

Many considered *Dream of a Sunday in the Alameda* to be Rivera's greatest mural, yet for eight years it remained hidden from public view. Not until the end of 1955, while he was in Moscow undergoing treatment for cancer, did Rivera, perhaps worried about his survival, send a message to the Catholic poet Carlos Pellicer to arrange to have the controversial words removed from the mural; in a second message, he said he would return to do it himself. On April 15, 1956, before a large audience of the public and press, he performed the ritual act and then announced to all, "I am a Catholic."[10]

Siqueiros had commented on the seriousness of the attack on freedom of expression that the covering up of the mural represented:

> Rivera had the absolute right to put in the hands of one of the personages he represented, in this case Ignacio Ramírez, a characteristic expression of the ideology of this person. . . . For our own part, we colleagues of Rivera who were defending the democratic liberties of our country were right in denouncing the attack on the mural. But . . . now . . . the problem has to be faced as to whether it is useful that this work should remain hidden indefinitely over a mere detail. I believe it should be uncovered and the cost of this concession would be another test of condemnation for the sectarians that imposed such a measure.[11]

When asked for his opinion on the comments of the bourgeois playwright Salvador Novo, who had said that Jesus Christ must have appeared before Rivera in Moscow and there converted him, Siqueiros replied:

> Diego has been converted with historical ideas: in Chinese, in Jewish, in Moorish, in French, and especially in Cannibal. He has also been converted into a partisan of Soviet academism, but in no way has he been converted into a Catholic. For it is public and well known that according to his own confession he entered the church of San Diego in Guanajuato at the age of four screaming at the top of his lungs: "God does not exist! God does not exist!" and provoking with his behavior—also according to him—the priest, aspergillum in hand, to throw holy water while shouting, "He's possessed by demons! He's possessed by demons!"[12]

As the hotel settled into the soft subsoil of Mexico City, small cracks began to spread over the surface of Rivera's mural. Eventually, with great difficulty, it was moved to the Alameda Park after the hotel suffered great earthquake damage.

The Mexican Mural Movement suffered a great loss when Orozco died suddenly of a heart attack at the age of 66 at 7:30 A.M. on September 7,

PLATES

PLATES

(Dimensions are in inches unless marked otherwise)

1. EL SEÑOR DEL VENENO, 1918, (23 x 18) watercolor and crayon. Collection Sna. Sofia Bassi.
2. THE DANCE OF THE RAIN, watercolor. An art nouveau illustration published in the newspaper "El Universal," January 24, 1919.
3. CARLOS OROZCO ROMERO, 1918, (34 x 23) oil on burlap. Private collection.
4. AMADO DE LA CUEVA, 1920, (50 x 36) oil on canvas. Patrimony of Jalisco, Guadalahara,
5. THE ELEMENTS, 1922, encaustic, ceiling over stairway. National Preparatory School, Mexico, D.F.
6. BURIAL OF THE MARTYRED WORKER, 1922-23, unfinished fresco in stairway. National Preparatory School, Mexico, D. F.
7. HEAD OF REVOLUTIONARY, 1922, pencil drawing. Private collection.
8. PEASANT MOTHER, 1929, (98 x 71) oil on burlap. Museum of Modern Art, Mexico,D.F.
9. ZAPATA AND LOMBARDO TOLEDANO, 1930, oil on burlap. Mexican Revolution threatened as seen in the distorted faces of Zapata and Toledano. The arm of the Revolution sinks in the shark-infested waters.
10. PORTRAIT OF A DEAD CHILD, 1931, (38' x 29') oil on burlap. Collection of Sra. María Asúnsolo.
11. HART CRANE, 1931, (33' x 25') oil.
12. PROLETARIAN MOTHER, 1929, (98 x 71) oil on burlap. Museum of Modern Art, Mexico
13. GUERRILLA FIGHTERS, 1932, (11 x 8.5) pencil and india ink; sketch for figures in mural Tropical America. Private collection.
14. TROPICAL AMERICA, detail, 1932, cement fresco mural (obliterated with white wash), Olvera Street, Los Angeles, California.
15. TROPICAL AMERICA (reconstructed rendering).
16. PORTRAIT OF PRESENT DAY MEXICO, 1932, mural in fresco. Private collection, Santa Monica, California
17. THE CHILD MOTHER, 1936, (30 x 24) pyroxylin. Santa Barbara Museum of Art, Santa Barbara, California
18. BIRTH OF FASCISM, 1936, (29.5 x 23.5) pyroxylin on Masonite. Sala de Arte Público Siqueiros, Mexico, D.F.
19. STOP THE WAR, 1936, (36 x 30) pyroxylin. Private collection.
20. GEORGE GERSHWIN, 1936 (100 x 63.5) oil on canvas. Private collection.
21. HEAD OF A WOMAN, 1936, (30.5 x 24) pyroxylin on Masonite. Private collection.
22. THE SOB, 1939, (48 x 24) pyroxylin. Museum of Modern Art, New York City.
23. ETHNOGRAPHY, 1939, (67.5 x 32) pyroxylin. Museum of Modern Art, New York City.
24. THE ECHO OF THE SCREAM, 1937, (49 x 35.5) pyroxylin. Museum of Modern Art, NYC
25. PORTRAIT OF THE BOURGEOISIE, 1939, 100m² pyroxylin, mural. Electrician's

Union, Mexico, D. F., Mexico

26. PORTRAIT OF THE BOURGEOISIE, detail, revolutionary fighter.
27. DEATH TO THE INVADER, 1941-42, 240 m² pyroxylin, mural. Escuela Mexico, Chillan, Chile.
28. ALLEGORY OF RACIAL EQUALITY, 1943, 40 m² pyroxylin. Mural destroyed. Havana, Cuba.
29. CUAUHTÉMOC AGAINST THE MYTH, 1944, 75m² pyroxylin. Tecpan de Tlatelolco, Mexico, D.F.
30. NEW DEMOCRACY, 1944, 54m² pyroxylin, mural. Palace of Fine Arts, Mexico, D.F.
31. EL CORONELAZO, 1945, pyroxylin, self-portrait. Museum of Modern Art, Mex ico, D.F.
32. SELF-PORTRAIT, 1946, pencil drawing. Private collection
33. OUR PRESENT IMAGE, 1947, (7' x 5.5') pyroxylin. Museum of Modern Art, Mexico.
34. PORTRAIT OF ANGÉLICA, 1947, (72 x 58) pyroxylin. Museum of Modern Art, Mexico.
35. JOSÉ CLEMENTE OROZCO, 1947, (48 x 39.5) pyroxylin. Carrillo Gil Museum, Mexico,DF
36. CAIN IN THE UNITED STATES, 1947, (36.5 x 30) pyroxylin. Carrillo Gil Museum
37. THE DEVIL IN THE CHURCH, 1947, (86 x 61.5) pyroxylin. Instituto Nacional de Bellas Artes, Mexico, D.F.
38. PORTRAIT OF DRAMATIST MARGARITA URUETA, 1947, (56 x 48) pyroxylin. Colle tion Sra. M. Urueta.
39. CHICHEN ITZA BURNING, 1948, (36 x 28) pyroxylin. Carrillo Gil Museum, Mexi co, D.F.
40. PATRICIANS AND PATRICIAN KILLERS, 1945-1968, 5,000 sq. ft., pyroxylin. Ex- Customhouse, Mexico, D.F.
41. PATRICIANS AND PATRICIAN KILLERS, viewed from below.
42. THE GOOD NEIGHBOR, 1951, (98 x 59) pyroxylin. Carrillo Gil Museum, Mexi co, D.F.
43. KING CUAUHTÉMOC, 1950, (72 x 51.5) pyroxylin. Instituto Nacional de Bellas Artes, Mexico, D.F.
44. TORTURE OF CUAUHTÉMOC, 1950, 8 x 5 meters, pyroxylin, mural. Palacio de Bellas Artes, Mexico, D. F.
45. TORTURE OF CUAUHTÉMOC, (24 x 17) pencil, detail figure study. Private collec tion.
46. TORTURE OF CUAUHTÉMOC, 1951, (33 x 24) poster.
47. CUAUHTÉMOC REBORN, 1950, 8 x 5 meters, pyroxylin, mural. Palacio de Bel las Artes
48. CUAUHTÉMOC REBORN, detail
49. TERESA ALFARO SIQUEIROS (niece), 1950, (72 x 36) pyroxylin. Private collection.
50. MAESTRO CARLOS CHAVEZ, 1949, (56 x 48) pyroxylin. Collection Carlos Chávez.
51. PRESIDENT VENUSTIANO CARRANZA, 1949, (48 x 40) pyroxylin. Ministry of the

Presidency of the Republic.

52. FOR COMPLETE SOCIAL SECURITY OF ALL MEXICANS, 1953-56, 310m^2, vinylite and pyroxylin. Hospital de La Raza, Mexico, D.F.

53. FOR COMPLETE SOCIAL SECURITY, detail, flaming figure.

54. FOR COMPLETE SOCIAL SECURITY, detail, miner.

55.& 56. MAN MASTER OF THE MACHINE AND NOT THE SLAVE, 1952, 59' x 13,' pyroxylin on aluminum.

57. EXCOMMUNICATION AND EXECUTION OF FATHER HIDALGO, 1953, 9m^2 pyroxylin. University of San Nicolas, Morella, Michoacán.

58. & 59. FROM THE NATION TO THE UNIVERSITY, From the University to the Nation,1953-56, 9 x 33 meters, ceramic covered sculpture. University City, Mexico, D.F.

60. NEW UNIVERSITY EMBLEM, 1952, (49 x 27.5) pyroxylin painted sketch. Pri vate collection.

61. VELOCITY, 1953, 240 sq. ft. , sculptured mosaic

62. STREETS OF MEXICO, 1956, pyroxylin. Private collection.

63. THE REVOLUTIONARY, 1957, (48 x 36) pyroxylin. Collection Adolfo Orive Alba, Mexico, D.F.

64. DEFENSE OF THE FUTURE VICTORY OF MEDICAL SCIENCE OVER CANCER, 1958; detail figures of pre-history, mural, acrylic. Hospital of Oncology, Mexico, D.F.

65. DEFENSE OF THE FUTURE VICTORY, detail, radiation treatment

66. HISTORY OF THE THEATER TO CINEMATOGRAPHY, 1958-63, mural detail, the repression, acrylic. Jorge Negrete Theater, Mexico, D.F.

67. HISTORY OF THE THEATRE, mural detail

68. HISTORY OF THE THEATRE, mural detail

69. SELF-PORTRAIT, 1961, (32 x 24) acrylic

70. SOLITARY CONFINEMENT, 1961, (32 x 24) acrylic

71. STRUGGLE FOR EMANCIPATION, 1961, (30 x 24) acrylic. Private collection.

72. WOMEN OF CHILPANCINGO, 1960, (32 x 24) pyroxylin on wood. Collection Albert Mitchell, New York City.

73. FROM PORFIRIO TO THE REVOLUTION, 1957-55, 419 m,2 pyroxylin and acrylic; right side, Porfirio Diáz. Museum of National History, Mexico, D.F.

74. FROM PORFIRIO TO THE REVOLUTION, center, the strikes.

75. FROM PORFIRIO TO THE REVOLUTION, left side, Carranza, Zapata, Obregon.

76. FROM PORFIRIO TO THE REVOLUTION, detail, horseman

77. FROM PORFIRIO TO THE REVOLUTION, epilogue

78. MARCH OF HUMANITY, 1965-71; interior surface 2165 sq. meters, acrylic on metal and wall surfaces. South wall, The Human Struggle. Siqueiros Poly form.

79. MARCH OF HUMANITY, north wall, Inferno

80. MARCH OF HUMANITY, west wall, Man, Grasping Hands

81. CHRIST, 1965, (32 x 24) acrylic. Vatican Museum

82. ENOUGH, 1961 (24 x 19) acrylic. Collection Sra. Blanca P. Antebi, Mexico, .F.

83. PEACE, 1961, acrylic. Private collection.

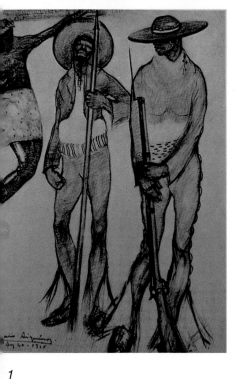

1

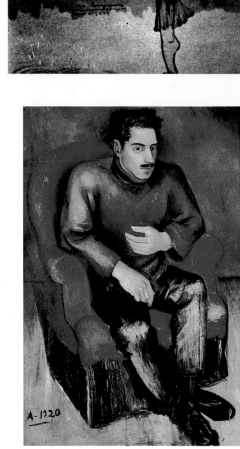

2

3

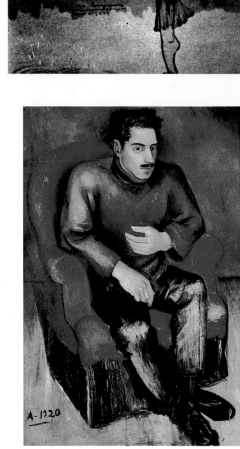

4

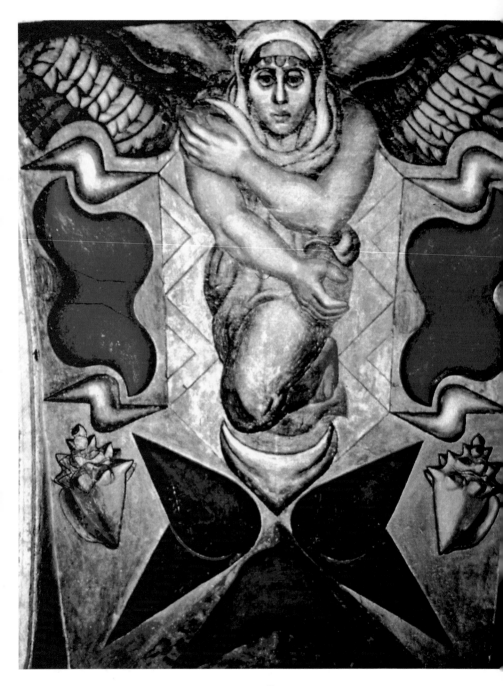

5

7

6

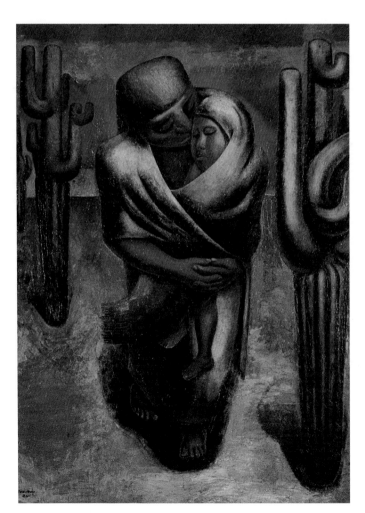

8

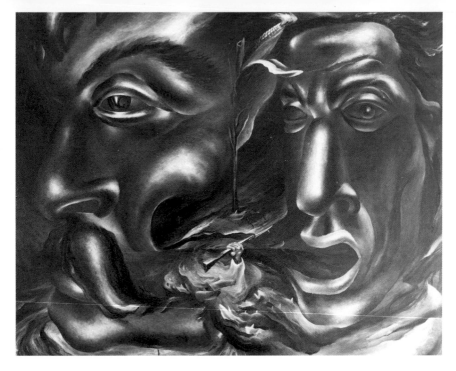

9

10

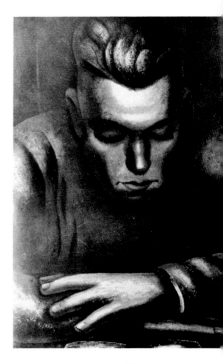

11

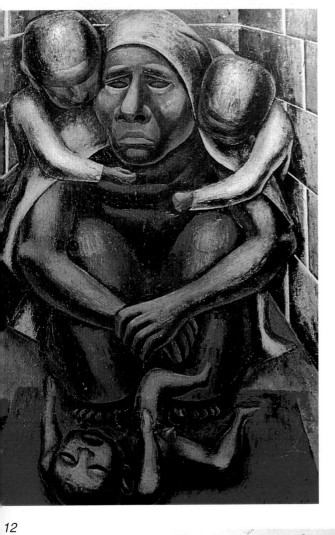

12

13

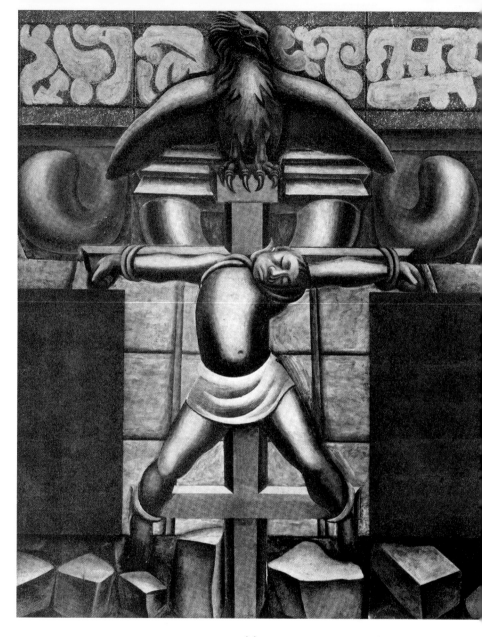

14

15

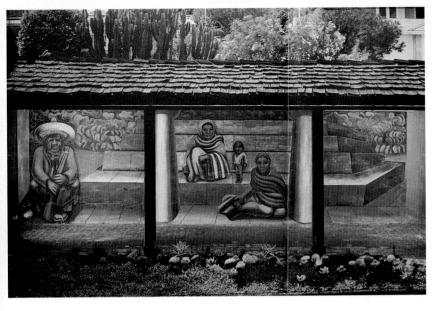

16

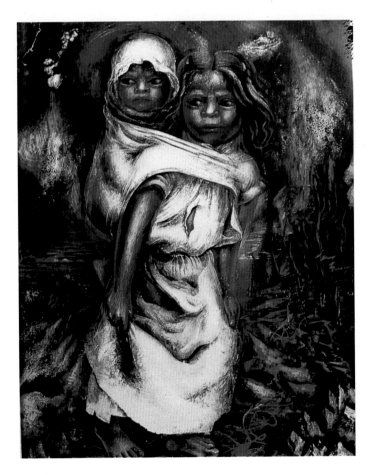

17

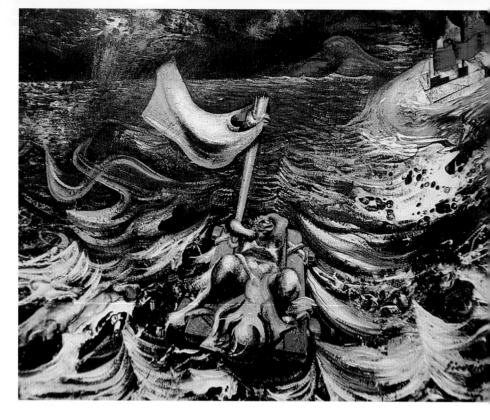

18

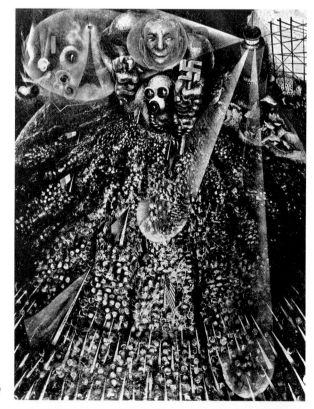

19

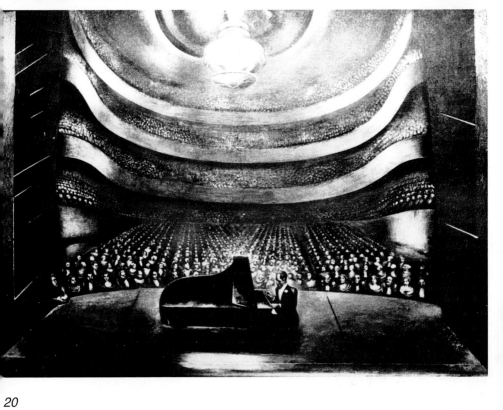

20

21

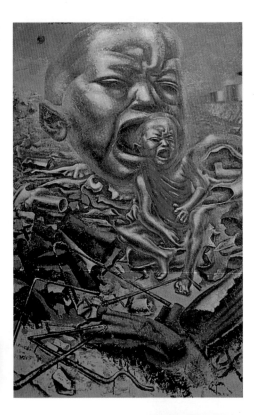

22

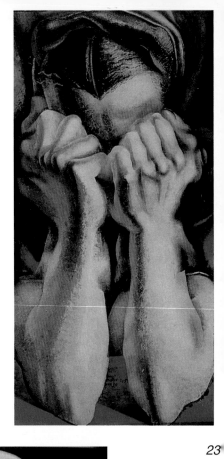

23

24

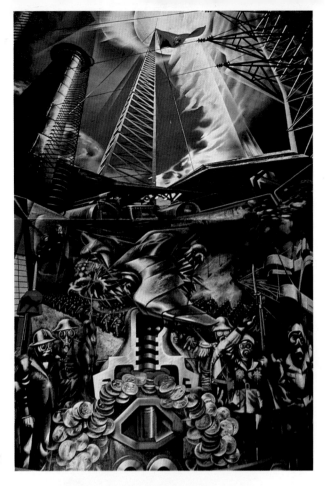

25

26

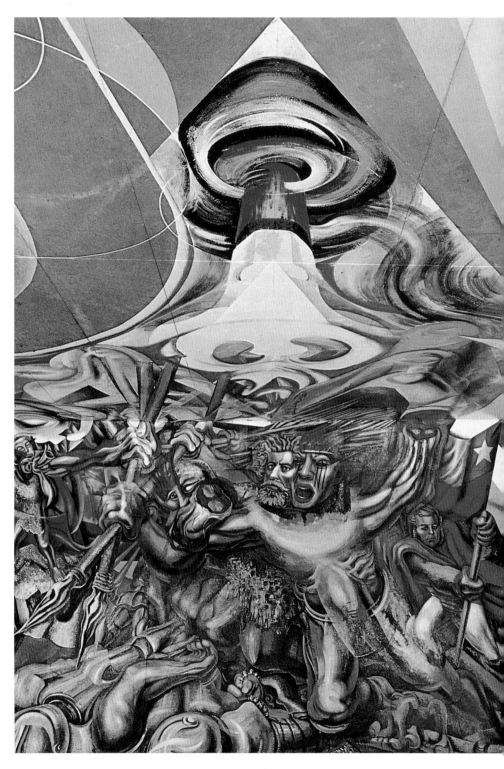

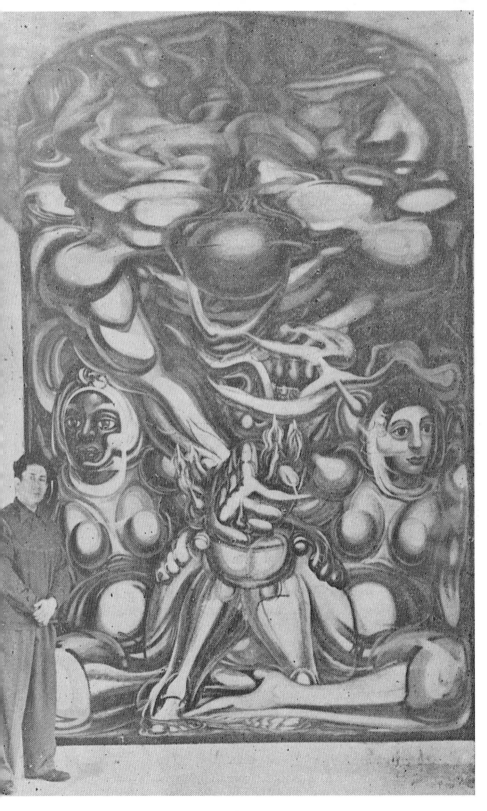

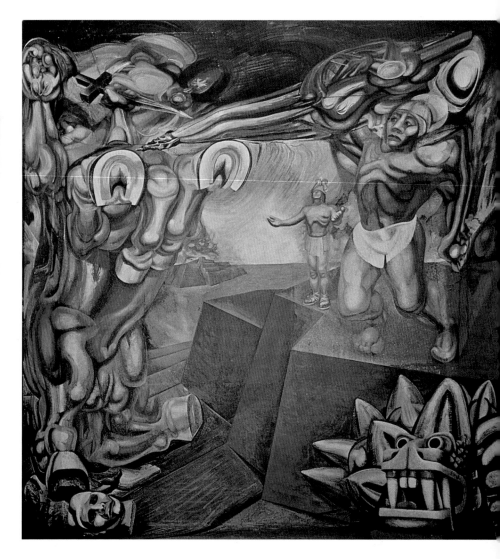

29

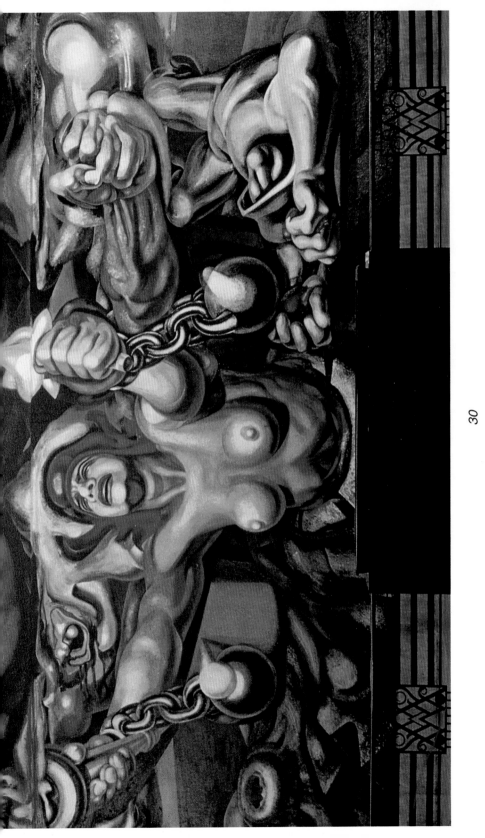

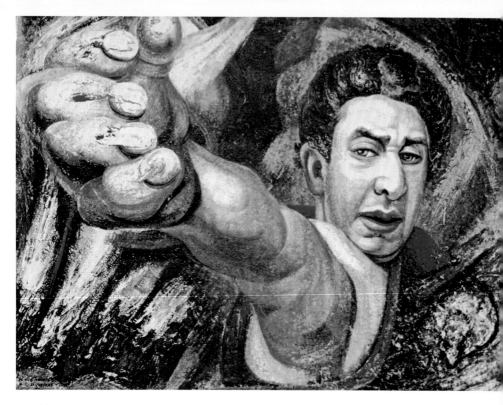

31

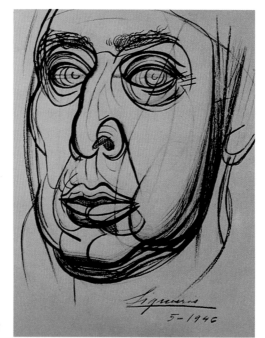

32

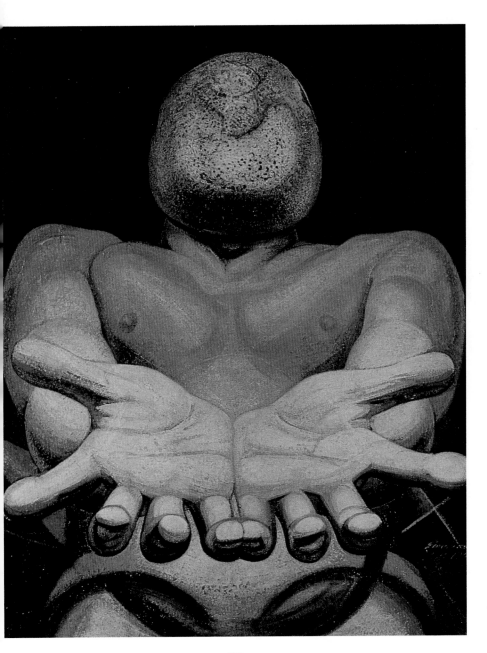

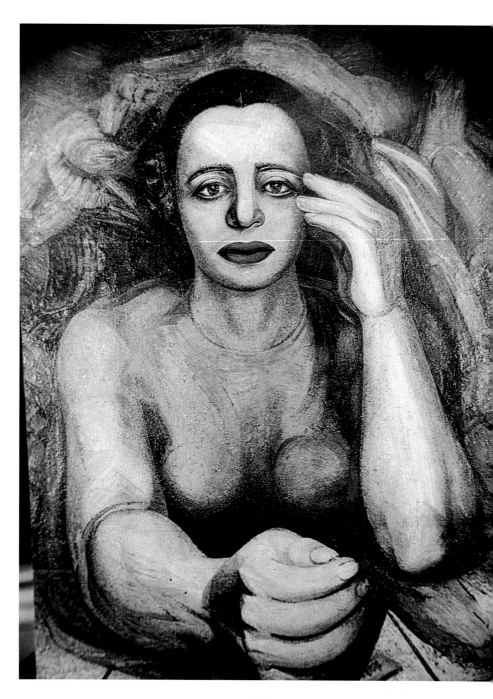

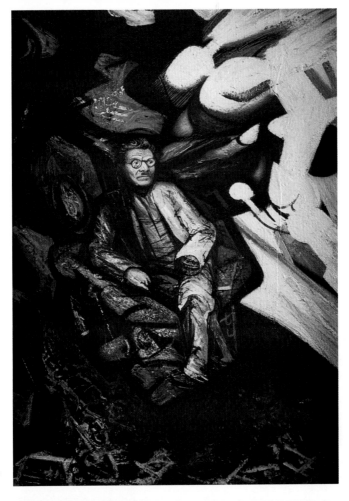

35

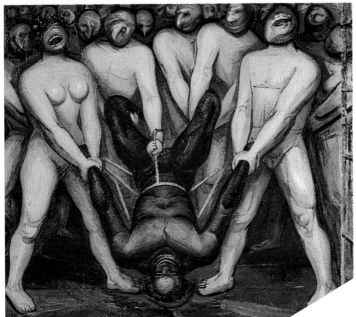

36

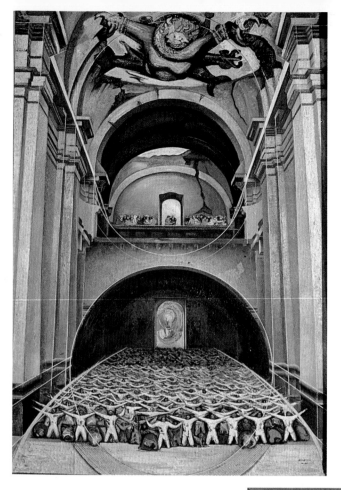

37

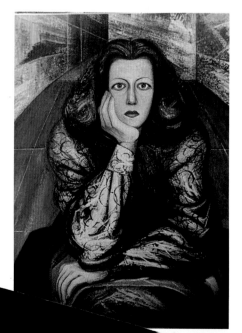

38

39

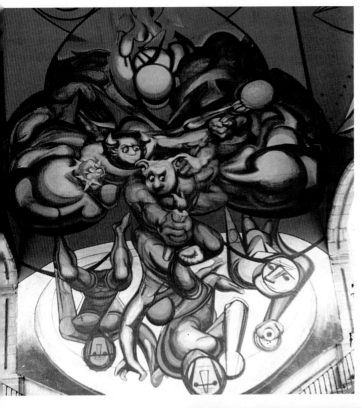

40

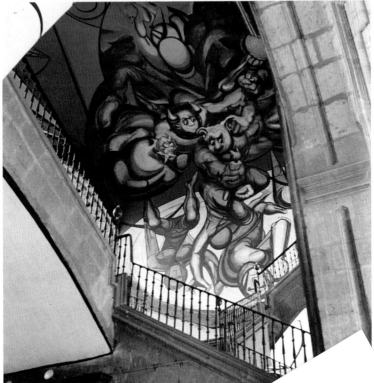

41

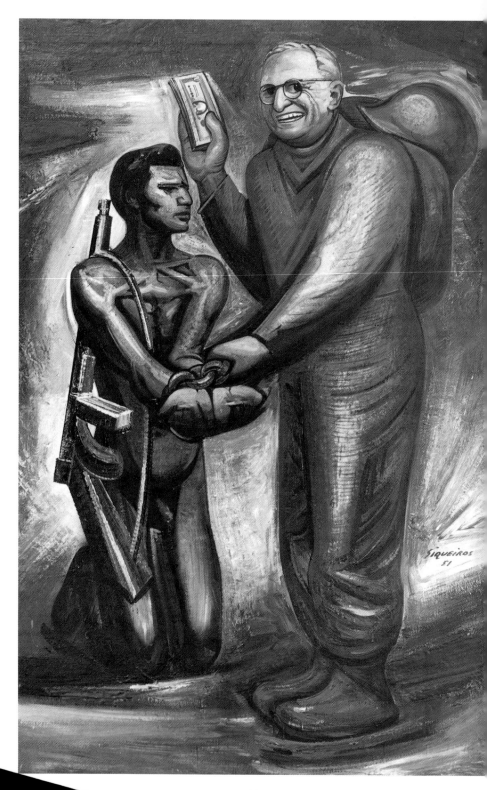

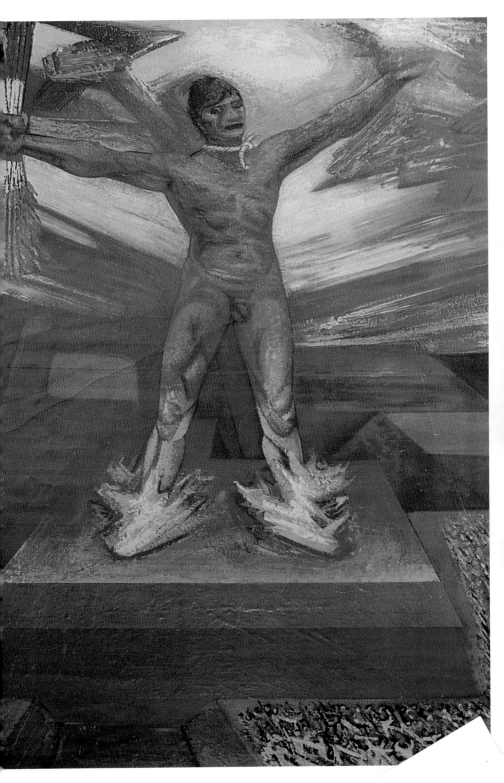

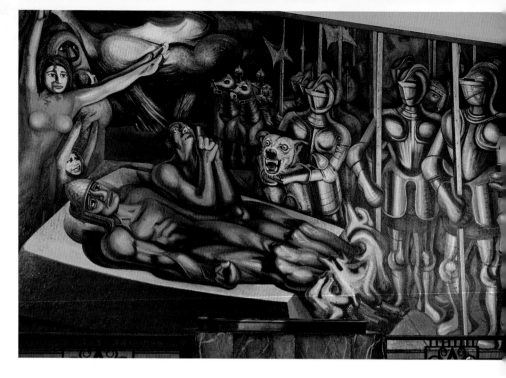

44

45

46

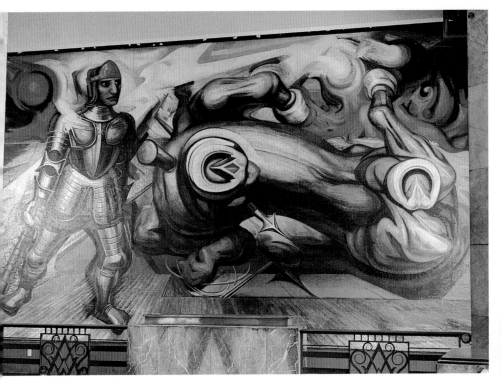

47

48

49

50

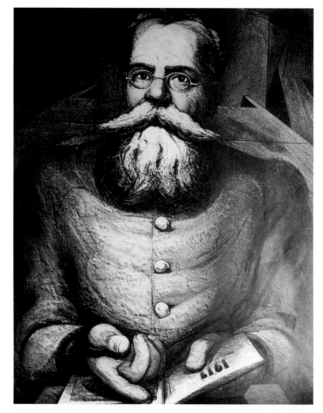

51

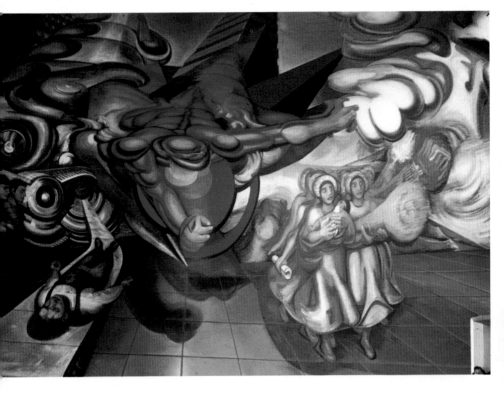

52

53

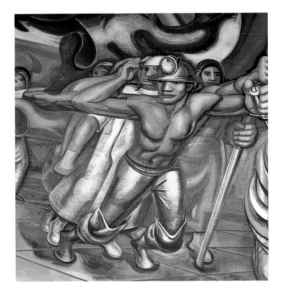

54

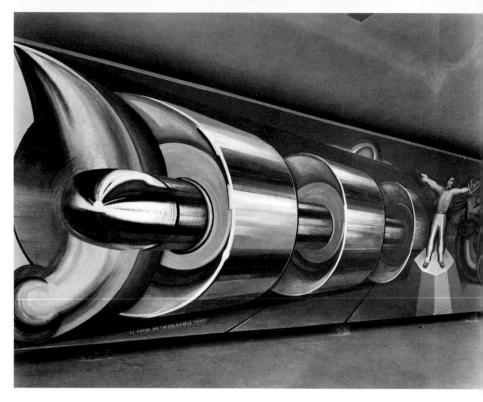

55

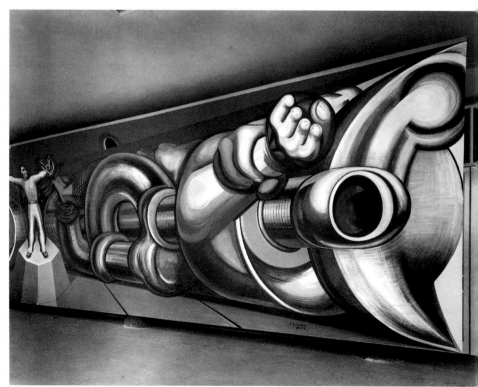

56

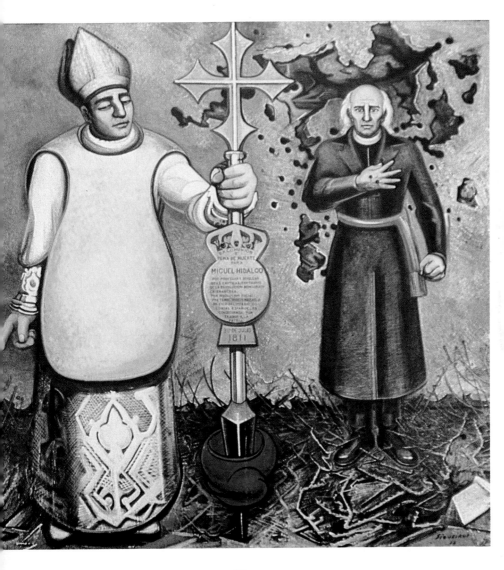

57

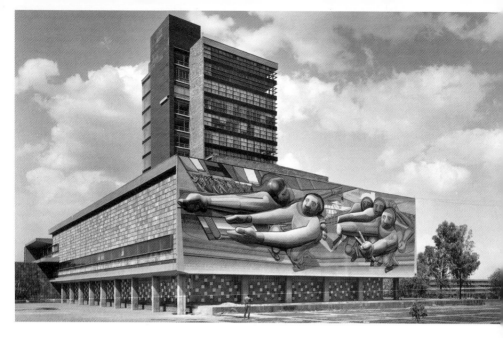

58

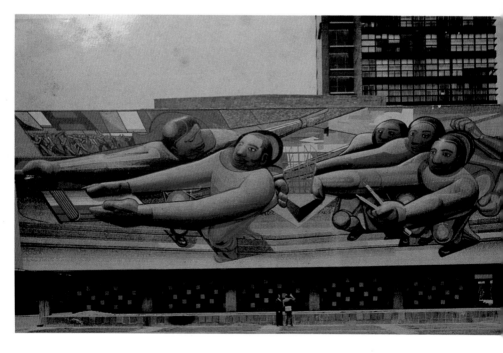

59

60

62

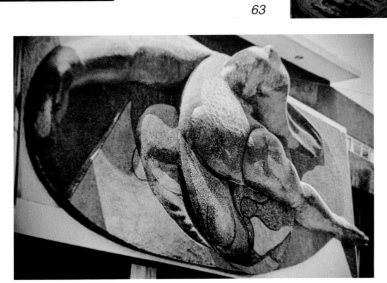

63

61

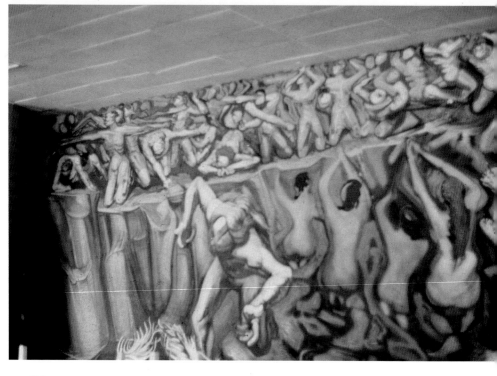

64

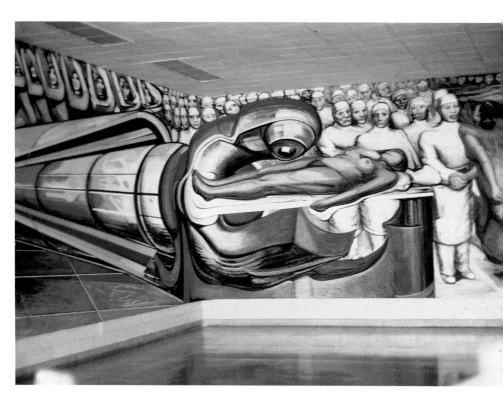

65

66

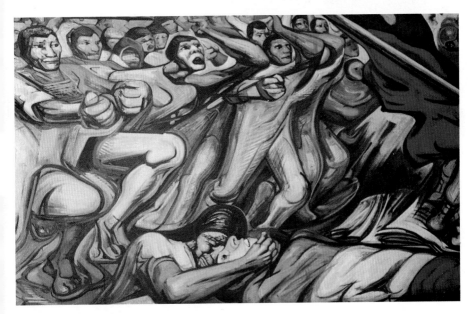

67

68

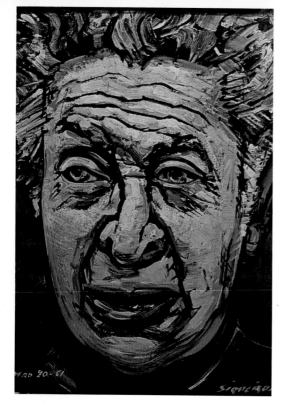

69

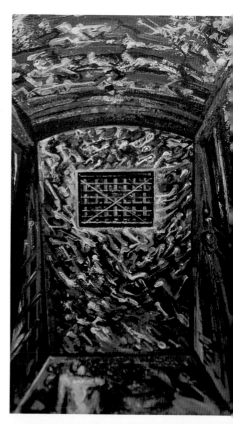

70

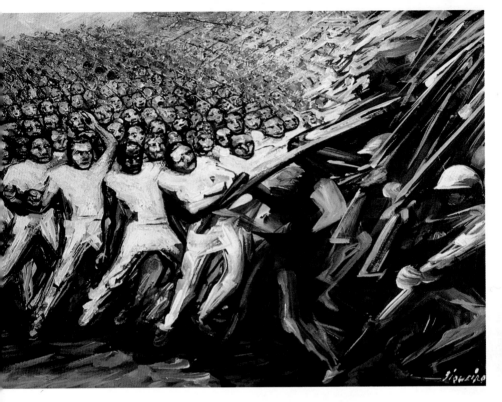

71

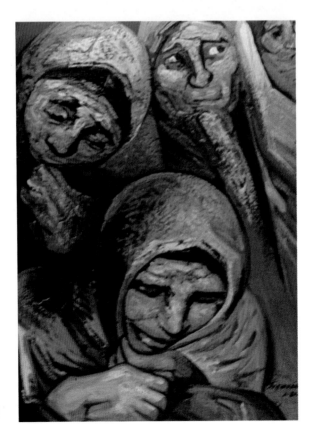

72

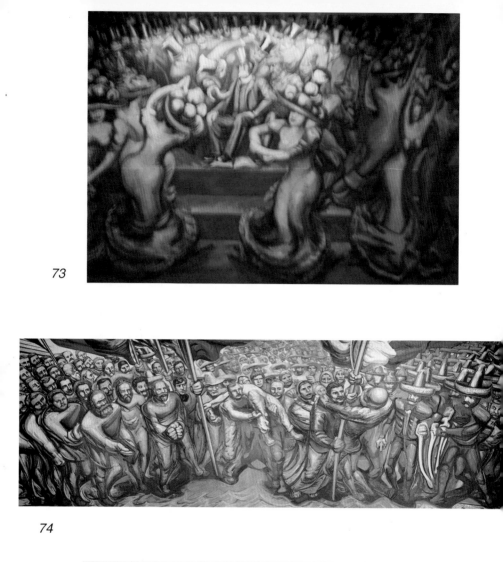

73

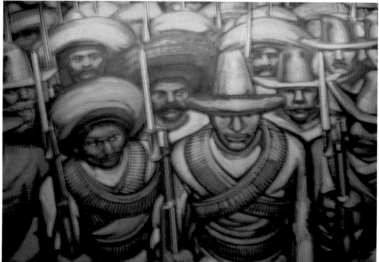

74

75

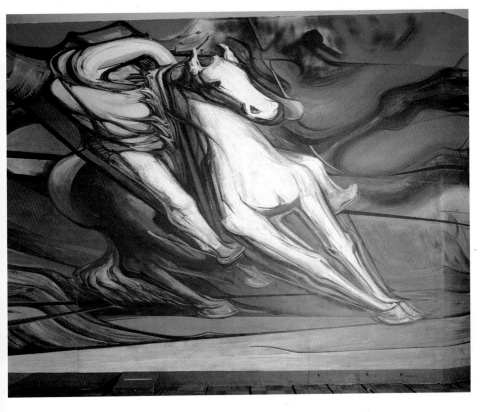

76

77

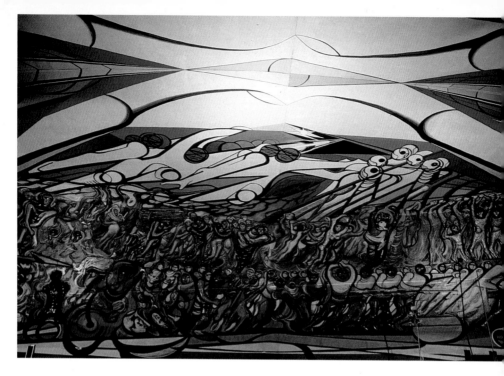

78

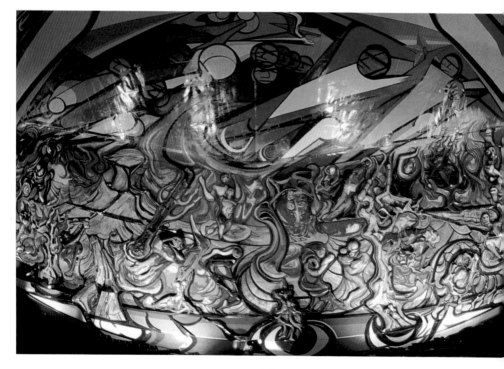

79

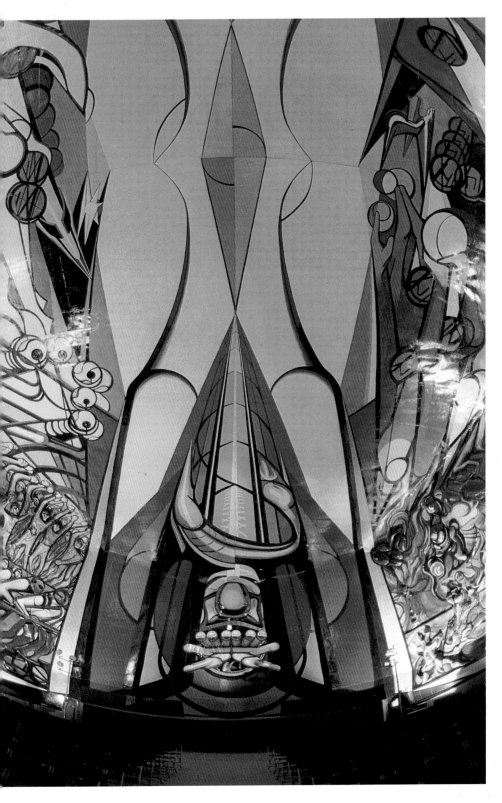

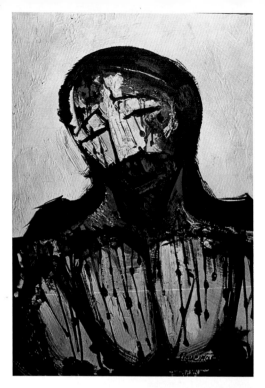

81

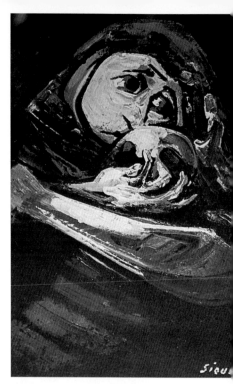

82

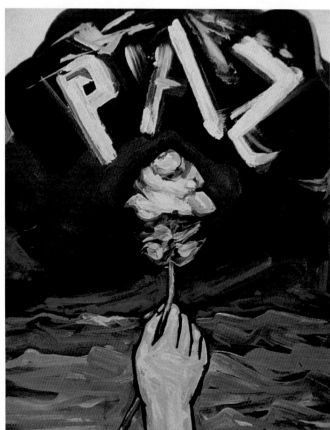

83

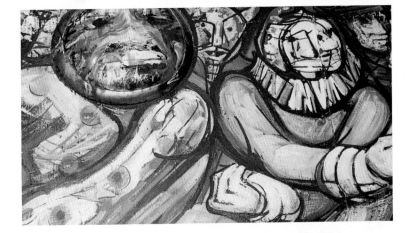

66

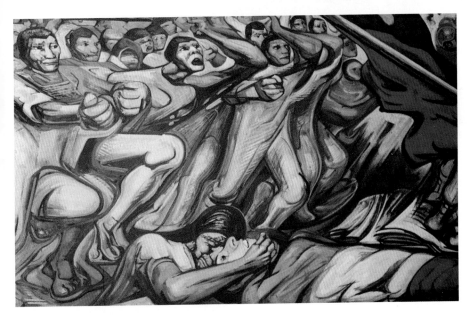

67

68

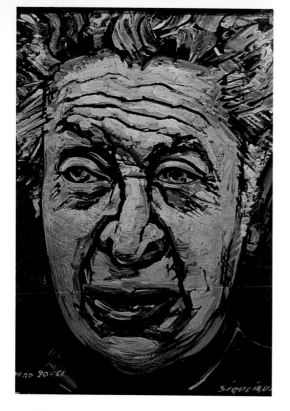

69

70

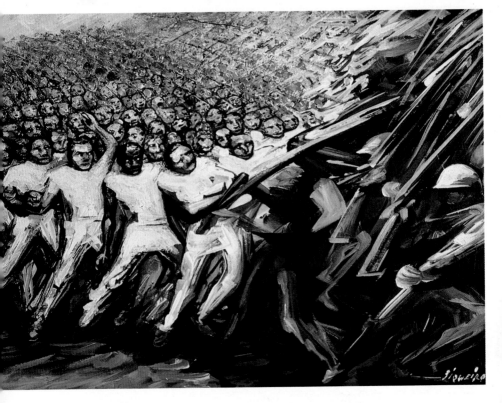

71

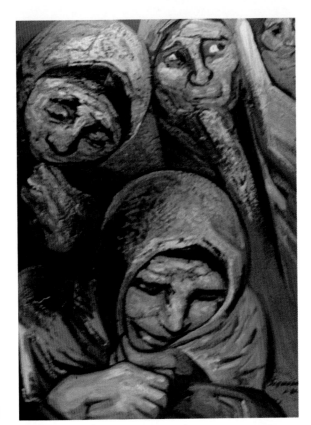

72

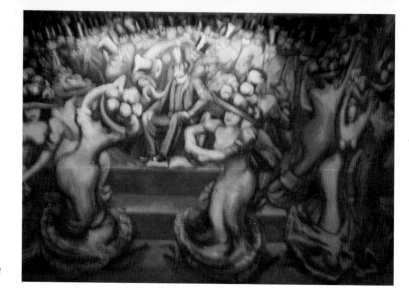

73

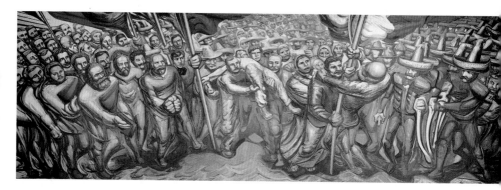

74

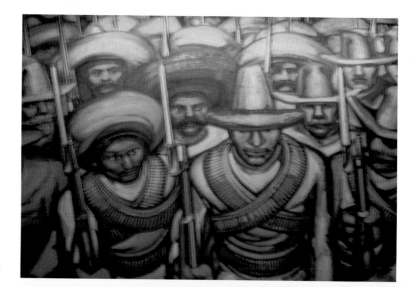

75

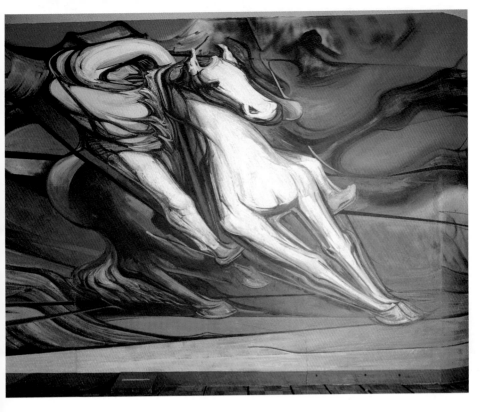

76

77

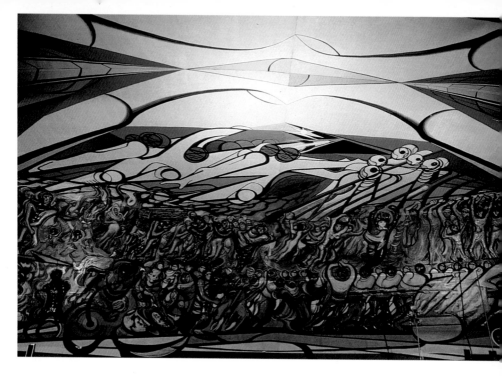

78

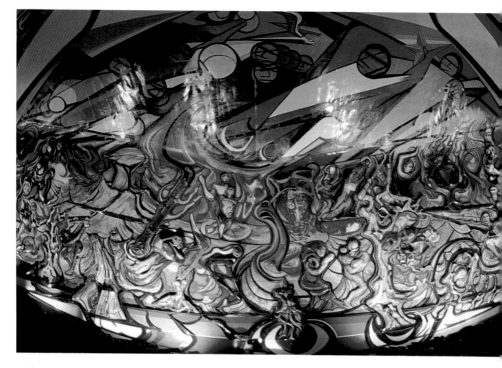

79

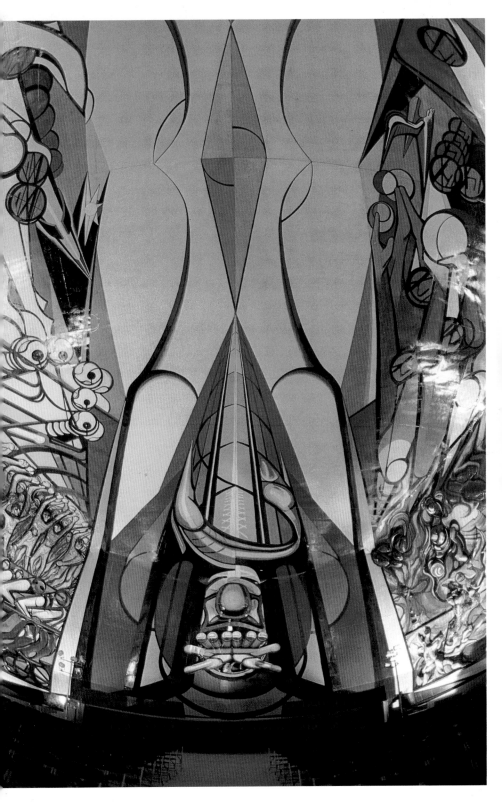

81

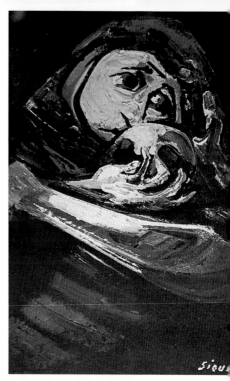

82

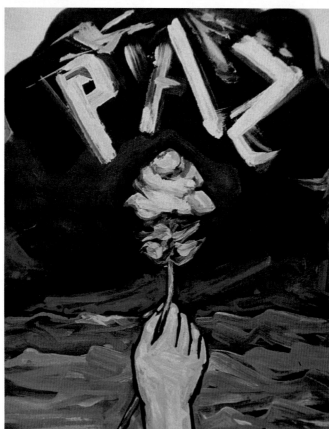

83

1949. He had been closer to Siqueiros than to Rivera, the latter having been a constant source of irritation to him. Siqueiros had introduced Orozco to Margarita Balladares, the sister of one of his close friends, before their marriage.

That sad morning both Siqueiros and Rivera rushed to the home of their deceased colleague at 132 Ignacio Mariscal Street in downtown Mexico City. There the two painters were surrounded by newspaper reporters eager to print any word they uttered. Siqueiros tried to do justice to the memory of his old friend:

> Orozco was the greatest painter of the greatest art movement of the contemporary world. The magnitude of his work will only be appreciated in its totality when most countries adopt as the fundamental expression of the art of painting the public norms he loved so much. He is thus the first Latin American figure whose work had a true universal projection. José Clemente Orozco is the most prodigious example of the significance of an art destined for an entire citizenry and not only for a minority sector of the pseudo-oligarchs. Knowing the social march of the world, I have not the slightest doubt that the name of Orozco will soon resound in all of the lands of the earth.[13]

Siqueiros and Rivera also notified the press that as spokesmen for the Mexican Mural Movement they were petitioning the President to honor Orozco by interring his body in the national shrine for distinguished citizens, *La Rotonda de los Hombres Ilustres del Cemetario de Dolores.* Ignacio Asúnsolo, director of the San Carlos Academy, closed its doors; with Guillermo Toussaint, he made the death mask of Orozco. The last great disappointment of the departed artist was that the mural for Rome had failed to materialize. This great freethinker and bitter enemy of the Church was at least spared the knowledge that the mortician placed a large death notice in the newspapers, complete with cross and the gratuitous phrase that he had died embraced by Christ, and all were urged to pray to God that his soul should rest in peace.

The petition to President Alemán got a positive response. Orozco was buried in the Rotunda, and both Siqueiros and Rivera delivered graveside eulogies. Later a reddish brown rectangular slab of stark simplicity, made of lava stone, was erected over the grave.

After the collapse of the mural project at San Miguel de Allende, Siqueiros worked on *Patricios y Patricidas* in the *ex Aduana.* Work proceeded sporadically. The mural was still hobbled with physical and bureaucratic problems. Though the antique architecture was a compatible setting for the mural, the building's roof had leaked and caused extensive damage to a corner of the work. The Federal District bureaucracy was delinquent in payments; after four years only a very small part of the mural had been completed. At that time three or four of the U.S. veterans who had been forced to leave San Miguel de Allende turned up. Eager

to assist Siqueiros, they were welcomed by him as he was then in the process of negotiating a contract with Fernando Gamboa, sub-director of the National Institute of Fine Arts, for two murals in the Palace of Fine Arts.

A large number of the U.S. art students who were part of the exodus from San Miguel de Allende were able to take up their studies at the National School of Fine Arts in Mexico City. The school, the *Escuela Esmeralda* (named for the street on which it was located), was directed by Antonio Ruiz, who would have been in charge of the new school in San Miguel had it succeeded. In any case, he readily agreed to permit those U.S. veterans who so desired to work with Siqueiros and receive credit. It was an act that deeply troubled the U.S. Embassy in Mexico City.

The adverse conditions at the *ex Aduana* mural were soon evident to the few U.S. veterans assisting Siqueiros, and they were soon contributing paint from the supplies allotted them by the Veterans Administration. Even so, work hardly advanced. Siqueiros was being worn down with visits to the offices of the Department of the Federal District, trying to remove the impediments that kept the mural in a state of limbo. Each morning he would issue instructions to his small team to keep up the appearance that work on the mural was still progressing. His helpers moved about, high on the precarious scaffold, repairing and retouching. The mural team had dwindled to two U.S. veterans: George Reed and myself.

At least Siqueiros succeeded in having the roof repaired, and the section of the ceiling with its painted cloud forms was repaired and repainted. Reinforcing and fastening the wide expanse of false ceiling more securely to its underpinning provided work, as did removing a great stone Seal of Mexico that intruded in the center of one wall of the mural. Surreptitiously it was chipped off the wall, and the pieces were secretly removed in burlap sacks. To request this favor from the bureaucracy was for Siqueiros a terrifying thought.

The two new murals for the Palacio de Bellas Artes were agreed upon and on March 14, 1950, Siqueiros signed the contract. Each was to be 8 meters long and 5 meters high, and on the walls directly opposite his mural *New Democracy*. The subject of the murals, as the contract stipulated, was to be Cuauhtémoc.

Diego Rivera had resumed work on his lifetime series of frescos in the National Palace, close by the *ex Aduana,* and from time to time he sent his Yucatecan helper with some sly message meant to annoy Siqueiros. More often than not, Siqueiros was not present, so a message from Rivera was left, such as: "Maestro Rivera says that Maestro Siqueiros is painting this mural with the color of excrement."

For the new Bellas Artes murals Siqueiros decided to use Masonite for

the wall surface, but his first experience with this material for a large plane surface proved a disaster. When the carpenter Miranda built the false wall as he usually did, with sheets of Masonite nailed to wooden stretchers, innumerable bulges formed where the Masonite had been nailed to the stretchers. The Masonite was ripped off, with the intention of substituting Celotex, a decidedly softer material. But by chance Siqueiros stumbled upon Homasote, a strong asbestos composition board available in an unusually large (3×4 meters) dimension. It was relatively light in weight, and the large size meant fewer seams. Once covered with overlapping pieces of muslin, held fast with carpenter's glue and then primed with gray pyroxylin paint, a superb surface was ready for the mural.

Cuauhtémoc was to be depicted in two themes: *The Torture of Cuauhtémoc,* signifying the destruction of the Mexican culture; and *Cuauhtémoc Reborn,* the apotheosis, the hero's spiritual transcendence. Following the technical methods he had developed, Siqueiros created a composition based on the movement of the spectator. With this understood, a fundamental composition was marked out on each wall, its dynamics based partly on geometrical divisions of the picture plane. Siqueiros then proceeded to create two detailed drawings of the thematic content and one large drawing of the figure of Cuauhtémoc. These were done with thick pieces of black lead on paper (1×1.3 meters) glued to Masonite. Working at an easel, Siqueiros made the drawings in front of the composition already on the walls. Smaller drawings numbered no more than three.

The open area where Siqueiros worked was blocked off to keep the museum visitors out. The spontaneous creation of the mural, which was not being enlarged from a preconceived sketch, called for intense concentration. Strong, emotional outbursts by Siqueiros were not unknown. A can of blue paint flung at the mural gave his assistants the unhappy task of removing the quick-drying pyroxylin as rapidly as possible.

Siqueiros turned his attention first to *Cuauhtémoc Reborn (plates 47, 48).* The towering figure of the Aztec emperor fills the height of the mural; he is a pillar of strength who has slain the "centaur of conquest." Spears lodged in its massive body, the centaur lies writhing on the ground, a huge hoof crashing out into the space in front of the mural. Powerful and heroic, having valiantly resisted the invaders, Cuauhtémoc stands poised in victory, clad in a suit of armor, *macana* (the Aztec mace) in hand and turquoise crown on his head. His suit of armor symbolically matches his adversary's technological advance and in it he is the victor.

The warning in the mural reinforces the vision of Cuauhtémoc inspiring the masses of contemporary Mexico. Cuauhtémoc stands atop an Aztec structure, his legs firmly planted, the slain centaur to his left, while below him, minutely painted, and as far as the eye can see, are the masses of

Mexican people nourishing his strength and vice versa. But the scene has also been jolted into the modern age in another way. Beneath the arm of the downed centaur, Siqueiros has painted a blueprint bearing the diagram of the nucleus of the atom, the blueprint of nuclear war threatening the world.

To overcome the distortions that would be experienced by the spectator moving at close range from one side of the mural to the other, Siqueiros painted superimposed forms. Thus, for example, he caused a leg that would normally appear too thin when viewed from a narrow angle, to appear normal. It was an innovation that also added considerable animation to the figures in the mural.

But work on the new murals did not proceed unhindered. His demanding outside activities intruded, so there was no possibility that the mural could monopolize his attention. Numerous portraits had to be done to supplement the meager pesos guaranteed for the mural. And political commitments abounded, with U.S. Intelligence and its multiple branches assigning him a high priority of surveillance and filling their "secret" Siqueiros file—105-64853—with any bits of information they could lay their hands on. Included was a dubious report gleaned from a small-town newspaper, *El Fronterizo* of Juárez, that Siqueiros "was a principal leader in [the] June 21, 1948, session of the Partido Popular constituent assembly in Mexico City."[14] An earlier report, also "secret," noted:

> Information was received from the State Department that Siqueiros was introduced at a public rally of the Popular Party (1947) in Mexico City. He was greeted with prolonged applause. . . . The State Department listed Siqueiros as one of a group of individuals who were active in a new organization known as "Sociedad de Amigos de Wallace," (Friends of [Henry] Wallace Society). The organizers were known communist sympathizers.[15]

U.S. Navy Intelligence told the FBI that in November 1948 Siqueiros was an alternate member of the Central Committee of the PCM. The State Department reported to the FBI that "Siqueiros criticized the recent ruling [August 1949] by Pope Pius XII of excommunication of Catholic communists." According to the FBI's own surveillance, Siqueiros supported the American Continental Congress for World Peace held in Mexico (September 1949).[16] Nor did they eschew the spurious report in *Novedades* on August 12, 1949, that Siqueiros was "a great painter who is a notorious assaulter in the pay of Moscow."[17]

The forces fighting for peace at this time were growing in strength and becoming more active, and the U.S. Government was doing all in its power to halt this trend. "Signatures to a peace [petition] outlawing the atom bomb included Siqueiros's signature," was information in the hands of the FBI.[18] Siqueiros had been a delegate to the Permanent Commission of the Mexican Peace Congress and he was refused a visa to enter the

United States when invited to attend the Cultural and Scientific Peace Conference of the National Council of Arts and Sciences, held in New York in March 1949, causing Diego Rivera to issue a sharp protest to the U.S. Embassy in Mexico City.

Each day Siqueiros did some work on the murals as well as writing, speaking and portrait painting. On August 27, 1950, he spoke at a rally sponsored by the Mexican Peace Committee and the FBI noted that in the speech "Siqueiros announced preparations for an art exhibit in November to express the desire of the Mexican people for peace, and urged that 'the agents of the FBI be expelled from Mexico.'"[19] In September he addressed a huge rally in Mexico City that was called to protest the intervention by U.S. troops in Korea, and he gave freely of his time to serve on a committee that was fighting the arrest of Communist Party members who were being held without charges. Amid stepped-up political conflicts, the center-right *Confederación Regional Obrera Mexicana* (CROM) was heaping on the press "evidence" of communist subversion, and it supplied a list of names of prominent Communists, on which *La Prensa Grafica* (December 30, 1949) commented that no great revelation had been made and of the list of names, "David Alfaro Siqueiros was definitely a communist."[20]

Retreating behind the barricade that enclosed the murals in the *Palacio,* Siqueiros warded off the numerous visitors and political colleagues who sought him out in the centrally located museum. Once the powerful pull of the wall gripped his attention, he was cut off from the world outside. Nevertheless, when he was called upon to gather signatures to the Stockholm Peace Appeal, he put down his brushes and took to the street. And at night before he retired, he would dictate to Angélica one of the articles for his lengthy series in the newspaper *Excelsior,* titled, "Criticism of the Criticism of Art" (which ran from November 1949 to April 1950).

Holding forth as a Marxist art critic, Siqueiros fought the verbal battle of Mexican new-realism against French formalism. He criticized the National Institute of Fine Arts for giving more support to easel painting than to murals and graphic prints, while at the same time it promoted literature for "the people" by bourgeois and snob writers. He directed a column to the Inter-American Congress of Philosophers meeting in Mexico City, offering them the model of the Mexican Mural Movement as an example of the direction they should follow. There were columns that explained the ramifications of works by the sculptor Henry Moore and the poet Pablo Neruda, both of whom were in Mexico at the time. When the Galeria Clardecor sponsored an exhibition of modern Mexican religious painting, Pax Romána, Siqueiros attacked the anachronistic attempts to revive religious art in Mexico.

[T]hey want to resurrect an art that as an important school or powerful collective movement has been extinguished in Europe for almost five hundred years; ending with the termination of the Middle Ages and the rise of the modern age with the appearance and political dominance of the neopagan, Protestant, and liberal bourgeoisie. It ceased to exist as a powerfully expressive art as the beginning of a native bourgeoisie arose in society and the first signs of liberal unrest in support of national independence were manifested. Now, what is wanted is the revival and resurrection of this religious art, and, as we have already seen, with the doctrines, theory, practice, and styles of modern art which the "intellectual vulgarian"—generalizing—calls, "modernism," "vanguardism," "Faithism," or simply "bedlam."[21]

The Pax Romána exhibition of the varied styles of 31 artists producing neoreligious painting in contemporary Mexico distressed Siqueiros, but at least it gave him the opportunity to critically analyze the relationship of religion, art and society.

Work on the Bellas Artes murals was interrupted whenever Siqueiros would climb down from his scaffold to receive a person arriving for a portrait sitting. On an isolated landing at the top of a staircase that led from the mural to the floor above, barely large enough to accommodate the painter and his sitter, Siqueiros painted the remarkable portraits of members of the Alemán administration: Finance Minister Román Beteta; Minister of Public Works Adolfo Orive Alba; Enriqueta Roca de Gual Vidal, the wife of the Minister of Education; archaeologist Alfonso Caso. There were other portraits, and in June he was working night and day on the mural, unaware that his paintings were causing a tremendous sensation in Venice.

The 25th Venice Biennial, which opened in June 1950, included 60 works of four Mexican painters. The Mexican government had been invited to send 15 works by each of the four: Orozco, Rivera, Siqueiros and Tamayo. On June 12, Siqueiros received the following telegrram from Italy:

> I wish to inform you that in the International Competition of Venice you have been awarded the prize of the Museum of Modern Art of Sao Paulo, Brazil.— Adolfo Ponti, jury President.[22]

Actually the competition had narrowed down to a choice between Matisse and Siqueiros; by a vote of 12 to 8, the "best of show," prize went to Matisse, a tribute to the 81-year-old painter. Then, by unanimous vote, the Sao Paulo prize for the best foreign painter was awarded to Siqueiros. The French critic Raymond Cogniat noted that "The Mexican painter received the prize of 500,000 liras (the most important for a non-Italian after the prize given to Matisse)."[23]

It was a startling turn of events, and once the dust had settled, the critics attempted to evaluate its significance. Had an aesthetic expression

so overwhelmingly powerful, one that spoke with such compelling clarity in directing itself to undeniable human needs, received recognition? The Swedish critic Nils Lindhagen wrote:

> One receives a blow of a very stimulating nature on visiting the Mexican Pavilion . . . the greatest surprise of the Biennial. Herewith a new continent of art has been presented in Europe. . . . full of vitality and originality that . . . is very extraordinary. This Mexican art is not "art for art's sake." For surely it possesses none of the joy of life; instead with all the power at its command it presents the problems of today's man . . . intimately and inseparably tied to the past and the future of its own people. Without knowing the new economic, political, cultural, and social orientation of Mexico during the last generation, it is impossible to understand this art.

After briefly describing the history that generated this art, Lindhagen continued:

> All these factors taken together have contributed to the creation of a monumental painting that . . . has no equal in the present; and we have to return to the Renaissance to find something similar. . . .
>
> Siqueiros is a man of excess, in his life as well as in his art. He presents his art as an assault and a violation. Never in the history of art has the means of illusion been utilized as powerfully as here. . . . Naturally this art will be horrible for a person who looks only for aesthetic sentiments. . . . Here perspectives are opened toward something that will be able to be a variation of the art of tomorrow, for nobody can escape from these volcanic visions that pursue one with the intensity of a frightful dream.[24]

The effect was profound and widespread. The Italian critic Marco Valsecchi could hardly get over the shock when he moved from the pavilion that housed the works of Kandinsky to the Mexican pavilion a few steps away.

> On one side the myths of abstractionism, the triangles, the colored circles and the severe surfaces of hermetic mysticism. On the other, the lofty discourse, the noisy and bloody voices of a people that want their history, their revolution, their fiestas to be reckoned with without delay. The painting of the Mexicans is an art of great collective preoccupations, didactical, propagandistic. . . . The painting is the substitute for the book and the newspaper. . . .
>
> Of the painters—with the exception of Tamayo, who follows tendencies that are clearly European and Parisian—I don't yet know at what point they will be able to enter the heaven of art as it is known on the Old Continent. But . . . one is taken by surprise and . . . falls victim to the vertigo of those dazzling colors, of that primordial and ferocious expression. Perhaps one is not completely convinced, but leaves with something nailed in memory.[25]

Newspaper people came knocking on the enclosure surrounding the mural, and Siqueiros agreed to speak to them. Putting down his brushes, he descended from the scaffold. "I am happy because . . . the prize con-

stitutes a tacit recognition of the importance of human and social content in the work of art of our time." He told the reporters that he felt the jury had undoubtedly been impressed with the social content of Mexican painting and that after two world wars the philosophy of "art for art's sake" was losing favor in a period when humanity was searching for a new humanism.

Asked why he had won the prize over his three compatriots, he mentioned Tamayo first, saying he

> . . . used elements of Mexican folklore in a manner similar to that of any painter of the School of Paris making a quick tour of our country. For that reason Tamayo's work must have seemed like a reflection of themselves, like some colonial of that intellectual metropolis. As far as Rivera was concerned, to me it is inexplicable that in the selection of his pictures they included mainly portraits and picturesque themes of Mexico. . . . About Orozco, I guess they did not send a good lot. They committed the error of sending semiabstract works of his later period which could not give a just idea of the true essence of this artist.[26]

His immediate reaction was that he had been awarded the $4,200 prize not because of the merit of his own work but rather because of the unrepresentative selection exhibited of his colleagues' works.

However, in a lecture later that summer Siqueiros delved deeper into the significance of the 25th Venice Biennial for the Mexican Movement. It was his impression that the award by the Europeans to the sociopolitical new-realistic painting of the Mexican Siqueiros had confounded almost everyone, including the Biennial hosts. He recalled that the Mexican government had first received an invitation to send only works by Tamayo. At the 1948 Biennial—when Braque, Picasso and Moore had won the awards—Tamayo had been the first and only Mexican invited.[27] Siqueiros saw the invitation again of only Tamayo as an attempt to deal a blow to the Mexican School of new-realism by ignoring it. But an Italian painter named Caprotti, after returning from a trip through Mexico, urged the Biennial Committee to extend an invitation for the works of the three muralists. Siqueiros confessed that he had expected Tamayo to be awarded first prize as a Mexican formalist, to discredit the work of the new-realists. "In Formalist Europe the Mexican painter who is a formalist will triumph," was his belief.[28]

As it turned out, Siqueiros's powerful social paintings—*Peasant Mother, The Devil in the Church (plate 37), The Sob, The Echo of the Scream* (the infant bombing victim), *Cain in the United States* (the massacre of a Black person), *Our Present Image* (man's greed)—astonished the judges and critics. It was impossible to deny the overwhelming power and beauty of the works of genius they faced.

Rivera too, spoke to the press about the Biennial:

Very well: The prize given to David Alfaro Siqueiros has great importance from various points of view. Without doubt, of our paintings sent to the Biennial of Venice, those of Siqueiros, aside from their plastic power, had greater political content and a greater incisive power as painting of agitation and propaganda against war; in addition, the paintings were nearer to the style and feeling of his murals than were ours, so that the jury . . . saw itself obliged . . . to admit to [the] superiority of [Mexican painting] . . . In any case it is an important victory over "artpurism" in precisely what until now has been the shrine of this tendency. . . .

The threat of war hangs over the living. No people want war, only the merchants of arms and explosives . . . Therefore, [David's] *The Echo of the Scream* and *The Sob* . . . were able to shame the esthetes . . . to the point that with clasped hands they pay homage to the hand from which comes the painting that insults their fat-lipped accomplices, the grand bourgeoisie.

For this we should all be delighted—and we . . . celebrate . . . the triumph of Mexican painting in the person of Siqueiros.[29]

Rivera's outpouring was typically effusive and elaborate, with more than a tinge of the farceur, but still, his words did express the tenets that impelled the Mexican Movement.

At home in the Tlacopac district of Mexico City on New Year's eve, Siqueiros was enjoying a rare period of relative calm. During the year 1950 he had succeeded in painting more than usual and had received the Biennial prize. Two days earlier he had reached his 54th birthday and he was enjoying excellent health. The family had gathered to welcome in the new year and celebrate David's birthday: Angélica, daughter Adriana; Mother Arenal, Angélica's brothers Luis and Polo; Macrina, Luis's wife; and my wife and I. There was dinner, during which Siqueiros told the many jokes he loved to tell, drank lightly, sipping small amounts of wine, and smoked incessantly.

Somehow, his smoking looked unnatural. He handled cigarettes awkwardly, as though not knowing what to do with them; they always seemed to be in his way. But a nervous quality could always be detected in him whenever he sat silent; he would hold on to his cigarette lightly, as though to keep his smoldering energy under control. Though he had at intervals during his life given up smoking, in the end the habit remained with him, though to a lesser degree. Drinking held less attraction; he drank socially, usually out of politeness, rarely refusing a drink when it was offered.

As midnight approached, Siqueiros led us all out of the house and into the garden. In the pitch-blackness under the stars, at the stroke of midnight, he drew from his pocket his bone-handled pistol* and emptied its

*For the most part, Siqueiros kept himself armed with that gun. A "dangerous" revolutionary, he had his share of more dangerous enemies. Often as he sat on a scaffold painting, the handle of his revolver could be seen protruding from a pocket.

shots into the sky above. In the distance could be heard the reverberating shots from other pistols.

18

From Cuauhtémoc to Truman

In March of the new year, festivities in faraway Chilpancingo forced Siqueiros to take a much needed break from his work; he was invited by the governor of the State of Guerrero to attend commemorative historical celebrations. For the occasion, Luis Arenal had painted a large mural in the patio of the State Capitol, and Siqueiros and the governor would inaugurate the mural with speeches. On Friday morning, March 2, 1951, Siqueiros, Angélica, their young nephew Emilio (son of Angélica's sister Berta), and my wife and I drove south in the gray Plymouth sedan, with Angélica driving, heading for Chilpancingo.

When we arrived in the late afternoon, the festivities were in full swing. Siqueiros was escorted immediately to the governor, who was waiting in the patio of *de Palacio de Gobierno*. There, amid the noise of fireworks, in front of Luis Arenal's mural, Siqueiros spoke of the mural, of Mexican art, and of the history of Guerrero.

Chilpancingo was jammed with visitors and the fireworks continued into the early morning hours. It was a sleepless night for most, but that Saturday morning Siqueiros suggested a drive to Acapulco, some 130 kilometers farther south. Though it was the height of the tourist season and accommodations would not be easy to find, Siqueiros was in a carefree, holiday mood. After we had dined, we departed the jungle heat of Chilpancingo and reached Acapulco in two hours. No hotel accommodations could be found, though Siqueiros spoke with many acquaintances in his search. At one point, near the shore, Siqueiros asked that the car be stopped and invited everyone to join him in dipping hands in the ocean. He liked to play at being superstitious, and claimed it was bad luck to reach the sea and not touch the water. He led the way to the water's edge, and we each touched the Pacific. Finally, with great difficulty, modest accommodations were located in the poorer section of town, but once settled in our rooms, we found they suffered from a lack of water. Aside from another sleep-disturbed night, caused this time by Acapulco's notorious night-barking dogs, Sunday was pleasant. Not ex-

pecting to visit Acapulco, no one had a bathing suit, but after dining well in a central restaurant, Siqueiros enjoyed sightseeing and strolling along the dock, the *malecon,* watching the fishermen bring in their catches.

Back in Mexico City, my visibly pregnant wife and I were deposited at our home, with a parting agreement that work on the Cuauhtémoc murals would resume the following morning. But on that morning, March 5, 1951, Siqueiros received a phone call that my wife, Gertrude, had just delivered a baby girl! The next day, Siqueiros, in paint-spattered overalls, arrived at the hospital accompanied by Angélica, with a huge bouquet of red roses for Gertrude and the new baby.

In April, Siqueiros finished *Cuauhtémoc Reborn* and turned his full attention to the more complex scene of *The Torture (plates 44, 46).* The many figures that made up the composition of this mural required a tremendous amount of detailed painting, and there were many hours of working late into the night to guarantee that the mural would be finished for the scheduled August inauguration. On one of those night sessions, Siqueiros suffered a bad fall while climbing to reach the scaffold platform; the ladder slipped on the freshly waxed museum floor, sending him flying from a height of seven feet. Momentarily blacking out, he lay dazed on his back, muttering, "What happened? What happened?" Fernando Gamboa, the museum director, who was in the museum late that night, appeared on the scene quickly. Siqueiros, forced to quit for the night, left the museum under his own power. An X-ray the following day determined that his cranium had suffered no damage.

A suit of armor, borrowed from the museum's storeroom as a model for Cuauhtémoc's attire in *Cuauhtémoc Reborn,* was positioned before the companion wall to serve as model for the army of armor-clad conquistadors in the torture scene. The staging and symbolism of the drama were majestically conceived. Cuauhtémoc is in the foreground. Naked except for his turquoise crown, he lies atop a trapeziform stone slab. The Aztec lord of Tacuba sits next to Cuauhtémoc's straight, tense body. Both are being tortured, their feet thrust into the fire that Cortés has ordered. Tears streaming down his face, the lord of Tacuba implores Cuauhtémoc to reveal the hiding place of Moctezuma's (nonexistent) treasure. It was at this moment that Cuauhtémoc made the famous reply that he himself was not enjoying the pleasure of his bath. Overseeing the horrific scene is the ominous figure of Cortés, painted totally encased in armor but identified by the head of Malinche—his interpreter, his mistress and betrayer of her people—who here whispers in his ear.

A young woman from the museum staff who had a strong attractive Indian face stood on the scaffold with Siqueiros, posing for the face of Malinche. I lay prone on the floor, shirtless, modeling for the figure of Cuauhtémoc. And in the secluded makeshift studio atop the stairway, Siqueiros created a powerful pencil drawing of a nude figure, for which

Angélica posed *(plate 45)*. This figure, clad in red, was painted in the mural to symbolize humanity protesting not only the scene of torture before her but all imperialist-instigated war. She stands at the vanguard of a group of mourning and suffering women, while a child,—a figure that at that moment emanated from the Korean War,—raises two bloody handless arms. The blood-drenched ensemble becomes a powerful voice for peace.

Siqueiros had adopted a method of printing and distributing his own handbills and leaflets whenever he deemed events serious enough to call for such action. With the Korean War raging, he had his leaflets printed in a small neighborhood printing shop. Then, late at night, when work on the mural had finished, Siqueiros and a couple of artists piled into the Plymouth with a bucket of paste and the leaflets. Angélica drove through the darkened city streets, making hasty stops while the leaflets protesting the Korean War were pasted on poles and buildings. One such leaflet stated:

Betrayal by Mexico
And A Criminal Offense to the People

What would you think of the position of a small country that would have sent foodstuffs to the French forces that invaded Mexico in 1863, or to the Yankee troops that invaded the terrotory of the Nation on any of three occasions?

Judge for yourself, today, June 1951, the position of the Government of Mexico in sending rice, sugar, etc. (articles of prime necessity for our people who are dying of hunger), to the troops invading Korea.

Speak out, write, telegraph or collectively demonstrate your energetic protest!

Thus you will contribute to stopping this persistent and enormous betrayal and crime.[1] [36]

TRAICION A MEXICO
Y CRIMINAL OFENSA AL PUEBLO DE COREA

¿Que opinaría Ud. de la actitud del Gobierno de un pequeño país que le hubiera enviado remesas de víveres a las fuerzas francesas que invadieron México en 1863, o las tropas Yanquis que invadieron el territorio Nacional en cualquiera de las tres ocasiones?

Juzgue Ud. hoy, junio de 1951, la actitud del Gobierno Mexicano al enviar arroz, azúcar, etc. (artículos de primera necesidad para nuestro pueblo que se está muriendo de hambre), a las tropas invasoras de Corea.

¡Diga, escriba, telegrafíe o manifieste colectivamente su más enérgica protesta!.

Asi contribuirá Ud. a impedir la persistencia de tan enorme traición y crimen.

Frente de Pintores Revolucionarios de México.

The leaflet was signed by the Front of Revolutionary Painters, the organization Siqueiros evoked whenever a protest, political act, or defense of an artist with a grievance was necessary. In 1950, when the government had ordered the decorative work of Carlos Mérida removed from the exterior of the new building of the Ministry of Water Resources, Siqueiros had called the Front of Revolutionary Painters into action, and with Rivera and all the artists offered Mérida support and the opportunity to fight to preserve his work on the building. Mérida, however, did not wish to move in that direction, and his work came down.

The realist painters did not hesitate to support the Frente de Pintores Revolucionarios de Mexico whenever Siqueiros or others put out a call. In their name Siqueiros addressed a meeting on January 28, 1951, organized by the PCM to commemorate the 27th anniversary of Lenin's death. Attacking "Yankee imperialism" as the greatest enemy of Mexican independence, he called it especially aggressive in its use of Mexican agents to attack the Mexican workers and democratic forces. But, as had been shown in the Soviet Union and China, a wall could be erected against imperialism, and the only way to build a powerful anti-imperialist peace movement in Mexico was to develop and strengthen the Communist Party.[2] While Siqueiros spoke, the atmosphere was charged with the news that 4,200 coal miners were on a long protest march to the capital. "The Caravan of Miners" was walking from Nueva Rosita south to Mexico City, a distance of more than 400 miles, to protest to the government their exploitation by foreign bosses. When the long line of destitute miners reached Mexico City more than a month later, the FBI added to its files a newspaper report of March 27 that "Siqueiros participated in a protest march of striking miners."[3]

As nominal head of the Front of Revolutionary Painters, Siqueiros next attempted to bring art into the district where the working poor lived. He organized an exhibit, which he called the "Salon of May," and quite unlike its French namesake, it was presented in a storefront gallery in the neighborhood of the people's Lagunilla Market. More than twenty-five artists participated, with paintings that expressed the theme of the show: "Mexican Art for National Independence and Peace, and Against Poverty."

The work that Siqueiros contributed was awesome. A large painting, 2.5 by 1.5 meters, bore the title *The Good Neighbor (plate 42), or How Truman Helps the Mexican People.* Depicted with a fiendish smile on his face, Truman grips the chains that are wound around the wrists of a kneeling naked Indian. Forcing the Indian to his knees with one hand, Truman holds high a packet of dollars in the other. A machine gun is slung on the victim's shoulder and both are surrounded by a pool of blood.

Unremittingly political in theme, and without question unacceptable in the mercantile art establishment, the painting was a technical and aes-

thetic masterpiece, rivaling the great bloody Christs of the Renaissance. The theme itself was a direct response to Truman's attempt at the time to buy off Mexico with a $3 billion inducement to join the United States in a military pact to "defend the American Continent against agression." In February of 1952, President Alemán agreed to hold talks with the United States, provoking the National Council of the Partisans of Peace, of which Siqueiros was a member, to mount a great protest. At that time Siqueiros's painting of Truman was reproduced on the front page of Lombardo Toledano's newspaper, *El Popular.*

To promote the Salon of May exhibit, Siqueiros produced two hand-bills. The first, "Picasso and Us," exploited the fact that Picasso had painted a work against the Korean War. When a reproduction of that painting reached Mexico, Siqueiros sent Picasso a telegram congratulating him and welcoming him to the side of the social realists. Picasso's powerful painting, *Massacre in Korea,* is a relatively literal depiction of a firing squad of mechanical soldiers executing a group of naked women and children. Siqueiros's handbill read:

> Has Pablo Picasso—the most important abstractionist painter of the School of Paris—entered the road of political new-realism, which has been the character of our modern Mexican painting for the last thirty years?
>
> If this be the case, does such a stance by Picasso constitute a new personal modality, or is it rather a part of a general current in Paris and Europe that is the consquence of instability in all aspects of social life?
>
> Visit the exhibition, "Salon of May." You will see there the most recent work of Picasso, *Massacre in Korea,* exhibited this past month of May in Paris.[4]

On view in Mexico's Salon of May was only a small black-and-white newspaper reproduction of the Picasso, but even amid the larger politically compatible Mexican paintings, its signficicance was not lost.

The second handbill was an announcement that Siqueiros would give a lecture at the Salon of May at 7:30 p.m. on June 14, the day the exhibit was to close, and the subject was: "The Judgment of the People On Our Political Painting."

> Is it possible to judge modern Mexican painting without pointing simultaneously to the social process in which it unfolds and was produced?
>
> Is it possible at the same time to analyze it without judging the full political history of the workers' movement of our country, especially that which in the last fifteen yeasrs is referred to as governmental proletarianism and collaborative "Marxism," that is, Marxism outside the Communist Party?
>
> Can this painting, our modern Mexican painting, reach a third stage of greater perfection, a stage of Socialist Realism, supported by a workers' movement that is destroyed and almost inert?[5]

The Salon of May fulfilled its objective and was a great success. During the two weeks it was open, some 30,000 working-class and poor people

entered the storefront gallery. These were not the art-buying public, no paintings were sold, but this had not been the object of the show. The humble souls who flocked to the show inscribed innumerable comments of gratitude in the gallery notebook and left tiny amounts of money that helped defray expenses.

Siqueiros and the Communist Party (which shared in organizing the event) were well satisfied with the experiment, but Siqueiros wrote an overall critique, "Notes for a Critical Examination," which he addressed to the Central Committee of the Party. In it he pointed out that the PCM, as the vanguard of the working class, was obligated to orient artists, not only those in the ranks but non-members as well, to the problems of creating "Socialist Realism that would inspire our national culture, even before the defeat of Capitalism."[6]

Of the paintings, Siqueiros expressed dissatisfaction with the level of realism the exhibit had produced, and explained just how close to Marxist political theories he believed art should be. In general, he found too many works had weaknesses in their lack of aesthetic quality, beauty and political content. After 30 years of the Mexican Movement, he found the results disheartening. The role of the Communist Party, he held, must be to encourage the further development of the modern Mexican school of art, especially murals and printmaking "for within the bourgeois world, this school is one of the highest and most advanced exponents of the national aspiration of the people in their struggle for economic, political and cultural independence."[7]

Siqueiros stressed that the Party must assist art to advance. He considered it a shortcoming that in no case had the Soviet Union been presented as the bulwark and leader of the world struggle for peace, nor had the significance of the Chinese Revolution been considered. The political and social restlessness of the radical painters did not compensate for their generally low level of political awareness. He noted the abundant negativeness and confusion in the paintings, and said that the artists were isolated from the life of the popular masses. Also, he found the theme the Party had selected too vague and abstract, making concrete solutions difficult.

Added to political deficiencies were problems of the cohesion of form and content. From the beginning, he pointed out, the movement had experienced contradictions between practice and the theoretical base, and he urged the Party to promote discussions among the artists of all styles to solve this problem. It was understood that an art for the people had to be made, yet the social-aesthetic path had been all but abandoned. This, Siqueiros explained, was caused by the economic dependence of painting on the bourgeoisie, which:

consolidating itself as a class, divorced itself from the program of the Mexican Revolution and gradually pulled painting into its camp, converting it, as it did with all natural and human products, into articles to be bought and sold, causing immediate corruption. This social crushing was not recognized or corrected by the working class, for by not moving closer to the artists, they did not create an economic base that would permit Mexican art to fulfill its popular social function and create the cultural forms of Socialism.[8]

More precisely, what he considered to be the failures of the artists were the repetitious use of symbols, an excess of intellectualism, and religious mysticism—all often confused or understood only by a small minority. Siqueiros advised artists to go back and

find the essence of reality, and then, only when they were able to communicate with clarity their message to the people, can they resort to the symbol. [Also offending]: an abuse of formalism. The most notable tendencies were Epicureanism, cubist derivations, archaism, primitivism, as well as bestial deformities, dehumanization of the figure, and other social and cultural contaminations of the bourgeoisie.[9]

Delving deeply into the innumerable flaws, at least as he saw them, Siqueiros raised the point of static anti-dialectic conceptions that failed to show "life in its developing form which is the premise of social realism." Thus, for him, most of the works of the Salon of May were incomplete, giving little hope and producing negative results. He did point out that socialist realism was not

a happy Socialist ending. Nothing could be further from what socialist realism asks of an authentic work of art, since as an expression of the revolutionary class resolving contradictions by means of class struggle, it is of no use to demagogically falsify reality in art nor to apply mechanical slogans from outside.

In consequence, the positive feeling ought to arise from within the artist, to sense and interpret forms, to transform social history, whether in a scene, a figure or a landscape, and at times for this a gesture or an attitude is sufficient to make the contradiction in the struggle felt.

Confusion also exists in believing that in order to make revolutionary art the artist must depict only the negative, the brutal, or simply objective reality. This lack of resolve has produced the existentialists and the many badly oriented artists and spectators. Contrary to being a revolutionary position, it is . . . depressing and reactionary.

The mission of all great art is to encourage humanity to struggle to reach a future of real happiness. The art of socialist realism, with its feet firmly planted in the reality of daily living, sees the future with a romantic, heroic and passionate vigor that is the product of historic determinism and not the result of a decadent romanticism that is false and utopian.

We consider it a shortcoming, which persists from the period of the founding of Modern Mexican School of Painting, to use almost exclusively the theme

of the peasant, presenting the Mexico of today as a homogeneous mass of peasants.

This fixation is indicative of a lack of knowledge of Mexican social evolution. New forces have developed, and even though the peasants continue to be numerically greater, the working class has been able to show its strength, and its intervention is a qualitatively superior and greater determining factor in the revolutionary struggle of the country.

The artist attracted to the beauty of the peasant tradition sees the past with a feeling of nostalgia derived from a reactionary postion and forgets the rising of a new life, which is felt to be hostile and deprived of enchantment.

This effects a creative impotence; the artist must produce poetry with the new materials, both social and physical. The proletariat and its function as the producers of the elements of life, offers the artist a new rich, complex, and strong world with which to dominantly complete their vision of a dynamic Mexico.[10]

Siqueiros attempted to educate his Party to the necessity of active support for an art movement that had already played an important role in the country's social development and that had a strong political potential. He ended his critique with a number of concrete proposals, which included the Communist Party sponsoring exhibitions throughout the country of paintings that would educate politically; Party-led meetings of artists to discuss and solve their problems; and the formation by the PCM of an artists' organization and workshop, geared to serve the struggle of the masses and develop an independent popular market. To achieve revolutionary ends and further develop a new realism, Siqueiros hoped to raise the Party's consciousness and draw from it a better understanding of the political role of the arts, and thus its greater cooperation. However, in the end his challenge was not fully comprehended, so alone, in his own work, he continued to pioneer and solve the problems he raised.

Cuauhtémoc Lives

Indian workers and peasants stood before the Cuauhtémoc murals thunderstruck and enthralled. Overawed and intimidated by the splendor of the *Palacio,* these humble Mexicans found their way to the third floor to see the murals. No one can adequately describe the mysterious feeling within them, the secret pulsations that emanated from the dreadful electricity of the powerful plastic realism that depicted their ancient leader, Cuauhtémoc.

Yet it was not to the downtrodden Indian alone that this Cuauhtémoc in the *Palacio de Bellas Artes* spoke. The murals were mentioned at an extravagant dinner in the swank Restaurant Ambassadeurs, given to honor Román Beteta, the finance minister, on the publication of his book, *Pensamiento y Dinámica de la Revolución Mexicana.* Speaking to an

audience of his former students at the law school, the faculty members and PRI politicians, Beteta evoked the name of Cuauhtémoc, who had come alive in the *Palacio*. He said the murals best expressed what he had to say and conveyed to the audience his opinion on

> the profound meaning of the picture: the people, when weak, are frequently subjugated with violence and terror by those who are more advanced and stronger, but in the long run, if the oppressed masses understand how to take advantage of the same instruments that were used to conquer them, they can liberate themselves; if in addition to their strength they have the courage and determination to do it.
>
> Only a true artist could synthesize, in a mural full of action, an idea as complex as this. We who do not pretend to have this divine breath called inspiration, nor this capacity to first analyze, then synthesize a work of art, have to use long and frequently tedious explanations to arrive at the same idea. Such is my book, but instead of a vigorous mural of impressive color it is some 570 pages of labored speech.[11]

Beteta spoke in April, and Siqueiros was then still at work on the murals, which were to be inaugurated in August, when the government was also to unveil a monograph on Siqueiros's works, to contain 215 reproductions.

Diego Rivera was also on the *Palacio*'s third floor with a commission for a new mural opposite to where Siqueiros was working. This new work was 10 meters long and 5 meters high, on the wall adjacent to his earlier mural, and was to be transportable so it could be exhibited in a number of European cities. After the acclaim received by the Mexicans the previous year at the Venice Biennial, the Mexican government had received invitations from Sweden, France and England; each wanted an exhibition of Mexican paintings.

Though they would not be easy to ship, murals by Siqueiros and Rivera were to be included. Rivera's new mural was being painted on canvas that could be rolled up for shipment, and when returned it would be permanently fixed to the wall where it had been painted. The Cuauhtémoc murals of Siqueiros were not transportable, yet *Cuauhtémoc Reborn* was to go abroad with the exhibition. The false wall on which the mural was painted was removed from the permanent wall of the museum. Siqueiros was not present while preparations were made to saw the mural into sections, but Diego Rivera appeared on the scene to examine the problem. He told me, "Make sure you do not cut this mural down the center. A seam down the center would produce a static effect. It will need two cuts." In effect, this was what was already planned. Two vertical cuts were made with an electric saw, and the three equal sections, protective tape covering their edges, were placed in one huge crate for shipment abroad. A large canvas by Tamayo, of mural dimensions, was included, but no fresco of Orozco's could be moved.

The two muralists painting on the third floor of the *Palacio* were attracting the attention of newspaper people, art lovers and curious tourists. Rivera's new mural with its pro-communist, antiwar theme was an irritant to a large number of tourists from the United States. Clearly visible in the work in progress were the dominant figures of Stalin and Mao Tse-tung. Siqueiros received some of the abusive remarks because U.S. tourists mistook him for Rivera. Usually Siqueiros walked out of the museum in his paint-spattered overalls to some nearby restaurant to take his midday meal. On these occasions he heard remarks such as "Does Diego Rivera always dress like that?" or "If he likes Russia so much, why doesn't he go there?" But there were also friendly people who would greet Siqueiros from all sides, and once he was seated in a modest restaurant, admirers would immediately gather around to hear him and to engage in conversation.

Working in so centrally located a place as the *Palacio* brought him a steady stream of visitors and interruptions. Art dealer Alberto Misrachi pushed an old painting through the barricade: "Would the Maestro please verify that the painting (a head of a man with a clay pipe, painted on cardboard) was one of his very early works?" The query went unanswered. Or film director Emilio Fernández might arrive to discuss a matter. When Pablo Neruda arrived, the interruptions were more prolonged and Rivera joined in. Neruda had come to Mexico City for the publication of his *Canto General,* a massive volume of his poems, with illustrations by Rivera and Siqueiros adorning the inside covers [42].

Rivera was painting with great speed, and as the theme of his mural came to light, both Director Carlos Chávez and subdirector Fernando Gamboa of the Ministry of Fine Arts became alarmed. They warned Rivera that the work he was developing could not possibly be sent by the Mexican government for exhibiting in Europe.

Considering the circumstances, Rivera painted what would seem to be a deliberately provocative work. *Nightmare of War and Dream of Peace* was an exceptionally clear indictment of the role of the United States in the Korean War. In it Stalin and Mao Tse-tung offer the pen of peace to the United States, England and France, who reject it; U.S. soldiers in the background are shooting and torturing people; painted in the foreground are people on the street gathering signatures on a peace petition.

During the early morning hours of April 13, the date planned for the *vernissage* of the mural in the *Palacio,* the government took matters into its own hands. The Secret Police cut the mural from its battens, unceremoniously rolled it up and took it away. The outcry was immediate, and Siqueiros, under the banner of the *Frente de Pintores Revolucionarios de Mexico,* rallied artists to Rivera's support. In the statement of protest that he wrote, Siqueiros accused President Alemán of having

"with the obvious complicity of the directors of the National Institute of Fine Arts . . . committed a serious attack against artistic creation and culture." Assaulting the mural as they did was a criminal act that logically could only be the consequence of their economic and political submission to the ever-increasing pressure of a foreign government, which he then identified as "the imperialist government of the United States." He demanded that the mural be returned immediately and that the director and the subdirector "deny immediately all complicity (or be fired), direct or indirect, in the attack in question." The mural should also be restored to the list of works to be exhibited in Europe and following this be reinstalled in its rightful place in the museum.[12]

A number of months later the mural was discovered in a government warehouse. It was never returned to its place of birth; Rivera found that the Peoples Republic of China was a willing recipient and the mural found a permanent wall in Peking.

Before shipping the official exhibit to Europe, the Mexican government removed Siqueiros's *The Good Neighbor* [*El Buen Vecino*] *or How Truman Pretends to Help the Mexican People* and a painting by Xavier Guerrero, *The Self Defense of Latin America.*

Though the wide gap between the government's goals and those of the mural painters created endless antagonism, the Mural Movement was still a force to be reckoned with. When the Alemán regime embarked on a vast building construction program, they were able to wring from it a number of mural commissions. On June 30, 1951, while still at work on the Cuauhtémoc murals, Siqueiros signed a contract to paint a semi-enclosed mural for the new dormitory of the National Polytechnic Institute in Mexico City. Close on the heels of this contract, architect Enrique Yanez secured a commission for a mural in a huge Social Security hospital that was under construction.

Twenty-six murals were being painted in Mexico in 1951. The number jumped to 48 in 1952, and in the following twelve years the number steadily increased.[13] In 1951, ground for a new site for the University of Mexico was broken in the *Pedregal,* the lava bed on the southern outskirts of Mexico City. It was to be a massive project that would move the National Autonomous University of Mexico from the antique buildings it occupied in the heart of the city to the new location. The prospect loomed for a new surge of mural painting.

Siqueiros watched the development of this project closely, especially the manner in which the architects approached the decorative aspects of the university buildings. Would they integrate the artistic production on the new walls with the architecture? While most Mexican artists would be content with any crumb of a wall tossed to them, Siqueiros expected the new university to be a monumental project, one that could foster a

planned integration of art and architecture that would lift the Mexican art movement to a higher plane.

With this in mind, Siqueiros took the initiative. He wrote to Carlos Lazo, the chief architect of the new University City, requesting a consultative position for the artist in the planning and design of the new university. In his letter Siqueiros stated that after thirty years of mural experience "it was impossible to imagine the construction of a university in present-day Mexico without the inclusion of painting and its natural corollary, sculpture."[14] He further pointed out that up until that time murals had been painted on old buildings, or on new ones only as an afterthought. He then questioned whether the architects and the engineers understood the importance of the opportunity before them—to become involved with the arts in the initial stage of planning. However, construction moved ahead, and it was evident to Siqueiros that architect Lazo had no intention of consulting with the artists and a big opportunity to integrate art and architecture was being missed.

Not satisfied to let the matter drop, Siqueiros next proposed that the decorative problems of the buildings already planned be discussed with the artists and that a commission of muralists and sculptors be added to the body of architects and engineers to deal with the interior and exterior polychroming of the buildings; to select the proper areas for decoration; and to consider the appropriate choice of themes. Anticipating a problem with different styles and tastes among artists and architects, he felt that an overall plan would help architects and artists to form teams with like-minded aesthetic ideas, achieving a degree of uniformity of style.

Siqueiros organized a provisional founding committee for the Mexican Union of Mural Painters and Sculptors, and on February 26, 1951, a Constitutive Act was signed by 26 artists, including Diego Rivera, Xavier Guerrero, Juan O'Gorman, José Chávez Morado, Rina Lazo, Luis Arenal and Luis Ortiz Monasterio. In all, the membership in the new union included over 60 artists.

The first order of business was to adopt Siqueiros's letter to architect Lazo as the union's position. An Action Commission was formed, made up of Rivera, Siqueiros, Chávez Morado, Ortiz Monasterio, Guillermo Monroy, Arturo García Bustos and Alberto de la Vega. All agreed with the main purpose of the union—to support one another in anticipated conflicts with the university directors over contract negotiations, and in defending their work.

The union did not succeed in bringing about the conditions set forth in the Siqueiros letter; it was not able to influence a shift on a grand scale to a planned integration of art and architecture. The union did, however, represent a semblance of the power of the Mexican artists, and it was responsible for their playing a role, even if it was only asserting their presence, in the creation of University City.

When the Cuauhtémoc murals were finished, Siqueiros paused for a moment before beginning work on two new murals. He accepted invitations from the Italian newspapers *Rinascita* and *L'Unita* to speak in Rome; the Venice Biennial of the previous year had stimulated great interest among the Italians in his work. So in October of 1951, Siqueiros and Angélica traveled to Europe for the first time since their days in Spain together. In Rome, Siqueiros spoke to an audience of workers on October 17 about the relationship of modern Mexican painting to the labor movement. Then, after a few more talks, the couple traveled on to Paris. There, on October 28, Siqueiros lectured before a group of Latin American artists who lived in France, along with Spanish artists in exile; his subject was "The Real Significance of Modern Painting Facing the Historical Expression of the Bourgeoisie, the School of Paris."[15]

Still in Paris, on November 1, Siqueiros and Angélica attended a reception given in his honor by *L'Union des Arts Plastiques,* at which Paul Eluard read his poem, *David Siqueiros parle,* and Pierre Courtade his *Un Homme Plein de Joie.* Siqueiros spoke in French about the Mexican experience in art, and the audience was spellbound.

From Paris they traveled to Warsaw, where on November 8 he addressed the Union of Polish Painters on the problems of socialist realism in a capitalist country. The Polish veterans of the Spanish war greeted the couple warmly and presented them with a banquet in their honor. Polish artists wanted Siqueiros to paint a mural in Poland and the idea was agreed upon, but Siqueiros's commitments at home prevented it from materializing.

Two final lectures took place in Europe, one on November 11 before the Czechoslovak Association of Artists, and the other on November 18 in Amsterdam, where he spoke in the Stedelijk Museum.

Once back in Mexico, Siqueiros put in order the diverse impressions he had gathered on his trip across Europe, and on January 24, 1952, presented his lecture, "Art Inside and Outside the Iron Curtain." Speaking to a packed audience in the *Sala Ponce* of the *Palacio de Bellas Artes,* he asked:

> How do the *formalists* of the capitalist world respond to the accusations of the partisans of socialist realism, that they are creatively impotent and mercenary bluffs? And how do the *social realists* respond to the charge of the partisans of the various branches of *formalism,* that they are theorists and practitioners of the worst bourgeois academism?[16]

As usual it was a provocative lecture, and another that followed on January 31, "Art in Today's Poland," was sponsored by the Polish Embassy. Essentially, he said that painting in a country that had expelled imperialism, socialized its society and allied itself with the Soviet Union had everything in common with the modern Mexican Movement and

that the artists of both countries should exchange their ideas and experiences.[17]

Soon Siqueiros was at work on the wall of the new dormitory of the National Polytechnical Institute. All his painting paraphernalia had been moved there from the *Palacio.* There was a large metal paint-mixing machine, manually operated, which held 14 one-gallon cans of the various colors; it was a dispenser used in the automobile trade, and most useful in keeping the rapidly evaporating pyroxylin paints sealed airtight yet easily available. Each can was equipped with a mixing blade connected to an outside handle, and the dispenser allowed the cans to be tipped forward to permit paint to pour from a spout when it was opened [36]. Also ready for use were the spray guns and air compressor, brushes, chalk, charcoal, snap-lines and straight-edges. His palette consisted of small empty food cans that held a full range of pigments.

The new surface to be painted, after discussions with the architect, was not a wall but rather a concave aluminum panel. Facing the street, it was hung on four of the building's unconcealed supporting columns. The panel's top and bottom edges were one-half meter from ceiling and floor; it was 15 meters in length and 4 meters high; and it was in clear view from the street, some 30 meters away. Set in the building's entrance, the mural was exposed to the outdoors yet protected from the elements by the ceiling. Ramps leading to the upper floors were on either side of the mural and would govern the flow of movement by the students. Siqueiros walked up and down the ramps and then—imitating the students—he ran. Following that trajectory, he created the composition [38].

Siqueiros saw the theme, befitting the National Polytechnical Institute, as the relationship between the human being and the machine. He wanted to convey the idea simply, with power and clarity in one great blow. He presented the theme in two parts—the *problem,* and the *solution.* For the spectator approaching the building from the street, the full mural is in view. Then movement is activated as the spectator walks by the mural and up the ramps on either side. If one moves up or down the right-hand ramp, a giant oxidized machine is seen, its moving parts combined with an agonized human form; it is half machine, half human *(plate 56).* A combination of sharp foreshortening and recreated forms causes the machine-human to lurch into movement when viewed by the passing spectator. A setting sun in eclipse is part of the scene of decay. Siqueiros had an old rusted automobile engine block hauled to the mural to be the model for the rusted capitalist mode of production.

In the mural's center, the *new* worker stands atop a pedestal. He points in the direction of a red sun rising behind an ensemble of beautiful shining whirling cylinders that generate power under his control. As the students walk or run up and down the opposite ramp, the spinning dynamo on the

elongated concave wall is activated amid an aesthetic play of color and form *(plate 55)*.

The worker in the mural's center holds aloft in one hand a symbolic atomic nucleus, the source of cheap and abundant energy. In 1951 that idea had unqualified support, and certainly Siqueiros was unaware then of the complexities and problems that would plague its future. For the student engineers, many of whom had come from poor peasant families of the Mexican villages, the mural was beautiful, proselytizing art.

When the mural—*Man, the Master of the Machine and Not the Slave*—was inaugurated on February 18, 1952, Siqueiros stood before it and spoke briefly about the technical problems that accompanied murals as they moved to building exteriors and of the "ideological language" for such murals. As for the one before them:

> Man is a victim of his own great scientific discoveries. He conquered atomic energy, the greatest physical force of the present and near future, and this force that is now used only for destructive ends will tomorrow be used for industrial purposes in a world of peace and progress. The vehicle of the industrial production of this world will no longer be the machine that oppresses men, the "man-machine," but the "machine-machine," absolutely controlled by man.[18]

The Mexican presidential election was to take place shortly and the "deeply entrenched pattern of praetorian behavior" of the PRI "Revolutionary Coalition" was once again selecting the new president.[19] Siqueiros had received a visit from a newspaper reporter asking his opinion on the call to the Mexican people by General Francisco J. Múgica that they rebel against this perennial "imposition" by the PRI. In paint-spattered overalls and his dark fedora, Siqueiros held his brushes in abeyance to answer the reporter's questions. On the following day the story appeared under the headline: "The Coronelazo Hurls a Strong Blast—Múgica Is An Inciter, Affirms David Alfaro Siqueiros."[20] Múgica was not the first to call for a break with the PRI dictatorship, but past attempts had ended with executions of the leaders, so Múgica's speech in Mexicali calling on the people to take up arms in the fight could be considered foolhardy and dangerous.

In Siqueiros's opinion,

> . . . incitement to armed struggle in these elections serves as a politics of provocation, and in this respect it is tactically stupid. As for the "imposition," it is no more than a form of government violence, and can bring with it a violent reaction against the popular masses by assaulting their democratic rights. It is for that reason that the aggression of the imposition is the first incitement to armed violence. In the country the climate for rebellion is not propitious; consequently, whoever proclaims it is a provocateur, of either good or bad faith, but in the end a provocateur.[21]

The new candidate for president selected by the PRI was Adolfo Ruiz Cortines, and when Siqueiros was asked if he thought this was an example of "imposition," he answered, after an explaining the political history of the country since the Revolution that it is true that he (Alemán)

> realized great material works, and it is true that Mexican social pictorial production, which represents a most transcendent support of the Revolution in the field of culture, has not been interrupted, but these are only details. . . . The artists should be grateful, and we are, for that which has been done for us. But . . . we are not thankful for what has been done to the country. The government of Alemán is supporting Ruiz Cortines the way Calles supported Cárdenas, and Cárdenas supported Ávila Camacho, which is to say he is being imposed. The expenses of Ruiz Cortines's campaign are paid with the nation's money and the indisputable official support he has is absolutely undemocratic, since in Mexico the states, the municipalities and the legislatures are a fiction.[22]

It was his hope that Ruiz Cortines, an old friend, would reject the ruling oligarchy that was "imposing" him.

When Siqueiros was asked how he could support Vincente Lombardo Toledano, the Popular Party's candidate for President, given his profound conflicts with him, he responded that there was a world of difference between Toledano and the other four candidates. Only Toledano's program took a strong position against Yankee imperialism, which was

> the fundamental root cause of all the troubles in our country. . . . Toledano's program is the . . . program that made the government of Cárdenas effective. It is a program that responds forcefully to the most serious and fundamental problems of the Mexican people at the present moment.[23]

Siqueiros and his family were now living on Calle Querétaro, a street well within the Mexico City limits, having moved there from the Tlacopac district in 1951. Angélica's mother, experienced in small real estate dealings, had purchased the old gray brick two-story dwelling that would require the addition of a studio. Its second floor became the living quarters for Siqueiros and Angélica, while Adriana and her grandmother had their rooms below. In a large front room on the first floor, Siqueiros installed his extensive collection of papers and boxes, and on the roof a third floor was added to serve as a studio. However, the new roof-top studio, its windows facing north, lacked the convenience of his ground-level Tlacopac studio, which had had a high, narrow slit door built for sliding large paintings in and out easily. Here the large works were moved with great difficulty.

On the other hand, the house on Calle Querétaro was more easily accessible to visitors, and the housemaid could often be seen answering the bell by leaning over the second-floor balcony and shouting down "Quien?" Poet Paul Eluard arrived from France and Siqueiros showed him the sights. When actor Gerard Phillipe arrived, Siqueiros enjoyed

the conversation in French. Composer Carlos Chávez came to Calle Querétaro, as did diplomats and the wealthy who sat for their portraits. When artist Jimmy Pinto from San Miguel de Allende brought Rico le Brun, the latter told Siqueiros that the search for new forms was of prime importance for art. To which Siqueiros replied, "Forms for the sake of forms?" And with regular frequency, members of the Communist Party arrived to discuss political matters.

From his first-floor archive on Calle Querétaro Siqueiros launched a new political-art newspaper. A forum was needed to defend the principles of the Mural Movement and respond to the ever-increasing attacks by enemies who were stimulated by the controversies swirling around the building of University City. The first issue of *Arte Público* in October 1952 reflected the clashes and conflicts between the university directors, its architects and the artists.

Arte Público, like *El Machete* of the past, was large in format and contained from twenty to forty pages. Donations and voluntary payments from writers to cover the cost of printing the material they submitted supplied most of the paper's funds. Sales of the paper, plus a few ads, added a meager sum. It survived for three issues and an equal number of reissued supplements. Typical of the opposition to it was artist Manuel Rodríguez Lozano's attack in a leading newspaper. He accused Siqueiros of doing everything in his power "to strangle Mexican art and de-Mexicanize it, converting it into something servile, which in Russia they call *art*. . . . [By propagandizing *socialist realism* he is working to brutalize the Mexican public and sterilize the Mexican artists."[24]

McCarthyism was rife in the United States, and its odor reached Mexico. U.S. citizens residing in the country felt its heat. "Foreign Reds Disguised as Tourists Meet and Conspire in Cuernavaca and Taxco," read the headlines of Mexico City newspapers, and they printed the names of North Americans accused of being communist conspirators.[25] It was a prolonged period of stark reaction, and Siqueiros once again had to face scurrilous attacks about the Trotsky affair. This time a Canadian "ex-communist" said that he had been selected by Lombardo Toledano and Siqueiros to be the one to shoot Trotsky, because he bore a resemblance to Trotsky's ill-fated guard, Sheldon Harte. The informant added other lurid details, and Trotsky's widow told the press that the Canadian spoke the truth. Toledano's reply that the charges were a vile calumny made headlines; he accused Trotsky of having been a spy for Nazi Germany, recalled that he and the Mexican Confederation of Workers had protested the granting of asylum to Trotsky, and said that the Trotskyites were dependent on FBI support.[26]

Diego Rivera commented: "From a great distance the affair has the smell of a Federal Bureau of Investigation. . . ." From the penitentiary, Jacques Mornard—Trotsky's assassin—called the story novel and reiter-

ated that he knew neither Siqueiros (the Canadian claimed he had seen them together) nor Toledano nor Sheldon Harte. Dionisio Encima, the Communist Party leader, said that Trotsky had not been killed for political motives but was the victim of a personal vendetta, and the Canadian's story was pure fiction.[27] Siqueiros attributed the new attack to "the Trotskyite section of the candidates for membership in the Secret Police of the Yankee Department of State," saying that when these "aspirants to the political police" finish with their "puerile techniques" of trying to sell their merchandise, he would present documents refuting their charges.[28]

Days no longer provided Siqueiros with enough hours for the immense amount of painting and all the other cultural and political tasks demanded of him. His nervous energy was at a high level and he began to experience sleepless nights. The wine that the doctor had advised him to take before retiring was of no help. He fought reaction with articles and lectures and the ever more powerful statements of his paintings. *The Good Neighbor* *(plate 42)*, one of the first works painted in his rooftop studio in 1951, showed Truman's imperialistic grip on Mexico.

Also painted there in 1953 was the small transportable mural *The Excommunication and Death of Miguel Hidalgo (plate 57)*, celebrating the second centennial of Hidalgo's birth. The mural had been commissioned by the Universidad Michoacana de San Nicolas de Hidalgo in Morelia and was an unequivocal statement of the historic event.

The mural, nine meters square, is painted on Masonite with pyroxylin. The spectator views the work from the station of a firing squad. With his back to a bullet-scarred wall, Hidalgo stands bareheaded and defiant. His right hand, which covers his heart, is marked by two large red bullet holes; his left hand, by his side, is clenched in a fist. The massive figure of a bishop stands in the foreground clutching a staff with the Cross on its top and its sharp bottom end piercing a red Phrygian cap and stuck in the ground. A round emblem attached to the staff's center bears the inscription:

> Excommunication and the penalty of death for Miguel Hidalgo for professing and spreading foreign ideas as a partisan of the democratic French Revolution. Through social dissolution he sought the independence of Mexico from Imperial Colonial Spain. Consequently he is a traitor to the country. July 30, 1811.

The high clergy who handed down the death sentence was, Siqueiros wrote,

> the inquisitorial arm of the Spanish colonial government and acted with the tacit (or implicit) consent of the Vatican. But is it not true that history repeats itself? That today, just as yesterday, high dignitaries of the Catholic Church, both national and Roman, in alliance with the "powerful," are fighting against

the contemporary causes of liberty, peace and social progress with persecution and excommunication.[29]

When the exhibition, "Mexican Art: From Pre-Columbian Until Today," opened in Paris at the Museum of Modern Art, both Siqueiros and Rivera were the objects of abusive attacks. Led by Trotskyites, the avant-garde and reactionaries sought to blot out any recognition bestowed on Mexican social realism. Surrealist Andre Breton and his followers were in the museum distributing leaflets attacking the museum and Siqueiros, "whose hands were stained with blood."[30] Benjamin Peret, who had been an associate of Trotsky in Mexico, wrote in the Paris weekly *ARS-Spectacle* that Siqueiros was "an assassin who stains the Mexican exhibition by his very presence," and "Rivera as a painter has degenerated because of his Stalinism."[31]

Two years earlier, in the same *ARS-Spectacle,* the critic Jean Bouret, writing of the Venice Biennial, had said:

> The consignment from Mexico has without doubt been the revelation of the Biennial. We expected an art that would be violent both in color and form but we were very far from realizing that the Mexicans had reached such a point of greatness, nobility, and powerful form. Their flame . . . is the sign of an extraordinary confidence in the destiny of their art and of their country.[32]

But when the Mexicans' work had been exhibited in Paris, Bouret had written nothing, which had led Siqueiros to comment: "Had the sinister hand of Yankee imperialism been at work? . . . Has there been politics, Yankee politics, among the partisans of apolitical art?"[33]

The publications of the French Communist Party had heaped praise on the exhibition and particularly on the work of the Mexican moderns, though Siqueiros thought their reaction revealed an incorrect evaluation of the significance of the Mexican Movement. What he wanted to know was whether Mexican social realism would inspire French intellectuals to question the nature and direction of French art? He had little use for commentaries that were "simply encomiums."[34]

A remarkable article, however, appeared in January 1954 in the semiannual *Twentieth Century,* a magazine intended for a devoted but elite public. Its pages were usually given to extolling the School of Paris but now suddenly had to deal with an important cultural event, the Mexican exhibit in Paris. The magazine's art critic, Philippe Soupault, "discovered" the Mexican School with enthusiasm, and presented a strong case in its favor. He compared his reaction to that upon seeing Egyptian art for the first time, and he was sure that the Mexican influence would be "irresistible."

Soupault expressed amazement at how the Mexican culture had endured and evolved over thousands of years, said it was still far from dead, actually more alive than ever. He found that

neither the wars of destruction between the peoples of ancient Mexico, the Spanish Conquest, nor the tyrannical influence of the United States had been able to interrupt its course. Its vitality is one of the most prodigious phenomenons of the history of art and cannot easily be explained.

Soupault had no knowledge of the Mexican socio-economic root causes and their cultural effects. However, his comprehension was deep and he was fully able to absorb the significance of the event, being especially perspicacious about the Mexican moderns.

Diego Rivera, in spite of his Parisian experience, his pronounced individualism, and the very marked differences between himself and his contemporaries Orozco and Siqueiros, was able to find the manner in which to be in agreement with them.[35]

To Soupault, the Mexican painters intended to confront Europe with their art by being "profoundly Mexican," and the effect was considerable.

The three great painters, precursors, indicated the road to the future. . . . European art, influenced or dominated by the painters of what has been the School of Paris, has without doubt for a long time been found to be on a dead-end street.

Soupault then apologized for being so categorical, and explained:

. . . viewing the strength and originality of the Mexican painters, the great majority of the "artists" of Paris refused to understand the eminent value of [their] painting. It can be said that they are fearful and like ostriches prefer not to see or admire them. Without doubt they have been disturbed and feel dwarfed or paralyzed before men who express themselves with complete freedom, without prejudice, without believing that they are obliged to adore and imitate the fetishes of fashion.[36]

Soupault understood that the Mexicans were not painting for a privileged circle of the "informed, and of rich amateurs," or even for the museums. Their art was mindful of the people, who received its message directly without the need of intermediaries to explain it.

The contact with the people of their country has permitted the Mexican painters to escape the asphyxiating atmosphere of the "studios," and to immediately know the reaction of those for whom the art is produced. They know that this way coincides with those creating the popular art that flourishes on every street corner to the far ends of the country.

He marveled at how the exhibition so ably "synthesized the evolution of a civilization that is still prodigiously vital, that continues its two-thousand-year march, and will be recorded as one of the most important facts of these last fifty years."[37]

For Soupault, the *revelation* of what the Mexicans had done throughout the history of their art was reason enough to discard the historians' classi-

fications of regular cycles in art history—of high, low and decadent periods. "Mexican art proves to us that given a favorable climate, a civilization can develop and renew itself without declining." He praised the Mexican artists for fearlessly showing their work in the heart of an art world created by European critics, speculators and North American merchants, though the "violence of the Mexican painters" could not avoid colliding with the "snobbism of the New York critics." This, Soupault wrote, was "natural and necessary," and the explosive nature of the Mexican paintings would produce its full effect in the "foul air where the artists of Paris live." Though he would not predict exactly what would result after the exhibition, he stated: "At any rate it seems impossible that a force so powerful, over a more or less long period, would not exercise some reaction."[38] It may be that Soupault's words fell on deaf ears, since the exclusive magazine was $12 per copy, but Siqueiros had the article reprinted for popular distribution in France.

19

Murals and Architecture

Rivera—Siqueiros Praxis

Siqueiros and Angélica, and Gertrude and I got out of the car, which Angélica had parked near the entrance of María Asúnsolo's house in the fashionable Pedregal section of Mexico City. At the front gate stood Diego Rivera greeting the many arriving guests, kissing the hand of each woman. The garden of the Asúnsolo home was the setting for a grand banquet that February 17, 1952, an act of homage being paid two guests of honor: Diego Rivera and David Alfaro Siqueiros. Among the more than a hundred guests assembled were General of the Revolution Heriberto Jara; Marte R. Gómez, Minister of Agriculture and Finance under President Portes Gil; archeologist Alfonso Caso, composer Blas Galindo, writers Carlos Noble and José Mancisidor, architect Enrique Yáñez, and Communist Party officials and members.

Rivera and Siqueiros, flanked by distinguished guests, were seated together at the center of a long table. Two long tables, perpendicular to it, were for all the other guests. A banner across the garden and over the main table carried a lauditory tribute to the two painters. Food and drinks filled the tables. When the long round of speeches and toasts ended, and the two painters had finished with their own rousing comments, simultaneously, as though they had rehearsed it beforehand, they whipped out pistols and fired into the sky above, while the guests jumped to their feet yelling and cheering. So varied a gathering rendering honor to the two communist painters (though Rivera would not be readmitted into the PCM until 1954) attested to the artistic and critical prestige they both enjoyed. Even though his third petition to rejoin the PCM had been rejected, Rivera remained a faithful supporter. But aesthetic and political differences between him and Siqueiros were as frequent as ever. Rivera had told a reporter that the

> Biennial was a business organized by the "merchant" of paintings Knoedler and other "dealers" of abstract and semi-abstract art for the purpose of selling pictures, and for this reason Siqueiros was trying at all costs to participate in it.[1]

Rivera wrote to Siqueiros asking him to join and help organize the boycott of the forthcoming Biennial in Sao Paulo, Brazil. Rivera had just returned from a meeting of the Congress of Culture held in Santiago, Chile, and he claimed that a committee of the Congress had passed a

formal decision that the Biennial of Sao Paulo was to be boycotted. As he said in his letter,

> . . . it was agreed that the exhibition was an instrument of imperialist penetration directed from behind the scenes of UNESCO and in agreement with the upper bourgeoisie, especially the Brazilian pro-Yankee bourgeoisie. The facts of this obvious tendency were confirmed by the different delegates . . .[2]

Siqueiros was amused, perturbed and wary when he read the letter, which also informed him that Rivera was fulfilling his obligation to bring the information to Siqueiros's attention. Mindful that Rivera might have other motives leading him to reject the Sao Paulo Exhibition (Siqueiros's triumph in Venice), Siqueiros minced no words in his reply:

> In the name of a supposed meeting of Communist painters in Santiago during the Continental Congress of culture, you who are not a member of the Communist Party ask me directly, painter to painter, without in the slightest concerning yourself with the political aspects, since *I am* a member of the Party, to swallow some sort of boycott, which seems to be only continental, against the Biennial of Sao Paulo. You say you can prove its character as a "maneuver of imperialism and UNESCO in support of decadent capitalist art." And you . . . [refer to] a petition of the Brazilians attending the above meeting, and nothing more.
>
> Do you perchance believe that such "surprises" of a . . . bureaucratic nature . . . are able to produce an effect on my conscience and will as a Communist? . . .
>
> I am naturally going to respect what the upper councils of my party determine, but you can be sure . . . the Political Bureau will absolutely not be able to make any determination if you do not respond in person before the artists of the Party to the following questions.[3]

In 18 questions, Siqueiros exposed the illogical nature of the boycott. Who exactly had convened the meeting in question? Who were the delegates, and whom did they represent? Were any of them Communist Party members, and if so, did they speak for their parties? Since the Mexican Communist Party had never received word from its delegates in Santiago, did Rivera know if other Latin American parties were conscious of the move? Could he explain what "documentary proofs" indicated the "imperialist maneuver"? And in what way was Sao Paulo politically different from the Venice Biennial, from Genoa, or from exhibitions in the Museum of Modern Art in New York? Who had been first to put forward the idea of a boycott? Picasso and other European artists would be in the exhibit; could Rivera explain to the artists of the Party why the boycott was to be only continental and not worldwide? And why had not Oscar Niemeyer, the Brazilian architect and Communist Party member who was designing structures for the Sao Paulo centennial celebration of which the Biennial would be a part, been asked to join the boycott? Could

Rivera also explain why Candido Portinari should not withdraw his mural for UNESCO? Did not Rivera and the others realize that the Mexican social realists, including the very political printmakers of the Taller Grafica Popular, would be playing the same role that they had in the Mexican exhibit which toured the world?[4]

Siqueiros ended his letter admonishing Rivera that advocating a boycott was a disruptive act, but he did not spell out his own conviction that Rivera would rather keep the Mexican artists from participating in the Sao Paulo Biennial than afford him, Siqueiros, the opportunity for having his works further acclaimed.

Rivera, choosing to remain in the good graces of the Communist Party, dropped the issue. Two months after his wife, Frida Kahlo, died and 25 years after he had been expelled, Rivera was welcomed back into the Party (July 13, 1954). The PCM was resigned to contending with the great painter's eccentricities, as was Siqueiros when the two shared the task of knocking on the doors of rich acquaintances from whom they sought donations to aid the Party.

Three new murals had been in various stages of development since early 1951: one at the Hospital de la Raza, one at the University City administration building, and a tiny work on the facade of the Fabricas Automex office building. The latter work, 10 meters long by 4 meters high, had a theme devoid of social content and could be said to be the experimental prototype for the University City exterior murals.

Fabricas Automex was a Chrysler Corporation assembly plant, and the architects of its new ultramodern office building, Guillermo Rosell and Lorenzo Carrasco, had designed a small wall facing the street expressly for a Siqueiros mural. On this wall—it was inclined slightly backward—Siqueiros created his first sculptured painting. Basically a bas-relief, it was covered with colored ceramic, the paint of that period being considered insufficiently permanent for outdoor use. This polychrome method, the ceramic mosaic, was an archaic technique that Siqueiros resorted to with great reluctance.

In keeping with the nature of the building's function, the mural's title was *Velocity (plate 61)*. Siqueiros studied the problem of the composition with a small scale model of clay, a bas-relief of a female figure in an attitude of speeding forward motion. In creating the composition, photographs were taken of the wall from various angles, which related to the spectator driving rapidly by; to search out the dynamics that would turn the wall toward such viewers, Angélica drove Siqueiros back and forth on the street past the wall. After he painted the composition on the flat wall, using a vinylite paint, workmen following the scale model built the relief, which was then covered with the colored ceramic by artisans.

At the Hospital de la Raza the false wall surfaces to be painted were

installed by three or four members of the mural team. Architect Enrique Yañez had modified the intersections of the plane surfaces of the spacious hospital auditorium lobby to conform to the shape that Siqueiros desired, eliminating their right angles with curves. Steel stringers fastened to the brick wall supported the surface to be painted, which was slightly curved and leaned a bit forward. The walls were of Celotex, the ceiling of plaster, and the curve that joined the walls was of concrete; the entire surface comprised 310 square meters and was reinforced with a covering of strong cotton cloth attached to the surfaces with carpenter's glue. The large smooth plaster surface of the ceiling had to be rasped by hand with stones before the cloth was glued on.

Here, too, José Gutiérrez supervised the priming of the surface, using clear vinylite prepared on the site by dissolving vinylite beads in methyl isobutyl ketone. Once the team had built the scaffold, which moved about easily on casters, Siqueiros was ready to analyze the mural surface. The first step was to determine the average trajectory of persons who entered the lobby, and this was marked on the floor. From various stations on this trajectory, Siqueiros conceived the fundamental forms of the composition. His first objective was to make the wall and ceiling surfaces disappear by creating an illusion—as forms and lines were extended from wall to wall, and wall to ceiling—greatly enhancing the effect of space.

For a mural in a hospital, a motif related to medicine was the logical choice, and it bore the title, *For a Complete Social Security of All Mexicans*. In the hospital's main entrance Rivera was painting a mural in fresco of the history of ancient and modern medicine. The director general of Social Security, Antonio Ortiz Mena, took the unusual step of requiring Siqueiros to submit a sketch of the work beforehand. Suspecting opposition to his work, Siqueiros complied with a scale model of the room that showed a painted scene of doctors operating, and of healthy happy humans. Once the project was approved, Siqueiros without further ado proceeded without a sketch to paint his Marxist solution to the problem of medical care.

The sequence of the mural's theme moves from dark to light *(plate 52)*. Factories and skyscrapers of modern capitalism, on the dark side, rise up on the left wall and reach to the middle of the ceiling. From the spectator's vantage point they rise vertically into the ceiling space. Below these structures a conveyer belt moves toward the spectator, producing a dead worker. The spectator's eyes move up to a floating, agitated red figure enveloped in flames *(plate 53)*. The "turning" head of the figure is in the confluence of the three planes of the mural surface—a center of gravity from which the action of the mural radiates. This figure, powerfully painted, dives toward the spectator, (when seen from the opposite side of the room) its feet trailing away from the viewer and off into space. Yet the entire figure, from the back of the head to the feet, is painted on

the ceiling. The feet, which appear to be farthest from the spectator, are in actuality nearest. The illusion is startling, for as the spectator moves forward the agitating figure of the "revolution" flips in the opposite direction, adding to the mural's cinematographic effect.

This was certainly more than the Instituto del Seguro Social had bargained for, but Siqueiros intended to paint medical doctors in the mural and perhaps this would allay some fears. Following next in the sequence, a procession of women march in the direction toward which the floating red figure points. Majestically painted, they bear in their arms elements of life: an infant, wheat, flowers, and a paper scroll on which are the rights of women. By this time Siqueiros's powerful nonacademic new-realism has taken hold of the spectator. The women marching across the space of the front wall are heading for a new life—the mural's denouement. Leading them, at the right end of the front wall, are a male and a female worker—the vanguard. The male worker, a miner, grasps in his hand the switch with which he controls the power to industry *(plate 54)*. Wearing a red dress, the female worker supports a huge swirling Mexican flag, the red of its tricolor wrapped around her hand symbolizing the unity of Mexican workers. Immediately behind this working-class vanguard is a group of doctors, symbolizing the medical profession and the only reference to medicine that Siqueiros saw fit to include.

Nor does the exegesis of the mural end with that group but rather on the ceiling above, where the socialist future is represented by a red Aztec pyramid, flanked on one side by a red Kremlin tower and on the other by a Chinese pagoda. In the foreground, connected to the switch held by the worker below, is a nuclear reactor. For the period in which they were painted, the combination of symbols was valid.

With this mural the cinematographic effect he was seeking seemed near at hand; his technical-compositional input produced results startling even to himself. "I have never done anything like this before," he thought aloud.

At one point the work had to be interrupted for a number of weeks while Siqueiros lectured in Poland. Not wanting to antagonize the Seguro Social bureaucrats, Siqueiros sought to cover up his absence by having me paint anything at all on the wall while he was gone. Whatever it was would be painted out the moment he returned to the mural. He came back with news of a new mural commission for Poland which, however, never materialized.

During the three years it took to paint the La Raza mural, work on the University City murals was also begun. Siqueiros was pushing hard to complete the hospital mural, putting in long hours on the job. When he put down his brushes to take his midday meal he crossed a dirt road near the hospital and entered a dingy working-class restaurant for soup and chicken (never *frijoles,* which disagreed with him). Usually accompanied

by a handful of painters who were assisting him, the conversation was most often full of good humor.

The day of his fight with Tamayo, Siqueiros arrived late at the mural. He was attired in his black business suit, white shirt, dark tie and gray fedora. That morning both he and Tamayo had served as judges at a government-sponsored art exhibit. When all those officiating gathered together for the occasion and were shaking hands, Tamayo balked. "I won't shake hands with that son-of-a-bitch," he blurted out, referring to Siqueiros. The two fell to blows, tumbling to the ground before they were separated. A short time before, Siqueiros had rankled Tamayo by sitting in the front row at a Tamayo lecture, taking issue with the points being raised.

When the *Los Angeles Times* commented on an exhibition of Tamayo's paintings that opened in Los Angeles, the report included some comments from Tamayo:

> There will be no call for critics to look for communist symbols in the earthy modernist works of Tamayo. For he among Mexico's great artists is an anti-communist. More than that he is a militant foe of communism. And he carried his feelings to such an extreme the other day that he hit David Siqueiros on the nose in a hot argument in a government art gallery in Mexico City. "I brought about the fight deliberately," Tamayo said proudly . . . "I thought it was time we brought our disagreement to a head. . . . I refused to shake his hand so we fought. . . ." As to the power of the Communist Party in Mexico, Tamayo is also outspoken. "The Communist Party is very small in our country. It has always been small. But like Communist activity elsewhere, it is very vocal. It shows its influence in many things, as in the work of my fellow painters Siqueiros and Rivera. Rivera is not now a party member—but this was because he was kicked out of the party. He still follows the party line."[5]

Siqueiros said only, "in the fight referred to, the only thing that was hit—and luckily, lightly—was the confessed provoking mouth of Tamayo. And this was clear to those present,"[6]

Tamayo had always defended his position outside the Mural Movement on the political grounds of anti-communism. Two years earlier his wife, Olga, had sent a letter to Rodrigo de Llano, director of the newspaper *Excelsior*. In it she said it was her duty to warn him about the ideological position of the French periodical *Les Lettres Françaises*. Allowing it to be quoted as a source of information meant that *Excelsior* was printing left-wing propaganda.

> . . . there [is] in all the Communist parties an order from Moscow not to praise any art but that done by their members and *social-realist,* that is, based on themes for which they have an affinity. . . . I don't think it necessary to point out to you the political affiliation of those Mexican painters who

themselves—and order their coreligionist writers to—cruelly attack not only Tamayo but all artists and writers who do not obey the party line.[7]

Olga Tamayo's letter was printed in *Excelsior* and Siqueiros attacked it in *Arte Público,* saying that it

was composed by [art critic] Margarita Nelkin, who was expelled from the Spanish Communist Party and is today a "passionate Marxist" enemy of Mexican painting of a social and realist intention; that her editing was known to Rufino Tamayo, the somnambulistic servant of the provocateurs, and was signed by his wife Olga. So it goes—so as to give comfort to the [FBI] in its struggle for "freedom of artistic expression in Mexico!"[8]

The incident with Tamayo passed into history, and the mural at the Hospital de la Raza was completed. Amid mutterings of discontent and glum expressions on officiating dignitaries, *For Complete Social Security of All Mexicans* was inaugurated on March 18, 1955. The director general of Seguro Social sent his subdirector, as did the director general of the Institute of Fine Arts. There had been many delays and attempts to halt the inauguration of the "shocking" mural, but in the end the authorities bowed to the awe-inspiring work of art, which had little in common with the model they had approved.

Critic Alberto Pulido Silva wrote:

This is perhaps Siqueiros' greatest achievement; it possesses such dynamism, both in its theme as well as in its projection over the surfaces, that it seems to be a three dimensional film scene of great color and brilliancy.[9]

Juan Crespo de la Serna wrote:

From the day it was inaugurated with all solemnity, it was to me a complete unity that was fully cohesive. There is no doubt that it is an example of the perfection of a plastic language. . . . He has on this occasion come nearer to filling the requisites of monumental public painting and contributing more to renovating the methods and visions in the modality of mural painting for the entire world.[10]

The seas remained calm for the mural. The medical professionals who walked beneath its message took it in their stride, and for Siqueiros no storm had to be weathered.

The University City Struggle

The *Rectoria,* the administration building of the National Autonomous University of Mexico—University City—was fifteen stories high. Never had Siqueiros had so much open space surrounding large exterior walls to be painted. Unable to influence the planners of the university to enlist their aid, the artists had to be content with the random walls issued them

in the seemingly haphazard university plan. The sense of a unified design with integrated areas for murals, which Siqueiros had forcefully urged in speeches and conferences, did not prevail. Instead, within the agreed modernist scheme, individual architects were assigned the various colleges to design and just so, in the end, were the painters assigned to various walls. At least the Mural Movement still had the strength to keep abstract painting—so much used by avant-garde architects—off the buildings, thus forcing a reluctant acceptance of realism.

Siqueiros moved around the *Rectoria* while it was still in its early stages of construction. The great outdoor space surrounding the building required strong forms in the murals; besides, they would be visible from a great distance. He circled the tallest university building and contemplated each of the four sides to be painted. The massive south wall, visible from the nearby highway, would have to be designed for spectators rushing by in cars. The bottom edge of the east wall, which projected out from the building, was five stories up. It would be the focal point for students moving about the quadrangle. The smallest wall, on the north, would greet students at the main entrance, and the west wall at 15 stories high, dominated that side.

At the top of the west wall he would paint a brilliant diamond that would send shafts of the light of knowledge down the 15 stories into the open hands of the recipients of learning. Siqueiros sent two helpers to the roof to paint a sample of form and color at the top of the wall. With brushes fastened to long sticks and cans of paint, they climbed the stairs of the unfinished building. On the roof, buffeted by the wind, they lay on their stomachs, reached over the edge with their long-handled brushes and painted a preliminary form in bright colors, as Siqueiros had instructed, on the dark brown ceramic brick. Eventually, as university support for the murals dwindled, Siqueiros was forced to abandon this wall.

With Angélica at the wheel, Siqueiros was repeatedly driven past University City on the Mexico City–Cuernavaca highway in order to study the south wall of the *Rectoria* from the moving vehicle. Two huge wooden scaffolds the height of the south wall were constructed to roll on a trestle with wooden tracks. Preliminary lines—diagonals and bisectors—divided the wall into its geometrical components. Thus Siqueiros searched out the dynamics of the rectangle (9×33 meters), and the harmonious divisions became the basis for the composition to follow.

Moving about, he strategically selected spectators' trajectories, including the highway. Siqueiros began to create the composition. Huge circles representing the heads of figures were put in place, and the bodies were established with straight and curved lines. At home in his rooftop studio, he produced a detailed scale painting of the mural on a masonite board (1×3 meters). He now titled the mural, *From the People to the Univer-*

sity—From the University to the People: For a New-Humanist National Culture of Universal Profundity (plates 58, 59).

Simultaneously, work was begun on the east and north walls of the building. Twelve student artists—most of them young—made up the mural team and were paid a small wage from the meager funds received from the university. Once the basic elements of the composition had been painted on the walls, the team—hopefully the extension of Siqueiros's fingers—carried the work forward, referring to small paintings that he had made of the details. But for the south wall, uncertainty remained as to what the finished form would be, for Siqueiros had not resolved the technical problems that would allow him to wrench from the wall the image that was burning in his mind.

The east mural's location and surfaces were unusual. A concrete box two stories high, which encased a small auditorium five stories above ground, protruded three meters into space. The team members worked from a five-tiered scaffold suspended by ropes from steel girders fastened to the cube's top surface, swinging in the breeze between the fifth and seventh stories. To be painted were the cube's wall that faced east, two partially visible side walls and the underside—some 250 square meters. On this multiple surface, overlooking the main quadrangle and visible from a great distance, two gigantic birds were painted: the eagle of Mexico and the condor of South America. This was a new representation of the university's emblem, titled: *New University Emblem.* The two birds symbolized Latin American unity *(plate 60).* The painting on the flat concrete surface was the prelude to the sculpture-painting Siqueiros hoped to achieve in this mural.

On the north side, over an unobtrusive main entrance, a long horizontal wall of 130 square meters welcomed the matriculating students with its mural, *The Right to Learning.* Repeated forms eliminate inaction—an arm, its hand grasping a pencil with which it points, is thrust the length of the wall, while other hands reach out ahead toward an open book displaying the important dates of Mexico's struggle for liberation, the final date entered by Siqueiros as 19??.

It took all of 1952 to cover the three walls of the Rectoria with what was for Siqueiros the *abbozzio,* the preliminary draft. A long pause followed, many technical and financial problems having arisen and put a stop to the work. But the public took the murals to be finished and began to comment adversely. Not only was Siqueiros experiencing great technical difficulties with the sculpture-painting that he had resolved to attempt for these murals, but the administrators in charge of construction were beginning to pressure him to give up on developing the murals any further. He fought for additional funds to build the cement reliefs and cover everything with ceramic mosaic. He detested the ceramic material, but the permanence of its color for outdoors made its use during that period

mandatory. Siqueiros hoped he could avoid the "Byzantine" appearance it usually had, as in the *Fabricas Automex* mural.

Siqueiros made some effort to find a better material. At one point a ceramic paint used to label bottles, which required the application of heat, was investigated and found not suitable over cement. Nor for that matter did he find it feasible to use colored aluminum, another new material he greeted with great enthusiasm. A German chemist who had developed a process of anodyne oxidation or electrolytic oxidation brought samples to the mural of the colored aluminum he created. In the end, the economic factor forced Siqueiros back to the ceramic mosaic. He did manage to bring some change to the ancient style by urging the manufacture of pieces in sizes as large as possible. With rectangular pieces that measured 5×15 centimeters, Siqueiros was able to escape the traditional tiny ceramic pieces.

In December 1952 the unfinished university mural had its Day of Dedication; it was being inaugurated prematurely to honor President Alemán, during whose regime it had been built. On that day Siqueiros's *New University Emblem* mural, his great eagle and condor, was obliterated, covered by a huge banner with the official university seal. To add insult to injury, the last checks issued by the Alemán regime to Siqueiros and Rivera bounced for lack of funds.

In June 1953, Siqueiros received a letter from the chief engineer of the *Rectoria* ordering him to remove his scaffolds within five days; if this was not done, the university itself would complete the task.[11]

Greatly distracted and irritated, Siqueiros wasted much time running from one bureaucratic office to another, but finally—with help from the new Ruiz Cortines administration—he was given the go-ahead to produce two samples of sculpture-painting directly on the north and south walls of the *Rectoria*. To carry out this task he was permitted to keep his scaffolds in place for another month, but then they would have to be removed at his own expense. It was agreed that the scaffolds were to be returned to their former position once certain construction on the building was completed. The new government also agreed to grant Siqueiros the equivalent of $1,500. to produce a model that would illustrate the nature of the sculpture-painting he intended for the eagle and condor on the east wall. Siqueiros, however, had no faith that the money would ever be forthcoming, and in the end he was right.[12]

It was at this time that Siqueiros sent a letter to the secretary general of the Communist Party, Dionisio Encina, explaining why he had to be excused from traveling to Monterrey to a meeting:

> Next week a crisis is coming in my struggle to keep my University City mural from being put off until next year. . . . If this is done it will cause me true economic catastrophe since I have spent out of my own pocket nearly forty thousand pesos . . . for which they do not wish to pay me. . . .

[F]our days ago I began the sketch for a portrait of architect Lazo. Saturday, here in my house, I begin the portrait, . . . with the promise to finish it the same week . . . he wishes to present it to his wife . . . for their anniversary. This portrait represents for me contact with the very gentleman on whom at this moment the [University] murals depend. . . .

Still more . . . I have to organize the collection of my works to go to Brazil . . . and finally the grave economic situation . . . has forced me in an extra urgent manner to paint a series of small things in order that tomorrow Saturday, and the next Saturday, the wages of my workers and helpers will be paid. In short, I hope you will understand my exceptional problems and why it is absolutely impossible for me to go to Monterey until all these problems are resolved.[13]

He also told Encina about his need for help in the struggle against the university and the reactionary forces that were mounting a campaign against him. He urged Encina to call a meeting immediately of the artists who were members of Friends of the Party, to enlist their support, since attempts were being made to sabotage his murals. Siqueiros further warned that there was among the Friends, "opportunism and a failure of intellectual probity," and that too many of them were for economic reasons ingratiating themselves with architect Lazo, who as the new minister of communications and public works had jurisdiction over murals on public buildings.[14]

In the midst of his battles with the University City architects and engineers, Siqueiros presented a lecture in their social and cultural center, Casa del Arquitecto—"International Architecture at the Tail End of Bad Painting: In Mexico the Abstractionism of Paris and Our 'Mexican Curios'* Plot its Destruction." He told his audience, mainly architects, that they could not deny the influence that the formalism of Paris held over Mexican architecture; that in the past, architecture had been plastically integrated with the arts but its dismemberment began during the Renaissance with the private acquisition of art. He quoted Raziel Cabildo, leader of the art students' strike in 1911 who, before the Revolution, had said, "Painting separated from architecture is like a dead organ ripped out of a vital body. And architecture without painting and sculpture is a body without a voice."[15]

Siqueiros made the point that after the Revolution the painters had adopted *realism,* whereas the architects had taken the road of *style,* developing neocolonialism or "Mexican colonialism." Neither the architects of the "sterile neocolonial style" nor the "functionalists" who followed Le Corbusier had seen fit to add art to their buildings. The architects of the Mexican colonial style claimed that the murals of the new Mexican art movement did not fit in with their architecture; on the other hand,

*Term used by Siqueiros in condemning Mexican painting that catered to the tourist trade.

the functionalists claimed their architecture possessed its own plastic integrity, so they did not support adding art to it.

After the Revolution, the new rich followed not only Le Corbusier but Frank Lloyd Wright and the modern Germans, and at the same time a false nationalism arose in the arts, a "Mexican decorativism." Finally, art for art's sake arrived from Europe and the United States.

> It was an art for the select few, our new rich were enthusiastic. There was nothing more interesting for a member of the new rich than that which they do not understand, and pure art, the aristocratic abstraction, began to develop. It is now bad taste not to follow the aesthetic line of Paris—in woman's fashion, and in painting, sculpture and architecture.[16]

Siqueiros next turned his attention to what those who had filled the small lecture room were waiting to hear, the design of University City. First he emphasized the importance of constructing such a vast architectural project and then reminded the architects that the claim had been made "that it would be built by Mexicans with Mexican materials."[17] The project should have been a great opportunity for the plastic arts of Mexico, and he expressed disappointment that muralists had not been included in its planning. Though he credited the architects with making an effort to abandon the Le Corbusier concept of the building as "machine," he lamented that architecture itself, as he described it, had become considered either sculpture or painting. For him Cuidad Universitaria represented Mexico's greatest architectural effort, but it was under the influence of European formalism.

> There is an enormous quantity of "ears," of useless cartilage with no reason for being, costing the nation millions. Such is the consequence of pictorial plasticism's influence on architecture. In University City the amount of useless designs . . . made for artistic reasons, for reasons of "beauty," is enormous; there are scenographic designs that lack any sense of architectural function. In University City there is evidence of the most negative thinking presently dominating the intellectual atmosphere of our country. I refer to this unrestrained love for the antique—the most paradoxical and strange thing in modern art—for the old, for the rudimentary, for the rustic.
>
> Following Frank Lloyd Wright, we put stones into the houses that fence in pigs in the country, "because the stones of these pigsties are beautiful." What are these patches, these cartilages . . . of University City? They are concrete, but covered with stone. Is there any difference between this architectonic fact and the hollow columns of California architecture? They are exactly the same. Is it that we, living in a land of great pre-Hispanic architecture, have forgotten that the walls or ramparts of stone, in truth constructed in stone, were invariably painted? This came about not only because form without color is not form—this was perfectly understood by *the classics*—but because the paint covering impermeabilized the stone.[18]

Siqueiros spoke of the two currents operating in Mexican architecture that were so evident in University City: the "Le Corbusier cosmopolites"

on the one hand, and on the other those who wanted to "Mexicanize" architecture by "covering the same cosmopolite structures with costumes: *huiples* (a native dress) and Mexican shirts—a typical North American just returning from Cuernavaca." Questioning the notion of creating a beautiful architecture with ornamental tricks, Siqueiros warned against copying pre-Hispanic monuments without understanding their relationship to the time of their creation. With soul-searching eloquence he told the architects they were in error and would be "lost," if rather than follow the solution to their problem they permitted their style to come first.

The one work of all the structures that he found architecturally valid was the sports stadium, but he criticized Rivera for having used archaic materials (natural colored stones of Mexico), which produced a primitive work. He decried the false idea that a Mexican national architecture could be created by covering the outside of the buildings with ancient and traditional Mexican motifs. Such an architecture for a country so poor,

> where people slept in the streets, hundreds of thousands of children were hungry, sixty percent of the population were illiterate; where peasants die of hunger, where so many fundamental things still remain to be done, these "snob" manifestations, suitable for fashion designers, are not only stupid, but criminal.[19]

Before ending his lecture, Siqueiros offered the architects hard advice, pointing out the direction they must take to create, for social reasons, a practical and realistic architecture. The "a priori cosmopolitan, pre-Cortésiana" artistic expression must end. Mexican architecture has to have a popular feeling, but not as it is being produced, with an "aristocratic intellectualist feeling disguised as popular. No decree can change it. Only through systematic and critical revision of what is being done can change be realized."[20]

His remarks were not happily received, and a few days later architect Mauricio Gómez Mayorga told the press that Siqueiros simply did not have any idea of what was going on in Mexico in recent times, that right after the Mural Movement started in 1922, Mexican architecture also started in a new direction with José Villagran García's Institute of Health, and Carlos Obregón Santacilia's Ministry of Public Health.

For Gómez Mayorga, Siqueiros's "integration" was seen as having political undertones, and the architects were not going to permit the painters to get a foot in the door of their domain. Plastic integration would come, Gómez Mayorga said, as a result of "stylistic maturity; one need not search for it but only arrive at it." What Siqueiros and the rest of the painters wanted, he said, was to

> put words to the architecture without concern as to whether it suited it or not—like the vulgar, who when they find a piece of music they like, cannot

resist putting words to it. They believe that in everything, through style, there is a message of "social redemption" or any other thing. They do not understand that a wall has a value, as does the beam or the column, that they have value for themselves, and it is not necessary that crude works, ridiculously putting down words in order to say something, be painted on top. It is he who does not feel the tectonic, the structural, the essential, the formative of the architecture. It is he who has to paint everything with a public message, who wants all our buildings to be painted because otherwise they would remain without knowing what to do.[21]

"The buildings should not be tattooed, not one vulgar nontranscendent tattoo!" Gómez Mayorga was quoted as saying. He defended modern Mexican architecture, which Siqueiros had called neo-Porfirioistic because of its political and intellectual dependence on foreign influence, as in the days of Porfirio Díaz, maintaining that the Mexican architects in their thirty years of struggle had broken away from the academy and Porfirioism, and had finally won "a struggle to the death with the patrons to make them accept the *modern* truth." Denying any neo-Porfirioism, as Siqueiros expressed it, Gómez Mayorga then proceeded to list the architects who had inspired the Mexicans, from Frank Lloyd Wright, Mies van der Rohe and Walter Gropius on through Le Corbusier. For him, revolutionary painting and modern architecture were in contradiction, and Siqueiros at the university had broken with the architecture; he "seeks to disintegrate it to the benefit of the painting." Siqueiros agreed that, for technical reasons, art was subordinate to architecture, but claimed the architects had employed art, not from the start, as an integral constituent, as he had urged, but as an afterthought.[22]

Architect Raúl Cacho Alvarez also joined the war of words and gave a statement to the press attacking Siqueiros and defending the highly touted modern architecture of Mexico. He charged Siqueiros, "a declared Marxist," with attempting to lead a new revolutionary movement while "he paints for the [North] Americans and attacks the architects on whose works he is painting murals."[23] Cacho Alvarez agreed with Siqueiros that problems could be resolved with cooperation, but then stated that today there was no necessity for "flashing *caudillos* or epic heroes." He took Siqueiros to task for his attacks against Mario Pani, Enrique del Moral, and Salvador Ortega, the architects of the *Rectoria,* and then asked:

> Why does this militant Marxist with his dislike for abstract painting, which he considers to be out of place in Mexico and a product of bad hidden desires that come from both the French and the North Americans, why is this enemy of the forces that he calls imperialist, painting a decorative mural on the facade of the building of the North American company, the Chrysler Corporation?[24]

Cacho called University City "the greatest example in the world within functionalist architecture" for architectural teamwork and he apologized for there being so few walls to paint. However, he praised the chief architect, Lazo, for affording the recognition and importance that he had

given to Mexican painting.[25] There were then only five painters doing murals on the huge university, and though Raúl Cacho claimed there was teamwork among the architects, there was little between architects and artists.

Siqueiros alone spoke out but his voice criticizing the foolishness and frivolity of the latest architecture was heard, and he very much upset the "daring" Mexican architects. The press sought his opinions:

> You can imagine tourists, seeing the sports area from the highway, saying "Look there is a pyramid. Stop the car, let's go investigate it." And when they get there what do they find? They find it's a modern fronton court.

The architects never failed to respond with personal attacks and never tired of accusing him of selling his works to the bourgeoisie. His portraits were always in great demand; even Carlos Lazo, chief architect of the university, sat for him. This brought more attacks from architects who could not afford the luxury, to whom Siqueiros responded:

> I sell my portraits, not my ideology. Perhaps painting this portrait implies the sale of my political ideology to the particular functionary? Or is it the reverse: the fact that I am producing such a work obliges architect Lazo to accept my own political or aesthetic points of view? Lazo pays me with money, and in no way with capitulation.[26]

Siqueiros also questioned whether there was not a similarity between

> the spectacularly artistic character of the Palace of Fine Arts (built by Porfirio Díaz) and the new-Porfirioist new National Conservatory of Music? . . . They are constructing buildings today that are obviously absurd, expensive and either totally or partially lacking all practical sense, as happened during the most demagogic period of General Díaz; with the money of the people they are building for the service of the select few.[27]

The furor stirred up by his Casa del Arquitecto lecture had produced so much distortion that Siqueiros invited the press and intellectuals of all persuasions to his studio to listen to a tape recording of the "odious" lecture. Then on October 9, in the larger Manuel M. Ponce auditorium of the Palace of Fine Arts, to a packed audience, he delivered a second lecture: "Artifice and Social-Aesthetic Truth in Architecture or, What They Said I Said, What in Effect I Said, and What I Failed to Say."

He continued with his thesis that the Mexican architects reflected

> the European and Yankee "Vanguard Styles" . . . developing an architecture that could be described as scenography, "sets," and this, for reasons primordially emotional and artistic they conceived through the apriority of style.[28]

Modern architecture, he explained, was outside any reality that would correspond to Mexican nationality. This "young architecture and fumbling plastic integration," was an obvious manifestation of a new Porfirioism, which new public construction and the "thousands of recent private

constructions in the districts of the rich" bore out. Besides, how could architects and artists of "aristocratic intellect, with no solid political base, whose doctrines and practice were more ornamentalist than constructive," meet the needs of the Mexican people, at their present historical stage, with functional architecture and plastic integration? With the government spending millions to meet national needs, as required by the Constitution, was the public responding, both practically and artistically, as they had in the past to "comparable great works"?[29]

Siqueiros hammered away at his points ever more forcefully. Was the new architecture "any different from the spectacles and pageants that Porfirioism produced during its epoch of great economic demagogy"? And now, all construction was permeated with "commercial speculation," affecting "a fundamentally decorativist plasticist tendency that disavowed any outside authentic functional fulfillment." He further claimed that combining the emphasis on the abstract of the Paris School with the Mexican decorative served the "commercially speculative and formalist inclination of architecture," an alliance little affected by the Mural Movement.[30]

In the end Siqueiros told his audience that it was the new national bourgeoisie that had developed out of the Revolution, combined with the "remains of the old Porfiristas," who were the power controlling commercial architecture as well as the plastic arts. He felt it was necessary to condemn their ignorance and negation of the positive forces in the plastic arts who were capable of bringing to fruition a truly national and universal culture in Mexico.[31]

With alacrity, activity was once again resumed in front of the great south wall. The tall rolling scaffolds, which had been lying on their sides on the ground, were now back on the trestle in front of the mural. The necessary funds had at long last been made available, at least an amount sufficient to cover the complete sculpture-painting of the Rectoria's south wall. Siqueiros brought sculptors Federico Canessi and Luis Arenal to the mural to assist in producing the clay bas-relief scale model, after which artisan cement workers built the enlarged forms on the wall. Polychroming with ceramic would be performed by skilled craftsmen faithfully following Siqueiros's large, detailed, painted sketch.

A dispute arose between two ceramic companies vying for the contract to cover the wall. *Mosaicos Venecianos de Mexico,* a domestic ceramic manufacturing company, protested to Siqueiros that the university had taken the contract away from them and given it to *Mosaicos Italianos,* who imported their ceramics from Italy. But in their letter to him, the latter company advised that all great artists use the "superior" Italian ceramic. Siqueiros scrutinized samples from the two companies and, unable to detect a difference, passed judgment that as far as he was con-

cerned the price would settle the matter, and it would be up to the university to decide.

The cheaper ceramics were chosen, and the experts of *Mosaicos Venecianos de Mexico* covered the 304 square meters, reproducing and delineating the colors in all their gradations in an excellent rendition. It took six months to finish this part of the job, but four years had elapsed since Siqueiros had begun his work on the *Rectoria*. However bitter the struggle, Siqueiros had finally succeeded in hammering out a powerful sculpture-painting mural on the exterior south wall. But he was unwilling to endure again the ordeal of seeking additional funds from the university, so the murals of the east and north walls were left in their unresolved state.

On March 27, 1956, a large crowd, including the administrators of the university, attended the inauguration of the mural. The sculpture-painting, brilliant in the sunlight, displayed a constantly modulating array of color values and changing shadows as the sun moved across the sky. Massive figures in the mural, their forms powerful and clear in the vibrant outdoor light, ascend steps and walk out of the mural and into the life of the country. These figures, symbolic students, bear the fruits of their learning and offer them to the nation that sent them to the university.

In explaining his experience with the theme of the mural, Siqueiros said:

> How is it possible to integrate political content when collaborating with architects who are against all political content? Furthermore, in University City there was no common theme . . . because the painters were denied the opportunity to participate with the engineers and architects. . . . We had to work where the architects wanted us to. . . . I would have urged that the walls be made convex with their upper part forward. The surfaces I was offered did not correspond to my theories of composition and perspective in the exterior. Because of all this, should I not have painted? Not at all! Even in conditions contrary to one's aesthetic principles, artists can and should develop their art; at worst it will serve as experience.[32]

Not only were the wall designs of concern to Siqueiros, but he also proposed that the general polychroming of the university be entrusted to the artists as both an aesthetic and economic measure. But of course, as we have seen, there was little chance the architects would agree to any real integration of art and architecture at the university. In any case, Siqueiros and Rivera—and to a small degree Jorge Gonzálas Camarena (a realist, though an antagonist of the Mural Movement)—produced sculpture-painting on the exterior. Throughout history the use of the method attested to the artist's understanding of the validity and necessity of using greatly strengthened forms for a work of art surrounded by the vibrant outdoors. Siqueiros, however, in his consideration of the moving

spectator, introduced into his forms the element of polyangularity. Raquel Tibol wrote that Siqueiros's mural, "though novel in its personal and artistic creation, is the most valuable experience for mastering a significant and authentic style for the present."[33]

When Siqueiros's themes for the university murals first came to light in October 1952, he and Vincente Lombardo Toledano argued about the nature of their political content. The U.S. State Department turned its attention to the polemic they developed, perceiving what it thought was an important split on principled grounds between two eminent Mexican leftists. They added to their files the public information that Lombardo Toledano had complained that the themes of the murals were "absurd and lacked revolutionary fervor."[34] So while Siqueiros was criticizing the failings of the architects, and vice versa, there was an attack against himself and other muralists at the university from this unexpected quarter.

The U.S. State Department followed the argument and recorded that Siqueiros, in his analysis of the political climate of the period, maintained that the time was not propitious for engaging in "direct political themes." But Lombardo Toledano held that the Mexican Revolution was still "democratic, anti-feudal, anti-imperialist, and always under the threat of Yankee imperialism"; that in the national and international atmosphere in which University City was constructed, the murals should express "democratic, anti-feudal, and anti-imperialist themes." Instead, he found "abstract signs, inoffensive figures, and conventional and innocuous symbols." He concluded with the question: "Why do the revolutionary artists evade their responsibility?"[35]

Also recorded were the fact that Lombardo expressed confidence that Siqueiros "would correctly portray revolutionary needs," and Siqueiros's own thoughts on the matter. Siqueiros saw that strong repressive forces of the period would not tolerate direct "revolutionary" thought; he cited the experience of Diego Rivera's Bellas Artes mural with its portraits of Stalin and Mao Tse-Tung.

> The burning Mexican reality, to which Lombardo referred, cannot be treated pictorially, except by engraving and reproductions of pictures, and even these only within conditions of semi-legality. I affirm that at this time the use of direct political themes in public buildings would be a grave tactical error and the result of premeditated provocation.[36]

Siqueiros defended the "social content" of the University City murals—even though they lacked "direct political themes." The errors made by the artists, he said "were not in the paintings, but in accepting the commissions from the Government, and in assisting this Government in obtaining the reputation of a promoter of culture."[37]

Intrigued by the controversy between the two revolutionaries, the First

Secretary of the U.S. Embassy in Mexico City, B. Smith Simpson, sent the following analysis to Washington:

> Siqueiros and Lombardo have had ideological conflicts in the past relative to the proper implementation of Communist activities and propaganda. Previous differences were glossed over, if not healed, when Lombardo entered the Presidential contest and campaigned with a verbal support from Siqueiros. The present difference is an indication, along with others, that all is not harmony among Mexican Marxists. It is also a little diverting to see Siqueiros shrink from provoking the authorities, which is a type of shyness for which he is hardly well known.[38]

Siqueiros, using his artistic gifts to strike hammer blows reinforcing the precedence of his political mission, fell increasingly under the ubiquitous eyes of the U.S. intelligence services. The fact that he joined the appeal for clemency for Ethel and Julius Rosenberg was information that the FBI guarded in its extensive dossier on him. It was also noted that a Captain John J. Abele of the U.S. Air Force—the acting director of Intelligence Headquarters Caribbean Air Command, stationed in the Canal Zone—had furnished the FBI with the information that in Mexico David Alfaro Siqueiros was protesting as "Yankee intervention" a bilateral military agreement being discussed between Mexico and the United States in February 1952.[39]

The FBI duly tucked into its file the fact that Siqueiros was a member of the International Conference for the Defense of the Rights of Youth, which met in Vienna in November 1952. An informer's "confession," volunteered to the FBI in April 1954 from a woman whose name the FBI would not divulge, stated that though she denied being affiliated with the Communist Party, Siqueiros—whom she had met at art exhibitions in South America in 1941—was the only person who had ever revealed to her that he was a communist.[40]

To the FBI it was also of significance that a magazine article had described Siqueiros as a "Red artist who used his art to promote communism," and they guarded the information that on

> April 17, 1954, an anonymous source made available a list of names and addresses which were contained in records located on the ninth floor of 832 Broadway, New York City, which area was occupied by New Century Publishers, "Political Affairs," and "Masses and Mainstream." . . . The following appeared on the list: David Alfaro Siqueiros, Querétaro 150, Mexico, D.F.[41]

Wherever Siqueiros walked he seemed to trip over FBI informers. Another unnamed person reported to the FBI that on March 18, 1955, at a celebration for the publication *Latin America Today,* in the Hotel Woodstock of New York, a tape recording was played following an anti-U.S. speech by the publication's editor, "which contained brief words from three Mexican CP members, one of whom was the painter,

Siqueiros."[42] It was also noted that he had written an article against atomic war in May 1955, and in July had addressed the "Latin American Conference for Freedoms."[43]

Though Siqueiros did not know for a fact that his every step in his own country was dogged by agents of a foreign power, he was always wary. It mattered little, however, to the course he had chosen.

When Frida Kahlo Died

Frida Kahlo died on July 13, 1954 at the age of 44. Her death provoked a political scandal manufactured by the newspapers, and brought Siqueiros to the defense of the director of the National Institute of Fine Arts, Dr. Andres Iduarte. Iduarte was being accused of complicity with Communists, and being made a scapegoat for an incident involving Frida Kahlo's body lying in state in the lobby of the Palace of Fine Arts. The half-open coffin was draped with the banner of the party of her political affiliation, the Communist Party [41], and throughout the period that tribute was being paid her in the Palacio, numerous honor guards, including important government figures, stood beside her hammer-and-sickle draped coffin. At one given moment, two former Presidents—Emilio Portes Gil and Lázaro Cárdenas—stood together with Diego Rivera and Siqueiros.

The following day, the day of the funeral, a hue and cry was raised by the newspaper: "The Communists Profane the Palace of Fine Arts."[44] As the funeral cortege of several hundred Kahlo admirers marched in the rain up Avenida Juárez, the furor in the press continued unabated. Siqueiros commented caustically:

> The voice of the imperialist Yankee boss has been heard making its first categorical threats to the Government: "May we call your attention to the rather embarrassing fact that you have permitted the lobby of the Palace of Fine Arts to be used under the pretext of a posthumous tribute for Frida Kahlo when her coffin was covered with the Russian flag and the National Anthem was played." Two miserable lies in a few lines![45]

Director Iduarte was forced to resign after the government accused him of permitting the "Soviet flag"—the label they tacked on the Communist Party banner—to be draped on Frida's coffin. About the incident, Siqueiros wrote:

> This was the price demanded by the reactionary and neo-fascist pro-imperialist sectors. . . . To fire a public functionary of the stature of the Director of the National Institute of Fine Arts, precisely for permitting freedom of expression, is the most brutal act of despotism that has been registered in the history of Mexico in recent times. It is the most flagrant violation of the Constitution, an act that reveals the degree to which the State Department of the Yankees

is pressuring the Government of Mexico, and to what degree the Government of Mexico is bending the knee in face of this pressure. Since when have Communists been denied having their bodies draped with the flag of their party? Has this been prohibited for persons of other ideological camps?[46]

Siqueiros went on to name two Mexican newspaper reporters as "petty agents" of the U.S. State Department who had initiated the "handiwork," the big fry being the newspaper publisher and the government functionaries who had taken advantage of the event to attack Cárdenas as a Communist. "But the real object," Siqueiros wrote, "was to surrender further the Mexican Government, and the entire Mexican nation, to the continental and international designs of imperialism."[47]

Amid these stirrings, which more often than not had been a normal part of the life she had lived, Frida Kahlo was laid to rest. Andres Iduarte delivered a eulogy that closed with the words:

> Friend, sister of the people, daughter of Mexico: continue living. Continue in the profound fraternity, in the solitary match, in the historic and legendary marriage, in the alive bond for a great artist, and for a companion whose abundant and tender protectiveness sheltered your genius and long agony.[48]

20

Time and Tide

The Open Letter

In September 1955, when work on the University City murals was in suspension, Siqueiros accepted invitations to lecture in the Soviet Union and in Poland. This was his and Angélica's fourth trip to Poland, where it was still anticipated that he would paint a mural for the new Tenth Anniversary Stadium in Warsaw. On September 23, shortly after they arrived, he held a press conference and explained his ideas for the mural. In this socialist country, however, he found himself facing tremendous opposition from Polish painters, almost all of whom were French-oriented, and the project succumbed under attacks from anti-Communist intellectuals and artists.

At the same time, there were painters in Warsaw who requested he undertake a critical appraisal of the works of 255 artists then being shown in the Arsenal Exhibition. To deal with so vast a quantity of individual works was difficult, and Siqueiros chose to offer a general opinion in a constructive manner in his "Open Letter to the Young Polish Painters."

From Warsaw, Siqueiros and Angélica went on to Moscow, and on

October 17 he spoke to the members of the Union of Soviet Painters. The lecture, which took place in the USSR Academy of Art, was presided over by Academy President Alexander Gerazimov, and among those attending were three prominent members of the Central Committee of the Soviet Communist Party.[1] Siqueiros decided to repeat the device he had used for the Polish artists and titled his talk, "Open Letter to the Soviet Painters, Sculptors and Engravers."

His "analysis and criticism" rested firmly on a Marxist foundation; with his exceptional credentials as a quintessential modern realist, he felt confident that he could for the first time turn his critical attention to the art of the Socialist bloc. In the citadel of the Academy of Art of the socialist nation he so profoundly admired, Siqueiros read his Open Letter in a most comradely manner and with meticulous care. Imploringly, with a sense of mission, yet in his customary open manner of speaking, he analyzed and criticized the art of the members of his political family, seeking to encourage them to aspire to even greater heights—for which, he told them, they had every opportunity.

Siqueiros praised his Russian comrades for their reaction against academism and naturalism, but he warned them about their drift toward French formalism, to an art dependent on "mercenary speculation" and out of step with the "social transformation of their country." Having thus somewhat forewarned the Soviet artists of his intent, he shifted his attention to their accomplishments. There was much to praise—the Soviet society had progressed far, the artists had been devoted and their contribution great. The work they had done to serve this progress was to be seen in public places throughout their nation, and fulfilled, he told them, a political function unequalled in history.

He confessed to them that Mexican art, though ideologically committed to realism, was bound "to suffer the contamination of formalism" in a bourgeois society. He then assured his listeners that their art had "not yet shown the effect of this leprosy, which has made the art of the capitalist world, in spite of its ingeniousness, both debased and degrading."[2] But then Siqueiros jolted his audience with his first critical statement:

> Your art suffers from another form of cosmopolitanism, that of formalistic academism—mechanical realism. If we compare the two, the formalism of Paris and academism, we find an element of similarity in both; they are two roads that denationalize and impersonalize art; the formalists in the manner of the School of Paris, and the academicians of the "Academy of Rome." It matters not the country, each is alike as two drops of water. No difference exists between the Argentine formalist and the Japanese formalist, as no difference exists between the Hungarian academic and the Guatemalan academic.[3]

At this point Alexander Gerazimov would hear no more; amid the startled murmurs of the audience, the President of the Soviet Academy

of Art left the platform and walked out. Siqueiros, confident that his audience was sympathetic with what he was saying, retained his composure; though disturbed by the loss of this most important listener, he continued with his discourse. He pointed out the weaknesses of Mexican painting—its "primitivism" and "archaeologism." Then, as he saw them, the problems of Soviet art:

> In your creations you have not used those surprises of your own national teaching. You still remain victims of a *parti pris* stylism, that use of the dead laws of international academism which arose at the close of the Renaissance.[4]

Was not the history of art the development of ever more realistic forms that could not be controlled by "formulas and immutable laws?" Citing examples in history when rigid "laws" were unable to stifle progress, he made it clear that he was in disagreement with those who maintained "no one work of art is superior to another work of art"; this, he felt, could likewise be said for periods of art:

> But this did not mean to deny the uninterrupted process of enrichment of form in the direction of a richer, more civilized, more eloquent realistic language. The desire of beings to become more alive, more sensual, more thoughtful, more expressive, as well as making the physical surroundings in which they move more palpable, has motivated all periods of art that have not been inhibited by *untouchable formulas. Realism cannot be anything more than a means of creation always on the march.*[5]

While Mexican painting was moving more toward indigenous primitivism and thus stagnation,

> you in the Soviet Union have perpetuated old realistic styles of the immediate past, styles of the realism of Yankee commercial art at the beginning of the century, an influence that I have observed in the work of Polish painters, and in general in the work of the painters of the popular democracies. If, together, we observe the lapse of time of your work, we will see in the thirty-eight years of its production that there has been no progress in its formal language. But in your technical virtuosity and in your artisanship you have improved. But do not forget that it is precisely this perfecting of the craft within a limited area of repetitious realistic creation that has always led to decadence.[6]

Here he pointed to the painters who immediately followed the Renaissance: "More skillful than their predecessors, but their work infinitely inferior. Raphael was formidable, but the Raphaelites that followed him were detestable." Nor did he believe that every exaltation of form was formalism. The formalists worshipped form for the sake of form in a purely plastic exercise,

> while the true realists have always used it *to achieve greater plastic eloquence for a greater thematic eloquence.* Any other way, no matter how beautiful and

right our political content was, would be no more than an artistic expression that was dull and tiring to the sensibility of any human being.[7]

Siqueiros ranged over the problems of the search throughout art history for new materials to better express realism.

In your case, Soviet painters, the problems are even more serious. First, because among you no interested parties have appeared who would enrich the material techniques, and second, because you are today in the state with the greatest capability of all times for providing the effective means and morals for transformation.[8]

He told them that the painters of the Paris School had made no contribution to enrich the "principles of composition and perspective," but had in fact lost everything that had been discovered by their predecessors. The Mexican painters attempted to solve some of the problems, but

Soviet painters remain subject to the methods, composition, and perspective that are common to all the academies of art in the world. And this you do in the only country . . . in the world where science in the service of the people would be capable of offering enormous help to solve the problem.[9]

With the search for realism far from finished, and with the Paris School denying ideology and humanity

there remained in the world at the moment only two important experiences: the Mexican, which today is subject to increasingly difficult political conditions; and Soviet painting, subject today to increasingly favorable political conditions. They are two currents that in the end can reciprocally help each other with criticism and self-criticism, eliminating their negative aspects and strengthening what is positive.[10]

He then complimented the Soviet artists for their talent, capability and rich tradition:

Soviet painters possess a professional discipline which we lack, and which in my opinion is unequaled in the world. They have begun to produce a true monumental art, an art joined to architecture, and the only remaining thing now is for the artists to shake off the routine forms that cause their immobilization.[11]

Expressing the hope that his words would be accepted as those of a *comrade* with long experience in art and politics, Siqueiros brought his mission to a close. His stirring up of the calm academic waters was resented by the older academicians, but the younger painters responded warmly and invited him to visit their studios.

In Mexico, the event in Moscow did not go unnoticed. The report in *Excelsior* was captioned, "From Russia Siqueiros Attacks Mexican Art."

He says our painting suffers from submission to imperialism, . . . In an open letter to his Soviet colleagues Siqueiros launched a sneak attack against Mexican art, causing amazement and indignation among his own disciples.[12]

Besides accusing him of using veiled remarks to attack Diego Rivera [who at the time happened to be in a Moscow Hospital, where Siqueiros and Angélica visited him daily], the newspaper report managed to include a ridiculous statement, attributed to Siqueiros, that those "who doubted that Communist art was the best in the world, were agents of the FBI and North American imperialism."[13]

On January 11, 1959, in a lecture at the Museum of Fine Arts in Caracas, Siqueiros told his Venezuelan audience about his reading the "Open Letter" in Moscow.

> The fact that it was possible reveals that one can discuss the problems of art, as well as any other problem. . . . [I]n my "Open Letter," I have condemned—although fraternally—the concept that the Soviet painters have, and have had for some time, of realism.

The poet Carlos Augusto León then read the letter to the audience, after which a discussion took place.[14]

In April 1955, before the trip to Warsaw and Moscow, Siqueiros had dispatched an important letter to his old friend Adolfo Ruiz Cortines, who was now President of the Republic. He wrote on behalf of the mural painters of the National Front of Plastic Arts, and appealed to the President to strengthen his administration's faltering support of mural painting and to eliminate the economic problems the painters were having with the government. He reminded Ruiz Cortines that the previous administration of President Alemán had recognized that murals were a national cultural treasure, had assured ample federal funds for the National Institute of Fine Arts budget, and had promised that murals would be included in the decoration of new government buildings.

Siqueiros was referring to a presidential edict of August 8, 1947, which had specified the amounts to be paid for murals, for artists and helpers, and had given the Institute of Fine Arts jurisdiction to contract murals. He urged Cortines to abide by this agreement and to strengthen his administration's support of those artists dedicated to mural painting.

> For Mexican mural art to develop with a professional dignity for its painters, a percentage of the money invested in public works must systematically go to pay for the work that we perform.[15]

Siqueiros's appeal had considerable effect in alerting Cortines to the plight of the muralists and helped free funds for his stalled University City mural. That they were "old friends" Siqueiros had learned in 1951, when he had an appointment with Cortines, then Minister of Government, to request his aid in arranging the residency papers of a foreign artist who was assisting him on the murals. He was sitting in the anteroom, reading his newspaper and awaiting his turn to be called. Ruiz

Cortines came out of his office to greet his friend from the past, astonishing Siqueiros, who had not realized that this was the same Cortines who had befriended him when as a youth he had run away to Veracruz and with whom he had fought in the Revolution. The Minister assured Siqueiros that he was that very same Cortines as he led him into his impressive office. The matter Siqueiros had come for was settled to his satisfaction, Cortines graciously accepted a small lithograph Siqueiros had brought for him, and the two embraced warmly.

Later, Cortines invited Siqueiros to dine out with him but left Siqueiros with the bill.[16] Fortunately, Angélica had made certain that he had money in his pocket when he left the house; most of the time when he was attired in his painting overalls, his pockets were empty of money. In fact, its daily use seemed unnatural to him; money appeared out of place in his hands and he handled it clumsily, always seeming to rid himself of it. Angélica was always close by to hand him what he needed, or he would turn to someone to borrow 20 centavos for the afternoon newspaper.

He did make sure, however, that he had sufficient funds in his pocket to pay for his own and Cesare Zabattini's dinner, when he welcomed to Mexico the Italian writer who had authored the film classics *Open City* and *Bicycle Thief*. There were some fifteen members of the Front of Revolutionary Painters—hastily called together by Siqueiros—seated at a long table in a modest restaurant in the heart of the city, all paying for their own dinners. Though there was a slight language barrier, Zabattini was toasted in genteel fashion. He told them "I have the impression that the government of your country in confronting your murals is similar to the Italian government in reference to our cinema; they use it only to bring glory to themselves."[17]

From the past came an old friend—Dudley Murphy, the Hollywood film director—who was in Mexico City talking about making a film based on the Siqueiros's life. On the patio wall of Murphy's Hollywood home, some 20 years earlier, Siqueiros had painted a strong theme expressive of Mexican life of that time. Murphy had opened many Hollywood doors for Siqueiros in the early '30s, one of the most notable being that of Charles Laughton. Laughton became a very supportive friend, and flattered Siqueiros by proclaiming that on his walls there would be no paintings other than those of Siqueiros. This Siqueiros was able to verify when he made an impromptu visit to Laughton's home in the outskirts of London. There he saw eight of his paintings, the only ones hanging in Laughton's house.[18]

With Angélica driving, Siqueiros took Dudley Murphy on a tour of the city, visiting mural after mural. Murphy's enthusiasm for making a film was fired anew and he began to express ideas for scenes in it. Siqueiros beamed, nodded his approval, and suggested, "You could have a scene,

how when a youth I ran away with two friends to Veracruz. We slept in a room over a butcher shop—you know the open butcher shops in Mexico? Well, we were so hungry and had so little money that we brought a stray dog to our room, and with a rope tied around the dog we let him down from the window to grab a piece of meat hanging outside the shop. That is how we sometimes ate."[19] The two excitedly exchanged ideas for the film, which Murphy hoped eventually to direct.

Siqueiros loved the movies and he recognized cinema's importance as an art form that in the proper hands could lift the minds of the masses. Often he had thought of what he would do in this medium if he were to take that direction. But cinema being what it was, he indulged and enjoyed the relaxation it had to offer. After concentrated painting, when sparks were flying, when his nerves were charged, his being tense and his emotions often bursting from his controlled appearance, he would retreat to the movies, his hands still stained with paint.

The restaurants of Mexico City served his recreational needs, too. He loved to be in a public eating place, whether modest or elegant, not so much for the food, to which he seemed to pay little heed, but rather for the sociability to be found when diners greeted him across the tables. In one of his favorite restaurants, Bellinghausen, he took delight in surprising his guests by ordering *aioli* (garlic mayonnaise), and steering clear of the frijoles and chiles that did not agree with him. Painters, writers and newspaper reporters sat in on discussions at his table, frequently confounding the North American correspondents who were incapable of evaluating world events from the Marxist viewpoint.

A ragged street urchin stared at them through a large window of the modest cafe. Siqueiros spread a paper napkin on the plastic tabletop, asked for a pencil, and sketched a portrait of the boy. After the bill had been paid by Angélica, Siqueiros led the way to the street, where he gave his signed sketch to the poor boy. But I went to the child and presented him with a handful of coins, thus retrieving the paper napkin. In the car, Siqueiros accepted the explanation that the delicate paper napkin could not long survive in the hands of a child of the streets, and the coins would be more meaningful to him.

At this time Siqueiros was concentrating on a number of easel paintings in his rooftop studio, trying to realize enough funds to make an upcoming trip to India comfortable. The invitation to lecture there had come from Prime Minister Nehru. Painting to accumulate wealth was never the raison d'etre behind Siqueiros's production; had he devoted his time to satisfying the demand for his paintings, he would have grown rich early in life. Murals commanded his attention, but when pressed economically, he faced the easel. His sheer artistic drive was powerful, and his production of easel paintings—all with philosophical content—was prolific.

Nearing sixty, he was not old. He had tremendous energy and in two

months turned out twelve paintings of relatively large size, including three portraits. He could get along without a gallery to sell his works, and on July 31, 1956, presented the new paintings to the public in a makeshift gallery on the first floor of his house.

He had created a series of futuristic landscapes, three portraits and a large work, *My Son!*, which depicted General Victoriano Huerta holding on his lap the mouselike figure of the CIA-installed Guatemalan usurper, Colonel Carlos Castillo Armas. These paintings he classified as "Illustrations of five problems of realism." Elaborating further, he explained the thought processes behind his latest conceptions:

> Direct objectivity and indirect objectivity in the portraits; mental objectivity rather than imitative in the landscape; objectivity in the fantasy and foretelling of future technology; and fitting objectivity in political caricature. In the landscape, I consider mental objectivity, not imitative, to be an entirely new problem. Through all of painting, landscape was expressed with all possible visible elements and was thus an objective imitation. But in nature there undoubtedly exist imperceptible phenomena, the true existence of which our intelligence understands as logical fact, feasible for representation. I believe the person of the era of the airplane is, in respect to landscape, less able to possess the same lyricism, the same romanticism that people have had in periods not dominated by *space*. The need for a cosmic landscape is part of their new nature. Mental objectivity is not only a solution for landscapes of an extraoptical panorama, but will make many great problems that involve volume better understood, from the mental rather than a visual point of view. From this it follows that mental comprehension of the problems should modify the *simplest* and *mechanical* concept of objectivity that the plastic arts have primarily suffered from. The cubists sowed the problem and they reaped fruits, bottles, guitars and coffee grinders. In representing these objects they used objective logic in addition to visual perception. In landscapes, the universal platform of human beings, they were limited to observing what could be captured from a real or imaginary window.[19]

The new paintings also served their economic purpose, and by September Siqueiros and Angélica were being photographed sitting atop camels, the Sphinx in the background.

Egypt was the first stop of a journey that would take them to Italy, France, Holland, Czechoslovakia, the USSR, China and India. On September 14, 1956, Siqueiros and Angélica were received by the Egyptian president, Gamal Abdel Nasser, who preferred discussing politics rather than art, and who was eager to know what, if any, impact the Bandung Conference of African and Asian peoples of the previous year had had on the peoples of Latin America. Nasser and Siqueiros agreed that it was imperative that the next conference include the Latin American countries, and Nasser stressed the fact that since the enemies of the people of Egypt were the same as those who oppressed the Latin Americans,

the two must therefore naturally support each other. He then said to Siqueiros that it was his dream that "after seventy years of suffering insatiable imperialist greed, Egypt would now take the road of independence and sovereignty and transform itself into a modern industrial nation."[20]

From Egypt, Siqueiros and Angélica went on to Rome, stopping there long enough to present a talk on September 25 to a group of intellectuals on the subject of his interview with Nasser.

They traveled across Europe, through the Soviet Union and into China. He was disappointed in Moscow to find that his "Open Letter to the Soviet Painters" had not been published, and he complained that in not having published it the Minister of Culture was incorrect, especially "given the justness of international dialogue between Marxists."[21] On arriving in Peking, both Siqueiros and Angélica received a jolt when they were greeted with copies of *Open Letter to the Soviet Painters,* already in Chinese.

The two were received in Peking by Prime Minister Chou En-lai and again there was extensive political discussion, which ended with agreement that an anti-imperialist front of African, Asian and Latin American peoples must be organized [44]. But Chou En-lai was also captivated by Siqueiros's ideas concerning modern monumental art for a socialist state. Wishing to impress Siqueiros with the monumental art of China's past, he arranged to have the painter and his wife flown to the sites of two of China's great art treasures: Yun Kang (Cloud Hill) in Shansi, and Tun-Huang in remote Kansu.

In Yun Kang, just west of Peking, Siqueiros and Angélica gazed with astonishment at the Colossal Buddha carved in living rock; then, in far-away Tun-Huang, they saw the Caves of the Thousand Buddhas, where sculptured clay figures and frescoes filled hundreds of caves. What he had seen affected Siqueiros deeply.

> The Buddhist cave murals at Tun-Huang and Yun Kang—one should call them communally integrated plastics rather than murals—are the greatest art I have ever seen, greater than the Gothic cathedrals. In front of them I said to my hosts: "If communism doesn't soon achieve a dynamic art comparable to this, then I'm afraid I'll have to become a Buddhist!"[22]

Siqueiros had roundtable discussions with Chinese officials in Nanking and Canton; they were very eager to hear his views on the political and economic problems of Latin America.

He and Angélica were then off to India, and no sooner had their plane landed in Calcutta than new forces began to shape events around their lives. Nehru was at the Calcutta airport amid a vast multitude of people;

he was awaiting the arrival of Sukarno and the various dignitaries who were guests of the Indian government. Included on the official guest list were the names of Siqueiros and Angélica.

While they were still seated in the airplane, having their medical documents checked, a military officer came aboard and motioned to what appeared to be an Indo-Chinese passenger to follow him off the plane. The two returned immediately, and the officer called out for any passenger who was Mexican. Siqueiros responded, and he and Angélica were thereupon summoned to follow the officer.

At the foot of the stairs leading from the plane stood Prime Minister Nehru, his daughter, Indira Gandhi; the Indian painter Sadich, and a large welcoming crowd. Siqueiros and Angélica were decked with garlands of flowers [43] while all joked about the case of mistaken identity. Nehru insisted that Siqueiros did not look Mexican. Siqueiros explained that most Mexicans are a mixture of "*gachupin* and Indian," and that "sometimes the *gachupin* is more predominant than the Indian." Indira Gandhi told Siqueiros that she could detect some red in his skin, and of course his nose in profile made it obvious that he was Mexican, except that she found his green eyes a little disconcerting. Siqueiros drew the conclusion that "the Indians have no conception of the Mexicans except as a type, 100% Aztec."[23]

The party moved off to the Governor's Palace. That evening, at a huge banquet in a grandiose setting, Siqueiros sat opposite Nehru. At one point during the dinner, when the conversation settled on comparison of the deliciousness of mangoes, with guests from India, the Philippines, Egypt and Mexico claiming the superiority of their native mangoes, Siqueiros made the point that the delectable quality of Mexico's mangoes was attested to by the fact that only in Mexico was a beautiful woman called a *mango*. The guests were further amused when Siqueiros asked Nehru if the clasped-hands greeting of the Indians, held near the side of the face in an inclined position, would not be too suggestive if the gesture were directed to "one of the millions of beautiful Indian women"? This was greeted with much glee, and Nehru's response was that the Latins were ingenious in such matters, but that in India the clasping of hands to the side of the face was only a signal directed to children who stay up too late.[24]

They were next to fly to New Delhi, and aboard Nehru's plane Siqueiros discovered, while casually reading a newspaper a few days old, that Nehru's comprehension of the Mexican Mural Movement was more profound than he had suspected. The newpaper carried a report of a speech Nehru had delivered in the Calcutta School of Fine Arts. Siqueiros was amazed to find that Nehru dealt in his talk with the experience of the Mexican muralists.

Nehru's theoretical exposition concerning our contemporary Mexican Movement, with his emphasis on painting tied to construction, was positively impressive. He presented our work, that fruit of the Mexican Revolution in the field of aesthetics, as the only exemplary experience anywhere in the world, not only for India but for the rest of the underdeveloped countries recently liberated from colonial dominance. At the same time, his speech, which was a clear diatribe against the Paris School, was in general against the vanguard currents of the Western World, which he considered to be a natural outgrowth of private property.[25]

The contrast in attitudes toward art manifested by high dignitaries in India and in Mexico did not escape Siqueiros's notice. With the exception of the Mexican Minister of Education—the poet Jaime Torres Bodet, who supported the muralists but "always with dreadful timidity"—no president or minister "had been able to formulate a thesis in as profound a manner" as had Nehru. It was Siqueiros's opinion that in Mexico all, including the critics, "have in every possible way camouflaged the Mexican pictorial movement under the cover of an exclusively nationalist impulse or kept it within a Latin American scale."

Nehru wandered through the plane, seating himself at various times next to Siqueiros to probe the question of art, and he was fascinated when they discussed what they found to be the similarities between the ancient art of India and of pre-Hispanic Mexico, particularly that of the Mayans. When they came to ideological and political concepts of art, Siqueiros was gratified to find that he and Nehru were in complete agreement.[26]

Taking in the art scene in New Delhi, Siqueiros was reminded of Mexico before the Revolution. Here, too, "painters, sculptors, and graphic artists were a poor replica of the currents of Paris with a little superficial varnish of national folklore."[27] He saw books of modern European art everywhere, the young Indian artists seeking success with their international style; those more nationalistically inclined were a distinct minority.

In two lectures on the 13th and 14th of November, both under the auspices of the Ministry of Education, Siqueiros's radical artistic views lifted a curtain as the Indian artists heard that a strong anti-European art movement had developed and flourished in a country as underdeveloped as they considered Mexico to be. He then attempted to impart a sense of pride and confidence in their own creative powers by pointing to the similarity between the great artistic past of India and that of Mexico, emphasizing the *inspiration* that could be drawn from this source. As he spoke, he could not help feeling that the Mexican Movement was at work in India.

Siqueiros and Angélica toured India for two months as guests of Nehru. Nehru marveled at the relative political prestige enjoyed by Mexican artists. "In Mexico," he said, "artists are more important than politi-

cians."[28] He had hoped that Siqueiros would leave a mural in India and offered him a number of walls to paint. But Siqueiros's stay in India was limited, and the walls he was offered did not arouse any enthusiastic response. Even so, as a matter of reflex, his eyes surveyed walls wherever he went. The domed ceiling of the Chamber of Deputies finally attracted him as a surface for a mural. When Siqueiros caught sight of the ceiling as he entered the great chamber, he lost interest in the debate of the deputies. As he stood there gazing upward, he was joined by Nehru and Angélica, and their eyes turned toward the ceiling, too. The debate on the floor stopped and the deputies gazed upward, wondering whether some impending disaster was about to befall them.

Siqueiros turned to Nehru. Could the plaster decorations be removed? To paint this mural he would use 25 artists from India and elsewhere in the Orient.

A Communist deputy, whose speech had been interrrupted because of Nehru's presence, requested that he be permitted to repeat what he had been saying. Siqueiros remembered:

> Nehru asked us to be seated, and I then heard, from one extreme to the other, one of the most violent charges against the highest authority of any land that I have ever heard. The orator's thesis consisted in negating the Prime Minister's claims about supposed insurmountable obstacles that stood in the way of more profound agrarian reform and greater industrialization, and as far as I was able to deduce from what the orator said, Mr. Nehru had placed religion as the prime obstacle, especially the type of religion dominating the people of India.

The Communist speaker then warned that if something was not done immediately, India's struggle for independence would be meaningless.[29]

The debate raged on, but Nehru left the chamber, followed by Siqueiros and Angélica. In the privacy of his office, Nehru explained:

> When I approach the Indian people, those that make up the great majority of the population, and I explain to them: your life must be improved, your children must eat and be better clothed, in short, in everything that obviously makes up the material life of all human beings in the world of our time, they answer me: "What have we done wrong, brother Nehru, that you wish us such enormous disgrace? Have you perhaps forgotten that this world is only a vale of tears and a place of transit to Nirvana, where we will find true happiness?" If you could see the condemnation in their eyes that is directed at me, as though saying, "You are a traitor to our religious principles, and what is more serious, you don't hide your betrayal. You have brought us the pagan materialism of the Western World."[30]

In spite of the problem compounded by his people's "fealty to the subjective, to the metaphysic, to the beyond," Nehru saw hope in the youth. It was an impression confirmed for Siqueiros in the response to his lectures.

For their family and friends, Siqueiros and Angélica brought trinkets from India and colored flower prints from China. On the prints he wrote *"Un recuerdo de China Nueva,"* with his signature. Refreshed after the long peregrination, Siqueiros was anxious to resume work on the murals. They had arrived back home in early January, 1957, and on the 17th Siqueiros held a press conference for the reporters who were waiting to hear what he would say about his trip. He held their interest as he described his discussions with the various heads of state and predicted that all the countries of the Near East would soon nationalize their oil. He added that at home a strong alliance of Latin American peoples would coalesce in a new struggle against colonialism and imperialism, a prediction that had been stimulated anew by his discussions with Nasser and Chou En-lai, consistent with his lifelong battle.

Physically strong and feeling well, Siqueiros at sixty was ready to soar to new aesthetic heights. His artistic accomplishments were universally acclaimed and opposition generated because of his political position was now more easily subdued. He was being sought for more mural commissions than he could comfortably handle, and the opinion was expressed in some quarters that the government kept him busy on murals in order to reduce the time he could devote to his considerably influential political activity. However, past experience had shown that Siqueiros never hesitated to put down his brushes when he felt political action had to be taken.

Chapultepec Castle was being refurbished as the Museum of National History, and Siqueiros was offered a commission to paint a mural in the newly designated Room of the Revolution. At first a wall of 80 square meters was offered; in the end, the mural expanded under his guidance to 419 square meters. It was a formidable task, for the mural was to be a document of the Revolution with portraits of its leading protagonists. Close by, in the Room of Independence, Diego Rivera was to paint a 72-square-meter mural in fresco, depicting the room's theme. Orozco already had a mural in the castle—*Juárez, the Clergy, and the Imperialists*—painted in fresco in 1948.

To begin creating the new mural's composition and its thematic content, Siqueiros needed to visualize the surface to be painted and its accessibility to the spectator. As the work began, Siqueiros—when he did not appear at the mural—would have an urgent message about the work and Angélica would chauffeur him to where I lived, since I had no telephone. He would ring the apartment bell at the street entrance, and when a head poked out of the fourth-floor window, would shout up some instructions.

The small four-story apartment building on Avenida Insurgentes happened to be next to a mansion surrounded by a high wall—the home of Luis N. Morones, a notorious former leader of the *Confederación Regional Obrera Mexicana* (CROM). Morones, who had retired with great wealth, had been subjected to threats against his life, and he kept two

armed guards seated in a car in front of his house. When Siqueiros arrived on the scene, the alert *pistoleros* immediately became vigilant. They watched as he rang the bell and heard him shouting up his instructions in English. The moment he departed, the *pistoleros* hurried from their car to the building entrance to discover what their enemy Siqueiros was up to. They were last seen writing down whatever it was they uncovered.

Siqueiros was amused when he heard about the incident, for though Morones was once considered the most powerful man in Mexico after President Calles, he was now, at 67, though rich and politically corrupt, no longer of any consequence in the political life of Mexico.

José Gutiérrez, master of the technical aspects of the mural, arrived at Chapultepec Castle to supervise the installation and preparation of the false wall for the mural. Siqueiros felt uneasy, knowing that if he was to deal adequately with the Mexican Revolution he would need more space. Meanwhile, the wall was constructed and made ready, its Celotex surface covered with a wide-mesh fiberglass cloth bonded to the surface with white acrylic priming paint. Siqueiros, however, persisted in his requests for more space, and in the end he was allowed to involve the room's remaining wall surfaces and even to add more by eliminating unnecessary doors and windows. Then he altered the room's nine varied permanent walls so that they would form a contiguous unified surface, on which the mural's scenes blended gradually one into the other as the moving specta-tor absorbed the optical phenomena of the play of perspective.

This mural, commissioned during the latter part of Ruiz Cortines's term of office, would be Siqueiros's exegesis of the Mexican Revolution. It was a subject in which he had been an active participant, and it had stirred him throughout most of his life. For the mural's centerpiece he planned to repre-sent the 1906 strike of Cananea, "the wellspring of the Revolution"; then, coming out on either side of that scene, sweeping around to the ends of the walls, he would paint the most vital details of the Revolution. The wall sections were divided by midlines and diagonals to yield their harmonious parts. The large air compressor with multiple spray guns attached was in use, and the first outlines of human figures were taking form. These were to be the striking miners of the Greene Cananea Copper Company in Cananea, Sonora. With startling and dramatic impact, Siqueiros gave the forms flesh. The prostrate body of a slain miner was borne aloft on the shoulders of miners, the vanguard of a great mass of strikers marching into the room toward those viewing the scene. The mural would contain more than forty portraits; "their likenesses," he said, "should be as close to the truth as possible."[31] But it was destined to require far more time than Siqueiros ever imagined, falling victim to political interference that drastically impeded its progress.

While the work was very intense in this early stage, Siqueiros's politi-cal activities did not diminish. He was at the time leading a movement

within the Mexican Communist Party, seeking to turn the PCM away from its sectarian stance toward a more broad-based political position. Then, too, when called upon he addressed political gatherings, such as the one on February 21, 1957, to commemorate the 23rd anniversary of the death of Nicaragua's General Augusto César Sandino—a meeting of which Siqueiros had been a sponsor, according to a "secret" memo from the U.S. State Department to the FBI.[32]

In February, U.S. Air Force Intelligence sent a report to the FBI that Siqueiros, through the PCM, had organized a new movement, the *Alianza de Patriotas Latinamericanos Contra el Colonialismo y el Imperialismo,* which "was composed of Latin American exiles and coordinated action against the U.S."[33]

With a presidential election upcoming, Siqueiros began to attack the government for imposing each successive president on the nation. The name of the "candidate" selected by the entrenched oligarchy was kept secret; cartoons showed the individual with a hood covering his head, and he was cynically and sarcastically labeled *la tapada,* the hidden one. On October 6, in a speech celebrating the 33rd anniversary of the PCM, Siqueiros spoke against the country's corrupt political system.

> What was I attacking them for? For the worst of their crimes, their suppression of democracy: their iron control through the PRI of the electoral machinery, the newspapers, everything to do with public opinion. You've noticed the way Mexicans come up to one another on the street and say: "Psst! You know who's going to be our next President?" "No. Who?" "They say Alemán wants . . ." or "They say Cárdenas wants . . ."[34]

In the last months of 1957, while he was pouring a pulsating and fiery emotion into the mural he called *From Porfirismo to the Revolution,* two new murals with contractual deadlines added to the pressures: one for the *Hospital de Oncologia* of the new *Centro Medico del Instituto Mexicano del Seguro Social,* and the other in the lobby of the *Teatro Jorge Negrete* of the *Asociación Nacional de Actores.* The walls for the new murals were being made ready while work was still progressing in Chapultepec Castle.

On the morning of November 24, in the midst of this flurry of mural activity, Siqueiros awoke to the sad news that his ailing comrade and lifelong colleague, Diego Rivera, had ceased to exist at midnight. With Angélica, he immediately went to Rivera's San Angel studio.

In flesh and blood, Mexico's "Big Three" could not endure long, but the fruit that their labors lavished on Mexico was phenomenal. Standing at Rivera's bedside, Siqueiros, now the lone survivor of the three, gazed down at the silent bulk of the dead genius. Thoughts of the stormy years of their lives as friends and enemies crowded his mind. Rivera was ten

years older than he, and death at 71 had come too soon. To Siqueiros he had been the "big brother"; and though battling brothers in art and politics, they had stuck together when it was necessary to repulse the attacks of the many detractors of the Mural Movement.

Within the vast differences of their personal styles, there were important similarities that resulted from their allegiance to the human form; both rendered it with great technical ability and profound emotion. And as members of the same political family, more often than not, the philosophy they believed in pulled them together. Not long before, the two painters had enjoyed the conviviality of an intimate wedding reception, which Siqueiros and Angélica had offered for their daughter Adriana and their new son-in-law Constantino.

On November 26, Rivera's ashes were entombed in the *Rotonda de los Hombres Ilustres del Panteon Civil de Dolores,* the national shrine. Of those eulogizing the departed muralist that day, no one was more deserving of participating than Siqueiros. Yet objections had been raised, and a scandal erupted at the graveside. Rivera's sole surviving daughter, Guadalupe, a lawyer who had no sympathy for her father's politics, caused a commotion among the mourners when she vehemently objected to Siqueiros's presentation. But Rivera the communist *was* eulogized by Siqueiros, who evoked their common interests and the struggles they shared.

The mural in fresco that Rivera was to have done in Chapultepec Castle's Room of Independence—the chamber opposite Siqueiros's mural—fell to Juan O'Gorman, whose technique belonged to the Rivera school. Rivera's death was a great blow to the Mural Movement; through the years, the Big Three had been its strong support. Though Siqueiros was its organizer, activist, theorist, guide and leader, it would be difficult now, alone, to prop up a weakened movement, with lukewarm government support and facing increasing opposition from the powerful bourgeois establishment.

While he resumed his painting, Siqueiros was at this time also heavily involved in leading the factional struggle within the PCM. Earlier, in August, he had presented a proposal to the executive committee of the Federal District Committee—the Party branch to which he belonged, and which Encina headed—calling for the election of new leaders of the Federal District Committee and a new political policy that eschewed sectarianism, seeking to unify all left parties for the national electoral struggle ahead.

In an atmosphere of increasing government repression, a special conference of the Federal District Committee was cautiously being prepared for September. There was reason to believe that a police spy had penetrated the National Control Committee, causing a special committee to

be set up, which included Siqueiros and two comrades. They were, according to a CIA report, "to ensure that [the National Control Committee] carries out the 'proper revolutionary vigilance so as to guard against and to uncover all police spies and foreign agents within the PCM.'"[35] That the information found its way to the CIA files affirmed that the fears of the PCM were well founded.

At the special conference of the Federal District Committee, Siqueiros's anti-sectarian position won new adherents, and the anti-Encina faction took over the committee. Siqueiros, however, continued to press for Dionisio Encina's removal from the Party leadership and for bringing the Party into an alliance with the other left parties, in order to act in the forthcoming presidential election.

Even with three murals demanding nearly all of his time, Siqueiros led the battle against sectarianism and the drive to organize a coalition of left forces. In October, at the PCM's 38th anniversary celebration, he carried his fight to the Party's national level. Five hundred delegates from around the country attended the anniversary meeting, and Siqueiros took advantage of the opportunity to place the problem before them. Encina was the first speaker, two others followed him, and then Siqueiros dropped his bombshell. He called for the ouster of Encina and his group, for being—as he was quoted by the CIA—"incompetent and misguided persons who are keeping the Party weak by fostering sectarianism."[36]

Siqueiros carried his fight to the rank-and-file members, distributing among them two pamphlets, one that enumerated the "mistakes" Encina had made during his twenty years as general secretary, and another, "Public Justification of the Speech I Made." During the next month, November, Siqueiros and others of his faction met with the leaders of the Workers and Peasants Party—*Partido Obrero Campesino Mexicano* (POCM)—to test the prospects of bringing the POCM en masse into the PCM.

Suddenly, in December, Siqueiros was drawn away from his painting and intense political activity. He received an invitation (his "Open Letter" notwithstanding) to attend the 100th anniversary of the Russian Academy of Fine Arts. While in Moscow, on behalf of the Soviet School of Monument Artists, he presented a lecture in the Pushkin Museum: "Experiences of the Mexican Mural Movement." He and Angélica remained briefly in Moscow; once back in Mexico, increasing political and aesthetic activities again encroached on his painting efforts.

With the approaching presidential election, Siqueiros's opinions were of growing interest to society as a whole. An *Excelsior* headline read: "The Communist Party as Well as the Popular Party Needs to be Reorganized, Says Siqueiros." He was advocating, especially during the election

campaign, that a unified opposition be formed to confront the frozen political process controlled by the *Partido Revolucionario Institutional* (PRI). Siqueiros blamed not only his own Communist Party but Vincente Lombardo Toledano and his *Partido Popular* as well. Both, he held, were responsible for the "absence of an authentic revolutionary opposition in the present election campaign." Lombardo Toledano was accused of inaction in his call for a "Patriotic Front," while Siqueiros summoned his own party to take the initiative to form an "authentic *opposition* in a coalition with the Partido Popular, the Partido Obrero Campesino, and all progressive forces."[37]

He believed there was still time for action. "It was like the old refrain everybody knows," he told the reporter. "Shrimp that are asleep, the current carries away." Then as he saw the left in relation to the elections, he changed the refrain to: "Shrimp that feign sleep, just so, the current *will* carry them away." When the two parties paid only lip service during the previous year to forming a united front, and failed to act, "the entire country," he stated, "was full of rumors and suspicions about the motives that determined such an inexplicable attitude."[38]

The newspapers imparted to his words the importance of those of a leading politician. In the context of the struggle for a democratic election, Siqueiros saw the time as most opportune for a "patriotic front of the parties of the left." Alone they were obviously ineffective. "If no one thinks seriously of creating an authentic democratic opposition, the politics of *tapadismo* [the imposition by the PRI of *the* candidate] will continue in its course with impunity."[39]

Along with the political struggle, Siqueiros fought to keep a vital movement of revolutionary art alive, without Orozco and Rivera. He took part in roundtable discussions with artists of the National Front of Plastic Arts, a loosely knit organization, contributing a talk in February 1958 titled: "General Review of the Universal Panorama that Produced the Mexican Movement, 1906–1940, 1940–1957."[40]

In September and October of that year, the Workers' University (*Universidad Obrera de Mexico*) sponsored a number of debates that examined the growing crisis in Mexican art. The topic for one debate was "Social Painting as Art. Realism and Abstractionism, the Current Situation in Mexico?" Siqueiros took the position that artists and critics were at fault in their misconceptions of the real cause of the crisis, and he took to task Antonio Rodríguez—one of the few critics in the camp of the muralists—claiming that he

> was retreating rapidly to his earlier orthodoxy, to a theoretical line of conciliation with the political-artistic ideology of the bourgeoisie and imperialism: thus positioning himself on a theoretically neutral . . . base that is in essence eclectic and for that reason opportunist in its politicaal consequences. . . . [T]he fundamental cause of the crisis in contemporary modern Mexican art

. . . is essentially political and must take into account the consolidation of the national bourgeoisie with the support of the oligarchic sector and the penetration in all forms of Yankee imperialism. . . . Antonio Rodríguez limits himself to pointing out a cause, which is only an effect: the "political-commercial surrender of the artists," and he makes this denunciation with a totally antidialectic method suitable for Puritan mystics and pharisees of the doctrinaire idealist camp.

In any event, the fundamental cause of the present crisis of our contemporary Mexican pictorial movement is one of abandonment in theory as well as practice of the essential postulates of our pro-realist, national, and social movement. If the present crisis of the Movement is political, then there can be no solutions but political ones, and to develop in the present conditions, these solutions must be tied strictly to a profound reorganization of the labor movement, the democratic parties of the people, and the artists themselves.[41]

Siqueiros never slackened in his own efforts to stimulate the Movement, but with Rivera gone he now faced ever-increasing odds. Younger painters resented Siqueiros's prestige and the strength of his influence for a modern Mexican art that was socially committed, and they turned to the art market of the New York galleries. With shrill voices they launched personal attacks against him that were particularly vicious and which found a sympathetic forum in the Mexico City press. Being subjected to attacks from an infuriated opposition was nothing new for him but now younger artists who felt threatened had joined the old chorus.

The ideas these younger painters so detested sprang from his unshakable political position, and to a U.S. correspondent Siqueiros explained where he stood.

I am a citizen artist, not a Bohemian. I don't believe in a world where each artist is a little god, each one with his own philosophy, each one with his own little kitchen to fry his abstract ham and eggs. The only bad painting is the one dominated by the individual ego. In Europe a private market has determined a private art. In Mexico the rich prefer to collect cars and many wives. They only began to buy pictures fifteen years ago. Here our art is for an audience of millions. Easel paintings whisper to a private few. Murals shout to the public.[42]

21

Cancer and the Actors: The Enemy

Siqueiros at 61 years was overflowing with abundant energy. Along with the lectures, political meetings, easel paintings—a series depicting children of poverty that he called *The Streets of Mexico (plate 62)*—and portraits, progress was being made on *From Porfirismo to the Revolution*. The moment arrived, however, when work on that mural had to be halted temporarily so that he could turn his attention to the one for the Oncology Hospital. The complete mural, 70 square meters, was expected in time for the building's inauguration later that year (1958).

He paced the floor of the waiting room and gazed at the empty walls of the "dread" interior of the new hospital at the great *Centro Medico*. Within himself he was struggling to choose between following his intuitive desire to deal openly with the building's purpose, and the path of ignoring that purpose and in effect creating something soothing and escapist for those who would unfortunately have occasion to occupy the cancer hospital's waiting room.

Siqueiros's choice was not to lull the spectator, patient or visitor with the spectacle of a painless happy dream. Rather, he would confront the enemy—cancer—and fight! No matter what, questions would be raised, as indeed they were by newspaper editor Julio Scherer García:

> Why, precisely in this room speak of cancer, especially with brushes? Why mention this subject to the sick of the Cancer Section of the Medical Center? Why hammer away at the anguish of the sick? Were there not perhaps, a thousand other themes? Is it not possible to imagine something that would distract the cancer victims from their terrible drama?[1]

Yet Scherer knew Siqueiros well and knew the answer:

> This type of thinking did not enter into his character. He belonged to the type of man who faced problems resolutely. He had always done so in life, come what may. He thought this should be the common behavior. He believed it was preferable to obtain a positive experience from a negative fact, even from the most painful, rather than to close one's eyes and make believe one does not see.[2]

Entering the lobby and waiting room of the hospital, the spectator is at first confronted by a panoramic human spectacle of great complexity.

Contemplation of this work is intended for a seated individual rather than one moving about. Siqueiros painted a philosophical work well within the grasp of the viewer, though it would not be fathomed immediately without some mental exertion. In broad general terms, humanity's struggle to eradicate the scourge of cancer, clinging to life, is the drama he painted around the room.

Beginning with the "darkness" of prehistory, a writhing human mass is portrayed groveling for existence on the earth's surface. Somber blue-grays, dark ochres and siennas cover the area as the epic begins. One lone figure symbolically breaks away from this concentration of early humans and dashes toward the future *(plate 64)*. In the historical progression civilization takes hold; towering personages are painted, representing ancient cultures with their incipient medical science. The colors brighten as the panorama moves into the modern age and medical science focuses on discovering a cure for cancer. In this age, a tumultuous group of people is depicted surging forward with red banners flying. A woman attired in red symbolizes the *vanguard* worker and leads the group. Facing her, grasping her hand, stands the symbolical doctor of advanced society's medical establishment—medicine under Socialism, combatting cancer.

The mural surges on after this. It is most luminous and glowing where, at the intersection of two walls, Siqueiros painted medicine's hope of triumphing over cancer. At the time radiation therapy was the symbol of this hope. Across the corner of the two walls, Siqueiros painted a huge "red" radiation machine, in effect painting out the corner. The nude body of a cancer victim lies on the machine's table, being cured before the group of doctors *(plate 65)*. Following the mural's sequence, radioactive emanations destroy symbolical representations of cancer—huge mutations of unheard-of monsters. Here, too, the right angle of two intersecting walls is made less obvious by the composition of the latter ensemble, united across the corner.

Finally, in the background stand the people of the future "new" society. Their arms are raised, and though we cannot hear them they seem to be singing a hallelujah chorus on the defeat of cancer. Painted with acrylic paint on the usual false wall, the mural throbs with action, from the dark past to the future song of joy.

No sooner had this mural—*Defense of the Future Victory of Medical Science Over Cancer; the Historical Parallel of the Scientific and the Social Revolution*—been inaugurated on November 19, 1958, than Siqueiros moved his paints and equipment into the lobby of the theater of the National Association of Actors. The Chapultepec Castle mural was still held in abeyance as he gave priority to the latest work and faced the challenge of how he would deal with *The History of the Theater*. When they commissioned Siqueiros to paint a mural for their new building, the

National Association of Actors were well aware of his reputation as leader of the movement dedicated to putting art at the service of the Revolution.

There was a restive feeling abroad in the land. The administration of President Adolfo Ruiz Cortines was to end on November 30, and his hand-picked successor, Adolfo López Mateos, would lead the country for the next six years. On October 17, when Siqueiros signed the mural contract with the *Asociación Nacional de Actores* (ANDA), the country was beset with increasing labor unrest. "Reactionary" *Ruiz Cortinismo* was being replaced by the "Material Progress and Revolution" of *López Mateismo,* which was based fundamentally on a program of anti-Communism and economic Pan-Americanism. Labor strife was particularly irritating to the new president. To the chagrin of the labor leaders, there was a great lack of cooperative spirit in support of the new administration among the rank and file union workers.

Railroad workers, telephone workers and teachers pressured the government with new demands, but they were opposed by the liberal intellectuals who supported López Mateos. Seeking to break away from their long-standing supportive ties to the government, the railroad workers of *El Sindicato de Trabajadores Ferrocarrileros de la Republica Mexicana* pressed demands for higher wages, lower rents and transportation costs, and higher freight rates for foreign companies profiting from Mexico's low costs. When the railroad workers went on strike, the President's reaction was immediate, and he called in the army. Five thousand railroad workers were rounded up, locked in army bases that became concentration camps; a number were tortured, and some were killed.[3] At the same time energetic strikes were being conducted by the school teachers, students and telephone workers.

These events were foremost in Siqueiros's mind as he prepared to paint the mural in the Actor's Union building. López Mateos, "elected" by the PRI's method of imposition, was resorting to open repression to stem the tide of popular discontent. Siqueiros was greatly disturbed by the murder of Román Guerra Montemayor, leader of the railroad workers in Monterrey and an official of the PCM, "by the members of the Federal Army. This crime which has been perfectly proven and denounced, has to this date not been subjected to the slightest legal action."[4] He was drawn into these sudden, sweeping events and became involved in organizing the Committee for Defense of Political Prisoners, editing its newspaper, *Liberation.*

The government, fearful that a victory of the *Ferrocarrileros*—the railroad workers—would influence workers throughout the nation to press their demands, continued its savage repression. Besides its use of troops, the new government stooped to using the communist conspiracy theory: "deliberate plotting" between the Partido Comunista, the Partido Obrero-Campesino and the Soviet Embassy were to blame for the strikes and

popular discontent. The leaders of the two parties were thrown in jail and the Soviet officials were expelled from the country. Siqueiros, with one foot in the workers' struggle and the other in the lobby of the Jorge Negrete Theater, was spreading on the walls a composition inspired by current events.

For the union members, the actors, the drama of *tragedy* was to be painted first. Preying on Siqueiros's mind at that moment was the great, predominantly tragic, scene of the rulers of society crushing with brute force the ever-erupting protest of people. This was the tragedy and drama of *actuality,* the raw material from which he intended to paint scenes that theater people could draw upon for their plays.

Preliminary lines and forms relating to the composition were spread over 160 square meters of wall surface. Under the general theme agreed upon in his contract—*The History of the Theater*—Siqueiros included a number of sub-themes: abstraction and realism, the epic, tragedy, adversity and heroism, the theater during the first stage of the Revolution, the period of Porfirio Díaz, the colonial period; the pre-Hispanic theater. The interpretation he sought was an ambitious and difficult one. It was not his style to illustrate these ideas in a literal fashion. Rather, he would seek an interpretation that evolved from unsolved problems of an integrated plastic representation.

He moved into the painting, expending long hours, working with great intensity and—due to the subject—with nervous tension. On the principal wall, 12 meters long and 3.5 meters high, tragedy, adversity and heroism are dealt with. He said he had taken the scene from "the real theater of life of the present."[5] The central motif portrayed a dead young worker wrapped in a Mexican flag and embraced by his mother, *(plate 66).* Siqueiros derived this scene from an actual experience, the killing of a young worker that resulted when fascist Golden Shirts attacked a 1952 May Day parade in which Siqueiros had marched. Diverging on either side of the scene of pathos, and over the full expanse of wall, are the workers in procession, painted in startling action and swirling banners of red and black (in Mexico, the strike colors), and they are being attacked by a force of federal troops in U.S. Army helmets. As the transmuted blue-eyed soldiers smash into the center of the marching strikers, they trample underfoot an open book, the number 17 visible on its page, signifying the violation of the 1917 Constitution.

The labor strife continued into 1959. The railroad workers and teachers continued to press their demands for a price freeze on the necessities of life, while their union leaders and many workers remained in prison. Siqueiros was putting long hours in on the mural and giving time to the workers' defense committee. By May the large scene depicting *tragedy* was nearing completion. Though the mural had been screened off from

public view while work was in progress, it did not entirely escape curious prying eyes.

On a Sunday early in May, a day he was "at rest," Siqueiros found locked doors blocking him from the mural.

> I arrived on Sunday at the lobby of the Jorge Negrete Theater, where for many months, and frequently long days without rest, I worked on the theme, "Theater Arts in the Social Life of Mexico." I wanted to look at my mural; it was a habit in my manner of working, after a relative rest on a holiday, to quietly observe what I had produced during the course of the week, in order to resume work the following day, that is on Monday. That was when I discovered the lobby had been locked with a key, and that I, the painter, was not able to enter. The building attendant informed me that he had strict orders not to give me the key, not to permit me to enter the building from the rear of the theater.[6]

As soon as his eyes caught the section of the mural that was nearing completion, Rodolfo Landa, secretary general of ANDA—who had just returned from an extended trip through Latin America—immediately ordered the mural sealed off and the work stopped. Without any previous warning that an act of this nature was a possibility, the suspension order came as a complete shock to Siqueiros.

> The hand of the Government has reached into the field of art, into the field of creativity. . . . When a nation arrives at the point of attacking art, of producing acts of inquisition against plastic thought, it is an omen that things are very bad for the working class and the people, and much better for the sectors of exploitation, both national and foreign.[7]

Siqueiros protested vehemently. Landa retorted that he had locked him out because what he had painted was unacceptable. He insinuated, however, that the work could resume if two demands were met: remove the book with the number 17 and remove the U.S. helmets. It had been a long time since Siqueiros had encountered such direct opposition. Landa's demands appalled him, and he responded with a firm "No!" He chided the members of ANDA's Executive Committee, who

> as leaders of an organization of artists, should not be accomplices of the Government, especially when my own work condemns a specific act of aggression by the Federal Government against a union organization of workers, as is their own.[8]

Once again Siqueiros explained the principles upon which the Mexican Mural Movement rested, and emphatically told the leaders of the Actors' Union that if he acceded to their wishes he would "simply participate in the destruction of that movement."[9] He insisted that the matter be brought before a meeting of the general membership, and if this was not done, threatened that he would reach the rank and file through large

notices in the newspapers, and would carry his protest from theater to theater.

An agreement was reached that the matter would be presented to the general membership, and it was reported in the newspaper that Siqueiros would accept the decision of the assembly.[10] The ANDA leaders, who fully supported President López Mateos and in turn were recipients of government favors, were intent on eradicating more than the two points of their initial complaint. Their ultimate intention was to do away with the mural altogether, on the grounds that Siqueiros had violated the contract. The argument finally revolved around the interpretation Siqueiros had made of the theme both parties had accepted. Partisan politics became the issue. "The leaders of the union," Siqueiros stated, "claimed that it was a problem of not confronting the will of the government, which was passionately against the railroad strike that I defended."[11]

The general membership meeting started at 11 a.m. on May 10, 1959, but Siqueiros had to remain outside until the matter reached the floor. Union members filled the Jorge Negrete Theater to capacity. The newspapers, hopefully anticipating a scandal, reported that "the most muscular members of ANDA were prepared to block Siqueiros's entrance into the building. Siqueiros himself maintained that a highly vocal segment of the membership, who had not seen the mural, were coached to express anti-Siqueiros sentiment.[12]

By 1 p.m. the regular union business had been disposed of and the subject of the mural reached the floor. Siqueiros had not yet been permitted to enter the auditorium. Union leader (and popular actor) Rodolfo Landa explained the nature of the problem to the membership. It was his position that the matter was a legal one, a violation by the artist of his contract with the union: Instead of painting the theme, *The History of the Theater,* he had painted the railroad strike. Landa then reminded the members that their unity had brought them great benefits, and warned that if that unity was now broken, they would fall on hard times.

"The intention was clear," stated *Excelsior.* "Landa seems to have said: 'Compañeros, we must form a united front against Siqueiros'"[13] A second member of the Executive Committee—Siqueiros had still not been admitted—smeared the artist by accusing him of serving outside interests, while a third member pointed out that Siqueiros had offended the 5,000 ANDA members by calling Landa a *cacique*—a boss. By this time the audience had been aroused to a passionate state and amid shouts of "Judas" and "traitor" the meeting erupted into a stormy affair, with skirmishes and blows struck between members of opposing views.

At 1:30 p.m. Siqueiros was ushered into the packed theater, his military bearing evident as he walked down the aisle to the stage. All eyes were on him, some belonging to many of Mexico's most famous actresses and actors. "Half the public," he wrote, "of actors, actresses, scenic design-

ers, directors, set builders, etc., received me with some jeering, while mixed with their whistles was some fifteen percent of applause." This "scheming and cowardly demonstration" by the opposition had been prepared beforehand, he was convinced, and it involved the most backward sector of the membership.[14]

Siqueiros mounted the stage, shook hands with the Executive Committee members, and was offered a seat at the end of the long table. Landa briefly reviewed the problem, actor Victor Junco (also of the Executive) uttered a few words in opposition to Siqueiros, and then, to accompanying whistles and applause, Siqueiros was given the floor. The audience became hushed; his manner was commanding.

"The situation is very serious," he began, "when an artist has to appear before other artists to solve their differences."[15] He then told the ANDA members that it was obvious they were unfamiliar with the history of Mexico's Mural Movement, and he digressed briefly to remedy that ignorance. The artists of the movement, he told them, "were not bohemians but citizen painters, civilians united in the popular causes. I myself am not a decorator."[16] He reminded them that after Nelson Rockefeller had destroyed Diego Rivera's mural dedicated to freedom in New York City, Rivera had been free to paint the same mural, with its portrait of Lenin, in the Palace of Fine Arts, a Mexico City government building. And had not Orozco painted a mural in the Supreme Court building "denouncing the venality of the judges, and exposed the corrupt judicial machinery"?[17]

The scene of poverty-stricken life in the Valley of Mezquital that he himself had painted in the mural under fire, he had done with the intention of encouraging the actors "to draw close to these people and assist them to produce works of their own, with their language, race, and customs." Further: "The hungry masses cheated by the Revolution, marching forward, was the epic drama. Heroism in adversity was the struggle against blue-eyed soldiers trampling the Constitution."[18]

The Mexican painters, he told them, never agreed to paint the ideology of those who commissioned the work instead of their own. Comparing painting to the creative involvement of writing a book or a dramatic work for the theater, he asked:

> What would be your opinion if a capitalist, investing in the theater, said to the playwright: "Here is the money for the creation of your work but I will be in charge of deciding the norms of form and content"? And what could be more serious in this matter than that my patrons are the artists of the theater themselves. The very ones who have themselves suffered the aesthetic and ideological imposition by the capitalist business partner and the government.[19]

He told his audience that together they should seek a solution to the problem so "the inquisition of the government would not be able to penetrate our own houses of art," and explained that when he painted murals

for a university, a union or a public school, it was his desire to have those for whom the mural was destined "participate in the thematic aspect of the work so that the work was not simply mine but of a team of humans." In any case his conclusion was, that for the section of the mural that portrayed *tragedy*, it could not be something like "a drug addict who kills his daughter and then commits suicide, but only what was resounding in the streets, and that meant to condemn the government's unconstitutional aggression against the railroad workers."[20]

Siqueiros spoke for 45 minutes, and "[i]n spite of the fact that before his presentation the assembly was predisposed against him, he received the greatest applause."[21] Landa thanked Siqueiros, but held firmly to his position that the contract had been violated. When another union official made a more furious reply to Siqueiros, his colleagues shouted him down and a member of the audience leaped to the stage to deliver a speech in support of the painter. Others followed this example and a melee erupted, first on the stage, then spreading to the auditorium. When a pistol was drawn, terrified actors and actresses ran from the theater. Yet, amid the commotion and above the din, Landa succeeded in pushing through his proposal that judicial action be taken against the mural. Then Landa invited everyone, including Siqueiros, to view the mural. Siqueiros excused himself with the comment: "The idea is not agreeable to me, it would be like a momentary visit to a child in an orphanage."[22]

In its own building, ANDA controlled the mural and covered it with plywood panels to hide its forbidden message from innocent eyes. On October 9, 1959, a preliminary hearing took place in front of the mural, before a judge of the 17th Civil Court, with his secretary, the ANDA leaders, the architect Vicente Leduc, Siqueiros, his lawyer María Teresa Puente, Angélica and reporters present. The mural was uncovered and the judge proceeded with his visual examination, dictating to his secretary exactly what his eyes beheld. It was a legal document, a dry literal description of the work's figures and details.

Siqueiros complained that the mural was being judged out of context and that he couldn't understand why, after a history of socialist and anarchist theater in Mexico, his work should now be considered dangerous. The ANDA leaders complained, "We asked him for pears and he wants to give us prunes."[23]

On December 12 both parties to the litigation appeared for a formal hearing in the judge's chambers. His attitude was made plain when he told Siqueiros that "a crime can also be committed with an artistic act, with plastic expression."[24] That evening Siqueiros gave a lecture in the Cervantes Library on "Freedom of Expression in Artistic Creation."

The case was now in the Mexican courts; the delay in its coming to trial was such that eight years would pass before work on the mural resumed.

That Siqueiros was able to make any progress at all on his murals was an achievement to be marveled at. Three murals were being painted, and older ones had yet to reach completion when Siqueiros became the leader of the Committee for Freedom of Political Prisoners and Defense of Democratic Liberties, sharing his time between painting and politics. The murals were of great complexity, the painting highly developed and technically unsurpassed, and all the while he immersed himself deeper in the working-class struggle, but he was well conditioned to endure the dichotomous situation.

In February 1959 the U.S. State Department was keeping a nervous watch on Mexican groups that were planning public protests of a planned visit by President Eisenhower to Acapulco. U.S. Ambassador Thomas Hill had informed Washington of the anticipated action, and in his message to the State Department had advised that Siqueiros was among the Communists "who may endeavor to cause disturbances," for it was he who "ignored PCM policy opposing demonstrations against Secretary Dulles at the time of the inauguration of President López Mateos." Siqueiros had "indicated he is determined in his plans to embarrass President Eisenhower's visit." And still more, according to the ambassador, a Russian, "a known intelligence agent working under Soviet Embassy direction is reported to have held meetings to organize Mexican Communist disturbance plans."[25]

For Siqueiros, Eisenhower's visit to Acapulco did represent an imperialist threat to Mexico, and he had objections. But he was inundated with mural work in Mexico City and unaware of the sinister plot in Ambassador Hill's fantasy. Other messages were relayed at this time from U.S. intelligence agencies in Mexico to Washington on Siqueiros's activities in support of the new Cuban government. Note was taken of the fact that among 200 delegates representing 16 Latin American countries who attended a meeting in Havana, Siqueiros was elected one of six honorary presidents. The U.S. Embassy in Mexico City also told the FBI that Siqueiros was a leader of the *Asociación Mexicana Amigos de Cuba,* and in July 1959 "Siqueiros was a speaker at the funeral of veteran communist Narciso Bassols."[26]

Since work on the Actors' Union mural was halted, Siqueiros turned his full attention to the walls in Chapultepec Castle. On the principal wall a scene similar to that which had so distressed the ANDA leaders was unfolding. Siqueiros was painting a symbolic rendition of the 1906 Cananea miners strike, which was an earlier counterpart of the current railroad workers' strike, and as powerfully painted as the scene in the censored work. The miners of Cananea had demanded from their North American bosses wages equal to those received by U.S. miners just across the border. Their strike had signaled the doom of the Díaz regime, but in

1959, similar far-reaching effects were not expected for the striking railroad workers, who faced such strong government repression.

Siqueiros was invited to Caracas, Venezuela, to examine the possibility of painting a mural there. The plans for a new building for the *Instituto Agrario Nacional* had been sent to him by Alváro Coto, a Mexican architect in Venezuela.

Enroute to Caracas, Siqueiros stopped in Havana. He was anxious to see the new Cuba after Castro's first year in power. He and Angélica had turned the trip into a family excursion, taking with them their daughter, Adriana; her husband, Constantino; and their little boy, Davidcito. At the airport in Havana, Siqueiros was welcomed by members of the Francisco Javier Mina Association of Spanish War veterans who hoped to enlist his help in rallying all Latin American Spanish War veterans to support the Cuban revolution.

Siqueiros felt the new spirit and excitement in the atmosphere and promptly expressed his thoughts to the Cubans:

> Without any doubt, you the people of the land of Martí, have in one year of Revolution been able to carry out transcendent measures that we Mexicans have not been able to bring to pass in fifty years of our own Revolution.[27]

At the same time he let it be known that he was ashamed that his own President, López Mateos—at that moment on a tour of South America—had excluded Cuba from his itinerary "in order not to disturb the policies of the U.S. Department of State." But Siqueiros assured the Cubans that they had the complete sympathy of the Mexican people.[28]

On January 6, 1960, less than a week after his arrival, Siqueiros presented his first lecture in "New Cuba," in the Theater of the Ministry of Culture. He spoke to the artists of the first socialist republic in the Americas on "Painting in the Cuban Revolution with the Experience of the Painting of the Mexican Mural Movement."

> Since the Christians had developed a powerful art to propagate Christianity, why should we not develop an equally powerful art to defend the process of the Mexican Revolution? Was not agrarian reform an adequate theme? Was not labor reform an adequate theme?

He noted as "adequate themes" a host of urgent problems in the struggle to improve life; these problems offered "magnificent themes, better than those of Greek mythology, for they were the themes of liberty, not themes that served privileged minorities, pro-slavery sectors, and aristocrats."[29]

Siqueiros reached further into the Mexican experience and warned the Cuban artists as to how the United States operated in the arts to destroy any incipient Latin American movement toward realism:

> The campaign against us became ever more intense as the cultural apparatus of the U.S. Government attacked our movement. At first they fought it very

hard, then later they silenced it. The Museum of Modern Art hid its collection of Mexican realistic painting, closed its doors to us, and attacked us in the monographs they edited.

He assured the Cuban artists that the United States was not interested in helping "people's revolutions," that they would stop the painters of Panama from demanding the right of their country to reclaim the Canal, and the painters of Puerto Rico from struggling alongside their people to gain their liberty. Claiming abstractionism as "the most advanced and revolutionary art, Yankee imperialism was using the money of the Organization of American States to combat figurative art that contained social content." However, Siqueiros did point out that the most "audacious" formal concepts could be employed within art of social content. "Everything that can be done in art without political content can fit within an art that is thoroughly committed."[30]

Siqueiros and his family had arrived in Cuba on New Year's Day, two days after his 63rd birthday. First they toured the city, hoping to find the three small murals he had painted 17 years earlier. Try as they might, he and Angélica could not remember the way to the Gómez Mena home, where the *Allegory of Racial Equality* mural had been painted, but Adriana, who was a child of nine when the mural was painted, now remembered the location and guided her parents to it. There was the house, standing just as they had known it, but the mural was no longer there. It had been "destroyed by the wealthy patroness, who did not like it," was the information they gathered in the neighborhood.[31]

Two Mountain Peaks of America still hung in its place in Havana's Museum of Modern Art. The painting of Martí and Lincoln, two giant heads, measured approximately 1.5 x 3 meters.

They joked over the memories, recalling how Siqueiros hid behind the columns in the Hotel Seville-Biltmore lobby to avoid encountering Batisti, the Italian owner, when their hotel bill was three months overdue.

Finally, Siqueiros had been ordered either to pay the bill or to paint a mural for the lobby. He painted *The New Day of the Democracies*.

But now, when Siqueiros and his family arrived at the Hotel Seville-Biltmore, the mural was not to be seen. Siqueiros, however, was greeted warmly by the hotel workers, who remembered when he had painted the mural and excitedly led him to the cellar where it was stored, wrapped in protective covering. They explained that during the days of the Batista overthrow, they themselves had taken it to the cellar for safekeeping. The mural was brought up into the light, Siqueiros cleaned it, and in his presence the new Cuban government installed it in Havana's Museum of Modern Art.

After eight days in Cuba, Siqueiros and Angélica left to keep their appointment in Caracas, leaving Adriana, Constantino and Davidcito in

Havana. When their plane landed at the Maiquetia airport, a short distance from Caracas, they were overwhelmed by the large welcoming party that included three cabinet ministers, various members of the Chamber of Deputies, Communist Party leaders, representatives of the Federation of University Students, and numerous delegations of workers carrying union standards and large banners bearing messages of welcome. So surprised was Siqueiros by this welcome that he could only attribute it to the prestige that Mexico and Mexican painting enjoyed in Venezuela. From the seacoast airport a long caravan of autos escorted Siqueiros and Angélica, racing the 16 km. through long mountain tunnels with their horns blaring all the way to Caracas. There was an air of excitement in anticipation of the lectures he had agreed to deliver at the university.

On the following day, January 9, Siqueiros attended to the first piece of business, a visit to the *Instituto de la Reforma Agraria* to inspect the wall that had been offered for a mural. As he had suspected when he had seen the building plans, the exterior wall proved unsuitable for his conception of the integration of mural and architecture, and since he did not encounter another surface that pleased him, the project began to fade away.

The University of Caracas had requested that he give three lectures, and for each they offered $1,500. Siqueiros accepted payment for one lecture for himself; the remaining $3,000 he donated to the people of Cuba, stipulating that the money be put toward the purchase of a military airplane.[32] In the meantime, back in Mexico charges were being raised that his visit to Caracas—which preceded that of President López Mateos by just a few days—had been planned deliberately to undermine the President's goodwill tour, the first abroad by any Mexican president.

In his first two lectures—in the Central University of Caracas on January 9th, and in the Museum of Fine Arts on the 11th—Siqueiros dealt with all the ramifications of modern art for a Latin America committed to social progress. But it was his third lecture, on the 12th, that would without premeditation sow a future whirlwind. He addressed 500 members of the Venezuelan Association of Newspaper Writers, seated in the front rows, and 2,000 more of the general public, who filled the auditorium. The content of his lecture is revealed in its title: "The Mexican Revolution, a Frustrated Revolution. Or the Work of the neo-Porfirians and Pro-Yankee 'Juniors.' The Concrete Case of the Last Presidential Elections."[33] Following his talks, Siqueiros took questions from the audience.

For the López Mateos government this was the last straw. How long could they tolerate Siqueiros's open criticism, combined with his charismatic influence, speaking abroad just steps ahead of their President, who was defending his own interpretation of the Mexican Revolution? In his first two lectures Siqueiros had revealed the plight of the Actors' Union

mural. In the third lecture he concentrated on the political aspects of Mexican life that underlay the controversy swirling about the mural.

Painting a vivid word picture, Siqueiros delineated the causes of the current labor unrest in his country. The crisis had broadened since August 27, 1958, when a group of young radical railroad workers had assumed leadership of the *Sindicato de Trabajadores Ferrocarrileros de la Republica Mexicana.* This event followed a series of strikes by government employees struggling to rise out of the utterly depressed conditions of life left by the outgoing administration of Ruiz Cortines. Now, after years of being fed the promises of the Revolution, workers were rebelling against the corrupt leaders of government-dominated unions.

Siqueiros outlined the sequence of events. The first to strike had been the telegraph workers, followed by the teachers and then the petroleum workers; after the telephone workers struck, the railroad workers stopped the Mexican railways. All this took place as López Mateos was beginning his six-year reign with a super-progressive image concocted by the demagogy of the political party in possession of all the power, the *Partido Revolucionario Institucional.* The PRI hailed López Mateos—"a new Lázaro Cárdenas has appeared on the horizon"—successfully rallying liberal and left support, including members of the Communist Party and the Workers' and Peasants' Party.[34]

None of this surprised Siqueiros, for he had long foreseen the steady winding down of the Revolution, and had earlier predicted the nature of the López Mateos government. One lone voice of opposition was raised in the Chamber of Deputies—newly elected Macrina Rabadan gained the support of a small group of deputies, senators and left-intellectuals and incurred the wrath of the President when she raised the issue of doing away with the sordid law being applied against the strikers for an "offense" called "social dissolution."

Siqueiros told how, when the railroad workers' strike intensified in March 1959, López Mateos's reaction was so sharp that any illusions about his revolutionary posture were soon dispelled. Siqueiros had been drawn into the struggle when called upon to organize and head the Committee for Freedom of Political Prisoners and Defense of Constitutional Guarantees. The effects of all this he explained, began to materialize in his Actor's Union mural.

Questions were then put to him by the Venezuelan reporters. They were shocked when he told them that at the moment 3,000 railroad workers were locked up in army concentration camps, and that López Mateos had resorted to "Nazi tactics" in expelling two members of the Soviet Embassy whom he accused of being behind the railroad strike. Now, after 13 months in power, the López Mateos administration—supported by a completely submissive Senate, Chamber of Deputies, Supreme Court and press—despotically sought to bring the labor movement to its

knees, and engaged in the worst persecution of the Communist and the Workers' and Peasants' parties of any previous administration.

"The secret apprehension late at night of Communists and partisans of the railroad workers continues without letup." It was obvious that López Mateos's anticommunism was "dictated from Washington," for the President adhered strictly to the line of the U.S.-dominated Organization of American States (OAS), the anti-Communist bloc which did not neglect to mold aesthetic tastes in the field of art. Besides having sold out the agrarian reform to imperialism, the government of López Mateos represented

> the latest stage of the counterrevolution that had been an uninterrupted process since the 1940-46 Administration of Ávila Camacho; and those that were responsible for this state of affairs were the bourgeoisified sons of the enriched revolutionaries holding power, and the speculators whose numerical proportion in Mexico is possibly unequaled in the bourgeois-democratic revolutions of other peoples.

He held up the example of the Cuban Revolution as the only resolution for this problem; it was "in essence a Latin American revolution." And he said, "There is no doubt that the people of Mexico are not disposed to wait another 50 years for the solution to their overwhelming problems."[35]

When Siqueiros had finished, he left the Venezuelans sitting stunned and bewildered. The Mexican Revolution had always been a source of inspiration for them, but now the military and the police smashed strikes and imprisoned thousands in army concentration camps. Were there no representative political parties in the Government? Siqueiros answered:

> None! No party is represented in the Government. The Government is represented by the PRI, for this being a party of the official bureaucracy it receives final orders from the Government, which names its own President and most of the Ministers. There is not the least internal democracy.

Nor did a parliament exist, at least as in other countries: "The deaf and dumb occupy the legislature, which is today worse than during the period of Porfirio Díaz." Only the executive branch is the possessor of power: "It decides—from the purchase of brooms to sweep the streets to who will be jailed and for how long."[36]

22

Committing the Unthinkable

Siqueiros and Angélica stopped off in Cuba to pick up their daughter, son-in-law and grandchild, and while there, Siqueiros was on Cuban television in a 20-minute interview at 3:30 PM on Sunday, January 16, 1960. On that day President López Mateos arrived in Caracas on the first leg of his Latin American tour. Siqueiros discussed on Cuban television Mexico's political and social problems and the ramifications of the President's trip to South America.

The moment he and his family stepped from the plane in Mexico, the nature of the unpardonable sin he had committed was thrown in his face. While he had been away, the metropolitan press had launched an extravagant and crass campaign of vilification against him, for he had done what no Mexican in his right mind would dare to do: from outside the country he had criticized the "revolutionary" regime of the first "revolutionary," President López Mateos.

Siqueiros was labeled a traitor to the country. He received death threats, including one from a member of the Chamber of Deputies. Forced to defend himself against this campaign of calumny by the powerful Mexican bourgeoisie, he held firmly to his position, repeating the claim that all power in Mexico rested in the executive branch of the government and the sum of that power was 400 executive privileges, while those of the legislative branch enjoyed only 40 special privileges. He said it was in his nature to answer questions truthfully, and in Venezuela he had answered them with the "real truth."[1]

A major smear campaign continued against him in the press, and Siqueiros invited the reporters to his home on January 21 to explain that he had not "betrayed" Mexico on his trip. The reporters jammed themselves into the two stuffed sofas and the few odd easy chairs, and squatted on the floor of the large, simply furnished living room. Siqueiros expressed the solidarity of the Mexican people with the Cuban Revolution, and proclaimed the urgent need of the rest of Latin America for such a revolution. He then inquired of the reporters whether the fact that the President had been abroad—for that matter, in the same country where he too had been just a few days earlier—should have obliged him to hide what he considered "the unquestionable truth about the political and cultural life of my own country."[2]

Sparing no details, Siqueiros gave a full account of the trip, augmenting the charges he had made abroad, stating that the ruling oligarchy in capitulating completely to Yankee imperialism was dragging Mexican art and culture along with it. For already the National Institute of Fine Arts, which had been a product of the Revolution, had been transformed into an appendage of the OAS, which, he emphasized, was under the control of the U.S. State Department. To this he added the charge that "federalism in Mexico today is a myth, and the Federal States as autonomous entities do not exist." Nor did he resist telling his disarmed audience that the President had so many powers that "he could be called the Emperor of the Republic of Mexico."[3]

Siqueiros told the newspaper reporters that the press they worked for was completely in the hands of the "presidential monarchy" and almost without exception against the Cuban Revolution. He decried the exclusion from the country of the two Soviet Embassy employees by "government ukase, and without the slightest proof of the government's charges. And he reminded them that while the government had released most of the 5,000 railroad workers who had been detained for over a year, 300—including the leadership—still remained in jail. Then, too, there were the numerous tortures of railroad workers by government agents.

Siqueiros continued raining his blows, charging the government with doing nothing to bring to justice the Federal Army soldiers who were responsible for the murder of Román Guerra Montemayor, a railroad worker and official of the Communist Party in Monterrey. Of grave concern also was the government's suppression of all public meetings in support of the railroad workers; nor, as Ernesto Che Guevara had told him in Cuba, were meetings supporting the Cuban Revolution permitted in Mexico, not to mention the fact that Fidel Castro himself could not enter the country. "It was no secret to anyone," he told the reporters, "that this was due to the direct and indirect pressure of the U.S. State Department."[4]

He then asked the crowd of reporters in his living room why General Lázaro Cárdenas had not been permitted to report to the Mexican people after participating in the July 26th celebrations in Cuba. A meeting organized for that purpose was suppressed by the police. And yes, he had answered in the affirmative when reporters in Venezuela had asked him if López Mateos's trip represented the "advance party" for President Eisenhower's next trip through Latin America, if by advance party they meant pressing ahead with

> a political policy of Pan-Americanism in ideology and economics as opposed to the Latin American politics of joining in a bloc to defend fundamental national interests against the imperialist force of the United States. In this case, President López Mateos, with demagogic help of revolutionary Mexico, was clearing the way for his colleague, the President of the United States.

With little concern for the dangerous position he could find himself in, Siqueiros hammered away at what he considered the real betrayal—that at this moment the United States judged Mexico under López Mateos, given his anti-Communism and his economic Pan-Americanism, as a model for the rest of Latin America, and that López Mateos hoped that Mexico, along with the rest of Latin America, "would be included in the Western Bloc, which was directed by the great financiers and monopolies of the United States."[5]

The reporters scurried back to their newspapers and wrote stories so distorted and personally maligning that Siqueiros was forced to issue a further statement, his "Open Letter to My Impugners," which named 15 of them and challenged them to debate Mexico's real political problems, the cause of the wide breach between them. Pointing to the extremes to which his adversaries were willing to go in their verbal assault, he culled from their stories the adjectives of abuse they heaped on him:

> . . . traitor, expatriate, renegade, mercenary, fraud, provocateur, slanderer, foreign agent, cunning, disloyal, perturber, unbalanced, stupid, infantile, intolerant, exhibitionist, insolent convict, swindler, obtusive, criminal with a brush, schizophrenic, decrepit, etc.

He reminded his detractors that those who had earlier fought in the Revolution were also called traitors, and he found a reverse analogy to August Bebel's query: "Old Bebel, what have you done wrong to merit the praise of this rabble?"[6]

In this letter Siqueiros listed the eight occasions in 1959 when he had spoken within the country on behalf of the railroad workers, and the five speeches he had presented abroad during the first month of 1960. Let the scribblers of the press refute publicly all he had affirmed. He reminded them that as yet Mexico had not taken possession of its own national sovereignty, that after 50 years the Mexican Revolution was still unfulfilled, "and still worse, the fundamental postulates of its *Carta Politica,* the 1917 Constitution, have during the last three administrations been in a retrograde movement, if such movement is limited to the capitalist frame."

Since the Cuban Revolution had destroyed the myths that retarded change in Latin America, the people of Mexico and of Central and South America have now been shown that they can be the masters of their own future. Therefore, he stressed, it was imperative that the Cuban Revolution be defended.

Neither his critics nor the government would take lightly the challenge he laid down: A new revolution would have to carry on from the earlier one if essential problems were to be solved:

> The oligarchy directing the State was attempting to find the solution to the great economic-political problems through classic capitalist conceptions and

programs almost identical to how the group of *Científicos*, in fact, determined the dictatorial politics of Porfirio Díaz during his last years, and which could do no more than cause a greater foreign dependence with less freedom and more hunger for the people.[7]

Confounding his critics further, Siqueiros told them that López Mateos had spurned Cuba, on this first trip abroad ever for a Mexican President, because he was tied to the international politics that did not correspond to the struggle of the Mexican people nor to their aspirations for "national sovereignty and the constitutional rights which they did not possess."[8]

Thus the lone artist spoke, and his voice, ever influential among the masses, plus the steadiness of his political position, inspired great respect. As he resumed work on his mural of the Revolution in Chapultepec Castle, he left no doubts concerning his position toward the government of López Mateos.

But it was a period that did not leave Siqueiros in peace to paint. The mural, *Del Porfirismo a la Revolucion,* demanded intense mental and physical exertions. The struggle of the railroad workers did not diminish, and within the Communist Party, Siqueiros was leading a faction pressing for a shift in policy. On the walls of Maximilian's castle, the panorama of objectified facts of Mexico's early 20th-century historical explosion continued to spread, though with increasing frequency Siqueiros had to lay down his brushes to attend to some political task.

As chairman of the National Committee for Liberation of Political Prisoners and Defense of Constitutional Guarantees, Siqueiros left the mural on March 27, 1960, to travel to Torreon, far to the north, to address a meeting on behalf of political prisoners. On April 2, the U.S. State Department informed the FBI that at the PCM's Eighth Federal District Convention, Siqueiros was elected a delegate to the Thirteenth National Party Congress.[9] This represented a victory for the Siqueiros faction over Encina, who at the time was one of the jailed political prisoners. This was the grist from which murals were formed; as he told a judge, "A man with my political life, who is at the same time an artist painter, cannot in his art remain on the outside of such a dramatic problem."[10]

Earlier, on March 14, Siqueiros appeared in court as a witness at the trial of J. Encarnación Pérez Gaytán, a PCM member charged with the political crime of social dissolution. The case against him was part of the government's persecution of the railroad workers. The government feared that if the railroad workers succeeded in their demands for better wages and improved working conditions, it would open the floodgates for all labor to press demands for a betterment of their lives. At all costs, the working class had to be held in check.

Pérez Gaytán was a schoolteacher and a member of the Executive

Committee of the PCM in Monterrey, and the government was out to prove that he was the conspiratorial link between the Communist Party and the *Sindicato Trabajadores Ferrocarrileros de la Republica Mexicana,* a link that received its orders from Moscow. This trial in the Second District Court in Mexico City was the principal element in the government's fabricated case to defeat the railroad strike.

The government charged that the aims of the 12th PCM Congress had been to provoke strikes and demonstrations that disrupted the tranquility of society. Siqueiros was called upon to testify for the defense and he first affirmed the Party's dedication to continuing the struggle against feudalism and imperialism; these, he asserted, "were the fundamental cause of the tremendous misery which our people suffer, and it is because of imperialist aggression that our Mexican Revolution is frustrated." The strikes were not the result of the PCM 12th Congress but had been caused by the steadily increasing cost of living, low wages, and the pernicious poverty that blanketed the countryside, forcing the exodus of the male population to the United States as migrant laborers. With a gesture of surprise, he pointed out that it was not the Party that *suddenly* provoked turmoil and violent activity among the people. Obviously, economic desperation and the intensified systematic violation of civil liberties were the reasons. "The PCM, of which I have been a member since 1924, has ceaselessly struggled against the conditions of misery of the Mexican people."[11]

Siqueiros openly criticized the government for its trumped-up charge that a conspiracy existed between the PCM and the *Sindicato de Ferrocarrileros* that went beyond the demand for higher wages and improved working conditions to actual overthrow of the government. This, he explained, was the government's method of "smothering in the cradle" the workers' just demands; they feared that if increases were granted the railroad workers, demands from others would soon follow, and they would not allow that to happen. To further build its case, the government had dragged in the Soviet Embassy, linking the two Soviet Embassy attaches, the PCM, Pérez Gaytán and the *Sindicato.*

To assure the court that Pérez Gaytán was not on Moscow's payroll, the defense questioned Siqueiros as to his knowledge about the defendant's economic condition. "Yes," Siqueiros replied, "all members of the Communist Party know perfectly well the private economic life of all other members." Since he had been a member of the Central Committee at various times, he had personal knowledge not only of the organization's economic situation but of the private economic life of each member. So he knew that Pérez Gaytán not only gave his life and time to the Party but did so at the expense of great economic deprivation. At this point, Siqueiros gave the court an example of the Party's concerns about its members' finances, telling them about a Communist miner on strike

in the past, in Jalisco who, when he suddenly came into possession of a goat, was required as a Party member to appear before a Party meeting with an explanation of this acquisition. "I can assure you," Siqueiros told the judge, "that on various occasions when I was a paid functionary of the Party, I almost died of hunger."[12] He was sure that Pérez Gaytán's financial condition was precarious.

When the prosecutor asked Siqueiros to tell what he knew about the "incrustation of Communist cells" in the factories of the country's basic industries, the defense attorney reacted immediately and demanded that the "insidious" question, asked in "bad faith," be striken from the record. The judge, however, stood by the prosecutor and directed Siqueiros to answer. The response was:

> The prosecutor with his question desires to know, implicitly, how the Communist Party functions organically within the national political life, and this I refuse to answer, as would any member of a legal party, and the Communist Party is a legal party.[13]

After explaining that no law existed which obliged him to reveal the internal activities and business of any political party, he lectured the court.

> Among the mass of industrial workers, there . . . are Communists, Socialists, Sinarquistas, Catholics, Protestants, Masons, and they . . . bring . . . their respective points of view and their respective positions. Communists bring the defense of the working class; the *Partido Acción Nacional* brings the cause of the most conservative sectors and of the hopeless bankers of the oligarchy . . . ; the PRI . . . brings their defense of the directives imposed by and tied to the bosses; the Masons look to make proselytes; the Catholics offer pilgrimages. . . . By this I wish to say that all political ideas, all political currents, in fact, constitute cells within the great mass of workers as well as within the people of the country. . . . Each tendency looks to defend and develop its respective political point of view. Why, then, habitually use the terms of a police investigation, as does the prosecutor, when he says "incrustation of Communist cells in the factories."?[14]

The prosecutor, sharpening his inquisitorial thrust, turned the trial of Pérez Gaytán into a trial of the PCM, and persisted in attempting to ruffle Siqueiros with provocative questions: What kind of information did the Communist Party newspaper, *La Voz de Mexico,* disseminate? What ties did the PCM have with other parties? What railroad workers were members of the PCM?

Siqueiros rejected the harassing questions and upheld the legality of the PCM—"this I must insist to the point of exhaustion"—reminding the prosecutor that as a legal party the PCM abided by the law, and that the contrary had not yet been shown by the court. Then, after further chiding the government for violating the civil liberties of the workers and trampling the Constitution, Siqueiros ended his testimony.[15]

Through the spring and summer of 1960, Siqueiros was fully occupied painting the highly detailed and complex mural in Chapultepec Castle. On March 31, after a day of intensive painting, he and Angélica sought to relax at an evening cinema. They had arrived too late for the 8 p.m. show at the Cine Prado; with time to while away before the 10 p.m. show, they purchased the evening papers and drove off in the direction of the Zocalo, a short distance away.

At that moment a protest demonstration was taking place in the Zocalo, in front of the National Palace. Angélica parked the car on a side street, left Siqueiros reading the newspaper, and went to investigate the meeting taking place around the corner. After briefly taking note of a gathering of teachers, she returned to find the car empty, its interior light still on. It was not like him to leave the car with the light on, and it was just moments ago that she had left him, his nose in the newspaper. A premonition gripped her.

The Special Security Police had the meeting under surveillance; they had recognized Siqueiros reading in the car, had asked him to step out, and had taken him away. They held him for three to four hours, trying to determine what connection, if any, there was between him and the teachers' demonstration. After frantically telephoning many places, Angélica finally located him in a police station.

The incident surfaced later in government accusations that he had directed the protest. Reporting to the Secretary of State in Washington, U.S. Ambassador Hill stated that the Embassy had had observers at the demonstration: "Communist artist David Alfaro Siqueiros [was] picked up by the police near site of demonstration but released after several hours with warning that disturbance of public order would not be tolerated."[16]

In July, Siqueiros was off for a brief trip to Cuba to address the Congress of Latin American Youth celebrating the anniversary of the 26th of July movement.* While he was in Cuba, Trotskyite enemies launched a campaign of vilification against Siqueiros, disseminating scandal sheets with stories that he was attending a secret meeting in Havana where plans were being hatched for the overthrow of the Mexican government, that the plans were financed by the Soviet Union and were to be put into motion with student demonstrations on August 1.[17] In view of the government's attitude toward Siqueiros and the undiminished labor unrest, hollow charges from such artful quarters could have serious consequences.

During this period Siqueiros moved from his home on Calle Querétaro, where he had lived and painted for ten years, to a new residence-studio,

*The date of Castro's 1953 attack on the Moncada Barracks is celebrated in Cuba as the beginning of their revolution.

Calle Tres Picos 29, just north of Chapultepec Park. Here, with ample space, he began to visualize a plan to convert the house into a public art center, a mural gallery, and a much needed archive for the vast amount of papers he had accumulated relating to the Mural Movement.

Besides the mural being worked on in Chapultepec Castle and the residue of unfinished works—the still-covered mural for the Actors' Union; the *ex-Aduana* mural, 15 years in process; and the seemingly hopeless San Miguel de Allende work—a new offer came from hotel owner Manuel Suárez for a very large mural in his new Hotel de la Selva in Cuernavaca. It would be larger than anything Siqueiros had done, and his mind rapidly filled with visions and ideas for the work.

While *Del Porfirismo a la Revolución* was unfolding in great plastic brilliance, with its color, form and masterful rendition, its surging movement and innumerable portraits of revolutionary personalities, Siqueiros was in one of his periods of intense artistic contemplation, oblivious to the political buffeting occuring on the streets outside. He heard none of the noises of student commotions surging from the National University at the city's southern end; nor, for that matter, from the Normal School at the center or the Polytechnical Institute to the west. He heard only the distant muted sounds of the impassioned ebb and flow of past scenes, which he was now painting. But soon the crescendo from the streets reached his ears and wrenched him from his enraptured state.

On the morning of August 4, 1960, 1,500 teachers and students gathered at the Normal School in preparation for a march to the National Palace, where they hoped to present to President López Mateos a petition containing a list of their grievances. Police agents had already infiltrated the teachers' planning meeting the previous night, and the authorities were well prepared to block the "unauthorized" march.[18]

The youthful marchers who assembled at the Normal School were surprised at the size of the police contingent on hand. The authorities were prepared to control the situation with more than 700 police, armed with guns, clubs, tear gas and water cannons. The police did not obstruct the assembling teachers and students, but had orders to disperse them once they started to march.[19] The procession, peaceful and orderly, displaying their messages on a variety of banners, started off, but the police remained back, enticing the marchers to move forward. Not far ahead, awaiting their arrival, were helmeted Mexican Grenadiers, the dreaded riot police. A squadron of mounted police came in from the rear. The teachers and students led into the trap were brutally clubbed, trampled by horses and gassed.

The general outcry in the press blamed "teacher agitators" for using students as "cannon fodder," holding a communist conspiracy operating behind the scenes was responsible for the violence. The two business

organizations of the bourgeoisie—the Confederation of National Chambers of Commerce (CONCANCO), and of industry (CONCAMI)—called upon the government "to repress with force whatever manifestations are contrary to our laws," and the CONCANCO statement included a direct reference to Siqueiros, accusing him of doubletalk."[20]

Through all of this Siqueiros remained closeted in Chapultepec Castle, hoping that his mural could be finished in time for the 50th anniversary celebration of the Mexican Revolution on November 20, less than four months off. But now, with a large number of the participants in the August 4th march thrown in jail, Siqueiros broke away from his painting once again and on August 8 presided over a press conference called by the National Committee for Freedom of Political Prisoners and in Defense of Constitutional Guarantees. In the committee's shabby office at Calle Donato Guerra 1, Siqueiros opened the conference with a statement condemning the government's repression of the August 4th march, informing the assembled journalists that a government that held political prisoners, used methods of terror with tear gas and clubs to prohibit the right of protest, had no right to speak of freedom. "It would be absurd to celebrate the 150th anniversary of the Independence and 50 years of the Revolution while 32 political prisoners, headed by Demetrio Vallejo and Valentín Campa, are not given absolute freedom." He further informed the journalists that the committee was going to conduct protests throughout the entire country, and "aggression by the police will not intimidate us." He accused the government of attempting to set a precedent with its action of prohibiting people from raising their voices in protest, "as was the case with the peaceful demonstration of the 4th of August." In spite of the blood that had flowed, that sort of precedent "would not take hold in the democratic life desired by the Mexican people."[21]

Siqueiros proclaimed that he personally would be at the fore with demonstrating students, teachers and intellectuals, at a meeting to protest the August 4 "massacre."

> The streets belong to the people, they have been won by the shedding of blood, and nothing and nobody can make the people leave the streets, which is the setting where they can freely engage in vigorous protests whenever their constitutional rights are trampled underfoot, and when the regime under which they live does not respond to the people's desires for democratic ideals.

When the police had not intervened to provoke participants in protest meetings "nothing happened, not one window was broken, and the event took place peacefully. Now the cruel, illegal, and mechanized violent acts of terror are worse than those the regime of Don Porfirio Díaz practiced." The López Mateos government had violated the Constitution, "not once, but hundreds of times."[22]

The violent repression had begun when the President destroyed the

"real" railroad union, "created special jails, concentration camps, and moved those they presumed responsible, from one state to another, inflicting terror on their lives." Siqueiros once again compared the regime with Porfirio Díaz's. When the centennial of Mexican Independence was celebrated in 1910, Díaz cleaned the beggars from the streets and out of sight of the many foreign dignitaries. Hundreds of beggars were locked in the stables of an important Mexican official who was then on the high seas returning to Mexico with European dignitaries on their way to the celebration. The Mexican official bragged about his thoroughbred horses and promised the Europeans that he would host their visit to his stables. "And what was their surprise," Siqueiros quipped, "when they arrived at them and found all the beggars together—that is, all the misery of Mexico displayed at once." He pointed out that once again the government was preparing for a gala celebration of an anniversary of the Independence, the 150th, and the President was hoping to keep political problems out of sight. But just like the beggars in the stables, the demonstrators now in jail as political prisoners "will reveal all the misery of Mexico."

Siqueiros promised more marches, protest meetings, and a petition drive to gather signatures throughout the country—hardly a call for open insurrection, as it was made out to be in the press.

The next day, August 9, Siqueiros resumed painting in the Castle. But his desire to be left to paint undisturbed as he approached the age of 64, to work with his creative mood unviolated, was an impossible dream.

There were powerful forces opposing him and they posed very real threats of physical attacks against his person and also against his painting, his life blood.

> *La Acordada* is a secret organization of assassins. It is a special type of police that is a dependent of each Mexican state. Composed of a chief and 6 to 50 subordinates, it was the job of *La Acordada* to eliminate the personal enemies of the governor or of political bosses, including bandits and those suspected of committing a crime, but against whom no proof exists. The officials pass on the names of the victims and the members of this body are given orders to kill silently and without causing a scandal.[24]

In 1911 John Kenneth Turner was referring to Porfirio Díaz's "hit squad." But *La Acordada* (con acuerdo—with agreement) had a history in Mexico prior to its official sanction by the Crown in 1722.

> While regretting the necessity of such a body as the *acordada* the viceroys generally backed it in its many disputes, often torn between a sense of justice and the priorities of internal order. The spector of internal disorder constantly forced the viceroys to place order before justice.[25]

On the day after his August 8 press conference Siqueiros was full of high hopes that, barring any unforeseen interruptions, he would have the

Chapultepec Castle mural finished on time. He had begun the day's work between 9 and 10 a.m. By 2 p.m. Angélica would arrive and, as was their custom, she would drive him the short distance home for the midafternoon meal.

What happened when the two arrived at their house was told to me by Angélica in 1974.

"I picked him up a few minutes before two o'clock from Chapultepec Castle, where he was painting. He was supposed to come home and eat, and then I would take him back. But a few minutes before I arrived, my brother Paul went to the Castle and told David that 20 meters from our house there were some special Jeeps with peasants sitting in them. They were on the same block and there were two cars. 'So nothing is happening,' David told him, 'you are always seeing strange things. They have nothing to do with me. I have done nothing wrong.'

"But the moment we arrived at our house on Tres Picos Street we saw two Jeeps moving down toward us. Siqueiros was going to get out, to face them. He acts that way all the time, he never saw danger in anything. But when I saw what was happening, I didn't pay any attention to him. I said, 'Close the door!' and drove off, and he said, 'Where is my gun?' He always had a gun. You're allowed to have a gun in your car or your house, but you can't carry one outside, according to the new law. "So where's my gun?' he asked.

"'I didn't bring it,' I told him. He wanted to use it to protect himself, but they would use that as a charge against him. I didn't give him a chance, for they were walking toward us with their car following. So I drove fast to the corner, and the moment I tried to pass the corner, I saw on the other street a long black car of the Secret Police with five men in it. At the corner they tried to cut me off. I jumped over the curb of the house in front and turned very fast to the left. The Secret Service came after us and hit my car on the side where Siqueiros was. They hit the door, damaging it, but I went so fast they could do nothing. So we were followed by the Secret Police and the men in Jeeps dressed like peasants with big hats.

"I was turning and turning from one small street to another, and while turning I heard shooting. I don't know what happened, I just heard shooting. I kept speeding and they couldn't see me because I was turning from one street to another, and before they could turn and follow us, I disappeared. Finally I got away. The tires on the care were shot, and one was absolutely destroyed. We left the car on a small street next to a big avenue where buses pass. We hid in a little entrance of an apartment house, and when we saw a bus, we jumped on. Siqueiros was in his work clothes, he looked like a real worker with paint on his pants and a little cap. You know, when he painted he got so dirty.

"We went with the bus, thinking, 'Where shall we go?' Well, we de-

cided to go to the Cuban Embassy. It was the first idea that occurred to me. It would be the safest place to hide at that moment. We got off the bus and took a taxi. I let Siqueiros off at the embassy and then left quickly with the taxi. But on that day the ambassador was not there. None of the official people were there. It was a holiday or something. So there was no one there to receive Siqueiros. Nobody but the guards. So when Siqueiros said, 'I am Señor Siqueiros, I want to see the ambassador,' the answer came, 'Well, señor, the ambassador is not here. The offices are closed today.' And I was so sure it was open that I left quickly and forgot that he didn't have any money. That was stupid of me. Since we were together all the time, I didn't think at that moment and forgot that he didn't have money.

"He didn't want to say anything to the guards, so when they said, 'Maestro, do you want us to get a taxi?' they got one for him. He did not know that he didn't have any money. At first he thought he would go to the house of his friend, Dr. Carrillo. But he didn't want to go there because a little more than a year before, when there were riots and they were putting people in prison, we had been hiding there for one or two nights. It was in Carrillo's house that Siqueiros painted the soldiers attacking the workers. He copied this exactly into the mural, and in Carrillo's collection you can see the painting of what is more or less in the mural of the Actors' Union.

"That's why he did not want to go to Dr. Carrillo. 'So where can I go?' he said. He went to the house of Carrillo's daughter, but she wasn't there. So finally he did go to Dr. Carrillo's. When he knocked, Dr. Carrillo came to the door and said, 'Go inside, I'll pay the taxi.' Maybe the driver told the police, but we don't know. Our telephone was tapped, absolutely tapped. I found out later that Señora Carrillo, trying to reach me, called Mama and said, 'Señora Arenal, the lady who is going to do the laundry arrived already.' So mother said, 'What? What do they want to do with the laundry?' Mama never understood these things. Maybe that's what happened, they got the connection with Dr. Carrillo, that's the most probable thing.

"Siqueiros stayed all afternoon and into the night. When there was a knocking on the door, Dr. Carrillo told Siqueiros to hide. Siqueiros went out back and hid atop a stone wall. But on the other side of the wall big dogs started barking. When Carrillo told the police they could not enter without a court order, they said 'Oh, we can enter.' He [Dr. C.] was a small man, and it was illegal, but they pushed him aside.

"With all the commotion Siqueiros knew it was impossible and he would have to surrender, so he came down. They were questioning all the servants and everybody behaved wonderfully. But Siqueiros appeared at that moment and said, 'I am here, I am ready to go with you.'

"Dr. Carrillo was wonderful because he even went with David. 'If you

take Señor Siqueiros,' he said, 'you must take me too. I want to make sure you are going to take him to the right place.' So Dr. Carrillo went with him and saw that they took him to the police station.

"They didn't have an order to arrest Siqueiros or to enter Carrillos' house. So they put in him a special basement room, a secret place below the building. Siqueiros spent a terrible night there. The room was very humid and there was no bed—nothing. Although the bars were covered with steel he could peek out, and he saw something fantastic. The Secret Police were dressed like students, like teachers, or like workers. They all arrived there and said, 'I did my job, here are my arms.' They took their arms, that means the Secret Police walk in the streets like workers and students with banners. They were really breaking things, they were provocateurs breaking windows and doing the worst things. Their tasks were to prove that the teachers and workers destroyed the streets.

"In the meantime they started interrogating him. I called up Señora Carrillo, the papers said he was captured. She said Dr. Carrillo went with him to the police station so I went there and asked for Siqueiros. They said he was not there. I said I had information that he came with Dr. Carrillo. They denied he was there. My son-in-law arrived and we found some reporters at the entrance. I told them that they took Siqueiros without a warrant, that they tried to take him at our house, and they shot up our car. I told them the car was near a certain avenue. 'It's standing there, you can see the bullets.' They were reporters I told, and what happened was, they were reporters who worked for the police. So they told the police and the car was brought to police headquarters. The police took it, but I have a piece of bullet I saved for a long time. I trusted the journalists, and they told the police where the car was.

"The police violated all the laws, that's why I think they wanted to kill him. Because they did everything outside the law. A few months before, a military man who strongly criticized the last President, Ruiz Cortines, and for different reasons, was picked up and sent to an isolated island in the Pacific. He was not a radical, nothing like that, but he could have been left to die there if his family didn't fight to get him back. So they could have done the same with Siqueiros. One reporter told him: 'The order is to shoot Siqueiros.' He didn't believe it when he was told they were following his steps. He didn't pay any attention. 'I haven't done anything wrong, so why should I hide?'

"They secretly interrogated him. It was all illegal, because by law they could hold him for only 72 hours. They treated him very badly and wanted to torture him. In the night they would take him to the fifth floor and ask him stupid questions. One time he couldn't move, his leg was cramped up from the humidity and sleeping on the floor, and they forced him to go out. He got very mad and shouted: 'Stupid, can't you see I can't move my leg?' But they paid no attention to him and took him out and started

the questioning: 'Why did you do this? Why did you do that? Why are you communicating with the teachers? Why with the workers? Why are you doing all this? You are responsible for everything.' Siqueiros told them: 'I agree with their demands, they are just. I am working with the committee of the railroad workers and I agree with them too. But I'm not organizing all these movements.'

"Illegally they questioned him for ten days. And he was afraid they were going to push him out the window. There was one moment when they were going to push him out to fall five floors. The plot against him was strong and dangerous, these people were not human at all. He went through many trials in his life, for a few months or a few days, but this was absolutely the worst ever. I protested in the papers. Everyone started saying: 'Where is Siqueiros?' It was a big scandal. The papers said nobody knows where he is, and that he was a traitor to the country. At the same time they published my opinion that if something should happen to him, I would hold President López Mateos responsible.

"They were picking up people everywhere. And while I was sitting in the police headquarters, waiting hours to see if I could see David, I saw the police preparing bottles of explosives, making Molotov cocktails. They didn't know who I was so I watched them preparing. So every manifestation, every demonstration, they would appear not as policemen but as provocateurs. After provoking riots they would beat the people. These were terrible days, and with the oppression of Siqueiros it was worse."

23

Mexican Due Process

Awaiting Siqueiros's return from his midday meal, Epitacio, his Indian helper, busied himself cleaning brushes and spray guns. That afternoon, however, Siqueiros did not return to the mural. The following morning Epitacio mixed and filled the cans of paint and readied the maestro's palette. Visitors who came by were told by Epitacio, *"Todavia no ha llegado el maestro."* ("The maestro hasn't arrived yet.") At that moment it was not possible to imagine that Siqueiros would not return to the mural for four years.

The police had launched their attack on Siqueiros with the greatest

secrecy and not until late on the following day did the newspapers learn he had been seized. And this only when Angélica, after the police refused to respond to her queries, went to the offices of *Excelsior* to publicize the fact and beg them to help her locate him. The press responded to the tale of Angélica's harrowing experience and her concern for Siqueiros's safety with coolness and deceit.

The newspapers, which were diligently doing the government's bidding in their denunciations of the protests and strikes, now began to print venomous reports about Siqueiros—that he had not been painting, nor had his car been shot at, but rather that he had been on the streets leading a protest march. The claim that his car had been shot at and that he had been forced to hide was just an alibi.[1] Another report stated:

> The police had knowledge some hours beforehand that the Communist leader, David Alfaro Siqueiros, as well as Oton Salazar (the leader of the teachers) and others leading the agitation, were instructing their shock troops in precisely the following: if people have to be killed, it would be preferable that they be students.[2]

Two students had been shot that day, though not fatally.

The government, intensifying its assaults against the strikers and protesters, charged Siqueiros with the "serious" crime of "social dissolution" on the grounds that he had been leading and causing the demonstrations of the teachers and students which had caused so many injuries. Siqueiros, the plastic paint still clinging to his fingers as well as his clothes, unshaven and weary after a sleepless night, was being accused in the newspapers of being "the principal instigator of the bloody events that occurred in the capital yesterday."[3] At the same time, the leader of the Senate, Manuel Moreno Sánchez—Mexico's Joe McCarthy—attacked the government for harboring communists, and singled out Siqueiros in his blustering and vicious speech.[4] Román Lugo, the attorney general, told reporters that outside elements had infiltrated the teachers' union and were responsible for the riots—but he was not referring to police provocateurs.

> If responsibility is found in the person of the painter David Alfaro Siqueiros, as the instigator of the fights between the students and the police, the Attorney General's office will prosecute with rigor but always within the law.[5]

As for "the luck of the ex-Colonel of the Spanish War," the investigators on the case would determine what part he had played in the current commotions. When questioned about Angélica Siqueiros's charge that the district attorney's own men had attempted to murder the painter, that official retorted: "She has a right to do whatever she wishes."[6] When the reporters wanted to know when Siqueiros would be released, the evasive attorney general would say only that he could not know "the degree of

his guilt" until the public office in charge of the interrogation took a deposition, and he assured the reporters that Siqueiros had not been detained but merely taken in for questioning about his part in the street riots.[7] It was the common belief that Siqueiros would not be held long, and that he would be released after they had interrogated him.

On the following day, however, the protests of the students intensified. Siqueiros's release took prime place among their demands: that police brutality cease; that the President dismiss Attorney General Lugo, chief of police General Luis Cueto Ramírez, the police colonels Marino Sierra and Mendrolea Zerecero, and the president of the Law School's student society. On the other hand, the bourgeoisie's Patronal Center of the Federal District, stated: "the detention of Alfaro Siqueiros would give the peaceful people a moment of rest with the hope that the agitation would end;" while the ultraright *Partido Acción Nacional* (PAN) called on the Mexican people to "oppose the advance of communism."[8]

The newspapers had Siqueiros pacing his cell like a "wild beast," while they railed against the demonstrators in the streets. "Bombs Thrown Against the National Palace and Businesses Yesterday, the First Act of Social Dissolution," shrieked the headline. "Two students," the newspaper reported, "were curiously shot in the back with a 22-caliber pistol." The pistol was one of those "captured" and put on display by the police. Dutifully the newspapers reported the scenario given them by the police. *El Universal Grafico* pointed out that the students who were shielded in the midst of the crowd of agitators could not have been shot by the "public force," and that "red agitators" passed weapons and Molotov cocktails to "gullible students" with instructions to smash store windows and hurl the "cocktails" at the National Palace.[9] The stage was being set and Siqueiros was to be cast in the leading role.

During the first 48 hours of his captivity, Siqueiros was locked in solitary confinement at the police headquarters located in the Plaza de la Republica. As soon as it became apparent that he had been ensnared in the net cast by the López Mateos forces, voices began to ring out in his defense. Thousands of students, demanding liberty for the painter they revered, marched from the National University to the National Palace behind a mock coffin bearing the Mexican Constitution. Urging tough action, politician Jorge Prieto Laurens, head of the ultraright *Confederacion de la Defensa del Continente,* called on the government not to be "bashful" in applying the full force of the law to stop the disorders, of which he found both Siqueiros and Oton Salazar to be the cause. For Prieto Laurens the strikes and demonstrations did not stem from national causes but from "the hands of the international Communist Party."[10]

After a lengthy and secret interrogation on August 12, the newspapers printed fanciful stories containing out-of-context statements by Siqueiros,

which had been leaked to the press by the district attorney. "We Communists Can Commit Crime, Says Siqueiros," read the headline.

> Openly, David Alfaro Siqueiros, the Communist painter who has been cited as one of the principal defamers abroad of Mexico, and the promoter of the disturbances of the teachers, yesterday, impelled by his blind ideology, said before the special public prosecutor, Eleazar García Rodríguez, that "Communists can commit crime."[11]

The newspaper further disclosed that Siqueiros had been subjected to twelve hours of interrogation, and that prosecutor García, from the declarations he had pried from the painter, "revealed many crimes pertaining to the common law but which all, however, are absorbed by one law only, Social Dissolution [sedition], that is, of the Federal order."[12] The press thus assumed that the attorney general of the republic now had the prerogative—that is, if one accepted the premise of the public prosecutor—to keep the painter in jail while the judge decided whether to prosecute or not.

The government had trotted out its secret weapon, the draconian "social dissolution." It was a law devoid of constitutional legality that was enacted during the world crisis in 1941. At that time it was used as a tool against Nazis and Fascists, but subsequently social dissolution was turned against "dangerous" leftist ideas whenever the government deemed it "necessary." Vague and ambiguous, its provisions allowed for arbitrary interpretation of acts that encourage rebellion, imperil "the territorial integrity of the Republic," obstruct the functioning of its institutions, including the act of "disturbing public order and peace." Those found guilty received sentences of from two to twelve years and a fine of 10,000 pesos. An average sentence of 7 years was usually served.[13]

The prosector and the press worked hand in hand, leaking statements attributed to Siqueiros to the reporters. Sinister implications were inferred from the fact that both Siqueiros and Oton Salazar were members of the Committee to Free Political Prisoners. And most baleful to the press was that Siqueiros admitted that as a Communist he did not exclude "armed revolution" as an instrument for change. "Just as," he was quoted as saying, "I do not reject, but applaud, the Cuban Revolution." In the newspapers, he was "advocating crime."

Answering their questions with bold pronouncements, Siqueiros galled the prosecutors. To some silly question he replied, "As a Communist, I and my comrades have always been disposed, and are always ready to employ multiple procedures to transform society." The inquisitors and the press were prepared to strike a shattering blow when he was reported to have said, "The tactic of the Communist is not violence . . . But of course this does not stop some [Party] cells from having guerrilla

thoughts. . . . And so, they can arrive at crime."[14] This was proof enough that he advocated criminal activity.

Siqueiros did not demand the protection of an *amparo* immediately. (Under Mexican law, the amparo is the equivalent of a writ of habeas corpus.) Officially, he had not been arrested or detained, but was merely being questioned. But the seriousness of his plight soon became obvious and he requested an *amparo* on the grounds that he was not being charged with any crime. The decision then rested with the Attorney General as to whether to charge him with the crime of social dissolution. If he was charged, and found guilty, then—as the newspapers speculated—he would be sent to the notorious Revillagigedo Islands in the Pacific Ocean, hundreds of miles off the Mexican coast.[15]

Slavishly serving the López Mateos administration's reactionary policies, the newspapers continued their vituperative campaign. One headline read: "Siqueiros Says Communism Can Take Possession of the Government in a Matter of Hours." The spurious report claimed that Siqueiros had signed a statement to the effect that Communists can seize control of the government in the event of a general strike.[16] Angélica, too, was taken to task for making "false claims" that Siqueiros had been held in solitary confinement in a dungeon. This, the press maintained, was obviously untrue—since she had been allowed to bring him food. The same press heaped lavish praise on the prosecutor, García Rodríguez, for "relentlessly pursuing the painter and being responsible for making him confess his part in the agitation."[17]

Excelsior blamed the 64-year-old artist for prolonging the "hearing." Disregarding his revolting experience at the hands of the government, they wrote: "He continually asked that the hearings be recessed under the pretext that he was mentally and physically exhausted." Repetitious questions poured out of two prosecutors in an endless stream: "On the 27th of March of this year, in a speech you gave in Torreon, you stated publicly that a radical transformation was necessary in the governing system of Mexico?" Siqueiros agreed it was true. But when the inquisitorial prosecutor pressed him to confess that since the Communists were disposed to employ every type of procedure, this included procedures that were not peaceful, Siqueiros answered:

> It was a question of modifying the judicial and constitutional structure of the country and not to restrain the collective initiative, but only the private and the reactionary. . . . Possibly in the not too distant future, procedures that are not peaceful will be necessary. For the State is incapable of enforcing its own laws. Even though there are legal recourses, they are not applied.

According to the press, "Here Siqueiros slipped into demagogic concepts and sneaked away."[18]

The prosecutor then wanted to know if it was true that Siqueiros, in

an official capacity, had lent his services to a foreign government without authorization from the Mexican Congress, thus violating Article 37 of the Constitution. Responding to this iniquitous thrust, Siqueiros reviewed his military career in Spain. "I didn't request authorization for all of this from Congress, for these were very special political circumstances."[19]

While continuing to whip up hysteria, the press tried to convince the public that the commotions in the street were taking place only in the capital, and that the rest of the country was calm, although it was well known that federal troops were standing guard in Poza Rica, over the oil workers; and in the state of Morelos, Zapatista peasant leader Reuben Jaramillo was threatening to occupy *latifundios* if government distribution of land was not carried forward. (Jaramillo, his wife, and three sons were murdered by the police on May 23, 1962.)

Siqueiros was a prisoner over whom the interrogators could gain little advantage. To each of their questions he responded with a political lecture, and he always laid the blame for the rioting on the government, which

> failed in the tactic to repress—or resolve—the great problems of the teachers by the a priori use of force. Before any commission of a crime, it should have held the forces in abeyance instead of taking it for granted that crimes are going to be committed.[20]

During the 48 hours he was held incommunicado, the long questioning twice exhausted him. "But with his loquaciousness," reported *El Universal,* "he never failed to harangue his interrogators." With 105 questions "they hope to disentangle the skein and publicly demonstrate that Alfaro Siqueiros, is in effect, one of the heads of the agitation."[21]

If they succeeded in pinning this charge on him, he would be handed over to the Attorney General's jurisdiction, pending a formal charge of social dissolution, a crime against the "agents of authority." The newspapers had already arrived at the conclusion that, from the way he had answered the questions, it was certain he was among those who led the demonstrations. Trotskyite elements, joining in the general "ganging-up," called for his immediate jailing, canceling his mural contracts, and, if destruction of his murals couldn't be effected, they should be covered up.[22] Added to the clamor were voices calling for his expulsion from the country on the grounds that he was no longer a Mexican citizen but a "dangerous agitator and the Secretary General of the Communist Party," who lost his rights when he volunteered to fight in the Spanish Army. At the same time, an anti-Communist bloc petitioned the government to apply Article 37 of the Constitution and deport him as a "dangerous foreigner to whatever 'Soviet paradise' he has been, and continues being, a fanatical propagandist."[23]

Angélica, frantically seeking to rescue him, ran from government office

to government office, from newspaper to newspaper, telling all who would listen what she knew of his plight. He was held incommunicado, in a dungeon without light, without a toilet or bed; stories in the press were untrue; he was ill and needed a doctor. "He's 64, and his intense life of civic and artistic activity has left him suffering from a bad liver condition."[24]

It had been near midnight when the Federal police led Siqueiros out of Dr. Carrillo Gil's house and placed him in a Jeep. Under heavy guard, the column of some ten cars had sped off, sirens screaming, to the Federal Judicial Police Headquarters in the Plaza de la Republica. Siqueiros was greatly troubled when he was not brought before some person of higher authority but was immediately hustled to a cell and locked up. It was a solitary-confinement cell in the basement of the building. It encompassed a space barely 1.5 x 1 meter. It was windowless, and a sheet of steel covered the bars on the door. There was no light except what passed through the slim space at the bottom of the door. There was only a concrete bench.

It was inexplicable to Siqueiros why he had been thrown into a punishment cell. He remained there all that night and all the following day, his whereabouts unknown to all but those who had brought him there. On the second night, between 3 and 4 a.m., his cell door opened and he was taken out. As yet he had not had any food, and attempts to sleep on the bare floor had been futile. All the while, thoughts had been racing through his mind: What was happening to him? What could have been the cause of such an assault on his person? He imagined only the worst. For he knew that if there had been grounds for his arrest, or even a desire on the part of the police that he appear for questioning, normal procedures would have sufficed. This terror attack had him speculating: Perhaps the President had been assassinated.[25]

When they came for him in the early morning hours, he was rudely pulled from the cell, surrounded by some 20 agents, and "mysteriously" pushed ahead through the building, up stairs, through storerooms, through deserted rooms, and up and up. After the outrage of the preceding hours, all that could pass through his mind was the ominous thought that he was being pushed to some disaster.

> Without doubt, the final part of the conspiracy could be nothing more than to bring me to the roof, and from there throw me down. It would later be explained that I had tried to escape, or that frankly, I had committed suicide. The idea began to grip my mind.[26]

The situation was threatening enough for Siqueiros to fear for his life. He was brought to a room on the top floor of the Federal Judicial Police building and brusquely shoved into a chair menacingly next to an opened

window. Outside, the blackness of Mexico City was disorienting, leaving him confused as to which direction the window faced. Adding to the grotesqueness of the scene was the arrival of the prosecutor and a typist. This was how the interrogation turned inquisition began.

Twelve hours of ruthless questioning were endured before it had run its course. From the beginning it was obvious to Siqueiros that the typist was not recording faithfully what he was saying, so when finally a statement was thrust before him to sign, he refused to do so. And at that moment he flew into a rage, striking at his tormenters until he was subdued by the police. After this grueling experience, he was taken to the basement and thrown into the pitch-black cell. Yet a feeling of relief overcame him, because the worst of his expectations had not materialized. When the same scenario was repeated at 3 a.m., he tried to assuage his fears, realizing that in this manner his jailers were trying to break him down psychologically.

As soon as it was learned on the outside what was happening to Siqueiros, there was immediately active support for him among the students and workers. As has been stated, the students marched in protest, but hundreds also took to the streets, stopping autos to solicit funds "to pay for the defense of Siqueiros." Others in their anger attempted to topple with explosives Ignacio Asúnsolo's huge granite statue of President Alemán, a detested symbol of PRI rule that stood on the university campus. At the protest meetings in support of Siqueiros that took place at the base of the statue, students were beaten with clubs and chains by goons from the university football team, about which the press commented:

> The faction of the Federation of University Students, of which Tenario Adame is said to be president, belongs to that group of communist agitators who are directed by the painter Alfaro Siqueiros, jailed on the charge of being the inciter of the insurrection, and directly responsible for the agitation and unrest that has been implanted in the National University.[27]

On the third day of his being "presented" for questioning, a federal judge handed down an order that Siqueiros was to be removed from solitary confinement, and that in the shortest possible time a judge must decide whether he was to be set free or brought to trial. At 4 p.m. on Sunday, August 13, Siqueiros was placed in a police van and taken the short distance across the city to the Penitentiary of the Federal District, Lecumberri Prison. There he was processed as an inmate to await his appearance before a judge. This procedure following the opinion handed down by the prosecutors that Siqueiros was indeed the initiator and intellectual author of the violent incidents that had been shaking the capital; he was charged with 9 counts of breaking the law.

Not 30 minutes after he arrived at the penitentiary, a second official of the Committee to Defend Political Prisoners was brought in—Filomeno

Mata Alatorre, age 72, a distinguished journalist, and like Siqueiros a veteran of the Mexican Revolution. The same charges—ranging from social dissolution, felonious assault, and possession of an unlicensed gun to resisting arrest—had been lodged against him. Mata and his father, Filomeno Mata the elder, had both been jailed earlier by Porfirio Díaz, when their newspaper, El Diario del Hogar, had advocated free elections. Mata, now publisher of Liberación, the newspaper of the National Committee for Defense of Political Prisoners, was finding history repeating itself under López Mateos.

Fingerprinted, photographed, and designated prisoner number 4678860, Siqueiros was delivered to cell block H [45]. A sickening pall settled within him; he knew well the cold finality of being entombed within the walls of Lecumberri Prison—El Palacio Negro. His residence there in times past had taught him that behind its walls the unfinished business of justice came to a halt and slipped beyond grasp.

Even with his "human rights"—so clearly guaranteed in the Constitution—monstrously violated, Siqueiros would not permit himself to imagine that his release would not come, perhaps in a matter of only hours or at most another day. For not even the Mexican National Bar Association ignored the illegal arrests, accusing the Attorney General of "open violation of the constitutional rights of those held, restriction of freedom of the press, and flouting of the guarantees surrounding peaceful assembly and association."[28]

When Siqueiros and Mata arrived at the penitentiary, they joined the more than thirty union leaders and railroad workers for whom the Committee for Defense of Political Prisoners had been functioning, and who had already been in the Palacio Negro 18 months awaiting trial. The committee for their defense was now all but wiped out.

On August 15, the first of a long series of judicial maneuvers began; Siqueiros and Mata went before Judge Salvador Martínez Rojas for a ruling on the charges lodged against them by the District Attorney. The small hearing room was packed with friends and the public. Students squeezed in, holding high a banner, "We demand immediate freedom for our teacher and leader, David Alfaro Siqueiros." Feelings were sanguine now that a public hearing had begun; surely Siqueiros speaking in open court could end the travesty. But it was just the first hearing, and it would not be long before it became apparent to all that the Mexican judicial process, in the case of political prisoners, would be a deliberate foot-dragging procedure, with each step of the way ensnaring and paralyzing its victims in a web spun by the divine right of the Mexican judiciary.

Siqueiros denied before the judge that it was he who had caused the disorder in the streets, but ventured that on the contrary, the cause was "the attack against the left movement." During the five hours of the hearing the spectators, despite the judge's repeated warnings and admoni-

tions, could not refrain from applauding and cheering whenever Siqueiros "attacked the North American government, the Federal Government, the FBI, the PRI, government officials, and especially the Attorney General, whom he labeled a 'traitor.'"[29]

The questioning, in its incongruity, always strayed from the real point of contention—the unconstitutional and arbitrary acts of the government. Siqueiros denied, when queried, that leaflets advocating violence, sabotage and assassination were the property of the PCM. He then tried to steer the hearing back on course by accusing the head of the Federal Judicial Police jail, General Carlos Martin del Campo, of holding him "incommunicado" for close to four days, only to be steered back "off track" by having to deny that the PCM received its orders from Russia. However, he added, the PCM "stands morally with all the Communists of the world."[30]

With the application of the law in this case so politically motivated, Judge Martínez Rojas had to obey orders, and—as sympathetic persons had earlier warned Siqueiros—they were orders that originated at the "highest levels." The judge found ample cause to warrant bringing the prisoners Siqueiros and Mata to trial. The nine charges alleged by the prosecution were upheld, and the two were remanded to prison to await a trial date.

Siqueiros now had been held more than a month; on September 20 he, Mata and a teacher, Ricardo Díaz Cortés, were brought before a three-judge appeals court to argue their illegal detention. Mexican Grenadiers and the Secret Police stood guard over the crowd who could not fit into the very small courtroom. Jammed inside, behind the defendants and their lawyers, stood some 20 family members, friends and undercover police. When Siqueiros was permitted to speak, he expressed the opinion that the anti-Communist leader of the Senate, Manuel Moreno Sánchez, was behind the order that he be jailed. The witch-hunting senator, Siqueiros charged, had been affronted when personally requested by Siqueiros to free the political prisoners. "My detention," he told the court, "is a reprisal for such an audacious act on my part."[31]

The lawyer for the defense, José Rojo Coronado, spoke for an hour and a half. He claimed that the charges against the two were without the least foundation, and held that the judicial decree committing his clients to prison must be revoked immediately. But the fact remained that even while it was being argued that no grounds existed for bringing them to trial, the rest of the political prisoners were still waiting, after 19 months, to be brought to trial. For Siqueiros and Mata, a month of captivity had already slipped by, and now, at the close of the hearing, they were informed that 15 days would be required before the court would reach a decision. A "confidential" report from the U.S. Embassy in Mexico City told the State Department that the

vigor with which the government prosecutes Siqueiros will be indicative of its determination to stamp out Communist agitation among students. Siqueiros, who has been arrested several times in the past, said the charges did not surprise him, and only served to prove the political nature of his arrest. While it is likely that Siqueiros may not be the sole instigator of student disturbances, his conviction would serve as a warning to others to desist from such activities.[32]

In the Bowels of the Black Palace

The prison experience was not new to Siqueiros but never had it been more unbearable, more unendurable, than now, happening during a period of his life when one would have thought such dangers for him were a thing of the past. "I would have done anything to prevent it," he wrote, "even with bullets, not to have had to return to jail, especially to the ancient Black Palace of Lecumberri."[33] It was obvious that his fame and worldwide recognition offered him no protection against the government's forcibly tearing him from his work and throwing him into jail, without evidence and on a flimsy pretext.

Siqueiros raged over the government's arbitrary and abusive violation of his freedom. The days in the Black Palace began to acquire numbers, and as the deliberate delays mocked the judicial process, he gathered his strength and prepared to fight back. By September 16, Independence Day, after more than a month's internment, Siqueiros and Angélica had planned a protest to mark the sacred holiday. It was a symbolic gesture; huge Mexican flags with two large ribbons—one yellow, the other black—attached, were draped over the façades of their own house and outside the office of the Committee for Defense of Political Prisoners. On the latter flag were also attached as many small black and yellow ribbons as there were political prisoners. The color black in this case stood for tyranny, and the yellow for imperialism and McCarthyism.

During his first days in prison Siqueiros was removed from his cell only for display behind bars for the benefit of newspaper photographers. His house and those of Angélica's family were searched, and undercover agents were sent into the jail to try to entrap him. When a "prisoner" sidled up to the bars of Siqueiros's cell, whispered that he had a message for him, and told him that he represented a group called *Los Venados* (The Deer), Siqueiros warily drew back and responded, "It sounds very *guerrillero*." The "prisoner" then told him that 4,500,000 peasants in the Sierra Madre Mountains in Sinaloa were waiting to follow Siqueiros's orders, and that the Cuban Embassy had sent him to relay the information. Siqueiros drew further back, mindful that this "courier" could reach through the bars and plunge a knife into him. The government had already

spread rumors that Siqueiros had a hidden cache of arms to promote guerrilla activity in the Mexican Sierra Madres.

It was stupid of the government to send agents into the prison, fools placing traps for a wise and experienced revolutionary. Agents

> were trying to discover my *guerillero* state of mind before the judicial authorities decided on a definite settlement of my case. That is, the Mexican government wanted to know, "What will Siqueiros do if we free him? Will he join *Los Venados* of Sinaloa?" In this idiotic fantasy of *Los Venados* would it not be advantageous to free Siqueiros and follow him to where the Venados are?[34]

Police spies hovered around Siqueiros as the government sought some scrap of incriminating evidence on which to build its case. Concerning the usefulness of guerrilla warfare at the present stage of Mexican history, Siqueiros's position was clear. He said he felt tempted to play along with the agent seeking to ensnare him, by handing him a message to carry to *Los Venados:* "Change the name of the organization, or else you will spend the whole period of the Revolution running like deer." But he would rather have told him that, like his grandfather, he was "against all armed romantic action."[35]

It was Siqueiros's belief that the government which "vacillated between taking the road to revolution or counterrevolution," could "take a political direction that corresponded to national independence, and this road would to a greater degree fulfill the postulates of the Mexican Revolution."

> Day after day, workers, peasants, and intellectuals are chained securely to a bureaucratic machine called the *Partido Revolucionario Institucional* (PRI), without in the least understanding that it is this state of affairs which should produce a great democratic movement capable of establishing in our land a respect for democratic liberties. If this necessity is not understood, who but the crazy would ask the great masses of workers and peasants of Mexico to effect an armed movement.[36]

He knew that police con men were best left ignored, and without equivocation stated: "I could not—even in the guise of a *venado*—except if I suddenly lost my reason, ask the Mexican people to take up arms to destroy the present government."[37]

Siqueiros studied the old familiar surroundings. Little had changed in this depressing "haven" for the poor. Living conditions within the prison walls were considered to be a notch above what most free but poor Mexicans had. Built at the turn of the century by French engineers, the Black Palace of Lecumberri—the Federal District penitentiary—was now considered a less severe jail of prevention. For Siqueiros, the sight of prisoners being released added to his melancholy when he watched them change from sturdy prison clothes to the rags that were their street clothes. He was moved by the poignant scenes on Sundays, when whole

families came to the prison in a festive holiday mood. The wives and children of the poor prisoners seemed to be enjoying an outing, looking forward to the Sunday treat of prison fare, their first scrap of meat in a week.

As for his own plight, Siqueiros could easily suffer spells of depression. So much had to be done. Every moment represented a precious brush-stroke lost. At first there was a strong sense of *deja vu*—he was in the very same cell in which he had spent seven months in 1930. Now he had to gather his strength anew and struggle to remain sane within the confines of the Black Palace. On Independence Day inmates customarily decorated their cells with flags and patriotic motifs, and that September 16th Siqueiros did his first prison painting. To celebrate the day and to honor the railroad workers in jail, he painted an onrushing locomotive on a large sheet of cardboard; it was hung in the passageway of the cell block. The locomotive was labeled "Liberty," and it bore down on an obstacle on the tracks labeled "Violations of the Constitutional Rights of Mexicans by Order of Washington." The political poster did not remain hanging beyond that day.[38]

Siqueiros made a superhuman effort to overcome the gloom that filled him, and gradually he was drawn into prison life. He accepted the task of painting scenery for the prison theater group and found himself stimulated by the political aspects of the prison plays. In November, the first play for which he had done the scenery, *Lawyer, Don't Worry*—written by imprisoned playwright Roberto Hernandez Prado—was presented to the inmates.

Still, those first few months were charged with expectancy, for he harbored the belief that at any moment the groundless charges against him would be dropped and he would be free to return to his work. But soon, seemingly without reason, both he and Mata were placed under strict guard and denied the usual limited freedom of movement allowed inmates. Confined to his cell, he could only step out with special permission and in the company of a guard. This, he was told, was to protect him from his enemies within the prison *(plate 69)*. To Siqueiros such restrictions represented a deliberate attempt to keep his contacts with the prison population to a minimum. However, as time dragged on, these restrictions were eased. But when painting scenery he was guarded by two jailers and a prison official, and he was not allowed to attend the performances of the plays.[39]

Siqueiros's popularity among the inmates, however, could not easily be fought. His warm rapport for the underdog soon propelled him into the role of counselor and jailhouse lawyer, thwarting the prison officials. Contacts between him and the other political prisoners—all of whom had been languishing in jail for a year and a half without a trial when Siqueiros arrived—could not be headed off.

On November 19, 1960, the political prisoners called a hunger strike, to force the authorities to end the procrastination and start up the judicial process. Filomeno Mata, 72, was the oldest; Siqueiros at 64 was next. There were 31 hunger strikes, including the union and political leaders. Simultaneously protests took place on the outside; in strategic sections of the city, demonstrators met, and banners were unfurled proclaiming, "Liberty for the Political Prisoners." But the police quickly snuffed out the demonstrations. At the same time, in solidarity with the political prisoners, a number of artists and students at the San Carlos Academy went on their own hunger strike.

Amid a complete press blackout, the hunger strike lasted six days. Siqueiros had to be hospitalized in the prison, and Mata, too, was forced to end the ordeal. A delegation of five wives, led by Angélica, went to *Los Pinos,* the President's residence, and presented a petition demanding the release of the prisoners. Because of the hunger strike, assurances were given them that the "unavailable" President would receive the petition. With the coordinated protest actions, and a growing worldwide interest in occurrences in Mexico, the government was forced at least to respond to the legitimate petitions for an *amparo.* When a judge ordered ten prisoners released, the hunger strike was ended.

Siqueiros, however, was considered too "dangerous." Now that the government had managed the first hurdle—seizing him and tossing him in jail—and gotten away with it, it was becoming increasingly difficult to slip out of the government's clutches. As secretary general of the PCM, Siqueiros knew the position he was in; the oppressive truth of his incarceration began to settle in his bones. He realized that he would have to resign himself to a longer confinement than he had dared imagine when he was moved out of the cell he had been sharing with three railroad workers and was placed in one by himself. He knew then that his release was not at hand, that he must recognize the reality of his plight; if he was to be kept behind bars for as long as his oppressors wished, then, reluctantly he must prepare to attempt to paint in his cell.

At first the authorities balked at his requests, but pressed with the argument that cultural pursuits promote rehabilitation, they finally granted him permission to have a small quantity of paint in his cell, and boards that measured no more than 50 x 60 centimeters, an unbearably small dimension for a muralist.

Cell 36 was his studio and living quarters. In a space 1.8 x 3 meters, with a small barred window at one end, were a cot, a stool, a tiny single-burner stove for heating food, eating utensils, etc., and a clutter of cans of paint, brushes, and boards to paint on. He barely found room to sit on a stool and paint. Everything in prison militated against his producing creative works—the obligatory daily prison routine, the chores involved

just to survive. Because his troublesome digestive system could not tolerate the prison fare, he was allowed food that Angélica sent daily.

Siqueiros had always painted without having to perform any household chores. But here his day began with the morning lineup and roll call, consuming 40 minutes. He prepared his own breakfast, and this took another hour—the stove took at least 20 minutes to ignite. He bemoaned the drudgery of cleaning up after eating: "I was not accustomed to doing it, not all inmates had the temperament of a housewife."[40] These tasks that interfered with his painting often drove him into paroxyms of rage.

Allowed newspapers, he received all the metropolitan dailies, which numbered at least five. His hunger for news of the outside world was insatiable, and he combed the papers for any bit of information that might bear on his case. The Mexican newspapers, however, irritated him sorely, especially their habit of considering everyone guilty who had been accused of a crime.

When he finally turned to painting, he tried to close out the din that pervaded the cellblock. Throughout the morning there was the constant bellowing of prisoners' names as they were ordered to report to the visitors' room. The clanging of cell doors reverberated through each brush stroke, shattering the creative mood. When he stopped for his midday meal, which the inmates' wives had delivered, he would join three or four prisoners in a cell away from the paint that filled his own. After the *comida* and the usual political conversation, Siqueiros returned to his painting, but soon faced the problem of diminishing light. Against prison regulations, he finally managed secretly to install a light bulb that was slightly brighter than the feeble one in the cell; he was always fearful that his misconduct would be discovered.

Of more serious consequence was his worry about living 24 hours a day in the cramped cell/studio amid cans of pyroxylin and acrylic paints that emitted toxic fumes.

> This difficult situation caused a degree of real hysteria in me. Without any doubt, the strong and persistent odor of my colors twenty-four hours a day, contributed very directly to the damage of my liver. As is well known, "bad humor affects the liver and a sick liver creates bad humor." It was a vicious circle which kept me living with a degree of agitation.[41]

He had cause to be concerned; one of his assistants had earlier had a spleen removed as a result of the toxic emanations of plastic paint solvents. He implored the prison officials to permit him to paint in one of the empty cells, but was reminded that he was in a most favored cellblock, enjoying a private cell, and no special privileges could be granted.

After some cans of paint were overturned on his bed, he had an uncontrollable fit of hysteria. The creative act for Siqueiros, we know, was not always outwardly calm. Fits of passion that led to his hurling cans of

paint and smashing paintings had always been an aspect of his creative processes; in his cell, with good reason now, he was hurling about paintings, furniture, anything he could lay his hands on. His outburst caused an uproar in the cellblock with the vilest taunts being shouted at him, further provoking him to shout at his tormenters with insults of an equally vile nature. Dionisio Encina came from his cell to calm him, assuring him they were all only joking.[42]

Angélica later told me what it was like for Siqueiros. "The cell was very narrow, with a small window giving poor light. If they would not have allowed him to paint, he would have gone crazy. From that period in jail he would come out with another aesthetic advance, more filmic. Every painting he made was a study for a mural. He did about 350 paintings in jail and the collectors quickly bought them all. Each was photographed in color, for he needed these for the murals.

"So he worked all day long, and I think the cancer from which he died was caused by those four years. He worked with modern plastics, acrylics; he didn't have ventilation, he was inhaling for four years without ventilation.

"Imagine, he's a man who thinks in terms of very big walls, to be forced to make pictures no more than 60 x 80 centimeters. For a man like Siqueiros, such small pictures are a great punishment. But he painted the easel works for his murals. So it was like double jail for him. Not only was he in jail, but his murals were away from him."

Angélica's struggle to get the word out and seek aid in combatting the political persecution taking place in Mexico was a superhuman one. She fought the press blackout and the government's clamp-down on any escape of information to the world both inside and outside of Mexico. Stories were sent out by foreign correspondents that conveyed the official government account of Siqueiros's arrest. *The New York Times,* quoting the Mexican ultra-rightists Jorge Prieto Laurens and Senator Manuel Moreno Sánchez, reported: "In 1952 he and Rivera were accused of fomenting riots on May Day when two persons were killed and fifty injured." In that event, Siqueiros and Rivera had marched peacefully in Mexico City's traditional May Day parade until it was broken up by an armed attack of the fascist Golden Shirts. *The New York Times* further falsely asserted: "In recent months he [Siqueiros] has been actively engaged in liaison work with members of the Cuban revolutionary groups."[43]

Following his arrest, *Excelsior* fancifully stated:

> The artist—was arrested Tuesday night while the police were beating down another leftist-led demonstration by 800 teachers, college students and others in downtown Mexico City. Police said Siqueiros spoke at the college just before the demonstration, which had been banned by the police.

It was also falsely stated that Dr. Alvar Carrillo Gil was a leftist who was

arrested with Siqueiros. *Excelsior* then ventured the opinion that the arrest of the artist "seemed designed to counter misgivings created by President Adolfo López Mateos's declaration last month that his government belonged 'to the far left within the constitution.'"[44]

At the end of May, three months before he was seized by the police, Siqueiros had been elected general secretary of the PCM and head of its political commission. The CIA, however, seemed partial to the ousted faction led by Dionisio Encina, for they reported to Washington that "Leading members of the *Partido Comunista Mexicano* (PCM) have agreed that Mexican authorities did the Party a real favor in arresting and jailing David Alfaro Siqueiros."[45]

With the press in her own country turning a deaf ear to her appeals, Angélica relayed an "urgent SOS" to the world via the Cuban *Agencia Prensa Latina:* "The painter Siqueiros has been abducted and is in prison."[46] A response from abroad was not long in coming. The French artists, including Picasso, joined in protest. Sixty artists and writers in the United States paraded in front of the Mexican Consulate in New York, chanting, "Siqueiros, Yes! Mateos, No!" The signs they carried read: "Mexico, Free Your Artist," and "President Mateos, Let Art Out of Jail."[47]

Mexicans began to rally to his support and letters of protest from around the world flooded the office of the Mexican president. A number of U.S. citizens wrote to President Kennedy and his wife, Jacqueline, requesting that they intercede with the Mexican government on behalf of the jailed artist. They received sharp responses from the State Department informing them of the charges against Siqueiros and of the inappropriateness of the U.S. Government's interfering in Mexican internal affairs.[48]

International protests intensified. Schoolchildren from around the world wrote letters to him, poets wrote for him, and committees to free Siqueiros grew in number. But López Mateos was determined to keep Siqueiros from sight, out of earshot, and hopefully out of mind for the duration of his term in office. New restraints were imposed on Siqueiros to isolate him from any contact with the forces working for his release.

"They were very hard with him in jail," Angélica said. "All prisoners have a right on Sunday to receive five persons of their own choosing, you don't even have to give the names. But in our case, every Friday we had to give a list, and if there was somebody not from the family on the list, they were not allowed to enter. So it was very hard for him. In the entrance there were journalists from the whole world. They waited to interview him but it was not permitted. In Mexico the press was closed. They kept on writing lies and attacking him. The press in Mexico during this last period has always been at the service of the government. The government said, don't publish anything by Señora Siqueiros, and for

one year I could not publish telegrams he received from the whole world. So Siqueiros had a special situation.

"The other political prisoners could receive their families and friends. Siqueiros was never allowed to receive other than his family in the four years he was there. That shows how they didn't want the journalists to come, didn't want friends to come, didn't want anybody, they wanted him to disappear as though he didn't exist. But maybe it was better he was caught and remained there. Because if they had taken him away, as they wanted, he would have disappeared and we would never have known where he was . . .

"It was all very hard. Like in the movies. I was able to keep calm and now I can tell myself that I was right, too. Even Siqueiros said he didn't know how Angélica could do all that. Because when I had turned the car fast, he could not get his gun. No, I didn't want him to get his gun out. The gun was there in the car but I went so fast there wasn't a possibility to do anything. It was like the movies, exactly like the movies. But there are unbelievable dramas when you demonstrate your capacity for control."

The bars and walls of the Black Palace could not completely insulate Siqueiros from the world outside nor stifle the character and habits of one so deeply immersed in art and politics. In March 1961 a message from him reached the Latin American Conference for National Sovereignty, Economic Emancipation and Peace, which was being held in Mexico City. Angélica brought to the conference a prison painting symbolizing its purpose, and a document titled, "Charges of the Political Prisoners," with the signatures of 21 of them.

A year and five months had passed. There had been no trial, no sentencing. Each interminable day he performed his tasks and cooperated in the routine of prison life. He painted scenery for a second theatrical work, title *The Road of the Rebel Without a Cause,* and, seeking some pleasure in recreation, he joined his fellow prisoners playing baseball in the prison yard. It was a game he enjoyed and had last played with the North American art students in San Miguel de Allende.

24

His Day in Court

The international stirrings, the demonstrations in front of the United Nations in New York, and the committees for Siqueiros's defense could no longer be ignored by the López Mateos regime. On January 18, 1962, Siqueiros and Mata were brought to trial, 17 months after their imprisonment. As in the earlier hearing, the trial was assigned to a courtroom barely large enough to hold the members of the defendants' families and a few newspaper reporters. In all, including three judges, court secretaries, lawyers and defendants, twenty persons were packed in the room. Outside were armed grenadiers to instill fear in the assembled public who could find no place in the courtroom. The atmosphere was tense, a sinister taint was imparted to the defendants and to the nature of the trial.

In the tiny packed courtroom, following judicial procedure, Siqueiros and Mata remained standing through the trial's duration—a 13-hour day. The prosecutor opened with his presentation of the government's case. "All disagreements with the policies of the regime can be qualified as crimes of social dissolution (i.e., sedition).[1] He offered no evidence to back up any charge.

Dr. Enrique Ortega Arenas, the lawyer for the defense, first pointed to the record and showed that Siqueiros had never been found guilty of a crime. He then asked that the charges against the two be read to the court, as the law required. Though the prosecutor could not comply with this request, there being no charges that could be substantiated and no witnesses to support any accusations, the trial nevertheless proceeded.

Ortega Arenas made it clear to the court that, as had been shown by the investigation of the Judicial Police, the public school teachers' strike and the street demonstrations of the week of August 4, 1960, were entirely an affair of the teachers' union; though the police report included the names of teachers and their union leaders, the names of Siqueiros and Mata were nowhere to be found.[2] Filomeno Mata spoke next; he accused the government of jailing himself and Siqueiros in order to destroy the Committee for the Defense of Political Prisoners.

When Siqueiros spoke, his voice was dry and raspy at first. Courteously he addressed the "Señores de la Quinta Corte Penal"—and began his two-hour argument. His first desire was to make the point that sitting

in judgment over the crime of social dissolution was "necessarily a subjective and political matter." To arrive at truth and justice, the historical—and equally—the political base of the law had to be revealed along with the specific national character in which the alleged unlawful acts had been committed. Then, after expressing his support for political prisoners, Siqueiros proceeded to expound on the country's current political state of affairs. With his customary candor, he laid the blame for it at the government's doorstep. With the courtroom now his forum, he likened the López Mateos administration to the regime of Porfirio Díaz and to those of a number of Latin American dictators.

He accused the politicians in power of having seized the reins of government by means of "one party" rule, with the support of submissive labor unions and peasant organizations. Then, by deception, they had spread their control over the country's entire intellectual life; this achieved, "they considered themselves possessors of political truth, and with fanatic fury, were determined to smash the opposition." Near the end of the previous government's term, the workers began to express their desire and impatience to improve the miserable conditions of their lives. It was then that they turned against their own corrupt union leaders and created a movement "the previous government could not totally repress," only to be "smashed in the shortest possible time by the leaders of the new regime."

> Because the country cannot industrialize without guarantees of appreciable profits, both for national and foreign investors, especially the latter with their need for high salaries. . . . If we permit the workers to become conscious of their unions and their class power, they will then confront the criterion and the will of the Government with demands that would soon become untenable. (Therefore) without any democratic discussion, the Government, in the most cowardly manner imaginable, resorted to the use of armed force against defenseless people.[3]

In his defense, Siqueiros clearly was not attempting to curry favor with the three judges. He moved on to compare the government's repressive actions against the strikers to the attacks suffered by the strikers of Cananea and Rio Blanco at the hands of Porfirio Díaz, and he condemned the last three administrations for exceeding the limits of their mandate to be "the highest executor of the law." Citing article 49 of the Constitution, he accused the government of acting illegally by the "repression of whomever, according to their opinion, challenged the principle of authority."[4]

As for the attempt to brand himself and Mata as instigators of the teachers' strike, Siqueiros cited the meeting in July 1960 when 13,765 teachers met and rejected the leaders imposed on them by their union's Executive Committee. It was a meeting, Siqueiros informed the judges, that he had not even been aware of; and the presence of Mata was as a

correspondent for his newspaper, *El Liberal*. The demonstration planned by the teachers had not taken place "because a powerful armed concentration of grenadiers, uniformed police, mounted police, motorized police, and secret police of all types, and even firemen, violently assaulted anyone attempting to peacefully demonstrate."[5]

Siqueiros assured the court that neither he nor Mata were teachers, and therefore they could not have been members of the teachers' union. Yet they were both being accused of being the force behind the teachers' strike. Neither he nor Mata had "influenced the union from far or near to influence the decisions they took," and they had not directed the union by letter or influenced isolated members. "The only thing that remained for Filomeno Mata and myself, was to transmit the proposals or give the orders of which we are accused by the District Attorney, by a spiritual transmission of thought, a faculty however, which we do not possess."[6]

But what was most amazing was that without the slightest evidence, both he and Mata were being held responsible for the labor unrest that was rocking the country. He complained bitterly that he and Mata had been held in prison now for 17 months. Mata had been deprived of earning his living as a newspaperman and he himself had been forced to abandon work on murals that belonged to the people of Mexico.

Though his long discourse was interspersed with events from his own personal history, he kept the focus on his immediate problem. Excoriating the judges for permitting the prisoners to be held for illegally long periods without trial, he cited the innumerable cables he had received from lawyers around the world, questioning and objecting to Mexico's arbitrary and absolute subversion of the judicial process. "In astonishment, they ask," Siqueiros told the judges, "is it possible a country exists in the world where workers are held in preventive detention for more than two and three years?" Why was it that Mexico imitated "everything bad, everything repressive, everything that was cruel in the United States?" But he also questioned why Mexico did not copy what was good in the United States, where "trial procedures, even for serious crimes, rarely confine a person for more than a very few months before they are brought to trial. While in Mexico, imprisoned workers are waiting for more than three years."[7]

Siqueiros then sadly explained his thoughts about the nature of the Mexican State and the meaning and worth of the revolutionary struggle. He turned first to the spectators in the courtroom and then, looking directly at the judges, asked:

> Who can deny that in Mexico the power of the Federal Executive is absolute; that all the powers are piled up in its hands, and by its nature, and its class obligations and commitments to imperialism, it is despotic, and its iniquity can reach inconceivable ends?[8]

Siqueiros had documents to back up what he was saying, but he complained that the court rules were so restrictive and oppressive that he could not present them; he was "not only forced to remain standing for so many hours, but in a place where the weak illumination barely reached. It is obvious that we the prisoners are kept in darkness."[9]

Why, he wanted to know, had such exceptional conditions been imposed on two political prisoners as himself and Mata? Why had they waited a year and a half to be put on trial? And why could they receive visits only from five previously identified members of the family?

Siqueiros brought forth each egregious violation of their rights, complaining that while prisoners were allowed to perform some duty that conformed with their professions or skills, he was suddenly relieved of the job of painting scenery. He had been pleased that in some way he could enrich the cultural life of the prison, and he had assumed the task diligently. His having been denied *this* job, he told the court, could only have resulted from orders that emanated from "powers above." For had not the prison authorities assured him repeatedly of their satisfaction with his work with the prison theatrical group? If "higher ups" controlled such small activities, was it not logical that his incarceration was controlled directly from "powers above?" Even when he had his freedom, the government gave him no peace, locking him up or keeping an extra close watch on him whenever a high U.S. dignitary visited Mexico. As for himself, he acted with his art, painting bitter scenes of the life of the people, who "after almost sixty years since the Revolution, still live in a state of misery, ill health and ignorance that is close to the Stone Age."[10]

He described his struggle on the side of the working class, and the determination to see the country develop without the "aid" of foreign investors "who seek to extend the territory of the United States over the geographical shoulders of our country, as much or more so than that which happened in violent physical form with the Yankee expropriation of Texas, California, and the rest."[11]

He assured the court that solutions offered in good faith by "bourgeois Utopians" had failed throughout the world for centuries, and that, "in the United States with all the benefits of their investments and industries around the world, they have not been able to defeat unemployment." He then pointed out that there had never been a response to the petition of grievances the Committee for Political Prisoners had submitted to the President; was this simply a case of bureaucratic bad manners, or was it that their petition was looked upon as coming from a "disgraceful, politically motivated despotic conspiracy" and thus would not be acknowledged?[12]

Siqueiros paused briefly and sipped a glass of water passed to him by Angélica; he had not yet come to the end of his argument. Continuing,

he drew a picture of the attitude that prevailed in Mexico between citizens and government representatives, asking:

> Is it not so that in our country, public functionaries are untouchable, "even with a rose petal?" Is it not so that you cannot criticize a high official because this act would cause jailing for the poor unfortunate who would do so? And jail for a-year-and-a-half without knowing exactly why?

Fatigued, he gathered strength and pressed on, and with increasing ire told the judges: "These things, Señores Judges, Señores reporters, can no longer continue! And this, from this jail, I assure you!" He then expressed the hope that his words were heard not only by the judges, the grenadiers standing guard at the doors, the Secret Service, and the FBI, but by the general public who had "been illegally excluded from the trial."[13]

His court argument turned into a major speech, which contained a grand plan to turn the country away from the "counterrevolutionary" direction in which Siqueiros saw it being led. He told of the glimmer of hope he had seen when the railroad workers rejected their corrupt leadership. Though he saw it as a small victory, it boded well for the future. It was a new beginning for effectively struggling against the high cost of living and ending the pervasive corruption of union leaders that infected Mexico. For this direction to continue, the union heads and the rest of the political prisoners must be freed, and "without question, Article 145 of the penal code, that nazi voice, reinforced by McCarthyism, which established the so-called crime of *social dissolution,* must disappear from Mexican jurisprudence, without leaving the slightest trace." He made it clear to the court that he did have hope for Mexican society, and freeing the political prisoners would be a first step to proving that the government intended democratic progress.[14]

Siqueiros confessed that at the beginning he was not unwilling to be conciliatory. Though he was one of the most skeptical of the left concerning any revolutionary hopes for López Mateos's administration, the political ferment and progressive stirrings at the time of López Mateos' advent to power had caused Siqueiros to think: "Perhaps I was mistaken about the anticipated character of the new government, and I was at the time even ready to declare my support and manifest my new confidence for the incoming administration." But this soon changed, for at the beginning of 1959 the new administration had reacted hysterically to the demands of the railroad workers. It was then that the falsehoods were spread that the railroad workers were tools of the Communists and were conspiring to overthrow the Government by force.

Siqueiros' voice cut through the courtroom. "Everyone, those who are present as well as those who are not, knows that what I am saying is the truth of what happened. It is the truth of what the Attorney General of

the Republic shouted in every imaginable tone of voice. We all know that when the Government spoke of a Communist conspiracy, they were speaking of subversion, and of armed subversion. For how else explain the furious creation of concentration camps in one Federal entity after another, the assassinations, the tortures, etc., etc.?"

When it came to backing up its charges, the Government remained silent, but still persisted with its accusations against the railroad workers, and the teachers, and that it was he (Siqueiros) alone who was the leader of the "rebellion" with a veritable arsenal of guns and ammunition stored in his home.[15]

Siqueiros accused the government and the press of counterrevolutionary crimes, "the lesson that had been learned well from the police of the Government of the United States and from the teachings of McCarthyism, the Yankee version of Italian Fascism, German Nazism, and the Spanish Falange."

He told the court that he had witnessed Mexican police, disguised as students and workers, provoking riots by throwing gasoline bombs and attacking people with iron bars. This, too, he laid at the door of the FBI: "which is perfectly free to operate in Mexico without restriction."[16]

He accused the press of acting as an arm of the government, remaining silent when more than 5,000 workers were locked in concentration camps, and when the *amparo,* the writ for their release, was ignored or ripped up by federal judges. Then, in vivid detail, he described the brutal murders of workers by federal troops, which also had gone unreported. Government ministers who strongly supported Mexican culture and took pride in their collections of modern Mexican paintings, yet could not bring themselves to speak out in his support, were subjected to his scorn and condemnation.

> The reality is, that day after day, my mural remains imprisoned behind a wall of boards and is the subject to be tried by the 17th Civil Court, while I the author am in prison. Yet more than in prison, sequestered, given the character of my apprehension, of my commitment, of my jailing, of the exceptional conditions to which I have been subjected.[17]

Mexico's academy of arts and sciences, the *Colegio Nacional* was not spared opprobrium. Ironically, while Siqueiros was in prison, the *Colegio* had commissioned him to paint a portrait of the writer Alfonso Reyes, yet had remained silent throughout this troubled period. He said of the Colegio Nacional that instead of being

> a live body, always alert, struggling daily to discover the germinating buds of all that was important, as well as . . . the serious aberrations of the national culture, it still remained a home for distinguished pensioners, an asylum of charity for philosophers and artists at the age of senility.

He further accused them of being "blinded by bureaucracy, of finding

refuge in being comfortably apolitical," and of supporting "an incredible neutralist and opportunist position." But he did acknowledge the honor of the commission they had bestowed upon him.[18]

Then Siqueiros spoke of the preventive detention of railroad workers, a punitive act that had also been applied to him. It was a particularly cruel punishment, causing more harmful stress since no definite time was set for their release. In scolding tones, his indignation increasing, Siqueiros demanded to know how, without rhyme, reason or trial, they all could be kept in prison, especially Filomeno Mata standing at his side, who though 74 years old had already been jailed for more than 18 months with the status of his case unresolved. He himself, now 65, had been forced to leave many works of art unfinished. Did not the judges suspect, as did most Mexicans and those abroad, that such a lengthy period in prison without charges or trial indicated something much deeper than a possible miscarriage of justice?

> In Mexico, in Mexico of the Revolution, can you sustain your accusation based on the principle, sui generis, of the crime of *social dissolution* when it is a complete contradiction of the fundamental political line of the Government? Not even the most counterrevolutionary and pro-nazi regimes of Latin America could formulate a more barbarous theory—a theory that is more appropriate of the worst periods of the political inquisition of the Middle Ages and Colonial Mexico.[19]

The judges sat immobile, compelled to listen to the argument. Siqueiros told of the death threats he received, how he had been labeled a traitor for defending the railroad workers, and he named a number of important government officials who had been rewarded with higher posts for their responsibility in the slaughter of workers. Without any outward sign that standing and arguing in court was wearing him out, Siqueiros complained angrily about the public being forbidden access to the trial, and he chided the judges for their lame excuse that inadequate electrical facilities would not permit loudspeakers for those who had assembled in the patio outside the tiny courtroom. He charged that the government's attitude toward him was vindictive, and he told how government prosecutors subjected him, at the time of his apprehension, to the most extreme solitary confinement and then released false statements to the press of his intention to overthrow the government. "They placed incredible lies on my lips that were emblazoned in some newspapers with 8-column headlines." He and the political prisoners were a special group who had been kidnapped by the Government, and the judges, acting with absolute authority, were operating outside the law by reason of orders handed down to them from superiors in the government who wanted to keep their plight secret.[20]

Blaming the police for provoking the violence in the streets, he pointed to the grenadiers standing guard in the courtroom and asked, "Who is

responsible for ordering the grenadiers to push the people from the door?—those who have every right and desire to hear what I would call our debates." It was always "the uniformed, following the premeditated, stupid, and illegal orders of their chiefs," who violated the legal activity of the citizens. Siqueiros said that he would not swear on the Bible, which was not his ethic, but offered his word of honor that he had personally witnessed—through a slit at the bottom of his cell door—the police preparing themselves, disguised as armed students and workers, to infiltrate the strikers' ranks. This was a course of action, Siqueiros contended, that was necessary for a President who held on to "absolute power." Even the judge, who had released a small number of political prisoners after the hunger strike, admitted that his action had been impeded by a telephone call from the President. "The President wants to industrialize the country—he says—but it cannot be industrialized if the Reds ask for higher salaries for the workers."[21]

In his lengthy and exhausting defense, he put the Government and the judicial system on trial. He also attacked the Mexican press vehemently for being unprincipled and irresponsible, and for having without restriction spewed slander about him and the others, finding them all guilty before any trial.

> On numerous occasions I spoke reproachfully to reporters about such a habit, a habit that was very cowardly, and contrary to the most elemental principles of justice. And important journalists responded: "This is the way things are in Mexico, Señor Siqueiros, what do you want us to do?"[22]

And he complained that allowing him only one-half hour a day to consult with his attorney made it impossible for him to prepare a proper defense. Such a legal process could not continue; not only were new laws required, but "principles of human rights that were more advanced."[23]

As the trial and the day were drawing to an end, Siqueiros inquired of the judges whether it was their intention to question both himself and Mata, or had they already taken the position of the Federal Government and made their decision? "By means of interrogation, a judge clears their [defendants'] doubts. Inescapably, a defendant is directed to the terrain of truth, and by this means the real discovery of the facts is reached."

Though the day had proved that there was not the slightest reason for him and Mata to be in prison, after 18 months in jail there was still no end in sight. "The Federal Government should know, and I say it from this tribune, we will not break, and this jail, as hard as is its deliberate despotism, cannot but be for us a higher tribune than is the street."[24]

Siqueiros had been speaking for two hours, standing, as he had through the entire 13 hours of the trial. What kept the flame burning inside him, renewing his strength, was that he had been pleading for Mexican democracy. At the end he told the court that the problem did not encompass

merely the plight of a Mexican newspaper man and a painter, but that the court's decision would influence the course the people will take "in the struggle against the antidemocracy and prevarication—more and more like the procedures of a Nazi court—that are lamentably developing in our land."[25]

25

The Interdiction of Murals

Now Siqueiros and Mata, not without misgivings, waited in their cells. It seemed senseless that it should take so long to reach a verdict, but they had been told it would be handed down in 15 days. In the end, they endured a torturous wait of 7 weeks before the preordained guilty verdict was thrown in their faces on March 10, 1962. Siqueiros and Mata received cruel and vindictive 8-year sentences that left them in a traumatized state. The arrogant stance of the government sent a shock wave throughout the world. The gang in power left little doubt that they meant business, and rumor had it that President López Mateos vowed that as long as he was in power Siqueiros would remain behind bars. Besides the 8-year sentence, Siqueiros was fined 2,400 pesos, or 4 months added to his sentence if it were not paid. Though no concrete charges could be substantiated, both men had been found guilty of violating the ensnarling Law of Social Dissolution.

Siqueiros now had to face and extinguish his burning desire to return to the murals—there was so much that he still wished to accomplish. At his age, the cruel and extreme punishment could not but cause bitterness within him. On the day of his sentencing, a reporter asked if he had any hope that the President would pardon him, and he replied, "I suppose the President will have to ask the United States before he acts." As for the judges, he was of the opinion that his words in court "did not even pass through one ear and out the other. The words simply did not enter in the least."

Even reduced by the 19 months that Siqueiros had already served, the cold fact of 8 years in prison could not be accepted. The worldwide campaign battering at the door of the Mexican Government intensified as thousands of letters of protest poured in from abroad and delegations of lawyers traveled to Mexico to investigate the case. In the United States,

the Artists' Committee to Free Siqueiros—Alexander Calder and Ben Shahn were co-chairmen—presented the first exhibition of Siqueiros's prison paintings at the ACA Gallery in New York in January 1962. A petition exhorting the Mexican President to free Siqueiros circulated during the well-attended opening, which included the prominent Communist leader Elizabeth Gurley Flynn. On March 17, after Siqueiros was sentenced, 200 artists marched in protest before the United Nations in New York.

The Artists' Committee to Free Siqueiros was immediately placed under FBI surveillance and its mail was intercepted in New York, Los Angeles and Mexico. In Los Angeles the FBI penetrated Communist Party meetings and gathered information regarding the Artists' Committee. Far to the south, the United States Consul in Mérida, Yucatán, was on his toes and informed the State Department in Washington of activities there. An unidentified anti-Communist group was countering pro-Siqueiros sentiment and activity by widely distributing throughout Mérida an anti-Siqueiros leaflet that was a typical product of rabid ultraright mentality. The U.S. Consul informed the State Department of the precise dates when the leaflet was distributed and that "it was well received in the poorer areas and the factory areas in Mérida." The consul further warned the State Department of an upsurge of activity of the Movimiento de Liberación Nacional (MLN) throughout Yucatán and sent to Washington a copy of its magazine, *Liberación,* which called for the freeing of Siqueiros.[1]

Recovering from the initial blow of the harsh sentence, Siqueiros gathered his strength to renew the struggle to free himself and his fellow political prisoners. Angélica worked tirelessly seeking outside help, while in his cell Siqueiros wrote letters, manifestos, and papers to be delivered to various international symposiums meeting in Mexico City. On September 9, 1962, he sent a message to the XIV General Assembly of the International Association of Art Critics, reminding them of the seminal fact of modern Mexican art—the 20th century re-discovery of mural painting in Mexico. His message moved a number of foreign critics to speak out on his behalf.

When the XIII International Congress of Philosophers met in Mexico City on September 11, 1963, Siqueiros sent a paper from jail in which he outlined for the philosophers the role philosophy played in modern Mexican painting and sculpture. He pointed out that, "in aiding the Government of the Mexican Revolution in the social transformation of the country, the ideological content of [the Mexican Movement's] work in the fine arts was necessarily political. Its theme was political, and in this virtue its content was philosophical."

Urging them to draw their own conclusions, Siqueiros reminded the

philosophers that he has been in jail for three years because his mural paintings were "symbolic and his ideology communistic."[2] A short time later an English translation of this paper was broadcast over Pacifica Radio in various U.S. cities.

Earlier, in November 1961, Nehru had made an official visit to Mexico. Siqueiros hoped that Nehru might speak to the President on his behalf, and in his cell he painted a small work for the Prime Minister—a tight group of figures moving toward a bleak empty horizon—titled *Running Without Direction*. Siqueiros inscribed the painting on the back to Nehru and added the comment: "But does anyone know, including themselves, where they are going?" The painting, delivered to Nehru by a delegation of Mexican artists, spoke for itself. But even if Nehru broached the subject to López Mateos, we know he had no effect.

Former President Lázaro Cárdenas came to visit Siqueiros and told him to be patient. Siqueiros bitterly scolded his old friend for permitting this incredible situation which so violated his person, and told him that he was not a "Christian martyr." Siqueiros's faith in Cárdenas was unbounded; though Cárdenas had loved him and did what he could, it was a new era and his influence proved ineffective.

With Siqueiros's sentencing came scurrilous attacks in the U.S. media. A Miami newspaper columnist wrote:

The fiery painter, a familiar figure in Communist-inspired street demonstrations in Mexico City during the last several years, had long claimed that the government was afraid to arrest a man of his prominence. "They dare not touch me," he boasted on more than one occasion. . . . Twenty months ago the government of President Adolfo López Mateos arrested him for taking a leading role ostensibly among students in the Mexican Capital. He was charged with treason but the Mexican legal terminology was "social dissolution," a law aimed at communism which makes it a criminal offense to engage in public disorders on behalf of any "foreign power." . . . Several other Communist labor and political leaders are still held in jail in Mexico under the "social dissolution" law, which permits the government to hold them without a trial for an indefinite period. It is likely that others will be sentenced now that the kingpin finally has been handed a specific term. In its own way, the leftist government has warned the Reds to keep their hands off the Mexican Revolution.[3]

When a leading art establishment magazine in New York received a letter from a reader urging support for the imprisoned Mexican painter, the editor commented:

Concern for Siqueiros' freedom is touching, but we should be a bit more moved by it had he shown any awareness of the artist's past activities as a

political assassin. Is Siqueiros's attempt on Trotsky's life—and his murder of Trotsky's body-guard—so far in the past that we have already forgotten it?★⁴

Government vigilance extended to the editors of the *Hispanic American Report* at Stanford University, who could not have taken any delight in being notified by the State Department officer in charge of Mexican affairs that in their article in the May 1961 *Reporter,* certain facts were "not mentioned." Siqueiros, the official informed them,

> is a member of the Mexican Communist Party and of its Central Committee, and has long been known as an agent for Moscow, since at least 1939 when he personally led an unsuccessful assassination attempt on Leon Trotsky. Siqueiros was one of the publicly identified leaders of a violently anti-government student demonstration in 1960, which culminated in a "Death to López Mateos" rally, and which was the real reason for his arrest.[5]

This warning "correction" to the editors of the "Hispanic American Report" from the State Department was intended, no doubt, so they would exercise greater care in the future.

On July 15, 1963, a group of distinguished Mexican lawyers directed a letter to Mexico's Attorney General and to lawyers attending the International Congress of Attorneys in Mexico City, calling for abolition of the law of Social Dissolution and warning the lawyers who represented Latin American countries that the Organization of American States (OAS) was pressing its members to recommend that their respective countries adopt the Mexican example of "Social Dissolution." Citing the case of Siqueiros and Mata, the twelve signers of the letter further urged the Congress of Attorneys to work for the liberation of "the hundreds of political prisoners who are still chained in the prisons of the Continent."[6]

Guided by Angélica, the wives and relatives of the political prisoners did not for a moment desist in their efforts to free their loved ones. Their repeated efforts to gain an audience with the President were without success. They carried letters to his home, "but no audience was ever granted."[7]

On August 9, 1963, the government, apparently reacting vindictively to the persistent worldwide campaign to free Siqueiros and the political prisoners, finally handed down sentences—after 4 years and 6 months—to those prisoners who still had none. The 27 political prisoners at last knew when they would be released. Demetrio Vallejo, the leader of the railroad workers, received a sentence of 16 years and a fine of 34,000 pesos; Valentín Campa, railroad union leader and Communist, 14 years and 32,300 pesos fine; and so the sentences ranged, down to two railroad workers with 4½ years each.

Siqueiros and Mata could be considered favored for having been in-

*The death of Sheldon Harte, Trotsky's bodyguard, remains an unsolved mystery.

formed of their sentences more than a year earlier. Mata had a close brush with death when he suffered a severe case of bronchial pneumonia, and he was released after 3 years—he was then 76. However, once out and recovered, he resumed his work with the Committee to Free Political Prisoners.

On December 29, 1963, Siqueiros, for the fourth time, celebrated his birthday in prison. Only his family were allowed to visit him, but his cell was filled with hundreds of birthday cards, letters, cables and red flowers, which were, wrote Angélica, "symbols of the heartbeat of his people."[8] Agencies of the U.S. Government also took an interest in his birthday. The FBI, CIA, and State Department were put on alert when 120 leading U.S. artists and writers signed a birthday greeting for Siqueiros that was printed in the newspaper *Excelsior*. The Mexico City FBI station sent a memorandum to Washington headed "José David Alfaro Siqueiros, Espionage." Enclosed were a copy of the newspaper birthday greetings and a translation from the Spanish:

> Greetings from the intellectuals of the United States. In this season of brotherhood, we, North American artists, urge that David Alfaro Siqueiros be freed in order that he may continue to enrich the art of Mexico and the world.

Listed were "numerous names," and extra copies were being furnished "in the event the Bureau desires to disseminate the enclosure to other offices. It is requested that the Bureau forward two copies of the enclosure to the New York Office.[9]

Another FBI memorandum, originating in Washington, advised that an article in *The Worker,* also birthday greetings, "sets forth a list of communists and Siqueiros's sympathizers in the Soviet Union, Latin America, and the United States; included in the list is the name"—at this point in the document, two blacked-out paragraphs follow.[10]

A State Department airgram from Mexico City to Washington advised: "American 'Intellectuals' Appeal for Release of Siqueiros," and said the newspaper advertisement was "'signed' by a number of 'intellectuals,' whose names are listed below as a possible interest to Washington agencies."[11]

The passage of prison time is eternally slow. 1964 arrived; in August, Siqueiros would be halfway through his sentence. Firm in his ties to the working class, Siqueiros agreed, along with fellow prisoners Valentín Campa and J. Encarnación Pérez, to be a candidate for the Mexican Senate. The three were nominated to run on the newly formed Frente Electoral del Pueblo (FEP) ticket; the national elections were to be in July. Though he considered it a minor and weak political effort, Siqueiros sent an acceptance speech from prison to the FEP convention held in Mexico City's *Nuevo Teatro Ideal.*

In his message to the convention—"We Struggle for a Congress of the Union which will not be Submissive to the Executive"—he spoke of being honored to be a candidate for the Senate. If he were elected he would use that tribune to see that the legislature declared its independence from the Executive, and that "it would refrain from being the incubator of laws and decrees that repress the most elemental liberties of the people, and above all, of the working class." The Mexican Congress must stop being a tool of the oligarchy, "deaf to the remonstrances of the popular masses and the intellectuals tied to these masses," for when it came to criticizing the Federal Executive it was without a voice. He had been impelled to "*accept*, even within the limitation of a bourgeois system," in order to struggle "for a democratic and just interpretation of the Constitution."[12]

Angélica at this time informed friends and supporters that the Court of Appeals had rejected his petition, and a new appeal by 9 prominent lawyers had been filed in January of 1964. But she reminded them, it was the President who was responsible for the whole affair and only he would give the order for Siqueiros's release. Therefore, to extricate the artist from his imprisonment, the round-the-clock struggle must continue, and she advised all to persist in protesting to the President.

> The international voices and protests must continue to be raised against the fraudulent trials, a stigma that without doubt undermined the international prestige of the Government of my country in regard to the other aspects of its policies: peace and peaceful coexistence, a foreign policy that contradicts its anti-democratic internal policy, violative of the most elementary human rights, and which represses and throttles the people of Mexico.
>
> The campaign for the freedom of David Alfaro Siqueiros and the other political prisoners should therefore continue. It is on the strength and constancy of international solidarity that the shortening of the terms of the dramatic sentence of Siqueiros depends—an artist who, at the age of sixty-seven, can yet return to his mural work, and whose genius promises even greater and more powerful realizations in the service of humanity.[13]

Before the Supreme Court could follow the example of the Court of Appeals, as was the general expectation, Siqueiros was freed by a presidential pardon on July 13, just 27 days short of completing 4 years in prison. The final measure he had pursued was Article 97 of the Mexican Penal Code, which allowed pardons to be granted "if the defendant has lent important services to the Nation."

This clearly was the only avenue left open, and Siqueiros in his petition on April 19 had argued that he had a vast quantity of work on public buildings unfinished, that age was creeping up on him, and that to await the end of a sentence that stemmed from "a trial lacking in reason and justice" was an intolerable situation. Therefore, he would leave it up to the President to work out a way for him to return to the work that he was performing for the government. Still, there had been no response;

on June 18, Siqueiros repeated his request and was forced to remind the President of all his achievements and good works in the interest of the nation. The President had been experiencing the continuous opprobrium of world public opinion, and now felt secure because the July elections showed the PRI in complete control of the Congress and the nation— even after political organizations had been allowed into the electoral process; on July 11 he signed the directive granting Siqueiros his liberty.

A report from the American Embassy in Mexico City to the State Department in Washington stated:

> The Presidential Directive came as a surprise. Observers here felt the artist would be kept in prison, at least until the end of the López Mateos administration because of the personal animosity which López Mateos was understood to feel towards Siqueiros. . . . The Embassy has no specific information as to why the Siqueiros release came at this time.

However, the U.S. Counselor for Political Affairs expressed the opinion that it was because of the strong PRI victory in the recent elections.[14] The FBI station in Mexico City sent the details of Siqueiros's release in confidential letters to the Director in Washington, the CIA, Army and Air Attaches at the Embassy, as well as the Political Section, and to the field offices in Albuquerque, El Paso, Phoenix, San Antonio, and San Diego.[15]

26

Sunlit Mexico City

More than 500 people were crowded at the entrance of the Lecumberri Prison when Siqueiros, accompanied by Angélica and Adriana, stepped past the huge brass-studded doors into the sunlight. It was a clamorous moment—tumultuous cheers and applause! He smiled and squinted in the bright daylight as newspaper photographers snapped his picture. His hair was grayer now and his outward healthy appearance belied the physical deterioration he had undergone.

The crowd showered flowers over him and burst into a chorus of the *Internationale* as they lifted him to their shoulders and carried him to his waiting car [46]. More crowds and mariachi orchestras greeted him on Calle Tres Picos. He attributed his freedom to the worldwide effort that had been conducted on his behalf, and once home, he lost no

time in conveying his thanks to all who had acted in the "extraordinary campaign."

In the festive atmosphere surrounding his arrival home, newspaper reporters sought answers to their queries. No, the pardon had not changed his political attitudes. "A muralist must have a theme; the mural is his pulpit."[1] Yes, he would continue his Communist Party activities. And he was happy to be free, both for his art and his politics. Were they to be "differentiated"? "You know that with me my art is a personal thing, but my party is my duty."[2]

More than anything now, including politics, he was anxious to resume work on the murals. His haste disturbed Angélica, for she feared that he would demand of himself a greater productivity to make up for lost time!

In 1974, Angélica recalled to me the days immediately after he was released from prison. "The thing that saved Siqueiros, I think," she said, "was the tremendous international pressure. When he came out of jail, there was great emotion. The people were waiting in the street with flowers. There was a big crowd and they put him on their shoulders as though he were a bullfighter. Everybody was crazy. And when he arrived at the house, musicians came and played. It was fantastic. But what did he do? On the same day he couldn't, but the very next morning he was in Chapultepec Castle at ten o'clock. It was very beautiful, two days later, when he went to the Castle, a big crowd was sitting on the floor before the mural and he gave a lecture explaining the mural again. He made contact with his mural.

"On the streets people went crazy. He didn't pay in restaurants, taxi drivers would not accept his money, in the theaters he didn't pay. He was the guest of honor in expensive and poorer places. Everywhere he was like a hero. He became a hero for the conservative Mexicans and the rich capitalists. Not because they had his paintings in their collections, or that they agreed with him politically—they respected him because he was honest all his life. At the same time, what is extraordinary about Siqueiros is that he did not bear any ill-feeling against anybody when he came out of jail. At the beginning there were a lot of artists who were very brave and fought for him, but later they became frightened and said that if they put a big personality in prison, they will put us in prison, too, if we defend him. It developed that everybody was afraid to speak, and if it weren't for the big international campaign it would have been harder. Of course we had a very important group of lawyers, they were honest and they took the case in their own hands and that helped a lot.

"So when Siqueiros went into the streets and saw his old pals, he said, 'How are you, what have you been working at?' He was full of pep and life. Like a little child enjoying his liberty. It was they who looked old and he looked like he had just returned from a trip abroad. He was inviting everyone to eat in the house or a restaurant. He was interested

in the work of each one. It was wonderful to see him. He had no negative reaction. There was no bitterness in him. That's one of his greatest characteristics. Even later, when the President, López Mateos, went to his studio, he received him with courtesy and showed him the mural. The President went to make peace with him. After Siqueiros showed him the mural he brought him to the house. They were drinking whiskey and he joked with the President about the period he was in jail. He was nice to the President. He wasn't bitter against him. He wasn't bitter against anything, he always understood it was politics, and if you have a conscience, in this world you are exposed to all those things and it's natural that it happens. It was illegal, but it's natural in repressive periods. That's why we have to work more and develop the conscience of the people so that in the future these crimes will happen less and less."

Exhilarated with his new freedom, Siqueiros hastened to the mural to survey what effects, if any, the four-year hiatus had wrought between himself and what he had painted on August 10, 1960. Had it been up to him, he would have gone directly to the mural from prison when he was set free, but it was on the following morning—functioning normally from all outward appearances—that he strode before the mural, silently taking in the scene as he cast about to revive the *interrupted* mood and put in order the next step to be followed.

The walls were cleaned, the paints made ready, and the historical facts for the theme of the mural were studied. On July 16, just three days after leaving prison, Siqueiros opened the Room of the Revolution to art students and public for a lecture before the mural. Three thousand people showed up, and for those who were able to fit into the room he spoke on the mural's political as well as aesthetic aspects.[3]

Though work on the mural had now resumed in earnest, on July 26 Siqueiros gave his first political speech since leaving prison. On that day, the 11th anniversary of Fidel Castro's attack on the Moncada Barracks, Siqueiros addressed the celebrants who filled the *Teatro Lirico*. It was clear how ineffectual his imprisonment had been when he told the audience that the Mexican Revolution must follow the Cuban example by effecting complete independence from the United States[4] [47].

Painting of the mural *From Porfirismo to the Revolution* was moving forward with ever more intense passion, but Siqueiros was also becoming aware of problems with two other murals. That for the Actors' Union, after six years, still remained covered and enmeshed in a legal web. But he was shocked to learn that the mural at Avenida Sonora 9, *Cuauhtémoc Against the Myth,* had been hacked to pieces while he was behind bars. Of the family, daughter Adriana was the last to have seen the mural intact. She was a ballerina, and when she had an injured leg she visited a doctor, one of a group with offices at Sonora 9. She told me that the

doctor, upon learning who she was, upbraided her for being the daughter of a Communist, whom he hated. Not only that, he told her how much he had despised the mural, thinking it ugly and suffering greatly living with it. Then, after this deliberate torment, he suddenly reversed himself and in a strong emotional display confessed that all that had changed. After living every day with the mural for five years, he had discovered the greatness of the work—to the point where he was convinced that it was the greatest painting of the age.[5]

But shortly after Adriana's experience, the doctors had vacated the premises and the mural fell to tenants of less lofty pursuits—Sonora 9 was turned into a brothel. The fact that the mural was in a house of ill-repute was discovered by a reporter from *La Prensa,* and his story brought unwanted publicity to the building's landlord. He resolved the problem by evicting the mural; it was ripped from its moorings, cut into pieces and carted away. But no one knew of this until a painter named Montero visited a carpenter shop to have a frame made. The painter was startled to see sections of the great mural stacked in the rear of the carpenter's shop. Without a moment's loss he telephoned the Siqueiros home, shocking Angélica with his discovery.

With Siqueiros then helpless in prison and his favorite mural a heap of discarded rubbish, Angélica raised a hue and cry. Architects and certain supportive bureaucrats responded to her alarm and offered a plan for the mural's possible salvation though its condition and the feasibility of its restoration were still unknown. The architects of the great Tecpan restoration project in the Nonoalco-Tlatelolco district of Mexico City planned a site for the mural in the chapel-like structure which was the spot where Cortés maintained his headquarters in Tlatelolco and where Cuauhtémoc had been held prisoner. In this disinterred shrine it was hoped that *Cuauhtémoc Against the Myth* could be restored.

In prison, Siqueiros had received word of the mural's destruction with unbounded incredulity. When it was determined that the mural, though in pieces, was still complete, Siqueiros joined the struggle to save the work. Family member Luis Arenal was able to consult with Siqueiros in prison and acted as an intermediary between him and the architects designing the Cuauhtémoc shrine. By the time the structure for containing the mural was completed, Siqueiros was a free man and thus able to oversee the project. With loving care, pieces were fitted one to the other and their interstices rendered invisible with filler and paint. The restoration was a success: the mural with its furious vitality shone brightly in its new gemlike setting.

Siqueiros had inscribed his prison paintings—more than 300 works—with the letters *C.P.* *(Carcel Preventiva)* or the words, *En Carcel* (In Jail) and *Celda 26* (Cell 26), and was aware that his prison production had

evoked great public interest. In September, only six weeks after his release from prison, 204 of the paintings—*My Prison Paintings*—went on exhibition at the Galeria Misrachi in Mexico City. In his cell Siqueiros had written on the reverse side of many of the paintings his thoughts about what he intended to express in them plastically:

RIM OF THE NIGHT: The successive moments around the circumference of the globe of the earth when the shadows move ahead imprisoning the light. The blue-black or green above and the red-black below. The cold black of the open atmosphere and the warm black of the earth.

GESTATION: Giant thistle, fifty times higher than a man; born and lives for millenniums—they say—in dry empty inlets where putrefying plants and wet clay fertilized the mud and slime, now already dry for centuries.

THE INCOMMENSURABLE POWER OF THE SMALLEST: Poor microbe that knows how to measure the stars and drill the earth, ripping the riches, blindingly dazzling, from its bowels; a flying ant, sufficiently retarded, once it discovers the insides of its own planet, is already, unfortunately, reaching for the universe of its nearest neighbors.

DIALOGUE OF FLOWERS: It is very possible that all the flowers speak among themselves to the point at times of arguing violently. But not of the slightest doubt is the existence of the giant flowering trees in the hidden recesses of the tropical jungles of America, and that during certain hours of the day the deafening noise of their conversation can be heard, which in some cases are horrible blasphemies; trees of flowers that speak with multiple voices.

REVERENT CACTUSES: Is it the same in the desert zones of southern Argentina? The truth is that in the arid zones of northern Mexico there exist giant cactuses—*biznagotas,* the nomadic laborers call them—which on torrid days keep cool by conversing in voices so low that they are barely audible. One could almost say that their dialogue is carried on with bows and signs. It is also said that certain parts of these *biznages* cause the most ardent Daltonism.

MESSENGER FLOWERS: What could the human being desire more than that flowers should come to them instead of them moving to posses the flowers? It is without doubt certain that in the highest places of the western Sierra Madres of Mexico, there exist flowering trees that walk; it is true that small trees, carrying their load of flowers on their backs, change their positions when the sun's rays get stronger. These small agile shrubs do the same when the earth gets dry.

THE THIN FLAMES: They are palms and giant thistles, six to nine meters in height, with hard flowers. I have seen them when I was a fugitive in the most hidden heights of the Sierra Madre. I do not know if they have been recorded in botany.

THE RATTLE TREE: It could be called a meteorological palm. Its immense bell-flower, a species of firm flower like that of the agave, announces with strange sounds the beginning and end of storms.

THE BLUE FIG CEIBA: From the stories of my companion Epitacio Mendoza; dancing around it the people become intoxicated without the necessity of alcohol.

CHRIST THE REDEEMER: Your doctrine of "Peace on Earth" was buried in the blood and ashes of two thousand years of wars each time more devastating.

CHRIST: "Only he who believes in Christ paints Christ," wrote Fra Angelico. Therefore I have painted him—no doubt thinking of those terrible Mexican Christs of the people in which I believed when I was a child.

CHRIST MUTILATED: First his enemies crucified him (2000 years ago). Later his "friends" mutilated him (during the Middle Ages). And today, his new and true friends have restored him with the political pressure of communism (post-Ecumenical Council). This small work is dedicated to the last.

BEAUTIFUL HERB: Diabolical plant that poisons a whole region.

TROGLODYTE JAIL: A subjective expression of judicial and prison reality in Mexico.

POSTATOMIC WAR LANDSCAPE: An immeasurable beauty—but nobody survives to contemplate it.[6]

The many landscapes, flowers, and human subjects that poured out of Siqueiros's cell had brought him days of beauty and escape.

From Porfirio Díaz to the Revolution was not even half completed when Siqueiros was snatched away to prison; only the center section would have been finished in time for the November 20 celebrations of the Revolution in 1960. Two more years would be required now to bring the mural to completion. On its 419 square meters would be the history of the Revolution—the Díaz dictatorship, the 1906 miners' strike of Cananea, Madero, the usurper Huerta, and the bloody aftermath.

For Siqueiros the mural would be the essence of the distillation of the caldron of the Revolution in aesthetic terms. Nourished by his own experiences in that cataclysmic event, he faced the mural with a sense of mission—a mission that imprisonment had strengthened. In the end it was a virtuoso performance, and the aesthetic quality he achieved deserved to be spoken of with the awe one accords such works as Rembrandt's *Night Watch*.

The portraits in the mural numbered close to one hundred, and their visages were to be readily identified by visiting school children. The scene seethed with ferment. Protagonists of the Revolution and earlier world social reformers were in the vanguard of countless masses that receded into the background space. With powerful plasticity Siqueiros rendered each portrait, displaying dominant forms and contours, the chiaroscuro artfully executed with glazes applied with both brush and spray gun. Beginning with the world of Porfirio Díaz, the mural winds its way around the room's irregular configuration and is to be seen as an uninterrupted panorama, which ends with an epilogue, a scene again with Porfirio Díaz.

The symbolism was neither allegorical nor metaphorical; new-realism, though speaking symbolically, spoke directly. Siqueiros's unambiguous rendition of the Revolution begins with a tumultuous scene of Porfirio Díaz surrounded by the high-living and cavorting bourgeoisie *(plate 72)*. He sits, top-hatted, on a throne, with a foot resting on the open pages of the Constitution. Seated just behind him, bedecked in a bright blue uniform trimmed with gold, is the future usurper, General Victoriano Huerta. *Los Cientificos*—Díaz's brain-trust, followers of August

Comte—act out their advisory role, gesticulating behind the dictator while elegantly attired women dance at his feet. The scene abounds with top-hatted officials of the dictatorship, secure in their power, but to one side the dancing women convey the impression that they are beginning to flee from the impending onslaught of the Revolution.

Designed for the moving spectator, the history of the Revolution unfolds in a continuous panorama, corners in the room disappear, and a roaring, throbbing human mass moves into the room with the roving viewer. In the tottering world of Porfirio Díaz, armed *charros*—representing the power of the big landowners, the *hacendados*—joined by U.S. soldiers, surge forward in an attack on the striking miners of Cananea. For Siqueiros, the 1906 Cananea strike was the seminal event portending the Revolution. There, just south of the Arizona border with Mexico, W.C. Greene, the U.S. owner of the Greene Cananea Copper Mining Company, crassly exploited the Mexican miners. In the mural, Greene is depicted cowering in the protection of the wealthy, *charro*-attired *hacendados* and U.S. troops. In the vanguard, in the central position in the mural, is the working-class family. They head a procession that bears aloft a dead miner's body, and they meet headlong the blows of capitalist resistance. Painted in this group are the portraits of the strike leaders *(plate 73)*.

As the history moves on, the great ideologists of revolutionary thought surge forward with the mass of workers. Karl Marx's figure, foremost on the picture plane, thrusts forward his book. Close by are Frederick Engels and forerunner Pierre Joseph Proudhon. John Kenneth Turner, whose book *Mexico Bárbaro* played an influential role in the downfall of Díaz, is present, as is people's artist José Guadalupe Posada. From the brilliant revolutionary thinker Ricardo Flores Magón to worker and political activist Aquiles Serdán, Siqueiros's restless brush paid its tributes. Following the mural's chronology, the picture-plane turns a right angle; the painted surface is now opposite and facing the scene of Porfirio Díaz and his world. Amassed on this wall are the army of the Revolution and its leaders. The insurgents—armed peasants and workers—glare threateningly toward the dictator on the opposite side of the room. Monumental stoic figures, bandoleers crisscrossing their breasts, stand in the front rank: the Yaqui Indian, the Zapatista from the south, the guerrilla fighter of the north, and the woman fighter, symbolized with a portrait of famed Margarita Ortega. Immediately behind them are the leaders of the Revolution, prominent among whom is Emiliano Zapata. In a stunning portrayal, Siqueiros painted a charismatic Zapata, adorned with a scarlet red sombrero and neckerchief, his face bursting forth in a sea of straw-colored sombreros of the peasant insurgents *(plate 74)*.

As the sweeping scene changes with the moving spectator, "the horseman of liberation" comes into view, dashing forward on a white charger

and skidding to a stop to avoid flying off the wall. Far into the distance in another scene is an endless row of cadavers, the dead of the civil war, the flames of the Revolution sweeping forward toward the horseman *(plate 75)*. Here Siqueiros used a photograph that documented the scene, and painted Leopoldo Arenal, Angélica's father, as first cadaver of the row—a historical fact.

The mural ends, with the epilogue high on the wall. In a setting of volcanic stone sits petrified, the hunched-up corpse of Porfirio Díaz; one hand is thrust forward grasping a dagger, the other clutches a newborn infant of deathlike pallor. Thus, Siqueiros warns of the birth of a new Mexican Porfirioism *(plate 76)*.

Shortly after he had returned to this mural, Siqueiros suffered a dreadful mishap, causing another interruption in the work. Usually nimble atop a scaffold, Siqueiros was now four years older than the last time he had climbed one, and he fell to the floor, suffering a painful injury to his spine. After being incapacitated for three months, he returned to work wearing a back brace and did his utmost to ignore his new problem. Still, he was in pain on September 18, 1966, when he attended the inauguration of the Diego Rivera Museum of Archeology, and two days later when he was present at the ceremonies that opened the new Mexican Museum of Modern Art.

The mural in Chapultepec Castle had attracted the attention of writers and critics even while Siqueiros was in prison and certainly for some time after it was finished. With this paean to the Revolution new wounds were opened, provoking a new round of arguments, discussion and opinions about the not-so-distant Revolution. In *El Universal,* one could read that the Revolution came about because "the mines were in the hands of North Americans and Jews," and that "Jewish North American capital had created a powerful enterprise controlling the growing industry in Chihuahua, Coahuila, and Neuvo Léon.[7]

John Canaday, art critic of *The New York Times,* had seen the unfinished work while Siqueiros was in prison, and found himself moved by the experience of viewing the mural in its condition of abandonment.

> The case of Siqueiros the political activist cannot be weighed here. But the mural can be judged, and it shows the artist at top form. This means that a major painter with something to say is saying it with full technical and esthetic command.

Of the finished central section of the mural he wrote:

> With full and powerful propagandistic force [it] moves like a great wave about to crash upon the observer. . . . The massed portraits, the capitalist caricatures, the sombreroed soldiers, the flying banners, the bodies of proletarian martyrs, have become a tiresome iconography. But in Siqueiros' hands they are as untrite as the painting of any Renaissance master whose Christian

and pagan iconography had been trite for centuries when used only as a formula. Far from threadbare, Siqueiros' familiar themes are as potently alive as if they were being used for the first time.[8]

The Brazilian critic Mario Barata, who was the regional secretary for Latin America of the International Association of Art Critics, had also seen the unfinished mural. In a lecture at the National School of Fine Arts of the University of Brazil, he said:

"The work in gestation, partially finished, forms a confluence of the strange vibration of the Mexican soul and the combative personality of the great artist. Perhaps for the first time, the profound lyricism of the *mestizaje* of this nation— in the words of the poet, 'with your look you fill our hearts'—is reached by the vibrant art of Siqueiros, and it provides a humanly loving and fecund point for the interpretation of feminine nature with which his plastic creation is enriched.

'The 'gay women' of the Dictator, and the dance of the people are counterposed in a rhythmic and beautiful spacial denouement, but they conform in the felicitous expression of the lyrical and luminous arabesques, almost musical in a sensual note that is rare in the well-known, predominantly structural, Latin American artist. The drawing of the lines and masses, for their content, decidedly express his political contribution to the analysis of the Mexican Revolution. And among other affirmations it demonstrates the ever present moral ponderousness of the differences that exist between the two feminine emanations—lascivious or joyful—in the surprising choreographic display of the forms lyrically set by the artist.

"Thus here, the art of Siqueiros continues to be aesthetic, political, and philosophical, but to a much higher degree, and more fully realized than his vehemence. The artist continues to penetrate and clarify the world, not through symbols as in the obscure but significant works of his youth in the stairway of the Preparatory School in 1923, but through the means of a simple and poetic visualization of the real world endowed with all the force of enchantment—with an almost magical power of the lyricism it possesses. The angularities, which until now had constituted the characteristic personal style of Siqueiros, gave way in the 'gay women' of Chapultepec, to curves in which the freedom of emotion gave birth to a singular pictorial beauty orchestrated in large and vigorous rhythms, but which are also smooth and feminine."[9]

Though Mario Barata was completely beguiled by the mural, his evaluation of a new feminine aspect to Siqueiros's style was perhaps derived more from a personal speculation and preference. The eroticism of the "gay women," enters Siqueiros's work more to serve the subject being expressed than because of any predilection the artist might have for curves for curves' sake.

President Gustavo Díaz Ordaz attended the inauguration of the mural on November 20, 1966, the day of the anniversary of the Revolution. "The treasures of Chapultepec Castle have been enriched with one of the

most important pictorial works, not only in Mexico, but of the entire orb and of all epochs,"[10] said a Mexican critic, noting also the dominance of red tones in the mural. Siqueiros responded that "color is a voice, an expressive means, and for that reason it is intimately tied to the theme of the painting."[11]

It was a major concern for Siqueiros that after an absence of four years, the stylistic unity of the mural should not suffer, that no break in style from what had previously been done should occur.

> A tremendous problem we had was precisely that of unifying the style. Because if we claim that a mural is as much an absolute unity as a painting fifty by thirty centimeters would be—then the style of the mural also has to be uniform. To have a coherent sense it must correspond to this principle.[12]

The Cuernavaca workshop-studio had been built while Siqueiros was in prison and with funds from his prison paintings. It was a vastly different structure from the small studio that adjoined his Cuernavaca house, where on weekends he could find an undisturbed moment to produce an easel painting that would bring in economic support. Now that old studio appeared merely a closet compared to the huge workshop that expanded outward in all directions. Siqueiros was astounded when he first set eyes on the challenging space. His brother-in-law, Polo Arenal, who was in the business of selling heavy machinery and hoists, had designed and supervised the construction of a facility that would accommodate the movement of huge sections of murals and eliminate the need for the aging artist to scramble about on scaffolds. But the original small studio, a box measuring 8 x 5 meters, with a high ceiling and a skylight, remained a place of solitude where he continued to produce his smaller works.

The new workshop-studio was 40 meters long, 20 wide, and 13 high. It was an amazing place, with four electric hoists, eight hand-operated ones, and pits two meters deep to receive the mural sections as they were hoisted up and down, allowing the painting to be done from floor level, as was the method in theatrical-scenery studios. Appended to the principal work space was a room for mixing and storing paint, a metal workshop for creating sculptured forms to be incorporated into the murals—and acknowledging the value he placed on photography as a tool in the hands of the painter—a photographic darkroom.

Siqueiros immediately visualized the unlimited possibilities that this facility could support in his restless quest for ever greater mural inventions that would keep abreast with modern life. In this big studio-workshop new fantastic murals could be born and he was inspired to confer on it the name of *La Tallera*, transposing the masculine, *el taller*—the workshop—to the feminine, *la tallera*.

The March of Humanity would be the first mural from La Tallera. Its

conception had commenced in 1965 when Siqueiros reached an agreement with the wealthy industrialist and hotel owner, Manuel Suárez. Suárez had sought a commitment from Siqueiros while he was still in prison, to decorate a new convention center that was being built adjacent to his Hotel de la Selva in Cuernavaca.

Once again, outside activities and commitments began to press in on Siqueiros from all sides. The seclusion to paint, which he so desired, had to be abandoned when invitations and entreaties stole the time he could barely spare. On February 8, 1965, he attended the belated unveiling in the National College of his portrait of Alfonso Reyes, and on that occasion had his first opportunity to meet the new President Gustavo Díaz Ordaz. In March, Siqueiros again interrupted his work when he accepted an invitation from the editors of *L'Humanite* to attend a reception in his honor in Paris. It was his first trip abroad since being released from prison and the Europeans were eager to see him.

From Paris he and Angélica went to Rome, where at the invitation of the Italian Communist Party they attended the 20th anniversary celebration of the liberation of Italy from the Fascist grip. During the celebrations Luigi Longo, general secretary of the Italian Communist Party, conferred on Siqueiros the gold medal of the Garibaldi Brigade, the Italian veterans of the Spanish Civil War. On April 7, the following day, Siqueiros was presented as the guest of honor at a lecture and reception in Rome's *Casa della Cultura*. Writer and painter Carlo Levi, and art critic Mario de Micheli spoke in praise of Siqueiros. De Micheli said:

> In more than one aspect, [Siqueiros] seems to me to be one of the painters who has been able to create the pictorial equivalent of the poetry of Mayakovsky. The impetuousness, the eloquence, the ideological passion, the vehement images, and the utilizing of many procedures of the vanguard, which have in a creative form been assimilated or rejected in the work of Siqueiros. Today Siqueiros has returned to painting, to mural painting, and he will be able, especially now, to paint the faces of the people with all the passion and impetuosity of which he is capable and with the incessant tumult of ideas that still continues to exist in him.[13]

Of the few days that Siqueiros and Angélica remained in Italy, almost every moment was consumed in lengthy interviews urged on him by reporters and critics. However, nothing gave Siqueiros greater pleasure than discussion, answering questions, and the chance to expound on his views, both political and aesthetic. He explained to them the "painting of movement," how the painted forms in murals conveyed the impression of movement and change in the eyes of a walking spectator. In modern society, he stressed, architects had largely ignored their integration with architecture. An architect such as Frank Lloyd Wright could integrate architecture and nature yet might never give consideration to integrating

a mural that dealt with a subject of the problems of humanity, or to the unified space of an architectural structure.

The Italian critics and journalists sought an answer from Siqueiros as to how he supported a powerful political and social art within an extraordinarily high aesthetic? How had he overcome the aesthetic problem that dealt with pictorial renditions, which, in the West were customarily labeled political propaganda? Yes, he shared with his interviewer the belief that the methodology of Marxist criticism had to undergo "innovations and renovations."[14] In his lecture at the *Casa della Cultura,* which was printed in *L'Unita* under the title, "This is the Way I See the Purpose of a Painter in Society," Siqueiros once again, in an attempt to clarify the point, read his 1955 "Open Letter to the Soviet Painters."

While enjoying his new freedom abroad, it would have not come as a surprise to him, nor to Angélica, that their lives were the subject of discussion in Washington and that their current activities were being monitored by agencies of the U.S. Government. In Washington, hearings were being conducted by the Subcommittee to Investigate the Administration of the Internal Security Act and Other Internal Security Laws of the Committee of the Judiciary, and the testimony of "patriotic" individuals tossed up, among other things, any scrap of innocuous information that related to the life of Siqueiros. The FBI station in Rome sent a two-page memorandum to J. Edgar Hoover in Washington, summarizing the movements of Siqueiros and Angélica during their days there. He was informed of details gleaned from the pages of *L'Unita.* "The caption under a photograph reported that Siqueiros was accompanied by Angélica Siqueiros." She had thanked Luigi Longo and the Italian Communist Party "for the campaign of solidarity which had been carried out in Italy for the liberation of Siqueiros from his Mexican prison." It was also noted that the Mexican cultural attaché, Ugo Gutiérrez Vega, and the Cuban charge d'affaires, Severino Mansur Jorge, had attended the Siqueiros lecture, which had closed with: "It was your magnificent united action which made my liberation possible. I thank you warmly and I ask that you continue to fight for the liberty of all Mexican political prisoners."[15]

When Siqueiros returned from Italy, nagging political problems, as usual, encroached on his painting and promised to do so forever. Railroad workers and their leaders, still imprisoned, kept him involved in that relentless struggle. Then, too, the intervention of the U.S. Marines in the Dominican Republic could not be ignored; on May 7, 1965, Siqueiros addressed an outdoor protest meeting at the Juárez Hemicycle. Addressing the crowd on Avenida Juárez, he said:

> Mexicans have taken to the streets to demonstrate our repudiation of the invasion by North Americans that the Dominican people are at present suffering. It is the Mexican people who were attacked in the past century; it is the

Mexican people who were invaded by the Yankee imperialists in Veracruz; it is the Mexican people who were invaded in Chihuahua; it is the anti-imperialist people of Mexico who have come to tell the Yankees: Hands off! You have no right to humiliate Latin America.[16]

A year later the FBI cited a Havana radio broadcast as the source of its information that Siqueiros had signed a declaration by the House of the Americas condemning U.S. aggression against the Dominican Republic and demanding withdrawal of foreign troops from Dominican soil.[17]

The intermix of art and politics was the accustomed mode for Siqueiros; they had nourished each other for most of his life, had strengthened his creative processes and the aesthetic quality of his painting. The sheer experience of living the thoughts that materialized plastically in turn enriched the creative abilities of his political activism. Yet the dichotomy of the two pressures, each vying for his attention, could not be denied. Now, with the inexorable advance of time, political life would have to allow art to assume a greater share. But this was not to happen suddenly, at least not while the railroad workers were still political prisoners and the general unrest in the country was fueled by a new strike of young doctors and nurses confronted with the full force of government resistance.

In September 1965, Siqueiros delivered a report to the inaugural meeting of the National Assembly for Release of Political Prisoners and Repeal of the Law of Social Dissolution. After the FBI had listened to it on a Radio Havana broadcast, they filed a report.[18] In March of the following year, Siqueiros again addressed the National Assembly for Release of Political Prisoners.

Along with innumerable political commitments, which included obligations as a member of the PCM's Central Committee, Siqueiros was single-handedly striving to hold the Mural Movement together. With great effort, the movement was being buttressed by his own works and those of a handful of older muralists. A steady increase in murals had culminated in 1964 with a peak of 98, but with a lack of interest from younger painters the decline was rapid and in 1969 only 14 murals were produced in the country.[19] Most of the younger painters were now from bourgeois families and could afford to seek a career in art; they were attracted to easel painting for the galleries of New York and Paris. As they turned their backs on mural painting, the Movement began to lose its vitality, and no leadership other than that of Siqueiros came to the fore.

In his lecture in the Sala Ponce of the Palace of Fine Arts he said: "Confrontation? Yes! But only between the two basic currents that today, battling, coexist in the plastic arts of Mexico—integral objectivity (realism) or subjectivity (abstractionism)." He lamented the fact that *formalism* had seriously penetrated the national art life, though it was not an exclusively *national* art but one that was "the base of a healthy interna-

tional movement." The signs of a breakdown of the Mexican Mural Movement and its easel-painting wing were becoming more evident, and perhaps for the first time Siqueiros, to his dismay, faced the problem.

> In no uncertain terms, *formalism* has penetrated and entered into the production of the younger generation of artists, who moving backward have climbed aboard; for in the methodology of their work there is no progress, only enormous retrogression.[20]

Still firmly rooted in his revolutionary position, Siqueiros was awarded Mexico's National Prize of the Arts two weeks before his 70th birthday. President Díaz Ordaz conferred the prize—a medal and 100,000 pesos— on December 15, 1966. That a government could so persecute one of its artists and then turn around and present him with one of its highest awards can perhaps be attributed to the ambivalence of its politicians when confronted with an artist of such stature and great renown.

Siqueiros, however, was not ambivalent and did not temper his words to suit the occasion. In his brief speech, he made the point that though the prize had been awarded to him, "implicitly" it belonged to the Mexican Mural Movement and to those muralists who had responded to "our primary liberal, anarchosyndicalist, and communist conceptions." In his opinion, the award was for everything that made it possible for an art movement to arise and develop that was against the *art for art's sake* proclaimed by the School of Paris. With the President listening, he said:

> It is just and opportune to emphasize today that [the murals] movement was able to develop because there were in the government apparatus officials of broad vision, such as the Secretary of Public Education, José Vasconcelos; the Director of the National Preparatory School, Vincente Lombardo Toledano; and because there was a President such as General Álvaro Obregón. It was he who was able to understand the importance of our creative force for concretely serving to defend the Revolution, which was moving in such a precipitous way in spite of its primary philosophical platform.[21]

Siqueiros gave the prize money, 100,000 pesos, to the cause of the railroad workers in jail, the Communist Party, and his brother Chucho, who had no visible means of support and claimed that David did not love him anymore.

Angélica remembered that Siqueiros "received from the new President, Díaz Ordaz, who had been the Minister of the Interior under López Mateos, the National Prize. There was a big commotion when he received the prize. It was received in the National Palace with the Minister, Torres Bodet; the great scientist, Arturo Rosenbluth; and somebody else. Each person could speak for only five minutes.

"Siqueiros made a very popular speech, saying that the prize he received he took in the name of Diego Rivera, Orozco, Revueltas and all the members who created the Mural Movement in Mexico. He said they

created the Mural Movement because they wanted to help the Mexican Revolution and were looking for a future of Socialism, and this they did as members of the Communist Party.That is how he spoke in the National Palace and they had to swallow it. It was a short speech but he said what he wanted. He spoke of the Communist Party right in the National Palace."[22]

December 29, 1966, was his 70th birthday, and he and Angélica accepted the long-standing invitation from the artists and writers of Rome, traveling there once again to celebrate with the convivial Italians. From Rome the two traveled to Switzerland, where their adored, over-indulged and spoiled grandson, Davidcito, was attending boarding school. The FBI, keeping an eye on their travels, reported from its station in Bern to the Director in Washington the information they had gathered from an announcement in the *Tribune de Lausanne*—the Siqueiroses had arrived in Leysin and Siqueiros had "contacted individuals connected with the field of art in Geneva." In the same "secret" message was a gratuitous reminder to the Director that on page 12 of Isaac Don Levine's book, *The Mind of an Assassin,* there was a description of Siqueiros's attack on Trotsky.[23]

A belated but festive birthday celebration for Siqueiros by friends in Mexico was held on February 21. At one point Siqueiros addressed the gathering seriously. In a pensive mood, he deplored the fact that no one present, including himself, had done all that was necessary for Mexico. He bemoaned the devitalizing effect of a stupid bureaucracy full of individuals who lacked understanding, and he told the story, which he swore was true, that a certain bureaucrat had advised him to stop wasting his time painting murals and grow rich by painting little works for the members of the government. Greatly indignant—and perhaps, due to the occasion, slightly fortified with drink—Siqueiros explained that any time he was in need, he could retire to a small room, paint a small picture and sell it, "to touch some money." But, he told his friends, even painting in this manner, "can be done with passion. Facing a work, the painter creates and does so with nobility. Art has to be the product of honesty and a profound creative will."[24]

27

Time the Devourer

Siqueiros had now reached a point, after years of unremitting political and artistic struggle, where he could not accommodate the demand for his murals and easel works. Time would not permit him to undertake a mural that the International Organization of Labor in Geneva had commissioned him to do. His artistic strength however, remained undiminished by the travails of his energetic life, nor would he admit to any signs of physical weakening.

In early 1966, work on five murals had piled up: the restoration of *Cuauhtémoc Against the Myth;* the completion of *Patricians and Patricides* for the ex-Aduana; *From Porfirio to the Revolution* in Chapultepec Castle; *History of the Theater to Contemporary Cinematography* for the Actor's Union; and the new *March of Humanity.* These would have to be finished before new commissions could be undertaken, and they would require every bit of his strength and time and there was still in the distant haze, the work at San Miguel de Allende.

The massive Suárez mural, *The March of Humanity,* was in its initial stage and was being worked on in the new Cuernavaca studio. Some steps to solve the problem of the Actors' Union mural were discernible. And, full of determination, Siqueiros hoped to finish the ex-Aduana mural, now 20 years since its inception. He did set to work on this latter mural as soon as he had finished in Chapultepec Castle. The composition was changed in the unfinished half of the ex-Aduana, a very small part was completed, then once again the work was abandoned.

In the meantime, the Actors' Union—under its new leader, Jaime Fernández—dropped the charges against the censored mural, drew up a new contract, and assured Siqueiros of their full backing. He was eager to finish the work. He had already personally extended an invitation to the President to attend its inauguration, when the President, while awarding him the National Prize [48], had remarked how favorably impressed he was with Siqueiros's murals.[1] However, it would be a year before Siqueiros could find time to give his full attention to *History of the Theater.* To facilitate the work, he painted the unfinished sections in the Cuernavaca studio.

In his 71st year, Siqueiros was awarded another prize—completely

unexpected by him, though certainly not undeserved. On April 30, 1967, he was notified that he would receive the Lenin International Peace Prize—a gold medal with the portrait of Lenin, a diploma noting the fact, and 25,000 rubles. A few days later, on May 2, Siqueiros announced that the prize money would be donated to the government of North Vietnam, saying:

> Who can deny or even argue the just reasons of the Vietnamese people? Who can remain indifferent to their marvelous heroism? These conclusions I have reached as a man and a citizen of a country which has, in its own particular circumstance and scale, suffered for a century the serious aggressions of North American imperialism.[2]

At a modest ceremony in the Soviet Embassy in Mexico City on September 28, Siqueiros was formally presented with the prize [49]. The Soviet writer Boris Polevoi, special envoy of the Committee of the Lenin Peace Prize made the presentation. In his short talk he spoke of the strength of the Mexicans and of their high esteem in world public opinion. Noting that two Lenin Peace Prizes had previously been awarded Mexicans—General Heriberto Jara and Lázaro Cárdenas—Polevoi stated:

> At their side today stands the third; my dear friend David Alfaro Siqueiros, a man who in my profound estimation has, since the years of his youth, dedicated his lifework to the struggle for social justice, for a true humanism, for world peace and is an example of why the word MAN rings proudly when it is written in capital letters in every language.[3]

Siqueiros responded, setting forth some of the basic thoughts that lent support to his political attitude:

> What more transcendent prize can an old combatant for peace receive than the Lenin International Prize? A prize that originated in the very country whose regime from the day of its appearance opened for the nations of the earth the conquest of peace . . .
>
> The value of the prize is incommensurable, but it is not only I who am honored. It is through my person and my work that the founders, the creators, and the continuers of the only artistic movement that made the struggle for peace the prime purpose of all their work in murals and prints. It marked the beginning of a plastic and graphic art, the material nature of which was put within the reach of the great masses, opening a field that was different, richer, and more generous than that of private appropriation by the individual buyers of the bourgeoisie.
>
> I do not wish on this occasion to be the only one to receive the prize, but simply rather the one who materially receives this significant and extraordinary distinction. Fraternally I share it with everyone in my country and with everyone on earth, who, following the example of the Soviet people and their government, have made the struggle for peace the reason for existence, since

peace is intrinsic with the transformation of human society by the roads of Communism.[4]

An airgram from the U.S. Embassy in Mexico City to the State Department in Washington took note of the event and carried an informant's report (the informant's name blocked out) that at the ceremony in the Soviet Embassy, Siqueiros remarked that he was sending the 25,000 ruble award to Ho Chi Minh to aid him "in killing American imperialists." The message further stated:

> This remark by one of Mexico's foremost communists is reported for the record, particularly in connection with any future application by the subject for a visa to enter the United States.[5]

And also during this year, the National University honored Siqueiros with a retrospective exhibition in the Museum of Art and Science in University City. The 200 works exhibited encompassed 50 years of painting, from the copy of Raphael's *Madonna of the Chair* painted at the age of ten (on loan from the collection of María Asúnsolo), to a self-portrait painted that June. At the close of the exhibition, which ran from August 7 to October 3, Siqueiros gave a lecture that included a self-critical analysis of his work as it related to developments in contemporary art.

Sad news had recently come to Siqueiros of the death of his old friend and prison comrade, Filomeno Mata. On August 30, at the burial, Siqueiros delivered a eulogy, recalling that Mata had come from a publishing family which had earlier fought the dictatorship, and how "arm-in-arm with his father he came nearer and nearer to the working class in the struggle to transform our country." He closed with the deeply-felt words: "Comrade of our struggle, we will always be together for the people and their cause!"[6]

Before settling down to the tasks awaiting his brush, Siqueiros took part in a final festivity that year. In November 1967, Siqueiros and Angélica traveled to Moscow as guests of the Soviet Union to share in the celebration of the 50th anniversary of the October Revolution and to receive the title of honorary member of the Soviet Academy of Art. His earlier constructive criticism of Soviet painting was now better appreciated, and Siqueiros, at a reception in his honor, was proffered a tribute by the vice-president of the Academy, Vladimir Kemenov, who spoke of him as a great revolutionary artist who had developed the best of the world's tradition of monumental art.[7]

His mind in a fervid state, teeming with ideas for the new mural he was in the throes of creating at home, and he was anxious to get back. However, on their way home, they made a brief stop on November 10,

in Belgrade, where Siqueiros and Angélica spent a pleasant interval with Tito [50].

Then, no sooner had he resumed painting at home, when on December 2 he had to go to Paris to lecture an audience of 200 artists and critics. Armed with a short film of his work in progress, *The March of Humanity*, he astonished the audience with what he had in mind for this largest of all murals.

In early January of 1968, he attended the World Cultural Congress in Havana, where his speech in Havana's Palace of Fine Arts drew a tremendous ovation; in the museum's lobby, special tribute was paid him with an exhibition of photographs of his murals. He was still not happy with the works of the Cuban artists, which he found insufficiently attuned to the needs of the people. "They had allowed a gulf to widen between themselves and the peasants and workers. Their work was overwhelmingly influenced by the Paris-New York School."[8] Mural art, he believed, would put them on the right road.

While he was at the Cultural Congress, a group of French Trotskyites accosted him. A woman among them—"a little lady of Paris," said Siqueiros—kicked him "delicately" in the shin. Though he found the incident amusing, he worried about what the Trotskyites might try to do in Cuba, for he recalled their treachery in Barcelona in 1939.[9]

In spite of all the differences, the Mexican government honored Siqueiros once more. His uncompromising stance, with which all were now familiar, commanded a high respect in government circles and on April 2 he was chosen to be the first president of the newly founded Mexican Academy of Arts. This, however, in no way deflected him from supporting the Mexican students when they pressed their demands on the government.

The great student strike of 1968 began in July. Siqueiros at that moment was deeply entrenched in work on two murals: the one for the Actors' Union, and the profoundly complex *The March of Humanity*. Though he had recently more than paid his dues to the repressive system, Angélica worried because as usual, members of the Communist Party were being seized by the police as the instigators of the student protests.[10] She was relieved that he was at work in Cuernavaca when the students went on strike in Mexico City.

Siqueiros—"the hours wearing away the days, the days nibbling away at the years"[11]—was making a supreme effort to devote himself completely to painting. There was so much left undone as the years gathered about him. Still, he could not be indifferent to the storm lashing the students in Mexico City and spreading to other parts of the country. From *La Tallera* in Cuernavaca, he sent a series of paid announcements

to the newspapers in the capital, in which he attacked the government's repressive acts and gave his support to the students' strike.

On October 2, Siqueiros was in Mexico City. That evening he was in the office of the Secretary of Gobernación (Internal Affairs), Luis Echeverría. A friend and admirer of the painter, Echeverría was slated to be the next president of Mexico. Siqueiros always appealed to government ministers to remove bureaucratic roadblocks that intruded on government-sponsored murals; or, as on many occasions, he might seek the aid of a Minister to assist a foreign art student in establishing residency in Mexico.

Angélica recalled that Siqueiros was with Echeverría on that day of the dreadful killings and at the very moment the shooting began in the Plaza of the Three Cultures in Tlatelolco. On this occasion, she told me, Siqueiros's business with the Minister was to enlist his aid in resolving an immigration problem that Adriana's Colombian husband was having with the Mexican authorities. And while in the Minister's office, Siqueiros witnessed Echeverría receiving a telephone call informing him that a massacre of students was taking place in Tlatelolco. The Minister reacted in a fit of anger and Siqueiros heard him heap abuse on President Díaz Ordaz, whom he held responsible.

The number of students and citizens slaughtered by the army ranged from the official figure of 49[12] to 300 as reported by *The New York Times*,[13] or 400, the number given by the student's National Strike Council (CNH).[14] That night was called the new *noche triste*. The original *noche triste,* the debacle suffered by Cortés at the hands of the Aztecs, took place in 1520, just a few blocks south of the Plaza of the Three Cultures in Tlatelolco.

When Echeverría was later accused of being responsible for the killings, Siqueiros stood by him when the minister insisted that he knew nothing of the orders to shoot down the citizenry.

Siqueiros nevertheless was not to be torn from his work, and the completed sections of the Actors' Union mural were the first work to leave *La Tallera.* On December 5, 1968, they were brought from Cuernavaca to Mexico City and joined to the previously completed section, finally consummating the work. In this mural Siqueiros incorporated his new sculptured metal forms. It was with feelings of relief when Siqueiros and the union leaders stood before the work and toasted the great accomplishment.

The mural was to be formally unveiled in January and Siqueiros prevailed on the union Executive Committee to face the square columns of the lobby with mirrors, not only permitting the mural to be reflected but minimizing the visual obstruction the columns posed. At the same time, the executive Committee approved with enthusiasm the installation of a

proper lighting system. The mural was then covered with a curtain to await its inauguration day.

Four days after the mural was secured in its place and hidden from public view, it again became the object of an enemy attack. The theater's evening performance on December 13 had ended, the lights in the building were out, and at thirty minutes past midnight a mob of 20 to 30 vandals broke into the theater, locked up the two watchmen, cut the curtain from the mural, and with powerful solvents proceeded to destroy the work. Great damage was inflicted on one fourth of the mural; large sections were completely eradicated, and only the darkness in the lobby saved it from even greater damage.

This act of political vandalism horrified the citizenry. Angélica drove Siqueiros, accompanied by Luis Arenal, rapidly from Cuernavaca to Mexico City. The awful defacement appalled Siqueiros and he pointed to agents in the pay of the police and to members of *Movimiento Universitario de Renovadora Orientación (MURO)*, the ultra-reactionary opposition to the student strike, as being responsible for the criminal act. "Naturally," he told reporters, "because of my adhesion to the students—from the outside."[15] Two more months of work were required to restore the mural. "This mural," he lamented, "has a special significance for me—I spent four years in jail because of its theme."[16]

The History of the Theater ranges from the theater of the Greeks to the birth of television. In addition to the scene of workers being attacked by the army, described earlier, there is painted a television or cinema screen reflecting the life of the impoverished people of the Mesquital (the arid area a short distance northeast of Mexico City) and a portrait of the deceased actor Jorge Negrete, for whom the theater is named. Counterpointed on the same wall, the tortured bodies of four railroad workers loom from ceiling to floor, hung by their arms, lashed to a freight car that drags them to their death. Here, too, the tragic scenes contrast with the brilliant colors of the faces of actresses, clowns and comics.

During the repainting of the mural, Siqueiros removed the large number 17 that covered the page of the symbolical Constitution being trampled underfoot by federal troops. He not only disliked resorting to the use of the written word in murals, but felt that the number, which represented the 1917 Constitution of the Revolution, and which had sparked so much objection, was unnecessary. In painting it out, he volunteered a gesture of coexistence.

He had feared at the time that the interruption of his work, especially the manner in which it happened, would cause a "demoralization and suffering" in him that would be difficult to overcome.[17] But in the end, the work suffered only a delay—a delay of ten years! As he had stated ten years earlier, the mural remained his most human work.

28

The March of Humanity

The March of Humanity now received Siqueiros' full attention. Manuel Suárez y Suárez, wanting to own a mural by Siqueiros, had first approached him in 1960. He was a businessman as well as a lover of the arts, and for him the purchase involved a financial investment for a profitable return. The Siqueiros mural would be a magnet to attract customers to his Hotel de Mexico, one of the largest in the world.

In 1965, Siqueiros had been commissioned to paint the mural for Suárez's Hotel de la Selva in Cuernavaca, but the immense size of the Hotel de Mexico became a greater attraction and in 1966 the mural became part of that complex. It was said that President Díaz Ordaz had suggested the change in order that the project be available to the greater number of tourists in the capital city. Architects Guillermo Rosell de la Lama and Román Miquellajauregui, consulting with Siqueiros, designed a structure that would be entirely decorated by him. The building, to suit Suárez's wishes, was given the shape of a cut diamond, with the exterior a dodecagon and the interior an octagon. The building housed a number of areas or forums where cultural activities—theater, dance, concerts and exhibits of art—would take place, and it acquired the name, the "Siqueiros Polyforum," though Suárez called it the Siqueiros Chapel.

Siqueiros welcomed the opportunity to paint a mural on a huge surface of his own design. Grateful to Suárez, he remained indifferent to the commercial motivations. Siqueiros's ideas for the mural had already been explored and developed in the many prison paintings and sketches he had produced, and though his bushy black hair was now turned gray, he seemed in robust health and was enthusiastic about the strenuous project awaiting him.

Time was now his enemy, but he would have to make the best of it. Angélica recalled:

"When he left jail he spoke to the Communist Party, for he was a member of the Central Committee, and said: 'For the first time comrades, I want to ask something of you. I have given most of the best years of my life to organizing workers, to political activity, to the fight against fascism. Now please, let me do my work, I think I deserve it. I have lost four years now, and many years before. So I don't want to march. I want

to do the minimum. I will keep on helping economically where I can, but please, I can't go to assemblies, I can't go to meetings, because I won't have time. You know when I get into art problems, they take hold of me.' I'm sorry the Party didn't understand that. In our Party the cultural level was weak, so perhaps they didn't understand the great effort and the great advance of that mural, which was so important because it was a great step forward, both in muralism and in the work of Siqueiros."

But Siqueiros did put down his brushes briefly early in 1969 to appear before a committee of the Mexican Congress. The extensive protests against Article 145, the law of Social Dissolution, had finally caused the President to order hearings on it. Siqueiros, well acquainted with the law's effects, was an important witness and argued forcefully for its repeal.[1] For the most part though, Siqueiros remained at work in Cuernavaca, far from the capital and the great students' strike.

In his work clothes—old pants, turtleneck shirt and cap, all black— Siqueiros puffed a cigarette and surveyed the work in progress in *La Tallera*. As the ideas unfolded and developed, the problems of their execution became more demanding. From the beginning, the materials and methods necessary for the structural design of the mural had to be newly tried and tested. The fact that the mural was being painted in a studio, away from the building whose interior it was destined to adorn—a building not yet constructed when the mural was begun—and the fact that the style of the mural was not simply flat painting on a plane surface but *esculto-pintura*—sculpture-painting—which required the securing of heavy molded metal forms to the mural's surface. This left no alternative but to paint on the wall itself rather than on a lightweight false wall which could later be fastened to the building's wall in Mexico City. Thus a prefabricated permanent wall that would support the heavy metal forms was painted in Cuernavaca and then transported to Mexico City. Great care was taken to assure that the wall sections were clean and free of moisture (to avoid that bane of all mural painters, moisture settling in walls, provoking the efflorescing of soluble salts and fungus growths). In the actual building, the Polyforum, there was an airspace of four meters between the wall of the mural and the building's external wall.

The interior vault was made up of 96 sections. Seventy-two measured 4 by 3.30 meters and 24 were 3.30 by 1.50 meters. The prefabricated wall sections were a mixture of cement and asbestos, reinforced with angle-iron frames. Each section weighed from 450 to 1000 kilograms. Though the actual shape of the interior mural was that of an octagon, the entire surface took on the appearance of an ellipse. When all the sections were installed and their joints filled with an epoxy paste mixed with talcum and asbestos powder, then covered with fiberglass cloth, the walls and ceiling formed a continuous surface without visible breaks. The twelve

separate planes of dodecagon shape of the exterior of the building were to be painted on the site.

Siqueiros's vision was that of an architecturally integrated mural composed of myriad forms, sculptured and painted—a polychromed sculptured mural. In the Polyforum, a building serving cultural needs, Siqueiros at last had the opportunity to integrate the mural with the architecture, and he did so on a grand scale. The great Mexican pre-Hispanic works of art and architecture forever served him as a source of inspiration. But he had also stood spellbound before the fantastic ancient sculptured temples of India, and had often spoken of the overwhelming impression the Hindu and Buddhist temples had made on him. These great works of art were for Siqueiros the products of a collective expression that served the psychic needs of an integrated society.

Siqueiros was now an isolated, lone artist, a survivor of the once vital Mural Movement, a member of a fragmented society who, surrounded by the conditions of the advanced stage of 20th century capitalism, was creating a work of art of monumental proportions that in its grandeur was a modern counterpart to the temples of ancient Mexico and India. Yet this work of integrated art and architecture necessarily would stand segregated and isolated in the chaotic environment of Mexico City.

At first Siqueiros had great difficulty understanding how to sculpture a painting of such vast proportions. The surface of the interior mural comprised 2,165 square meters—there was no larger mural surface in the world. He reconsidered the technical aspects of Rivera's *Tlaloc*, done in 1951 for the Lerma waterworks in the forest of Chapultepec. As Siqueiros contemplated the outdoor polychromed sculpture of the Nahua rain god, he concluded that it was the most important sculpture of contemporary times. Rivera had polychromed his work with natural colored stones and glass mosaics, the only materials that offered permanency of exterior color at that time. Rivera's *Tlaloc* was an "important milestone," and it helped to renew Siqueiros's confidence in proceeding with the sculpture-painting of the Polyforum.

Of the interior mural: In Cuernavaca, the composition and its development were first painted on the flat surface of the wall sections; then followed the difficult feat of copying Siqueiros's painted forms in metal sculpture by a team of sculptors and iron workers. Out of 18-gauge cold-rolled steel sheets were produced beautifully modeled sculptures which were then bolted to the prefabricated wall sections. Before the polychroming was begun, to allay any possibility of rust attacking the metal surfaces, they were sandblasted with silicate sand to rid them of all impurities. The metal was then quickly sprayed with a coat of inorganic zinc, and to further protect it from humidity it was covered with an anticorrosive resin before color was applied. Chemists close to the work had advised these protective measures.

Special care was given to the choice of paint and related products for their permanency, especially for the exterior dodecagon. The acrylic paint came from the Carboline Company of St. Louis, Missouri, which manufactured paint for ocean liners, offshore oil rigs and space-launch towers. They also produced the anticorrosive synthetic resin Versikote, and the solvent Toluol. The latter material was similar to benzene, though less toxic, and mixed with the acrylic (methyl methacrylate) for a lower viscosity and the thicker, richer quality paint that Siqueiros preferred.

Concentrated in the all-encompassing, ambitious general theme, *The March of Humanity*, was the sum total of humanity's struggle to survive, as expressed with Siqueirian artistic technique and philosophical thought. The external decorations are the first ones seen by spectators, including air travelers and hotel occupants who can observe painted forms on the roof. The exterior murals—the twelve separate walls—can be considered the overture to the main work on the inside. These exterior separated walls contain no sculptured forms; each section is 10 meters wide and 18 meters high and each presents a different subject. However, the formal elements of their composition seek to compliment the architecture, and an overall integration is achieved through the philosophical mood that is established.

On these exterior walls Siqueiros presented a prevision of various human and natural actions, which reflected the theme of the mural on the inside. Even in brilliant sunlight, the mood was unrelentingly somber, Siqueiros having projected a strong sense of urgency into the color, form and content of each trapezoidal face of the dodecagon. The work begins with the wall above the Polyforum entrance, titled, *Leadership Calls the Masses to Action*. As the spectator follows the walk that encircles the cultural center, the sides of the dodecagon come into view one by one: *The Dry Leafless Tree Reborn in the Spring; The Circus: Transition from Spectacle to Culture; Stop Aggression*—agitated figures making the gesture; *Moses Enraged Smashes the Tablets of Laws; Christ the Leader: "What Have You Christians Done With My Doctrine in Two Thousand Years?"; The Dance—The Destruction of the Indigenous People before the New Divinity; Sacrifice for Freedom; Winter and Summer—The Drama of Nature; Mingled Races—The Drama Unleashed by Love During the Conquest; Music—the Non-discriminating Art—From Primitive Beginning to the Infinite; The Atom as Triumph of Peace Over Destruction*. The outside could be compared to an overture by Beethoven; the inside, by Shostakovich.

Ascending by stairs or elevator into the main auditorium, the Universal Forum, spectators are greeted by a spectacular and breathtaking sight of Siqueirian plastic fury. In the hushed, great domelike chamber a meditative mood takes hold of the viewer. The space embraced by the mural-covered dome is 45 meters long, 30 wide, and 13 high. Standing within

it, the spectator is completely surrounded with sculpture-painting. The floor is a revolving platform 25 meters in diameter, and rotates 800 seated spectators around the mural in fifteen minutes. In the main work, Siqueiros set down the apocalyptic truth of humankind's desperate struggle to survive on earth, as he saw it. The vast surface of sculpture-painting churns and throbs with a mass of humanity, relieved only by a female symbol and a male symbol, at opposite ends, and by future prognostications on the ceiling.

A maelstrom of turbulent human action marks the starting point of the *March (plate 77)*. A swirling mother figure clutches an infant; a mutilated torso of a lynched black man—a fully sculptured figure—hangs surrounded by flames. Evil forces at work are symbolized by the Aztec *nahual,* the demon of evil. Above this group are depicted the enslaved masses of hungry workers, women and children, toiling amid cruelty and suffering to build civilizations. The tortured mass—workers under heavy loads, women with arms wrapped around babies—surges forward. They fall prey to the demagogue who leads them astray, symbolized by a startling sculpture-painting, a white-masked clown. As the people progress, ever so slowly, the repressive forces of militarism appear in ordered file. Bourgeois revolutions are achieved, but the people are still in rags. Continuing on the opposite wall, the north side, Siqueiros depicts humankind facing its most bitter, difficult struggle yet, using sculpture-painting to show the hell humanity must pass through under capitalism before it reaches the future revolution and communism.

An inferno sweeps across the north wall *(plate 78)*: volcanos erupt, the demon *nahual* exerts its evil power. Hope appears as a lone figure and chops down a poisonous tree of evil. The landscape is barren and desolate, as though devastated by a nuclear bomb. Hope appears again—the *amatl* grows, and though in reality it never blooms, it does so here, putting forth flowers that give rise to new leaders for humanity's everforward march. Women now move to the fore and point out the direction the leaders will follow. Another volcano erupts, shooting flames of napalm on defenseless people; a lone figure extracts fire from it to light the torch of revolution as *The March of Humanity* moves to its final goal—the red star of Communism, which Siqueiros has painted on the ceiling, along with rockets in space.

Woman and *Man* appear at opposite ends of the mural. *Man,* with his arms outstretched, his hands in a grasping attitude of action, is the initiator, the doer, he holds the power *(plate 79)*. *Woman,* her outstretched hands palms up in a gesture of supplication, imploring for a humanized society, is the symbol of culture and the longing for peace. From these two beings at opposite poles, these two forces, emanate powerful charges that shoot upward and join in the center of the ceiling in peace and love.

Siqueiros labored for six years on *The March of Humanity,* most of

that period during the days that were not long enough. Too often he worked under extreme duress, caused by technical failures, lack of funds,and political disagreements and arguments that began to develop between himself and members of his Party. Then, too, there was a terrible tragedy when his niece, Electa Arenal, who was helping on the mural, fell to her death from atop a scaffold. The sadness of the loss of this 33-year-old artist and relative stayed with him the rest of his days.

The mural's financial troubles began when millionaire backer Suárez, who expected a quick cheap mural, began to balk at paying the bills; Siqueiros's ideas were becoming too expensive for him. In order for the work to continue, Siqueiros had to begin paying the expenses out of his own pocket.

When I interviewed her in August 1974, Angélica explained the situation. "Suárez the owner, made a contract and paid for the first two years," she said.

"But there were six years. Later on he didn't pay a penny. He said he would not pay for any experiments of steel sculptures. Then he started taking all of Siqueiros's things, his sketches and models for the mural. He said that everything of the mural belonged to him. There were a lot of problems but Siqueiros was amiable because he wanted to keep the work going. A good deal of the time we used our own money. Señor Suárez said he didn't have any more. There were a lot of difficulties but Siqueiros worked tremendously. For me, that was the greatest mural, and the one that took the most energy from him. He worked more than ever, like crazy on that mural.

"Another thing I would like to say about this work. Through the whole history of the Mexican Mural Movement, the muralists were very badly paid by the government. When the muralists started working in 1923 and 1924 they were paid four pesos a square meter. Later on of course it was not the same price, but it was equally unsatisfactory. Rivera, Orozco and Siqueiros would have to come down from the murals and paint easel works in order to pay the salaries of the young painters assisting them.

"In this last work the owner of the property, Señor Suárez, talked big and said he was going to pay Siqueiros millions of pesos. Of course all of that was stupid because he didn't pay for the mural. He paid very limited expenses for materials and Siqueiros even put himself on a salary of eight thousand pesos a month, a little over six hundred dollars.

"Siqueiros wanted to be democratic, and he put his own money into the work by selling easel paintings. Not only did he contribute money to the mural, but he made a heroic effort of work. I think those six years of working so intensely were bad for his health. He worked until eleven and twelve at night, even on Sundays. And at times until two in the morning, creating the theme for the next day's work. He had great energy but I think he abused it.

"So the story that his critics, and even people in the Communist Party believed, that Siqueiros was making money, was stupid. You could say that he made the mural for free. The owner Suárez paid the least possible for the building construction. He got paintings from Siqueiros for his family and he

kept two big studies for the mural. So in a way, Siqueiros suffered more for that mural than in any other mural. But he considered the Polyforum his greatest work. Not in relation to its size, but for its contribution of new elements."

A powerful aesthetic experience awaited the mural's spectators, for which they may well have been ill-prepared and ill-equipped. Siqueiros had taken a huge leap, springing from the end of the Italian Renaissance period and soaring over the multitudinous art movements of the interval to land with his final great work as a continuation of the monumental and philosophical vein of the Renaissance. Siqueiros, aided by modern techniques, created as powerful a plastic expression as he could of the nature of human history—past, present and future. The challenge now was for people to be drawn as they were meant to be, into the powerful emotional and intellectual plastic expression that had poured from Siqueiros.

The Siqueiros Polyforum was inaugurated on December 15, 1971. A crowd numbering in the thousands attended, spilling onto the street and halting traffic. President Luis Echeverría presented the opening official pronouncements—"a speech of noble concepts expressed with elevated thought."[2] Manuel Suárez, the proud owner, also spoke, as did architect Guillermo Rosell and the writer Salvador Novo. Siqueiros's brief comments ended with "Forward over the interminable road that is the great adventure of life, the march of humanity is a total march, impelled by man's tremendous desire to overcome."[3]

The Polyforum fell on the literati of Mexico with all the weight of its massive form. The obvious was too difficult to evaluate for those schooled in the abstract. If not curtly rejected, the work required special analysis over a long period. A critic wrote:

> Is it the best mural of Siqueiros? It will have to be studied. Everyone will have an opinion. It will be later, when time has passed, when the critic and the study that has been undertaken year after year for dozens of years, when a work of this magnitude enters into the history of art, that, after a number of generations, the aesthetic evaluation will be defined, determined, and assayed.[4]

Another critic was less uncertain:

> The public traveling on the revolving platform with the display of lights and accompanying music* were able to follow the breathtaking march of the people. It was pictorial architecture. The walls unfolded into incredibly diversified forms of relief and hues of color. . . . The Polyforum is a reality, a work, a creation shared. Something original, unsurpassed. I like it. One has the right to say it.[5]

*The lights and music were intruded on the mural by owner Suárez.

Art critics for the nation's newspapers were less inclined toward the Paris-New York School than to the Mexican Mural Movement, whose tenets they had absorbed through the years. The critic for *Diario de Mexico* wrote:

> *The March of Humanity* over a lacerated and desolate earth, falling repeatedly over roads full of obstacles, yet finally victorious in the conquest of their world and their reaching into space. . . . Human and revolutionary triumph, that eliminates, in a perspective where hope lives, however much opposed: misery, aggression, atavistic mythicism and its demagogues: the sum—exploitation. . . . Siqueiros, seen with the changing time, retracing the seventy-five years he completes this December 29th, is a being without rest, a man on the move who wants to march with his time and with his contemporaries; who many times, through his courage and visionary sense, gains the leadership of the victorious vanguard that ends up on the ceiling of the principal forum of the Polyforum. . . . And one could also ask: Where has David found the time for so extensive and profound an artistic work? How did the political battles, the armed battles, the well-locked jails, the difficult exiles, the ailments he had, permit it? But it was not that these fights permitted his fulfilling his work, it was rather their inspiration—he partook in them and made his work their consequence. Muralism, gigantic in Diego Rivera and in Orozco, has acquired with Siqueiros, in this older period of his life, the new dimension of sculpture-painting. For some it is too much, too much space, too great an encumbrance of volume. As everyone does, it will be discussed. And basically this is the Polyforum: a human product where there has been a conjuring of intellect with science, destruction with landscape, man with his weapon, struggle with victory, procreation with peace, the earth with the sky. An image, an account of gest and prophecy: the revolutionary victory of man.[6]

Anticipating that the work would be attacked, critic Juan Cervera wrote that he had just viewed "one of [Siqueiros's] greatest works, perhaps the greatest realized in the field of art in Mexico in the last decade.[7] He conceded that it may be too soon to evaluate the importance of the Polyforum but he was convinced that in the future it would be acclaimed. Though already he heard voices describing the Polyforum as a complete failure, he was confident that their voices would not be remembered, while the Polyforum would remain.

> His work was never directed to sweetening the palate of aesthetes, of classroom-educated critics, or of painters who paint to the dictates of the classes of high acquisitive capacity. Siqueiros paints for men and women who suffer, for the still forsaken marginal masses. Siqueiros does not paint to bring anyone ecstacy, or pseudo-contemplating the "marvelous." Siqueiros paints to incite, to move, to awaken consciences, and is animated by a great love of *man*—as Unamuno says, "of flesh and bone."

> That Siqueiros was "only human" was the best tribute one could pay. "*The March of Humanity* is his high point, and this march that Siqueiros with his work impels, nobody will be able to stop."[8]

The art crowd—critics, artists and vangardistas— practically with one voice condemned the work. "Useless Iron—"Coffin of Muralism Without Unity"—"Mexican Curiosity" and "Tomb of Art" were some of the criticisms that appeared in the press.[9] The critic Antonio Rodríguez, who through the years had lent support to the Mural Movement, wrote three lengthy installments in which he dismissed *The March of Humanity* as a self-indulgent exercise that in every way failed to advance the Movement. Citing the example of composers who had made revolutionary advances using electronics, he pointed to "the great creative adventure that the prodigious means of our time offer artists who have broken their brushes, and sculptors who have broken their chisels." Curiously Rodríguez raised the question of how the mural should be approached: "from the aesthetic point of view, as a work of pure art, or from a social point of view—how does the artist wish the work analyzed."[10] This assumed that in the Mexican Movement the aesthetic and the social were separate factors.

Rodríguez titled his analysis, "The Siqueiros Polyforum: Does It Really Constitute A Contribution To The Art Of Our Time Or Is It Only A Work Of Large Dimensions?" In his opinion, Siqueiros was too old and lacked the energy for the demanding work of so huge a project as the Polyforum, especially after his prison confinement. "Siqueiros is in a period of his life," he wrote, "when the artist deserved to rest—if the case is, that at some time the artists rests—or he should labor on work requiring less tension and expenditure of energy."[11] This advice to artists that they slow down reveals a lack of understanding of the nature of the artist. Whether it be Rivera or Orozco—both in the throes of painting murals when they died—or Michelangelo, swamped with work when he died at 89, leaving St. Peter's unfinished. Rest, or withdrawing from work, was for these artists an alien concept. To his dying day Siqueiros labored on monumental works, in the end from his wheelchair, assisted by a nurse. Rodríguez conceded that with the Polyforum, Siqueiros had made a great contribution to the integration of art and architecture, but contended that Siqueiros hated tiny works and was obsessed with creating gigantic ones.[12] Siqueiros, however, continued to pursue his goal, which was to speak with clarity in a mural of revolution and human progress—in modern plastic terms and with the help of modern technology.

The mural was not free of the conflicts and contradictions bound to develop in an incompatible relationship of painter and patron. Though the theme of *The March of Humanity* had not been interfered with by the patron, there had been the economic problems; now the mural, in private hands, was less accessible to the people. When Jacques Michel, the reporter from *Le Monde,* pointed out the obvious to Siqueiros, that the price of admission charged by Suárez excluded the majority of Mexican people, Siqueiros responded, exasperated, "What can we do? The merchants are not only in the temple, they own it!"[13] Michel was im-

pressed by what seemed to him the incongruities of Mexican society. He wrote that, in Mexico, "everything begins—or better, ends—with a painting; that is a symbolical act." He described the inauguration of the mural as a solemn occasion involving "the President, a painter, and a businessman." He insisted on calling the mural *The Revolución,* and he described it as being the center of Mexico's contradictions and confusions, and located "in a neighborhood of abundant wealth." Michel reported that in his speech at the inauguration President Echeverría had called for a struggle against imperialism; former President Miguel Alemán, whose statue in University City had been repeatedly attacked and bombed by students, was in attendance; and Siqueiros himself, who "was recently removed from the Directive of his party for his complacent attitude to the regime, was considered a national glory and feted by the multitudes as if he were a movie star." As for Manuel Suárez, "he had with his own money financed the architectural framework that was destined to serve as the background for a social painting that was vehemently anticapitalist."[14]

"I'll tell you one thing," Angélica Siqueiros said, "there would have never been for Siqueiros an end of his work."

"But I think he left his greatest things. And even if he lived he could not have left more than he left. The Polyforum for him was the greatest experience he ever had. In the big studio in Cuernavaca, we were all surprised when he started to use metal sculpture for the mural. He had experience in other murals with integrated art, such as the mural in Chillán, where he worked on the ceiling and walls. Then in Mexico he painted *Cuauhtémoc Against the Myth.* It was a great work, not as big as Chillán, but a great work in its totality, with sculpture and the architectural concavity. These were great experiences for him before 1945. The mural of the *Hospital de la Raza* was integrated with painting and architecture, as were other murals to a greater or lesser degree. But the Polyforum is his greatest work, we were all amazed. I followed each step of his creative work all of his life.

"But I and everybody who worked with him did not know when he started to use metal, what he was going to do. He would make a piece, put it on, take it off, put on another. We saw things of great modernity that were unbelievable, great experiments, and very great form. Besides his preoccupation with new modern composition for murals was his preoccupation with integrated art. He considered sculpture, architecture and painting, combined, as integrated art. He always found this when he made his trips to China, India and Italy.

"In Paris, when he spoke to French artists, he said, 'Look at Chartres, here you have the stained windows, the sculptures, and the architecture together as a unity.' And in front of Chartres he explained those things to the French artists. So for him, I think the Polyforum was his biggest dream. One of his great contributions in what he considered to be the fourth period of the Mexican Mural Movement, was the possibility to create big polychromed monuments in the street.

"He always used to say in his speeches, that the white marble of the immortal Greeks was not white marble, it was all polychromed. That the whole of Chinese culture was polychromed. The whole of Hindu culture was polychromed. That all the great pre-Hispanic monuments were polychromed. So he said, why, when we live in a very modern world, don't we use the science of today to make a vanguard art. As in the past, he said, a mural cannot be done by the creator alone. A collective group of artists and workers is needed, with a master to unite everything.

"In this mural he had the biggest group of artists and workers he ever had. They came from all over the world and he paid artists out of his own pocket. He gave scholarships to those who wanted to come and work with him. Critics came from all over the world but in Mexico it was a little harder. Our young artists in general were not interested in muralism. All they wanted was to make an exhibition every month, get money and good reviews from the critics. They knew that for the masters, working on the murals was a difficult task—that they also fell from the scaffolds. Siqueiros fell from the scaffold three times, Rivera twice. It's dangerous, the work is tremendous and requires great strength.

"We are sorry the younger generation in Mexico, as yet, does not understand the importance of muralism, and even the importance of the greatest work that Siqueiros has left."

29

Finishing Up

Siqueiros was ill, but neither he nor Angélica knew it. He showed little concern for the physical wear and tear that his strenuous exertions laboring on the Polyforum required. He thought of himself as normal and healthy, but there was gnawing within him a cancer, which at the time left no telltale signs in his appearance. He carried as heavy a workload as ever.

Angélica told me, "After the Polyforum, Siqueiros continued working 16 to 18 hours a day in the Cuernavaca *taller* and in the *Siqueiros Sala de Arte* in Mexico City, which used to be our home. In this house, on the walls, he worked on the problems of composition, and he made two beautiful murals. Also on the walls he utilized photographs to present the composition of the most important murals he had done. He worked a year at the *Sala de Arte* and it will be called the Museum of Public Art of Siqueiros. He was a man who was crazy all the time. He did not want

to lose any moment of the day, any moment of the night. He wanted everything to be concentrated on his work. After the work in Mexico City, he went to the big studio in Cuernavaca."

But Siqueiros began to complain more often about not feeling too well. He had less appetite, and he suffered more from indigestion. He did not give up smoking, but he rarely drank whiskey. He would never see a doctor. He always found pure rest difficult to contend with. His trips abroad were always for purposes other than rest. He never fancied himself taking a vacation, but on occasion, to escape the aesthetic demands that possessed him, Angélica would drive him into the countryside and sometimes to his favorite Veracruz, often with no definite destination, just to tour about visiting villages and towns.

Siqueiros was converting his house on Calle Tres Picos into a museum of mural painting, the *Sala de Arte Público,* and was working feverishly to complete it, to see it functioning as a vital art center. This did not happen in his lifetime, but Angélica guided the project to its completion and saw Siqueiros's idea fulfilled. On the walls Siqueiros had painted a fantastic display of the dynamics of each mural, revealing the secrets of their composition. Two new murals were painted in the building, each measuring 5×7 meters, and innumerable studies for murals were on display. His archive was put in order, and a large lecture and exhibition room was built, so the *Sala,* under Angélica's direction, became a vital and active cultural center.

In early 1970, Siqueiros was invited to contribute a painting to the new Vatican Museum of Art. He had turned out four small Christ paintings in prison, and these—by a Communist, an atheist—had caused raised eyebrows and an article in the magazine *Siempre*—"Siqueiros the Religious, Thus He is Revealed in His Paintings of Christ."[1] With the "suffering Christ" theme, Siqueiros had pointed to the hypocrisy of Christian society. However, this did not deter the Vatican from inviting Siqueiros, and he graciously accepted, producing for the occasion an angry, defiant head of Christ with an accusatory gaze *(plate 80).* On a small plaque attached to the painting's frame he inscribed "Christian: what have you done to Christ in the two thousand years of his doctrine?" The painting was sent to the Vatican in June 1970, and in return Siqueiros received from Pope Paul VI a huge book on Vatican art and a letter of appreciation.

After the Polyforum, Siqueiros remained without a mural commission; a respite he needed. He moved between the *Sala de Arte Público* and the Cuernavaca studio, contemplating and experimenting with mural ideas, which for lack of time never fully unfolded. When the First National Congress of the Plastic Arts was convened in the Palace of Fine Arts in April 1972, he attended all six sessions, hoping to encourage and stimulate greater activity in mural painting. But he found himself engaging in verbal skirmishes with disruptive elements who represented the grow-

ing tendencies among young painters to reject muralism. He advocated an "art of the streets," pointing to "the supremacy of murals in the outdoors over the hidden interior mural." He called for painting in the streets "on the free and hidden sides of skyscrapers—in plazas and in parks." And he told the artists: "Extend your perspective to the cities—connect with the flow of traffic and bring your work to millions of people." But he also saw a lack of will to participate in the political life of the country obstructed the resurgence he called for.

Besides the increasing lack of interest in the Mural Movement among the younger artists, Siqueiros complained that the Party had formulated no position concerning art even though it wanted the artists' solidarity. It was Siqueiros's belief that the Party had not properly understood the concept of the primacy of art as a weapon. Angélica thought the indifference of the Party in relation to art was because it was "undeveloped in the intellectual field. Artists in the Party," she said, "that's all . . . Diego they liked to have, Siqueiros they liked to have. Many artists, that's all."[3]

On a recent trip to France, Siqueiros had found the same condition true in the French Communist Party. In a discussion there with members of the Central Committee of the French Party, Siqueiros at one point sat quietly as Angélica defended his belief in socially committed art. "You are very happy to have Picasso," she told the French party leaders, "you are very happy to have the most important artists in your party, but the Communist Party of France has no position in relation to art, absolutely no position. And now you avoid presenting Siqueiros's position. Why? Because he is Mexican? Because we represent backward countries?"[4] Angélica was accusing the French Party of deliberately putting off publishing Siqueiros's theoretical writings, his socio-aesthetic essays, which had been in their hands for a number of years. With them, Siqueiros hoped to open a dialogue with French artists of the left. (When *L'art et la Revolution* finally was published in May 1973, Siqueiros was quite ill.)

Siqueiros, astonished, listened to Angélica press her argument as she told the Cultural Secretary of the French CP that discussion had to be encouraged; that the party, of course, should not break with the artists, but it should take a position. No, it should not force the artists to do special work, but the Party had no policy toward its artists. Siqueiros, she explained, had argued for the vanguard position of art as it related to revolution, a point he had raised in his writings.

She later told me, "The French Party was very opportunistic. They received a lot of money from Picasso and probably other known artists— that is all they care about. So Picasso was great—you shouldn't touch Picasso and you should not touch any artist. You should not disagree with them."

On the other side of the globe the Japanese had fallen under the spell

of Siqueiros's work, and on June 15, 1972, they mounted a major exhibition of his paintings in the Central Museum of Tokyo. The Japanese newspaper *Asahi Shimbun,* in collaboration with the Japanese and Mexican governments, sponsored the show. The retrospective of 80 works was to be seen in Tokyo for one month, and in the Museum of Modern Art of Hyogo in Kobe for another month. Invited to the opening, Siqueiros and Angélica were making their first trip to Japan, and the FBI station in Mexico City duly informed Washington of the fact. From Washington a "confidential" memorandum was sent to the Tokyo FBI station, briefing them about Siqueiros's political background and including his travel plans.

> The Siqueiros' will leave Mexico City on June 9 for Los Angeles via Western flight 638. On June 10 they will depart Los Angeles via Japan Air Lines, flight 51, for Honolulu. As of June 12 they will travel to Tokyo via Japan Air Lines.[5]

The FBI monitored their movements in Tokyo, but the contents of the "confidential" memorandums sent to Washington on June 31, August 10, and August 18 were withheld from public access. Siqueiros gave a few lectures in Japan; he and Angélica were back in Mexico by mid-August.

While hastening along the work on his mural museum in Mexico City, Siqueiros was painting three large murals in Cuernavaca and a "plastic box" in his now converted small studio. These works were being done as pure experiments. A huge wall surface, mounted in *La Tallera,* was laid out with a composition of pyramidal motifs in black, gray and white. Its roots lay in the art of pre-Hispanic Mexico, though it was left unfulfilled, a very small developed section in one corner conveys a strong, beautiful and mysterious feeling.

Speaking of these last works, Angélica told me:

> "They were related to the problems of composition. For Siqueiros the mural had to be an integral part of the whole structure. Any artist of the School of New York or of the School of Paris who saw the murals would say the Maestro was becoming abstractionist. What you will see in Cuernavaca are compositional problems for new murals. People who see them will say they are beautiful, but they will not understand that they are compositions for murals.

> "One of these murals is a synthesis of our pyramids. He was always obsessed with the pre-Hispanic works in Mexico. He said that those of the past were the great masters, that the modern muralists have done nothing important, and that we have to keep following those of the past. He wanted to leave in Cuernavaca a synthesis of the importance of the pre-Hispanic work: but very calculated, very symmetrical, very mathematic, very exact. Another work he left was one small studio in Cuernavaca that he painted as a plastic box. The ceiling, the walls and the floor are painted. For him this was the preparation for a big mural where these problems could be applied."

Experimental murals, easel works, political activity and family prob-

lems continued to occupy Siqueiros until the end of his life. He looked remarkably well for his 76 years, at least at the beginning of 1973, when I last saw him. Two years earlier he had undergone surgery for a prostate condition, and now a wound in the leg that he had received in the Revolution was beginning to pain him. His appearance did not betray his inner disease; no one imagined the illness that was consuming him. A constant stream of visitors, reporters, politicians, ambassadors, artists, intellectuals and distant relatives passed in and out of the *Sala de Arte Público* in Mexico City and *La Tallera* in Cuernavaca. Since the interruptions frustrated the labors he was anxious to complete, he did his best to maintain his composure, though not always with success.

When a mural commission demanded all of his time, Siqueiros was shielded from the distress caused by the problems of his close relatives, but with freer time familial troubles engulfed him. There were the problems of incorrigible Davidcito, the grandson; Constantino, Adriana's alcoholic husband, dead at 33; Chucho, Siqueiros' enigmatic brother; and Teresita, Chucho's scheming daughter. As doting grandparents, Siqueiros and Angélica shared a good deal of the blame for the incredible troubles that Davidcito had caused them. Yet they had loved the child so furiously, blind to the grief their overindulgence would bring them and the youth in his adolescence and early manhood. Having assumed a good percentage of the responsibility for rearing him (Adriana, a dancer, was bedeviled by problem marriages), the grandparents were overwhelmed with an endless stream of their grandson's dreadful problems, involving drugs, alcohol, guns and wrecked cars.

Favor-seekers came in a steady procession and Siqueiros was a soft touch. He found it very difficult to say no, and Angélica was compelled to serve as a buffer in his defense. Chucho, an actor, performed only rarely in a one-man show and survived mainly from the sale of paintings and prints that his brother gave him. Teresita, Chucho's daughter, also tugged at her uncle. Siqueiros had painted a magnificent full-length portrait of her in 1950, when she was sixteen *(plate 49)*; now she, too, was an actress and pressed Siqueiros to speak to people he knew, to get their help so she could make a comeback as an actress on television.

These family matters were extremely stressful. Angélica had an ulcer, and Siqueiros was provoked, too often, into a dreadfully agitated mood, when both his paintings and Angélica would feel the brunt of his ill temper. Because of Teresita's pressure on her uncle, Angélica's plans to get him to Cuernavaca for much needed rest, peace and quiet were being disrupted. Angélica hoped that once they were in Cuernavaca, Siqueiros could complete a few small easel works standing unfinished in his small studio. There was an urgent need for the funds they might bring in.

The day before the planned departure for Cuernavaca, Siqueiros, Angélica, Chucho, Teresita, her husband Jorge and their 16-year-old daugh-

ter Veronica, and my wife and I were seated in the crowded restaurant *Viena* in Mexico City. Teresita, in customary heavy makeup and frilly dress, was insisting that her uncle return to Mexico City on the Monday following the weekend in Cuernavaca, to accompany her to meet a television executive whom Siqueiros knew. Angélica refused to agree that Siqueiros would return, claiming that he had already written many letters for Teresita and that it was useless for him to go. Siqueiros was not saying no about the matter, which he had originally agreed to. But Teresita, who even harbored the belief that her uncle's paintings should belong to her, especially those he had planned to leave to the State, became angry at Angélica's objection; raising her voice enough to cause the roomful of noisy diners to cease their conversation and watch what was transpiring at the Maestro's table, she proclaimed that Chucho was not her real father and that she was the illegitimate daughter of Siqueiros. Since Siqueiros was her father, and he always helped everyone, he must help her. Siqueiros laughed at the story, but when Teresita insisted that she was David's "real family," Angélica became incensed, knowing that Teresita was scheming to lay claim to Siqueiros's paintings.

Angélica was adamant about Siqueiros not cutting short his period of rest in Cuernavaca, but on Saturday morning, as they were preparing to leave, Chucho arrived at the *Sala* to remind his brother to be sure to return to Mexico City on Monday. Tension mounted, Angélica's ulcer flared up, and Siqueiros was kicking a few paintings around. They bickered about his returning to Mexico City on Monday, and when they were seated in the car and ready to depart for Cuernavaca, Siqueiros admitted that he had agreed to return on Monday. Angélica burst into tears, rushed from the car, removed her things from the trunk, handed Siqueiros some money and told him to go to Cuernavaca by himself. But Siqueiros quickly consoled her with sweet talk and promised that he would not return until Wednesday.

We drove off, stopping at the first newsstand to purchase every available newspaper, thus preparing Siqueiros for the drive that lay ahead. I drove the car, and Angélica was in the back seat with my wife, Gertrude. Siqueiros and Angélica puffed nervously on cigarettes, and a few friendly comments passed between them as reconciliation progressed. Angélica later confessed that it was foolish of her to fight back. She, too, was feeling ill. Besides her ulcer, she claimed to have too many red corpuscles, the result, she said, of a bout with hepatitis, and her liver was not good. Organizing and keeping Siqueiros's life in order and keeping petty disturbances from reaching him had taken its toll on her. Though at the moment she was tired, she still possessed incredible energy, for otherwise she could not have kept pace with him. And without her, he could not have kept up his own mad pace. Remarkably competent, she kept his visionary road clear of debris. Now in the tenseness and quiet of the

drive to Cuernavaca, her soul was on her face. Her place in the Mural Movement was as a writer, but also she had to see that Siqueiros accomplished as much as possible of all that he was determined to do.

Upon reaching Cuernavaca, we went directly to the *Hosteria las Quintas,* a favorite place of theirs, to dine. There in a patio surrounding a beautiful garden and in the midst of other diners, their quarrel flared up anew. Siqueiros, passing the threshold of exasperation, smashed his fist on the table, the dishes clattering loudly. Dramatically they agreed to separate. He stroked her cheek and attempted to comfort her. She grasped his hand and kissed it, bid him good-by, and told him that even at his age he could have all the women he wanted. But this too passed, as had all the small spats between these two strong-willed individuals, so dependent on each other.

At home in Cuernavaca, Siqueiros could retreat undisturbed for a few hours in his small studio, which adjoined *La Tallera.* Three paintings on Masonite panels, in various stages of development, were on three easels that stood side by side atop a platform at least a half meter high. With the agility expected of a mural painter, Siqueiros stepped up on the platform and picked up a brush with a meter-long handle made of aluminum tubing. His hat, which he always wore while painting, this time was of straw. In deep thought before one painting, his left hand carried a cigarette to his lips.

He began to paint, his arm moving with deliberate slowness as each long brushstroke searched for the secret of the painting, unsure where his train-of-conscious-thought would take him in the abstract beginnings of the composition. Dreamlike he moved from one painting to the other, certain only that in the end the finished painting would express a belief of his inner being.

Visitors arrived! An Italian artist, a Romanian artist, and others in their party had found him in Cuernavaca. The peace was shattered but Siqueiros was delighted. Drinks were brought out—Russian vodka and the best Mexican tequila, which was "a present from the Governor." The Maestro was in high spirits, charming and fascinating his visitors with his warm conversation, and he invited all to stay for dinner. Later, surfeited with food and banter, Siqueiros slipped away quietly to his studio, leaving Angélica to answer the endless questions.

Late in the afternoon that day, the house emptied of its visitors, Siqueiros came out of his studio in need of a rest. He seated himself in the patio where Angélica, Gertrude and I were waiting for him. In the waning afternoon, the Cuernavaca weather was soft and warm, and the garden with its birdsong was lush with beauty and fragrance. Siqueiros sipped a glass of mineral water and began quietly to muse about his experience with the Polyforum. His purpose had been to make what he thought was a *real* mural. As he described it—his English somewhat halting after the

long day—it concerned "the decorative solution of the inside and outside of a building that had been built exactly to be decorated with paint." It had taken him a long time, he explained, to convince the patron that a real mural was not a small or a large rectangle—that its resolution must be sought in the structure of the building.

"A mural" he said, "is not like an exhibition of paintings—something produced for a spectator who slowly marches by the canvas to see a number one, a number two, a number three, etc. A mural forces you to see from all angles, from right to left, from up to down, from the floor to the vaults, from the vaults to the floor. From 3 meters distance, from 20 meters distance, from two miles.

"I used to say that a mural is more like a concert. An important musical concert has a lot to do with acoustics. Mural painting is the same. If the spectator doesn't move, the mural doesn't move. That makes the movement in the mural—the dynamic of the spectator.

"For that reason, this was the first opportunity to paint a real mural. I worked very much preparing the composition that belongs to the problem— the problem that concerns the structure of the mural, that concerns its theme. The theme as you know, *The March of Humanity*, means that I want, in relation with its content, to make the spectator, exactly with *his* march in front of the mural, to make the *march of humanity*. So that is what I wanted to do in *The March of Humanity*—that means the progress in the different periods of history—from the beginning to the last—to our time. And I am sure the patron understood that. Because in reality he gave me the opportunity to work together with the architect, with the engineer, to find the first solution, which was the construction of the building.

"I think every new conception in mural work can give the spectator, who is not in the habit of seeing a mural, a surprise. Don't forget we live in a time of easel painting. In reality the only thing we have that concerns the creations of the present are the exhibitions. In the mural there is the need for many important things. One, the mural is going to be seen by a public who have not exactly come to see it. The public is going to see the mural even if they don't want to see the mural. The mural is in their path. In the process, they are forced to turn their heads—to see one side, to the other side, to see the vaults. To see from up to down, from right to left, even if they don't want to. I think it is very easy to understand that. It means the spectator cannot escape from the mural. He is going to see it. Only if he is blind, will he not see it. If he is not blind, he sees it even if he doesn't want to. The painting in sculpture is very important. I think the concrete unity of all the elements that are in the mural oblige the spectator to see. It's like a speech in a high voice—it is not possible to close your ears, not to hear.

"In the beginning, I suppose I thought that a painting on the wall, if it's in relief, has more violent forms of expression. I think that muralists have not made murals with volumes because they understood there were tremendous problems. It is true, that in this mural, I went through many periods in the process of creation, when I said, perhaps it is not possible to make murals

with volume, perhaps not possible. And I started the work thinking perhaps it is easier for the spectator if they have no volume, no sculpture. But at last I understood, that with the sculpture we give one hundred percent more of the impression of volume, of the impression of active reality in the mural."

Siqueiros paused a moment. After a day full of activity he was bound to show signs of fatigue. But he was immersed in the subject about which he loved to converse and he indicated no desire to break away and rest. When asked if he thought the Mexican Mural Movement had come to an end with the completion of the Polyforum, he thought not, and preferred to see the Polyforum as inspiring a new upsurge of mural painting. "For all the artists that can make, perhaps more and much better murals than myself, it is a starting point, for new solutions, for murals in the future." He reemphasized that the problem of movement and dynamism could best be solved with the use of the painted sculptured form.

Movement was for him the fundamental problem in murals. "It is true," he said "that a form in volume, a form with a sculpture, has much more dynamism for the same reason that I have said before. In painting, in flat painting, it is necessary to do what I did in my mural in Chillán. I worked form with painting to make a dynamic relation of forms, developing the static forms with dynamic elements. I think that was a small step in arriving to the Polyforum."

He pointed to the use of the concave surface in his earlier murals and how its use helped to create a more active mural. He thought that if the Mexican muralists don't make use of sculptured painting in the next period, they will do less active murals. "I don't want to say worse murals. Perhaps they will make wonderful murals. But they are not going to put together the elements that the spectator needs—motion in a mural that has painted forms and reality combined."

The conversation turned to the events surrounding his four years in prison. Speaking in English for a long period was now a strain and his voice was growing tired. Angélica was worried and felt that he should rest, but he showed no concern for his own person and was anxious to please his company. His voice was pensive as he began:

"This time I was in prison for the railroad strike. I spoke along with Vallejo and the other leaders of the railroad union in front of the railroad station— the demonstration the army wanted to stop. The General arrived to attack. He used tanks. They surrounded us with tanks. Of the speakers, I was the first to speak. Later the Government explained the only thing they didn't want us to do was to march to the center of the city—that they didn't want to attack. The same President told me—the President of this time—that they were going to attack us to keep us from crossing the section where you enter the center of the city. In reality they did that, but the masses dissolved little by little. They didn't want to provoke the army and they didn't march to the center of the city. I spoke, and I said, don't make provocations. We said

everything we wanted to say at that moment. The Government did not have a right to interfere, but we didn't want to have a collision with the army and with the policemen—with tanks.

"We did not want to provoke. They knew that our idea was to make a simple democratic and civilized demonstration without violence from our part. And I want to say that that was my opinion in many other circumstances. I was the leader of the miners and on many occasions my efforts were to make impossible the collisions. I was the leader, the General Secretary of the Confederation of Labor—the Confederación Sindicato Uniteria—well we had many strikes about problems we had in the mines. Problems in *Cinco Minas*, in *El Amparo*, in the State of Jalisco. We had many problems of this kind with the army, to see that they don't attack, because we don't provoke. But they sent in the army to protect the house of the owners, or the house of the managers who direct the work in the mines.

"In reality, in all my activities, I don't want to be a provoker. I have never been a provoker. When I understood it was physically impossible to make a demonstration, I didn't want to provoke the army and create a problem between the soldiers and the workers. Many examples I have told about that. On many occasions I make an effort, I use the time, the moment, to explain to the soldiers and the workers together—I explain to the soldiers, you belong to the same class as the workers, your fathers are peasants, your fathers are miners, your fathers are carpenters, your fathers are people who have worked. You need to understand that we are fighting for your families, for your rights as people. I am sure you are not going to make any provocation, and if there are any provokers here you can be sure that they don't belong to our organization, you can be sure that he is not inside of our discipline.

"In all the towns where we make demonstrations, we explain: be careful, don't do anything that is supposed to be a provocation. If they arrive to fight against us we will defend ourselves in the form that we can. But never to take the offensive. We will not. What are we going to do if they beat us? We can defend ourselves and make it impossible for them to beat us, but never to provoke a *choque* between the organization of workers and the organized army.

"This is my point of view and there are many pamphlets in which I speak about that problem. And I denounce the leaders for violent expressions, who invite collisions with the army of policemen. Perhaps they come from the same policemen, from the secret forces of the Government. Even the demonstration—a more or less energetic violence of words—means for the policeman, a provocation. But the reality in Mexico is that the provocation comes all the time from the *provocateurs*—from the army or the police that are introduced into the lines of the workers."

He gave an example of how on one occasion when the police had been responsible for provoking a riot he had gone directly to the police and lodged a complaint.

"I went to speak to the police—they didn't invite me—I went myself in relation to the demonstration because the newspapers made a tremendous provocation and I went to say that it was not true. I said to the Chief of Police; 'You were there you know. You can tell me, have we provoked something?'

"He said, 'No, you don't provoke, but the speeches of the leaders were very violent.' I asked him in what sense? In attacking the Government? With insults? 'No,' he says, 'but the speeches were very violent.'

"I said, 'Violent? In what sense? They protest? They ask something concrete in favor of the workers?'

"'Well yes, they were tremendously energetic.'

"'Tremendously energetic? What does that mean? You know they need to be. They didn't make insults. Many, many of the workers say that in the back where the masses were, there were *provocateurs*. Do you suppose they were policemen like you? Perhaps you have sent them to provoke?'"

The police had ordered the demonstration of the railroad workers disbanded. But Siqueiros, objecting that the police had no right to disband the peaceful and legal demonstration, told the workers: "Be careful, go ahead with your demonstration in a peaceful form." The Chief of Police then accused Siqueiros of provoking trouble and intended to arrest him. On that occasion, Siqueiros sought refuge inside the Soviet Embassy, where he hoped to await the simmering down of the confrontation. "I was in the Soviet Embassy. They wanted to arrest me. The Ambassador said to me, 'There are many policemen outside but they cannot touch you inside the Embassy.'"

Later he had been able to leave safely. Then things quieted down for a while and he had worked daily and routinely on his mural. But they had finally seized him at Dr. Carrillo's home.

"I tried to escape," he said, "it's normal—to see a lawyer, to say they want to take me, to ask for protection of the law—so I would be protected. But even with that, they would put me in jail. It happens in all the countries of the world. But in Mexico it is very often."

He joked about painting in prison. "I can say that everybody in prison makes paintings. If they are not painters before, in jail they make paintings. I was not the only one—even the Director paints. You go to any *crujia*—our sections in the jail—and there are many people who paint."

He left the subject of prison and touched briefly on women mural painters. His niece had been killed working on the Polyforum. "Well in Mexico many women have painted murals. More or less, four or five. They have painted very good murals, as good as the murals of many a young artist and as bad as many other paintings of artists. But let me tell you, for women it's more complicated. It's more complicated because it's physically more difficult. Perhaps someday a woman will appear with enough strength to work on a mural."

His voice was fading, fatigue was settling over him. Yet he wanted to sum up with an observation about the distressing state of the world. The words in English were becoming more difficult to find. He searched for the words to express that he had no doubt that the world would progress.

"Yes, absolutely, if the progress is done in a correct form. It is not the many problems of the life of the masses that interferes with progress. The large masses need to be in favor and not against it. The problem is those who do things only to stop the world. It is not true that the provokers are the masses. But in reality we know—you and myself—and everybody knows who is the most violent force that provokes war—and why they provoke it. Well, we need to give their name—it's imperialism. Not only of one country—of many countries of the world. The imperialists want to keep the same conditions, the benefits, the economical solutions for them that interferes in the life of the large masses of the people. This is the fundamental provocation. That means, we can say, it is the capitalist who is provocateur number one."[6]

When the discussion had come to an end, Siqueiros preferred to go out for his *cena*—the light evening meal. When he entered a delightful Spanish Colonial restaurant, the greetings from the owner and the diners were effusive. He was seated with his party at a round table on the piazza, overlooking the garden. Everyone in the restaurant turned to him. Jokes, conversation, and discussion increased, intensified.

Since he was a member of the Mexican Communist Party, Siqueiros was barred by the U.S. State Department from entering the United States. He had last set foot there when the ship returning him from Spain had docked in New York in 1939. He and the rest of the Mexican Spanish War veterans were then hustled under escort across the country to the Mexican border.

Now, with the passage of time, the government began to soften its position toward the illustrious painter. When he took a chance and in April of 1973 requested a visa to visit Los Angeles, much to his surprise, the U.S. Government set aside his "ineligible status" and granted him a waiver.[7]

Siqueiros hoped to visit the Los Angeles sites of his first murals in the United States, murals that had been suppressed and destroyed. His *Tropical America* was buried beneath successive coats of whitewash; the work had been given up as hopelessly lost by artists and restorers who had endeavored to reclaim it. However, at the last minute these plans were changed when the International Labor Organization invited him to come to Geneva to discuss the commission of a mural for their new building.

Their visa destination was altered, and Siqueiros and Angélica were granted permission to enter the United States at Houston. As was reported to Washington by the FBI, the couple were flying "via Air France, Flight zero six." Also reported was that "subject was ill and changed travel plans."[8] It is possible that Siqueiros did not wish to divulge the fact that a commission for a mural might await him in Geneva and thus requested the visa change on the grounds that he was ill and would seek medical help in Europe. In reality his malady *was* causing him greater

discomfort, but both he and Angélica—always avoiding a visit to a doctor—continued in the dark about it.

On April 6, feeling far from well, Siqueiros and Angélica left for Geneva. They also planned to visit Rome and Moscow, to turn the trip into a real vacation. In Geneva, Siqueiros accepted the commission to paint a mural, the theme of which would concern the labor movements of the world. His choice of walls, either in the library or the salon for receptions, would be made upon the completion of the building. When they reached Rome, Siqueiros's physical condition had grown worse. Still, he refused to see a doctor and was determined to be in Moscow for the May Day celebrations. When he boarded the plane in Rome for Moscow, he was sick enough to cause a message about his condition to be relayed ahead. An ambulance was waiting at the airport. However, he brushed aside any thought of being ill and refused to board the ambulance or accept medical attention.

Angélica told me in 1974, "Siqueiros never wanted to see doctors." All his life he was a healthy and strong man, but he did start having problems in 1973. "When we went to the Soviet Union the doctors there wanted to give him a checkup but he wouldn't have it. He was the enemy of doctors and clinics of the whole world. So he said, 'No, comrades, I feel very good. I don't want my health checked. I've come here to be together with the artists and to give some lectures.'

> "So they finally decided to let him rest and we made a fantastic trip to the Black Sea and Sochi. I am happy now because he enjoyed it and it was the first time he didn't have any pressures. He was enjoying the old monuments, the Christian churches, the Arab influence of the mosques, and the culture of that region of thousands of years ago. After six years on the Polyforum and two more years of work in Mexico, we decided to really rest. But there were plenty of small banquets and he did plenty of what he would never do in Mexico. And though he didn't care about drink, whenever somebody would offer him a drink, he did drink. There would be a toast, he would answer the toast, and they would drink cognac and vodka.
>
> "He didn't eat at all. He was already sick and he did not know it. His not eating was part of his sickness, but he was enjoying himself. It was very hot there and I am so glad he was there.
>
> "In Moscow he was invited to a meeting of the Presidium of the Soviet Union in the Palace of Columns. It was the old place where Lenin and all the workers used to get together. Siqueiros was amazed, because he returned to the same room he had been in when he first came to the Soviet Union in 1927 as a delegate of the miners of Jalisco. He never expected to be back in 1973."

This last visit to the Soviet Union lifted his spirits though he was suffering the effects of his rapidly deteriorating health. Soviet Georgia bore striking similarities to Mexico, and the great social progress he witnessed satisfied him even more.

Back in Mexico, though he resumed working on his experimental murals in Cuernavaca and in the *Sala de Arte Público* in Mexico City, he could no longer avoid facing the doctor and he was compelled to submit to a medical checkup. As Angélica recalled, Siqueiros thought his spine, which had been injured earlier, was now causing him new physical problems. But the three days of medical tests in May 1973 confirmed the truth. The doctors were surprised that he looked so strong, for they discovered that his previous cancer of the prostate had spread throughout his body. They gave him five to six months to live. The prognosis was not revealed to him nor was the nature of his illness. Angélica did her best to assist him in carrying on his work in the manner he desired.

Siqueiros sensed that time was not on his side, and he worked as intensely as he could. During only the last two months of his life did his strength begin to leave him. Though he could no longer exert full control over his labors, he continued pressing forward. "In those last two months," said Angélica, "when his legs could not support his body anymore, he walked in small steps followed by a nurse. He didn't like to be followed by a nurse and he got mad."

Six weeks before he died he was still working in *La Tallera*. There, from a wheelchair, while the fatal disease sapped his strength, he hoarsely called out directions to those who were assisting him on his murals. His powerful spirit was rapidly losing the body machine to follow his dictates. He struggled to reach the murals but failed to lift himself from his couch. Pain killers were administered, but he was never told he had cancer.

Death grimly mocked him when he was brought to the Hospital of Oncology for X-ray treatments. Angélica made some excuse to cover his face with a towel lest he see that his stretcher was being wheeled in front of his mural—*The Future Victory of Medical Science Over Cancer*. For it was he who now entered the fearful drama of the mural, becoming the subject in the very scene he had created.

He pleaded with Angélica: "Tell me the truth, why are so many nurses taking care of me? Why do I take medicines? Why am I being taken care of as though I were a sick man? Tell me the truth. This has never happened in my life. You know I have been strong. Tell me the truth if I am going to die."

There was so much work Siqueiros wanted to do. His creative powers were not weakened, but he could not escape the scourge of a pitiful and rapid wasting away.

Despite his deteriorating condition, Siqueiros was still pursued by his niece Teresita. Desperate in her quest for fame as an actress, and for her uncle's paintings, her crass covetousness was not to be deterred. Chucho, supported by David for years, kept pestering his dying brother for lithographs and monographs of his paintings for Teresita to hand out. But more infuriating for Angélica—and for Siqueiros—was Teresita's thrust-

ing into his hands a letter and a pen for signing it, while he was in an oxygen tent. Siqueiros scribbled his name on the paper without informing himself of its contents and with whatever strength he could muster flung the pen away. Nor did Angélica know what was on the sheet of paper, at least not until its contents were revealed—after some time—by Señora Echeverría, the President's wife. Siqueiros had unwittingly signed a letter addressed to the President, imploring him to see to it that after Siqueiros's death, his "beloved" niece Teresita would be well provided for.

Teresita's scheming did not end there. When the body of the dead painter finally lay in state in the Palacio de Bellas Artes, she brought attention to herself by screaming hysterically in front of the coffin that she was Teresita Siqueiros. When she attempted to enter the Cuernavaca studio to steal paintings, Angélica was forced to seal its doors.

During his last month of life, Siqueiros could not get out of bed. During his last ten days he no longer asked Angélica to tell him the truth. Death came on Sunday morning, January 6, 1974 at 10:17 a.m., a week after his 77th birthday. The night before, Adriana said, "He was in pain and did not sleep." Angélica's brother Polo said, "He died without saying a single word. Death took him without pain. He made no gesture on dying."[9]

Days before, word had spread from Siqueiros' bedside that his condition was critical. In Cuernavaca a small crowd of artists, workers, friends and reporters maintained a vigil on Calle Venus at the entrance to his house. An hour before he passed away, Doctor Roviera Adame came to the door and announced that there remained very little time for Siqueiros to live. Upon his death, there was no holding the tears back nor the people out. Reporters and all the others entered, bringing a hushed animation to the still house. Just moments after Siqueiros had breathed his last, Angélica was being photographed by reporters, sobbing and embracing her dead husband. At 11:30 a.m., Mario Moya Palencia, the Secretary of Gobernacion, accompanied by other officials, arrived from Mexico City, dispatched by President Echeverría to present condolences to Angélica.

Siqueiros, the "firebrand"; Siqueiros, Mexico's most "dangerous" communist—the lifelong battler against the capitalist system, against the foreign imperialism that imperiled the lives of the Mexican people. The nation knew they worshipped at the shrine of Mammon, and now the voice of their conscience was gone. Siqueiros's honesty and integrity had remained unsullied in the midst of the sea of capitalist corruption that so destroyed his beloved land and people.

When Orozco died, Siqueiros and Rivera had petitioned the government to grant him the honor of burial in the *Rotonda de los Hombres Illustres*. When the Communist Rivera died, Siqueiros saw to it that he was accorded the same honors as Orozco. Alone now, would he have suspected that he would receive the blessings of the entire nation? With-

out urging from any quarter, Echeverría decreed that Siqueiros, too, would be buried in the *Rotonda*. The presidential decree said:

> In view of the fact that as a citizen he served the Mexican Revolution in the armed services, and in the pictorial movement of our country. . . . With great power and consciousness of his time, he brought together in his work the dynamic currents of revolutionary thought; that through his artistic activity—nurtured by the advanced social currents of our Revolution—he contributed to the better understanding of the emancipating process of the Mexicans.[10]

There was a tremendous outpouring of citizens paying their last respects. His body lay in state in the great lobby of the Palacio de Bellas Artes. Shortly after 9 a.m. on January 8, President Echeverría arrived, accompanied by the Ministers of the Government. They were the first to stand guard at the bier. Their solemn tribute was followed by Angélica, Chucho, composer Carlos Chávez, and Rufino Tamayo standing at the coffin's side. Thereafter, throughout the day, there was a constant changing of the guard. Thousands filed by the dead maestro. Classes of uniformed school children came, accompanied by their teachers. Hundreds of huge floral wreaths arrived, from every workers' organization. Exiles from Chile, carrying their flag, stood guard at the casket. The widow of Chile's slain President Allende sent a wreath; so did the underground Partido Guatemalteco del Trabajo. A message from Soviet President Nikolai Podgorny to President Echeverría stated: "The Soviet people will never forget David Alfaro Siqueiros, painter of world renown, tireless fighter for the peace and friendship of peoples."[11]

At 10 a.m. on January 8 the funeral cortege with over three hundred huge floral wreaths and hundreds of persons in vehicles moved slowly down Avenida Juárez toward the Paseo de la Reforma on the way to the *Pantéon Civil de Dolores*. Thousands of people were gathered in the cemetery to witness the burial. President Echeverría opened the ceremony with instructions that his Presidential Decree authorizing the interring of the painter's remains in the Rotonda be read. Twelve military school cadets, attired in elaborate dress uniforms, placed the coffin on a black stand close to the Eternal Flame burning in the Rotonda's center. Upon the Mexican flag draping the coffin were two bouquets of red roses.

The Minister of Education, Victor Bravo Ahuja, in presenting the official eulogy, spoke with sincerity as he evaluated Siqueiros's significance for Mexico, and—along with Orozco and Rivera—the importance of the "three" for the art of Latin America.

> Mexico, deeply moved, receives the mortal remains of the magisterial artist, that so many loved; it was a love that gave the artist a lofty pride, that maintained him before the forces of nature and man; being himself a force always in ignition, he now returns to the origin of action and the word, to the origin of human existence that is consolidated with the passing of time.[12]

It was a remarkable tribute the people of the country paid to one of their artists. The cadet military escort marched with the civilian pallbearers to the gravesite close by, followed by the President, Angélica and mourners of the family. When the coffin had been lowered and covered with earth, the President and Angélica stepped forward and together placed a large laurel wreath atop the grave. All the while the National Symphony Orchestra played the funeral march from Beethoven's Third Symphony.

In the main, Siqueiros's political family—PCM leadership—did not take part in the homage the Mexican nation was paying its dead communist artist. In fact, at that very moment certain PCM members were attempting to have Siqueiros posthumously expelled from his Party. Valentín Campa, among them, whined in his memoirs: "It is well known how the Government of Echeverría controlled the ceremony of his burial in the *Rotonda de los Hombres Illustres* of the *Pantéon de Dolores*. The truth is, Siqueiros died as an active *Echeverrísta*."[13] This seemed to be the Party's excuse for forsaking one of its most faithful members. Campa and the PCM leadership were grossly sectarian at the time Siqueiros died, but gradually reversed themselves and fell into line with the positions Siqueiros had consistently advocated.

Siqueiros had tried to bring the left together in order to carry on a dialogue with President Echeverría, who was eager for it. But the Party was then blindly following, rather than leading the rampaging students. The PCM leadership attacked Siqueiros for criticizing them, and also for his defense of the Soviet Union in relation to events in Czechoslovakia. But let it not be said that the PCM leaders did not offer in the Party paper—no matter how gratuitously—a wish for Siqueiros' speedy recovery as he approached death.[14] Not all the PCM members followed the shabby behavior of these particular leaders. When the throngs of mourners had left the cemetery, a group of some fifty young PCM members appeared at the fresh gravesite; lifting their voices in unison, they sang the *Internationale*.

30

Will the Brotherhood Break Up
when I'm Not There (Nahua)

The Mexican Mural Movement was a force to be reckoned with in the current of 20th century Western art. For at least fifty years it survived the attempts of the established art-business world—which, in Marxist terms, reflected the interests and ideas of the dominant class—to suppress the aesthetic and philosophical influence of the Mexican artists on contemporary art. The Mexican Mural Movement was the first art movement in history to embrace the sociopolitical theme as the raison d'etre of modern painting and sculpture—especially of murals. The artists of the French Revolution had faced the problems of "artistic propaganda," of linking aesthetic and moral-social values in art. Painters of the Russian Revolution, with their art of agitation, sought to combine formal abstraction and utilitarian functions in their "agit art."

In 1922, Siqueiros' *Manifesto a los Plásticos de America* issued from Barcelona, explicitly pointed out the direction for a new art and laid the groundwork for the Mexican Mural Movement. Mexican artists, partisans of the Revolution, resurrected the lost art of mural painting and brought to it the revolutionary idea of utilizing social themes and political-economic ideas. Though the genius of the Big Three could not be denied, all the artists of the Movement put their considerable talents at the service of the Revolution and established the Mexican school of social-realistic mural painting.

With most of the original painters of the Mural Movement departed from the world, Angélica, whose life for 36 years had been devoted to Siqueiros and to the Movement—though with pen rather than brush—continued in a leading role of stimulating and encouraging all that pertained to the Movement and mural painting. For a while she converted the great studio in Cuernavaca into a school of mural painting with Luis Arenal as the director, and continued as director of the Sala de Arte Público.

It had been difficult for Angélica, who in her years alongside Siqueiros in the Movement, had written articles, edited books and fought in political and bureaucratic battles, to see to it that the life of the restless and

impetuous painter was kept orderly and disciplined, and what she told me in August 1978 is a fitting epilogue to what that life was all about.

"In the first place," said Angélica, "all the people of our country who love murals never thought that when Orozco and Rivera died, they were finished. Don't forget there was a big mural movement. You cannot separate the three of them, each one made his contribution.

"For Siqueiros, Rivera was like the trunk of a tree. He was in Europe for a long time and had had the greatest experience as a practical painter. In Mexico he was considered a master, the trunk of the Mural Movement. It is true that he always painted with the same rules of the past, as in his composition. He didn't think of an integral art. But it is true that he was a great worker. He worked the frescoes like the greatest masters of the past. He is the one who left more murals than any of the three.

"Orozco was more preoccupied with aesthetic problems than Rivera. Rivera was happy with what he was doing; Orozco, no. Orozco was never happy with what he did. In that way I consider him more artist than Diego Rivera. He didn't like to paint in fresco and sometimes he used different materials in his murals. In his last years he had discussions about the materials with Siqueiros.

"One day Siqueiros found Orozco in his studio using the spray gun and automobile lacquers out of cans. When he discovered that, he said, 'Oh, you say I am using these things and it's bad, that I am using paint from cans. You are using the same thing and you have machinery.' Orozco was closer to Siqueiros. It is true that he had his unrest about the murals, but he was a great artist, a great master. Maybe color was not so much for him, but he was strong in his graphics.

"Even if Orozco didn't follow a correct political line, he was more of a political artist. He didn't believe in any doctrine, he attacked communism, he attacked fascism, he attacked everybody. He attacked the Mexican Revolution, saying it betrayed the workers. He attacked the priests and the Church. He was very political even in his confusion. For him it was easier to satirize the Revolution in its bad aspects. Or to make a satirical thing of democrats, or fascists, or of the communists. That was his expression, it was easier for him.

"Siqueiros, you could say, was an artist who loved color and movement. For him it was a challenge to paint murals with a symbolical preoccupation that related to his doctrines. He was very honest, and at times he would say: 'The challenge is great, because sometimes I just want to fly and make forms in space without any worries. But I can't do it, because life for the artist is to have his feet on the ground, and I have a doctrine, which with our art, we have to help all humanity, and with our art we have to transform the conditions of Mexico.' He was sure that what the muralists were doing was to help Mexico and all humanity. He

was confident that when he wasn't working as a militant communist, he was helping the world through his artistic production.

"Siqueiros of course, was the youngest of the three, and he had a political doctrine. He was a real communist all his life. Many times he left painting to organize workers. He organized the miners of Jalisco and Hidalgo. He worked together with the railroad workers, organizing them many times. Don't forget he was in the Mexican Civil War and the Spanish Civil War. All that strengthened his contribution to art.

"Besides his contributions to art: his conception of the theory of composition with the problems of geometry in space; the materials you have to use in big murals; his conception of integral art, he left many books and articles about his ideas. He never read a lecture but they were recorded when he gave them. He left a great amount of material that will be of help for future artists, for his archives are probably the richest any artist ever left. About a month before he died he made his will. He said that his valuable property in Mexico City, with his archives, books, paintings, and murals, were for the Mexican people. The same thing with his workshop in Cuernavaca with its four big murals. With this we both completely agreed and he left me with the responsibility to organize a trusteeship to handle the property.

"When he was too sick to go to the studio, he would repeat to me many times; 'Angélica, take care of my work, take care of my work.' He always thought I was in his work. He included me in his big team of artists and workers. I was always a member of everything.

"Sometimes we would start working at one o'clock in the morning. I was asleep. I wanted to sleep and he would wake me up. 'How my dear. You're not too tired? Why are you not sleeping?' he would say.

"'No I'm not sleeping, because you woke me up.' Then he'd say: 'Can we write? Can we write?' So we start working and sometimes I would be in pain because I had an accident with this shoulder. By three or four o'clock in the morning I would get the pain. I would get tired, but he never gets tired. Sometimes I think, 'Oh David, I can't take it any more!' So finally he stops. That was Siqueiros's political things when he wanted to publish a manifesto. So I was working too. It's no use. It's a life like that.

"The problem for me was paper, because he wanted every paper to be kept, even his small notes. He would say, 'Keep it, keep it.' Then he would say, 'Where did you hide it? Where did you put it?' So I had so many pieces of paper sometimes, but he didn't want me to throw away anything, nothing at all.

"In the last ten years I use to say to him when he protested that I was very bad for paper: 'Look, I'm very tired. I work a lot, so now I need a vacation. You are free to get married again! You can marry a chauffeur;

you can marry a writer; you can marry a typist; you can marry an administrator. You need about five or six, five or six. Look at what I do.'

"And he says, 'Would you let me choose beautiful ones?' 'Yes! I'll let them have you too. I'm already too tired.' All the time I was feeling more tired than he. He never grew tired. Honestly, there were times in the last five years, there were moments, we saw so many people, we had so many things on our minds, that the only thing I said was that I am going to pass away before David, I can't take it any more. My life with Siqueiros was tense all the time. No, I could not have been a writer, living with David. Not even a member of the Party. I should have gone to my meetings. With David, you take it or you leave it. I know he did it with everybody, it was not only my case, he was absorbing."

Angélica and the others were consumed by Siqueiros as he consumed himself, in the belief that the purpose of art was to serve the people, to change the world for humanity's benefit. Art for him was the natural vehicle to express most effectively the philosophical concepts which were his beliefs. For this purpose Siqueiros perfected a superb painting technique that endowed his ideological concepts with an amazing proselytizing power, both politically and aesthetically. For this, his political faith gave him strength.

Though Siqueiros endured conflicts with his comrades of the PCM, Angélica, his closest comrade, said, "He was at all times, and to the last moment of his life, absolutely a Communist. He would always say, 'If my Party, for any wrong reason, would throw me out, if they threw me out the door, I would come back in the window.'"

NOTES

Chapter 1. In the Midst of the Great Lake They Created Thee

1. This Nahua poem and the ones on page 4 and 7 are in Irene Nicholson's *Firefly In the Night* (London: Faber and Faber), 1959.
2. Mueller-Freienfels, cited in L. S. Vygotsky, *The Psychology of Art* (Cambridge: M.I.T. Press, 1971), p. 211.
3. D. A. Siqueiros, "Tres Llamamientos," *Vida Americana, No. 1,* Barcelona, May 1921.
4. *Ibid.*
5. John A. Crow, *Mexico Today* (New York: Harper & Row, 1972), p. 46.
6. Agustin Cue Canovas, *Historia Social y Económica de Mexico, 1521–1810* (Mexico: Editorial America, 1946), p. 48.
7. Bernal Bíaz del Castillo, *Historia de la Conquista de Nueva Espana* (Mexico: Editorial Porrua, S.A., 1976), p. 55.
8. Miguel León Portilla and Angel Ma. Garibay K., *Vision de Los Vencidos* (Mexico: Universidad Nacional Autonoma, 1976), p. 90.
9. Díaz del Castillo, pp. 269, 369.
10. Samuel Ramos, *Man and Culture in Mexico* (New York: McGraw Hill, 19), p. 35.
11. Crow, p. 21.
12. Victor Wolfgang von Hagen, *The Ancient Sun Kingdoms of the Americas* (New York: World Publishing Company, 1961), p. 395.
13. Erwin Panofsky, *The Life and Art of Albrecht Dúrer* (Princeton: Princeton University Press, 1955), p. 209.
14. Jacob Burckhardt, *Judgements on History and Historians* (Boston: Beacon Press, 1958), p. 96.
15. Nickolas Muray, "Pre-Columbian Fine Art," *Natural History,* March 1958, p. 128.
16. Miguel León Portilla, "Justino Fernández," *Novedades,* (Mexico City), Supplement, "Mexico en la Cultura." December 7, 1958, p. 14.
17. Ramos, p. 35.
18. Michael D. Coe, *Mexico* (London: Thames & Hudson, 1962), p. 103.
19. Díaz del Castillo, pp. 169–170.
20. Irene Nicholson, p. 99.

Chapter 2. Arrows Are Raining and Dust Spreads

1. William Z. Foster, *Outline Political History of the Americas* (New York: International Publishers, 1951), p. 208.
2. Agustin Cue Canovas, *Historia Social y Económica de Mexico, 1810–1854,* (Mexico: Editorial America, 1947), p. 178.
3. *Ibid.,* p. 223.
4. *Ibid.,* p. 226.
5. T. R. Fehrenbach, *Fire and Blood* (New York: Macmillan, 1973), p. 402.
6. Canovas, p. 250.
7. *Ibid.,* p. 255.
8. V. L. Toledano, *Contenido y Trascendencia del Pensamiento Popular Mexicano* (Universidad Obrera de Mexico, 1947), p. 18.
9. Lesley Byrd Simpson, "The Tyrant: Maize," *The Cultural Landscape,* ed. C. L. Salter (Los Angeles: University of California, 1971), pp. 90–92.
10. *Ibid.,* p. 91.
11. J. Guadalupe Ramírez A., *Querétaro* (Querétaro: Imprenta Paulin, 1945), p. 52.
12. V. L. Toledano, p. 18.
13. *Ibid.*
14. John Kenneth Turner, *Mexico Bárbaro* (Mexico, D.F. Editorial-Epoca, S.A., 1978), p. 105.

Chapter 3. Siquieros—In the Beginning

1. Anita Brenner, *Idols Behind Altars* (New York: Biblo and Tannen, 1967), p. 263.
2. Raquel Tibol, *David Alfaro Siqueiros y Su Obra* (Mexico: Empresas Editoriales, S.A., 1969), pp. 17–19.
3. Angélica Arenal, "Biografia Humana y Professional de José David Alfaro Siqueiros," *70 Obras Recientes* (Mexico: INBA, 1947), p. 13.
4. *Ibid.,* p. 13.
5. David Alfaro Siqueiros, *Me Llamaban El Coronelazo* (Mexico, D.F.: Biografias Gandesa, 1977), pp. 30–31.
6. Gabriel Fernández Ledesma, "El Triunfo de la Muerte," *Mexico en el Arte* No. 5, November 1948, p. 12.
7. Siqueiros, *Me Llamaban,* pp. 46–49.
8. David Alfaro Siqueiros, *Mi Respuesta* (Mexico, D.F.: Ediciones "Arte Público," 1960), p. 12.
9. Siqueiros, *Me Llamaban,* p. 34.
10. *Ibid.*
11. *Ibid.*
12. David Alfaro Siqueiros, *Como Se Pinta Un Mural* (Mexico: Ediciones Mexicanas, 1951), p. 105.
13. Siqueiros, *Mi Respuesta,* p. 13.
14. Antonio Luna Arroyo, *Siqueiros, Pintor de Nuestro Tiempo* (Mexico, D.F.: Editorial Cultura, 1950), p. 15.
15. William Z. Foster, p. 314.
16. Sir Nicolas Cheetham, *A Short History of Mexico* (New York: Thomas Y. Crowell Co., 1972), p. 221.
17. N. M. Lavrov, "La Revolucion Mexicana de 1910–1917," in *La Revolucion Mexicana: Cautro Estudios* (Mexico: Ediciones de Cultura Popular, 1977), p. 108.

Chapter 4. Battallón Mamá

1. Jean Charlot, *The Mexican Mural Renaissance 1920–25* (New Haven: Yale University Press, 1963), p. 191.
2. Siqueiros, *Me Llamaban,* p. 100.
3. *Ibid.* pp. 99–100.
4. Foster, p. 308.
5. Siqueiros, *Mi Respuesta,* p. 14.
6. Siqueiros, *Me Llamaban,* p. 75.
7. José Clemente Orozco, "Un Fragmento de la Autobiografia," *El Nacional* (Mexico), September 25, 1949, p. 2.
8. Siqueiros, *Me Llamaban,* p. 101.
9. Siqueiros lecture, early 1950s, Palacio de Bellas Artas, Mexico City.
10. Angélica Arenal, "Siqueiros, Soldado Constitutionalista," *Novedades, Mexico en la Cultura,* September 23, 1951, p. 4.
11. Siqueiros, *Mi Respuesta,* p. 16.
12. Juan Barragan Rodríguez, *Historia del Ejercito y de la Revolucion Constitucionalista* (Mexico, 1946), vol. II, p. 376.
13. Angélica Arenal, 70 Obras Recientes, p. 15.
14. Tibol, *Siqueiros,* p. 27.
15. D. A. Siqueiros, "Filosofía y Pintura," *Excelsior* (Mexico City), January 18, 1950.
16. Siqueiros, *Me Llamaban,* p. 52.
17. Charlot, p. 196.
18. Siqueiros, *Me Llamaban,* p. 52.
19. *Ibid.,* p. 128.
20. *Ibid.,* p. 134.
21. *Ibid.,* p. 135.
22. Siqueiros lecture, early 1950's, Palacio de Bellas Artes, Mexico City.
23. Siqueiros, *Me Llamaban,* pp. 431–434.
24. Siqueiros, *Mi Respuesta,* p. 19.
25. Siqueiros lecture, early 1950's, Palacio de Bellas Artes, Mexico City.
26. *Ibid.*
27. Siqueiros, "Filosofía y Pintura," *Excelsior* (Mexico City), January 18, 1950.
28. John W. F. Dulles, *Yesterday in Mexico* (Austin and London: University of Texas Press, 1972), p. 72.
29. D. A. Siqueiros, *No Hay Mas Rutta Que La Nuestra,* (Mexico: 1945), p. 51.
30. Siqueiros lecture, early 1950s.
31. D. A. Siqueiros, "Tres Llamamientos," *Vida Americana* No. 1 (Barcelona), May 1921.

Chapter 5. Murals for the Revolution

1. James A. Leith, *The Idea of Art as Propaganda in France, 1750–1799* (Toronto: University of Toronto, 1965), p. 111.
2. Arnold Hauser, *The Social History of Art* (New York: Vintage Books, 1957), vol. 3. p. 147.
3. Milton W. Brown, *The Painting of the French Revolution* (New York: Critics Group, 1938), pp. 29–30.
4. *Ibid.*, p. 60.
5. Karl Marx, *The Eighteenth Brumaire of Louis Bonaparte* (Moscow: Foreign Language Publishing House, 1954), p. 17.
6. Hauser, vol. 3, p. 153.
7. Herbert Marshall, *Mayakovsky* (New York: Hill and Wang, 1965), p. 18.
8. N. Leizerov, "The Birth of a New Art," *Marxist-Leninist Aesthetics and Life*, ed. Kulikova and Zis (Moscow: Progress Publishers, 1976), pp. 158–59.
9. Siqueiros, *Mi Respuesta*, pp. 21–22.
10. Charlot, p. 201.
11. Siqueiros, *Mi Respuesta*, p. 22.
12. Charlot, p. 203.
13. The fact that a Mexican artists' union had been formed was noted in a U.S. State Department document: "In 1924, Carlos Orozco Romero and David Alfaro Siqueiros organized the group of revolutionary painters known as "The Alliance of Labor Painters.'" FBI file 121-32178-20.
14. Siqueiros, *Me Llamaban*, p. 214.
15. Tibol, *Siqueiros*, pp. 19–20.
16. Bertram D. Wolfe, *The Fabulous Life of Diego Rivera* (New York: Stein and Day, 1963), p. 154.
17. Siqueiros, *Mi Respuesta*, p. 26.

Chapter 6. El Sindicato, *El Machete* and Murals: Stormy Days

1. Siqueiros, *Cuadernos del Archivo Siqueiros I* (Mexico: Sala de Arte Público), p. 1.
2. *Ibid.*, pp. 3–4.
3. Siqueiros, "Al Margen del Manifiesto del Sindicato de Pintores y Escultores," *El Machete*, num. 1, March, 1924.
4. *Ibid.*
5. Brenner, *Idols Behind Altars*, p. 263.
6. Charlot, *The Mexican Mural Renaissance*, p. 207.
7. Siqueiros, *Me Llamaban*, pp. 205–208.
8. *Ibid.* p. 222.
9. *Ibid.*, pp. 222–223.
10. Tibol, *Siqueiros*, pp. 99–100.
11. *Ibid.*, p. 96.
12. *Ibid.*, p. 97.
13. *Ibid.*, p. 97.
14. *Ibid.*, p. 98.
15. Siqueiros, letter to Casauranc, June 17, 1925. Siqueiros archive.
16. *Ibid.*

Chapter 7. Into the Crucible—Labor Leader

1. Siqueiros, *Me Llamaban*, p. 220. (The Newspaper later changed its name to the *Voz de Mexico*.)
2. Fehrenbach, *Fire and Blood*, p. 557.
3. Siqueiros, *Me Llamaban*, p. 409.
4. Tibol, *Siqueiros*, p. 44.
5. Siqueiros lecture.
6. Christine Barckhausen-Canale, *Verdad y Leyenda de Tina Modotti* (Havana: Casa de las Americas, 1989), p. 118.
7. Sacco and Vanzetti, left wing labor agitators suffered a deliberate miscarriage of justice in 1920. Falsely accused of murder and robbery, they were executed in spite of conflicting and circumstancial evidence and the confession of another man to the crime.
8. Tibol, *Siqueiros*, pp. 44–45.
9. On January 10, 1929, Mella was assassinated on a Mexico City street by orders of the Cuban dictator Machado. He was the beloved of Tina Modotti.
10. Angélica Arenal, *Paginas Sueltas Con Siqueiros* (Mexico, D.F.: Editorial Grijalbo S.A., 1980) p. 222.
11. Fernando G. Cortés, "La Revolución Democrático-Burguésa de Mexico, Traicionada por la Burguesía," *La Voz de Mexico*. (no date)
12. Siqueiros, *La Tracala* (Mexico, D.F., 1962), p. 16.
13. Fernando G. Cortés, in *La Voz de Mexico*.
14. Siqueiros, *La Tracala*, p. 16.
15. Angélica Arenal, p. 17.

16. Tibol, *Siqueiros*, p. 31.
17. According to Angélica Siqueiros, this was when Calles ordered that Siqueiros be killed, but the general who headed the army in Jalisco protected Siqueiros by hiding him in his house.
18. Tibol, p. 32.
19. Related to author by Angélica Siqueiros.
20. Siqueiros, *Me Llamaban*, p. 232.
21. *Ibid.*, p. 234.
22. *Ibid.*, p. 235.
23. *Ibid.*, p. 236.
24. *Ibid.*, p. 240.
25. James W. Wilkie, *The Mexican Revolution* (Berkeley: U. of California Press, 1973), p. 65.
26. Siqueiros, *Me Llamaban*, p. 241.
27. Speech to Worker-Management Convention, November 1928. Siqueiros archive.
28. Speech to CROM convention, Dec. 1928, Siqueiros archives.
29. In June 1929 the FBI received information from the U.S. State Dept. that Siqueiros was General Secretary of a "Revolutionary Trade Union Center formed in Mexico" (FBI archive file).
30. Tibol, *Siqueiros*, p. 38.
31. *Ibid.*, p. 38.
32. Fehrenbach, p. 567.
33. Siqueiros manifesto, May 1, 1929. Siqueiros archive.
34. Siqueiros, *Me Llamaban*, p. 280.
35. Tibol, *Siqueiros*, p. 42.
36. Fehrenbach, p. 571.
37. Barckhausen, *Verdad Y Leyenda de Tina Modotti*, p. 131.

Chapter 8. The First Long Sentence

1. Siqueiros, *Me Llamaban*, p. 563.
2. *Ibid.*, p. 265.
3. Tibol, *Siqueiros*, pp. 21–22.
4. *Ibid.*, p. 22.
5. *Ibid.*, p. 23.
6. *Ibid.*, pp. 23–24.
7. Siqueiros, *Me Llamaban*, p. 268.
8. *Ibid.*, p. 268.
9. *Ibid.*, p. 283.
10. Ione Robinson, *A Wall To Paint On* (New York: Dutton, 1946), pp. 191–94.
11. Tibol, *Siqueiros*, pp. 241–243.
12. Siqueiros, *Me Llamaban*, p. 303.
13. Siqueiros lecture, Palace of Fine Arts, Mexico City, August 25, 1950.
14. Siqueiros, *Me Llamaban*, p. 303.

Chapter 9. Los Angeles, and A Future Wife

1. Siqueiros, *Mi Respuesta*, p. 28.
2. *Ibid.*, p. 29.
3. *Ibid.*, p. 28.
4. *Ibid.*, p. 29.
5. *Ibid.*, p. 31.
6. Blanca Luz Brum, in *El Universal*, Mexico, D.F., August 17, 1932.
7. Author's interview with Angélica Siqueiros.
8. *Ibid.*
9. Tibol, *Siqueiros*, p. 24.
10. Interview with Angélica Siqueiros.
11. Siqueiros, *Como Se Pinta Un Mural* (Mexico, D.F.: Ediciones Mexicanas, 1951), p. 143.
12. Don Ryan, "Parade Ground," *Illustrated Daily News*, Los Angeles, October 11, 1932.
13. Tibol, *Siqueiros*, pp. 102–104.
14. B. H. Friedman, *Jackson Pollock* (New York: McGraw-Hill; 1972), p. 11.
15. George Biddle, *An American Artist's Story*, (Boston: Little Brown, 1939), p. 268.
16. William F. McDonald, *Federal Relief Administration and the Arts* (Ohio State University Press, 1969), p. 357.
17. Donald D. Egbert, *Social Radicalism and the Arts* (New York: Alfred A. Knopf, 1970), p. 505.
18. McDonald, p. 364.

Chapter 10. Exile: Montevideo—Buenos Aires

1. Tibol, *Siqueiros*, p. 194.
2. Tibol, *Siqueiros*, p. 46.
3. *Ibid.*, pp. 47–48.
4. Siqueiros, *La Tracala*, p. 21.
5. Tibol, *Siqueiros*, pp. 48–49.
6. *Ibid.*, p. 50.
7. Tibol, *Siqueiros*, pp. 248–249.
8. Siqueiros, *Me Llamaban*, p. 410.
9. *Ibid.*, p. 412.
10. Pamphlet about the mural *Plastic Exercise*, printed in Argentina, December 1933. Siqueiros archive.
11. *Ibid.*
12. *Ibid.*
13. Tibol, *Siqueiros*, p. 115–121.
14. Siqueiros, *La Tracala*, p. 23.

Chapter 11. Siqueiros Experimental Workshop, New York City

1. Interview with Angélica Siqueiros.
2. Emanuel Eisenberg, "Battle of the Century," *New Masses*, December 10, 1935.
3. Siqueiros, "Rivera's Counterrevolutionary Road," *New Masses*, May 29, 1934.
4. *Ibid.*
5. *Ibid.*
6. Eisenberg, in *New Masses*, December 10, 1935.
7. *Ibid.*
8. Siqueiros, *La Tracala*, p. 25.
9. Interview with Angélica Siqueiros.
10. Tibol, *Siqueiros*, p. 203.
11. Siqueiros, *La Tracala*, p. 23.
12. Tibol, *Siqueiros*, p. 197.
13. Siqueiros, *Mi Respuesta*, p. 35.
14. Siqueiros, *Me Llamaban*, p. 299.
15. *Ibid.*, p. 301.

Chapter 12. Spain: Captain to Lt. Colonel

1. José Renau, "Mi Experiencia Con Siqueiros," *Revista de Bellas Artes*, (Mexico), Jan.–Feb., 1976, p. 2.
2. Herbert L. Matthews, *Half of Spain Died* (New York: Charles Scribner, 1973), p. 96.
3. Tibol, *Siqueiros*, pp. 249–252.
4. *Ibid.*, p. 205.
5. Siqueiros, *La Tracala*, p. 26.
6. Siqueiros, *Me Llamaban*, pp. 322–23.
7. Angélica Arenal, *70 Obras Recientes*, p. 22.
8. Siqueiros, *Memorial Relativo a le Hoja de Servicios del Suscrito*. Siqueiros archive.
9. Interview with Angélica Siqueiros.
10. *Ibid.*
11. *Ibid.*
12. Siqueiros, *Me Llamaban*, p. 342.
13. Tibol, *Siqueiros*, p. 206.
14. José Renau, p. 4.
15. Siqueiros, *Me Llamaban*, pp. 342–43.
16. *Ibid.*, p. 345.
17. *Ibid.*, pp. 337–38.
18. Tibol, *Siqueiros*, p. 206.
19. Siqueiros, *Me Llamaban*, p. 349.
20. José Renau, p. 9.
21. Siqueiros lecture, early 1950's, Siqueiros archive.
22. Renau, p. 18.
23. Angélica Arenal, *70 Recent Works*, p. 24.

Chapter 13. Leon Trotsky

1. Siqueiros, *Me Llamaban*, p. 369.
2. Isaac Deutscher, *The Prophet Outcast*, (New York: Oxford University Press, 1963), p. 419.
3. *Ibid.*, p. 357.
4. Dolores Ibárruri, *They Shall Not Pass*, (New York: International Publishers, 1976), p. 282.
5. Siqueiros, *Me Llamaban*, p. 364.
6. *Ibid.*, p. 365.
7. *Ibid.*, p. 366.
8. Leandro A. Sánchez Salazar, *Asi Asesinaron A Trotski* (Mexico, D. F., Populibros "La Prensa," 1955), p. 65.
9. *Ibid.*, p. 36.
10. *Ibid.*, p. 52.
11. *Ibid.*, p. 55.
12. *La Voz de Mexico*, June 23, 1940; see also *Excelsior*, September 20, 1953, p. 2, col. 3.
13. FBI Correlation Summary, p. 128.
14. *Ibid.*, p. 13.

15. *Ibid.*, p. 16.
16. *Ibid.*, p. 12.
17. *Ibid.*, p. 13.
18. *Ibid.*, pp. 6, 58, 151, 29.
19. *Ibid.*
20. *Ibid.*, pp. 15, 16.
21. Salazar, p. 214.
22. *Ibid.*, p. 218.
23. *Ibid.*, p. 218.
24. *Ibid.*, p. 220.
25. *Ibid.*, p. 223.
26. Siqueiros, *Me Llamaban*, p. 373.
27. *Ibid.*, p. 375.
28. *Ibid.*, p. 376.
29. *Ibid.*, p. 226.
30. Siqueiros, *El Asalto a la Casa de Leon Trotsky.* Siqueiros archive, p. 2.
31. *Ibid.*, p. 3.

32. *Ibid.*, p. 3.
33. *Ibid.*, p. 4.
34. *Ibid.*, p. 5.
35. *Ibid.*, p. 5.
36. *Ibid.*, p. 6.
37. *Ibid.*, p. 8.
38. *Ibid.*, p. 9.
39. *Ibid.*, p. 10.
40. *Ibid.*, p. 11.
41. *Ibid.*, p. 11.
42. *Ibid.*, p. 12.
43. *Ibid.*, p. 13.
44. *Ibid.*, p. 13.
45. *Ibid.*, p. 14.
46. *Ibid.*, p. 14.
47. *Ibid.*, p. 15.
48. Siqueiros, *Me Llamaban*, p. 380.
49. Interview with Angélica Siqueiros.

Chapter 14. Exile in Chile

1. Salazar, p. 237.
2. Siqueiros, *Me Llamaban*, p. 383.
3. *Ibid.*, pp. 386–394.
4. *Ibid.*, p. 395.
5. *Ibid.*, p. 396.
6. Interview with Angélica Siqueiros.
7. Siqueiros, *Me Llamaban*, p. 405.
8. Lincoln Kirstein, "Through an Alien Eye" in the magazine *Forma*, quoted in Tibol, *Siqueiros*, p. 255–258.
9. Siqueiros, *Me Llamaban*, p. 407.
10. Letter, Museum of Modern Art to State Department, March 19, 1943, State Department Archives.
11. *Ibid.*
12. State Department Memorandum, April 14, 1943.
13. Telegram, State Department to Bowers, January 4, 1943.
14. Letter, American Embassy, Lima, to State Department, Washington, D.C., April 9, 1943.
15. State Department letter, Philip W. Bonsal to Spruille Braden, April 14, 1943.
16. Gustavo Durán, memorandum to Ambassador Spruille Braden, April 16, 1943, U.S. State Department.
17. FBI correlation summary report, p. 21.
18. Siqueiros, "Boletin Editado Por El Comité Continental De Arte Para La Victoria," October 1943, Siqueiros archive.
19. Siqueiros, *Me Llamaban*, p. 423.
20. Siqueiros, *Como Se Pinta Un Mural*, p. 119.
21. Tibol, *Siqueiros*, p. 142.
22. *Ibid.*, pp. 150–151.
23. *Ibid.*, p. 152.
24. *Ibid.*, p. 152.
25. Siqueiros, *Me Llamaban*, p. 425.
26. Letter, June 8, 1943. Siqueiros archive.

Chapter 15. Cuauhtémoc Against the Myth

1. Updated newspaper account, *Excelsior.* Siqueiros archive.
2. Siqueiros, *Centro de Arte Realista Moderno* leaflet, 1944.
4. José Chávez Morado, "Siqueiros y el Centro de Arte Realista," *La Voz de Mexico*, July 16, 1944.
5. *Ibid.*
6. *Ibid.*
7. *Ibid.*
8. Siqueiros, "Centro de Arte Realista Moderno," leaflet.
9. Siqueiros, "Carta Abierta a Jaime Torres Bodet, Secretario de Educación Pública," *Asi!*, September 1, 1945.
10. *Ibid.*
11. Angélica Arenal de Siqueiros, *70 Obras*, p. 30.
12. Siqueiros, "Cine Nacional o Falsificador?", *Asi!*, September 15, 1945.
13. Siqueiros, "Funcion de El Colegio Nacional," *Asi!*, Sept. 22, 1945.
14. Siqueiros, *No Hay Mas Ruta Que La Nuestra*, (Mexico, 1945).

Chapter 16. *Patricios y Patricidas*

1. FBI correlation summary.
2. *Ibid.*
3. *Ibid.*
4. Siqueiros lettter to Maestro Carlos Chávez, May 27, 1947. Siqueiros archive.
5. *Ultimas Noticias*, September 7, 1949, p. 1, col. 7.
6. Tibol, *Siqueiros*, p. 300.
7. Eduardo Pallares, "Revelación Estética," *El Universal* (Mexico) December 9, 1947.
8. *Ibid.*
9. *Ibid.*
10. "Escuela Sin Maestros," *Tiempo* (Mexico), July 29, 1949, p. 25.
11. Siqueiros, *Como Se Pinta Un Mural*, p. 164.
12. J. Palomin, "El Mural de Siqueiros en San Miguel," *Excelsior* (Mexico, D.F.), May 8, 1949.
13. *Ibid.*
14. *Tiempo* (Mexico, D.F.), July 29, 1949, p. 27.
15. Siqueiros, "Rompe Con El Director." Letter, July 6, 1949. Archive.
16. Petition addressed to President Harry S. Truman. Signed by 93 U.S. citizens in San Miguel, September 1949.
17. FBI Correlation Summary Report.
18. *Ibid.*
19. Siqueiros, "El Monoculo del Artepurismo de Paris en Mexico," *Mexico en el Arte* (Mexico, D.F.), No. 4, October 1948.
20. *Ibid.*
24. *Ibid.*
25. *Ibid.*
26. *Ibid.*
27. *Ibid.*
28. *Ibid.*
29. *Ibid.*

Chapter 17. Artists and Communists

1. Orlando S. Suárez, *Inventario Del Muralismo Mexicano* (Mexico: Universidad Nacional Autonoma de Mexico, 1972).
2. Valentín Campa, *Mi Testimonio* (Mexico, D.F.: Ediciones de Cultura Popular, 1978), p. 88.
3. *El Machete*, April 1930, No. 180, pp. 2–4.
4. Pacheco, Anguiano, and Vizcaino, *Cárdenas y la Izquierda Mexicana* (Mexico, D.F.: Juan Pablos Editor, S.A., 1975) p. 325.
5. Letter to Presidium del Pleno Del Partido Comunista Mexicano, February 1947. Archive.
6. Letter, Chairman of the Central Committee to Siqueiros, February 15, 1947. Archive.
7. *Tiempo* (Mexico, D.F.), June 11, 1948, p. 5.
8. *Ibid.*, p. 6.
9. *Ibid.*, p. 5.
10. Bertram D. Wolfe, *op. cit.* p. 409.
11. *Mañana* (Mexico, D.F.), December 1955, p. 20.
12. *Ibid.*, p. 20.
13. *Ultimas Noticias*, September 7, 1949, p. 2, col. 2.
14. FBI Correlation Summary.
15–18. *Ibid.*
19. *Ibid.*
20. *Ibid.*
21. Siqueiros, "Cultura Colonial," *Excelsior*, April 25, 1950.
22. Siqueiros archive.
23. Raymond Cogniat, *Arts* (Paris), June 23, 1950, no. 268.
24. Nils Lindhagen, *Prisma* (Stockholm), July 5, 1950, Nos. 5–6.
25. Marco Valsecchi, *Paese Sera* (Rome), June 13, 1950.
26. *Tiempo* (Mexico), June 30, 1950, pp. 24–25.
27. Siqueiros, Lecture, Palacio de Bellas Artes, August 25, 1950.
28. *Ibid.*
29. Diego Rivera, *El Nacional* (Mexico), June 18, 1950, Editorial page.

Chapter 18. From Cuauhtémoc to Truman

1. "Traicion A Mexico," Leaflet, Frente de Pintores Revolucionarios.
2. *La Voz de Mexico,* February 15, 1951, p. 8.
3. FBI Correlation Summary.
4. *Picasso y Nosotros,* handbill, 1951.
5. *Nuestra Pintura Politica Ante El Jucio Del Pueblo* handbill, 1951.
6. "La Exposicion, 'El Arte de Mexico por la Independencia Nacional Contra la Miseria y Por la Paz.'" Mimeograph, 1951.
7. *Ibid.*
8. *Ibid.*
9. *Ibid.*
10. *Ibid.*
11. *Novedades* (Mexico, D.F.), April 5, 1951, p. 1, col. 2.
12. "Declaraciones del Frente de Pintores Revolucionarios de Mexico," *Arte Público* (Mexico, D.F.) October 15, 1952, p. 2.
13. Orlando S. Suárez, *Inventario Del Muralismo Mexicano* (Mexico: U.N.A.M., 1972), p. 383.
14. Letter to architect Carlos Lazo, February 20, 1951. Siqueiros archive.
15. Tibol, *Siqueiros,* p. 62.
16. *Ibid.* p. 62.
17. *Ibid.* p. 63.
18. *Tiempo* (Mexico, D.F.), February 15, 1952.
19. Roger D. Hansen, *The Politics of Mexican Development* (Baltimore: Johns Hopkins, 1974), p. 177.
20. *Atisbos* (Mexico, D.F.), February 2, 1952, p. 4.
21. *Ibid.*
22. *Ibid.*
23. *Ibid.*
24. Manuel Rodríguez Lozano, "Desfiguracion del Arte Mexicano," *Excelsior* (Mexico), May 25, 1952.
25. *Excelsior,* June 6, 1953.
26. *Excelsior,* September 19, 1953, p. 16.
27. *Ibid.*
28. *Excelsior,* September 25, 1953, p. 4.
29. *Arte Público,* Leaflet, February, 1953.
30. *Siqueiros, "Conclusiones Sobre el Articulo de Philippe Soupault," Arte Público,* November 1954, p. 22.
31. *Ibid.*
32. *Ibid.*
33. *Arte Público,* October 15, 1952, p. 8, col. 7.
34. *Ibid.,* p. 9.
35. Philippe Soupault, "Une Tache Gigantesque," *Arte Público,* November 1954, pp. 20–21. Spanish translation.
36. *Ibid.*
37. *Ibid.*
38. *Ibid.*

Chapter 19. Murals and Architecture

1. Radar, "Diego Pinta Nuevo Mural," *Excelsior,* September 1953.
2. Letter, Rivera to Siqueiros, May 29, 1953. Siqueiros archive.
3. Letter, Siqueiros to Rivera, June 3, 1953. Siqueiros archive.
4. *Ibid.*
5. *Los Angeles Times,* June 1954, reprinted in *Arte Público,* November 1954.
6. *Arte Público,* November 1954, p. 23.
7. *Arte Público,* October 1952, p. 16.
8. *Ibid.*
9. Alberto Pulido Silva, "Interpretación Estetica Del Mural De Siqueiros En 'La Raza'," *Excelsior,* "Diorama de la Cultura," September 23, 1956.
10. Juan Crespo de la Serna, "Siqueiros' Mural," *Universidad de Mexico,* Vol. IX, Nos. 10–11, July 1955.
11. Letter from engineer Carlos Colinas, June 3, 1953. Siqueiros archive.
12. Letter from architect Gustavo García Travesi, June 9, 1953. Siqueiros archive.
13. Letter to Secretary General of the Communist Party Dionisio Encina, August 13, 1953. Siqueiros archive.
14. *Ibid.*
15. Siqueiros, "La Arquitectura Internacional a la Zaga de la Mala Pintura," *Arte Púbico,* November 1954, p. 36.
16. *Ibid.*
17. *Ibid.*
18. *Ibid.*
19. *Ibid.*
20. *Excelsior* (Mexico, D.F.), September 21, 1953, p. 1-B, col. 7.
21. *Ibid.*
22. *Ibid.*
23. *Excelsior,* September 24, 1953.
24. *Ibid.*
25. *Ibid.*
26. *Excelsior,* September 25, 1953, p. 4, col. 5.

27. *Ibid.*
28. Siqueiros, "Artificio y Verdad Social-Estetica en la Arquitectura," *Segunda Conferencia, Palacio de Bellas Artes,* October 9, 1953.
29. *Ibid.*
30. *Ibid.*
31. *Ibid.*
32. Tibol, "El Pueblo, A La Universidad," *Novedades* (Mexico), March 25, 1956, Cultural Supplement, p. 5.
33. *Ibid.*
34. "Leftist Controversy Over Murals in University City," U.S. State Department memorandum, October 23, 1952.
35–38. *Ibid.*
39. FBI Correlation Summary, p. 52.
40. *Ibid.,* p. 15.
41. *Ibid.,* p. 61.
42. *Ibid.,* p. 81.
43. *Ibid.,* p. 65.
44. "Homenaje Postumo A Frida Kahlo," *Arte Público,* November 1954, p. 3.
45. *Ibid.*
46. *Ibid.*
47. *Ibid.*
48. *Ibid.*

Chapter 20. Time and Tide

1. Siqueiros, *Mi Respuesta,* p. 75.
2. Siqueiros, "Carta Abierta," *Arte Público,* January 1956.
3. *Ibid.*
4. *Ibid.*
5. *Ibid.*
6. *Ibid.*
7. *Ibid.*
8, 9, and 10. *Ibid.*
11. *Ibid.*
12. *Excelsior,* November 18, 1959, p. 4.
13. *Ibid.*
14. Siqueiros, *Mi Respuesta,* p. 75.
15. Letter, *Los Muralistas Se Dirigen Al Señor Presidente Demando Condiciones Mas Justas de Trabajo,* April 1955. Siqueiros archive.
16. Siqueiros, *Me Llamaban,* p. 64.
17. *Arte Público,* November 1954, p. 34.
18. Siqueiros, *Me Llamaban,* p. 296.
19. Related in the author's presence.
19. Tibol, *Mexico en la Cultura, de Novedades* (Mexico, D.F.), August 12, 1956.
20. Tibol, *Siqueiros,* p. 66.
21. *Ibid.*
22. Selden Rodman, *Mexican Journal* (New York: Devin-Adair, 1958) p. 151.
23. Siqueiros, *Me Llamaban,* p. 447.
24. *Ibid.,* pp. 449–450.
25. *Ibid.,* pp. 450–451.
26. *Ibid.,* p. 451.
27. *Ibid.,* p. 453.
28. Rodman, *Mexican Journal,* p. 151.
29. Siqueiros, *Me Llamaban,* p. 456.
30. *Ibid.,* pp. 456–457.
31. Tibol, *Siqueiros,* p. 294.
32. FBI Correlation Summary, p. 133.
33. *Ibid.,* p. 91.
34. Rodman, *Mexican Journal,* p. 275.
35. CIA report, CS-3,329,863, September 25, 1957.
36. CIA Information Report, CS-3/337,850.
37. *Excelsior,* March 6, 1958.
38. *Ibid.*
39. *Ibid.*
40. Tribol, *Siqueiros,* p. 68.
41. *Ibid.*
42. *Newsweek,* (New York), October 28, 1957, p. 100.

Chapter 21. Cancer and the Actors: The Enemy

1. Julio Scherer García, "Siqueiros Con La Pistola En La Mano," *Excelsior, Diorama de la Cultura,* January 11, 1959.
2. *Ibid.*
3. Siqueiros, *Mi Respuesta,* p. 42.
4. Ibid., p. 104.
5. *Ultimas Noticias,* October 19, 1959.
6. Siqueiros, *La Tracala,* p. 37.
7. *Ibid.,* p. 38.
8. *Ibid.,* p. 38.
9. *Ibid.,* p. 39.
10. *Excelsior,* May 11, 1959, p. 8.
11. Siqueiros, *La Tracala,* p. 39.
12. *Ibid.,* p. 39.
13. *Excelsior,* May 11, 1959, p. 8.
14. Siqueiros, *La Tracala,* p. 39.
15. *Siglo* (Mexico, D.F.), May 24, 1959, p. 6.
16. *Excelsior,* May 11, 1959, p. 12.
17. *Ibid.,* p. 8.
18. *Ibid.*

19. Siqueiros, *La Tracala*, p. 40.
20. *Ibid.*
21. *Excelsior,* May 11, 1959, p. 8.
22. *Ibid.*
23. Tibol, *Siqueiros*, p. 71.
24. *Excelsior,* December 15, 1968.
25. U.S. Department of State telegram, Mexico City to Washington, February 17, 1959.
26. FBI Correlation Summary, pp. 79, 135.

27. Siqueiros, *Mi Respuesta*, p. 100.
28. *Ibid.*
29. Tibol, *Siqueiros*, p. 73.
30. *Ibid.*, p. 74.
31. Siqueiros, *Me Llamaban*, p. 426.
32. Siqueiros, *La Tracala*, p. 52.
33. Siqueiros, *Mi Respuesta*, p. 85.
34. *Ibid.*, p. 86.
35. Siqueiros, *Mi Respuesta*, pp. 92–93.
36. Siqueiros, *La Tracala*, p. 55.

Chapter 22. Committing the Unthinkable

1. Siqueiros, *La Tracala*, p. 57.
2. Siqueiros, *Mi Respuesta*, p. 99.
3. *Ibid.*, pp. 102–103.
4. *Ibid.*, p. 104.
5. *Ibid.*, p. 105.
6. *Ibid.*, pp. 107–108.
7. *Ibid.*, p. 111.
8. *Ibid.*
9. FBI Correlation Summary, p. 136.
10. *Siqueiros,* La Tracala, p. 59.
11. *Mi Respuesta*, p. 116.
12. *Ibid.*, p. 128.
13. *Ibid.*, p. 131.
14. *Ibid.*, pp. 131–32.
15. *Ibid.*, p. 135.
16. U.S. Embassy telegram 2375, April 1, 1960.

17. *Tabloide* (Mexico, D.F.), August 9, 1960, p. 1; *Zocalo* (Mexico, D.F.), August 23, 1960, p. 1.
18. *Ultimas Noticias*, August 4, 1960, p. 5, col. 1.
19. *Ibid.*
20. *Ibid.*, August 9, 1960, p. 1.
21. *El Universal* (Mexico, D.F.), August 9, 1960, pp. 11, 23.
22. *Ibid.*
23. *Ibid.*
24. John Kenneth Turner, *Mexico Bárbaro*, (Mexico, Epoca, S.A., 1978), p. 130.
25. Colin M. MacLachlan, *Criminal Justice in 18th Century Mexico* (University of California Press, 1974), p. 90.

Chapter 23. Mexican Due Process

1. *Ultimas Noticias*, August 10, 1960, p. 8.
2. *La Prensa* (Mexico, D.F.), August 10, 1960, p. 26.
3. *Ultimas Noticias*, August 10, 1960, p. 1.
4. *La Prensa*, August 10, 1960, p. 24.
5. *El Popular* (Mexico, D.F.) August 11, 1960, p. 2.
6. *Ibid.*
7. *Ibid.*
8. *Novedades*, August 11, 1960, p. 13, col. 3.
9. *El Universal Grafico*, (Mexico, D.F.), August 10, 1960, pp. 3, 4.
10. *Ultimas Noticias*, August 10, 1960, p. 8.
11. *Excelsior,* August 12, 1960, p. 1.
12. *Ibid.*
13. Harvey O'Connor, "McCarthyism in Mexico," *Monthly Review* (New York), April 1961, p. 597.
14. *Excelsior,* August 12, 1960, p. 10, col. 1.
15. *Ibid.*
16. *Excelsior Extra,* August 12, 1960, p. 1.
17. *Ibid.*, p. 8.

18. *Ibid.*
19. *Ibid.*, p. 8, col. 4.
20. *El Universal*, August 12, 1960.
21. *Ibid.*
22. *A.B.C.* (Mexico, D.F.), August 12, 1960, pp. 2, 12.
23. *Ultimas Noticias*, August 12, 1960.
24. *El Universal Grafico* (Mexico, D.F.), August 12, 1960, p. 22.
25. Siqueiros, *Me Llamaban*, p. 508.
26. *Ibid.*, p. 509.
27. *Ultimas Noticias*, August 14, 1960, p. 9.
28. Harvey O'Connor, "McCarthyism in Mexico," p. 599.
29. *Ultimas Noticias*, August 15, 1960, p. 1.
30. *Ibid.*, p. 7.
31. *Excelsior,* September 21, 1960.
32. U.S. State Department memorandum, August 18, 1960.
33. Siqueiros, *Me Llamaban*, p. 546.
34. *Ibid.*, pp. 524–525.
35. *Ibid.*, p. 526.

36. *Ibid.*, p. 526.
37. *Ibid.*
38. *Ibid.*, p. 546.
39. *Ibid.*, p. 558.
40. *Ibid.*, p. 535.
41. *Ibid.*, p. 541.
42. *Ibid.*, p. 541.
43. *The New York Times*, August 11, 1960.
44. *Excelsior*, English language page, August 11, 1960.

45. CIA report, CS-3/451,923, September 16, 1960.
46. Angélica Arenal, *Paginas Sueltas Con Siqueiros* (Mexico, Editorial Grijalbo, 1980), p. 198.
47. *The Worker*, (New York), December 18, 1960, p. 3.
48. U.S. State Department, FBI re: Siqueiros letters.

Chapter 24. His Day in Court

1. *The Worker*, March 4, 1962, p. 3.
2. *Ibid.*
3. Siqueiros, *La Tracala*, p. 10.
4. *Ibid.* p. 11.
5. *Ibid.*
6. *Ibid.*
7. *Ibid.*, p. 17.
8. *Ibid.*, p. 18.
9. *Ibid.*
10. *Ibid.*, p. 19.
11. *Ibid.*
12. *Ibid.*, p. 33.

13. *Ibid.*
14. *Ibid.*
15. *Ibid.*
16. *Ibid.*, p. 35.
17. *Ibid.*, p. 44.
18. *Ibid.*
19. *Ibid.*
20. *Ibid.*, p. 65.
21. *Ibid.*, p. 67.
22. *Ibid.*, p. 71.
23. *Ibid.*, p. 72.
24. *Ibid.*, p. 74.
25. *Ibid.*, p. 75.

Chapter 25. The Interdiction of Murals

1. U.S. Department of State Airgram, August 14, 1962.
2. Siqueiros, "Al XIII Congreso Internacional De Filosofia," September 9, 1963.
3. Hal Hendrix, *The Miami News* (Miami, Florida), March 25, 1962.
4. *Arts* (New York), May–June 1961, p. 7.
5. State Department letter to Director of Institute of Hispanic American and Luso-Brazilian Studies, Stanford University, August 28, 1962.
6. Lawyers' letter to the Attorney General of the Republic and Representatives of the American States at the International Congress of Attorneys, July 15, 1963. Siqueiros archive.

7. Letter to President López Mateos, April 18, 1963. Siqueiros archive.
8. Angélica Arenal de Siqueiros, letter to the public, January 9, 1964. Siqueiros archive.
9. FBI memorandum, January 8, 1963.
10. *Ibid.*, January 30, 1963.
11. U.S. State Department airgram, January 3, 1963.
12. Message to the *Frente Electoral del Pueblo*, April 24, 1964.
13. Angélica Siqueiros letter, March 27, 1964. Siqueiros archive.
14. U.S. State Department airgram, July 17, 1964.
15. FBI memorandums, July 14, 1964, July 24, 1964.

Chapter 26. Sunlit Mexico City

1. *Newsweek* (New York), July 1964, p. 46.
2. *The New York Times*, July 143, 1964.
3. *The New York Times*, January 3, 1968, p. 44, col. 4.
4. Tibol, *Siqueiros*, p. 81.
5. Adriana Siqueiros, author interview, August 1980.
6. The comments on the paintings are translated from the Spanish as quoted in Tibol, *Siqueiros*, pp. 304–306.
7. Manuel Arrellano Z., "El Mural de Siqueiros en Chapultepec," *El Universal* (Mexico, D.F.), April 20, 1969.
8. J. Canaday, *New York Times*, September 24, 1961.
9. Mario Barata, "Siqueiros y el Muralismo Mexicano," *Vida y Obra de Siqueiros, Juicios Criticos* (Mexico, Fondo de Cultura Economica, 1975), p. 170.
10. F. Díaz de Urdanivia, "Siqueiros Termina Otra Gran Obra," *Vida y Obra*, p. 182.
11. Tibol, *Siqueiros*, p. 295.
12. *Ibid.*
13. *Vida y Obra*, p. 177.
14. *Ibid.*, p. 179.
15. FBI memorandum to Director from Rome, April 13, 1965.
16. Tibol, *Siqueiros*, p. 82.
17. FBI report, April 22, 1966.
18. FBI report, Foreign Broadcast Information Service 173, September 8, 1965.
19. Suárez, *Inventario Del Muralismo*, p. 383.
20. Tibol, *Siqueiros*, p. 82.
21. *Ibid.*, p. 83.
22. Angélica Siqueiros interview, August 1974.
23. FBI memorandum, February 28, 1967.
24. Tibol, *Siqueiros*, p. 83.

Chapter 27. Time the Devourer

1. *Excelsior*, December 15, 1966.
2. Tibol, *Siqueiros*, p. 84.
3. *Ibid.*
4. *Cine Mundial* (Mexico, D.F.) January 8, 1974, p. 2.
5. State Department airgram, November 5, 1967.
6. Tibol, *Siqueiros*, p. 85.
7. *Ibid.*
8. Joseph North, "Siqueiros, Wizard of the Mural," *American Dialog*, Spring 1968, p. 10.
9. *Ibid.*
10. Evelyn P. Stevens, *Protest and Response in Mexico* (Cambridge, Mass., MIT Press, 1974, pp. 187, 199.
11. Luis de Gongora, *Obras Completas*, Soneto 374.
12. Stevens, p. 237.
13. *The New York Times*, March 19, 1981, p. 2, col. 3.
14. Information Bulletin #6, International Information Brigade of the CNH.
15. *Excelsior*, December 15, 1968.
16. Ibid.
17. "Mexico en la Cultura," *Novedades* (Mexico, D.F.), May 11, 1959. p. 8.

Chapter 28. The March of Humanity

1. Article 145 was repealed in July 1970 but the Penal Code was amended to include all the crimes it had sanctioned. In addition, the penalties were increased. Evelyn P. Stevens, *op. cit.*, pp. 253–54.
2. P. Fernández Marquez, "Inauguracion Del Polyforum Siqueiros," *El Nacional* (Mexico, D. F.), December 26, 1971.
3. Ramón de Ertze Garamendi, *Excelsior*, December 23, 1971.
4. P. Fernández Marquez, *El Nacional*, December 26, 1971.
5. Ramón de Ertze Garamendi, *Excelsior*, December 23, 1971.
6. Luis Suárez, "Siqueiros Victoria del Hombre," *Diario de Mexico*, December 16, 1971.
7. Juan Dervera, "El Polyforum, Gran Obra Cultural," *Ovaciones* (Mexico), December 23, 1971.

8. *Ibid.*
9. *Magazine de Excelsior* (Mexico, D. F.), December 12, 1971.
10. Antonio Rodríguez, "El Polyforum Siqueiros," *El Día* (Mexico, D.F.) February 29, March 1, March 3, 1972.

11. *Ibid.*
12. *Ibid.*
13. Jacques Michel, "El Polyforum Siqueiros, la 'Revolución' y . . . la Demagogia," *Excelsior,* January 8, 1972.
14. *Ibid.*

Chapter 29. Finishing Up

1. *Exposición Homenaje Siqueiros* (Mexico, D.F. INBA 1975), p. 108.
2. *Excelsior,* April 23, 1972.
3. Angélica Siqueiros interview, August 1977.
4. *Ibid.*
5. FBI message from Mexico City to Acting Director, Washington, June 7, 1972.
6. Author's last conversation with Siqueiros, February 1973.
7. FBI teletype message from Mexico City to Acting Director April 4, 1973.
8. *Ibid.*

But as late as May 26, 1982, the deputy director of the U.S. National Security Agency, Ann Caracristi, refused to release information on Siqueiros that the agency contained in its files. She stated:

I can appreciate your difficulty in understanding the national security rationale for withholding the information. Please be assured that I have carefully reviewed these records and determined that they must continue to be classified. It may help you to understand that the records located in response to your request are foreign intelligence reports derived from the intercept of foreign communications. None of these records were originated within the United States; nor do they reflect any relationship between the U.S. Government and Mr. Siqueiros.

. . . Classification of the information is required because its disclosure will reveal the intelligence sources and methods which it was derived, the revelation of which would cause damage to the national security interests of the United States. . . In conducting this review, I have weighed the significant need for openness in government against the likelihood of damage to our national security at this time and have determined that the information should continue to be classified.

(National Security Agency letter to author, May 26, 1982.)

9. *Cine Mundial,* January 7, 1974, p. 2.
10. *Excelsior,* January 7, 1974, p. 1.
11. *Cine Mundial,* January 8, 1974, p. 4.
12. Tiempo (Mexico, D.F.), January 14, 1974, p. 11, col. 1.
13. Valentín Campa, *Mi Testimonio,* p. 95.
14. *Oposición,* (Mexico, D.F.), First Fortnight, January 1974.

372

Acknowledgements

The author thanks the following for permission to reprint short extracts:

from *An American Artists's Story* , by George Biddle. Copyright 1939, Little, Brown and
Company, Boston.

from *Criminal Justice in Eighteenth-Century Mexico: A Study of the Tribunal of the Acordada*, by Colin MacLachlan and Jaime Rodriguez O. Reprinted by permission of the University of California Press, Berkeley.

from *Fire and Blood*, by T.R. Fehrenbach. Reprinted by permission of the author and the author's agents, Scott Meredith Literary Agency, L.P.

from *Firefly in the Night,* by Irene Nicholson, copyright 1959, Faber and Faber, London.

from *Life and Art of Albrecht Durer*, by Erwin Panofsky. Copyright 1955 by Princeton University Press, Princeton.

from "Mexican Journal," by Selden Rodman, 1958. Copyright by Devin-Adair, Publishers, Inc., Old Greenwich, Connecticut, 06870. All rights reserved.

from *The Mexican Mural Renaissance 1920-1925*, by Jean Charlot. Copyright Yale University
Press, 1963, New Haven.

from *Mexican Revolution: Federal Expenditure and Social Change since 1919*, Rev. Ed., by James Wilkie. By permission from the University of California Press, Berkeley.

from *The Social History of Art*, by Arnold Hauser. Vintage Books, 1957. Permission from Random House, New York.

APPENDIX

The Party Dispute

Siqueiros had been expelled from his seat on the Central Committee, though not from the Communist Party, on July 1, 1971. Differences had long existed between him and leading Party members over policies and tactics. His disagreement, based on his fight against sectarianism, rose to the surface in the confines of inner-party conferences and discussions where Siqueiros strongly criticized the Party for what he considered its narrow approach to the country's problems. Valentín Campa, a member of the Central Committee who had been in prison along with Siqueiros (though he had been kept there for ten years), adhered to a sectarian line and led the attack against Siqueiros for his "militant" political posture.

Campa, who would later be the Party's presidential candidate in the national elections, had been expelled from the PCM in 1940; at that time he had formed another party—the Partido Obrero Campesiano Mexicano (POCM). Years after Siqueiros died, Campa wrote:

> Siqueiros in Lecumberri, and even before prison, had assumed an agitating and alarming left attitude. In Lecumberri, at the top of his voice, he criticized the leadership of the Party. Not only for being deficient, but in a thoughtless manner he also criticized the PCM about activities that it was not at that moment in a position to undertake. Nor did he hide his sympathy for certain guerrilla activities.[1]

Communist or not, Siqueiros was recognized in the outside world as a rare and uncommon artist, a perception the PCM often ignored while also not accepting him as a creative thinker. Outspoken, and possessing great political acumen, Siqueiros incurred the wrath of Party leaders, who told him he was being expelled from the Central Committee "owing to your activity contrary to the political line of the Party and your repeated violation of its internal norms."[2]

This decision aroused great interest in the press, and Siqueiros, responding to a reporter's query, said:

> It was a way to discipline me but it did not imply that I was expelled from the Party. I am confident that about some of the fundamental points I made concerning the national political situation, time will prove me correct. I think that steps toward a democratic opening merit support—I refer here to the

moves being made by the government of *Licenciado* Luis Echeverría—because the contrary, the predominance of ultra-reactionary and pro-imperialist tendencies, would be catastrophic for our people. Member of the Central Committee or not, I reiterate, for what remains of my life, my intention of fidelity to my Party and to the proletarian internationalism that it represents in my country.[3]

To further clarify his position in the polemic that was now in the open and of interest to the general public, he released a statement, "Self-Questions and Their Answers."

As is well-known, I never consider it unnecessary to repeat that I have my Party, the Communist Party of Mexico, of which I have been a member for more than half a century. The fact that measures have recently been taken to expel me from the Central Committee by reason of discrepancies over distinct positions concerning national and international problems, is an internal matter which in no way affects my militancy, and much less my convictions as a Communist. I am not a man in search of a party, and equally I can say, I look with a greater sympathy at the fact that currents and people of the left have a criterion and a place in this struggle. They organize politically, act as a functioning party, and all of them in some measure give rise to the strengthening, rather than to more fragmentation of the Mexican left. In any case, that which is fundamental—and not for tomorrow, but for today—is to search for concrete forms of unity of action in everything on which we can agree.

In my judgment then, there is no doubt about the options: we must stimulate and we must struggle, so that we broaden and advance everything that represents resistance and a blow against imperialism and extreme local reaction. Congruently, we must oppose whatever antipopular, antidemocratic, and pro-imperialist tendency is favored. This we must do without wavering, and naturally we would not disregard our [the Party's] own objectives, understanding that it does not mean renouncing our own struggle, but rather is a part of it.[4]

The crux of their differences was contained in his urging a closer linking of the PCM with other left parties so as to utilize to a better advantage the new *apertura democrática*. The "democratic opening," though instituted in a token manner that deceived no one, allowed an opportunity for the previously barred PCM and other left parties to run a candidate for President in the national elections. Echeverría, President from 1970 to 1976, faced the unfulfilled Revolution with a progressive attitude that produced strong opposition in the powerful capitalist sector. During his tenure he imposed a ceiling on profits, instituted a 22% wage increase, and put tight controls on the flourishing private investment banks.[5] Siqueiros was sympathetic to Echeverría's efforts; they were good friends.

It wasn't until after Siqueiros' death that ex-CIA agent Philip Agee pointed out that Echeverría had had ties to the CIA before he became President. Angélica was dumbstruck by Agee's assertion that the CIA had penetrated the highest office of the land, so that Echeverría, then Secretary of Gobernación, found himself in a trap. The CIA station chief

in Mexico City, Winfield Scott, had become an intimate friend and confident of President Díaz Ordaz and provided the President with daily CIA briefing reports. The period was one when the Díaz Ordaz regime was plagued with widespread civil disorder and the CIA's role was to help him hold on as President by furtively defusing the grassroots opposition movements. Echeverría, who had been selected by the PRI to be the next President, had the choice of either resigning his minsterial post and forfeiting the Presidency or obeying the orders of Gustavo Díaz Ordaz and playing ball with the CIA. Agee wrote:

> [Winfield] Scott has problems, however, with Echeverría, the current Minister of Government, who is generally unenthusiastic and reluctant in the relationship with the station. Scott fears that Echeverría is following Díaz Ordaz's orders to maintain joint operations with the station only under protest and that the current happy situation may end when Echeverría becomes President in 1970.[6]

Not content with having Siqueiros expelled from the Central Committee, Valentín Campa also pressed for his expulsion from the Party. Rankled by envy of the painter's fame, the dour Campa engaged in a scurrilous campaign of vilification against him. Campa rebuffed Siqueiros when Siqueiros was released from prison before him, accusing Siqueiros of capitulating to the President and refusing, in writing, to permit Siqueiros to seek a pardon for him.[7] Ignoring the fact that an unprecedented worldwide clamor had played a major role in obtaining Siqueiros' release, Campa, embittered, later complained that Siqueiros had broken with Party discipline, and had, without informing the comrades in jail or the Party outside, "inopportunely taken steps" to request a pardon of the President; and that no sooner had he been released than he had "assumed the attitude of an opportunist," befriending the President and others of the government, while surrendering to the Secretary of Defense by removing the date 1917 being trampled underfoot by federal soldiers in the Actors' Union mural. "Thus the militancy of the mural was removed," wrote Campa, "for it represented the aggressiveness of the Army against the rights [of the people, guaranteed] in the Constitution of 1917."[8] Campa, in denying the mural's militancy, ignored the unrelentingly powerful scenes of workers being shot and killed by soldiers and dragged to their death tied to boxcars.

Campa's fulminations appeared in print after Siqueiros' death, and brought a response from Angélica, who labeled him a liar. He had lied, she said, when he wrote that Siqueiros had appeared on television to urge people to vote in an election when the position of the Party was one of abstention. He had lied too, she said, when he wrote that it was the unanimous opinion of the members of the Central Committee to expel Siqueiros from the Party and only Siqueiros's illness had delayed them

from acting. For whatever underlying reason may have existed, "comrade" Campa's invidiousness was without bounds, and he attacked when there was no fear of a withering response from the dead Maestro.

In part of his character-assassinating tirade, Campa had accused Siqueiros of being a wealthy landlord who possessed five large apartment buildings. Siqueiros had owned the small apartment in Mexico City in which he lived—his final abode in the city. Through the years he had lived in many parts of the city, mostly in a one-family house, which he had owned. If he moved, the house was sold, and Angélica, with the help of her mother, would purchase another. Their last dwelling in Mexico City had been the two-bedroom flat they owned in a very small apartment building on Calle Spencer. Siqueiros and Angélica had purchased a more modest apartment in the same building for their grandson to live in and use for a photography studio. Siqueiros had also owned the one-family house on Calle Tres Picos (a few blocks from Calle Spencer), which housed his studio and archive, and which he had been shaping into a museum of public art destined to become the property of the government after his death. As for his Cuernavaca house and studio, these were also willed to the government. After Siqueiros's death, Angélica sold the apartment on Calle Spencer and rented a modest two-bedroom flat near her daughter.

Campa was at his most perfidious in his memoirs when he stooped to using the spurious printed matter published by Siqueiros' worst enemies—the Trotskyites. Concealing the fact that his source of information was a Trotskyite publication, Campa quoted a story that claimed Siqueiros had admitted he intended to kill Trotsky and that Stalin had handed down the orders. The Trotskyite publication had printed what they claimed was an interview Siqueiros had granted a reporter—someone he did not know and had never seen before from the Dominican Republic magazine *Ahora*. Angelica called the reputed interview a fabrication; published on October 9, 1972, it described Siqueiros as being sixty-three and robust, when he was seventy-five and ill.[9]

It wasn't long before Siqueiros was proved correct in his analysis of the political situation and the tactics—the cause of such tension between himself and the Party—he had recommended the PCM adopt. After his death, the Conference of Latin American and Caribbean Communist Parties, meeting in Havana in 1975, stated:

> Although proud of considering themselves genuine representatives of socialism in Latin America, Communist Parties are willing to participate in the struggle with all those who seriously fight for similar objectives at present. The possibilities opening for Latin American revolutionaries in this period of struggle, the proximity of great decisive confrontations with the imperialist enemy and the oligarchies which support them, demand the greatest efforts for unity and

mutal understanding among all those who are part of the anti-imperialist forces.[10]

In Mexico the PCM gradually shifted away from the sectarianism of which Siqueiros had been so critical. The correctness of his protestations was again confirmed when in May 1977 the 18th National Congress of the PCM formally adopted the "Declaration of Unity," an agreement they signed with the Mexican People's Party (MPP) and the Revolutionary Socialist Party (RSP). Its stated intention was:

> to set up the mechanisms needed to bring about their early merger; to conduct joint mass activities; to develop a common program for a way out of the economic, social and political crisis; to promote united action with other left-wing forces: campaign for a mass working-class party capable of uniting broad sections of the people as a counterweight to bourgeois parties; and organize the struggle for much-needed antimonopoly, anti-imperialist, and democratic change.[11]

What Siqueiros believed necessary for Mexico was now moving toward an integration that, it was hoped, would unite all the Marxist-Leninists and supporters of socialism. The Declaration of Unity encouraged the formation of a single Marxist-Leninist working-class party:

> The party needed by the working class must be guided by Marxist-Leninist theory as applied to national reality. It must combat everything that hampers its growth as well as such harmful trends as sectarianism, opportunism, revisionism, and dogmatism.[12]

The PCM and Siqueiros would now have been in agreement, and Siqueiros would have concurred with the stated aim of the *Declaration:*

> What the democratic movement needs is not the formation of divergent blocs, but unity of the whole left on the basis of agreement on key political issues. Working out a platform of Mexico's left in the broadest sense is objectively of great importance. Its attainment will stimulate the creation of a new political force in the country.[13]

1. Valentín Campa, *Mi Testimonio*, (Mexico, Ediciones de Cultura Popular, 1978), p. 94.
2. *Tiempo* (Mexico, D.F.), January 14, 1974, p. 9.
3. *Ibid.*
4. *Ibid.*
5. Susan Eckstein, *The Poverty of Revolution* (Princeton University Press, 1977), p. 16.
6. Philip Agee, *Inside the Company, CIA Diary* (New York, Stonehill Publishing Company, 1975), p. 525.
7. Valentín Campa, *Mi Testimonio*, p. 94.
8. *Ibid.*
9. *Intercontinental Press* (New York), November 13, 1972, p. 1238.
10. *Political Affairs* (New York), August 1975, p. 34.
11. Alejo Mendex García, "The Basis for Uniting Left Forces in Mexico," *World Marxist Review*, August 1978, p. 53.
12. *Ibid.*, p. 54.
13. *Ibid.*, p. 59.

THE MURALS

1922—THE MYTHS. Encaustic. THE ELEMENTS. Encaustic. National Preparatory School. Mexico, D.F.

1923—BURIAL OF THE WORKER. Fresco. National Preparatory School, Mexico, D.F.

1924—CALL TO LIBERTY. Fresco. National Preparatory School. Mexico, D.F.

1932—WORKERS' MEETING. Fresco on cement, 6 x 9 meters. Chouinard School of Art. Los Angeles, California. (Mural destroyed because of its content.)

1932—PORTRAIT OF PRESENT DAY MEXICO. Fresco, 16m². Commissioned by film director Dudley Murphy for his home in Santa Monica, California.

1932—TROPICAL AMERICA OPPRESSED AND DESTROYED BY IMPERIALISM. Fresco on cement, 6 x 30 meters. Italian Hall, Olvera Street, Los Angeles California. (Mural obliterated because of its content.)

1933—PLASTIC EXERCISE. Fresco on black cement. Bar of the country house of Natalio Botana. Don Torcuato, Buenos Aires, Argentina.

1939—PORTRAIT OF THE BOURGEOISIE. Pyroxylin on cement 100 m². Mexican Union of Electrical Workers. Antonio Caso 45, Mexico, D.F.

1941–1942—DEATH TO THE INVADOR. Pyroxylin on Masonite and Celotex, 160 m². Escuela Mexico, Chillán, Chile.

1943—ALLEGORY OF EQUALITY AND FRATERNITY OF THE WHITE AND BLACK RACES IN CUBA. Pyroxylin on Masonite, 40 m². The penthouse apartment of Señora Luisa Gómez Mena. Havana, Cuba. (Destroyed by owner because of its contents.)

1943—NEW DAY OF THE DEMOCRACIES. Pyroxylin on Masonite, portable work, 7.5 m². National Museum of Cuba, Havana Cuba.

1944—CUAUHTÉMOC AGAINST THE MYTH. Pyroxylin on cloth-covered Celotex and plywood, 75 m². Sonora 9, Mexico, D.F. (Reinstalled in 1964 in the ancient restored TECPAN of Tlatelolco, D.F.

1944—NEW DEMOCRACY. Pyroxylin on cloth-covered Celotex, 54 m². Palace of Fine Arts, Mexico, D.F.

1945—VICTIMS OF THE WAR AND VICTIM OF FASCISM. Two panels complimenting NEW DEMOCRACY, Pyroxylin on cloth-covered Masonite, 4 x 2.46 meters each. Palace of Fine Arts, Mexico, D.F.

1945–1966—PATRICIOS Y PATRICIDAS (patricians and patrician killers). Pyroxylin on cloth-covered Celotex, 400 m². Ex-Aduana de Santo Domingo, Republica del Brasil 31, Mexico, D.F. (incomplete)

1949—MONUMENT TO GENERAL IGNACIO ALLENDE. Vinylite on cement. Chamber 17 meters long, 7 meters wide 6 meters high. All surfaces were to be painted, including the floor. Ex-Convent of Santa Rosa, San Miguel de Allende, Guanajuato, Mexico. (never completed)

1950—CUAUHTÉMOC REBORN. Pyroxylin on cloth-covered Homosote, 8 x 5 meters. Palace of Fine Arts, Mexico, D.F.

1950—TORTURE OF CUAUHTÉMOC. Pyroxylin on cloth-covered Homosote, 8 x 5 meters. Palace of Fine Arts, Mexico, D.F.

1952—MAN MASTER OF THE MACHINE AND NOT THE SLAVE. Pyroxylin on aluminum. Concave surface, 18 x 4 meters. Instituto Politécnico Nacional, Mexico, D.F.

1953—EXCOMMUNICATION AND EXECUTION OF HIDALGO. Pyroxylin on Masonite, 16m². Universidad Michoacana de San Nicolas de Hidalgo, Morelia, Michoacan.

1953—VELOCITY. Sculpture-painting covered with mosaics, 3 x 7.5 meters. Fabricas Automex, Mexico, D.F.

1952–1954—FOR COMPLETE SOCIAL SECURITY FOR ALL MEXICANS. Pyroxylin and Vinylite on cloth-covered Celotex, 310m². Social Security Hospital Number One, Mexico, D.F.

1952–1956—THE PEOPLE TO THE UNIVERSITY AND THE UNIVERSITY TO THE PEOPLE. Sculpture-painting covered with mosaics, 304.15 m². Unfinished walls: THE RIGHT TO CULTURE. Vinylite on cement, 130 m² and NEW UNIVERSITY EMBLEM. Vinylite on cement, 250 m². Administration building, University City, Mexico, D.F.

1957—FROM PORFIRIO DÍAZ TO THE REVOLUTION. Acrilic on Celotex and plywood covered with fiberglass cloth, 419 m². National Museum of History, Chapultepec Castle, Mexico, D.F.

1958—DEFENCE OF THE FUTURE VICTORY OF MEDICAL SCIENCE OVER CANCER. Acrilic on plywood covered with plastic cloth, 70 m². Oncology building, of the Centro Médico Nacional del IMSS, Mexico, D.F.

1958—DRAMA AND COMEDY IN THE SOCIAL LIFE OF MEXICO. Acrilic on pressed wood covered with fiberglass cloth, 160 m². Teatro Jorge Negrete, building of ANDA, Mexico, D.F.

1965—THE MARCH OF HUMANITY. Acrilic on asbestos-cement and steel sheets, 4600 m². POLYFORUM CULTURAL SIQUEIROS, Avenida Insurgentes Sur, Mexico, D.F.

1968—HOMAGE TO DIEGO RIVERA, JOSE CLEMENTE OROZCO, JOSE GUADALUPE POSADA, LEOPOLDO MENDEZ, DR. ATL. Sculpture-painting, acrilic on asbestos-cement and steel sheets, 24 x 4.6 meters. POLYFORUM CULTURAL SIQUEIROS, Avenida Insurgentes Sur, Mexico, D.F.

EXHIBITIONS, CATALOGUES AND MONOGRAPHS (by date)

Casino Español. *Siqueiros,* exhibition of 60 oils, xylographs, lithographs and drawings. (Mexico, D.F.) January 25 to February 18, 1932.

Pierre Matisse Gallery. *Siqueiros,* 16 pyroxylins on masonite. (New York) January 9 to February 3, 1940.

Instituto Nacional de Bellas Artes. *Siqueiros 70 Obras Recientes,* exhibition catalogue, (Mexico, D.F.) October 1947.

Instituto Nacional de Bellas Artes. *Siqueiros,* monograph. (Mexico, D.F.) Talleres Gráfico de la Nación, 1951.

Galeria de Arte Mexicano. *Siqueiros,* 21 portraits. (Mexico, D.F.) June 22 to July 11, 1953.

Siqueiros, Mural del Hospital de la Raza, ocho laminos. (Mexico, D.F.) *Arte Público,* 15 de diciembre 1954.

ACA Gallery. *Siqueiros,* exhibition commemorating his 65th birthday while in jail. (New York) January 1962.

New Art Gallery. *Siqueiros,* exhibition including paintings done in jail. (New York) February 1964.

Museum of Art and Science, University City. *Siqueiros Retrospective*, (Mexico, D.F.) August 7 to October 3, 1967.

Art Gallery Center for Interamerican Relations. *David Alfaro Siqueiros—Paintings 1935–1967*, exhibition catalogue. (New York) 1970.

Museo de Tokyo. *Siqueiros-Exposición Retrospectiva*, exhibition catalogue. (Tokyo) 1972.

Azpetia Carrilla Rafael. *Siqueiros*, monograph. (Mexico, D.F.) Secretaria de Educacion Publica, 1974.

Palacio de Bellas Artes. *Siqueiros:* Exposición de Homenaje, exhibition catalogue. (Mexico, D.F.) Instituto Nacional de Bellas artes, 1975.

Nostra Antologia Promossa Dalla Regione Toscana E Dal Museo d'Arte Moderna Di Citta del Messico. *Siqueiros*, exhibition catalogue with text by Mario Micheli (Firenze) 1976.

Instituto Nacional de Bellas Artes. *Siqueiros-Visión, Técnica, y Estructural*, commemorating tenth anniversary of Siqueiros' death. Monograph with essays by Albert Hijar and Felipe La Couture. 1984.

Dallas Museum of Art. *Images of Mexico*, exhibition catalogue. (Dallas) 1988.

Christie's. *Portrait of Present Day Mexico*, "A Mural by David Alfaro Siqueiros," exhibition catalogue. (New York) 1991.

BOOKS BY SIQUEIROS

Me Llamaban El Coronelazo. Mexico: Biografías Gandesa, 1977.

No Hay Mas Ruta Que La Nuestra. Mexico: Secretaría de Educación Pública, 1945.

El Muralismo de Mexico. Mexico: Enciclopedia Mexicana de Arte, Ediciones Mexicanas, 1950.

Como se Pinta un Mural. Mexico: Ediciones Mexicanas, 1951.

Mi Respuesta. Mexico: Ediciones "Arte Público", 1960.

La Trácala. Mexico, 1962.

A un Joven Pintor Mexicano. Mexico: Empresas Editoriales, S.A., 1967.

L"Art et La Révolucion. Paris: Editions Sociales, 1973.

Art and Revolution. London: Lawrence and Wishart, 1975.

SOME PAMPHLETS AND LEAFLETS WRITTEN BY SIQUEIROS

Plastic Exercise. Pamphlet (Argentina) December 1933. Siqueiros archive.

Centro de Arte Realista Moderno. leaflet, 1944. Siqueiros archive.

Boletín Editado Por el Comité Continental de Arte Para la Victoria. October 1943. Siqueiros archive.

Arte Público. Leaflet. February 1953. Siqueiros archive.

"Los Manifiestos, Los Vehículos de la Pintura, Dialéctico-Subversiva." *Cuadernos del Archivo Siqueiros I*. Mexico: Sala de Arte Público. (undated)

ARTICLES BY SIQUEIROS

"*Tres Llamamientos*." *Vida Americana* No. 1. (Barcelona) May 1921.

"Al Margen del Manifesto del Sindicato de Pintores y Escultores." *El Machete* num. 1 (Mexico) March 1924.

"Rivera's Counterrevolutionary Road." *New Masses*, May 29, 1934.

El Asalto a la Casa de Leon Trotsky. 1940. Siqueiros archive.

"Carta Abierta a Jaime Torres Bodet, Secretario de Educación Público." *Asi*. (Mexico) September 1, 1945.

"Cine Nacional o Falsificador?" *Asi!* (Mexico) September 19, 1945.

"Función de El Colegio Nacional." *Asi!* (Mexico) September 22, 1945.

"El Monóculo del Artepurismo de Paris en Mexico." *Mexico en el Arte* No. 4. (Mexico, D.F.) October 1948.

"La Exposición 'El Arte de Mexico por la Independencia Nacional Contra la Miseria y Por la Paz'." 1951.

"Declaraciones del Frente de Pintores Revolucionarios de Mexico." *Arte Público* (Mexico, D.F.) October 15, 1952.

"Conclusiones Sobre el Artículo de Philippe Soupault." *Arte Público* (Mexico, D.F.) November 1954.

"La Architectura Internacional a la Zaga de la Mala Pintura." *Arte Público* (Mexico, D.F.) November 1954.

"Homenaje Póstumo a Frida Kahlo." *Arte Público* (Mexico, D.F.) November 1954.

"Carta Abierta." *Arte Público* (Mexico, D.F.) January 1956.

"Lectures to Artists." *New University Thought,* Public Art Workshop reprint, (Chicago) 1962.

"On Returning to Major Art." *Review I* Monthly Review Press (New York) 1965.

Series of articles by Siqueiros under heading: "Crítica a la Crítica del Arte."

"Anticipo teórico a las opiniones de los críticos profesionales sobre la Exposición 'La Ciudad de Mexico Interpretada por sus Pintores'." *Excelsior* (Mexico, D.F.), December 13, 1949.

"Lazo, Mérida, Tamayo, Castellanos, Siqueiros, Rivera y Orozco, en el Libro 'La Nube y el Reloj, de Luis Cardoza y Aragon," *Excelsior* (Mexico, D.F.) December 23, 1949.

"Los Pintores Rufino Tamayo y Julio Castellanos en el Libro 'La Nube y el Reloj, de Luis Cardoza y Aragon," *Excelsior* (Mexico, D.F.), December 27, 1949.

"El Autor de Este Articulo en el Libro 'La Nube y el Reloj." *Excelsior* (Mexico, D.F.), January 3, 1950.

"Una Clara Voz de París en Nuestros Debates de Mexico," *Excelsior* (Mexico, D.F.), January 10, 1950.

"París Reniega del Artepurismo," *Excelsior* (Mexico, D.F.), February 7, 1950.

"Tres Años de I.N.B.A.—Carlos Pellicer y Carlos Chávez," *Excelsior* (Mexico, D.F.), February 14, 1950.

"La Sociedad de Arte Moderno," *Excelsior* (Mexico, D.F.), February 21, 1950.

"El Caso de Lincoln Kirstein," *Excelsior* (Mexico, D.F.), February 28, 1950.

"El INBA y la Historia de la Plástica," *Excelsior* (Mexico, D.F.), March 7, 1950.

"Picasso y Nuestro Arte Social," *Excelsior* (Mexico, D.F.), March 14, 1950.

"¿Qué ya lo Saben?—Preambulo al Tema: Moore y Neruda en Mexico," *Excelsior* (Mexico, D.F.), March 28, 1950.

"Moore y Neruda en México—Arte Formalista y Arte Social," *Excelsior* (Mexico, D.F.), April 4, 1950.

"Dos Cometidos—El Aristocrático de la Escultura de Moore y el Civico o Ciudadano de la Poesía de Neruda." *Excelsior* (Mexico, D.F.), April 11, 1950.

"Cultura Colonial—Sus Efectos Para LosFines de un Supuesto Arte Religioso Moderno en México." *Excelsior* (Mexico, D.F.), April 25, 1950.

Series of articles by Siqueiros under heading: "Filosofía y Pintura."
"Con el Ejemplo del Movimimiento de Pintura Moderna en México." I, *Excelsior* (Mexico, D.F.), January 18, 1950.
"Con el Ejemplo del Movimiento de Pintura Moderna en México." II, *Excelsior* (Mexico, D.F.), January 24, 1950.
"Con el Ejemplo del Movimiento de Pintura Moderna en México." III, *Excelsior* (Mexico, D.F.), January 31, 1950.

LECTURES AND SPEECHES GIVEN BY SIQUEIROS (by date)

Palacio de Minería (Mexico, D.F.).
 Addresses meeting in support of Sacco and Vanzetti. May 1, 1925.
Sala Vista Alegre (Guadalajara, Jalisco).
 Speech to Unions: "Yanqui Imperialism." June 13, 1925.
Confederation of Labor groups of Jalisco (Guadalajara).
 Speech in support of Sacco and Vanzetti. August 10, 1927.
Teatro Degollado (Guadalajara).
 Speech commemorating the 10th anniversary of the October Revolution. November 7, 1927.
Comité de Frente Único (Guadalajara).
 Speech: "Hands off of Nicaragua:" February 4, 1928.
Escuela Nacional Preparatoria (Mexico, D.F.).
 Speech for the Committee of the Defense of the Proletariat. December 8, 1928.
Anti-imperialist meeting (Mexico, D.F.).
 Speech: "Down With Mr. Hoover; Viva Sandino!" December 21, 1928.
Meeting commemorating the Paris Commune (Mexico, D.F.).
 Speech, March 18, 1929.
Casino Español (Mexico, D.F.).
 "Rectification of the Plastic Arts in Mexico." February 18, 1932.
Chouinard School of Art (Los Angeles, California).
 "The Mexican Renaissance." July 1932.
The John Reed Club (Hollywood, California).
 "The Vehicles of Dialectical-Subversive Painting." September 2, 1932.
Asociacion Amigos del Arte (Buenos Aires).
 "The Mexican Renaissance." June 1, 1933. "The Resurrection of Painting." June 17, 1933.
The Faculty of the Humanities (La Plata, Argentina)
 "The Mexican Renaissance and the Movement of Los Angeles." June 24, 1933.
Salon La Argentina (Buenos Aires)
 "Is Art an End in Itself or on the Contrary a Social Function." June 28, 1933.
Biblioteca Argentina (Rosario de Santa Fe, Argentina).
 "Birth of Mexican Proletarian Art." July 3, 1933.
Escuela Normal No. 2 (Rosario de Santa Fe, Argentina).
 "The Painter's Bloc of Los Angeles." July 4, 1933. "Plastic Art of the Future." July 5, 1933.
Palacio de Bellas Artes (Mexico, D.F.).
 "Art." Address to a group of American educators. August 28, 1935.
Town Hall (New York).
 "The Mexican Experience in the Plastic Arts." February 15, 1936.
Star Casino (New York)
 Address to Latin American Colony of New York. February 1936.
A.C.A. Gallery (New York)
 Gives conference on the activities of the workshop-school of the League of Revolutionary Writers and Artists (LEAR). April 15, 1936.
University of Valencia (Valencia, Spain)
 "Art as a Tool of Struggle." February, 1937.

Galerie d'Anjou (Paris)
"Art in the Contemporary Social Battle." November 21, 1938.
Teatro Imperi (Santiago, Chile)
"The History of Mexican Painting, Its Doctrines and Techniques." May 31, 1942.
Ateneo de Temuco (Temuco, Chile)
"The History of Modern Mexican Painting." August 10, 1942.
Teatro Baquedano (Santiago, Chile)
Speech to support the World War II war effort with art. February 7, 1943.
Teatro Baquedano (Santiago)
Address to the Provisional Continental Committee in support of the art of Latin America serving the Allied war effort March 3, 1943.
Teatro Municipal de Bogotá (Bogotá, Columbia)
"Art For Victory." April 2, 1943.
Universidad Nacional de Panamá (Panamá)
"Art For Victory." April 6, 1943.
Anfiteatro Municipal de Havana (Havana, Cuba)
"In War, Art of War." April 20, 1943.
Centro de Dependientes de Havana (Havana)
"Mexican Modern Painting and its Ramifications Abroad at the Service of the Democracies." May 8, 1943.
Lyceum de Havana (Havana)
"The Future of the Plastic Arts in Latin America." May 13, 1943.
Frente Nacional Antifascista (Havana)
Speech. May 20, 1943.
Anfiteatro Muncipal (Havana)
Speech to Confederation of Workers of Cuba. May 20, 1943.
Escuela Nacional de Artes Plásticas de Lima (Lima, Peru)
"Mexican Modern Painting and Art For Victory." March 22, 1943.
Salón del El Telégrafo (Guayaquil, Ecuador)
"Mexican Modern Painting and Art For Victory." March 24, 1943.
Universidad Central de Quito (Quito, Ecuador)
"Art For Victory." March 26, 1943.
Escuela de Bellas Artes de Bogotá (Bogotá)
"The Materials and Tools of the Plastic Arts For the Present Epoch." April 1, 1943.
El Salón Anual de Pintura Y Escultura de Artistas Cubanos (Havana).
"Open Letter To The Modern Painters and Sculptors of Cuba." September 1943.
El Colegio Nacional (Mexico, D.F.)
"The Historical Course of Modern Mexican Painting." February 15, 1945.
Instituto de Intercambio Cultural Mexicano-Ruso (Mexico, D.F.).
"Mexico and the Soviet Union and the Art of Painting." October 15, 1945.
Arena Mexico (Mexico, D.F.)
Speech honoring the Mexicans who fought in Spain against Franco. May 8, 1946.
Palacio de Bellas Artes (Mexico, D.F.).
Self-critical discourse at the close of his exhibition. December 10, 1947.
Instituto Politécnico Nacional (Mexico, D.F.).
"Chemistry and the Art of Painting." April 29, 1948.
Villalogín 50 (Mexico, D.F.).
"The Plastic Arts in the Battle For Peace." July 20, 1948.
Escuela Universitaria de Bellas Artes de San Miguel de Allende
(San Miguel de Allende, Guanajuato, Mexico). September 1948.
Anfiteatro Bolivar de la Escuela Nacional Preparatoria (Mexico, D.F.).
Eulogy on death of Orozco. November 15, 1949.
Palacio de Bellas Artes (Mexico, D.F.).
"The Work of David Alfaro Siqueiros." August 25, 1950.
Palacio de Bellas Artes (Mexico, D.F.).
"Affirmations and Contradictions in the Plastic Arts of Mexico." November 24, 1950.

Presented by the Newspapers *Rinascita* and *L'Unita* (Rome).
 "The History of Mexican Painting and the Workingclass Movement in My Country."
 October 17, 1951.
Centro Bolivar (Paris).
 "The Real Significance of Modern Painting Facing the School of Paris." October 28, 1951.
Maison de la Pensée Francaise (Paris).
 Discourses about his murals with slide projections. November 1, 1951.
Union of Polish Painters (Warsaw)
 "Our Modern Mexican Painting, a Humble Experience of Social Realism in a Capitalist
 Country." November 8, 1951.
Union of Plastic Arts (Prague).
 Lecture, November 11, 1951.
Stedelijk Museum (Amsterdam)
 Lecture, November 18, 1951.
Palacio de Bellas Artes (Mexico, D.F.)
 "Art Inside and Outside of the Iron Curtain." January 24, 1952
Palacio de Bellas Artes (Mexico, D.F.).
 "Art in the Poland of Today." January 31, 1952
Instituto Politécnico Nacional (Mexico, D.F.).
 "Man The Boss and Not The Slave of Technology." February 18, 1952.
Teatro Arbeu (Mexico, D.F.).
 "For Freedom of Expression." March 30, 1952.
Sindicato de Telefonistas (Mexico, D.F.).
 "Socialist Realism in Painting: My Reply to the Enemies of Soviet Art and Modern Mexican
 Painting." April 24, 1952.
Palacio de Bellas Artes (Mexico, D.F.).
 Three lectures before the National Assembly of the Plastic Arts. May 12, 13, 14, 1952.
Casa del Arquitecto (Mexico, D.F.).
 "Architecture on the Tail End of Bad Painting." September 10, 1953.
Tribuna de Mexico (Mexico, D.F.).
 "*Neoporfirismo* in Art." October 16, 1953.
Universidad Obrera de Mexico (Mexico, D.F.).
 "The Yankee Imperialist Conspiracy Against the Mexican Pictorial Movement." October
 23, 1953.
Casa del Arquitecto (Mexico, D.F.).
 "Enemy Critics and Friendly Critics of Mexican Contemporary Painting." March 23, 1954.
Casa del Arquitecto (Mexico, D.F.).
 "Towards Realism in the Plastic Arts." July 2, 1954.
Palacio de Bellas Artes (Mexico, D.F.).
 "A Healthy Presence of Mexican Art in the Capital of Formalism in France." August
 26, 1954.
La Tribuna de Mexico (Mexico, D.F.).
 "Italy, Paris and Mexico in the Art of Painting." August 5, 1955.
House of the Painters (Moscow).
 Lecture, October 8, 1955.
House of the Painters (Leningrad).
 Lecture, October 13, 1955.
Soviet Academy of Art (Moscow).
 "Open Letter to Soviet Artists." October 17, 1955.
Nuevo Teatro de Danza (Mexico, D.F.).
 "The Dance as Plastic Art." February 21, 1956.
Instituto de Arte de Mexico (Mexico, D.F.).
 "The Mexican Pictorial Movement Enters its Second Stage." April 20, 1956.
Auspices of Ministry of Education of India (New Delhi).
 "Origins and Motives of Mexican Painting." November 13, 1956. "Team work and Plastic
 Integration." November 14, 1956.

Academy of Fine Arts (Calcutta).
 Discourse on Mexican art. November 20, 1956.
Sindicato Mexicano de Electricistas (Mexico, D.F.).
 Speech honoring Sandino on 23rd anniversary of his death. February 21, 1957.
38th Anniversary of Communist Party of Mexico (Mexico, D.F.).
 "The Party Role in the System of Imposing a Mexican President." October 6, 1957.
Rotonda de los Hombres Ilustres (Mexico, D.F.).
 Eulogy at burial of Diego Rivera. November 26, 1957.
Pushkin Museum (Moscow).
 "Technical Experiences of the Mexican Mural Movement." December 1957.
Frente Nacional de Artes Plásticas (Mexico, D.F.).
 "The General Revision of the Plastic Arts on the Producing of the Mexican Movement 1906-1940 and 1940-1957." February 11, 1958.
Universidad Obrera de Mexico (Mexico, D.F.).
 Polemic: "Social Painting as Art." September 1957.
Sociedad Mexicana de Geografía y Estadística (Mexico, D.F.).
 "The Art of Painting and the Mexican Revolution." November 21, 1958.
Asociación Nacional de Actores (Mexico, D.F.).
 "Defense of Freedom of Expression." May 9, 1959.
Museum of Modern Art of Havana (Havana).
 "Painting in the Cuban Revolution and the Experience of Painting in the Mexican Revolution." January 6, 1960.
Universidad Central de Caracas (Caracas).
 "Plastic Artes and the Revolution in Latin America." January 9, 1960.
Museo de Bellas Artes de Caracas (Caracas).
 "Public Art in the Revolution and the Mexican Experience in Muralism." January 11, 1960.
Asociación Venezolana de Periodistas (Caracas).
 "The Mexican Revolution, A Revolution Frustrated." January 12, 1960
Channel 4, Cuban Television (Havana).
 "Scale and Motives of the Aggression of the Government of Mexico Against the Movement of Railroad workers." January 17, 1960.
XIV General Assembly of the International Association of Art Critics (Mexico, D.F.).
 Letter from prison to critics explaining Mexican Mural Movement. September 9, 1962.
XIII International Congress of Philosophy (Mexico, D.F.).
 From prison sends open letter urging Philosophers to interest themselves in fighting for philosophy in art as against an art devoid of any philosophical content. September 11, 1963.
Nuevo Teatro Ideal (Mexico, D.F.).
 As a candidate of the Electoral Front of the People for senator, sends an address from prison. "We Struggle for a Congress of the Union Not Subject to the Executive." April 24, 1964.
Room of the Revolution of the National Museum of History (Mexico, D.F.).
 "A Muralist Should Have a Theme and the Mural is His Pulpit." July 16, 1964.
Teatro Lirico (Mexico, D.F.).
 XI anniversary of the assault on the Moncada Barracks, Cuba. "The Anti-imperialist Caracter of the Mexican Revolution." July 26, 1964.
L'Humanite (Paris)
 Speech at event in his honor. March 26, 1965.
Communist Party of Italy (Rome)
 Speech on receiving the Medal of the Garibaldi Brigade. April 6, 1965.
House of Culture (Rome)
 "Mural Painting and Easel Painting." April 7, 1965.
Hemiciclo de Juárez (Mexico, D.F.).
 Meeting protesting U.S. invasion of Dominican Republic. "Mexico was Invaded by the Yankee Imperialists in the Past Century, in Veracruz, in Chihuahua." May 7, 1965.
Comité por la Libertad de los Presos Politicos (Mexico, D.F.)
 Speech, March 21, 1966.

Palacio de Bellas Artes (Mexico, D.F.).
 :"Confrontation? Yes, Between the Two Basic Currents in Mexico: Objectivity (Realism) or Subjectivity (Abstractionism)." May 4, 1966.
Teatro Lirico (Mexico, D.F.).
 Speech: Solidarity with Cuba and Vietnam meeting. July 31, 1966.
Room of the Revolution, National Museum of History (Mexico, D.F.).
 "Muralism is Alive and on the March." November 18, 1966.
Palacio Nacional (Mexico, D.F.).
 Speech on receiving the National Prize of Art. December 15, 1966.
70th Birthday Dinner (Mexico, D.F.).
 "We Have Not Done All That is Necessary For Mexico." February 21, 1967.
Embassy of the Soviet Union (Mexico, D.F.).
 Speech on receiving the Lenin Peace Prize. April 30, 1967
Auditorio Justo Sierra, Cuidad Universitaria (Mexico, D.F.).
 Discourse at inauguration of retrospective exhibition. August 22, 1967.
Burial of Filomeno Mata (Mexico, D.F.).
 Eulogy: "Comrade of Our Struggle We will Always be Together For the People and Their Cause." August 30, 1967.
Museum of Science and Art, University City (Mexico, D.F.).
 Self-critical analysis of his work. October 2, 1967.
Conference before 200 critics and artists (Paris).
 Explains mural, *March of Humanity*. December 2, 1967.

LETTERS AND ARCHIVAL MATERIAL

Siqueiros, letter to Casauranc, June 17, 1925. Siqueiros archive.
Museum of Modern Art to State Department, March, 1943, U.S. Govt. archive.
American Embassy, (Lima) to U.S. state department, April 9, 1943, U.S. archive.
State Department, Philip W. Bonsal to Spruille Braden, April 14, 1943, U.S. Govt. archive.
Gustavo Durán, memorandum to Ambassador Spruille Braden, April 16, 1943, U.S. State Department.
Siqueiros letter to maestro Carlos Chávez, May 27, 1947. Siqueiros archive.
Siqueiros' open letter to the press "Rompe con el Director," explaining problems of mural *Monument to Ignacio Allende*, July 6, 1949. Siqueiros archive.
Siqueiros' letter to architect Carlos Lazo, February 20, 1951. Siqueiros archive.
Rivera to Siqueiros, May 29, 1953. Siqueiros archive.
Siqueiros to Rivera, June 3, 1953. Siqueiros archive.
Engineer Carlos Colinas to Siqueiros, June 3, 1953. Siqueiros archive.
Architect Gustavo García Travesí to Siqueiros, June 9, 1953. Siqueiros archive.
Siqueiros to Secretary General of the Communist Party, Dionisio Encina, August 13, 1953. Siqueiros.
Siqueiros to Adolfo Ruiz Cortines, President of the Republic: *Los Muralistas se Dirigen al Señor Presidente Demando Condiciones Mas Justas de Trabajo*, April 1955. Siqueiros archive.
Siqueiros *Al XIII Congreso Internacional de Filosofía*, September 9, 1963.
Siqueiros to Frente Electoral del Pueblo, April 24, 1964. Siqueiros archive.

BOOKS ABOUT SIQUEIROS

Alvarez Bravo, Carrillo, Mendez, Pellicer, Zevada. *Mural Painting of the Mexican Revolution, 1921-1960*. Mexico, D.F.: Editorial Fund for Mexican Plastic Arts. Auspicies of Banco Nacional de Comerceo Exterior, S.A., 1960
Arenal, Angélica. *Paginas Sueltas Con Siqueiros*. Mexico: Editorial Grijalbo, 1980.
Brenner, Anita *Idols Behind Altars*. New York: Biblo and Tanner, 1967.
Campa, Valentín. *Mi Testimonio*. Mexico, D.F.: Ediciones de Cultura Popular, 1978.

Charlot, Jean. *The Mexican Mural Renaissance 1920-25*. New Haven: Yale University Press, 1963.

Fernandez, Justino. *Arte Mexicano*. Mexico, D.F.: Editorial Porrua, S.A., 1975.

Gual, Enrique. *Siqueiros*. Mexico, D.F.: Galeria de Arte Misrachi, 1965.

Hurlburt, Laurence P. *The Mexican Muralists in the United States*. Albuquerque: University of New Mexico Press, 1989.

Luna Arroyo, Antonio. *Siqueiros-Sinopsis de Su Vida y Su Pintura*. Mexico, D.F.: Editorial Cultura, 1950.

Micheli, Mario de. *Siqueiros* New York: Harry N. Abrams, Inc., 1968.

Neuvillate-Ortiz, Alfonso de. *10 Pintores Mexicanos*. Mexico, D.F.: Ediciones Galerias de Arte Misrachi, 1977.

Robinson, Ione. *A Wall To Paint On*. New York: Dutton, 1946.

Rochfort, Desmond. *Mexican Muralists*, Universe Publishing, New York, 1994.

Rodman, Selden. *Mexican Journal*. New York: Devin-Adair, 1958.

Sánchez Salazar, Leandro A. *Asi Asesinaron A Trotski*. Mexico, D.F.: Populibros "La Prensa", 1955.

Sichev, Stanislav. "Glorificar El Mundo," *Invitación al Dialogo*. Moscu: Editorial Progreso, 1986.

Solis, Ruth. (ed.) *Vida y Obra de Siqueiros, Juicios Criticos*. Mexico: Fondo de Cultura Economica, 1975.

Stein, Philip. *The Mexican Murals* Mexico, D.F.: Editur, S.A., 1984.

Suárez, Orlando S. *Inventario del Muralismo Mexicano*. Mexico: Universidad Nacional Autonoma de Mexico, 1972.

Tibol, Raquel and Reyes, Victor. *David Alfaro Siqueiros*. Argentina: Editorial Codex, S.A., 1964.

Tibol, Raquel. *David Alfaro Siqueiros y Su Obra*. Mexico: Empresas Editoriales, S.A., 1969.

———. *Documentación Sobre el Arte Mexicana*. Mexico: Archivo del Fondo 11, Fondo de Cultura Económica, 1974.

ARTICLES IN PERIODICALS, NEWSPAPERS AND PAMPHLETS ABOUT SIQUEIROS

Arenal, Angélica. "Siqueiros, Soldado Constitucionalista," *Novedades* (Mexico City), Supplement, "Mexico en la Cultura," September 23, 1951.

Arrellano Z., Manuel. "El Mural de Siqueiros en Chapultepec," *El Universal* (Mexico, D.F.), April 20, 1969.

Atisbos (Mexico), February, 1952.

Brum, Blanca Luz. *El Universal* (Mexico, D.F.), August 17, 1932.

Cardoza y Aragón, Luis. "Nuevas Notas Sobre Alfaro Siqueiros," *Mexico en el Arte* (Mexico), October 1948.

Cervera, Juan. "El Polyforum, Gran Obra Cultural," *Ovaciones* (Mexico), December 23, 1971.

Chávez-Morado, José. "Siqueiros y el Centro de Arte Realista," *La Voz de Mexico* (Mexico, D.F.), July 16, 1944.

Crespo de la Serna, Juan. "Siqueiros' Mural," *Universidad de Mexico* Vol. IX Nos. 10-11, (Mexico, D.F.), July 1955.

Eisenberg, Emanuel. "Battle of the Century," *New Masses*, December 10, 1935.

El Universal (Mexico, D.F.), August 9, 1960, pp. 11, 23.

El Universal Gráfico (Mexico, D.F.), August 10, 1960, pp. 3, 4.

"Escuela Sin Maestros," *Tiempo* (Mexico), July 29, 1949.

Estaño, Felipe. "In the Tradition of Siqueiros," *World Magazine* (New York), Supplement, "The Daily World and People's World," September 24, 1977.

Excelsior (Mexico, D.F.), September 25, 1953, p. 4, Col. 5.

Excelsior (Mexico, D.F.), "Diorama de la Cultura," January 11, 1959.

Excelsior (Mexico, D.F.), May 11, 1959, pp8, 12.

Excelsior (Mexico, D.F.), November 18, 1959, p.4.

Fernández Marquez, P. "Inauguracion del Polyforum Siqueiros," *El Nacional* (Mexico, D.F.), December 26, 1971.

Goldman, Shifra M. "Las Criaturas de la American Tropical: Siqueiros y Los Murales en Los Angeles," *Revista de Bellas Artes* (Mexico, D.F.), Enero-Febrero 1970.

Hijar, Ortega, Arriaga. "La Legislación del Trabajo y Siqueiros," *Cuadernos del Archivo Siqueiros* 2 (Mexico, D.F.), Sala de Arte Público, 1970.

Hurlburt, Laurence. "The Siqueiros Experimental Workshop," *Art Journal* XXXV/3 Spring 1976.

――――. "David Alfaro Siqueiros' Portrait of the Bourgeoisie," *Artforum* (New York), February 1977.

Kirstein, Lincoln. "Through An Alien Eye," *Forma* (Chile), December 1942.

Leon Portilla, Miguel. "Justino Fernández," *Novedades* (Mexico, D.F.), Supplement, "Mexico en la Cultura," December 7, 1958.

Los Angeles Times June 1954, reprinted in *Arte Público* (Mexico, D.F.), November 1954, p. 23.

Malvido, Adriana. "El Muralismo Como Lenguaje," *Hechos* No. 4 (Mexico, D.F.), Multibanco Mercantil de Mexico, July-August 1984.

Meinhard, Hermine. "David Alfaro Siqueiros and Phil Stein: A Revolutionary Tradition," *Artworkers News* Vol. 9, No. 9 (New York), Foundation of the Community of the Artist, May 1980.

Newsweek, October 28, 1957, p. 100.

North, Joseph. "Siqueiros, Wizard of the Mural," *American Dialog* (New York), Spring 1968.

Novedades (Mexico, D.F.), April 5, 1951, p. 1, Col. 2.

Pallares, Eduardo. "Revelación Estética," *El Universal* (Mexico, D.F.), December 9, 1947.

Palomin, J. "El Mural de Siqueiros de San Miguel," *Excelsior* (Mexico, D.F.), May 8, 1949.

Pineda, Sergio. "Siqueiros, El Coronelazo," *Prisma* (Havana), September 1980.

Pulido Silva, Alberto. "Interpretación Estética del Mural de Siqueiros en 'La Raza'," *Excelsior* (Mexico, D.F.), Supplement, "Diorama de la Cultura," September 23, 1956.

Renau, José. "Mi Experiencia Con Siqueiros," *Revista de Bellas Artes* (Mexico, D.F.), January–February 1976.

Rivera, Diego. *El Nacional*, editorial page. (Mexico, D.F.), June 18, 1950.

Rodríguez, Antonio. "El Polyforum Siqueiros," *El Dia* (Mexico, D.F.), February 29, March 1, March 3, 1972.

Rodríguez Lozano, Manuel. "Desfiguracion del Arte Mexicano," *Excelsior* (Mexico, D.F.), May 25, 1952.

Ryan, Don. "Parade Ground," *Illustrated Daily News* (Los Angeles), Oct. 11, 1932.

Scherer García, Julio. "Siqueiros Con la Pistola en la Mano," *Excelsior* (Mexico, D.F.), Supplement, "Diorama de la Cultura," January 11, 1959.

Siglo (Mexico, D.F.), May 24, 1959, p. 6.

Siqueiros Imprisoned—1960-4". *Public Art Workshop* (Chicago), 1960.

Soupault, Philippe. "Une Tache Gigantesque," *Arte Público* (Mexico, D.F.), November 1954.

Suárez, Luis. "Siqueiros Victoria del Hombre," *Diario Mexico*, December 16, 1971

Suárez, Orlando. "David Alfaro Siqueiros—A Guide to the Study of His Life and Work," *Arte Público*—special edition (Mexico), Jan.–Feb. 1969, pamphlet.

Tibol, Raquel. "El Pueblo, a la Universidad," *Novedades* (Mexico, D.F.), Supplement, "Mexico en la Cultura," March 25, 1956.

――――. *Novedades* supplement, "Mexico en la Cultura," (Mexico, D.F.), Aug. 12, 1956

――――. "Siqueiros y la Transormación del Arte," *Mexico en el Arte* No. 5 (Mexico, D.F.), Instituto Nacional de Bellas Artes, Junio 1984.

"Palabras Pronunciadas En El Decimo Aniversario De La Muerte De David Alfaro Siqueiros," *Cuadernos del Archivo Siqueiros* (Mexico, D.F.) 6 de Enero 1984.

GOVERNMENT DOCUMENTS

Material was compiled from documents released under the Freedom of Information Act from the following government agencies:

Federal Bureau of Investigation
National Archives
National Security Agency
The Central Intelligence Agency
United States State Department

BACKGROUND BOOKS

Agee, Philip. *Inside the Company, CIA Diary*. New York: Stonehill Publishing Company, 1975.

Barckhausen-Canale, Christiane. *Verdad y Leyenda de Tina Modotti*. Havana: Casa de Las Americas, 1989

Barragan Rodríguez, Juan. *Historia del Ejército y de la Revolución Constitucionalista* Vol. II. Mexico, D.F., 1946.

Biddle, George. *An American Artist's Story*. Boston: Little Brown, 1939.

Brown W., Milton *The Painting of the French Revolution*. New York: Critics Group, 1938.

Buendia, Manuel. *La CIA en Mexico*. Mexico: Ediciones Océano, S.A., 1984.

Burckhardt, Jacob. *Judgements on History and Historians*. Boston: Beacon Press, 1958.

Campa, Valentín. *Ni Testimonio*. Mexico: Ediciones de Cultura Popular, 1978.

Cheetham, Nicholas Sir. *A Short History of Mexico*. New York: Thomas and Crowell Co., 1972.

Coe, Michael D. *Mexico*. London: Thames and Hudson, 1962.

Crow, John A. *Mexico Today*. New York: Harper and Row, 1972.

Cue Canovas, Augustin. *Historia Social y Económica de Mexico, 1521-1810*. Mexico: Editorial America, 1946.

Deutscher, Isaac. *The Prophet Outcast*. New York: Oxford University Press, 1963.

Díaz del Castillo, Bernal. *Historia de la Conquista de Nueva España*. Mexico: Editorial Porrua, S.A., 1976.

Dulles, John W.E. *Yesterday in Mexico*. Austin and London: University of Texas Press, 1972.

Eckstein, Susan. *The Poverty of Revolution*. Princeton: Princeton University Press, 1977.

Egbert, Donald D. *Social Radicalism and the Arts*. New York: Alfred A. Knopf, 1970.

Fehrenbach, T.R. *Fire and Blood*. New York: Macmillan, 1973.

Foster, William Z. *Outline Political History of America*. New York: International Publishers, 1951.

Friedman, B.H. *Jackson Pollack*. New York: McGraw-Hill.

Hansen, Roger D. *The Politics of Mexican Development*. Baltimore: John Hopkins, 1974.

Hauser, Arnold. *The Social History of Art* Vol. 3. New York: Vintage Books, 1957.

Ibarruri, Dolores. *They Shall Not Pass*. New York: International Publishers, 1976.

Lavrov, N.M. "La Revolución Mexicana de 1910–1917," in *La Revolución Mexicana: Cuatro Estudios*. Mexico: Ediciones de Cultura Popular, 1977.

Leith, John A. *The Idea of Art As Propaganda in France, 1750-1799*. Toronto: University of Toronto, 1965

Leon Portilla, Miguel and Garabay K., Angel Ma. *Visión de Los Vencidos*. Mexico: Universidad Nacional Autónoma, 1976.

MacLachlan, Colin M. *Criminal Justice in 18th Century Mexico*. Berkeley: University of California Press, 1974.

Marshall, Herbert. *Mayakovsky*. New York: Hill and Wang, 1965.

Marx, Karl. *Eighteenth Brumaire of Louis Bonaparte*. Moscow: Foreign Language Publishing House, 1954.

Matthews, Herbert L. *Half of Spain Died*. New York: Charles Scribner, 1973.

McDonald, William F. *Federal Relief Administration and the Arts*. Columbus: Ohio State University Press, 1969.

Nicholson, Irene. *Firefly in the Night*. London: Faber and Faber, 1924.

Pacheco, Anguiano, and Vizcaíno. *Cárdenas y la Izquierda Mexicana*. Mexico: Juan Pablos Editor, S.A., 1975.

Panofsky, Erwin. *The Life and Art of Albrecht Dürer*. Princeton: Princeton University Press, 1955.

Ramos, Samuel. *Man and Culture in Mexico.* New York: McGraw-Hill, 1962.

Stevens, Evelyn P. *Protest and Response in Mexico.* Cambridge: MIT Press, 1974.

Turner, John Kenneth. *Mexico Bárbaro.* Mexico: Editorial Época, S.A., 1978.

Von Hagen, Victor Wolfgang. *The Ancient Sun Kingdoms of the Americas.* New York: World Publishing Company, 1961.

Vygotsky, L.S. *The Psychology of Art.* Cambridge: MIT Press, 1971

Wilkie, James W. *The Mexican Revolution.* Berkeley: University of California Press, 1973.

Wolfe, Bertram D. *The Fabulous Life of Diego Rivera.* New York: Stein and Day, 1963.

BACKGROUND ARTICLES IN NEWSPAPERS, PERIODICALS AND PAMPHLETS

Cortés, Fernando G. "La Revolución Democrático-Burguésa de Mexico Traicionada por la Burguesía," *La Voz de Mexico,* early 1950's undated newsclipping.

Cruells, Manuel, "El Asesinato de Trotski," *Historia y Vida* No. 41 (Barcelona-Madrid), Agosto 1971.

Fernández Ledesma, Gabriel. "El Triunfo de la Muerte," Mexico en el Arte No. 5 (Mexico, D.F.) I.N.B.A., November 1948.

International Information Brigade, National Strike Council, Mexico City, "Notes From The Underground," *Evergreen* No. 64 (New York) March 1969.

Leizerov, N. "The Birth of a New Art," *Marxist-Leninist Aesthetics and Life,* ed. Kulskova and Zis. Moscow: Progress Publishers, 1976.

Leon Portilla, Miguel, "Justino Fernández," *Novedades* (Mexico, D.F.) Supplement, "Mexico en la Cultura," December 7, 1958.

Linghagen, Nils. *Prisma* Nos. 5–6 (Stockholm), July 5, 1950.

Machete No. 180 (Mexico, D.F.), April 1930.

Manana (Mexico, D.F.), December 1955.

Mexican Art and Life No. 5 (Mexico, D.F.) January 1939.

Muray, Nickolas. "Pre-Columbian Fine Art," *Natural History,* March 1958.

O'Connor, Harvey. "McCarthyism in Mexico," Monthly Review (New York), April 1961.

Orozco, José Clemente. "Fragmento de la Autobiografia," *El Nacional* (Mexico, D.F.) Supplement, "Revista Mexicana de Cultura," seccion de libros, September 25, 1949.

Ramírez, J. Guadalupe A., *Querétaro,* Editorial Querétaro, (Querétaro, Mexico) 1945.

Simpson, Lesley Byrd. "The Tyrant Maize," *The Cultural Landscape,* ed. C.L. Salter, University of California, 1971 (Los Angeles).

Tiempo (Mexico, D.F.), June 11, 1948.

Toledano, V.L., "Contenido y Transcendencia del Pensamiento Popular Mexicano," *Universidad Obrero de Mexico,* 1947

Valsecchi, Marco. *Paese Sera* (Rome), June 13, 1950

INDEX*

*Murals are in small caps. Paintings in italic. Periodical names in quote marks.

393